Deserts of the World
Déserts du monde

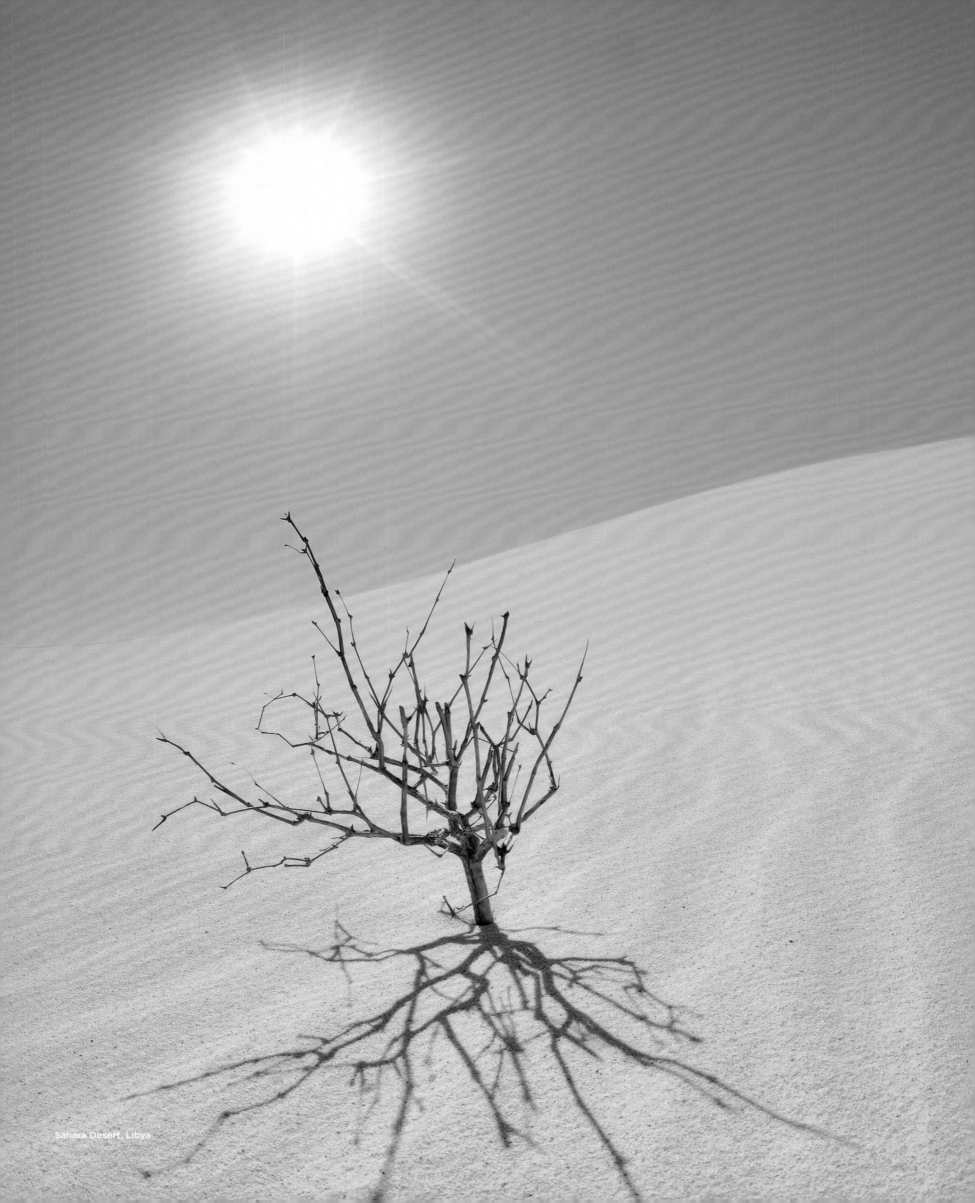

Sahara Desert, Libya

Deserts of the World
Déserts du monde

Susanne Mack
Anthony Ham

ÉDITIONS
PLACE DES
VICTOIRES

KÖNEMANN

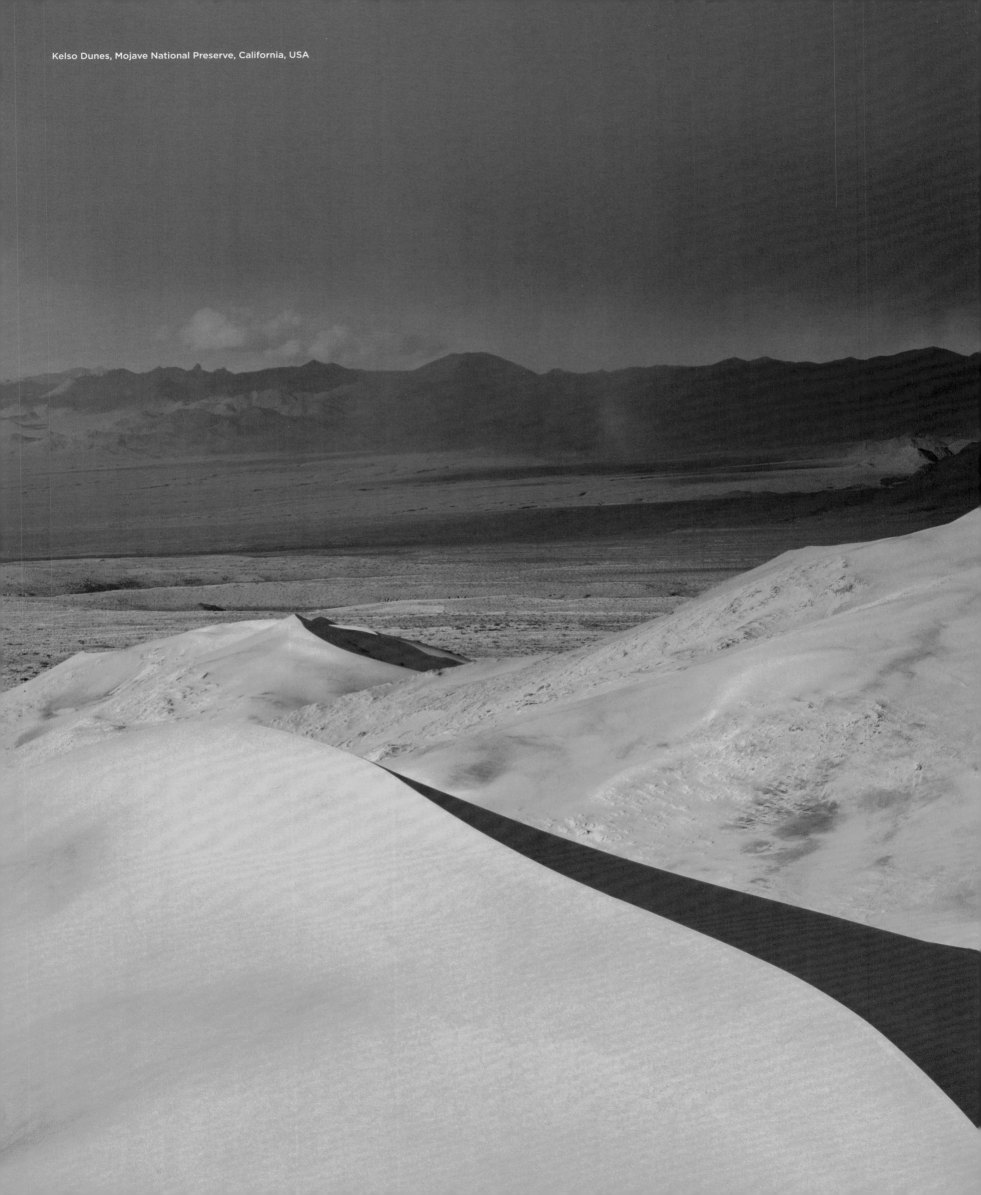

Kelso Dunes, Mojave National Preserve, California, USA

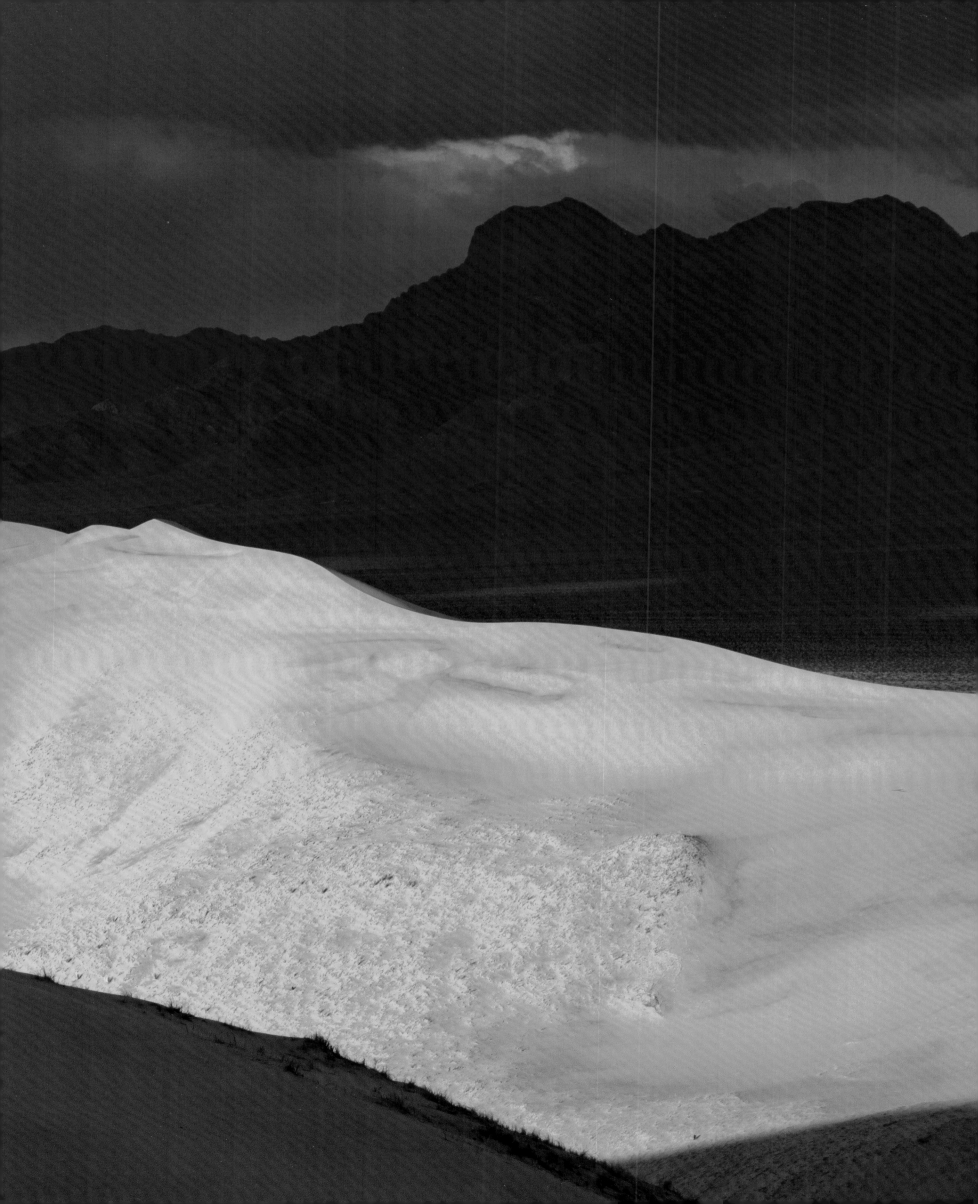

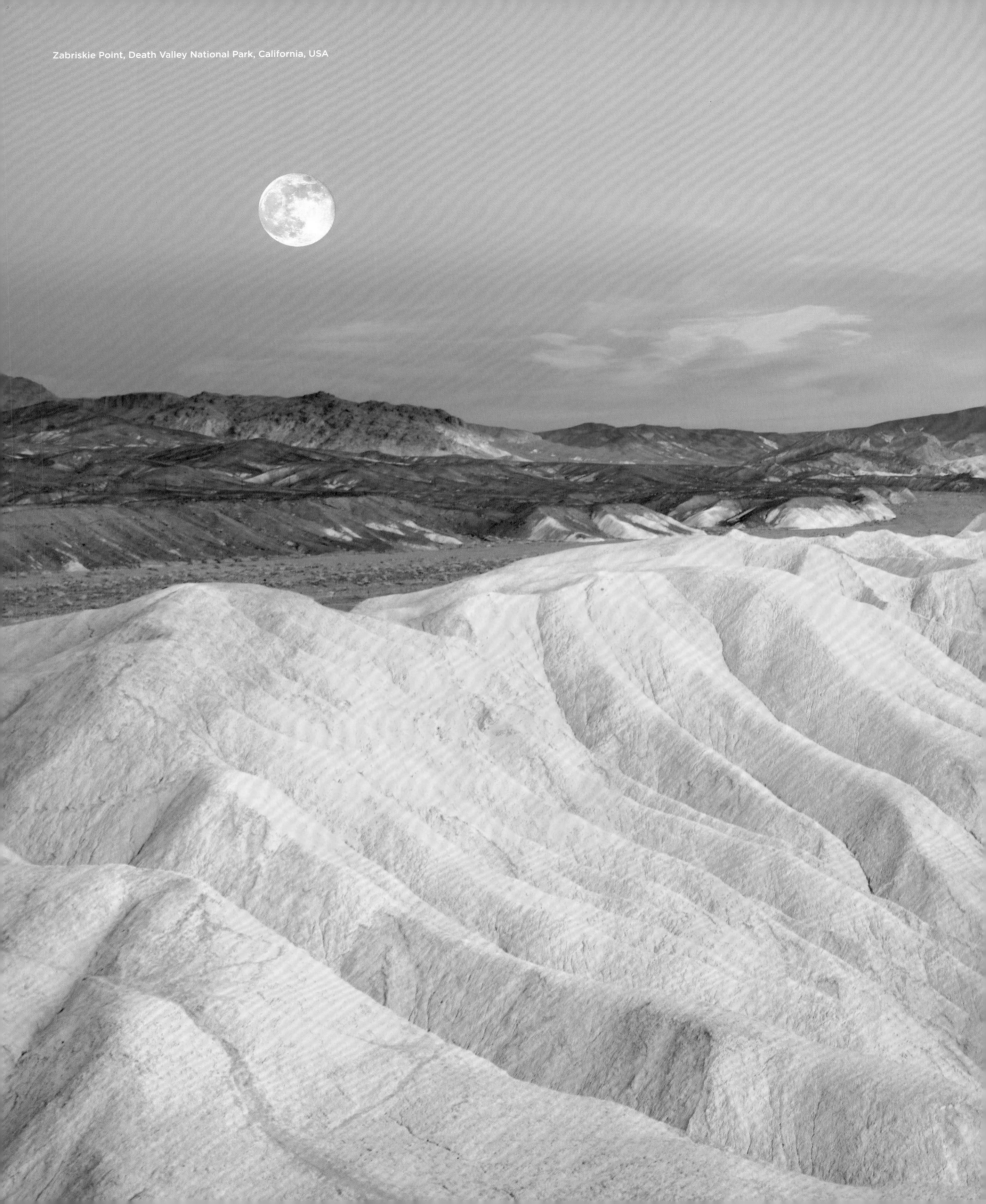

Zabriskie Point, Death Valley National Park, California, USA

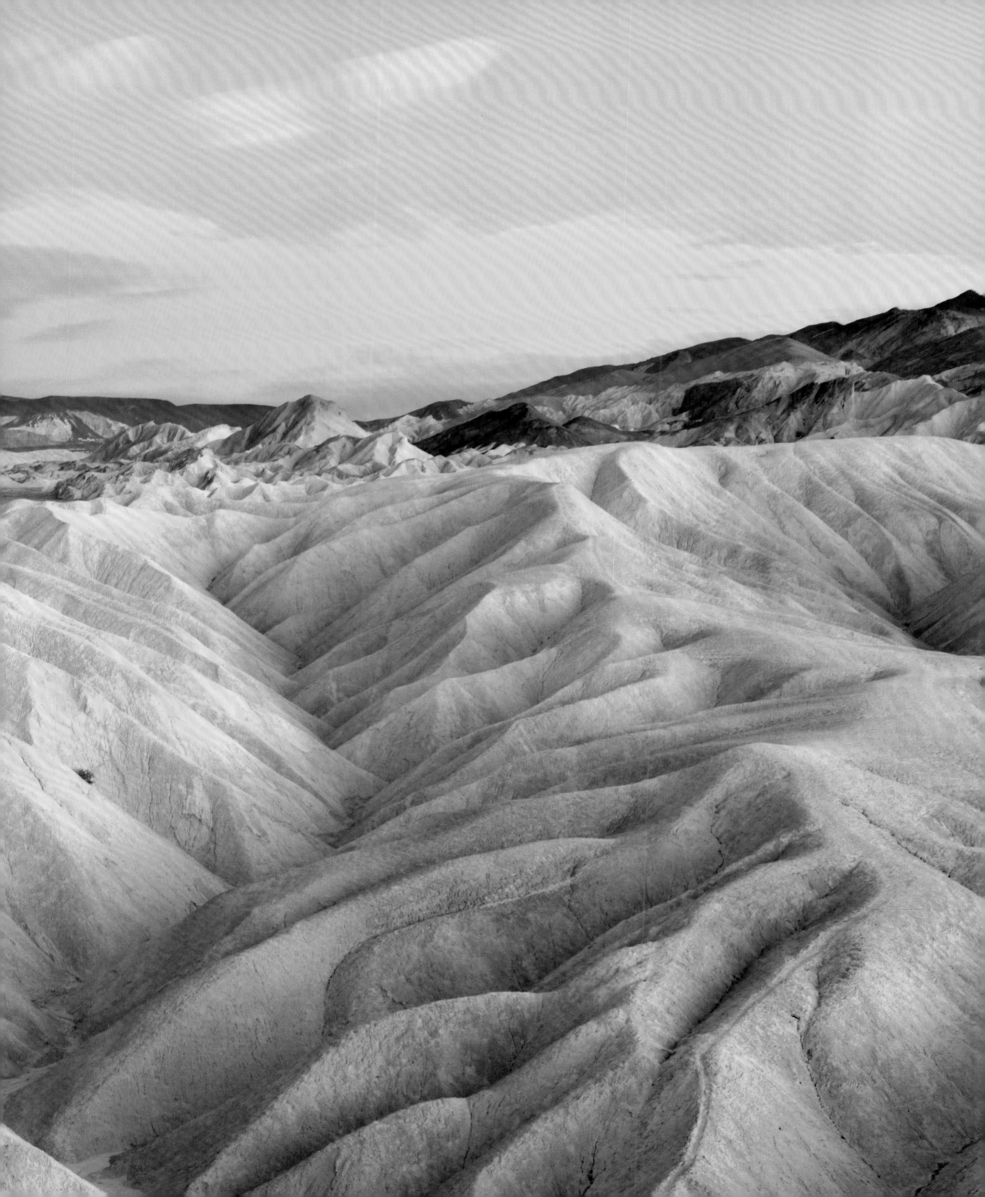

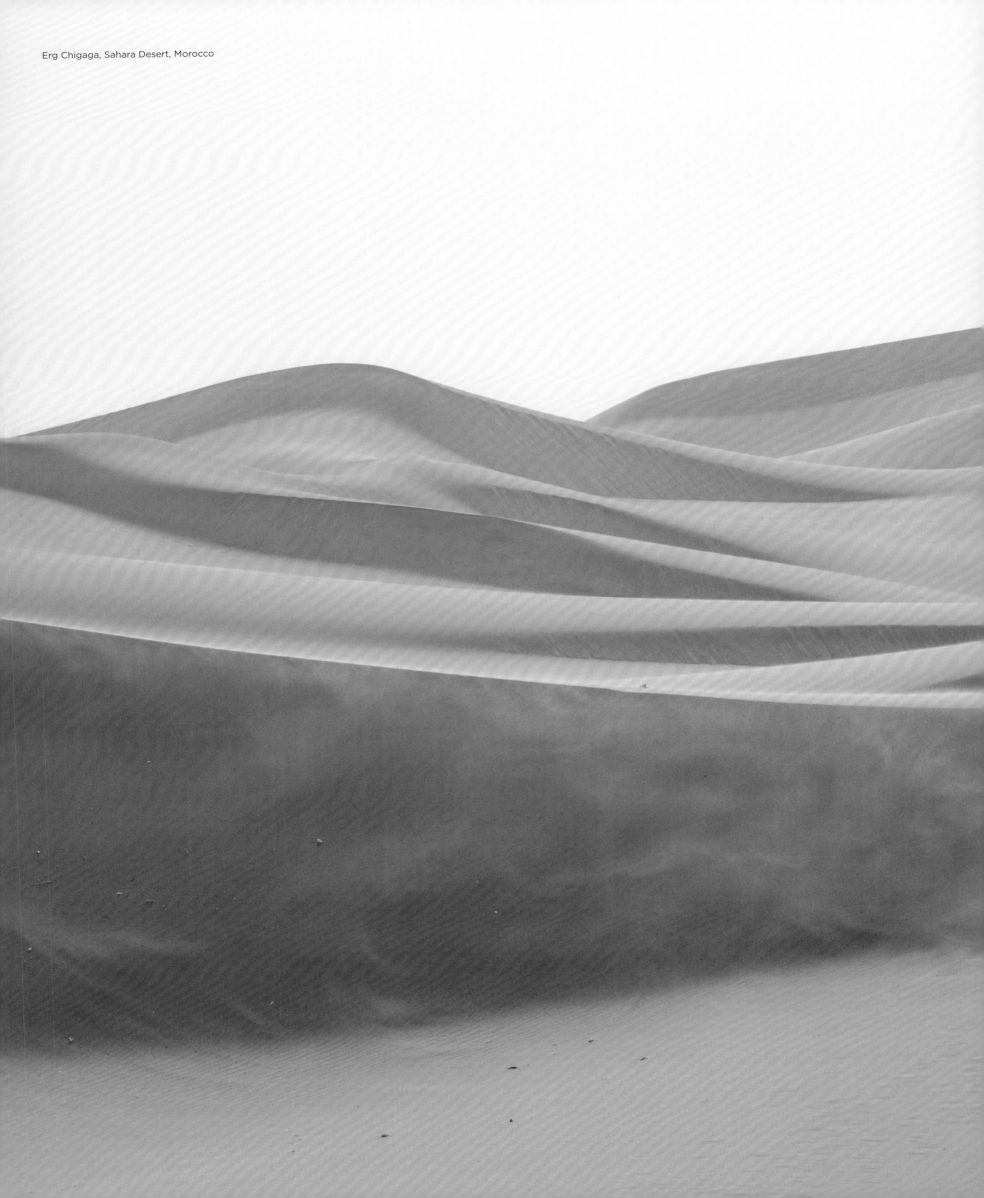

Erg Chigaga, Sahara Desert, Morocco

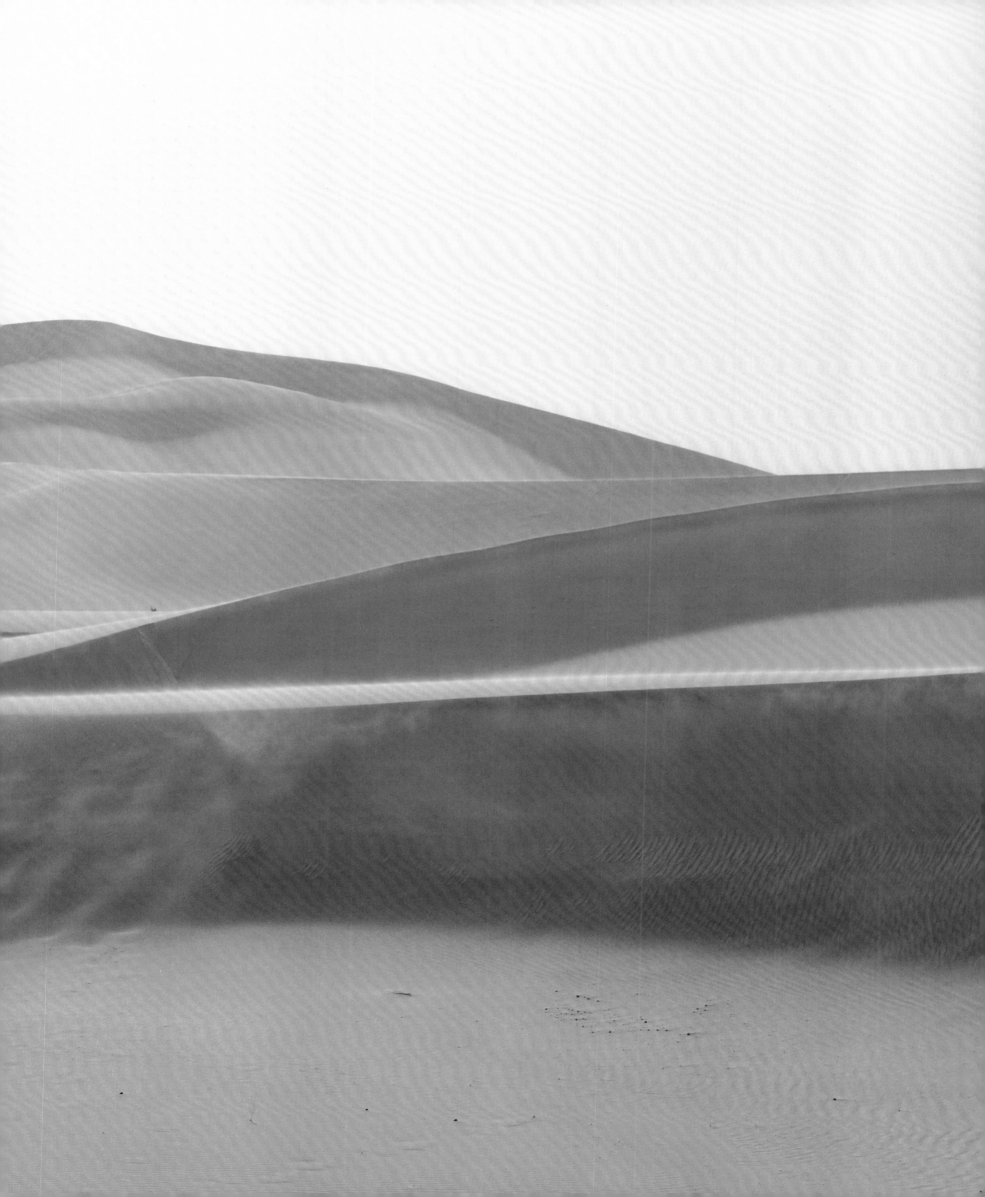

Coast of Western Australian Desert

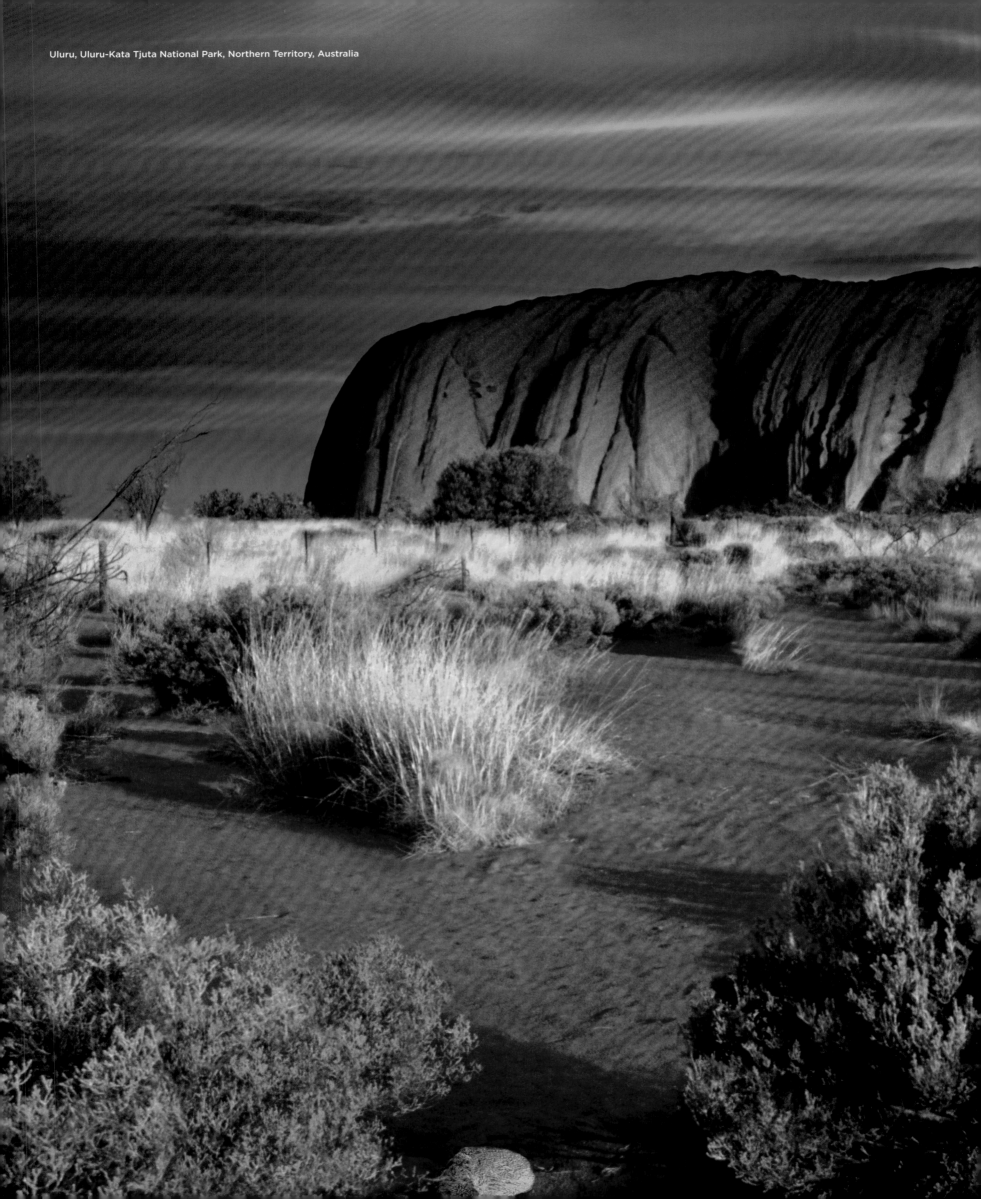

Uluru, Uluru-Kata Tjuta National Park, Northern Territory, Australia

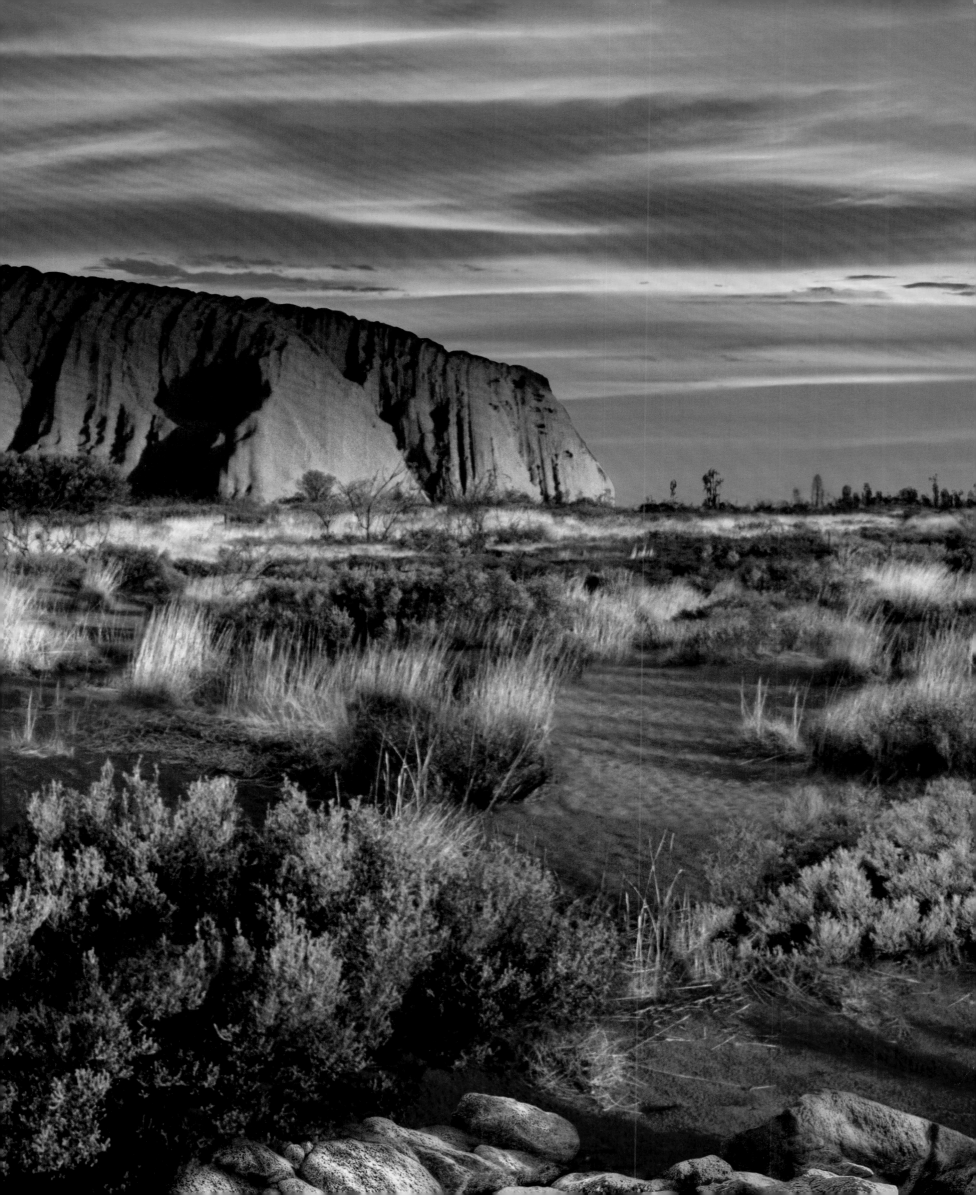

Contents · Sommaire · Inhalt

Índice · Indice · Inhoud

Introduction

Imagine a sea of sand dunes the size of a European country, a world in motion, exquisite ridge lines perfectly sculpted by the winds and stretching to a layered horizon. Or a remote mountain massif in black rock or sandstone, hewn by the elements and marked in red ochre by passing ancient rock artists. Or a salt pan shimmering to a seemingly endless horizon. Welcome to the world's deserts, a realm of astonishing and dramatic beauty, as much places of the soul and the imagination as actual physical terrain. No continent is without a portfolio of rare desert beauty, from the high-altitude deserts of South America to the hallucinatory shapes of the legendary American West. Europe's only true desert, in Spain, makes a living impersonating that same Wild West, while Asia's deserts echo with tales of the Silk Road and the great civilisations of antiquity. But it's in Australia and Africa where the deserts are continental in scale, less features of a landscape than their dominant personalities. The Sahara, the Outback, the Kalahari, the Namib: these are names of desert legend, epic, timeless places to go with those whose very names – the Gobi, Mojave, Atacama, Rub al-Khali and Death Valley – echo with images at once sinister and uplifting. That's because deserts are a reflection of the human soul, the fount of the world's biggest religious faiths, and among the few places on earth where we can catch so many glimpses of eternity.

Introduction

Imaginez une mer de dunes de sable grande comme un pays européen, un monde mouvant, d'exquises rides sculptées par les vents qui s'étireraient vers un horizon stratifié. Ou bien, dans le lointain, un massif montagneux de roche noire ou de grès équarri par les éléments et marqué à l'ocre rouge par d'anciens artistes. Ou encore un plateau de sel chatoyant près d'un horizon apparemment infini. Bienvenue dans les déserts de la planète, un monde d'une beauté à la fois étonnante et spectaculaire, des lieux pour l'âme et l'imaginaire autant que des reliefs physiques bien réels. Tout continent possède sa propre gamme d'unique beauté désertique, des déserts de haute altitude d'Amérique du Sud à ceux du Far West américain, aux formes et légendes hallucinatoires. Situé en Espagne, le seul véritable désert d'Europe gagne sa vie en se faisant passer pour ce même Far West tandis que les déserts d'Asie résonnent d'histoires sur la route de la Soie et les grandes civilisations de l'Antiquité. Mais c'est en Australie et en Afrique que les déserts semblent des continents par la taille, et moins les caractéristiques d'un paysage plutôt que sa personnalité dominante. Le Sahara, l'Outback, le Kalahari, le Namib sont les noms de déserts de légende, de lieux épiques et éternels assortis à ces autres noms – les déserts de Gobi, Mojave, Atacama, Rub al-Khali et la vallée de la Mort –, qui résonnent d'images à la fois sinistres et inspirantes. Reflétant l'âme humaine, les déserts sont à l'origine des croyances religieuses les plus influentes de la planète. Et parce qu'ils comptent parmi les rares endroits sur Terre où l'on peut avoir un aperçu de l'éternité.

Einleitung

Stellen Sie sich ein Meer von Sanddünen von der Größe eines europäischen Landes vor, eine Landschaft der dauernden Veränderung, fein ziselierte, perfekt von den Winden geformte Dünenkämme, die sich bis zum vielfach geschichteten Horizont erstrecken. Oder ein abgelegenes Bergmassiv aus schwarzem Fels oder aus Sandstein, das von den Elementen geformt wurde und in dem vor Urzeiten durchziehende Künstler Felsenbilder in rotem Ocker hinterlassen haben. Oder eine Salzpfanne, die bis hin zu einem scheinbar endlosen Horizont schimmert. Willkommen in den Wüsten der Welt, einem Reich von erstaunlicher und dramatischer Schönheit, ebenso sehr Orte der Seele und der Fantasie wie tatsächliche physische Landschaften. Kein Kontinent ohne ein Portfolio seltener Wüstenschönheit, von den hochgelegenen Wüsten Südamerikas bis hin zu den halluzinatorischen Formen und den Legenden des amerikanischen Westens. Die einzige echte Wüste Europas liegt in Spanien und dient als Kulisse für Filme über diesen Wilden Westen, während die Wüsten Asiens von Geschichten über die Seidenstraße und die großen Zivilisationen der Antike zu erzählen wissen. In Australien und Afrika sind die Wüsten jedoch weniger Landschaftselemente als die dominierenden Charakterzüge ganzer Kontinente. Die Sahara, das Outback, die Kalahari, die Namib: Das sind Namen legendärer Wüsten, epische, zeitlose Regionen, die mit anderen in einem Zug genannt werden – Gobi, Mojave, Atacama, Rub al-Khali und Death Valley. Wüsten sind ein Spiegelbild der menschlichen Seele, die Quelle der größten religiösen Glaubensrichtungen der Welt; sie gehören zu den wenigen Orten der Erde, an denen wir immer wieder so tiefe Einblicke in die Ewigkeit gewinnen können.

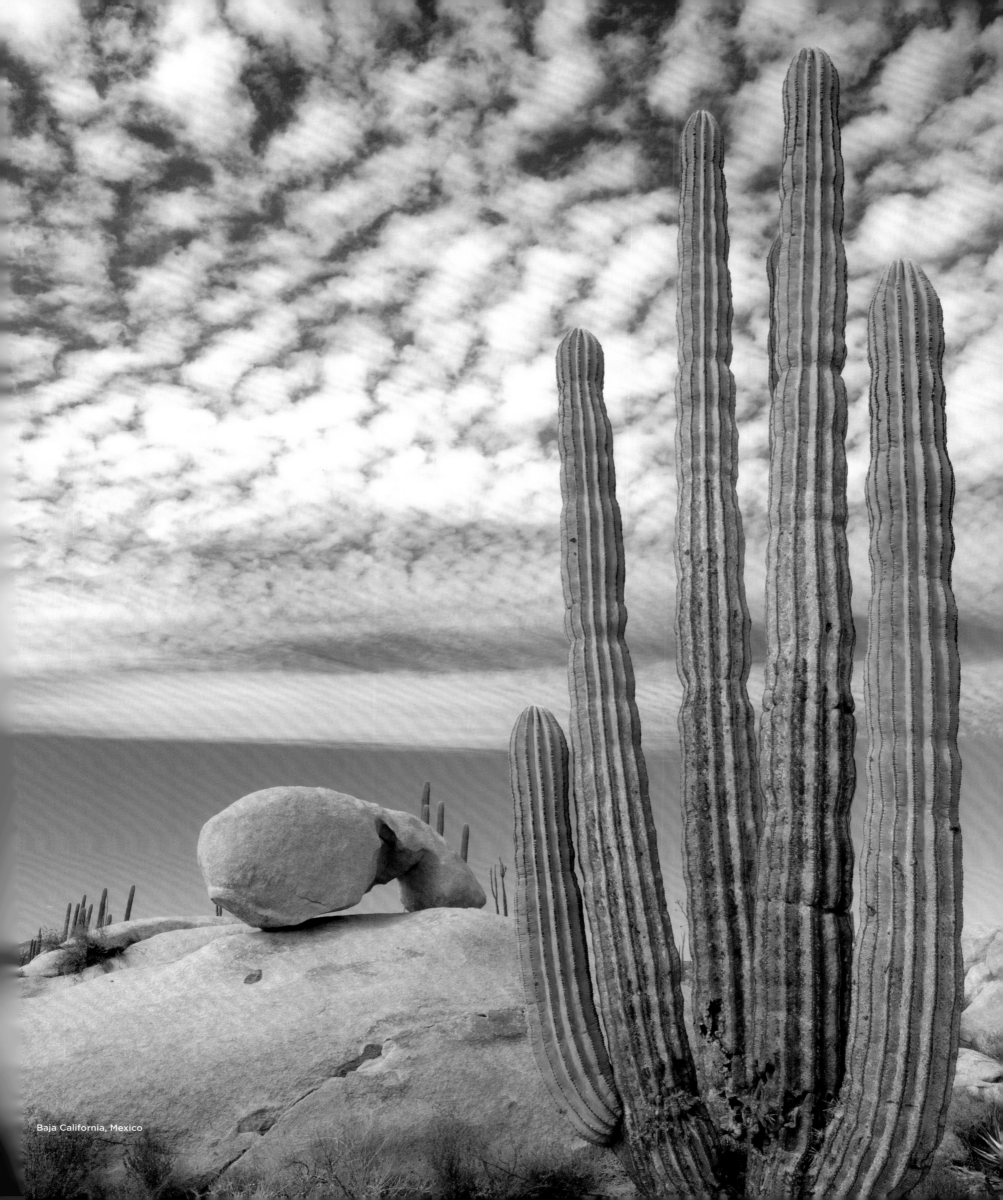

Baja California, Mexico

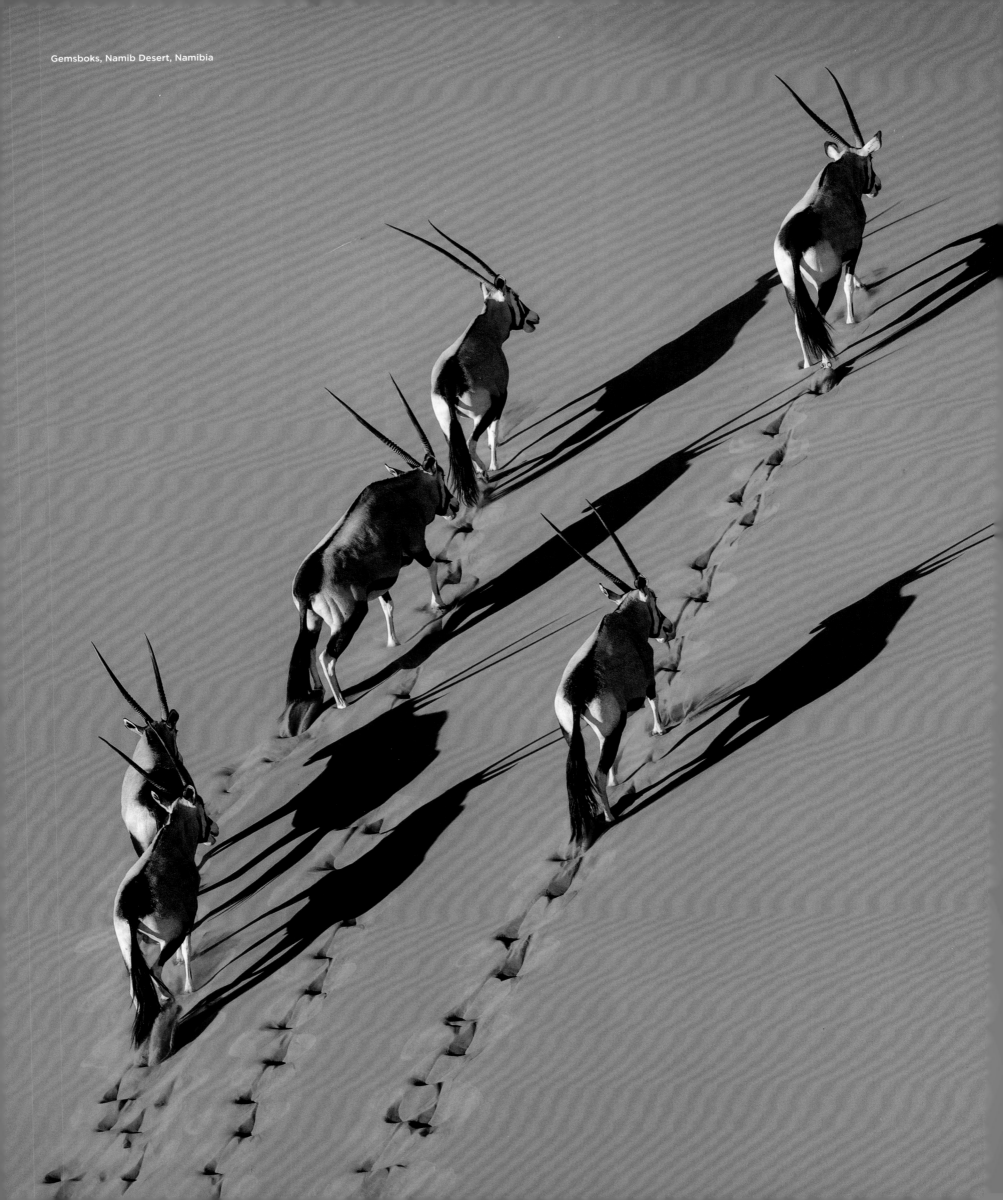

Gemsboks, Namib Desert, Namibia

Introducción

Imagine un mar de dunas de arena del tamaño de un país europeo, un mundo en movimiento, exquisitas líneas de cresta perfectamente esculpidas por los vientos y que se extienden hasta un horizonte en capas. O un remoto macizo montañoso de roca negra o arenisca, labrado por los elementos climáticos y marcado en ocre rojo con el paso de artísticas rocas antiguas. O un salar que resplandece en un horizonte aparentemente interminable. Bienvenido a los desiertos del mundo, un reino de asombrosa y dramática belleza, tanto lugares del alma y de la imaginación como terreno físico real. En todos los continentes encontramos alguna rara belleza desértica, desde los desiertos de gran altitud de Sudamérica hasta las formas alucinógenas y las leyendas del Oeste Americano. El único desierto verdadero de Europa, que se encuentra en España, se gana la vida haciéndose pasar por el mismo Salvaje Oeste, mientras que los desiertos de Asia resuenan con cuentos de la Ruta de la Seda y las grandes civilizaciones de la antigüedad. Pero es en Australia y África donde los desiertos parecen de escala continental, menos características de un paisaje que sus personalidades dominantes. El Sahara, el Outback, el Kalahari, el Namib; son todos nombres de leyendas del desierto, lugares épicos e intemporales para acompañar a aquellos cuyos nombres (el Gobi, el Mojave, el Atacama, el Rub al-Jali y el Valle de la Muerte) resuenan con imágenes siniestras y, a la vez, inspiradoras. Esto se debe a que los desiertos son un reflejo del alma humana, la fuente de las mayores creencias religiosas del mundo y uno de los pocos lugares de la tierra donde podemos ver tantos destellos de eternidad.

Introdução

Imagine um mar de dunas de areia do tamanho de um País europeu, um mundo em movimento, as belas linhas rochosas perfeitamente esculpidas pelos ventos criando um horizonte em camada, uma montanha maciça em rocha negra, ou arenito, talhado pelos elementos e marcado a vermelho ogre por antigos pedreiros, ou uma panela de sal, brilhando no horizonte aparentemente interminável. Bem-vindo aos desertos do mundo, um reino de beleza surpreendente e dramática, tantos lugares da alma e da imaginação quanto o terreno físico real. Nenhum continente escassa no seu portfólio a rara beleza do deserto, desde os desertos de grande altitude da América do Sul até as formas alucinatórias e lendas do oeste americano. O único verdadeiro deserto da Europa, na Espanha, ganha a vida personificando o mesmo Velho Oeste, enquanto os desertos da Ásia ecoam os contos da Rota da Seda e as grandes civilizações da antiguidade. Mas é na Austrália e na África que os desertos parecem de escala continental, menos características de uma paisagem do que suas personalidades dominantes. O Saara, o Outback, o Kalahari, o Namib: estes são nomes da lenda do deserto, lugares épicos e intemporais para acompanhar aqueles cujos nomes - Gobi, Mojave, Atacama, Rub al-Khali e Vale da Morte ecoam com imagens de uma só vez. Sinistra e edificante. Isso é porque os desertos são um reflexo da alma humana, a fonte das maiores religiões religiosas do mundo, e entre os poucos lugares da Terra onde podemos captar tantos vislumbres da eternidade.

Inleiding

Stelt u zich een zee van zandduinen voor ter grootte van een Europees land, een landschap dat steeds verandert, fijn uitgesneden, door de wind gevormde bergkammen die zich uitstrekken tot een gelaagde horizon. Of een afgelegen bergmassief van zwarte rots of zandsteen, uitgehouwen door de elementen en in het voorbijgaan door oude rotskunstenaars gemarkeerd met rode oker. Of een zoutpan die glinstert voor een schijnbaar eindeloze horizon. Welkom in de wereld van woestijnen, een rijk van ontzagwekkende en dramatische schoonheid, evenzeer plaatsen van de ziel en de verbeelding als daadwerkelijk fysiek terrein. Geen continent is zonder een portfolio van zeldzame woestijnachtige schoonheid, van de hooggelegen woestijnen in Zuid-Amerika tot de hallucinogene vormen en legendes van het Amerikaanse Westen. Europa's enige echte woestijn, in Spanje, dient als decor van films over dat Wilde Westen, terwijl de woestijnen van Azië verhalen kunnen vertellen over de Zijderoute en de grote beschavingen uit de klassieke oudheid. In Australië en Afrika ogen de woestijnen continentaal qua schaal en zijn ze minder kenmerken van een landschap dan de dominante persoonlijkheid daarvan. De Sahara, de Outback, de Kalahari, de Namib: dit zijn de namen van legendarische woestijnen, epische, tijdloze plekken die in één adem genoemd worden met de Gobi, Mojave, Atacama, Rub al-Khali en Death Valley. De beelden die zij oproepen, zijn sinister en opbeurend tegelijk doordat woestijnen een weerspiegeling zijn van de menselijke ziel, de bron van 's werelds grootste religies. Ze behoren tot de weinige plaatsen op aarde waar we glimpen van de eeuwigheid kunnen opvangen.

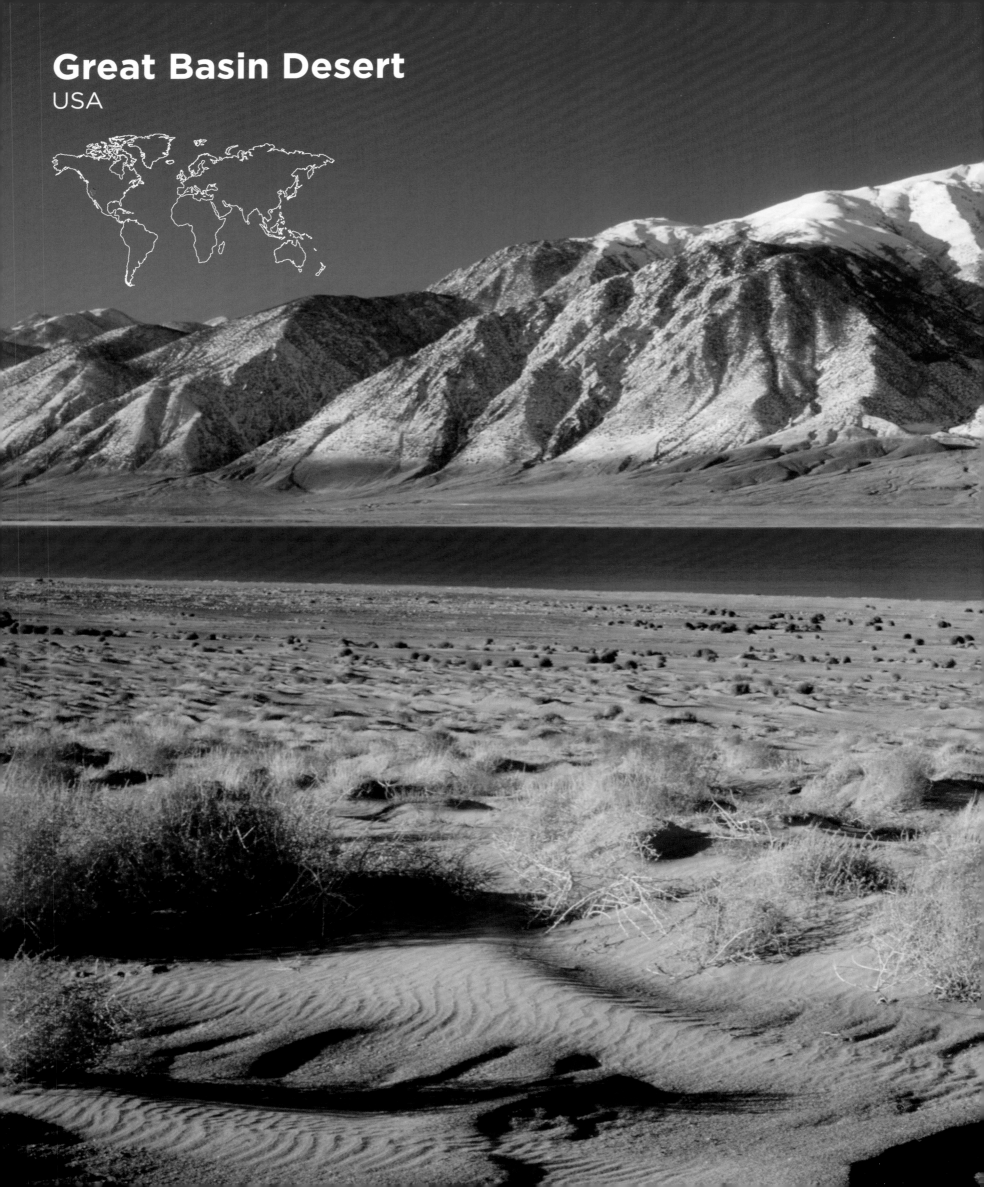

Great Basin Desert
USA

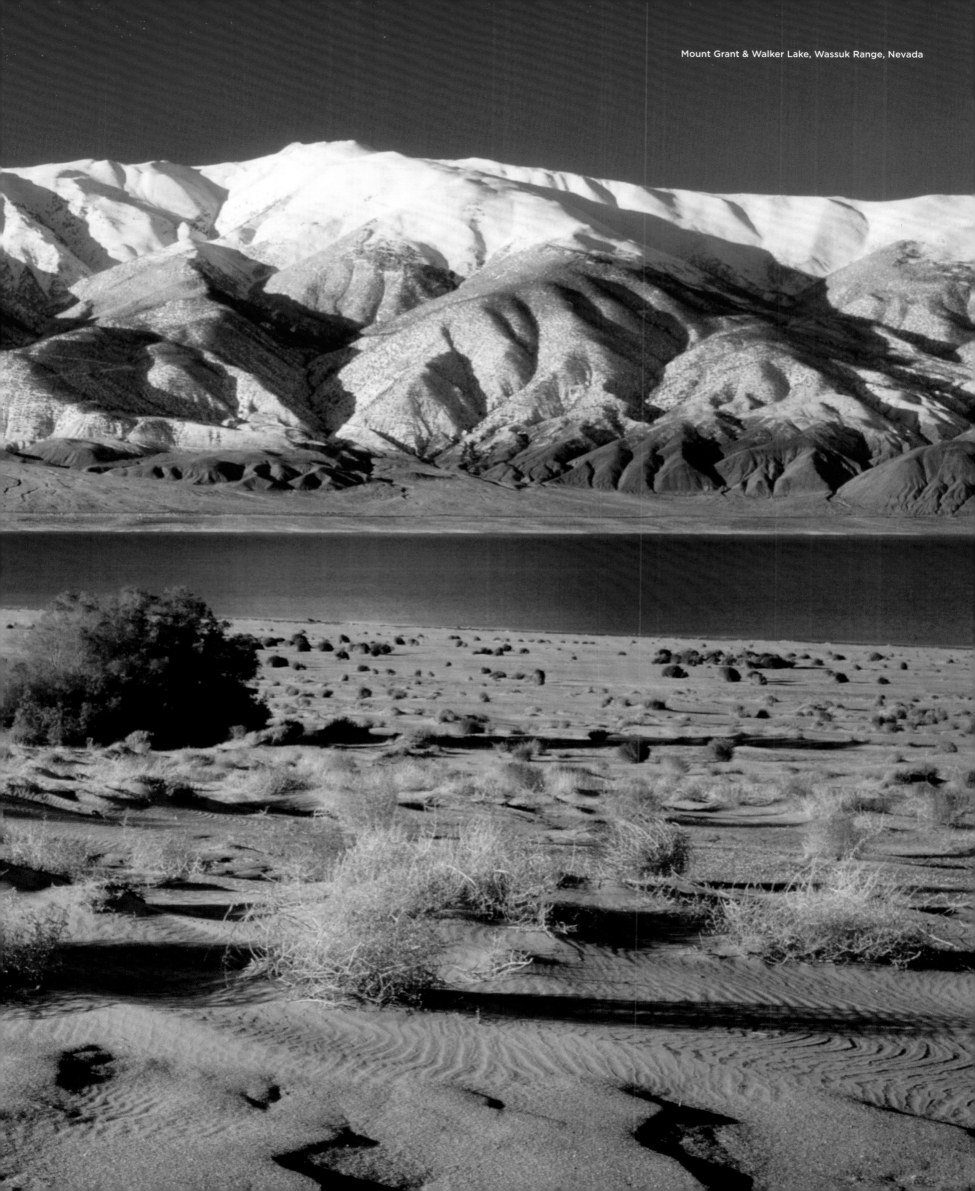

Baker, Nevada

Great Basin Desert

Covering much of Nevada, but spilling over into Utah, Idaho, California and, depending on which scientist you're talking with, a tiny sliver of Oregon, the Great Basin Desert is defined by its mountain massifs that run roughly north-south, including more than 30 summits that rise more than 3 000 m above sea level. The mountain ranges serve as ecological islands, home to a number of endangered species that have become isolated from other, similar populations, thanks to the arid surrounding country: between these mountains lie high-altitude valleys of shrubland and steppe.

Désert du Grand Bassin

Couvrant une grande partie du Nevada, mais aussi de l'Utah, l'Idaho, la Californie et, selon le scientifique avec lequel vous discuterez, un petit fragment de l'Oregon, le désert de Grand Bassin se définit par ses massifs montagneux courant du nord au sud, et compte plus de trente sommets de plus de 3 000 mètres au-dessus du niveau de la mer. Ses chaînes de montagnes sont des îlots écologiques, qui abritent un grand nombre d'espèces menacées d'extinction isolées les unes des autres, des populations similaires, et ce, grâce à l'aridité de la campagne environnante. Entre ces montagnes s'étirent des vallées de haute altitude couvertes d'arbustes et de steppes.

Great Basin Desert

Die Great Basin Desert bedeckt einen großen Teil von Nevada, erstreckt sich aber bis nach Utah, Idaho, Kalifornien und, je nachdem, mit welchem Wissenschaftler man spricht, auch nach Oregon hinein. Sie wird durch ihre Bergmassive definiert, die in etwa von Nord nach Süd verlaufen, darunter mehr als 30 Gipfel, die mehr als 3 000 m über dem Meeresspiegel liegen. Die Gebirgszüge sind ökologische Inseln: Hier leben eine Reihe gefährdeter Arten, die dank der trockenen Umgebung der zwischen den Bergen liegenden Hochtäler aus Strauchland und Steppe von anderen, ähnlichen Populationen isoliert sind.

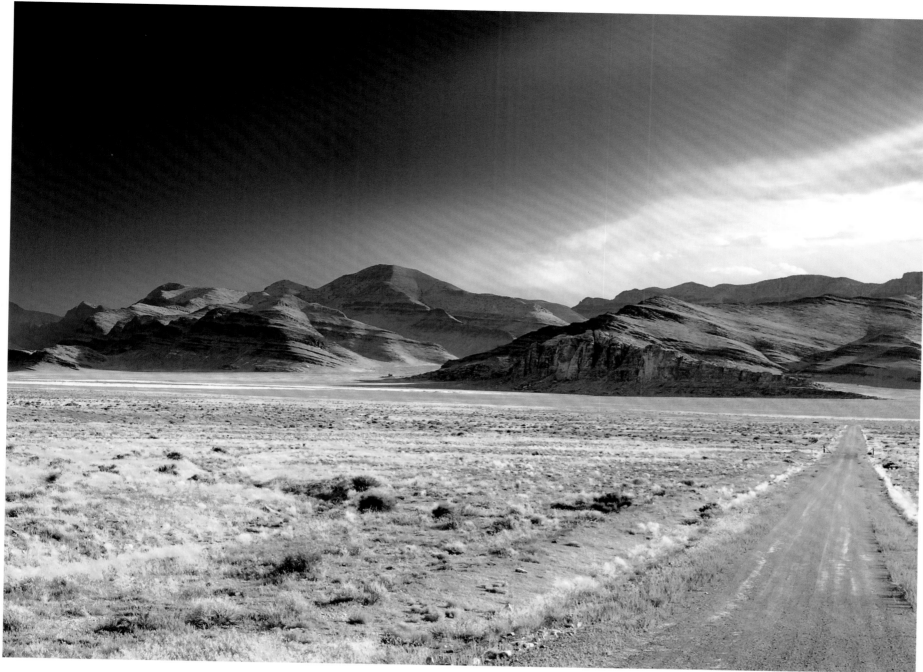

Great Basin National Park, Nevada

Desierto de la Gran Cuenca

Cubriendo gran parte de Nevada, pero derramándose en Utah, Idaho, California y, dependiendo del científico con el que esté hablando, una pequeña franja de Oregón, el Desierto de la Gran Cuenca se define por sus macizos montañosos que corren aproximadamente de norte a sur, incluyendo más de 30 cumbres que se elevan a más de 3 000 m sobre el nivel del mar. Las cordilleras sirven como islas ecológicas, hogar de una serie de especies en peligro de extinción que se han aislado de otras poblaciones similares, gracias al árido paisaje circundante: entre estas montañas se encuentran valles de matorrales y estepas a gran altitud.

Great Basin Desert

Cobrindo grande parte de Nevada, mas transbordando para Utah, Idaho, Califórnia e, dependendo do cientista, uma minúscula faixa do Oregon, o Grande Deserto da Bacia é definido por seus maciços montanhosos que correm de norte a sul, incluindo mais de 30 cimeiras que se elevam mais de 3 000 m acima do nível do mar. As cadeias de montanhas servem como ilhas ecológicas, lar de várias espécies ameaçadas que se tornaram isoladas de outras populações semelhantes, graças ao árido país circundante: entre essas montanhas encontram-se vales de grande altitude de matagal e estepe.

Great Basin Desert

De Great Basin Desert beslaat een groot deel van Nevada, maar loopt over in Utah, Idaho, Californië en, afhankelijk van met welke wetenschapper je praat, een klein stukje Oregon. De Great Basin Desert wordt gedefinieerd door de bergmassieven die globaal van noord naar zuid lopen, inclusief ruim dertig toppen die meer dan 3 000 meter boven zeeniveau liggen. De bergketens dienen als ecologische eilanden: hier leven enkele bedreigde diersoorten die dankzij het droge omringende land geïsoleerd zijn geraakt van andere, vergelijkbare populaties: tussen deze bergen liggen hooggelegen dalen met struikgewas en steppe.

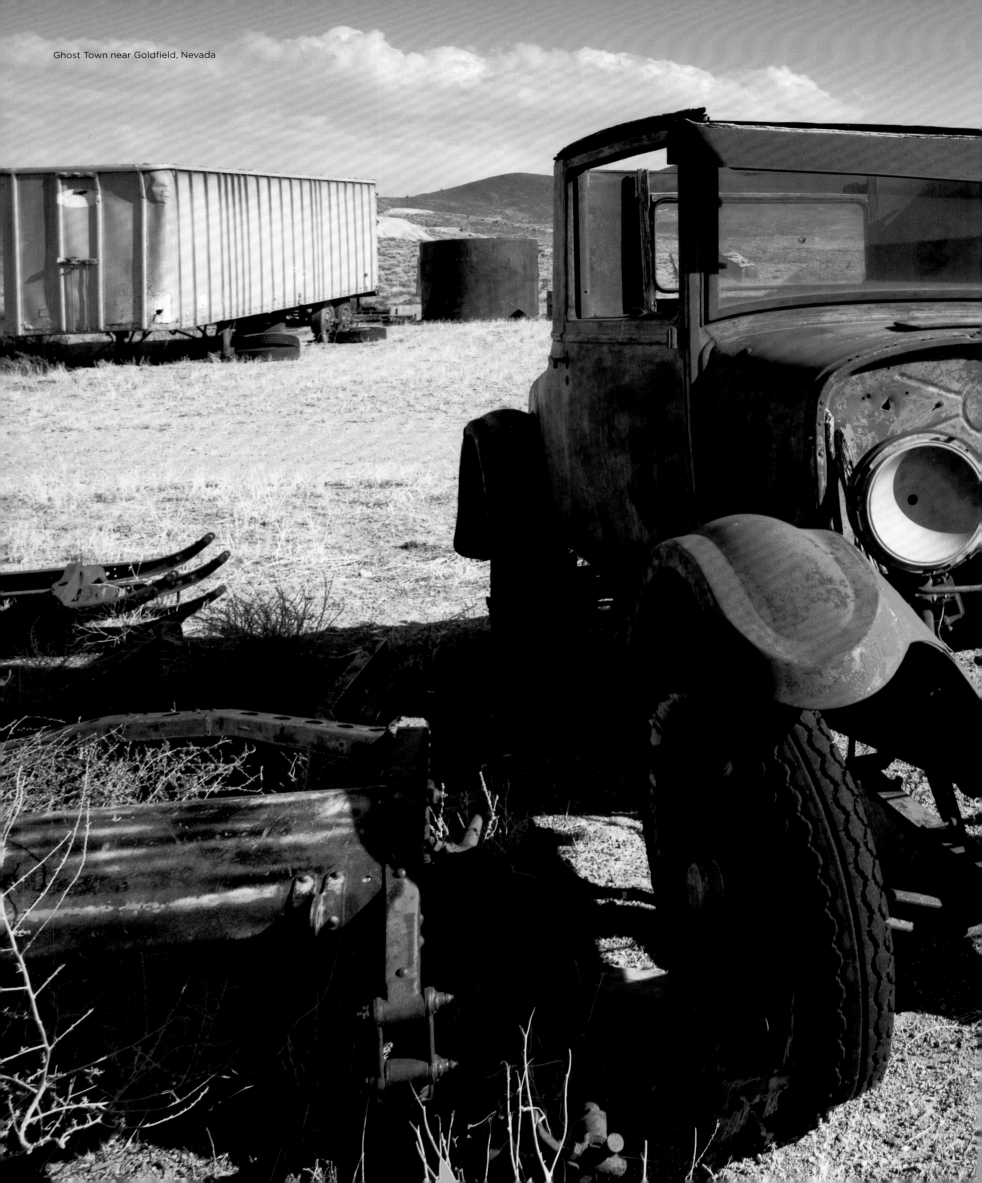

Ghost Town near Goldfield, Nevada

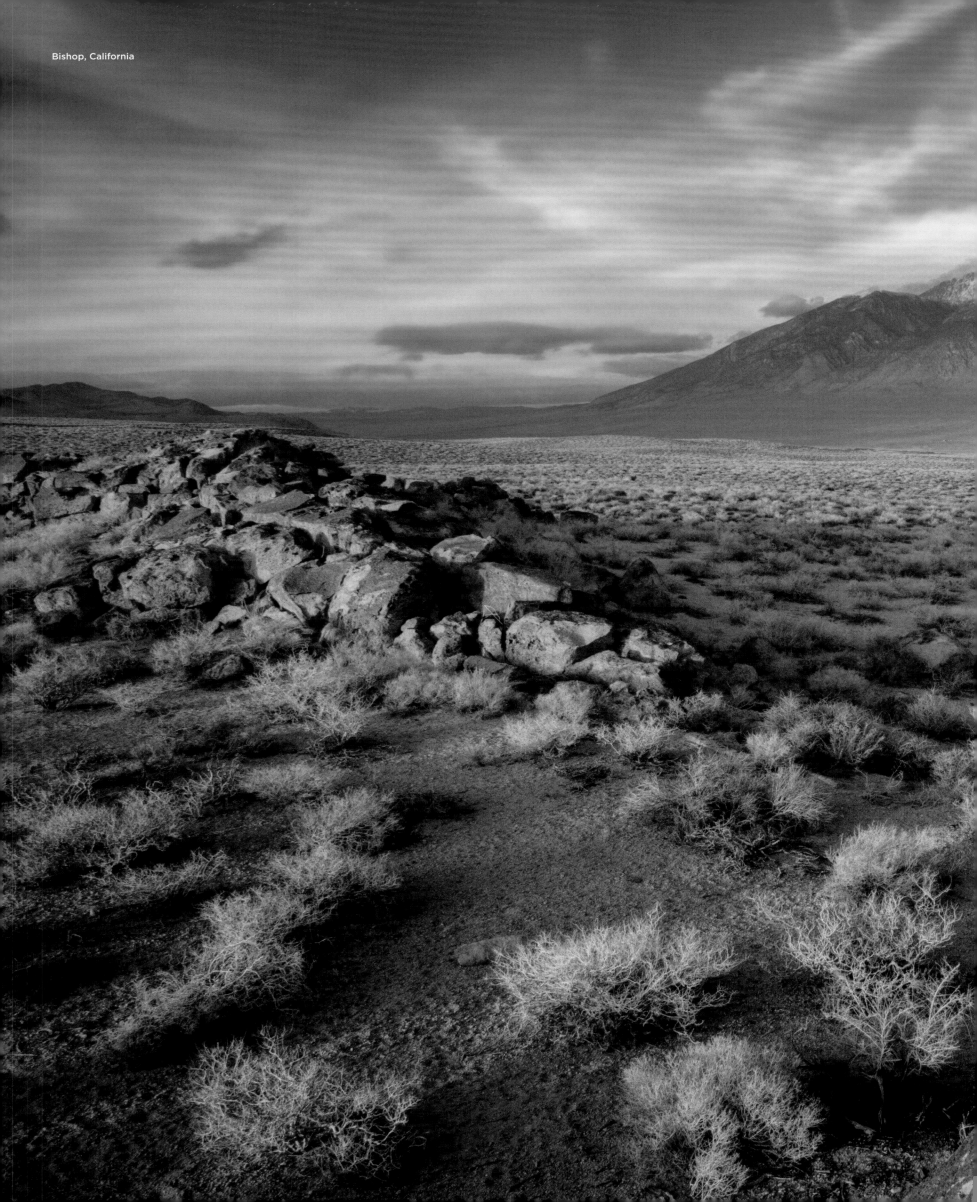

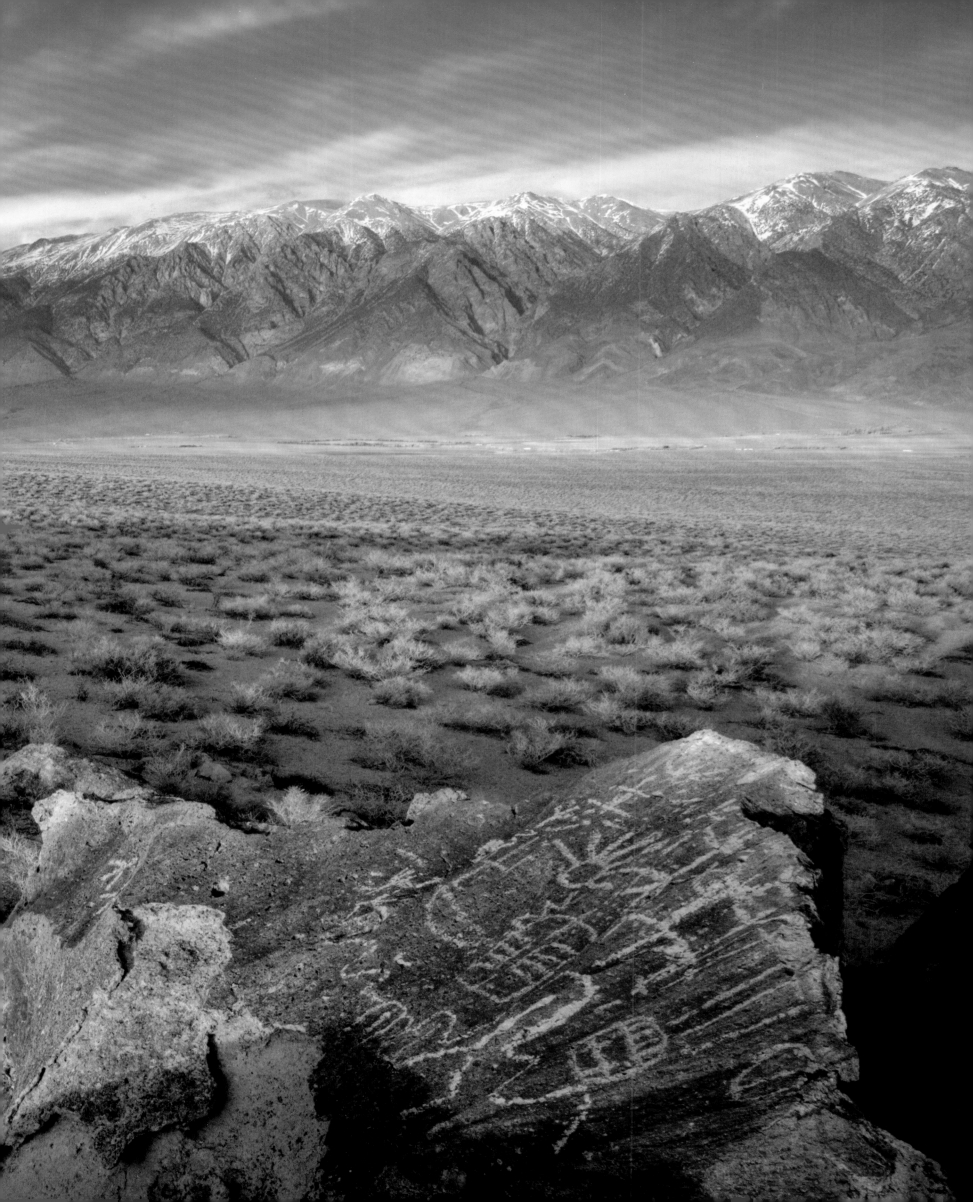

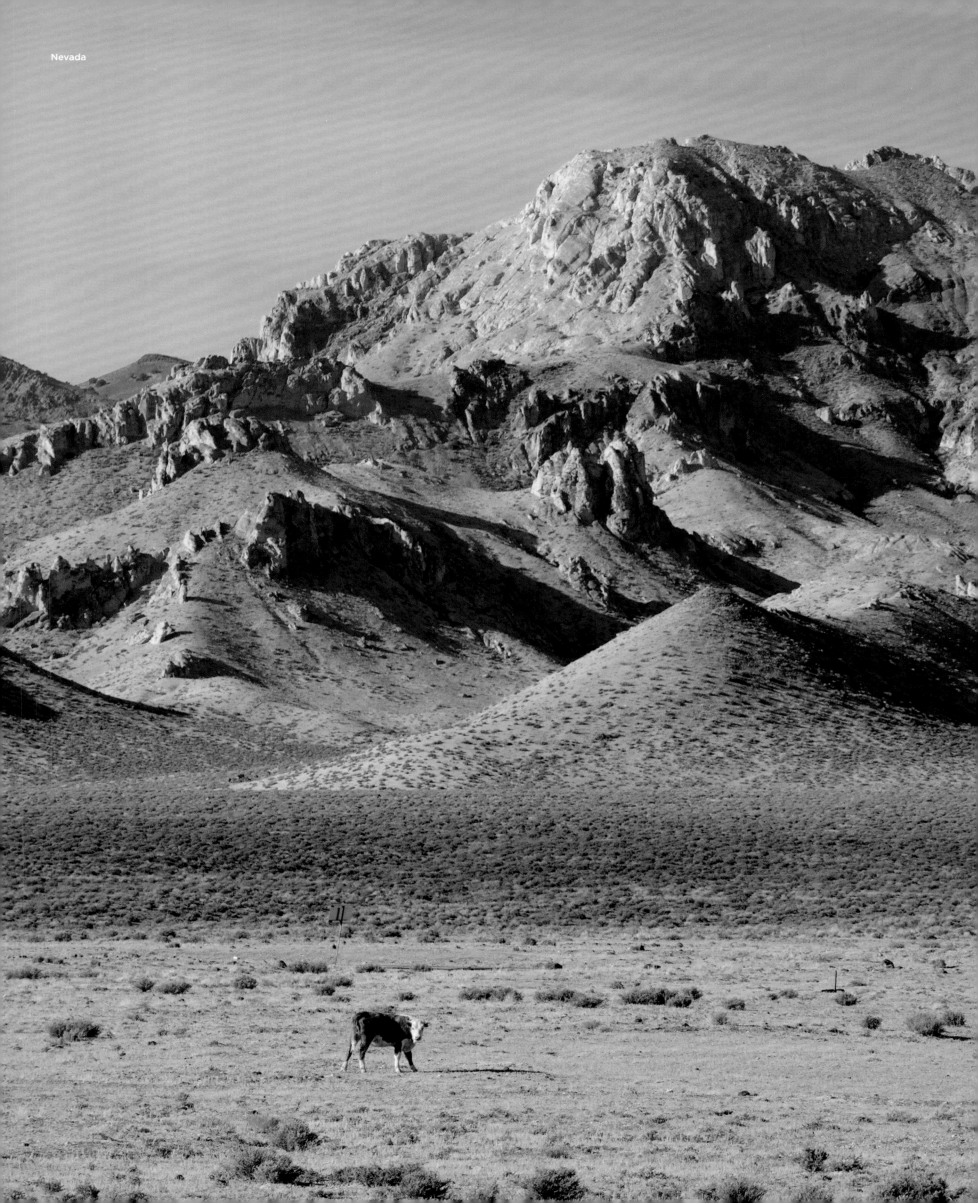

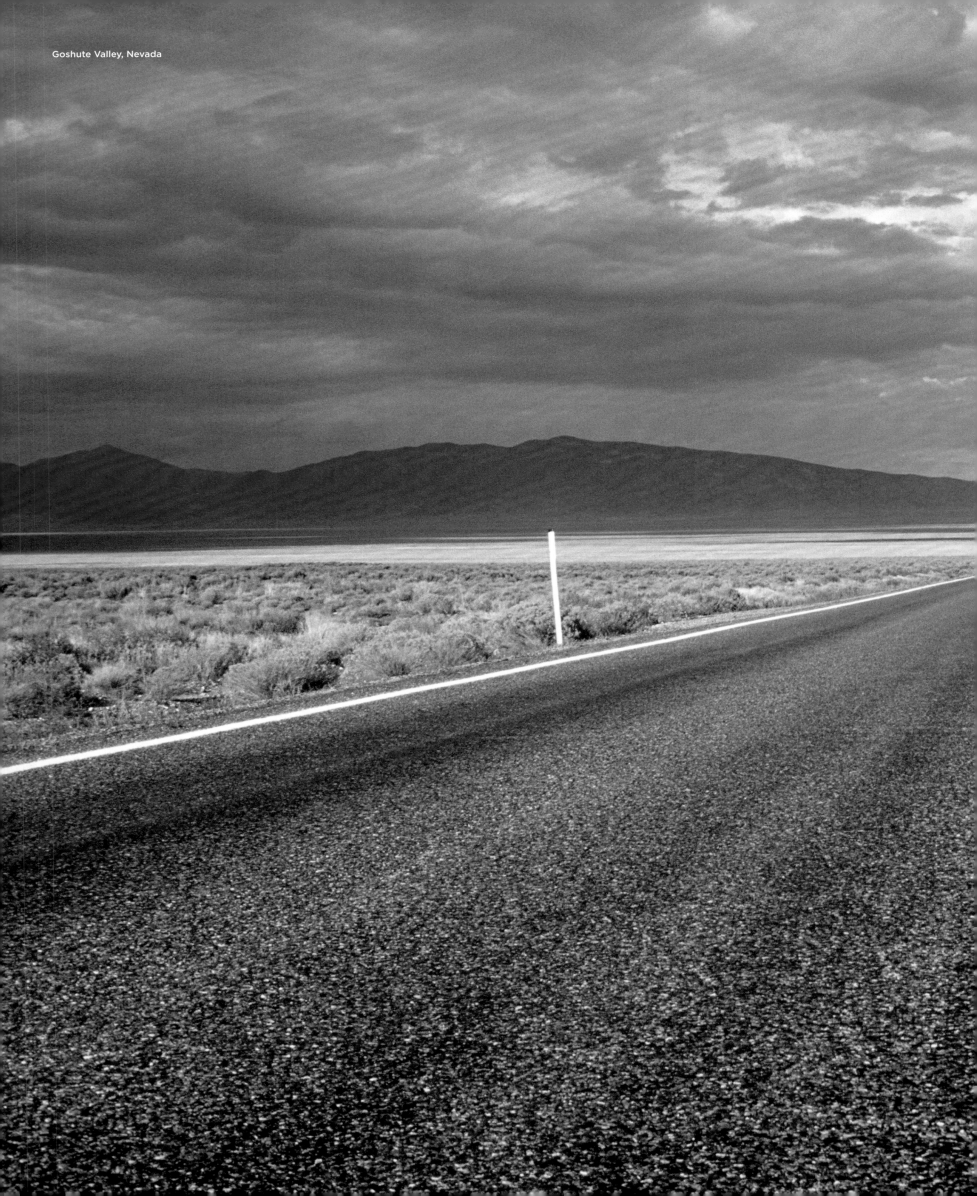

Goshute Valley, Nevada

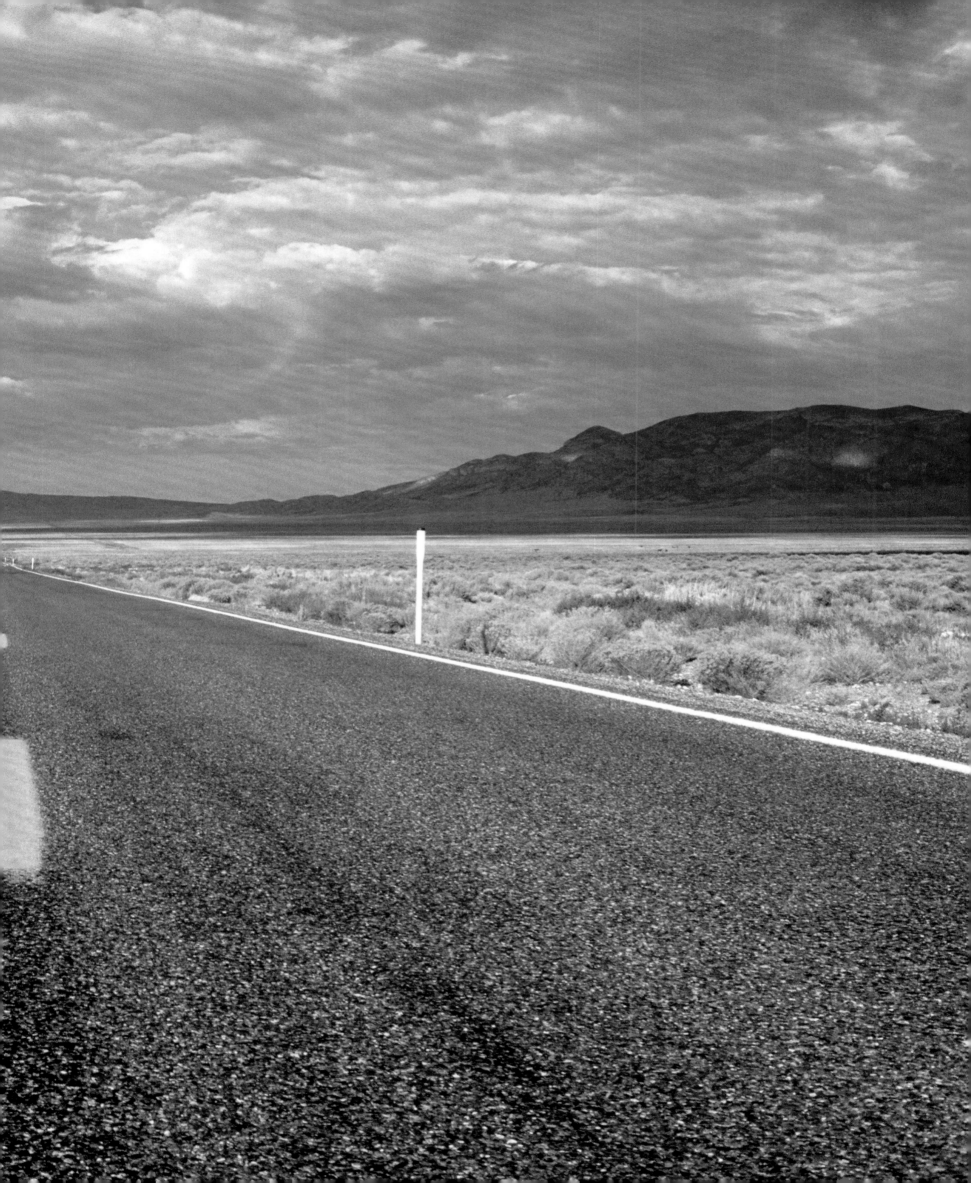

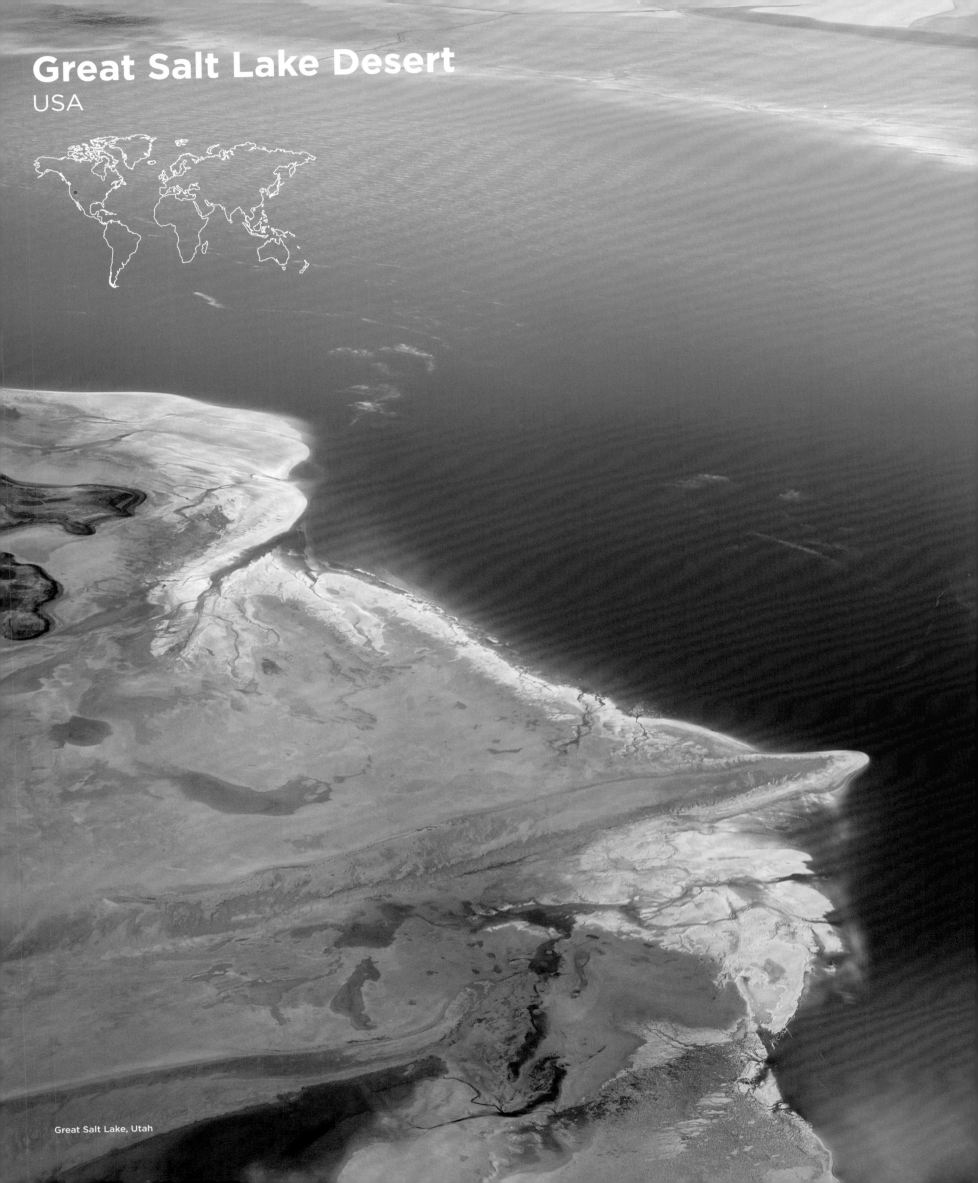

Great Salt Lake Desert
USA

Great Salt Lake, Utah

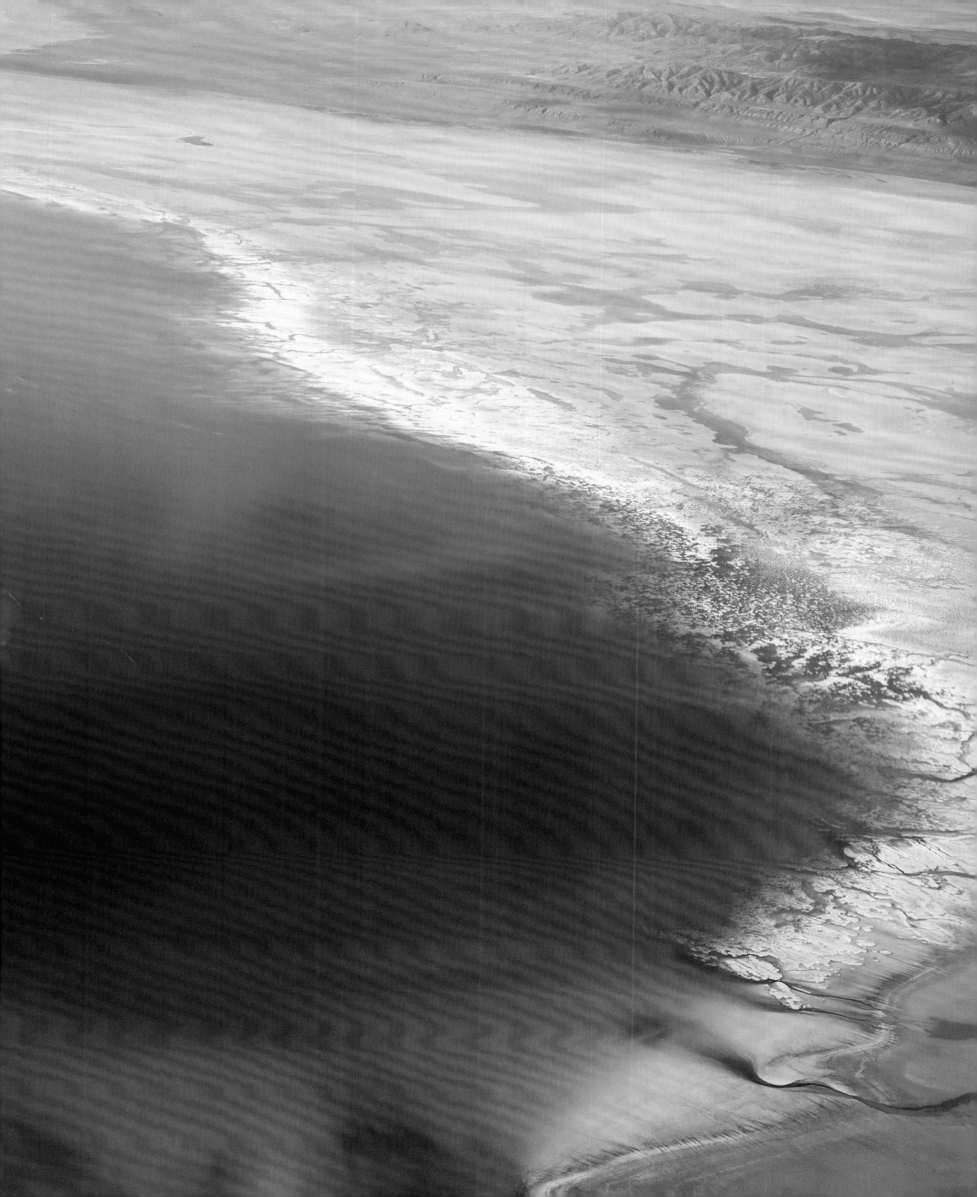

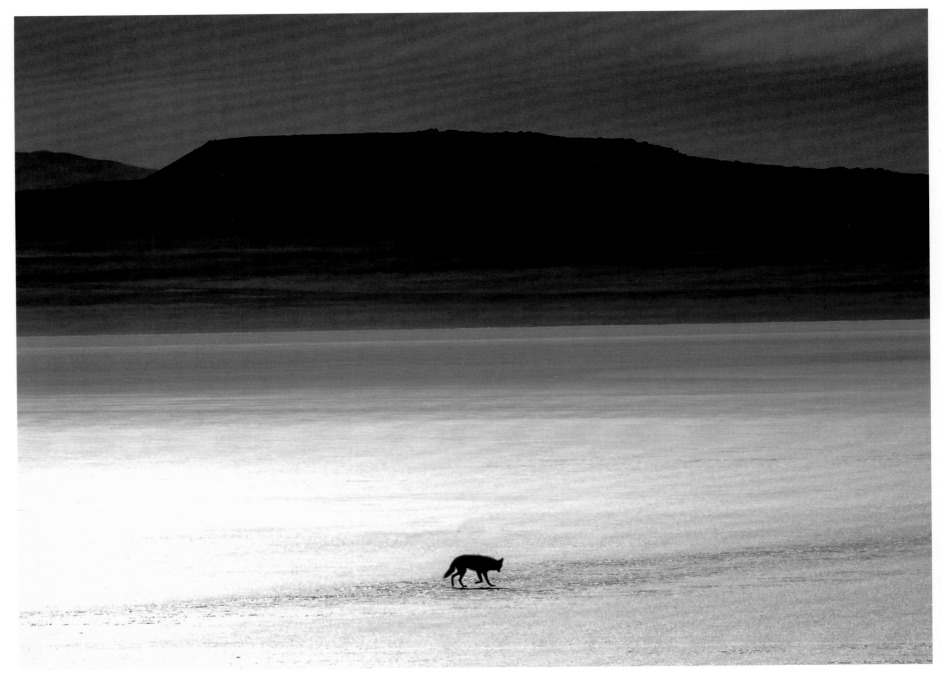

Coyote, Antelope Island State Park, Utah

Great Salt Lake Desert

Visible from space as a white scar upon the northern and western reaches of Utah, the Great Salt Lake Desert covers nearly 6500 km² and is all that remains of an ancient lake system that, 18 000 years ago, covered ten times that area but has evaporated in the course of the millennia. Even today, when rain falls in the desert, it evaporates quickly, leaving behind salt-crust deposits. In those areas of standing water, the lake has a salt content second only to the famously salty Dead Sea. The desert is bordered by mountain ranges such as the Cedar, Lakeside, Sliver Island, Hogup, Grassy and Newfoundland Mountains.

Désert du Grand Lac Salé

Cicatrice blanche barrant les étendues au nord et à l'ouest de l'Utah, vu depuis l'espace, le désert du Grand Lac Salé couvre près de 6500 km². Il est le vestige d'un ancien système lacustre qui, voici 18 000 ans, couvrait dix fois sa surface actuelle, mais qui s'est évaporé au fil des millénaires. Aujourd'hui encore, lorsque la pluie s'abat sur le désert, elle s'évapore en laissant derrière elle des dépôts de sel croûté. Le taux de salinité de ces zones d'eau dormante classe le lac au second rang derrière la fameusement salée mer Morte. Des chaînes de montagnes telles que Cedar, Lakeside, Silver Island, Hogup, Grassy et Newfoundland bordent le désert.

Große Salzwüste

Die Great Salt Lake Desert, die vom Weltraum aus als weiße Narbe am nördlichen und westlichen Rand Utahs sichtbar ist, umfasst ca. 6500 km². Sie ist alles, was von einem alten Seensystem übrig geblieben ist, das vor 18 000 Jahren das Zehnfache der heutigen Fläche bedeckte, aber im Laufe der Jahrtausende verdunstete. Auch heute verdunstet das Wasser schnell, wenn Regen in der Wüste fällt, und hinterlässt Salzkrustenablagerungen. In Gebieten mit stehendem Wasser hat der See einen Salzgehalt, der nur von dem des berühmten Toten Meers übertroffen wird. Die Wüste wird von Gebirgszügen wie den Cedar, Lakeside, Sliver Island, Hogup, Grassy und Newfoundland Mountains begrenzt.

Bonneville Salt Flats, Wendover, Utah

Gran desierto de Lago Salado

Visible desde el espacio como una blanca cicatriz en el norte y el oeste de Utah, el Gran Desierto de Lago Salado cubre casi 6500 km² y es todo lo que queda de un antiguo sistema de lagos que hace 18 000 años cubría diez veces esa área, pero que se ha evaporado a lo largo de los milenios. Incluso hoy en día, cuando la lluvia cae sobre el desierto, se evapora rápidamente, dejando tras de sí depósitos de costras salinas.
En esas áreas de agua estancada, el lago tiene un contenido de sal solo comparable a la del Mar Muerto, que tan famoso es por su alto contenido de sal.
El desierto está bordeado por cadenas montañosas, como las montañas de Cedro, Lakeside, Sliver Island, Hogup, Grassy y Newfoundland.

Great Salt Lake Desert

Visível do espaço como uma cicatriz branca nas regiões norte e oeste de Utah, o Grande Deserto de Salt Lake cobre quase 6500 km² e é tudo o que resta de um antigo sistema lacustre que, 18 000 anos atrás, cobriu dez vezes essa área, mas evaporou através de milênios. Mesmo hoje, quando a chuva cai no deserto, ela evapora rapidamente, deixando para trás depósitos de crosta salgada. Nessas áreas de água parada, o lago tem um teor de sal secundário apenas no famoso Mar Morto salgado. O deserto é cercado por cadeias de montanhas, como Cedar, Lakeside, Sliver Island, Hogup, Grassy e Newfoundland Mountains.

Great Salt Lake Desert

De Great Salt Lake Desert, die vanuit de ruimte als een wit litteken op de noordelijke en westelijke rand van Utah zichtbaar is, beslaat bijna 6500 km² en is alles wat er is overgebleven van een oud merenstelsel dat, 18 000 jaar geleden, tien keer zo'n groot oppervlak besloeg, maar in de loop van de millennia verdampt is. Zelfs nu nog verdampt het water snel als het regent in de woestijn en laat het een zoutkorst achter. In gebieden met stilstaand water heeft het meer een zoutgehalte dat alleen wordt overtroffen door dat van de beroemde Dode Zee. De woestijn wordt begrensd door bergketens, zoals de Cedar, Lakeside, Sliver Island, Hogup, Grassy en Newfoundland Mountains.

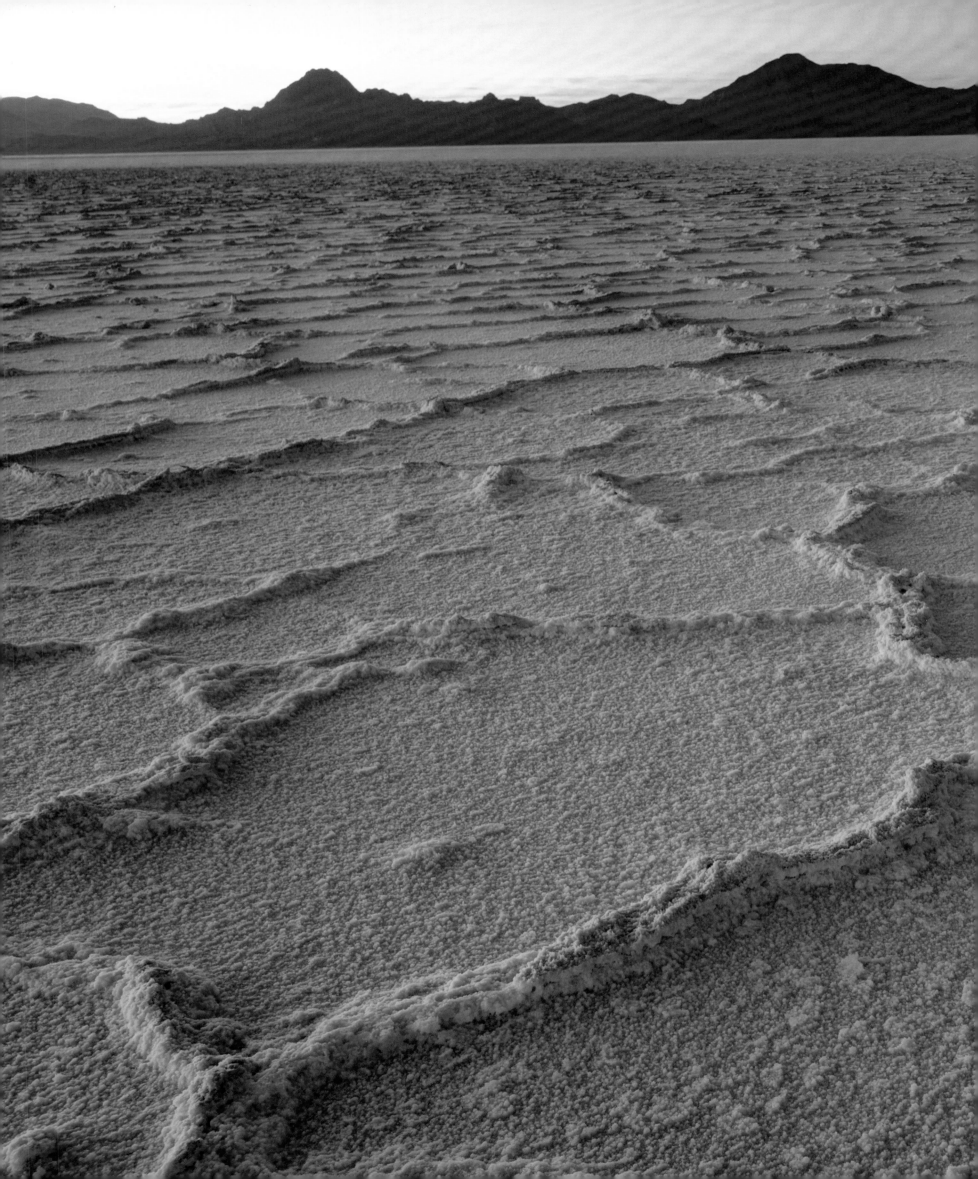

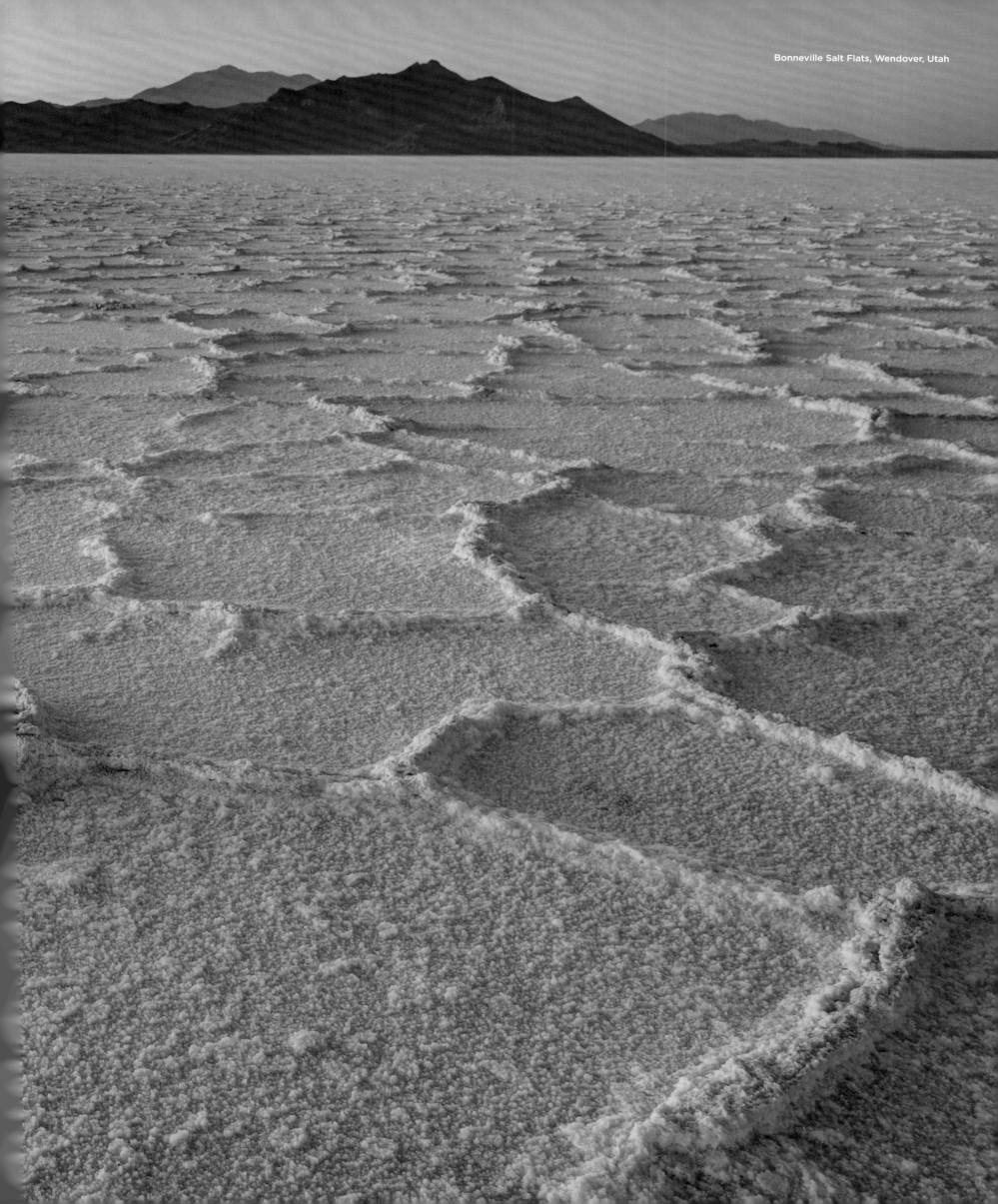

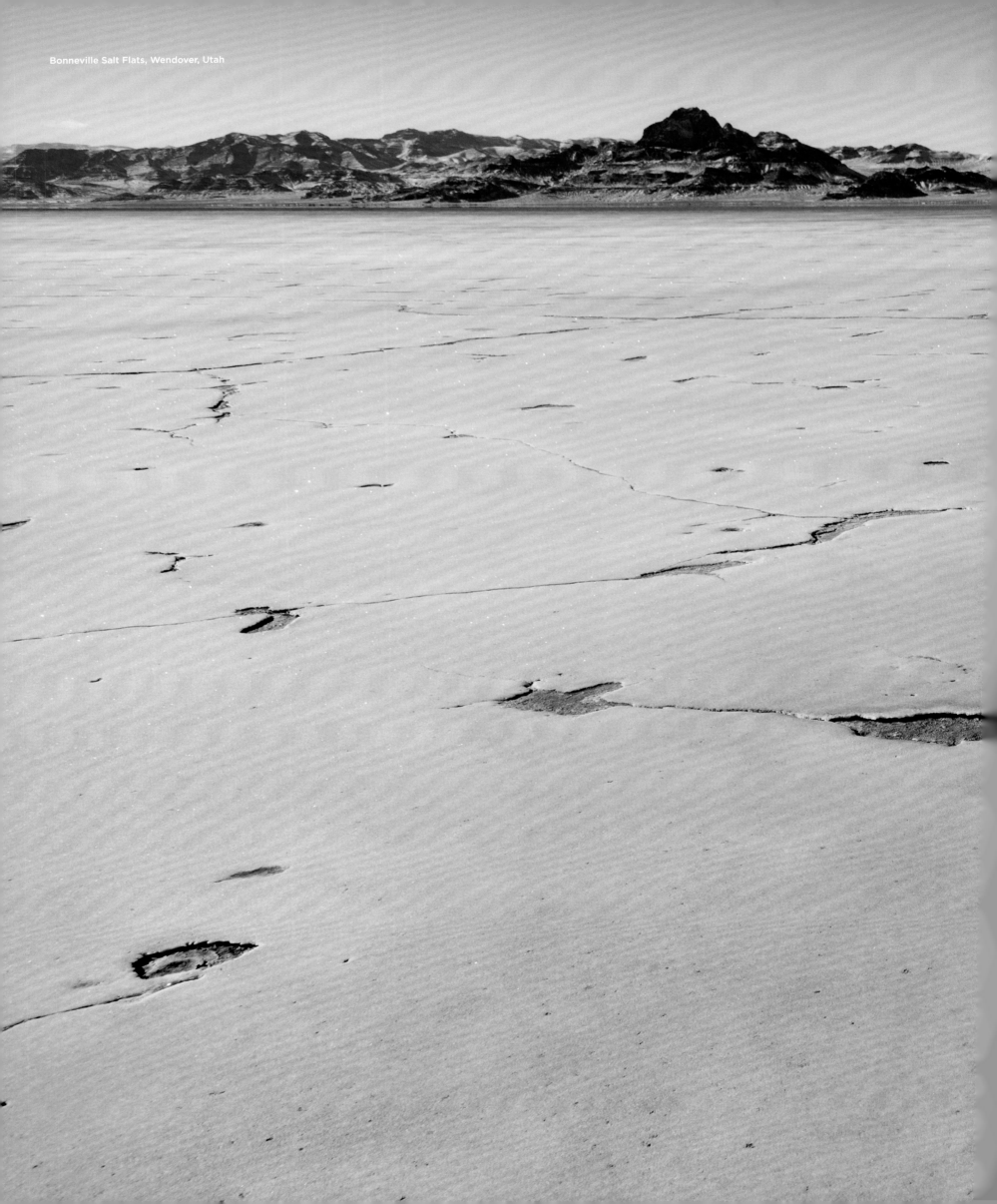

Bonneville Salt Flats, Wendover, Utah

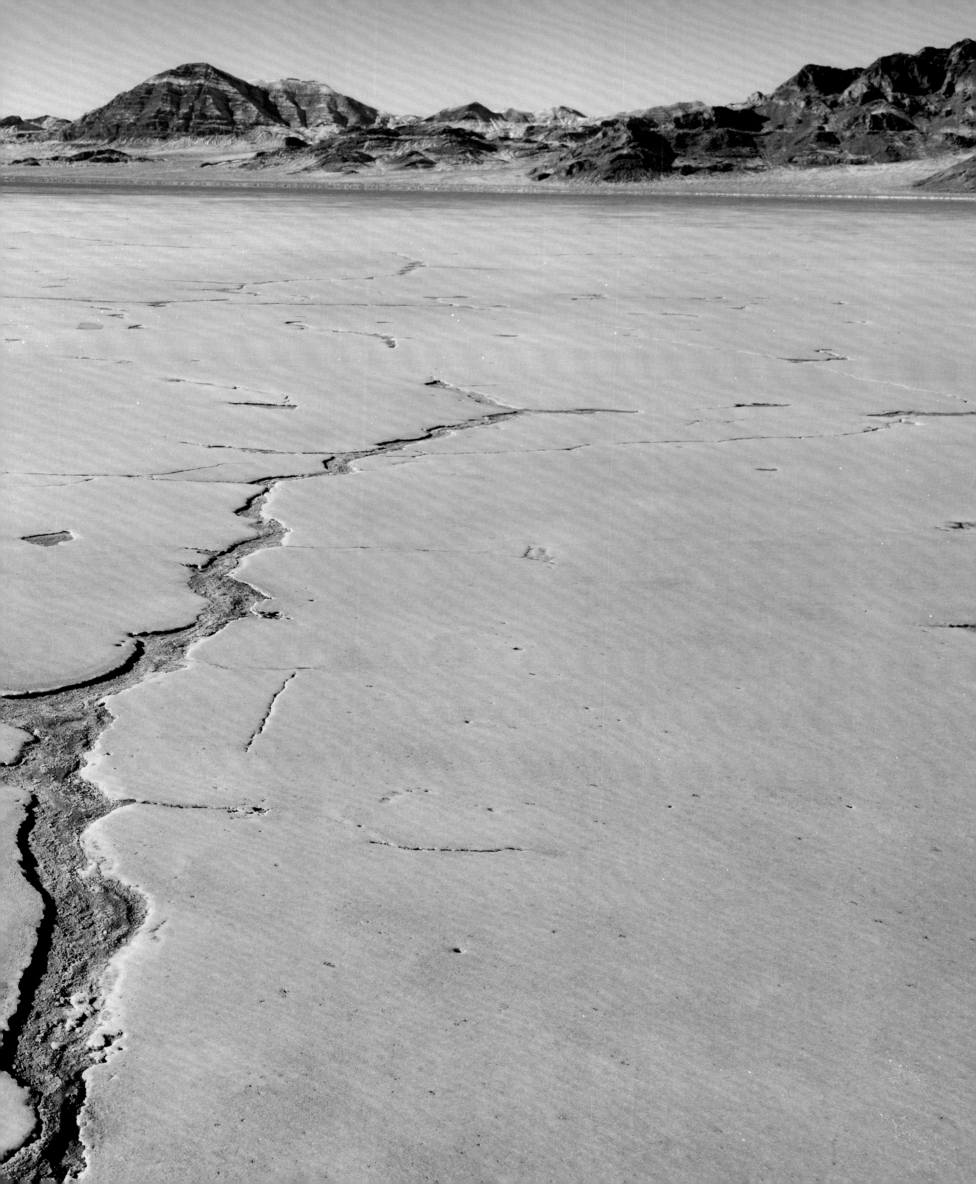

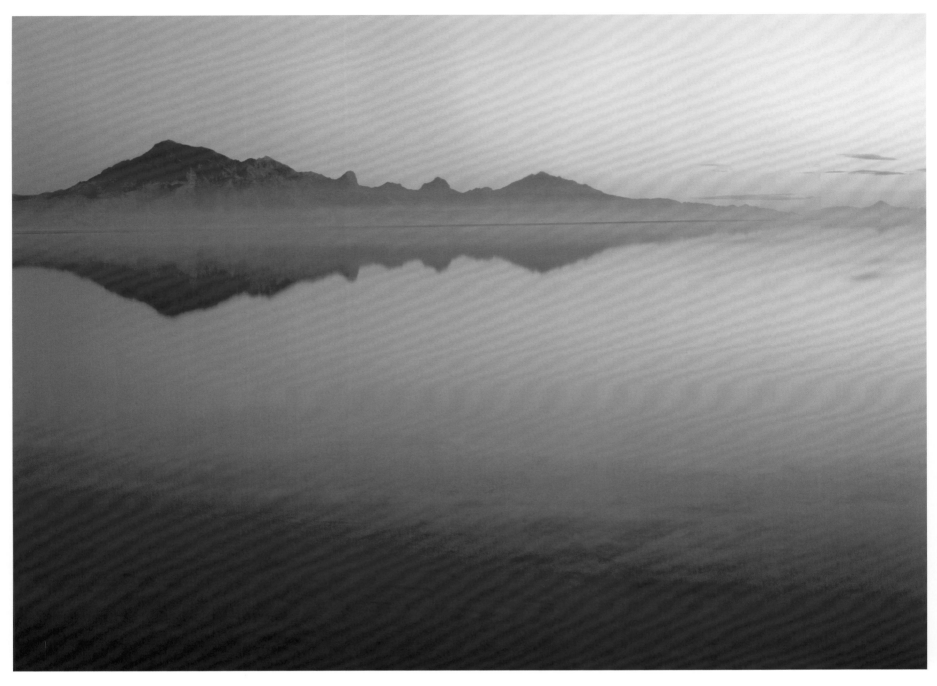

Bonneville Salt Flats, Wendover, Utah

Bonneville Flats

The salt pan that makes up Bonneville Flats is famous throughout the world for having been used for attempts, some of them successful, a breaking the land-speed records on its vast, perfectly flat surface. The most recent of these was the motorcycle land speed record (310.99km/h) in 2007. Such is its perfection of form as a desert salt pan that Bonneville has been used in dozens of feature films, including *Knight Rider, Independence Day, Pirates of the Caribbean: At World's End, and Star Wars: The Last Jedi,* as well as for rocket landings by the NASA space program.

Bonneville Salt Flats

La plaine salée, qui forme Bonneville Flats, et sa gigantesque surface parfaitement plate sont célèbres à travers le monde pour avoir servi à des tentatives, dont certaines fructueuses, de records de vitesse sur terre. Le plus récent est celui de vitesse (310,99 km/h) à moto datant de 2007. La perfection de la forme du désert salé de Bonneville a servi de décor à des dizaines de films et séries célèbres, dont *K 2000, Independence Day, Pirates des Caraïbes : jusqu'au bout du monde, Star Wars : Les Derniers Jedi,* et pour l'atterrissage des fusées du programme spatial de la NASA.

Bonneville Flats

Die Salzpfanne der Bonneville Flats ist wegen der Geschwindigkeitsrekorde weltbekannt, die auf ihrer riesigen, vollkommen ebenen Oberfläche aufgestellt wurden. Der jüngste war der Geschwindigkeitsrekord mit dem Motorrad (310,99 km/h) aus dem Jahr 2007. Die Salzpfanne ist ein derartig perfektes Beispiel dieser Landschaftsform, dass Bonneville in Dutzenden von Spielfilmen als Kulisse diente, darunter *Knight Rider, Independence Day, Pirates of the Caribbean: At World's End und Star Wars: Die letzten Jedi.* Aber auch manche Raketen des NASA-Weltraum-programms landeten hier.

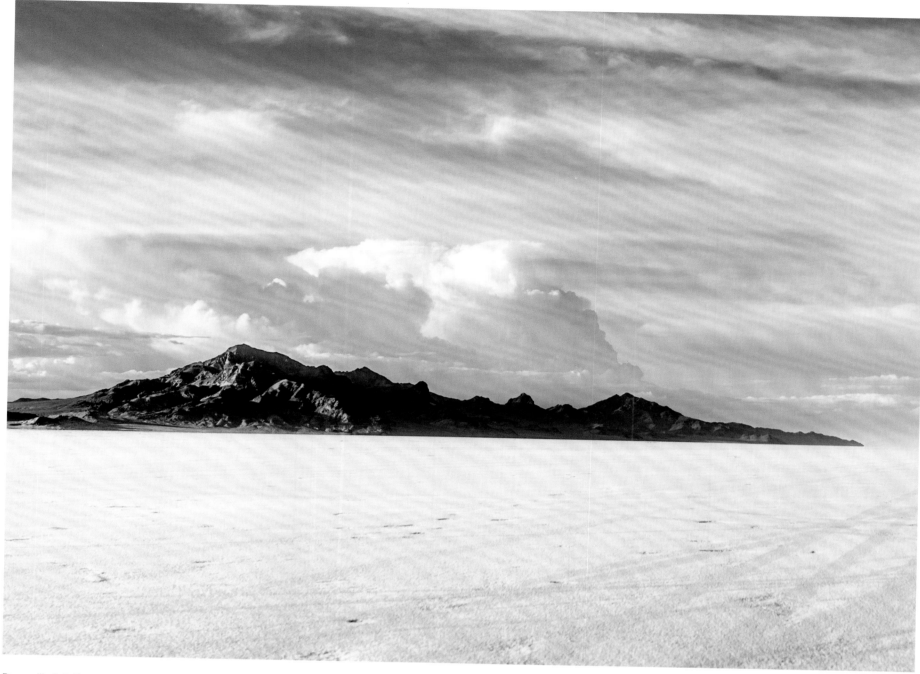

Bonneville Salt Flats, Wendover, Utah

El Salar de Bonneville

La salina que conforma el Salar de Bonneville es famosa en todo el mundo por haber sido utilizada en intentos, algunos de ellos exitosos, de batir los récords de velocidad terrestre en su vasta y perfectamente plana superficie. El más reciente de ellos fue el récord de velocidad en tierra de las motocicletas (310,99 km/h) en 2007. Tal es la perfección de su forma de salina del desierto, que Bonneville ha sido utilizada para docenas de largometrajes, entre los que se encuentran *Knight rider, Independence day, Piratas del Caribe: en el fin del mundo, y La guerra de las galaxias: los últimos jedi*, así como para los aterrizajes de cohetes del programa espacial de la NASA.

Bonneville Flats

A bandeja de sal que compõe Bonneville Flats é famosa em todo o mundo por ter sido usada para tentativas, algumas delas bem-sucedidas, quebrando os recordes de velocidade em terra em sua vasta superfície perfeitamente plana. O mais recente deles foi o recorde de velocidade terrestre da motocicleta (310.99 km / h) em 2007. Tal é a sua perfeição de forma como uma salina do deserto que Bonneville tem sido usada em dezenas de filmes, incluindo *Knight Rider, Independence Day, Pirates do Caribe: No Fim do Mundo, e Star Wars: The Last Jedi*, bem como para pousos de foguetes pelo programa espacial da NASA.

Bonneville Flats

Het zoutbekken dat Bonneville Flats eigenlijk is, is wereldberoemd om de snelheidsrecords over land die men hier op de uitgestrekte, volkomen vlakke vlakte steeds probeert te breken. De recentste daarvan was het snelheidsrecord voor motorfietsen (310,99 km/u) in 2007. Het zoutbekken is zo'n perfect voorbeeld van een woestijnlandschap dat Bonneville in tientallen speelfilms is gebruikt, waaronder *Knight Rider, Independence Day, Pirates of the Caribbean: At World's End en Star Wars: The Last Jedi*. Ook veel raketten van het NASA-ruimtevaartprogramma zijn hier geland.

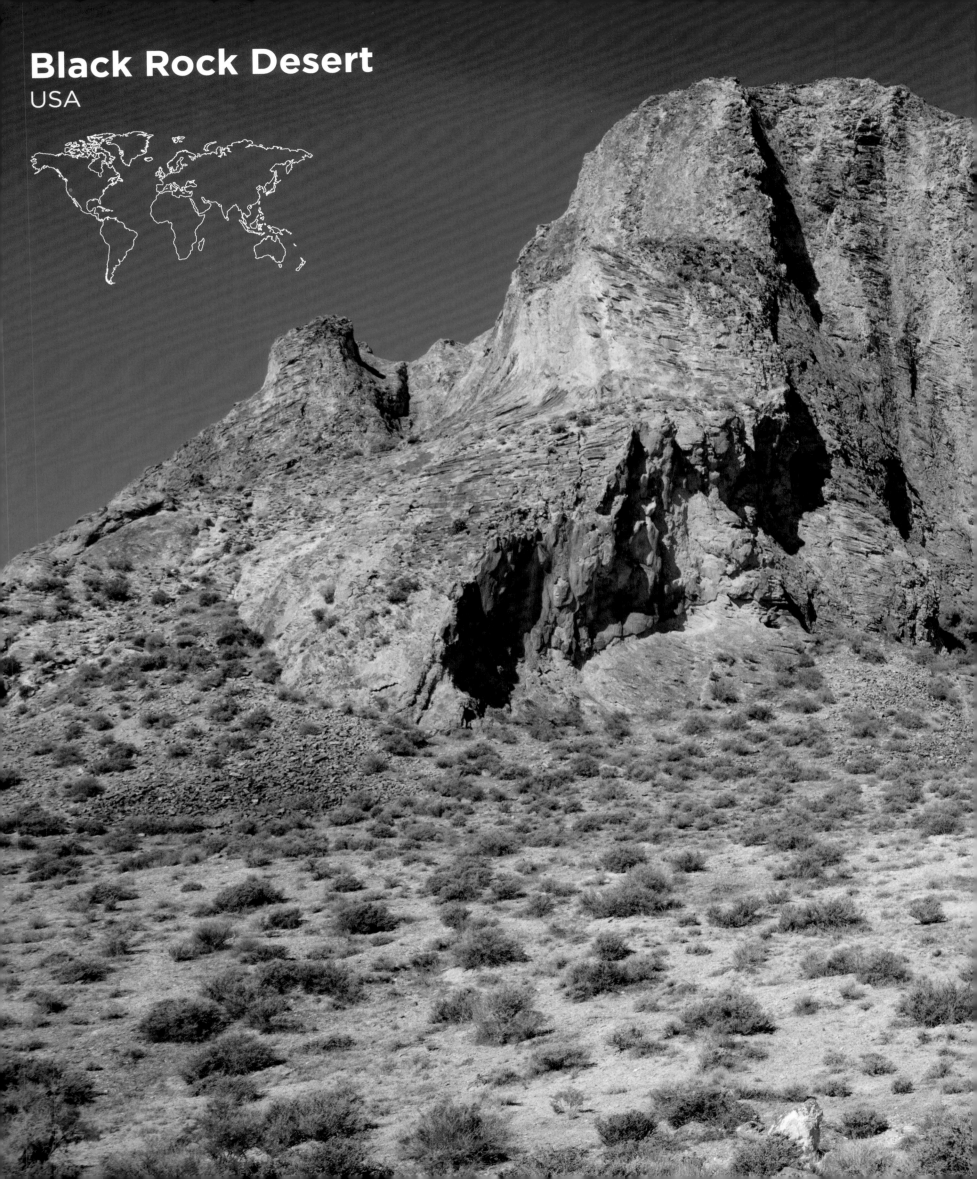

Black Rock Desert
USA

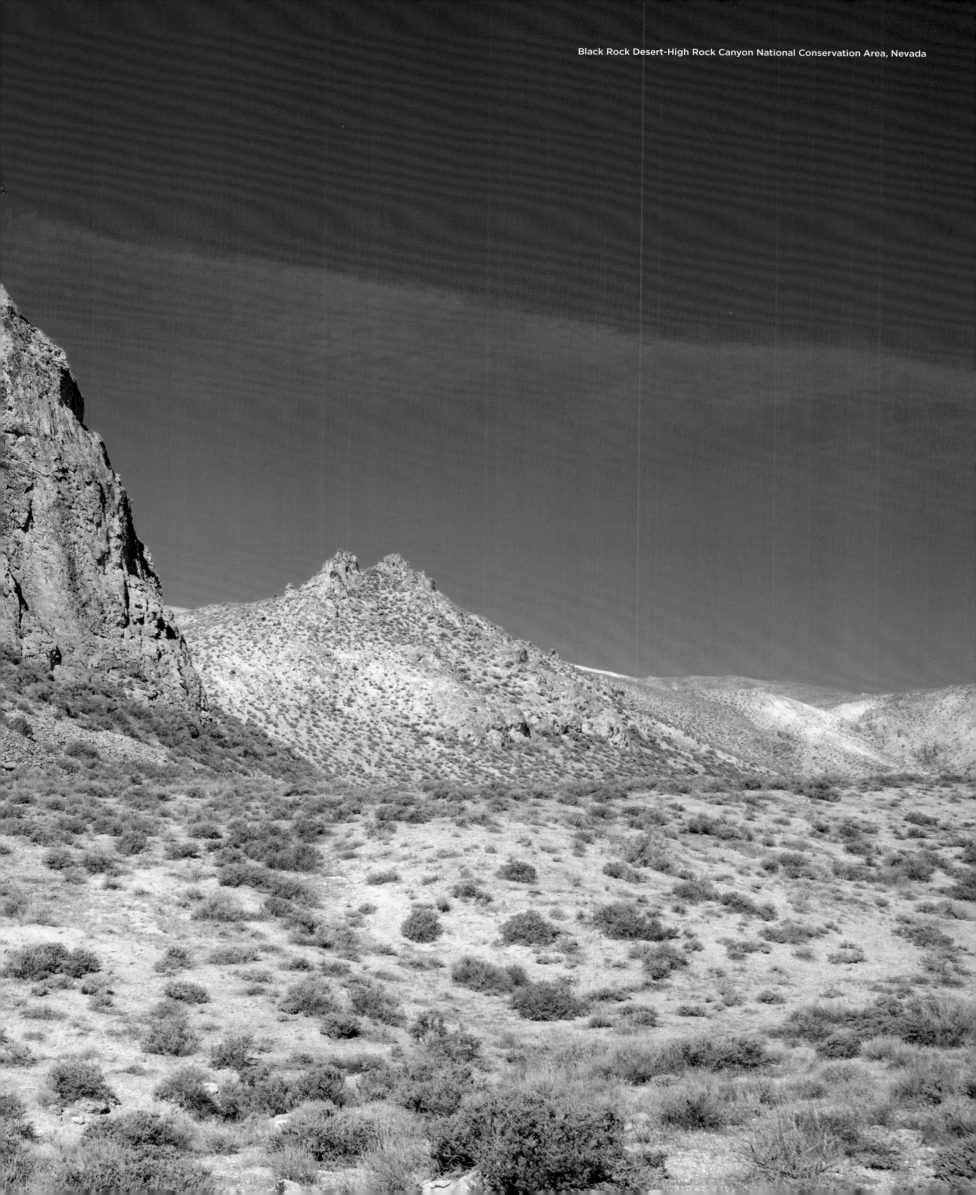

Black Rock Desert-High Rock Canyon National Conservation Area, Nevada

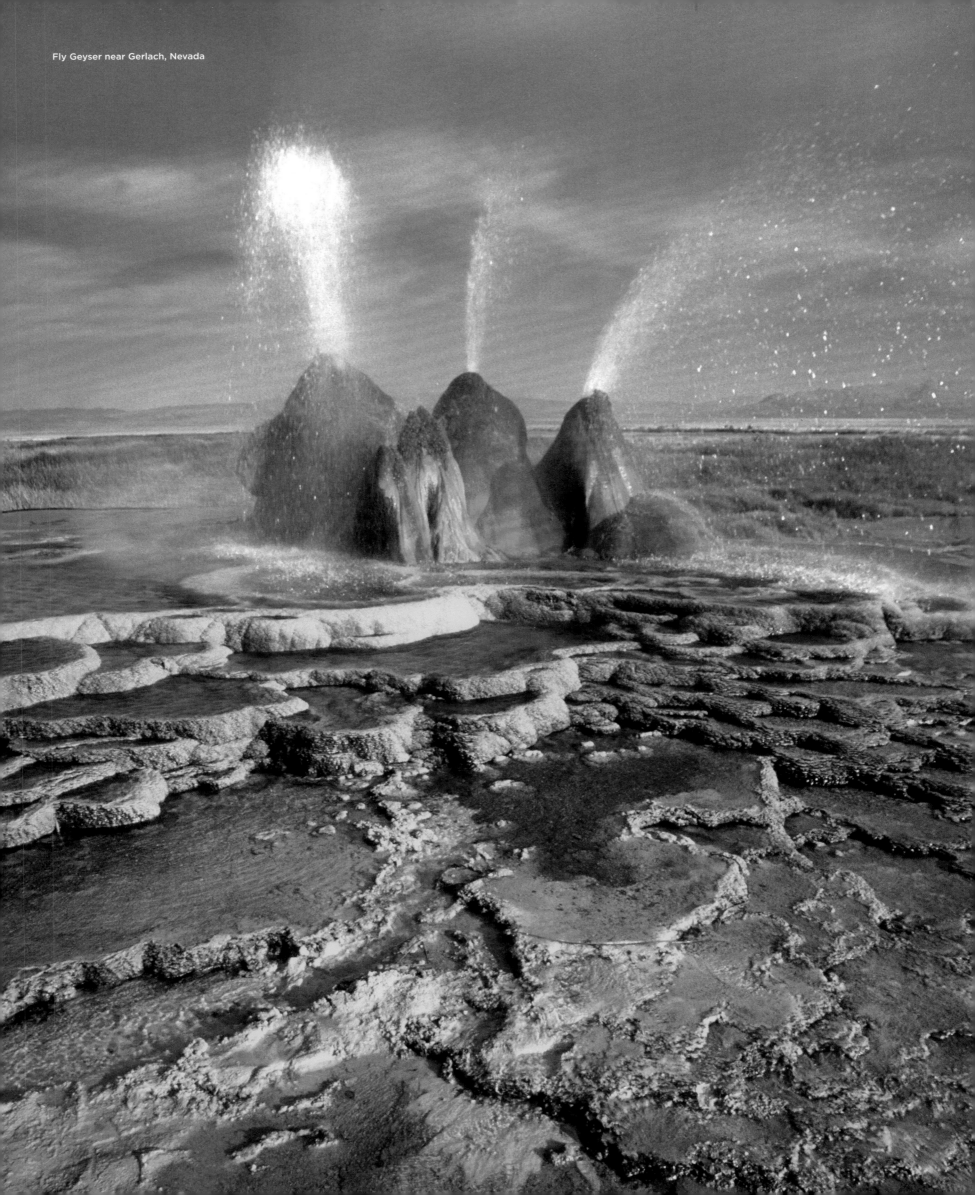

Fly Geyser near Gerlach, Nevada

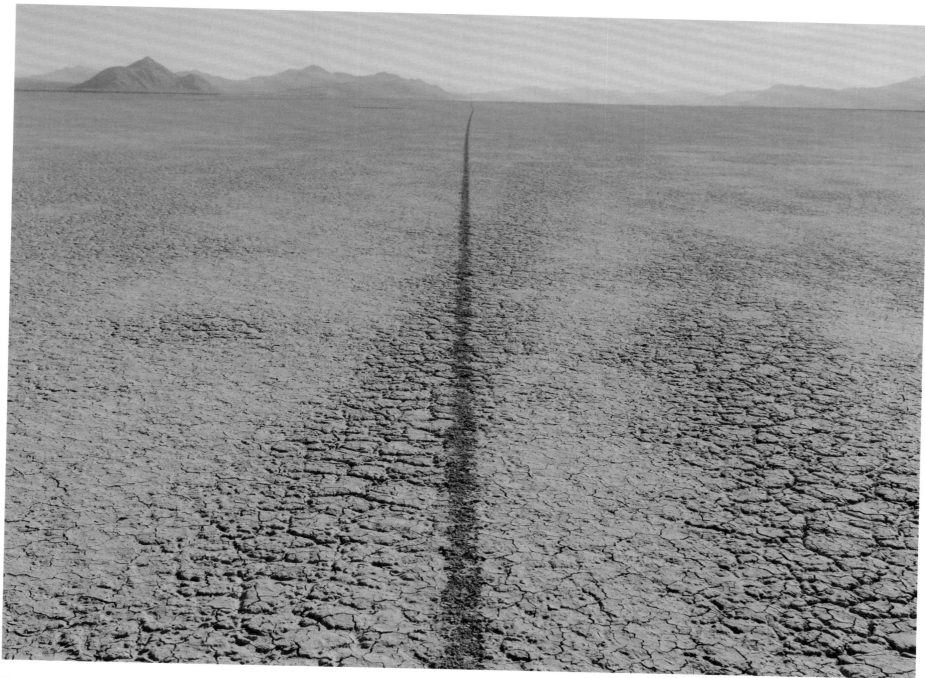

Playa, Nevada

Black Rock Desert

The Black Rock Desert in Nevada's north includes 23 different mountain ranges. Records of human habitation here date back 13 000 years. Much later, it took on great significance in the pioneering days of white expansion and settlement – up to half of those heading west to the Californian Gold Rush in 1849 passed through this desert.

Désert de Black Rock

Situé dans le nord du Nevada, le désert de Black Rock compte vingt-trois chaînes de montagnes. Les plus vieilles habitations humaines recensées datent de 13 000 ans. Plusieurs millénaires plus tard, ce désert a joué un rôle majeur durant les premiers jours de l'installation et de l'expansion blanche – la moitié des gens en route pour la ruée vers l'or californienne de 1849, l'ont traversé pour rejoindre l'Ouest.

Black Rock Desert

Die Black Rock Desert im Norden Nevadas umfasst 23 verschiedene Gebirgszüge. Spuren menschlicher Besiedlung reichen etwa 13 000 Jahre zurück. Viel später erlangte sie in den Pioniertagen der europäischen Expansion und Besiedlung Amerikas große Bedeutung: Knapp die Hälfte derjenigen, die der kalifornische Goldrausch 1849 nach Westen lockte, durchquerten diese Wüste.

Desierto de Black Rock

El desierto de Black Rock, que se encuentra en el norte de Nevada, incluye 23 cadenas montañosas diferentes. Los registros de la presencia humana aquí se remontan a hace 13 000 años. Mucho más tarde, adquirió gran importancia en los principios de la expansión y colonización de los blancos: hasta la mitad de los que se dirigían al oeste hacia la fiebre del oro de California en 1849 pásaron por este desierto.

O deserto de Black Rock

O deserto de Black Rock, no norte de Nevada, inclui 23 diferentes cadeias de montanhas. Registos de habitação humana datam de 13 000 anos atrás. Muito mais tarde, assumiu grande importância nos dias pioneiros de expansão e colonização branca – até metade dos que seguiam para o Oeste da Corrida do Ouro da Califórnia em 1849 passaram por esse deserto.

Black Rock Desert

De Black Rock Desert in het noorden van Nevada omvat 23 verschillende bergketens. Sporen van menselijke bewoning hier dateren van 13 000 jaar geleden. Veel later, in de pioniersdagen van de Europese expansie en kolonisatie van Amerika, werd hij van grote betekenis: bijna de helft van de mensen die in 1849 tijdens de Californische goudkoorts naar het westen trokken, kwam door deze woestijn.

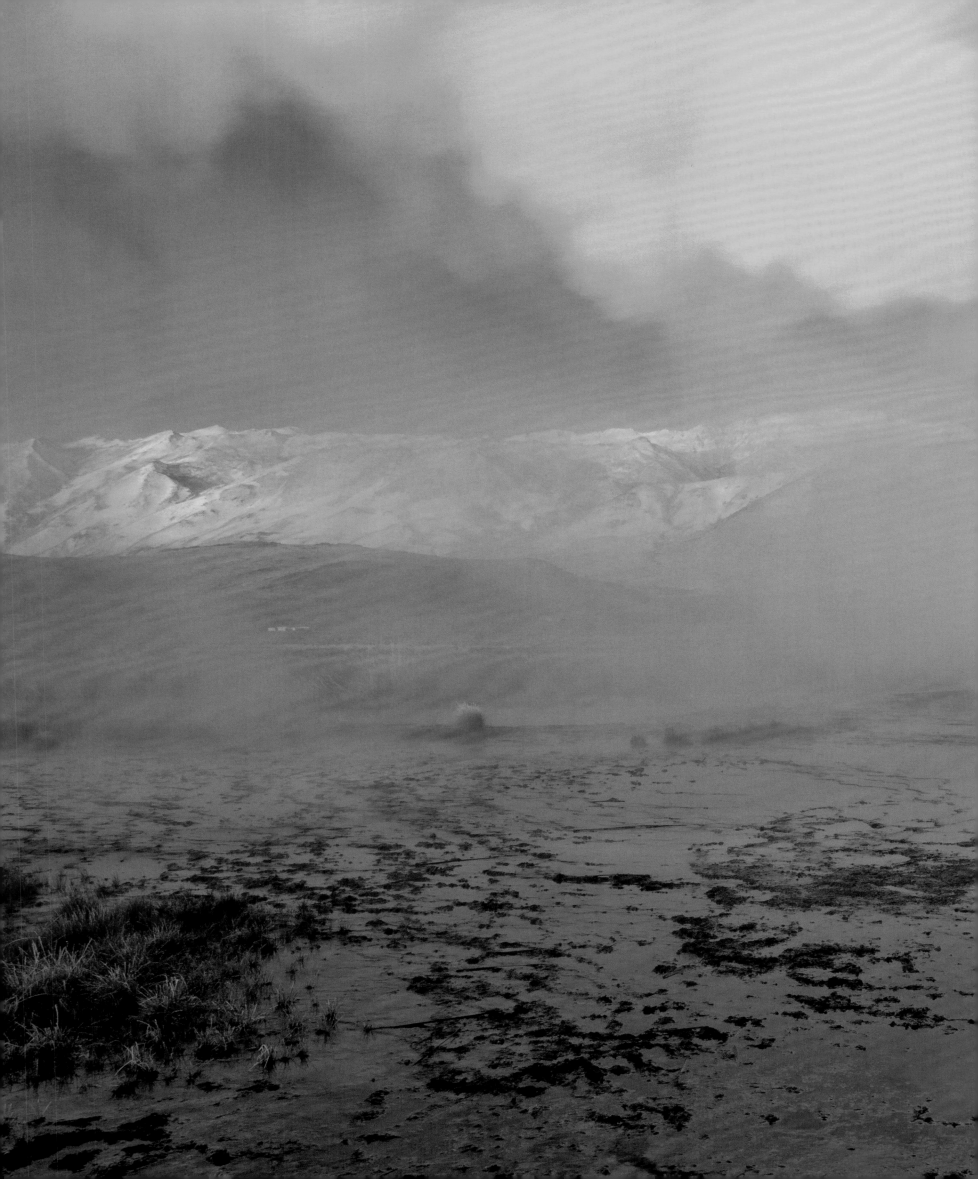

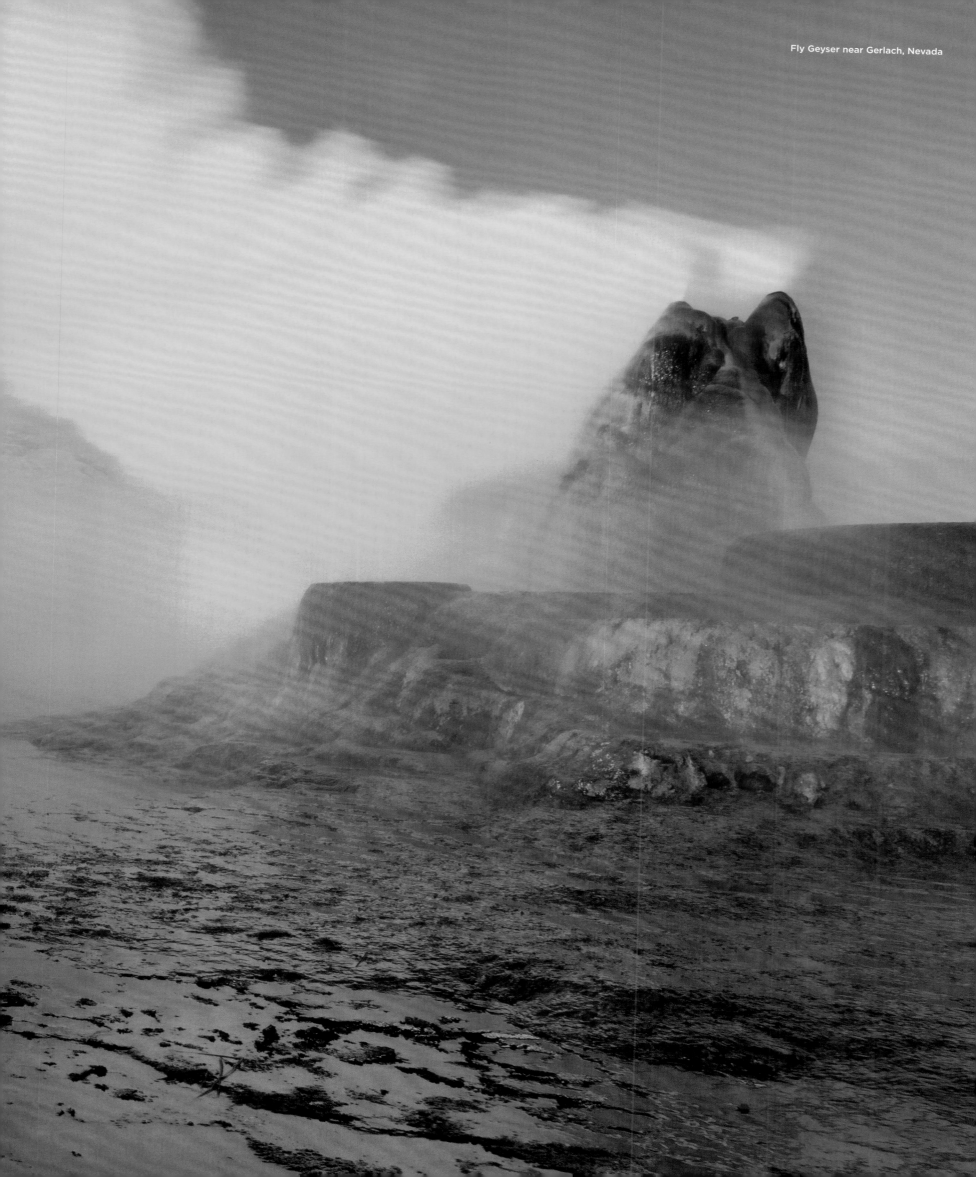
Fly Geyser near Gerlach, Nevada

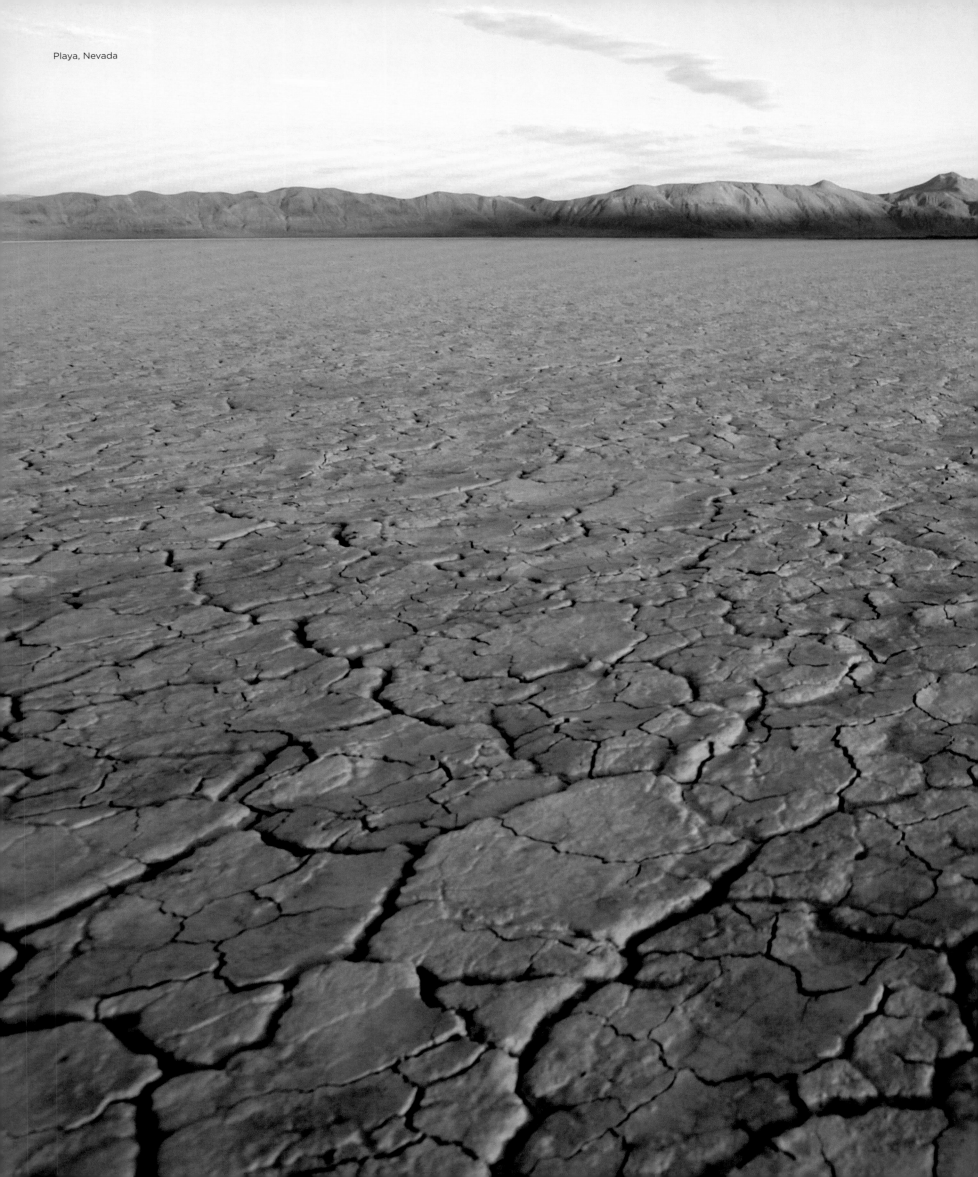

Playa, Nevada

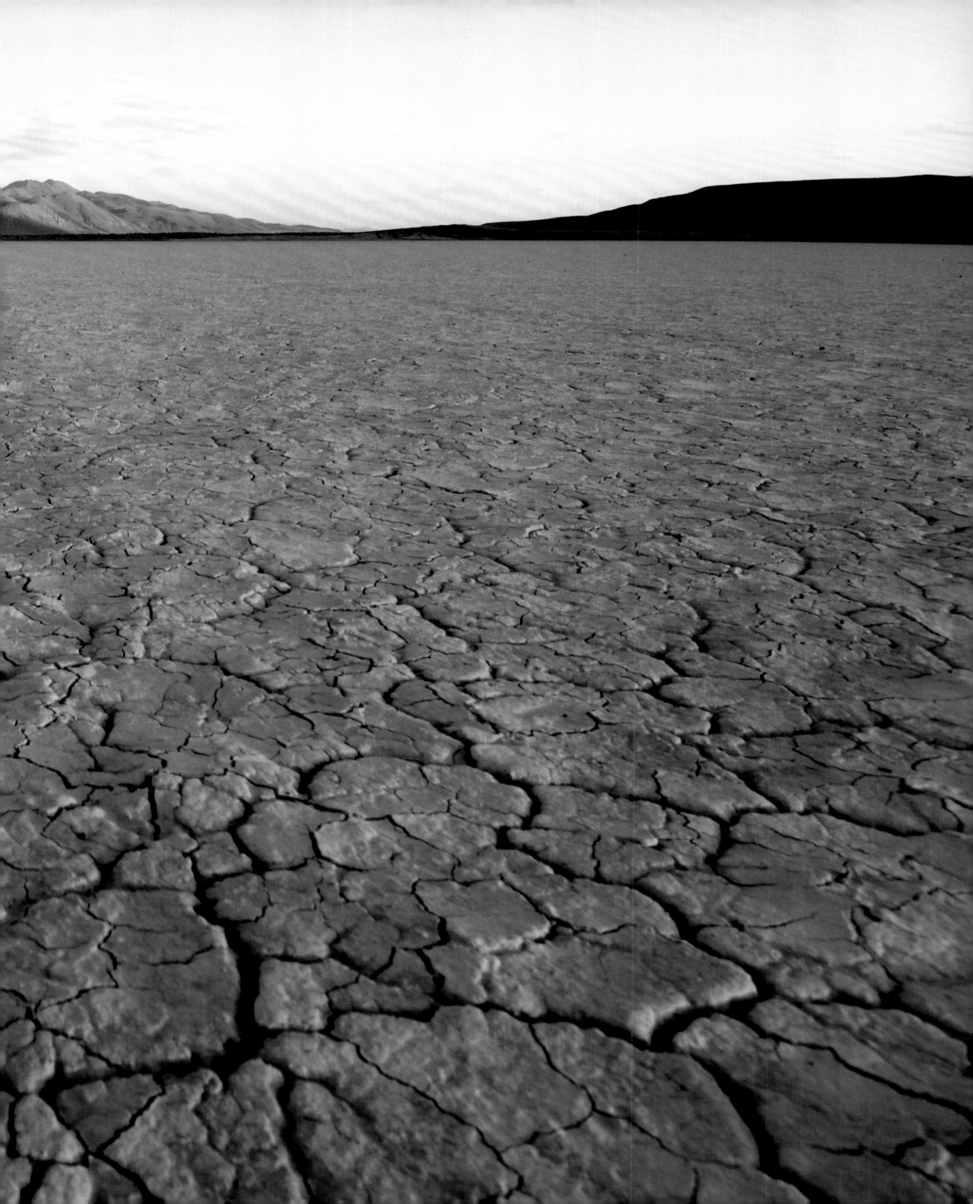

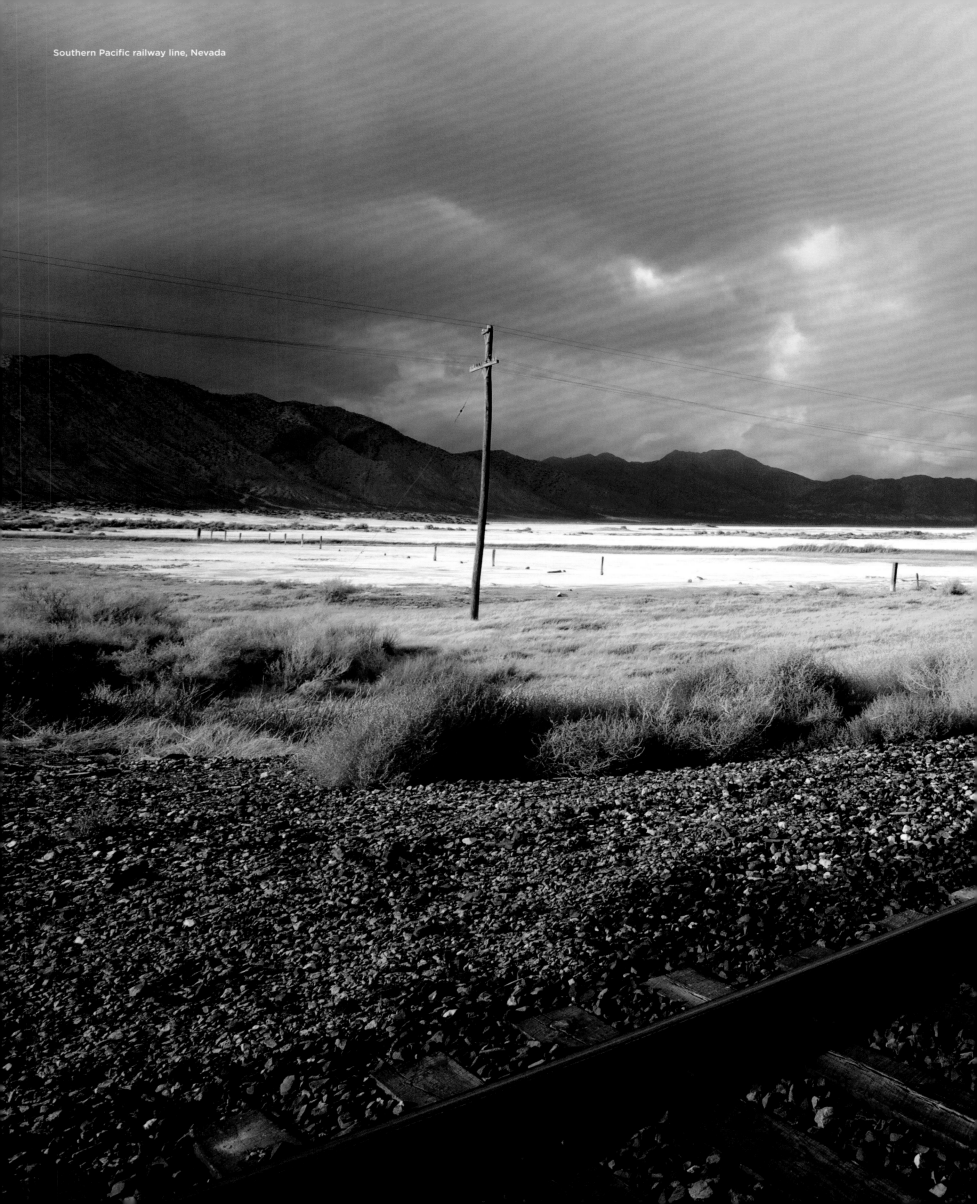

Southern Pacific railway line, Nevada

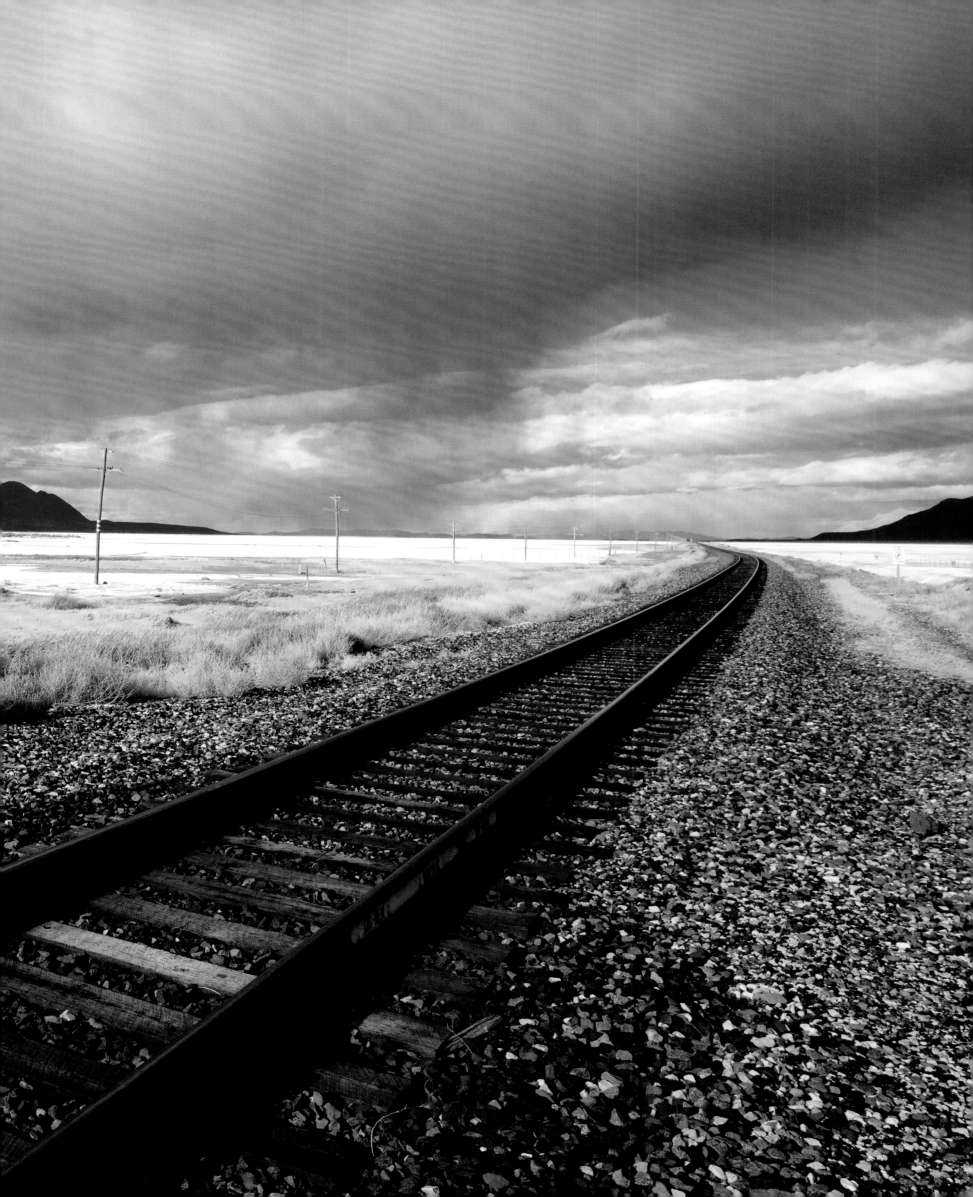

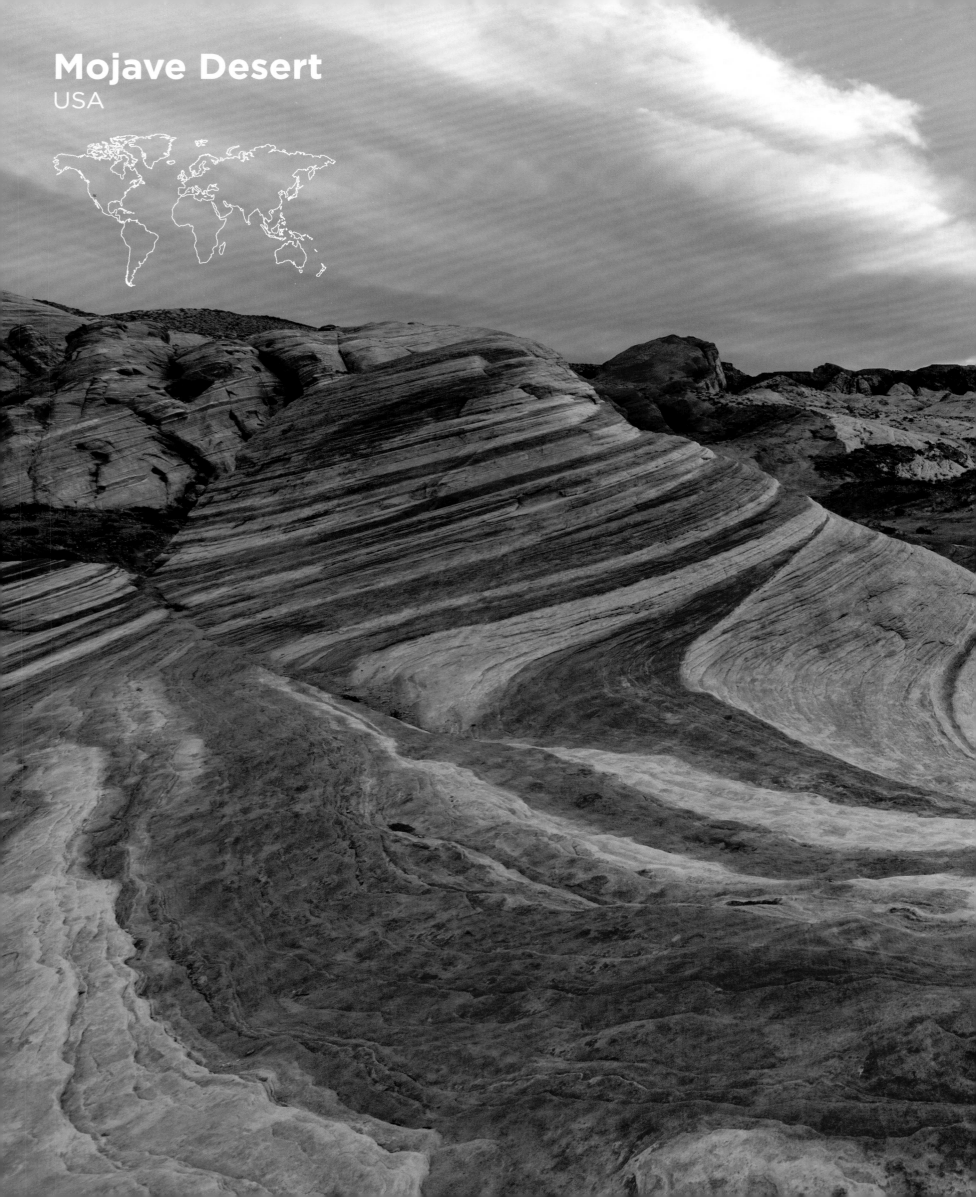

Mojave Desert
USA

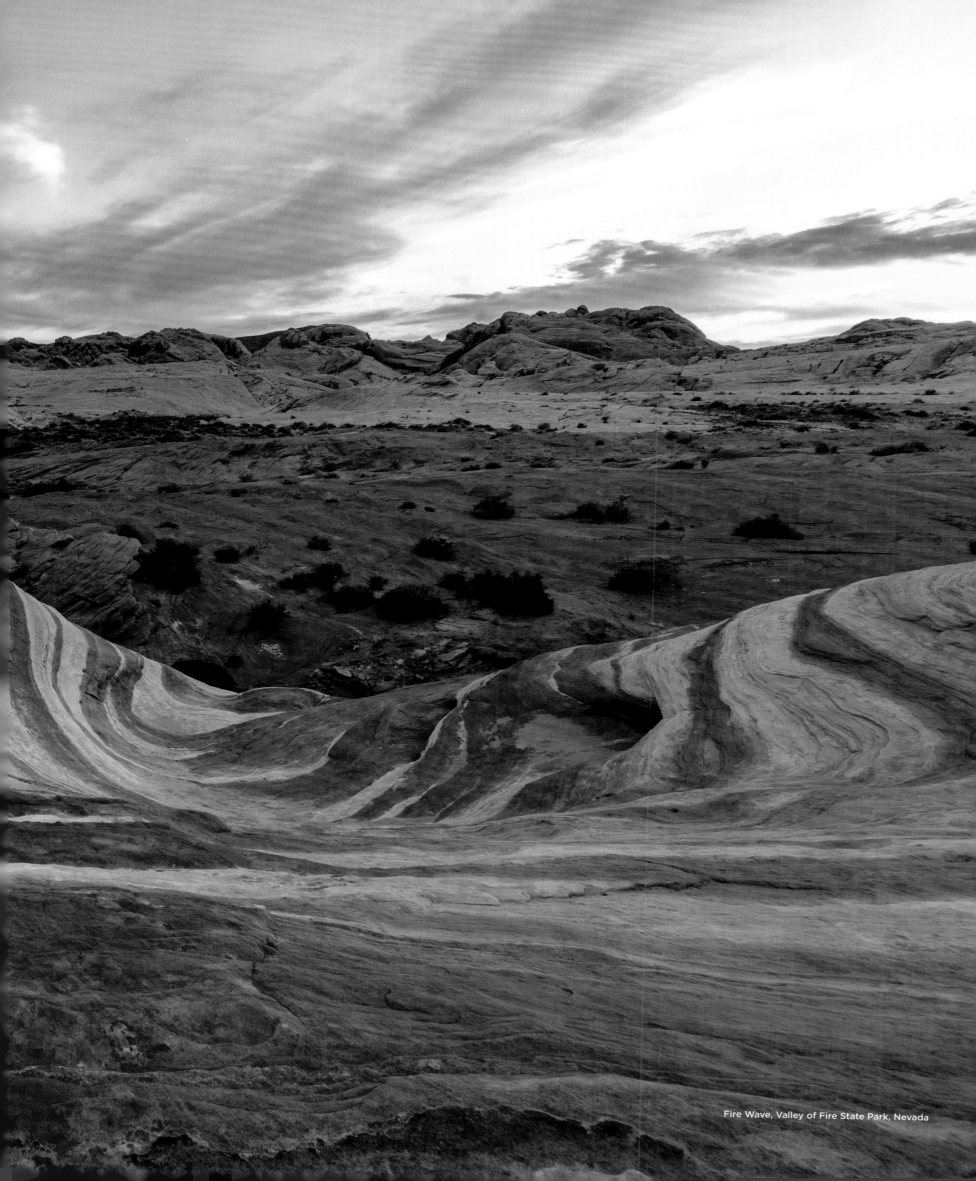

Fire Wave, Valley of Fire State Park, Nevada

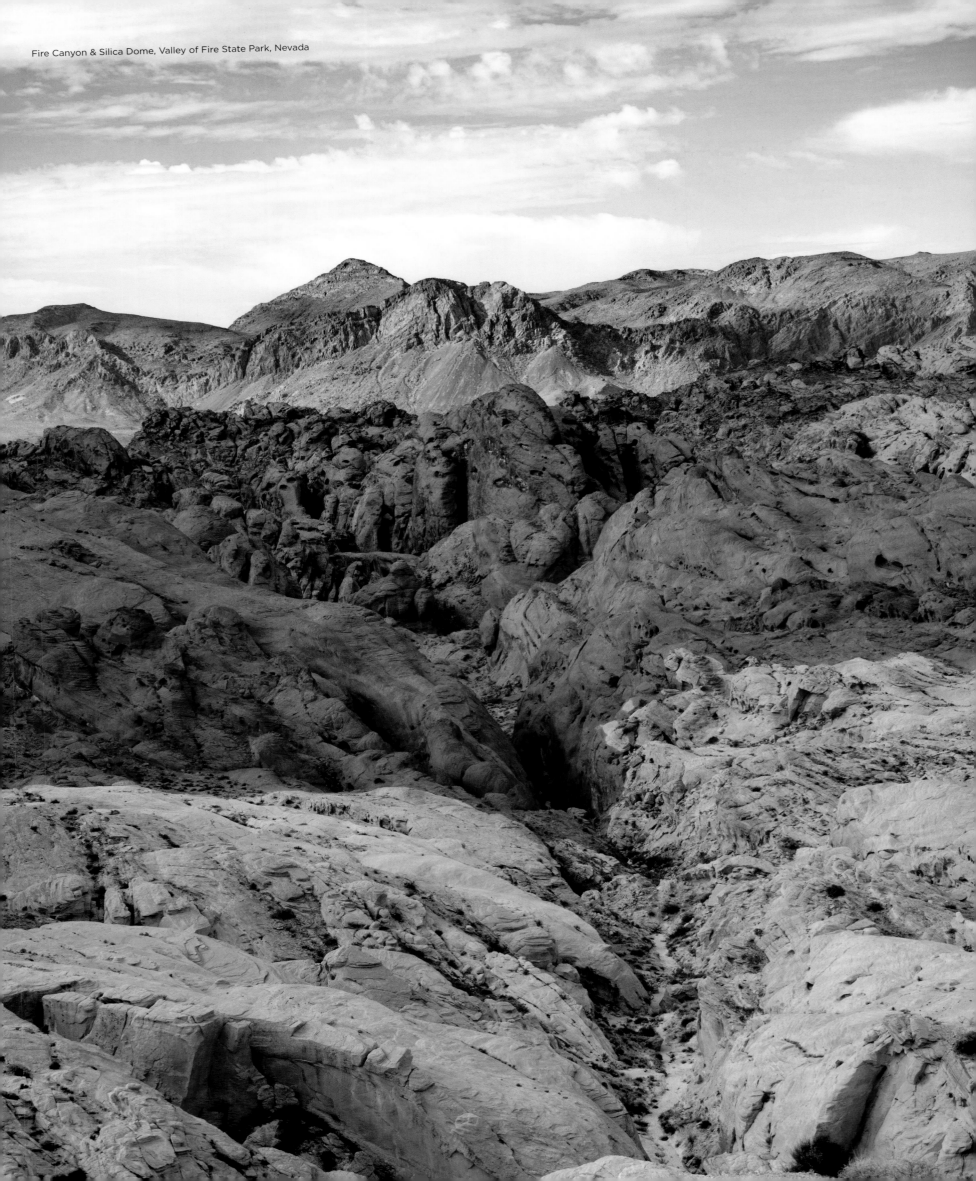

Fire Canyon & Silica Dome, Valley of Fire State Park, Nevada

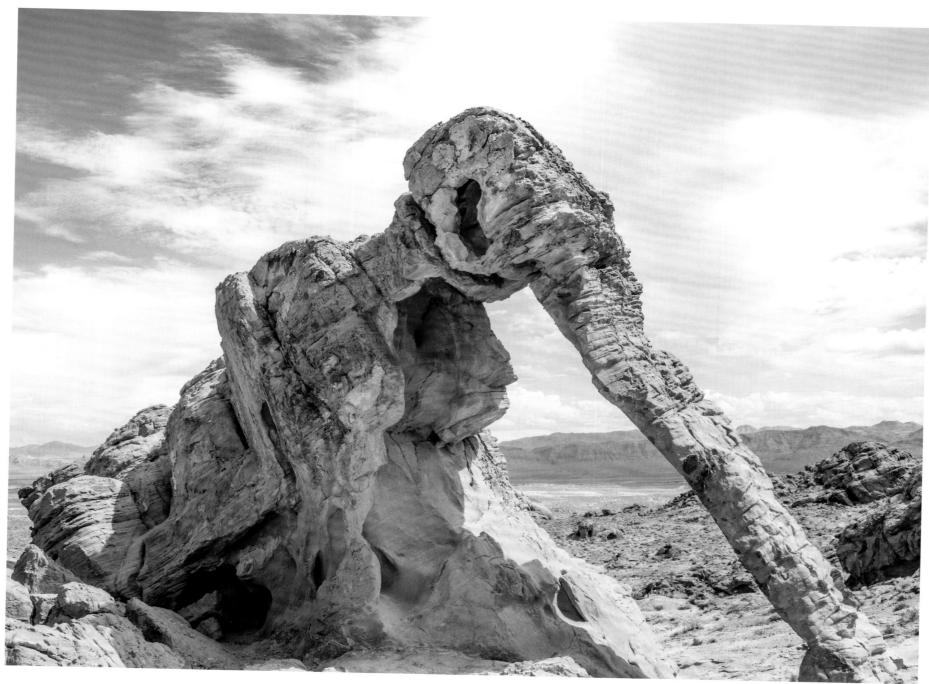

Elephant Rock, Valley of Fire State Park, Nevada

Mojave Desert

North America's driest desert, the Mojave, occupies south-eastern California and southern Nevada, as well as smaller tracts of Utah and Arizona. The desert is named after the Native Mojave Tribal Nation, and is famous for its Joshua Trees that only survive in this type of desert.

Désert de Mojave

Désert le plus aride d'Amérique du Nord, le Mojave occupe le sud-est de la Californie et le sud du Nevada ainsi que des petites parties de l'Utah et de l'Arizona. Le désert doit son nom à la nation indienne autochtone des Mojave. Il est connu pour ses arbres de Josué, qui survivent uniquement dans de tels déserts.

Mojave-Wüste

Die Mojave, die trockenste Wüste Nordamerikas, liegt im Südosten Kaliforniens und im Süden Nevadas sowie in kleineren Gebieten von Utah und Arizona. Die Wüste ist nach dem indigenenen Volk der Mojave benannt und ist berühmt wegen ihrer Joshuabäume, die nur in dieser Wüste vorkommen.

Desierto de Mojave

El desierto más seco de Norteamérica, el Mojave, ocupa el sureste de California y el sur de Nevada, así como pequeñas extensiones de Utah y Arizona. El desierto lleva el nombre de la Nación Tribal Nativa Mojave, y es famoso por sus árboles de Josué, que solamente sobreviven en este tipo de desierto.

Mojave Desert

O deserto mais seco da América do Norte, o Mojave, ocupa o sudeste da Califórnia e o sul de Nevada, além de áreas menores de Utah e Arizona. O deserto é nomeado após a nação tribal nativa de Mojavee é famosa por suas árvores de Joshua que só sobrevivem neste tipo de deserto.

Mojavewoestijn

De droogste woestijn van Noord-Amerika, de Mojave, beslaat het zuidoosten van Californië en het zuiden van Nevada, net als kleinere delen van Utah en Arizona. De woestijn is vernoemd naar het inheemse Mojavevolk en is beroemd om de boomyucca's (Joshua trees) die alleen in deze woestijn voorkomen.

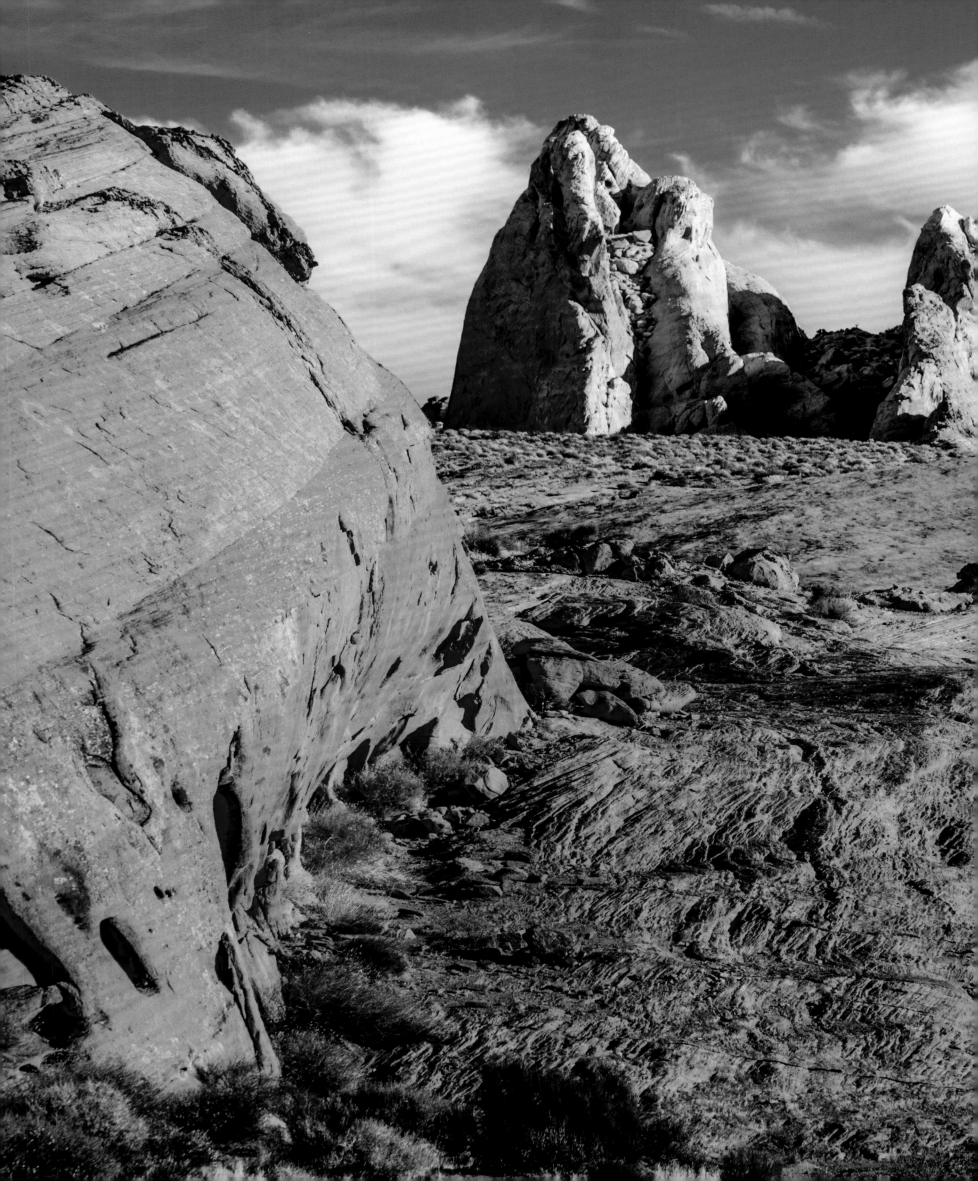

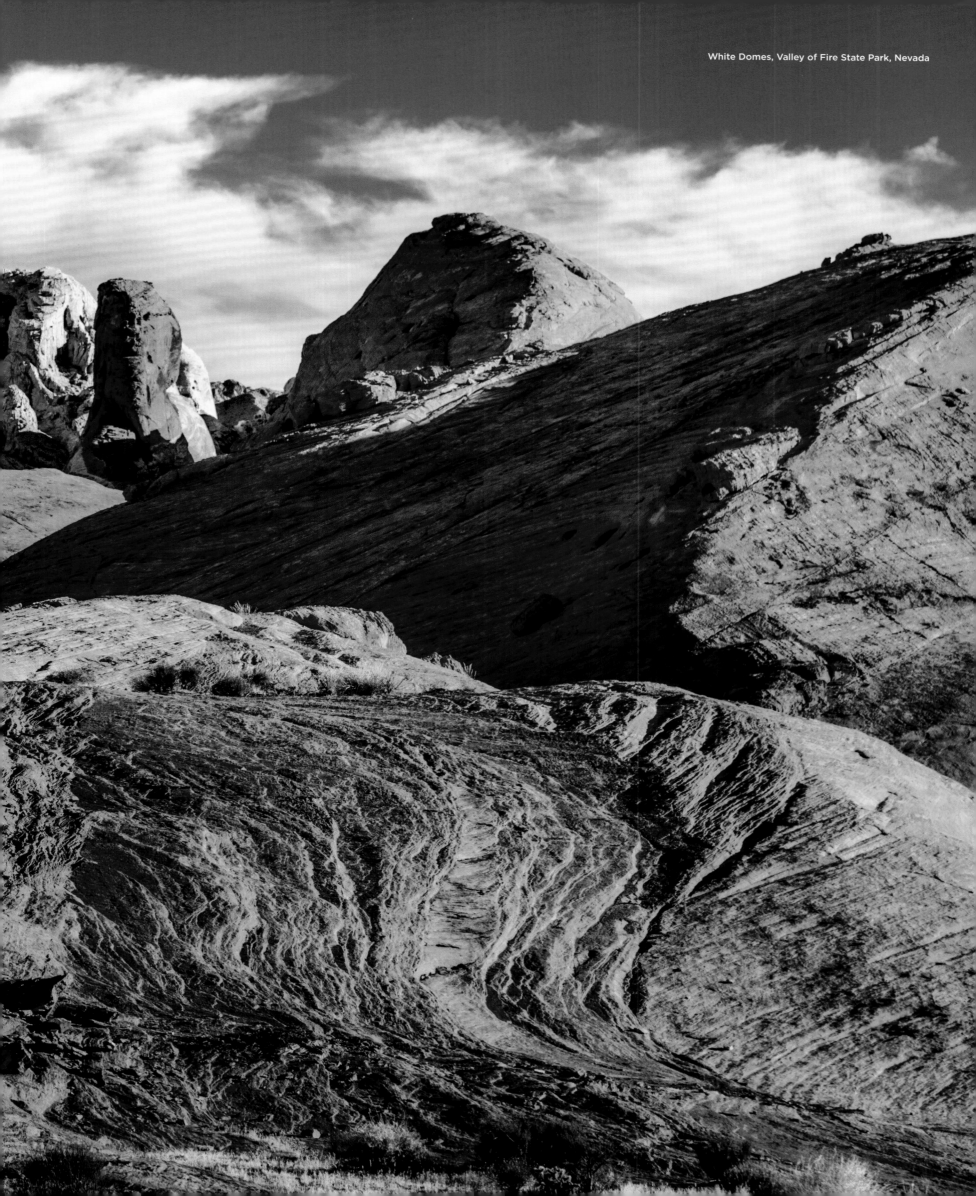
White Domes, Valley of Fire State Park, Nevada

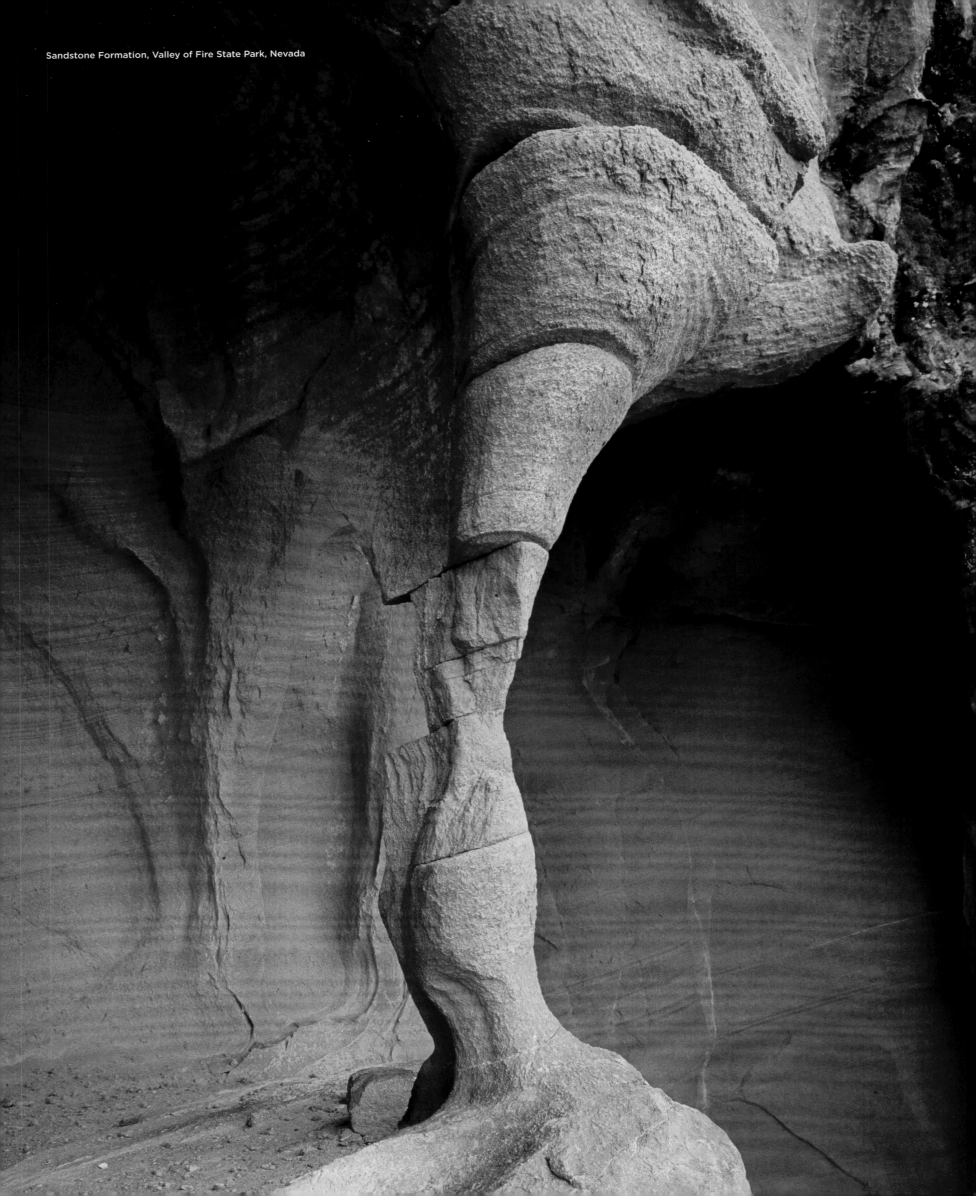

Sandstone Formation, Valley of Fire State Park, Nevada

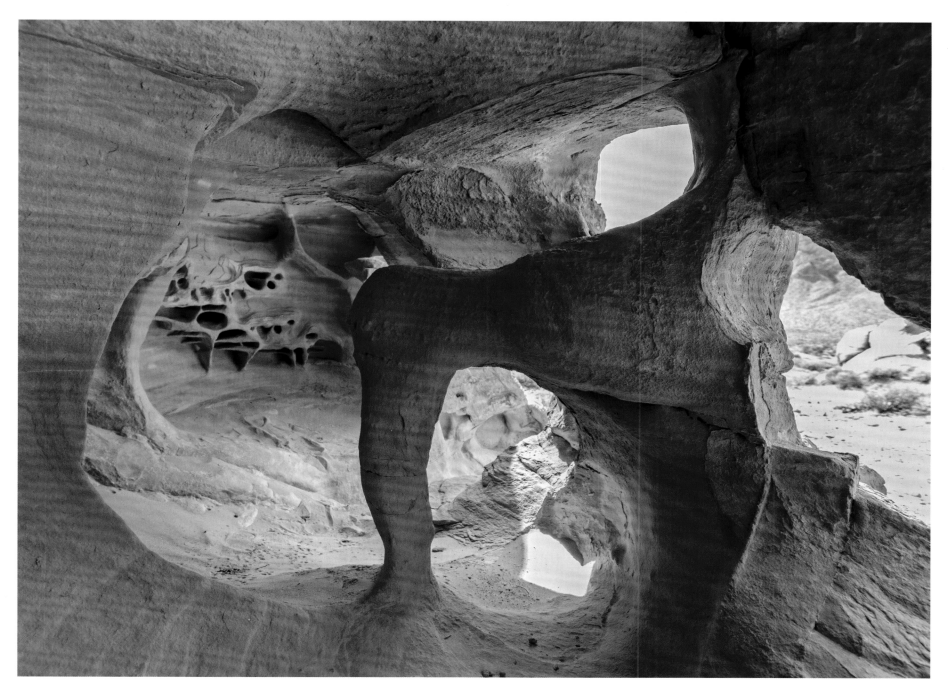

Windstone Arch, Valley of Fire State Park, Nevada

Stone Formations

Among the Mojave's defining attractions are the weird-and-wonderful rock formations, weathered by wind and water through millions of years; shapes include elephants, mushrooms and skulls. Most lie along wide valley systems or rock faces that border open plains and face the prevailing winds. The soft stone was also used for rock carvings by ancient peoples.

Formaciones rocosas

Entre los atractivos que definen el Mojave se encuentran las formaciones rocosas, extrañas y maravillosas, erosionadas por el viento y el agua a lo largo de millones de años. Las formas incluyen elefantes, hongos y calaveras. La mayoría se encuentra a lo largo de amplios sistemas de valles o paredes rocosas que bordean llanuras abiertas y se enfrentan a los vientos dominantes. La piedra blanda también fue utilizada para tallas en roca por pueblos antiguos.

Formations rocheuses

Ces formations rocheuses à la fois étranges et extraordinaires, battues par le vent et la pluie durant des millions d'années, comptent parmi les attraits du Mojave. La plupart de ces formations aux allures d'éléphants, de champignons et de crânes sont disposées le long d'un vaste réseau de vallées, ou de parois rocheuses en bordure des plaines ouvertes, orientées face aux vents dominants. Ce matériau tendre était également utilisé par des peuples anciens pour leurs sculptures en pierre.

Formações de Pedra

Entre as atrações definidoras do Mojave estão as estranhas e maravilhosas formações rochosas, desgastadas pelo vento e pela água ao longo de milhões de anos; formas incluem elefantes, cogumelos e crânios. A maioria encontra-se ao longo de grandes sistemas de vales ou faces rochosas que limitam as planícies abertas e enfrentam os ventos predominantes. A pedra macia também foi usada para esculturas rupestres de povos antigos.

Steinformationen

Zu den charakteristischen Attraktionen der Mojave gehören die seltsamen und wunderbaren Felsformationen, die über Millionen von Jahren durch Wind- und Wassererosion geschaffen wurden: Man meint Elefanten, Pilze und Totenschädel zu erkennen. Die meisten liegen an breiten Talsystemen oder Felswänden, die an offene Ebenen grenzen und den vorherrschenden Winden ausgesetzt sind. Der weiche Stein wurde auch für Felszeichnungen von urzeitlichen Völkern verwendet.

Steenformaties

De Mojave wordt onder andere gekenmerkt door de schitterende, grillige rotsformaties die in de loop van miljoenen jaren door de wind en het water zijn gevormd: je kunt er olifanten, paddenstoelen en schedels in herkennen. De meeste liggen langs brede dalen of rotswanden, die grenzen aan open vlaktes en blootgesteld zijn aan de heersende winden. Oeroude volkeren gebruikten de zachte steen voor rotstekeningen.

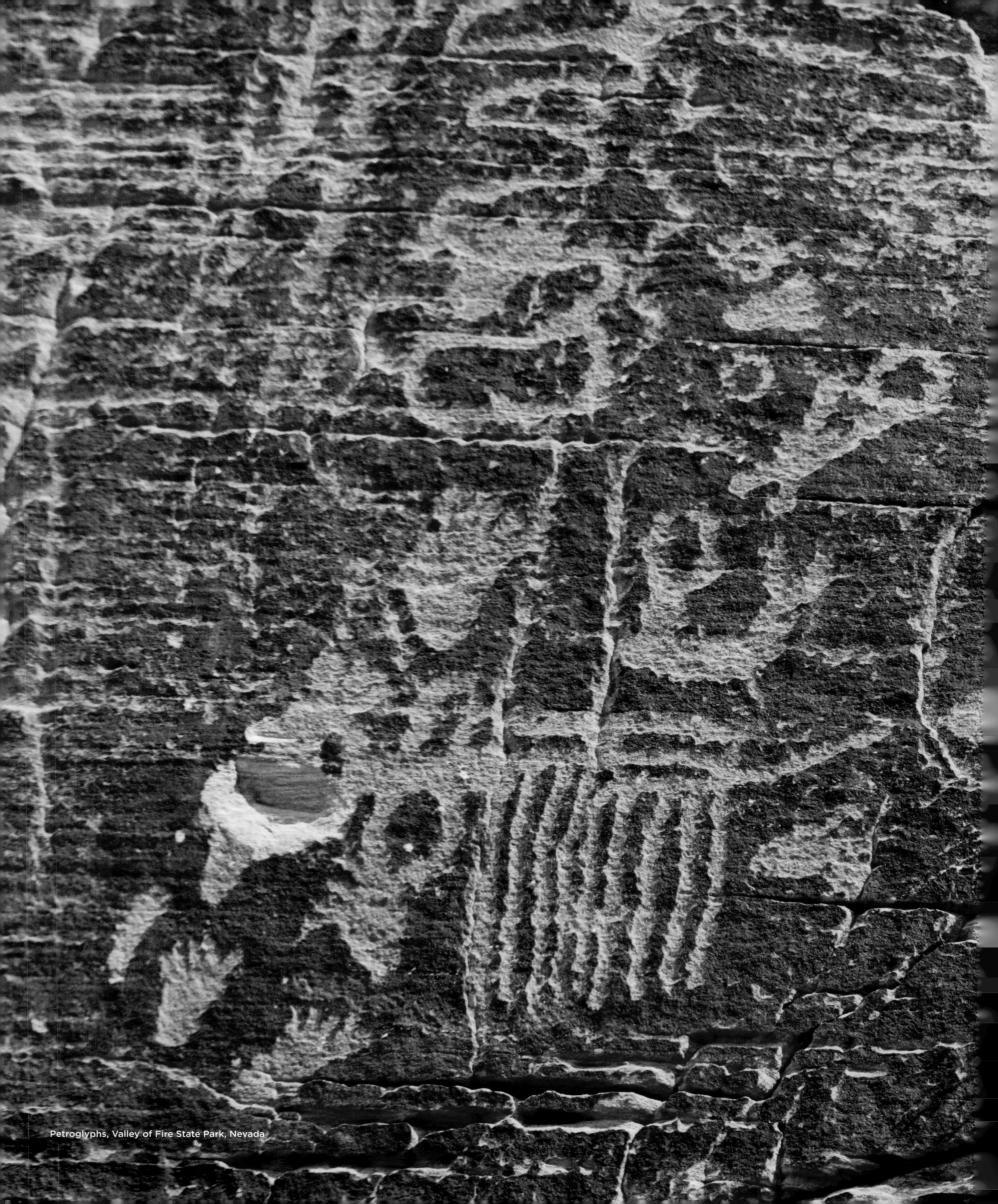

Petroglyphs, Valley of Fire State Park, Nevada

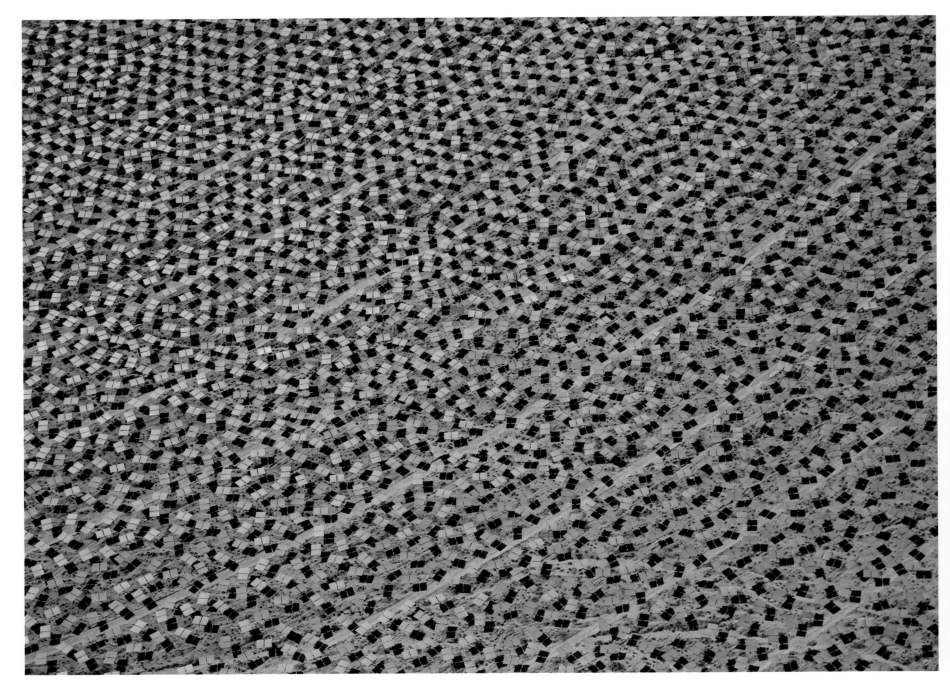

Ivanpah Solar Electric Generating System, California

Ivanpah Solar Electric Generating System

Sunshine is one thing that deserts have in abundance and harnessing the energy this produces is the reason for the Ivanpah Solar Electric Generating System at the base of Clark Mountain in California's south. It was the world's largest solar thermal power station when it opened in 2014. It uses thousands of heliostat mirrors that deflect sunlight to receivers in three 69-storey solar towers, from where the created energy is distributed. It produces enough energy to power 140 000 homes and produces 400 000 m³ of carbon dioxide less than an equivalent fossil-fuel-driven power plant – that's the same as taking 72 000 cars off the road.

Centrale solaire thermodynamique d'Ivanpah

S'il est une chose dont les déserts sont prodigues, c'est de soleil. Implanté au pied de la montagne Clark, dans le sud de la Californie, le générateur électrique solaire Ivanpah fonctionne grâce à l'énergie qu'il produit. Plus grande centrale électrique thermique au monde lors de son ouverture, en 2014, elle fonctionne grâce à plusieurs milliers de miroirs héliostats, qui dévient la lumière du Soleil vers des récepteurs implantés dans trois tours solaires de 69 étages, depuis lesquelles l'énergie créée est distribuée. Elle en produit assez pour fournir 140 000 foyers et produit 400 000 m³ de dioxydes de carbone de moins qu'une centrale équivalente fonctionnant à l'énergie fossile – ce qui reviendrait à retirer 72 000 voitures de la circulation.

Sonnenwärmekraftwerk Ivanpah

Sonnenlicht ist etwas, das Wüsten im Überfluss haben. Die Nutzung der daraus zu gewinnenden Energie ist der Grund für das Ivanpah Solar Electric Generating System am Fuße des Clark Mountain im Süden Kaliforniens. Bei der Eröffnung 2014 war es das größte solarthermische Kraftwerk der Welt. Es verwendet tausende von Heliostatspiegeln, die das Sonnenlicht zu den Absorbern in drei 69-stöckigen Solartürmen leiten, von wo aus die erzeugte Energie verteilt wird. Es produziert genügend Energie für 140 000 Haushalte und produziert 400 000 m³ Kohlendioxid weniger als ein gleichwertiges Kraftwerk mit fossilen Brennstoffen – das ist dasselbe wie 72 000 Autos von der Straße zu nehmen.

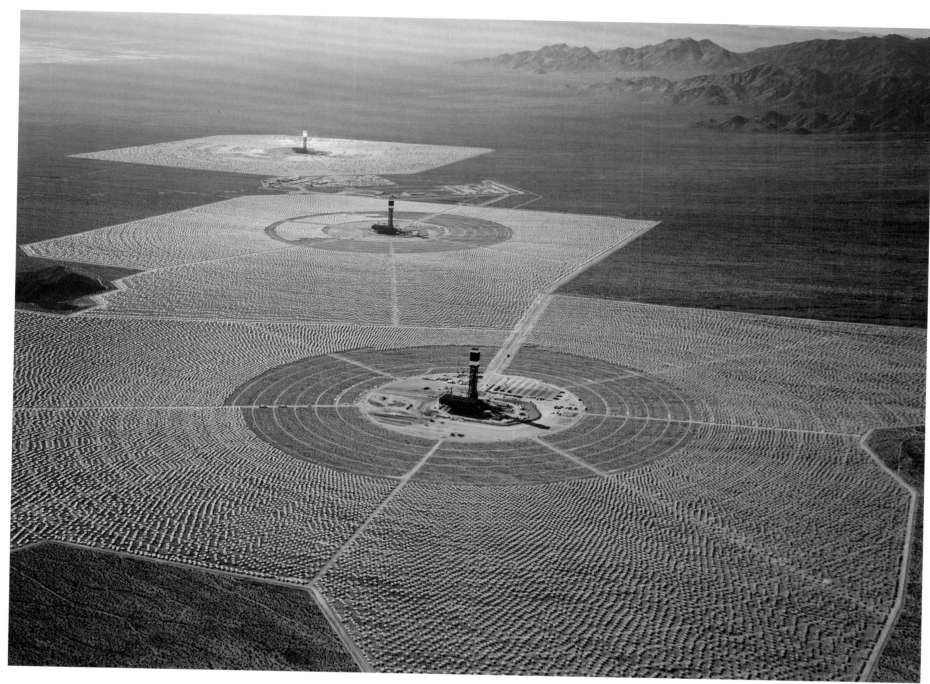

Ivanpah Solar Electric Generating System, California

Sistema de generación eléctrica Ivanpah Solar

El sol es algo que los desiertos tienen en abundancia y aprovechar la energía que este produce es lo que impulsa el Sistema de Generación Eléctrica Solar de Ivanpah en la base de Clark Mountain, en el sur de California. Cuando se inauguró, en 2014, era la mayor central termosolar del mundo. Utiliza miles de espejos de helióstatos que desvían la luz solar hacia los receptores en tres torres solares de 69 pisos, desde donde se distribuye la energía creada. Produce suficiente energía para abastecer a 140 000 hogares y produce 400 000 m³ de dióxido de carbono menos que una central eléctrica equivalente impulsada por combustibles fósiles, lo que equivale a retirar 72 000 automóviles de las carreteras.

Sistema Gerador Solar Elétrico Ivanpah

O sol é uma coisa que os desertos têm em abundância e o aproveitamento da energia que isso produz é o que impulsiona o Sistema de Geração Elétrico Solar Ivanpah na base da Montanha Clark, no sul da Califórnia. Foi a maior central térmica solar do mundo quando foi inaugurada em 2014. Ela usa milhares de espelhos heliostáticos que desviam a luz do sol para recetores em três torres solares de 69 andares, de onde a energia criada é distribuída. Produz energia suficiente para abastecer 140 mil casas e produz menos de 400 mil m³ de dióxido de carbono do que uma usina de energia equivalente movida a combustível fóssil – é o mesmo que tirar 72 mil carros das ruas.

Ivanpah-zonnecentrale

Zonlicht is één ding dat woestijnen in overvloed hebben. Benutting van de daaruit gewonnen energie vormt de basis van de Ivanpah Solar Electric Generating System aan de voet van Clark Mountain in het zuiden van Californië. Bij de opening in 2014 was het de grootste thermische zonne-energiecentrale ter wereld. Hij gebruikt duizenden heliostaatspiegels die het zonlicht afbuigen naar ontvangers in drie 69 verdiepingen tellende zonnetorens, vanwaaruit de opgewekte energie wordt gedistribueerd. De centrale produceert genoeg energie om 140 000 huishoudens van stroom te voorzien en stoot 400 000 m³ kooldioxide minder uit dan een gelijkwaardige energiecentrale op fossiele brandstoffen – dat komt overeen met 72 000 auto's van de weg halen.

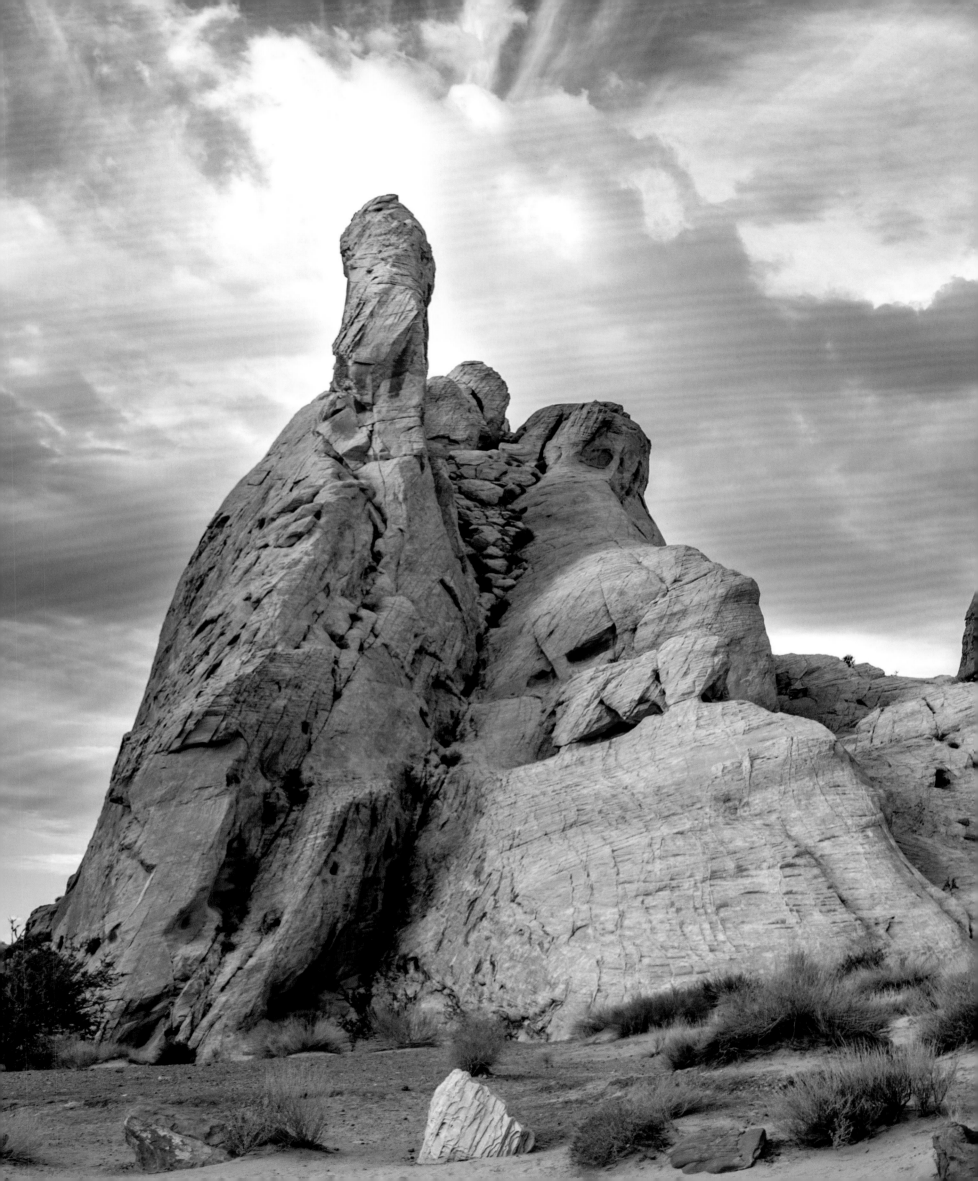

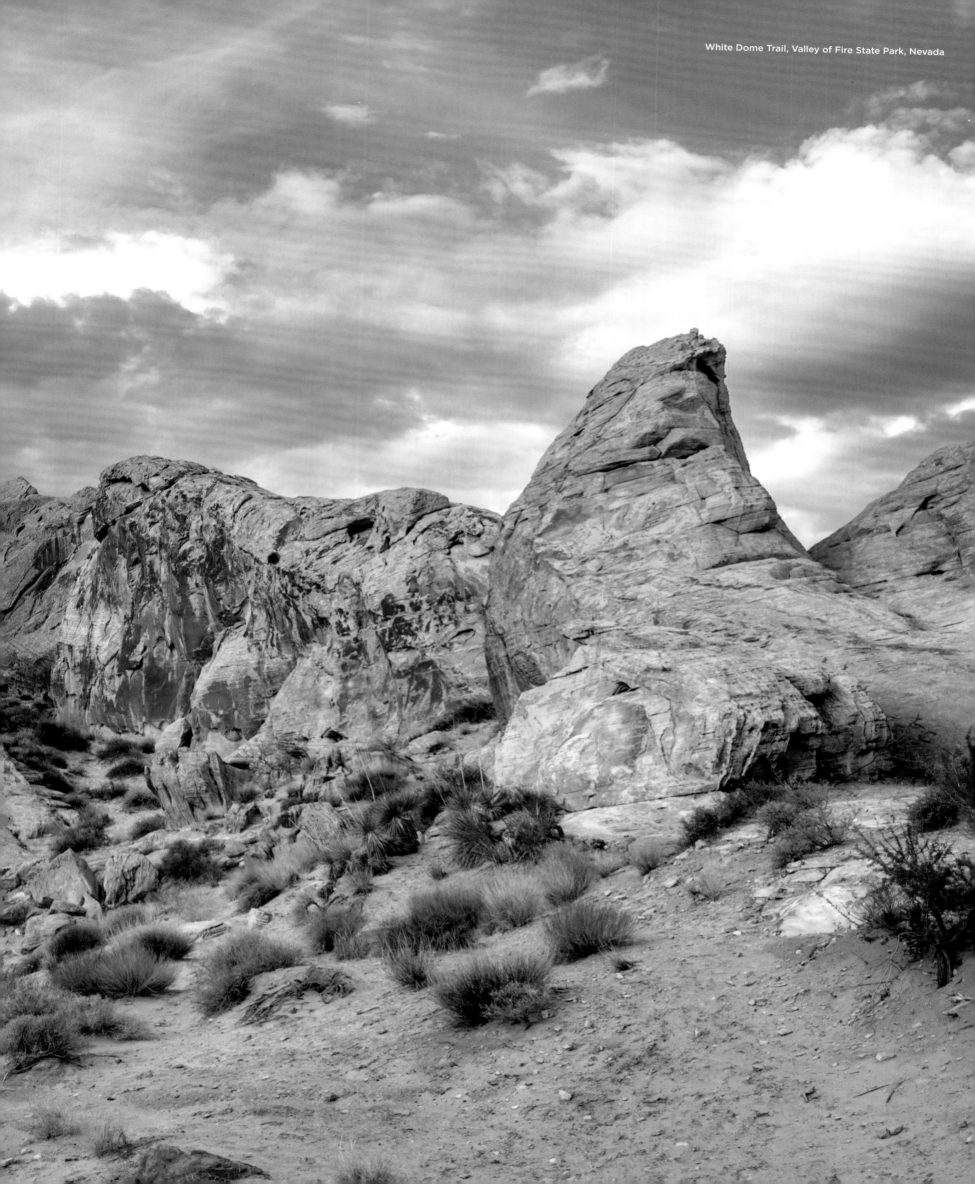

White Dome Trail, Valley of Fire State Park, Nevada

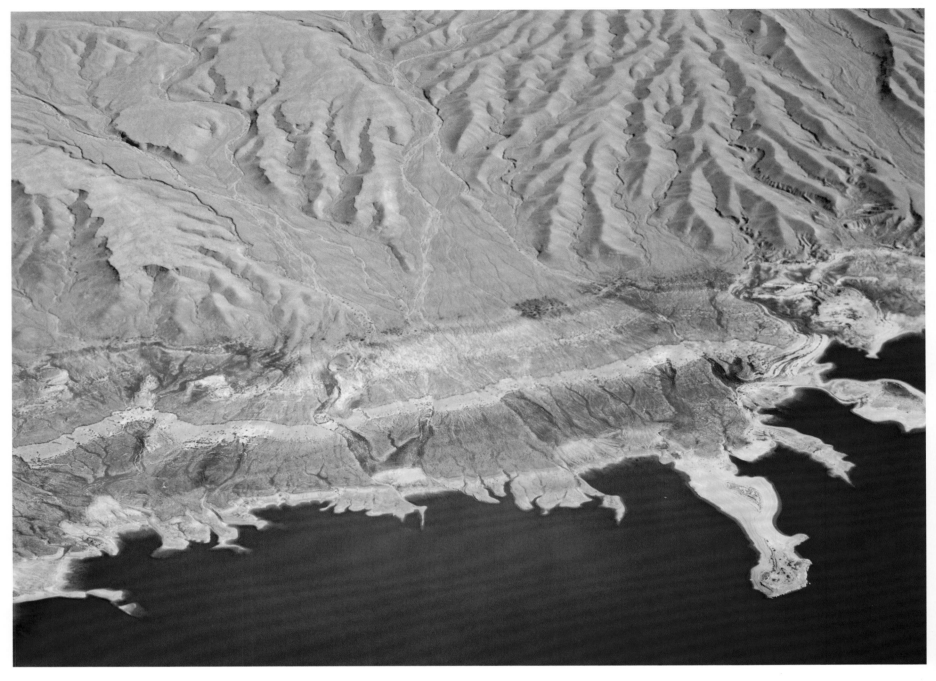

Desert near Las Vegas, Nevada

Las Vegas

The bright lights of Las Vegas may be the antithesis of desert silence and space, but Las Vegas remains America's quintessentially desert city. Resembling a man-made oasis, Las Vegas (whose name translates as 'the meadows' in Spanish) occupies a desert basin surrounded by 3 000 m-high mountains. It is a city of great contradictions – associated with excess, it is surrounded by North America's driest desert; water scarcity is a major concern with up to a quarter of its water coming from underground sources (the rest is piped from the 400km-distant Colorado River), yet the city has been susceptible to flash flooding in the past.

Las Vegas

Les lumières de Las Vegas sont peut-être l'antithèse du silence et de l'espace du désert, mais cette cité n'en reste pas moins l'archétype de la ville du désert américaine. Telle une oasis créée par l'homme, Las Vegas (dont le nom signifie « les prairies », en espagnol) occupe un bassin désertique cerné de montagnes culminant à 3 000 mètres d'altitude. C'est le lieu de toutes les contradictions : associé à l'excès, il est implanté au cœur du désert le plus chaud du continent nord-américain ; le manque d'eau y est un problème majeur vu que seul un quart de son eau provient de sources souterraines (le reste est extrait et acheminé du fleuve Colorado, situé à 400 km de là, via des canalisations). Et cependant, la ville a connu des crues soudaines par le passé.

Las Vegas

Die hellen Lichter von Las Vegas sind das Gegenteil von Wüstenstille und weiter Landschaft, aber dies ist und bleibt Amerikas Wüstenstadt par excellence. Las Vegas (Spanisch für „die Wiesen") ähnelt einer künstlichen Oase und liegt in einem von 3 000 m hohen Bergen umgebenen Wüstenbecken. Es ist eine Stadt mit großen Widersprüchen – sie lässt an Überfluss denken, ist aber von Nordamerikas trockenster Wüste umgeben. Wasserknappheit ist ein großes Problem, da bis zu einem Viertel des Wassers aus unterirdischen Quellen stammt (der Rest wird aus dem 400 km entfernten Colorado River heran geleitet), dadurch hat es in der Vergangenheit immer wieder Sturzfluten gegeben.

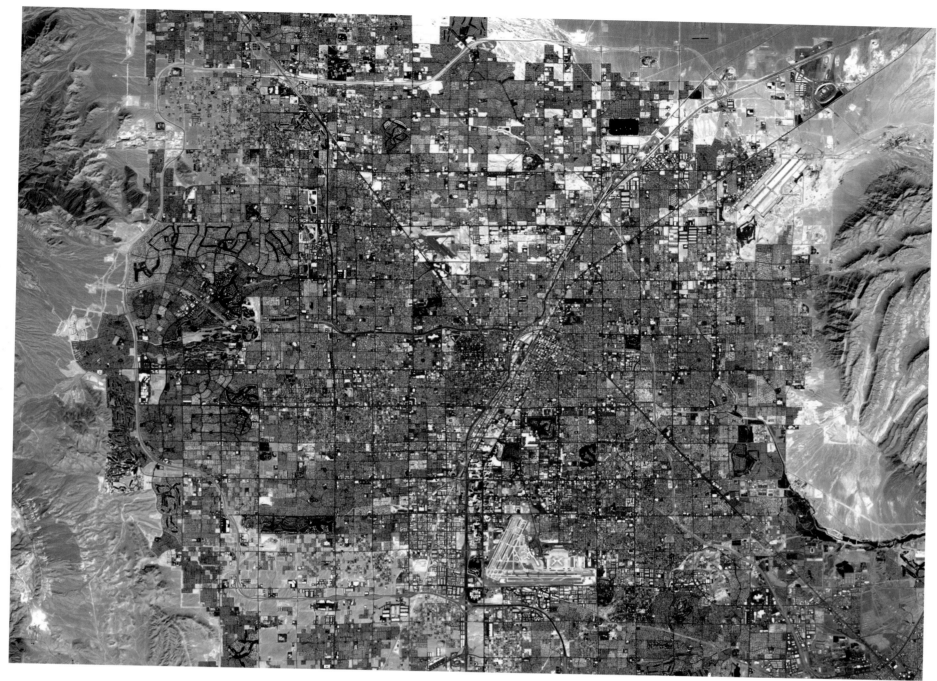

Las Vegas, Nevada

Las Vegas

Las brillantes luces de Las Vegas pueden ser la antítesis del silencio y el espacio del desierto, pero sigue siendo la quintaesencia de la ciudad desértica de Estados Unidos. Parecida a un oasis hecho por el hombre, Las Vegas (cuyo nombre es sinónimo de «prados») ocupa una cuenca desértica rodeada de montañas de 3 000 metros de altura. Es una ciudad de grandes contradicciones: asociada con el exceso, está rodeada por el desierto más seco de Norteamérica; la escasez de agua es una gran preocupación, ya que hasta una cuarta parte de su agua proviene de fuentes subterráneas (el resto se canaliza desde el río Colorado, a 400 km de distancia); sin embargo, la ciudad ha sido víctima de repentinas inundaciones en el pasado.

Las Vegas

As luzes brilhantes de Las Vegas podem ser a antítese do silêncio e do espaço no deserto, mas continuam a ser a cidade essencialmente desértica da América. Assemelhando-se a um oásis feito pelo homem, Las Vegas (cujo nome significa "prados" em espanhol) ocupa uma bacia deserta cercada por montanhas de 3 000 m de altura. É uma cidade de grandes contradições - associada ao excesso, é cercada pelo deserto mais seco da América do Norte; a escassez de água é uma grande preocupação, com até um quarto de sua água proveniente de fontes subterrâneas (o restante é canalizado do distante 400 km do rio Colorado), mas a cidade tem sido suscetível a inundações repentinas no passado.

Las Vegas

De felle lichten van Las Vegas zijn misschien wel de tegenpool van woestijnstilte en landschappelijke weidsheid, maar dit is en blijft Amerika's woestijnstad bij uitstek. Las Vegas (Spaans voor 'de weiden') lijkt op een kunstmatige oase en ligt in een woestijnbekken omringd door 3 000 meter hoge bergen. Het is een stad met grote tegenstrijdigheden: ondanks alle overdaad wordt de stad omgeven door de droogste woestijn van Noord-Amerika. Waterschaarste is een groot probleem, aangezien een kwart van het water uit ondergrondse bronnen komt (de rest komt van de 400 km verderop gelegen Coloradorivier). Daardoor waren er in het verleden vaak plotselinge overstromingen.

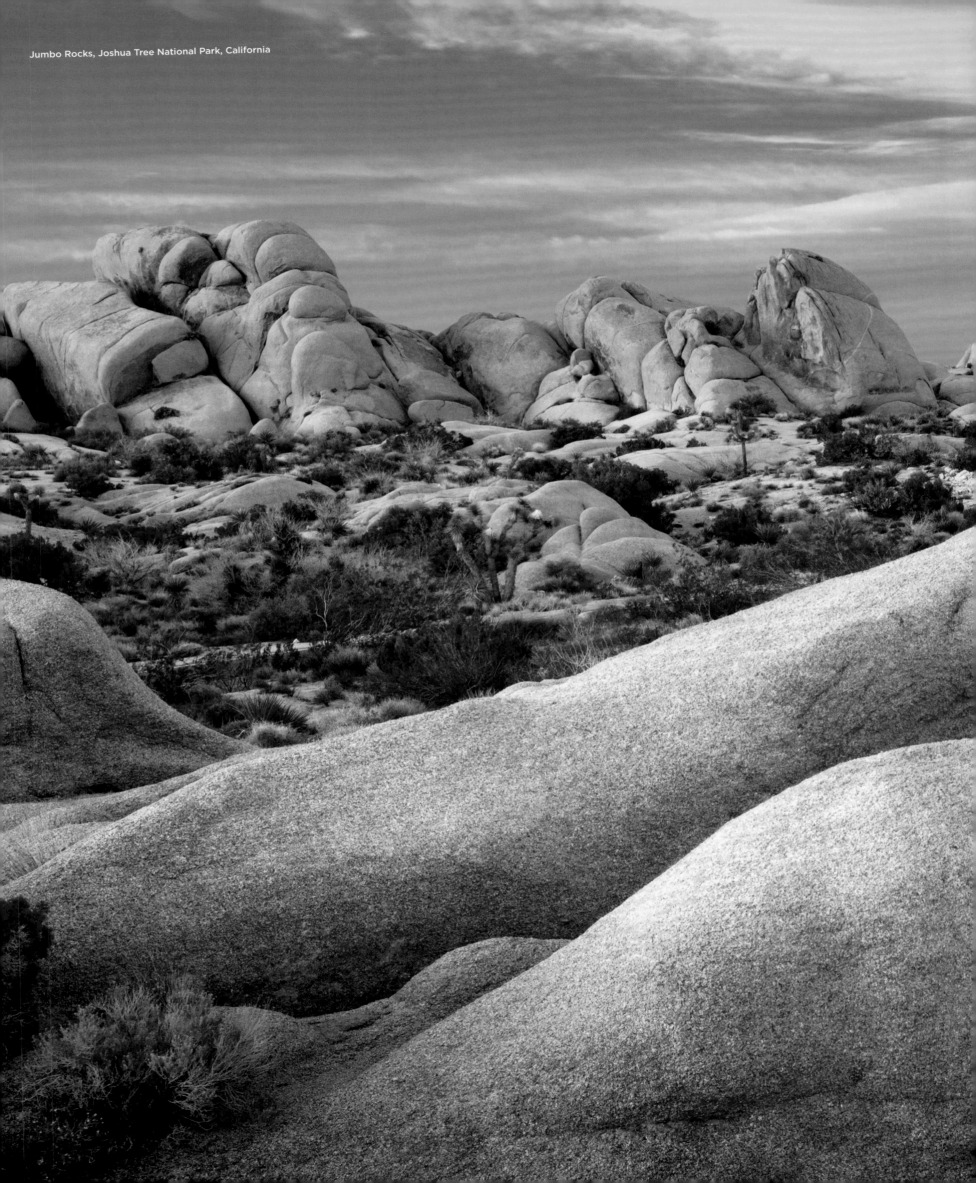

Jumbo Rocks, Joshua Tree National Park, California

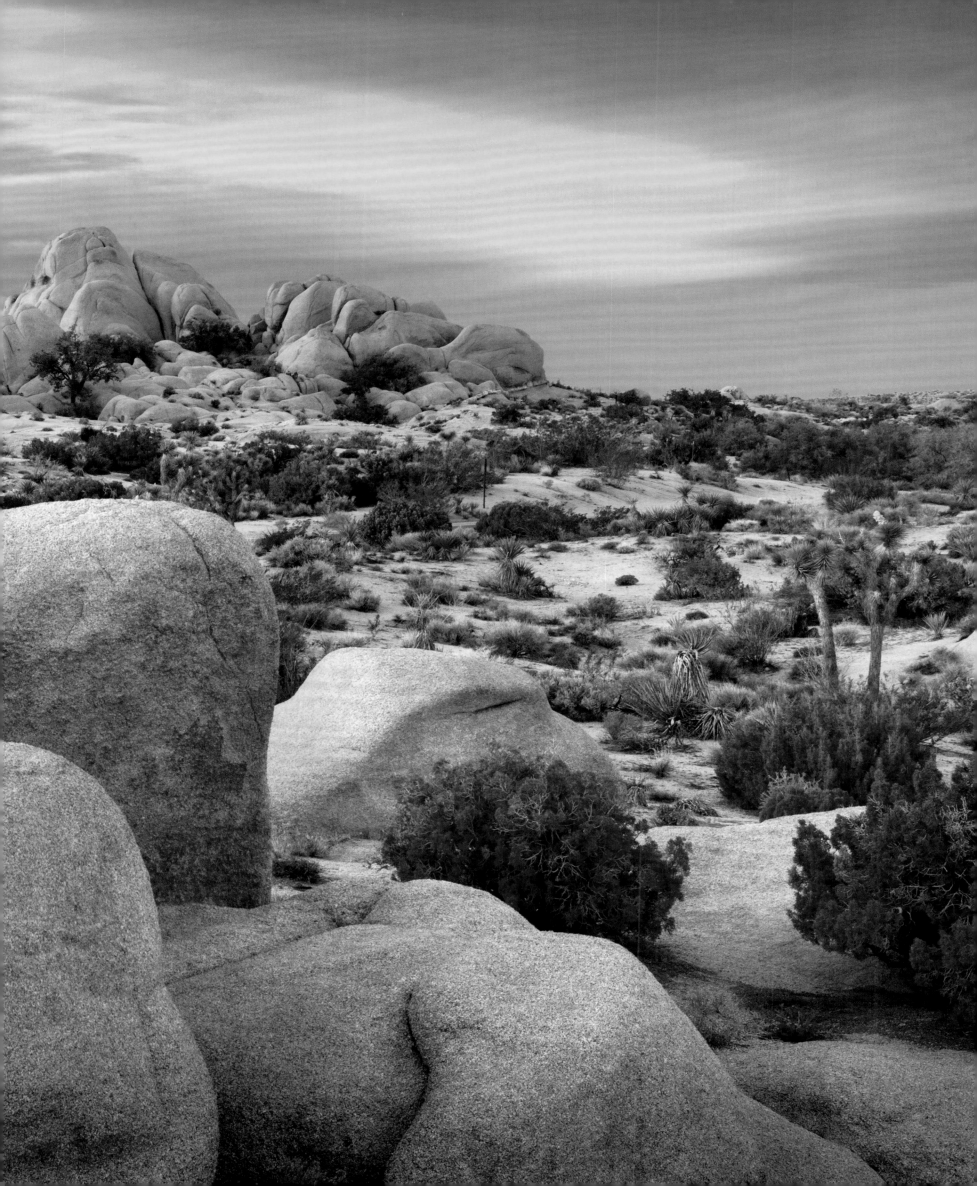

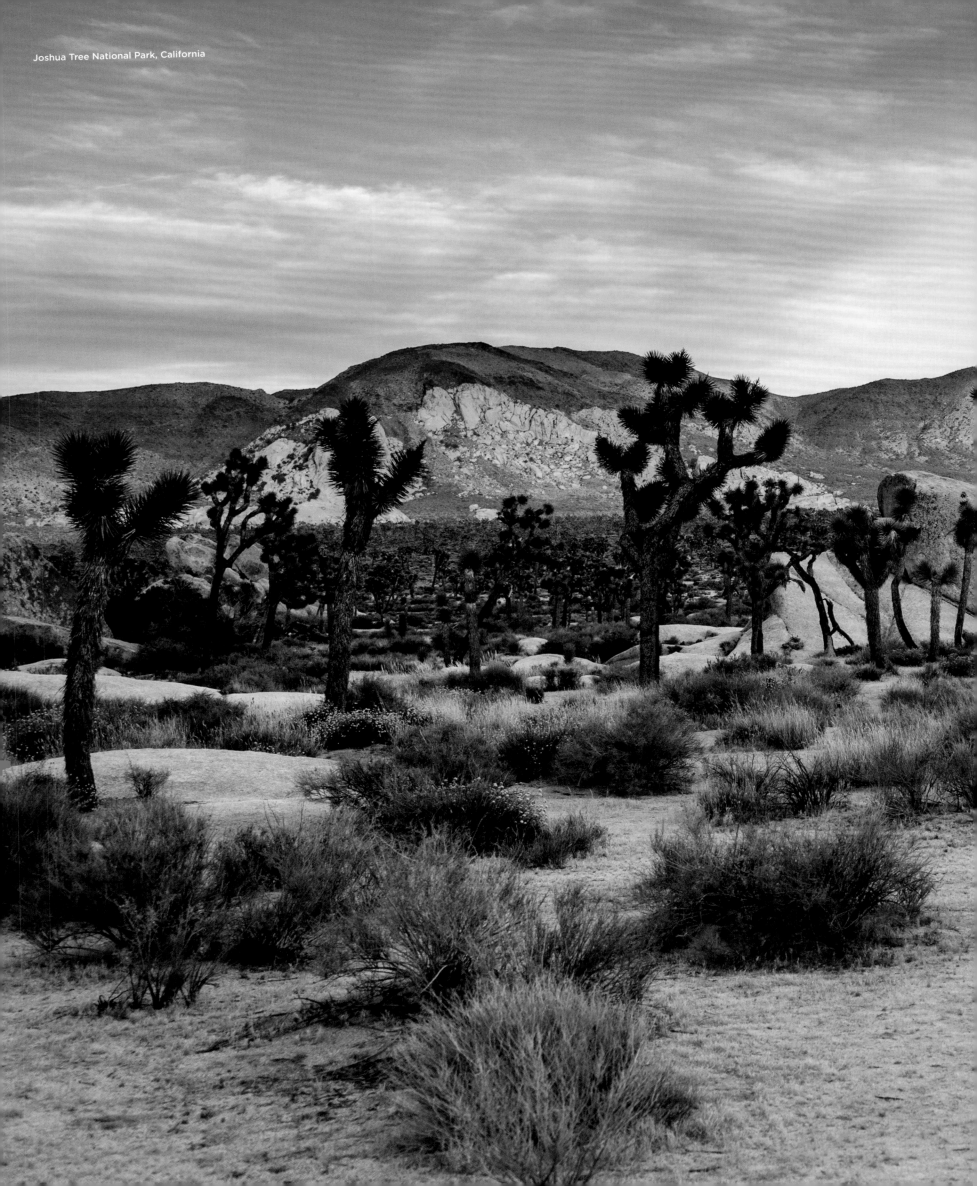

Joshua Tree National Park, California

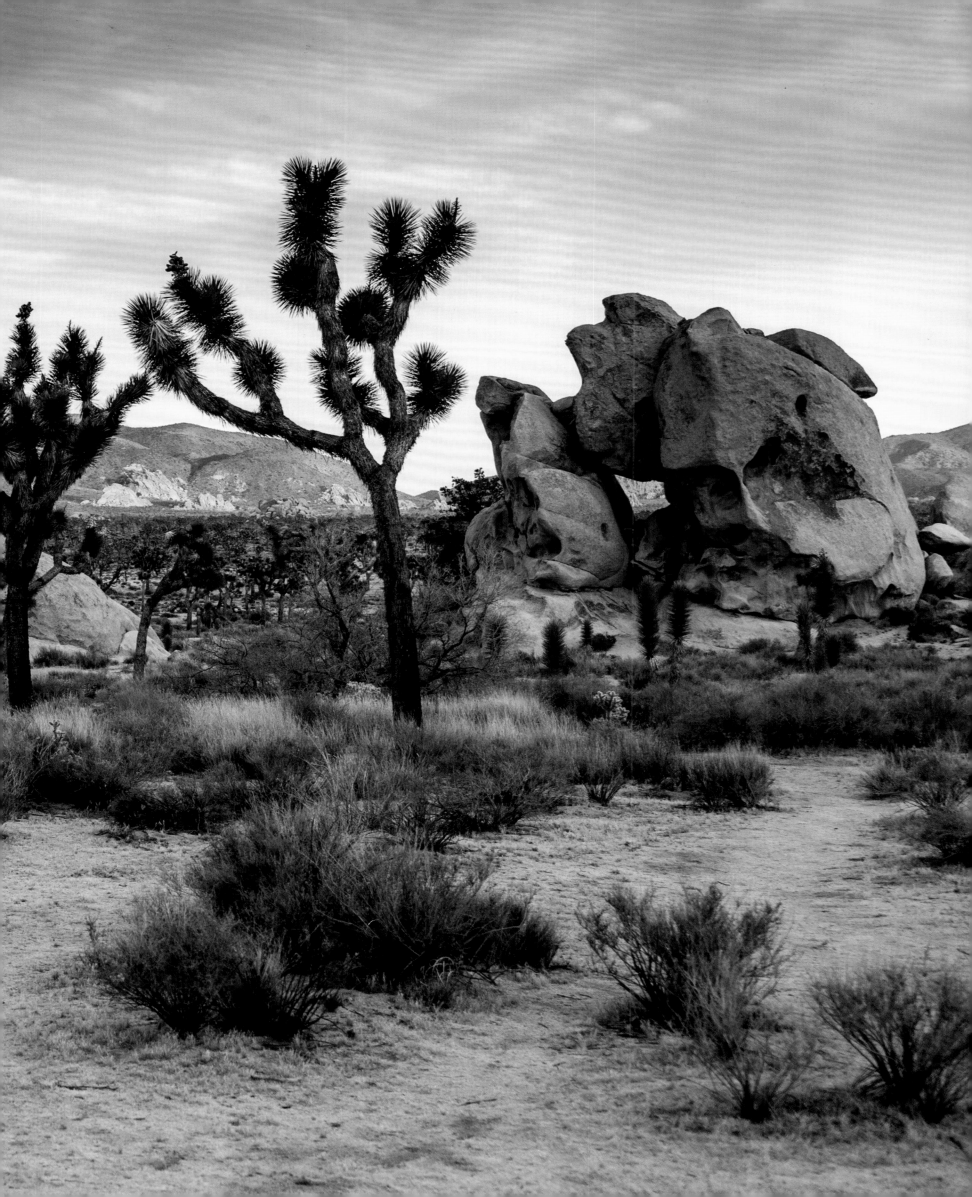

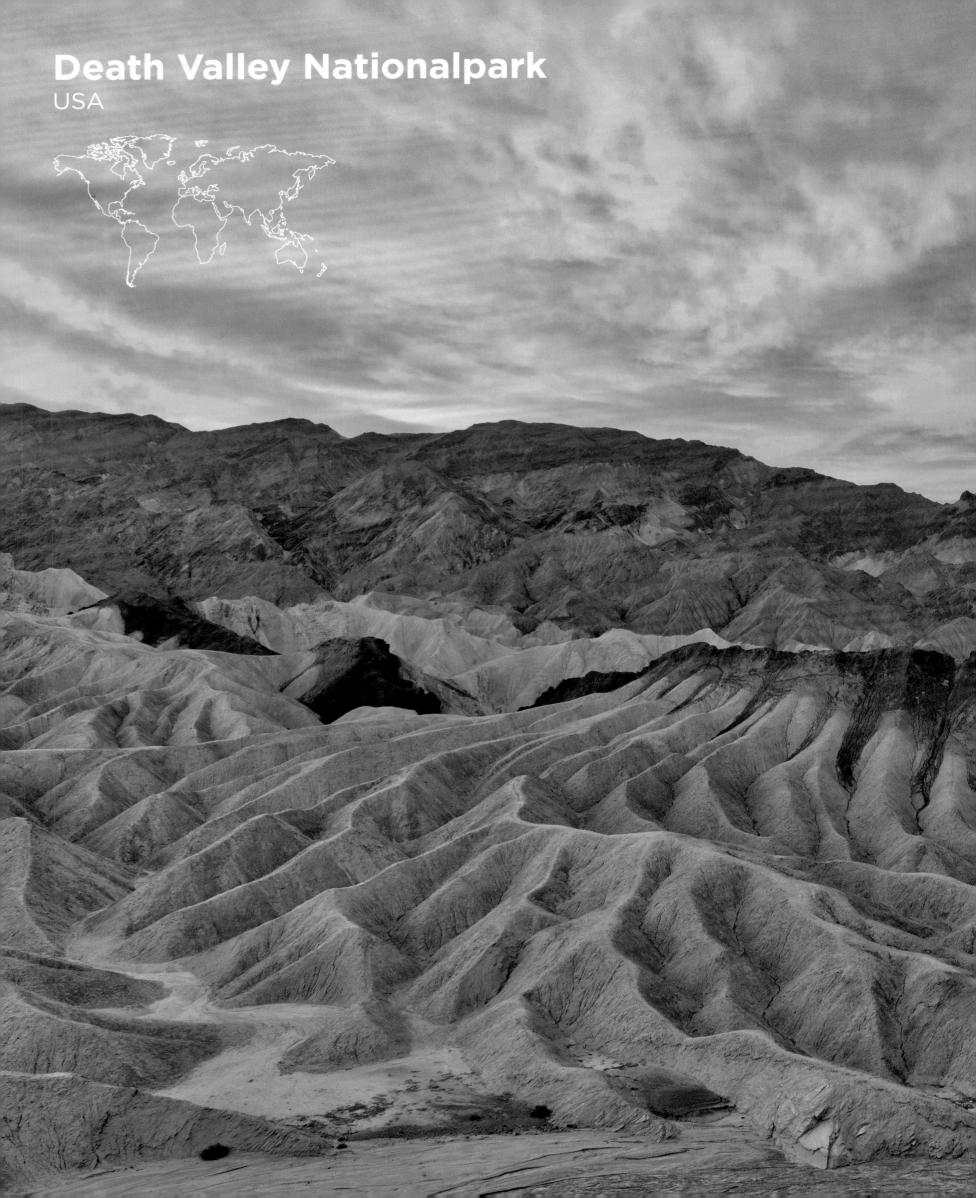

Death Valley Nationalpark
USA

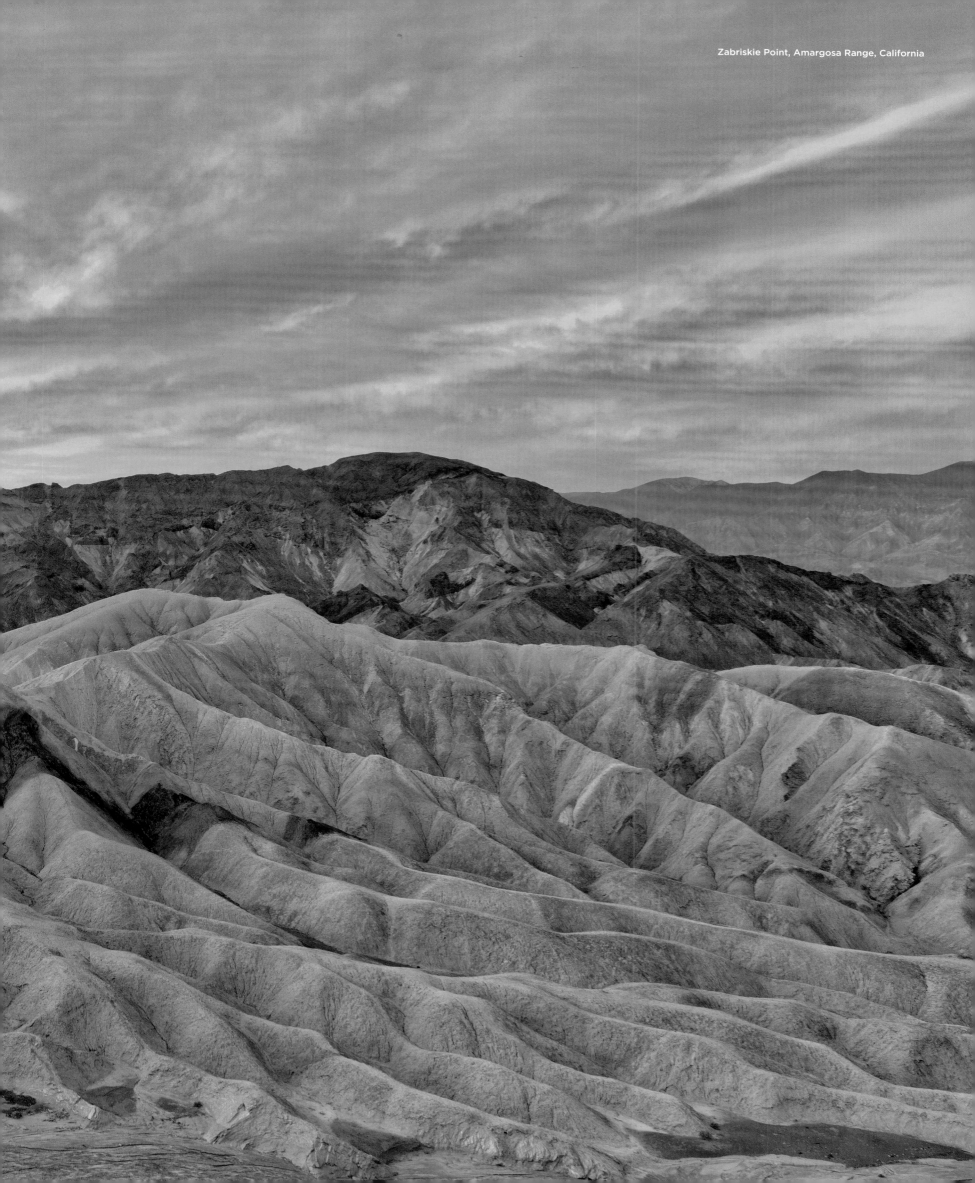

Aerial View Death Valley, California

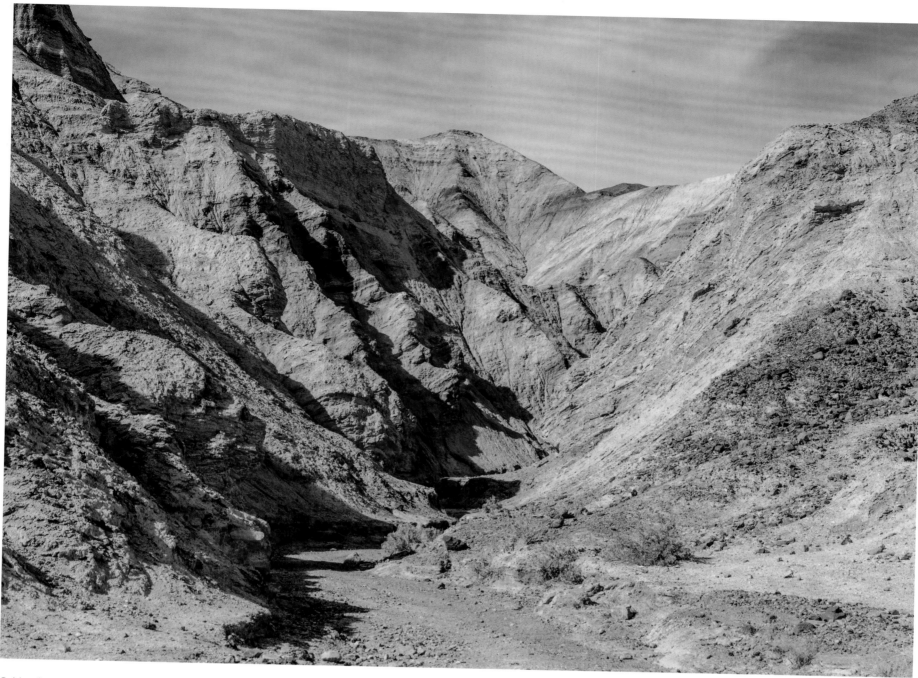

Golden Canyon, California

Death Valley National Park
The largest national park in America's Lower Forty-Eight States, Death Valley is also the hottest and lowest-altitude of all US national parks. It was named in 1849 by a pioneering party who lost one of their number to the extreme conditions. It holds the record for the highest ambient air temperature (134 °F or 56.7 °C) ever recorded at the surface of the Earth.

Parc national de la vallée de la Mort
Plus grand parc national des quarante-huit États du sud des États-Unis, celui de la vallée de la Mort est également le plus chaud et le plus bas en altitude de tous les parcs nationaux américains. Il a été baptisé en 1849 par un groupe de pionniers suite à la mort de l'un d'entre eux à cause de ces conditions extrêmes. Avec une pointe à 56,7 °C, il détient le record de chaleur jamais enregistré à la surface du globe.

Death Valley Nationalpark
Death Valley, der größte Nationalpark der USA, ist auch der heißeste und am tiefsten liegendste aller US-Nationalparks. Das Tal erhielt 1849 von einer Pioniergruppe seinen Namen, die eines ihrer Mitglieder aufgrund der extremen Bedingungen verlor. Death Valley hält den Rekord für die höchste Umgebungsluft-temperatur (56,7 °C), die jemals an der Erdoberfläche gemessen wurde.

Parque Nacional del Valle de la Muerte
El parque nacional más grande de los cuarenta y ocho estados más bajos de Estados Unidos, el Valle de la Muerte es también el más caliente y de menor altitud de todos los parques nacionales de Estados Unidos. Fue nombrado en 1849 por un grupo pionero que perdió a uno de ellos debido a las condiciones extremas. Mantiene el récord de la temperatura ambiente más alta jamás registrada en la superficie de la Tierra (56,7 °C).

Parque Nacional do Vale da Morte
O maior parque nacional dos estados mais baixos da América, o Vale da Morte é também a mais quente e a mais baixa altitude de todos os parques nacionais dos EUA. Foi nomeado em 1849 por um partido pioneiro que perdeu um deles para as condições extremas. Ele detém o recorde para a mais alta temperatura do ar ambiente (56,7 °C) já registrada na superfície da Terra.

Death Valley National Park
Death Valley, het grootste nationale park in de Lower Forty-Eight States van Amerika, is ook het heetste en diepst gelegen park. Het dal kreeg in 1849 zijn naam van een groep pioniers die een van zijn leden verloor aan de extreme omstandigheden. Death Valley bezit het record voor hoogste omgevingsluchttemperatuur (56,7 °C) die ooit aan het aardoppervlak is gemeten.

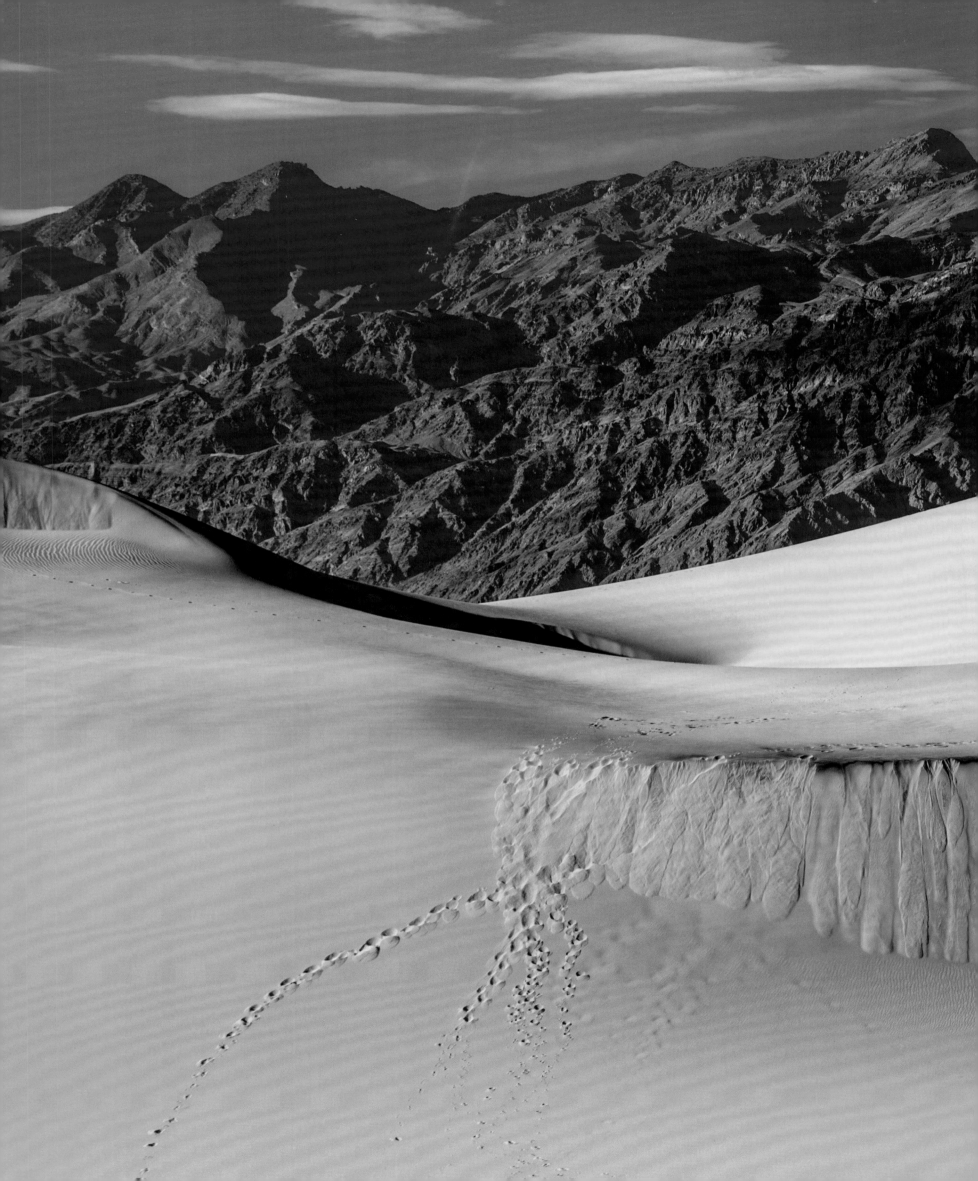

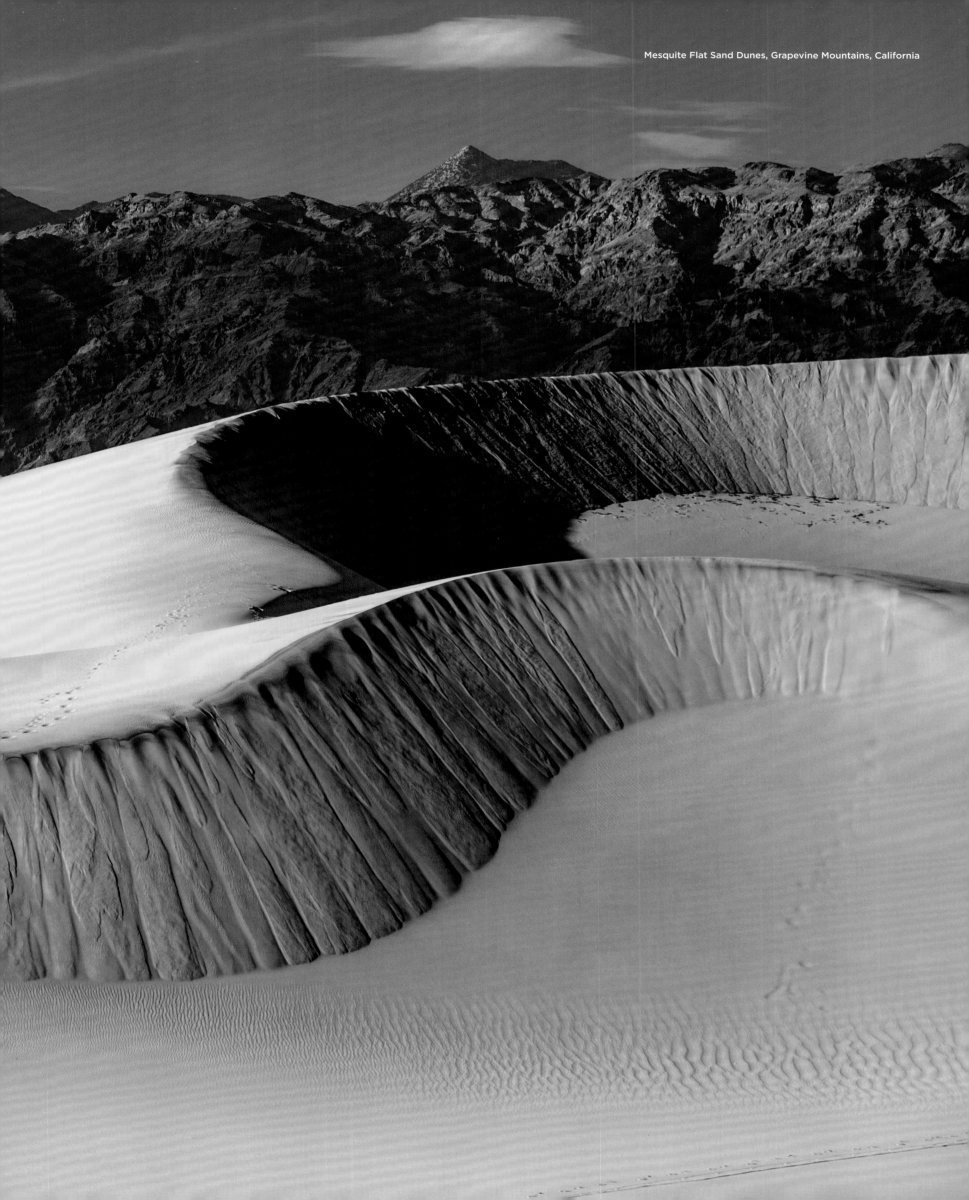

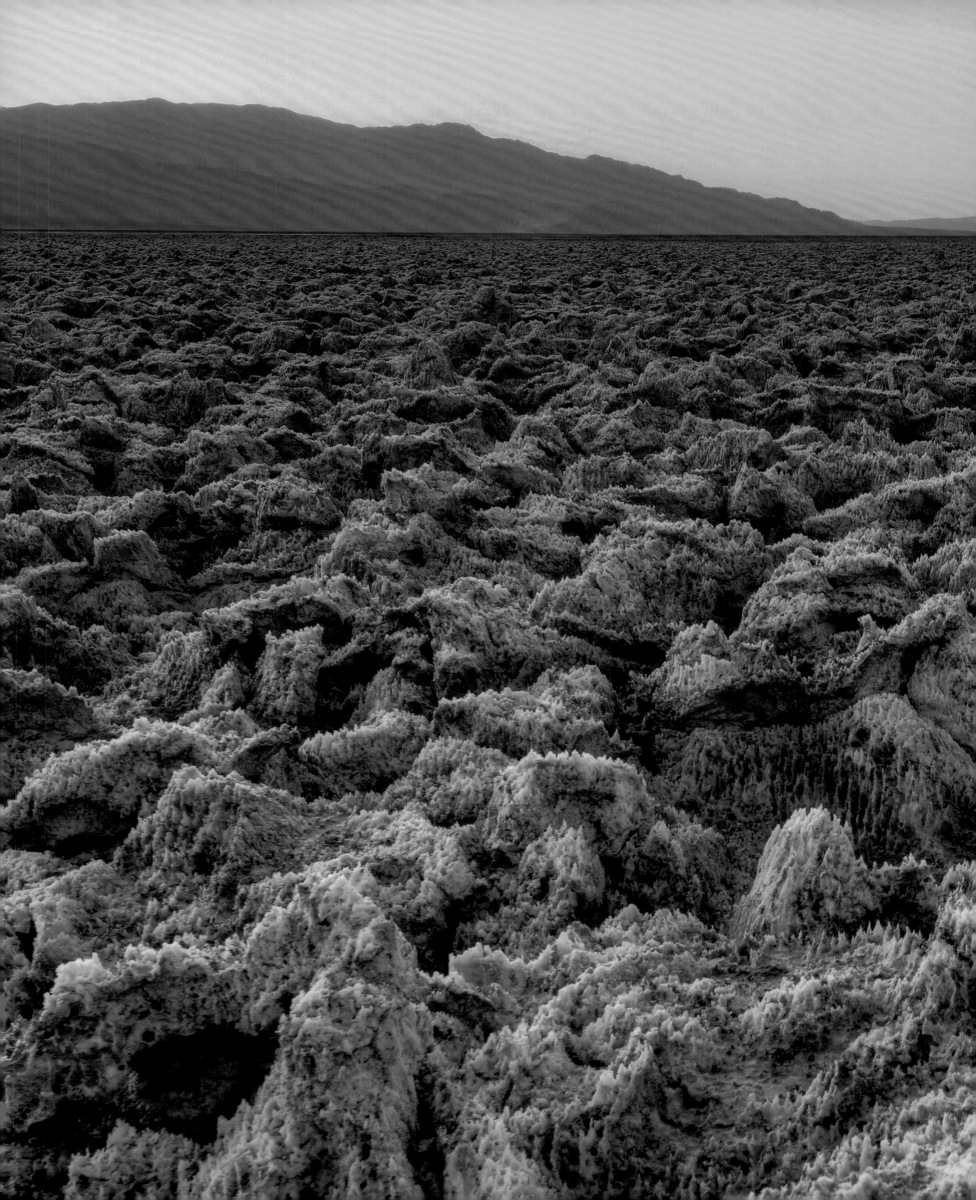

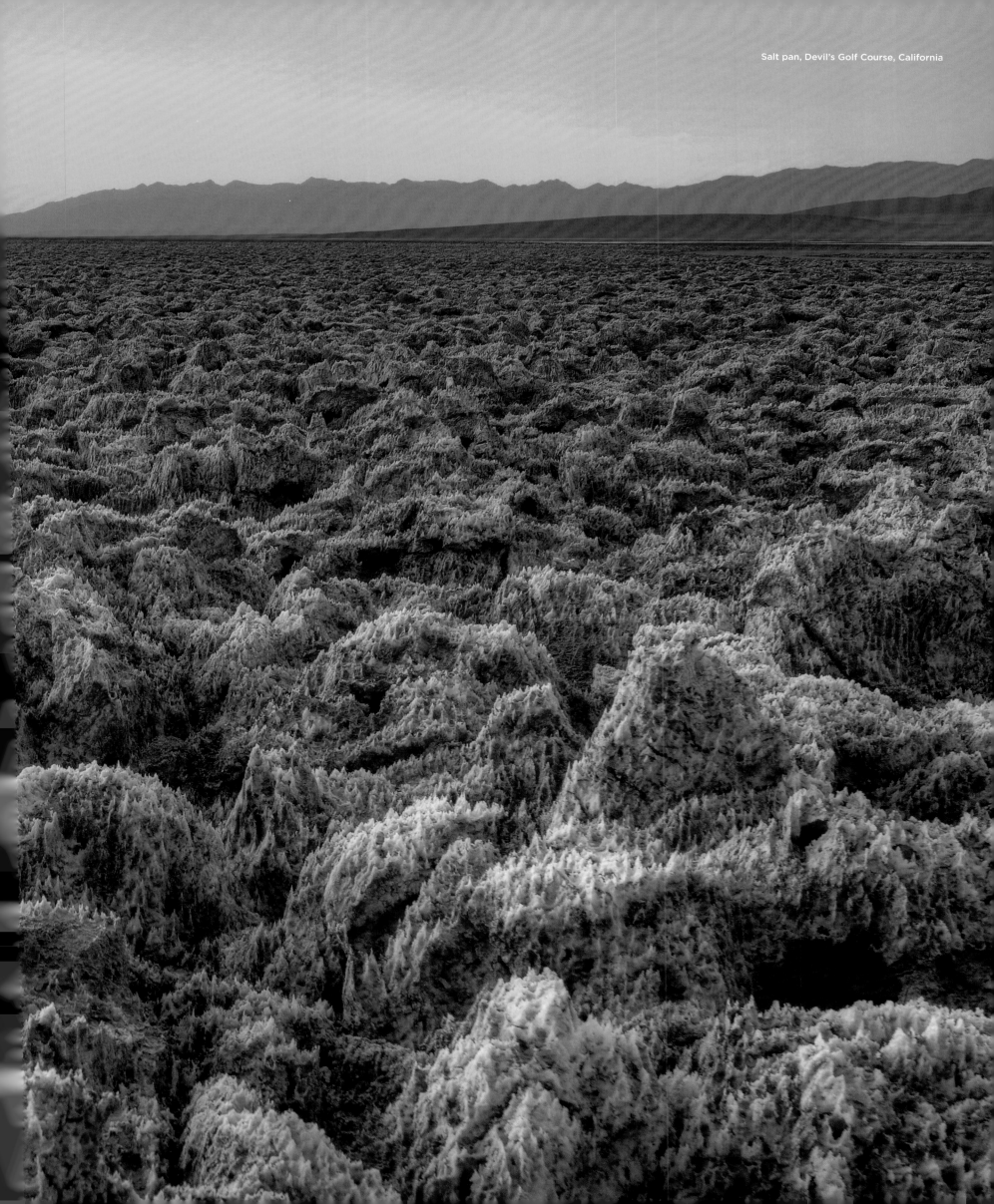

Salt pan, Devil's Golf Course, California

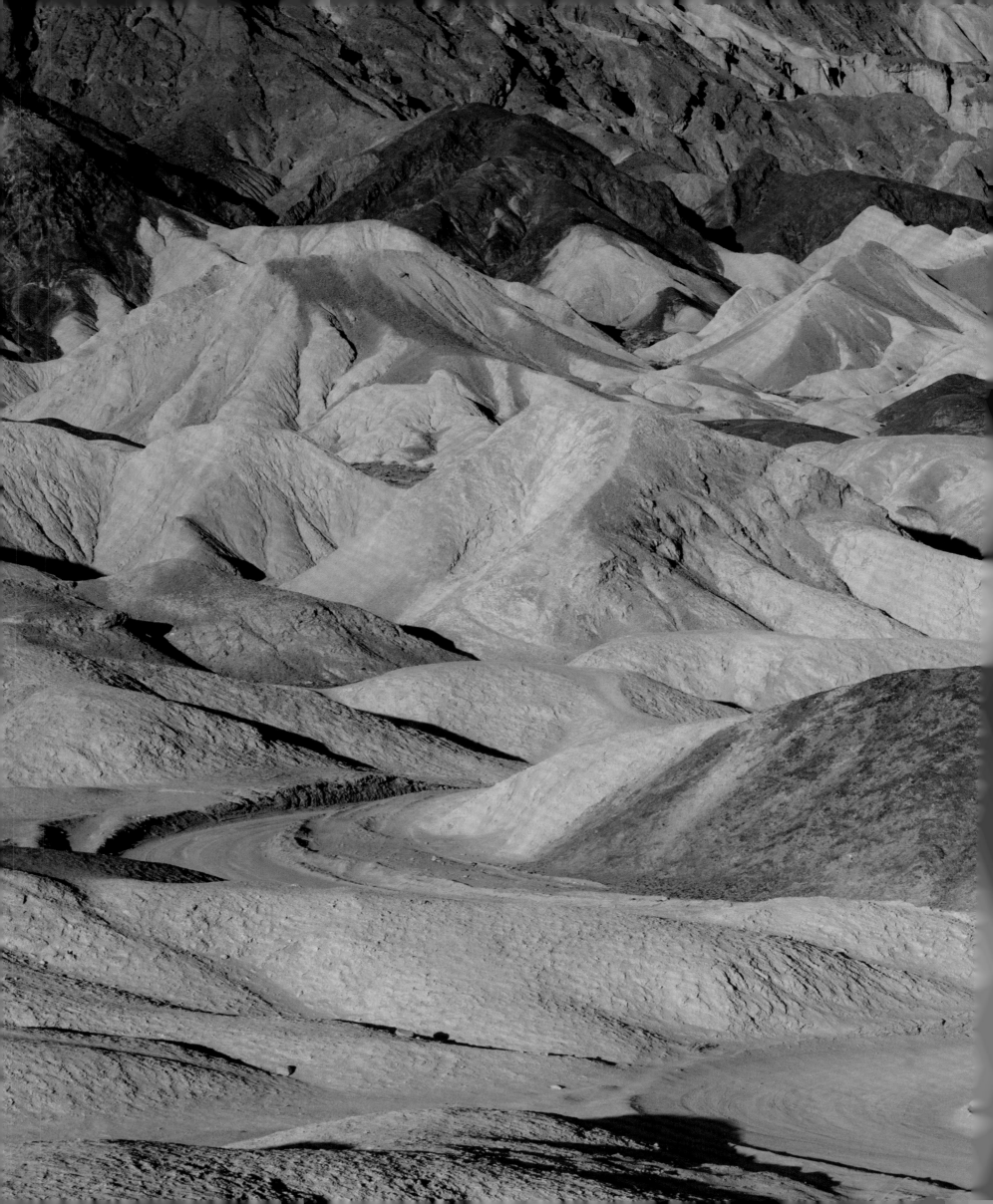

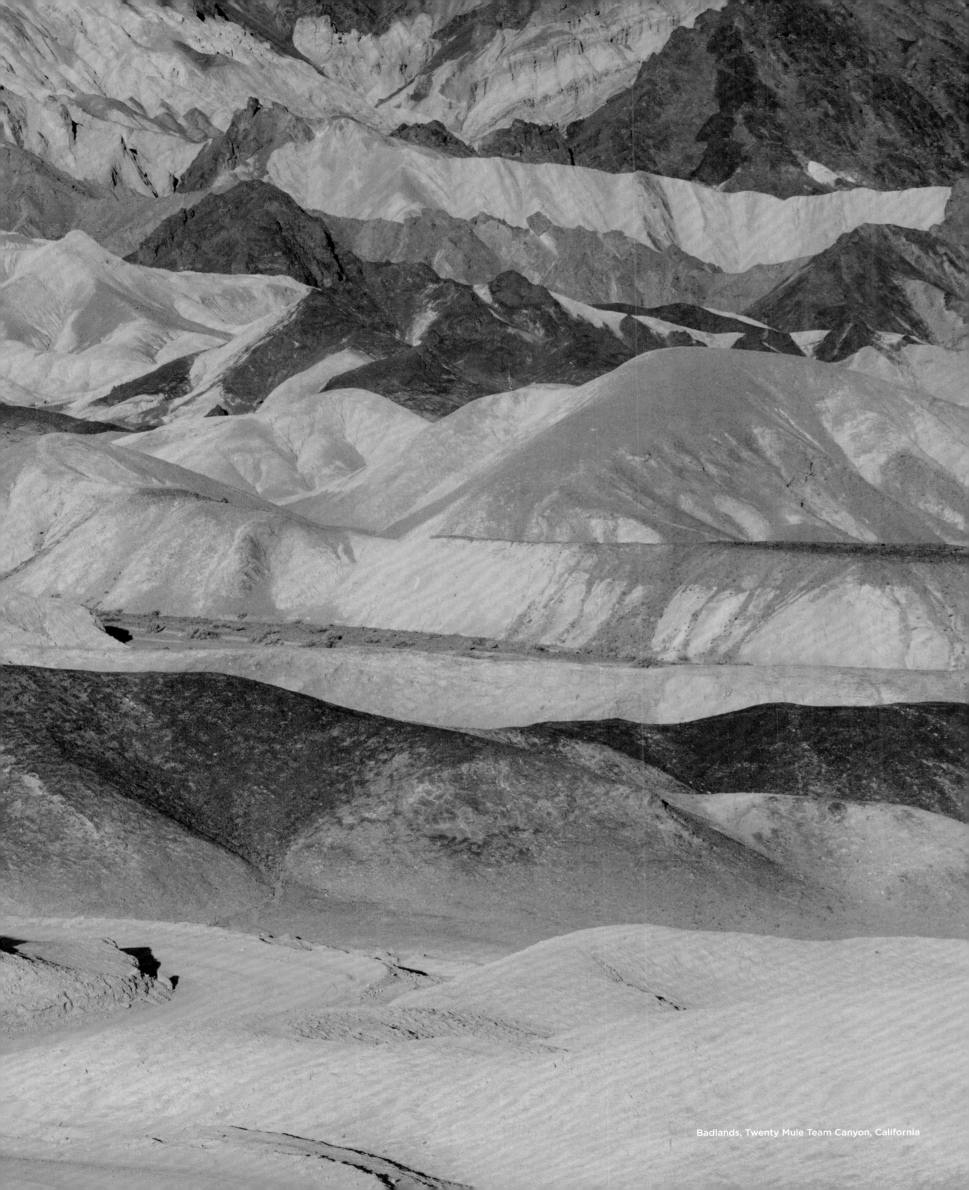

Badlands, Twenty Mule Team Canyon, California

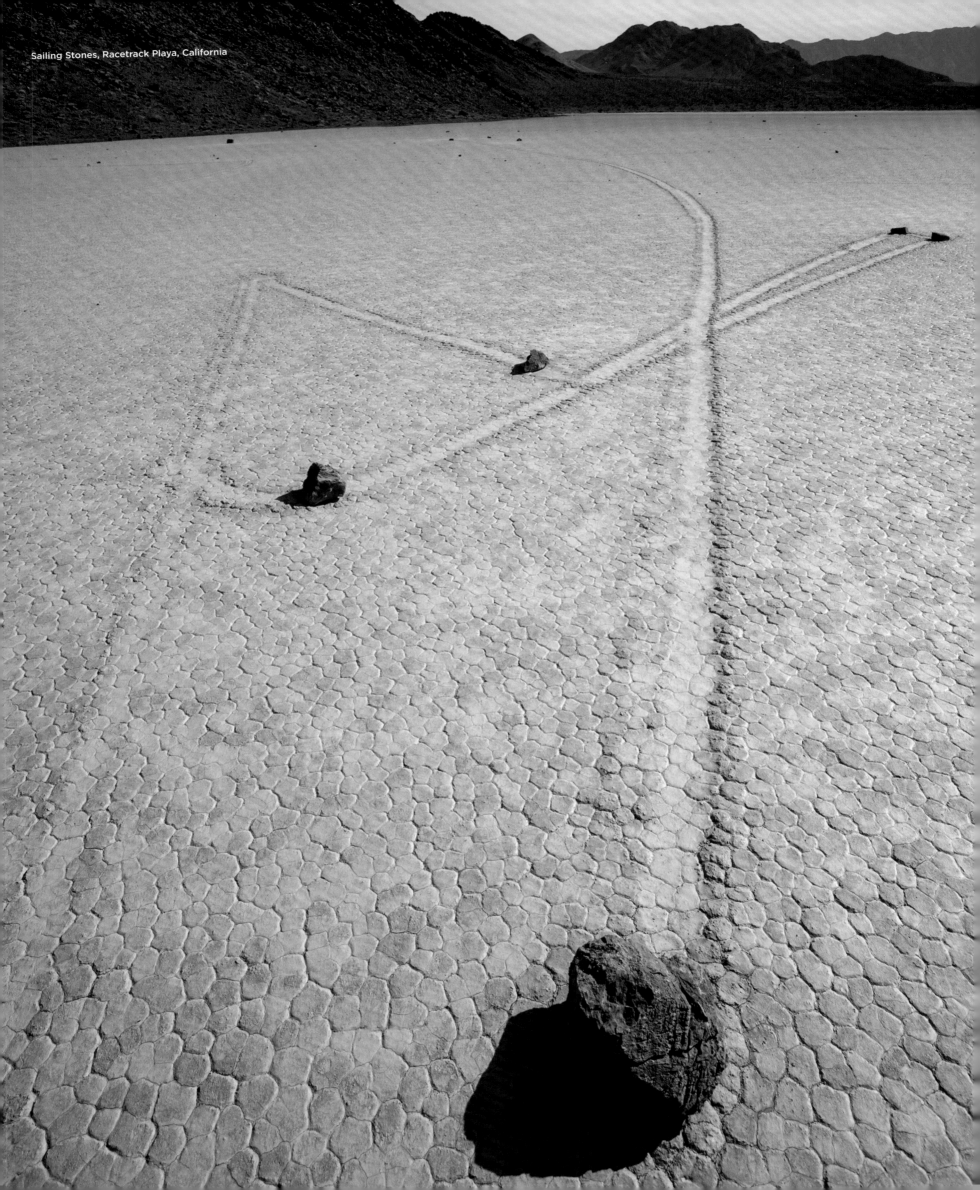

Sailing Stones, Racetrack Playa, California

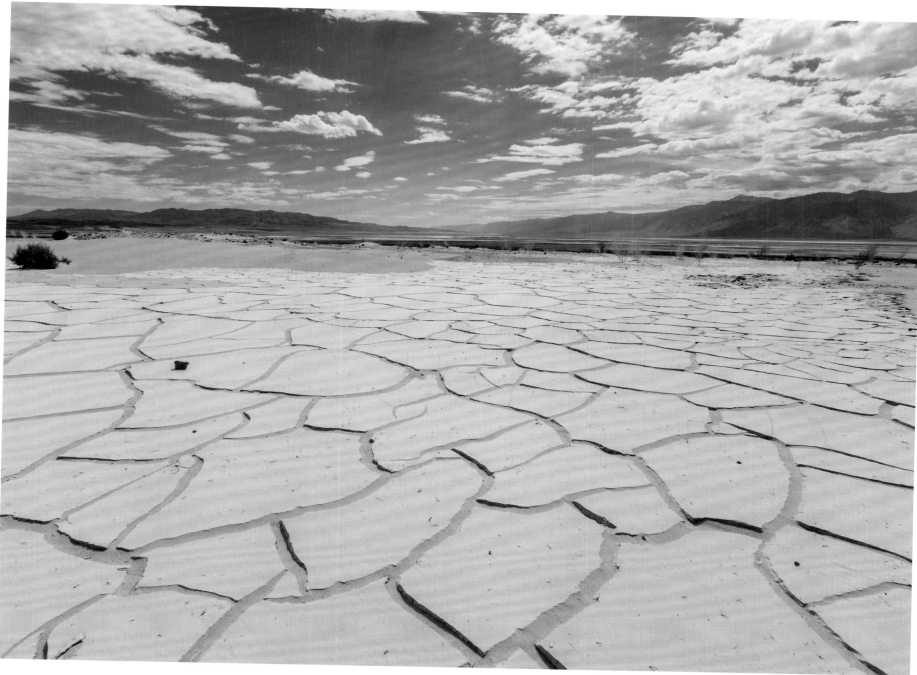

Racetrack Playa, California

Racetrack Playa

This dry lake bed (measuring 2 km by 4.5 km) is known for the polygon shapes that form upon the surface after water dries, and for its 'sailing stones' – chunks of dolomite or syenite that move when wafer-thin ice sheets beneath them melt and they sail across the surface with the wind, leaving racetrack-like designs upon the mud and salt.

Racetrack Playa

Le lit de ce lac asséché de 2 km sur 4,5 km est connu pour les polygones, qui se forment sur sa surface une fois toute l'eau évaporée, et pour ses « pierres qui naviguent » – de gros morceaux de dolomite ou de syénite, qui se déplacent lorsque les plaques de glace fines comme du papier à cigarette fondent et voguent avec le vent sur sa surface en laissant dans la boue et le sel des traces similaires à celles d'un circuit.

Racetrack Playa

Das trockene Seebett, was 2 km x 4,5 km misst, ist bekannt für die Polygonformen, die sich nach dem Trocknen des Wassers an der Oberfläche bilden, und für die ‚Wandernden Steine' – Dolomit- oder Syenit-brocken, die sich bewegen, wenn hauchdünne Eisschichten unter ihnen schmelzen und sie vor dem Wind über die Oberfläche segeln, wobei ein renn-streckenartige Muster auf Schlamm und Salz entsteht.

Racetrack Playa

Este lecho lacustre seco (que mide 2 km por 4,5 km) es conocido por las formas poligonales que se forman en su superficie después de que el agua se seque y por sus «piedras de vela», trozos de dolomita o sienita que se mueven cuando las delgadas capas de hielo bajo ellas se derriten y navegan con el viento por la superficie, dejando unos dibujos parecidos a los de un hipódromo sobre el barro y la sal.

Pista de corridas Playa

Este leito de lago seco (que mede 2 km por 4,5 km) é conhecido pelas formas poligonais que se formam na superfície após a secagem da água, e por suas 'pedras de navegação' - pedaços de dolomita ou sienito que se movem quando folhas finas de gelo sob eles derretem e navegam com o vento pela superfície, deixando desenhos semelhantes a pistas de corrida sobre a lama e o sal.

Racetrack Playa

Deze droge meerbodem (2 km x 4,5 km) staat bekend om de veelhoeken die zich op het oppervlak vormen nadat het water is opgedroogd en om zijn 'zeilstenen'. Dat zijn brokken dolomiet of syeniet die bewegen wanneer flinterdunne ijskappen eronder smelten en met de wind over het oppervlak zeilen, waardoor racebaanachtige patronen in de modder en het zout achterblijven.

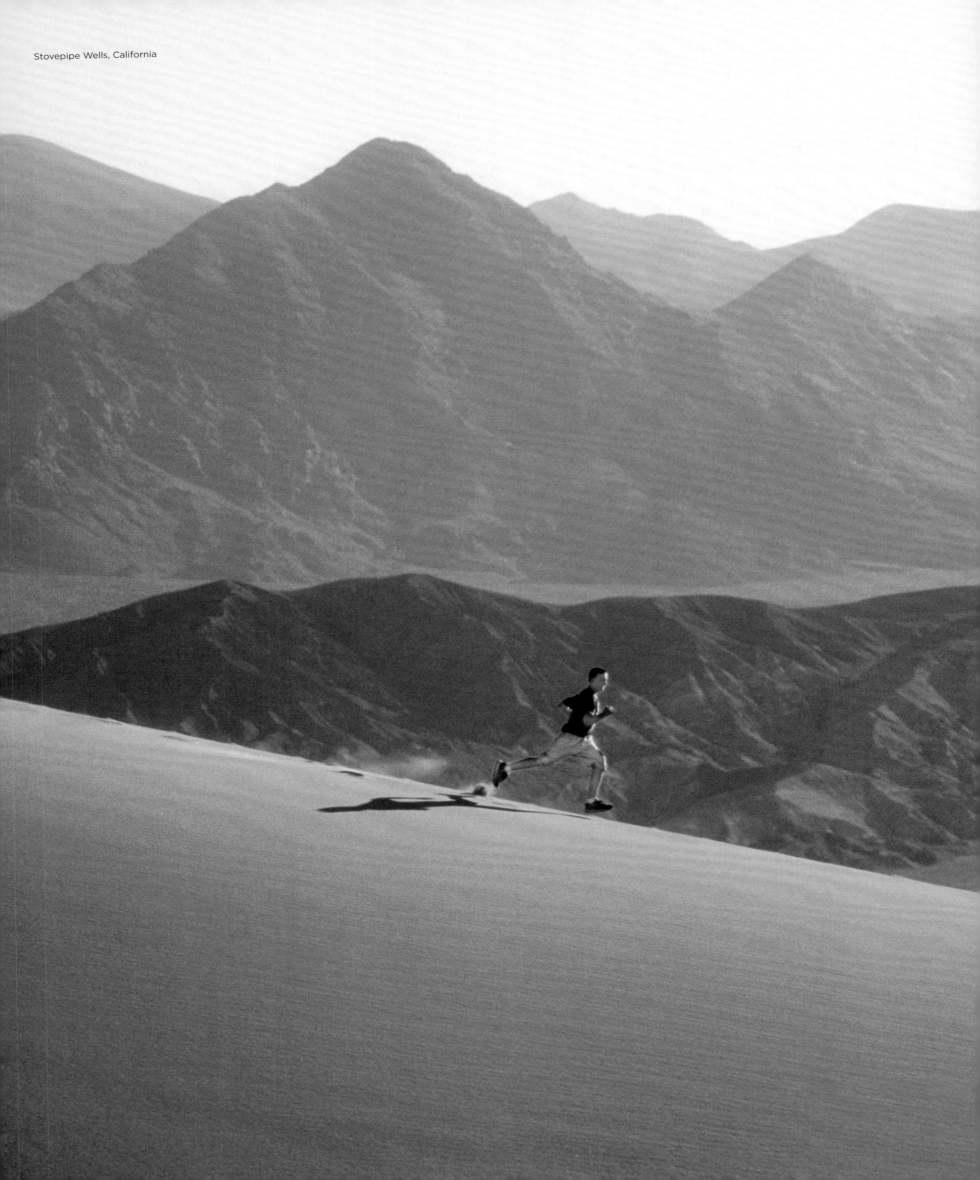

Stovepipe Wells, California

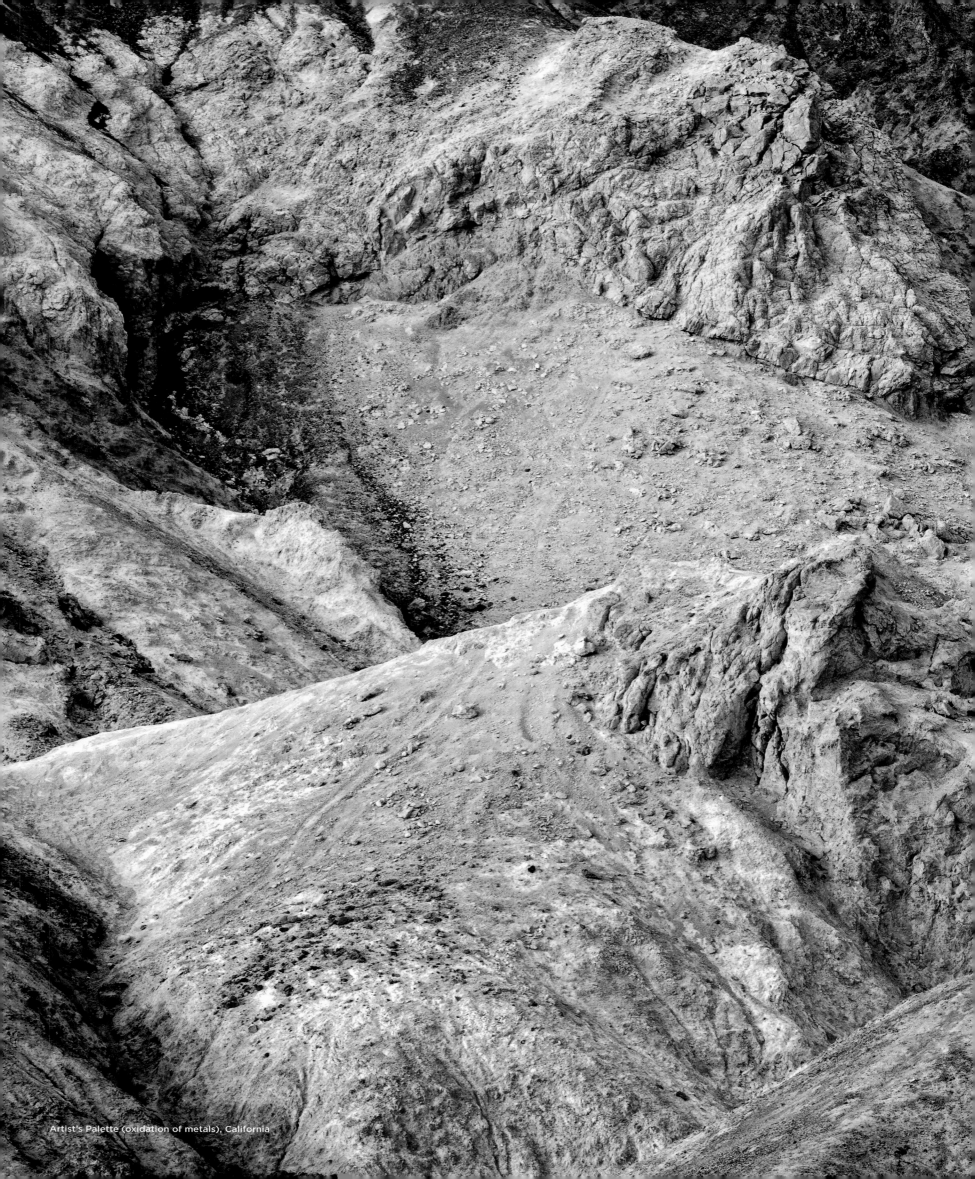

Artist's Palette (oxidation of metals), California

Ubehebe Crater, California

Ghost City

Signs of Death Valley's historical human story lie scattered through the park. The region's indigenous inhabitants left mysterious stone patterns and rock engravings, while treks of pioneers abandoned entire wagon teams. The discovery of gold in 1903 led to a small gold rush. But the extreme climate and absence of water meant that settlements rose and fell in the cycles of boom and bust – some of their remnants survive to the present day.

Ville fantôme

Des poteaux indicateurs informant sur l'histoire humaine de la vallée de la Mort sont disséminés à travers le parc. Les autochtones de la région ont laissé de mystérieux motifs en pierre et en ont gravé d'autres dans la roche tandis que les premières équipes de chemin de fer abandonnaient des attelages entiers sur le site. À partir du début du XXᵉ siècle, la vallée de la Mort est devenue l'une des sources les plus prolifiques de borax au monde (le borax servant à la fabrication du savon). La découverte d'or en 1903 a suscité une mini ruée vers l'or. Mais le climat extrême et l'absence d'eau ont vu surgir et disparaître des colonies au gré des cycles d'expansion et de récession – certains de leurs vestiges ont survécu jusqu'à aujourd'hui.

Geisterstadt

Hinweise auf die menschliche Vergangenheit im Death Valley sind überall im Park zu finden. Die indigenen Bewohner der Region hinterließen geheimnisvolle Steinmuster und Felsgravuren, während die durch-ziehenden Wagentracks der Pioniere ganze Pferdewaggons aufgaben. Die Entdeckung von Gold im Jahr 1903 verursachte einen kleinen Goldrausch. Aber das extreme Klima und der Wassermangel führten dazu, dass die Siedlungen abwechselnd immer wieder wuchsen oder verlassen wurden – in einigen Fällen haben ihre Überreste bis heute überdauert.

General Store, Stovepipe Wells Village, California

Pueblo Fantasma

Los letreros de la historia humana del Valle de la Muerte se encuentran dispersos por todo el parque. Los habitantes indígenas de la región dejaron misteriosos patrones de piedra y grabados en rocas, mientras que los equipos pioneros de carros abandonaron equipos enteros de carros. El descubrimiento del oro en 1903 condujo a una mini fiebre del oro. Pero el clima extremo y la ausencia de agua hicieron que los asentamientos subieran y bajaran en los ciclos de auge y quiebra (algunos de sus restos sobreviven hoy en día).

Cidade Fantasma

As placas de sinalização para a história humana histórica do Vale da Morte estão espalhadas pelo parque. Os habitantes indígenas da região deixaram misteriosos padrões de pedra e gravuras rupestres, enquanto equipas pioneiras de vagões abandonaram equipes inteiras de carroções. A descoberta do ouro em 1903 levou a uma pequena corrida pelo ouro. Mas o clima extremo e a ausência de água fizeram com que os assentamentos subissem e caíssem nos ciclos de altos e baixos – alguns de seus remanescentes sobrevivem hoje.

Spookstad

Overal in het park vindt u verwijzingen naar het menselijke verleden in Death Valley. De inheemse bewoners van de regio lieten mysterieuze steenpatronen en rotsgravures achter, terwijl de pioniers op de huifkarsporen hele paardenkoetsen achterlieten. Sinds het begin van de 20e eeuw is Death Valley uitgegroeid tot een van de productiefste boraxbronnen ter wereld (voor de zeepproductie). De ontdekking van goud in 1903 veroorzaakte een kleine goudkoorts. Maar het extreme klimaat en het gebrek aan water leidden ertoe dat de nederzettingen afwisselend weer uitgroeiden of werden verlaten – in enkele gevallen zijn de overblijfselen tot op heden bewaard gebleven.

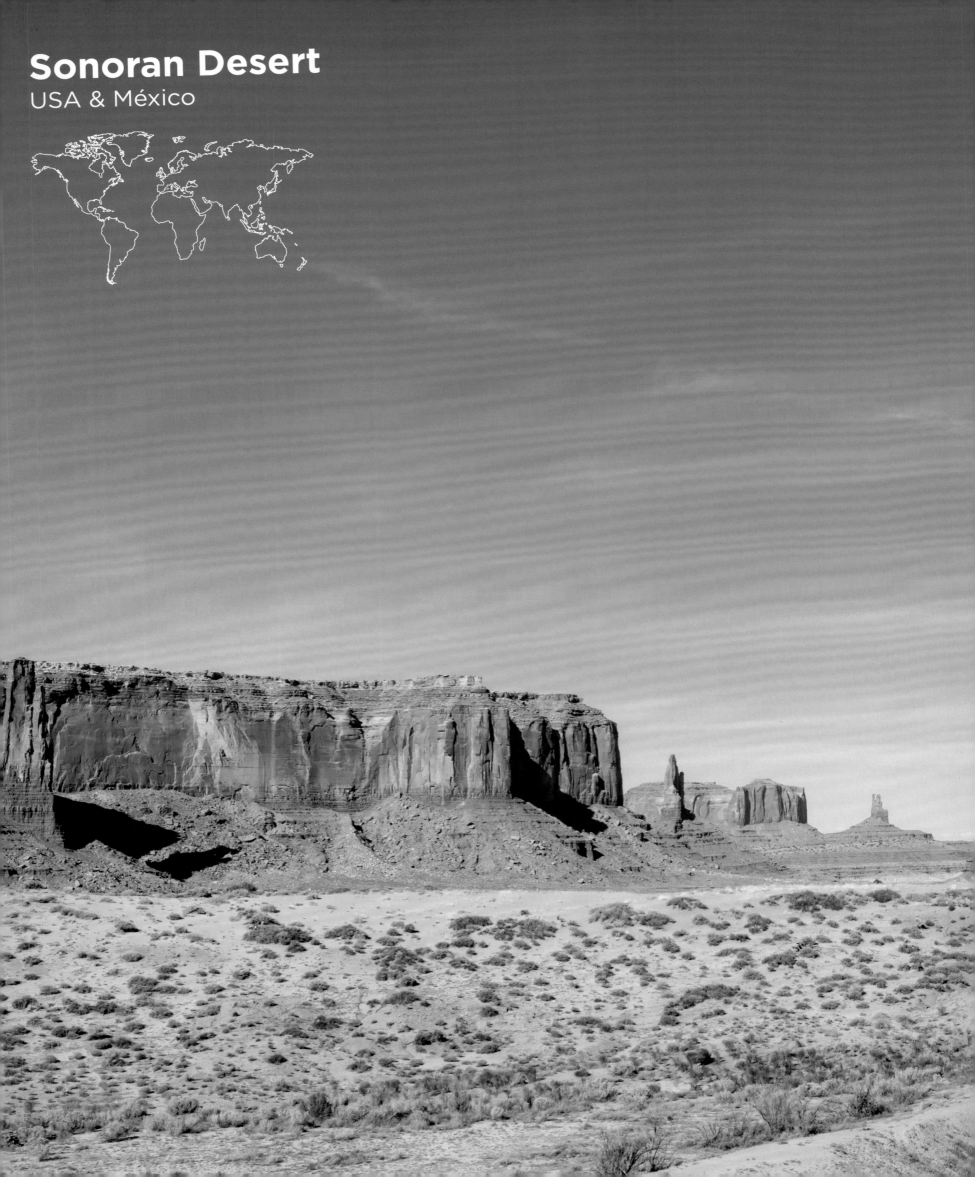

Sonoran Desert
USA & México

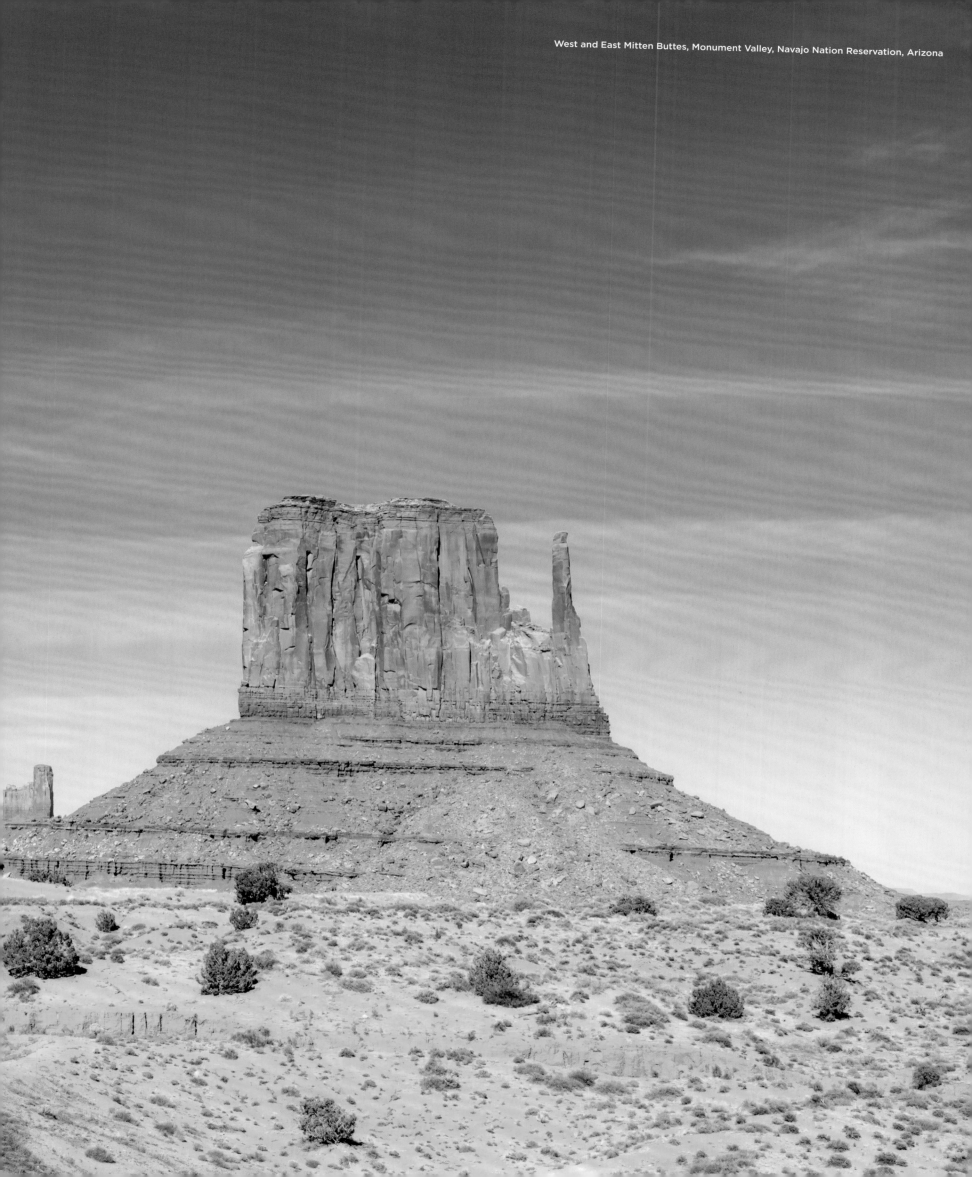

West and East Mitten Buttes, Monument Valley, Navajo Nation Reservation, Arizona

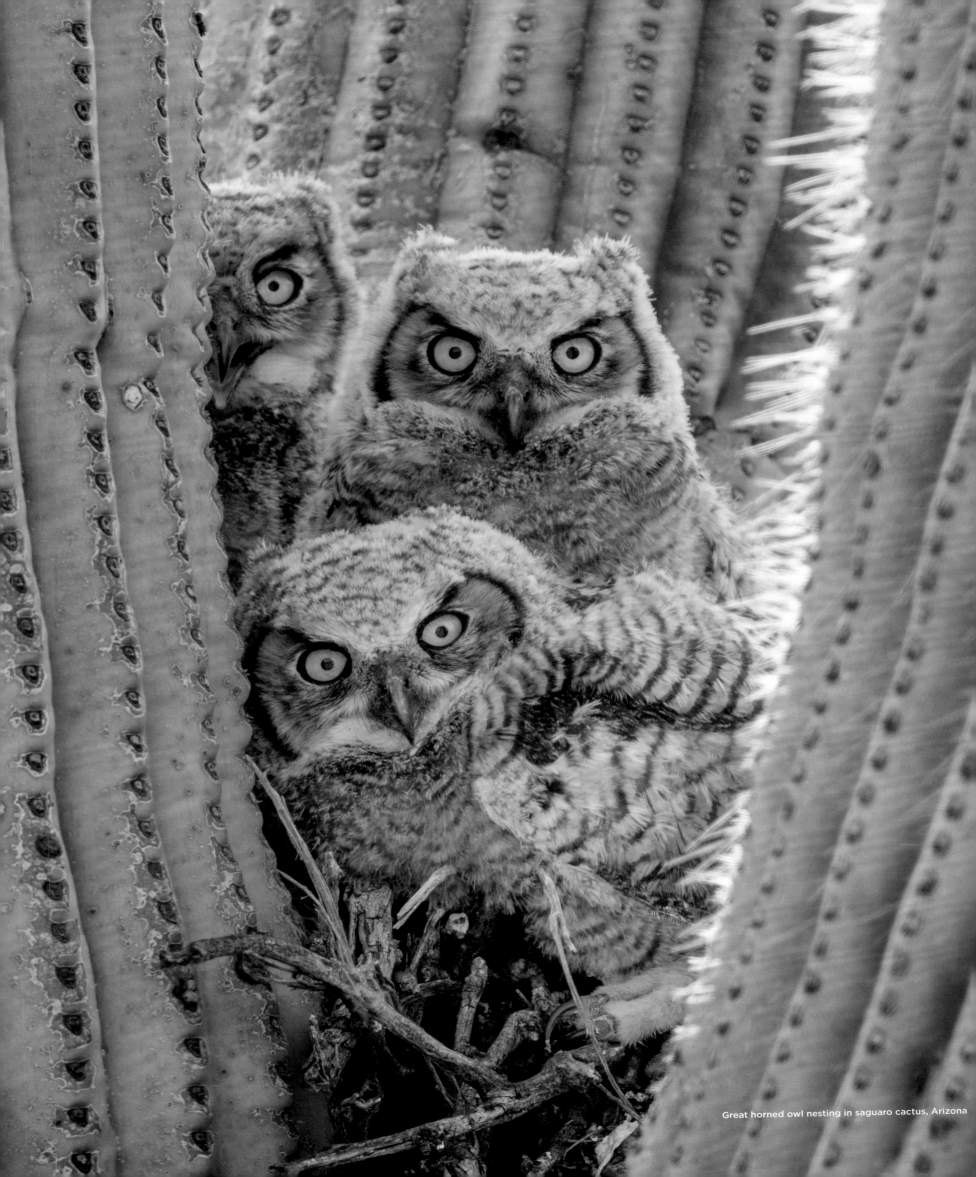

Great horned owl nesting in saguaro cactus, Arizona

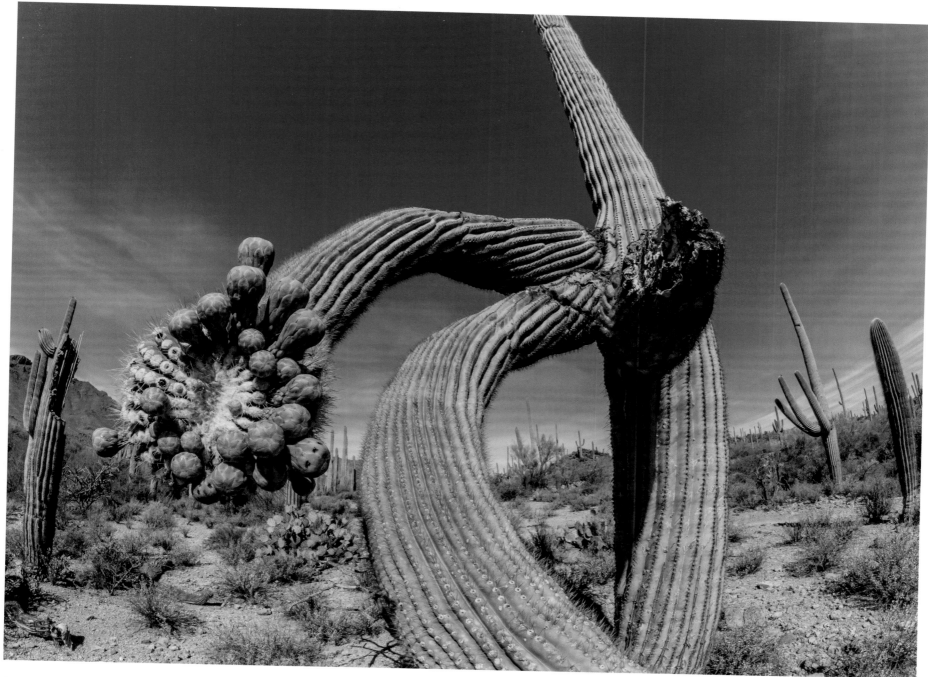

Saguaro cactus, Tucson, Arizona

Sonoran Desert

The transfrontier Sonoran Desert takes in southern California and Arizona and northern Mexico, including the Sonora region that gives the desert its name. It is known for its wind-weathered rock formations and imperious cactus formations, one of which gives its name to the Saguaro National Park in Arizona. The desert is also home to 60 mammal species.

Désert de Sonora

Le désert transfrontalier de Sonora englobe la Californie du Sud, l'Arizona et le nord du Mexique, dont la région de Sonora, de laquelle le désert tient son nom. Il est connu pour ses formations rocheuses érodées par le vent et ses cactus impérieux, dont l'une des espèces a donné son nom au parc national de Saguaro, en Arizona. Le désert abrite également 60 espèces de mammifères.

Sonora-Wüste

Die grenzüberschreitende Sonoran Desert erstreckt sich über Südkalifornien und Arizona sowie Nordmexiko, einschließlich der Region Sonora, die der Wüste ihren Namen gibt. Sie ist bekannt wegen ihrer vom Wind verwitterten Felsformationen und der riesigen Kakteenarten, von denen eine dem Saguaro Nationalpark in Arizona ihren Namen verliehen hat. In der Wüste leben auch 60 Säugetierarten.

Desierto de Sonora

El desierto transfronterizo de Sonora abarca el sur de California y Arizona y el norte de México, incluida la región de Sonora que da nombre al desierto. Conocida por sus formaciones rocosas azotadas por el viento y por sus imperiosos cactus, uno de los cuales da nombre al Parque Nacional Saguaro en Arizona. El desierto es también el hábitat de 60 especies de mamíferos.

Deserto de Sonora

O deserto de Sonora transfronteiriço leva no sul da Califórnia e Arizona e norte do México, incluindo a região de Sonora que dá o nome do deserto. Conhecido por suas formações rochosas resistentes ao vento e formações imperiosas de cactos, uma delas dá nome ao Parque Nacional Saguaro, no Arizona. O deserto também abriga 60 espécies de mamíferos.

Sonorawoestijn

De grensoverschrijdende Sonorawoestijn strekt zich uit over Zuid-Californië, Arizona en het noorden van Mexico, inclusief de Sonoraregio die de woestijn zijn naam geeft. Hij is bekend om zijn door de wind verweerde rotsformaties en reusachtige cactussoorten, waarvan er één zijn naam gaf aan het Saguaro National Park in Arizona. In de woestijn leven ook 60 zoogdiersoorten.

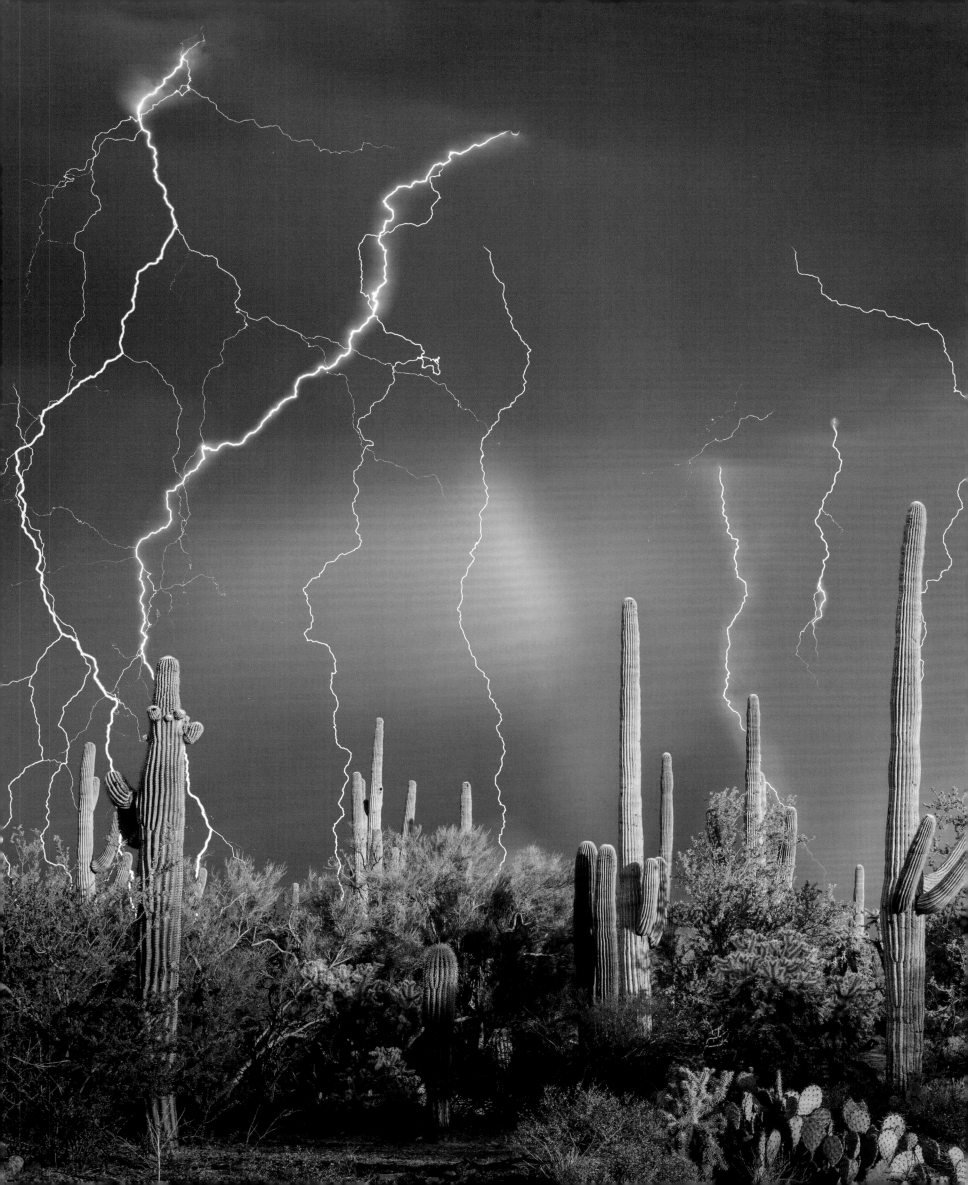

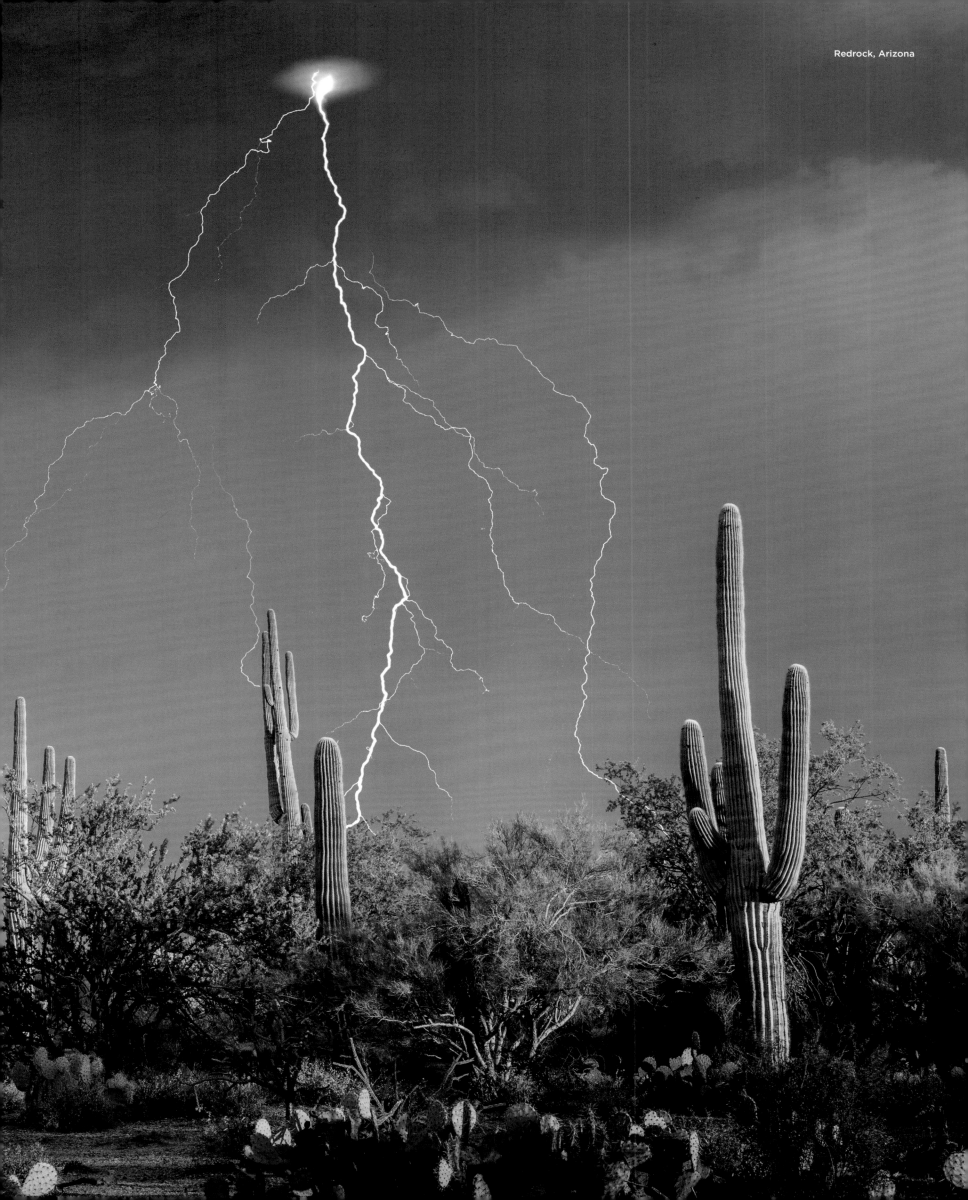

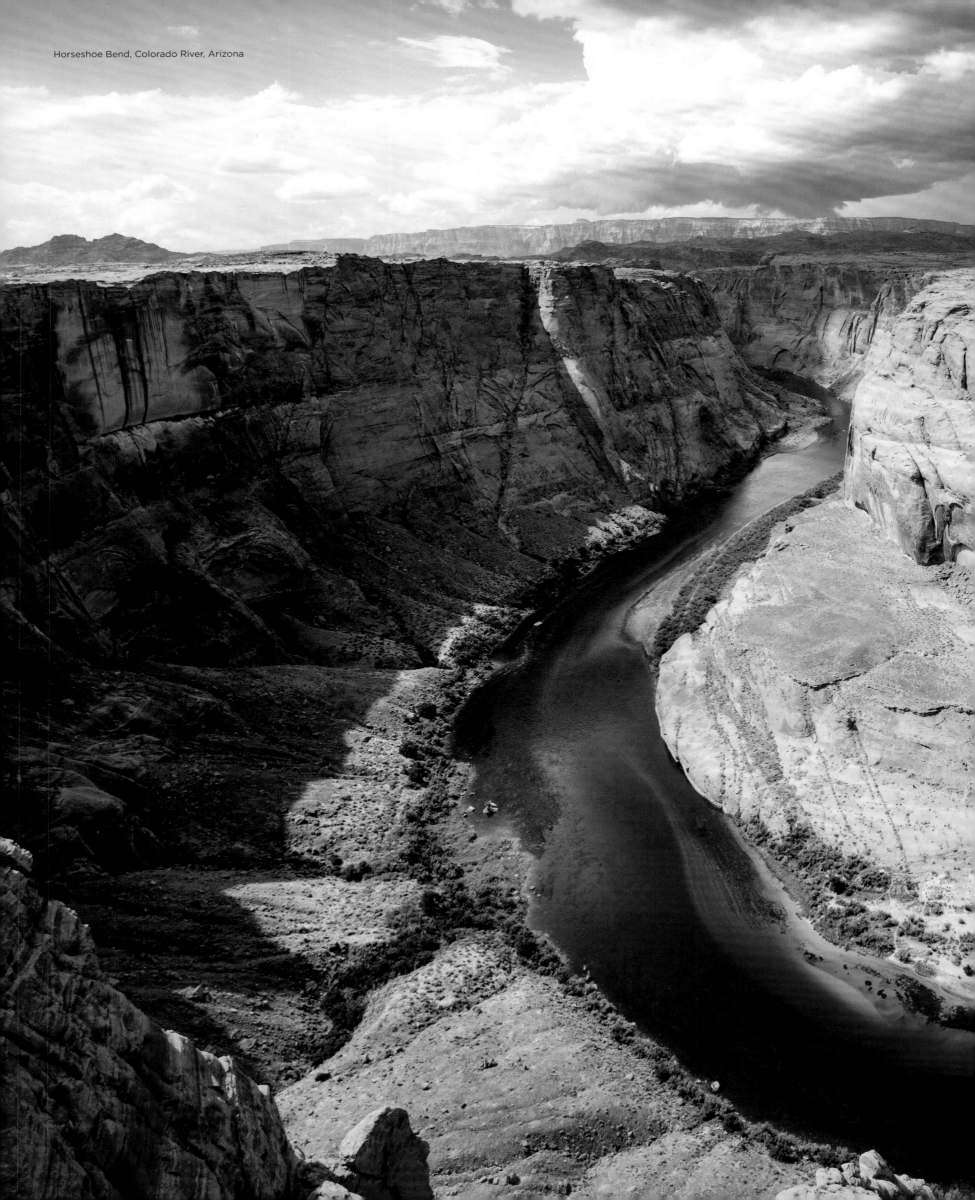

Horseshoe Bend, Colorado River, Arizona

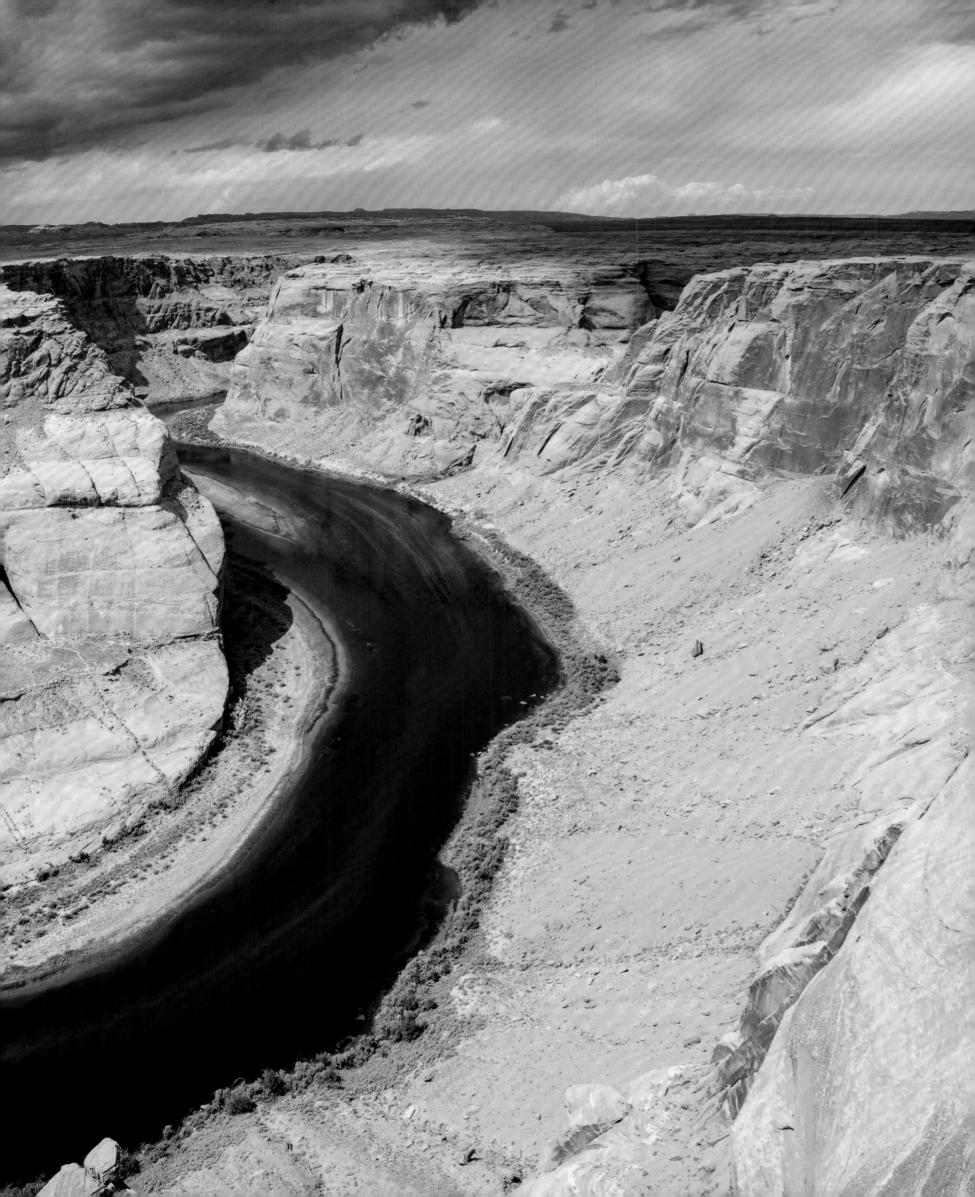

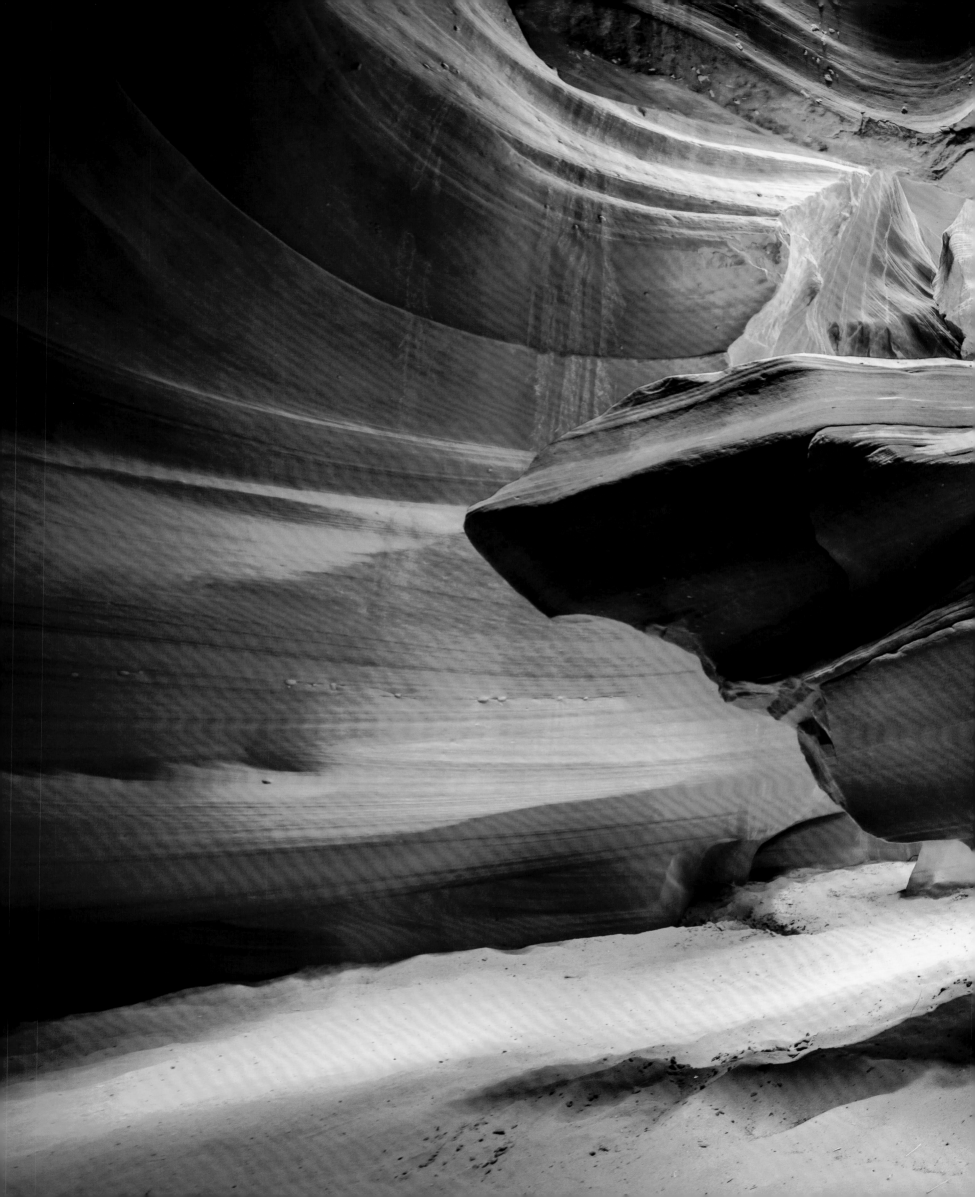

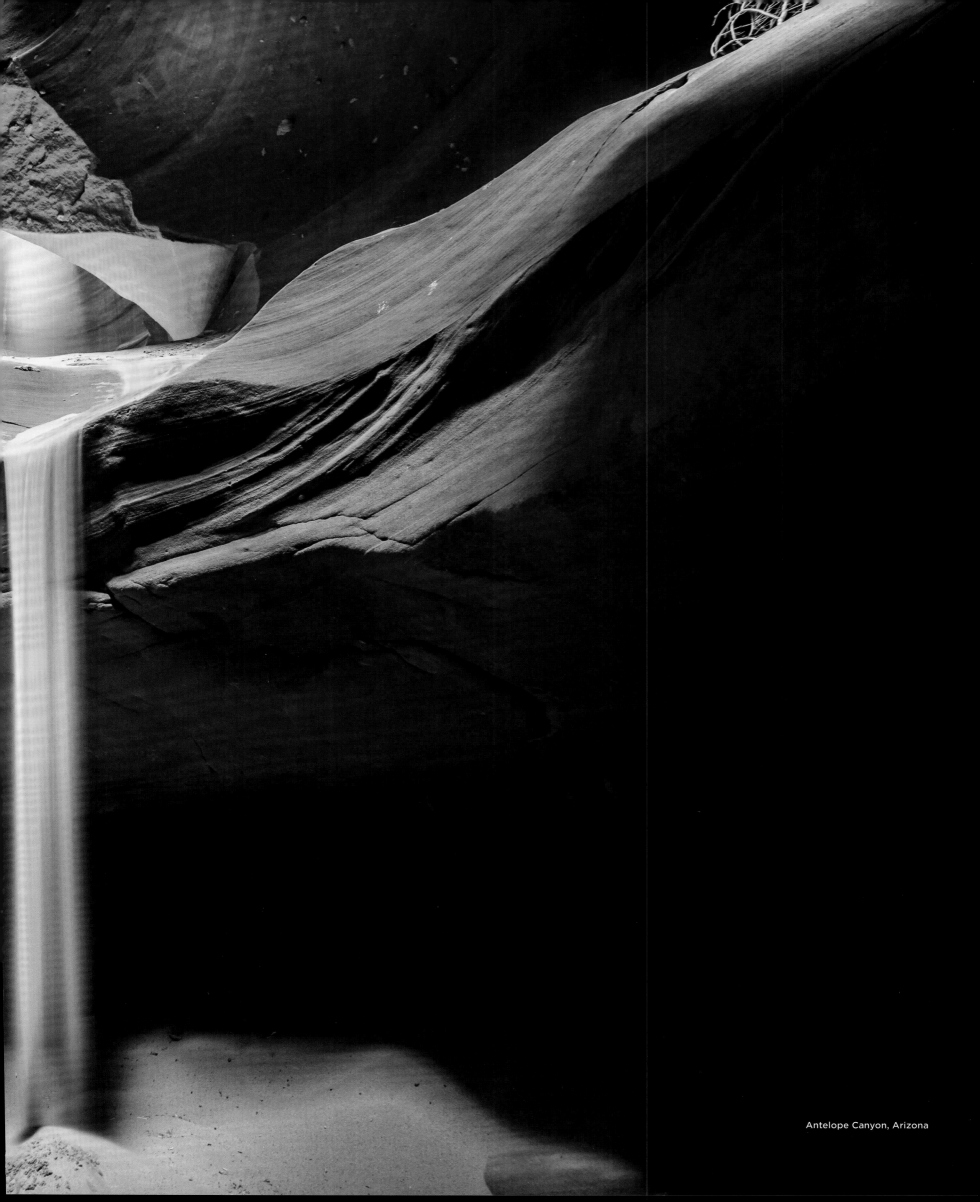

Antelope Canyon, Arizona

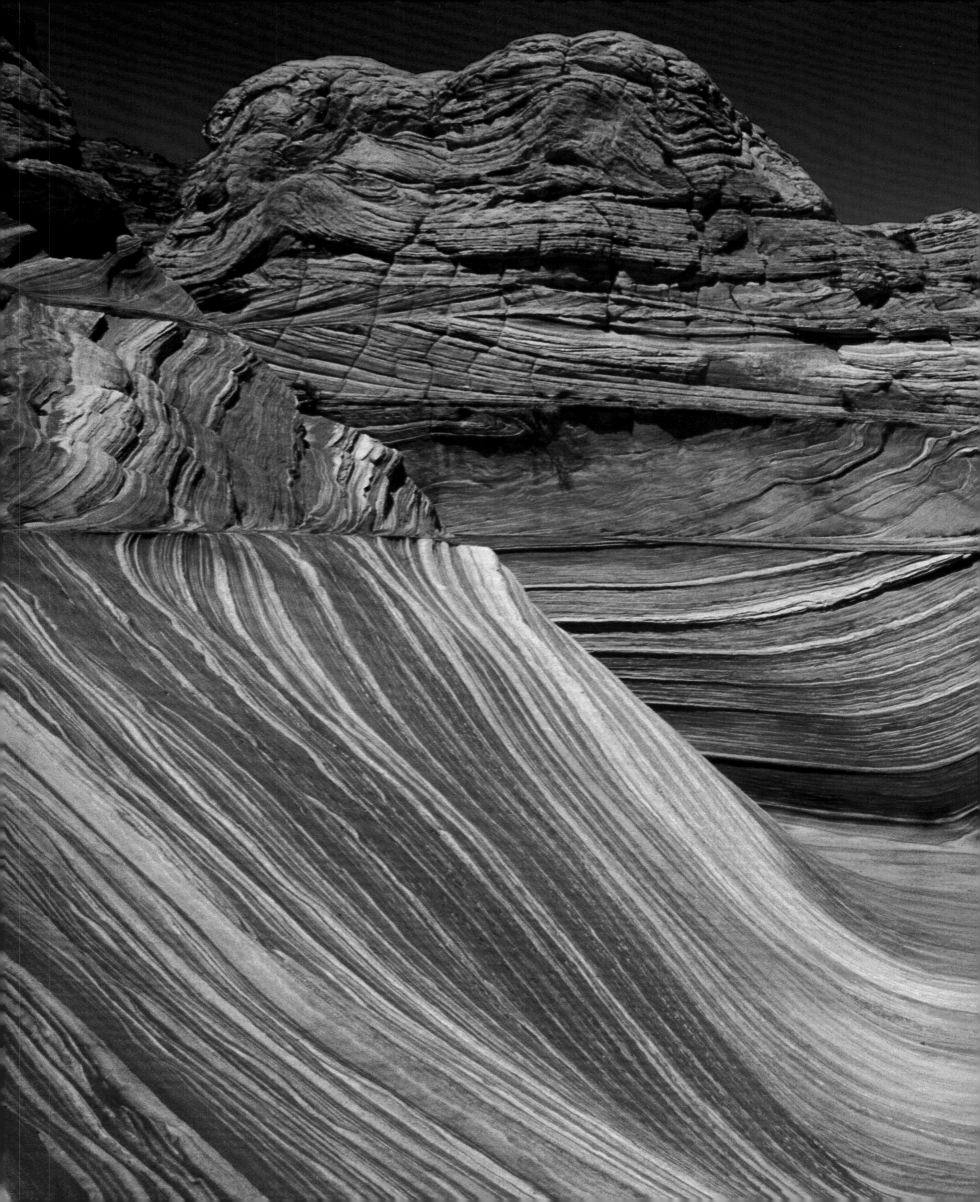

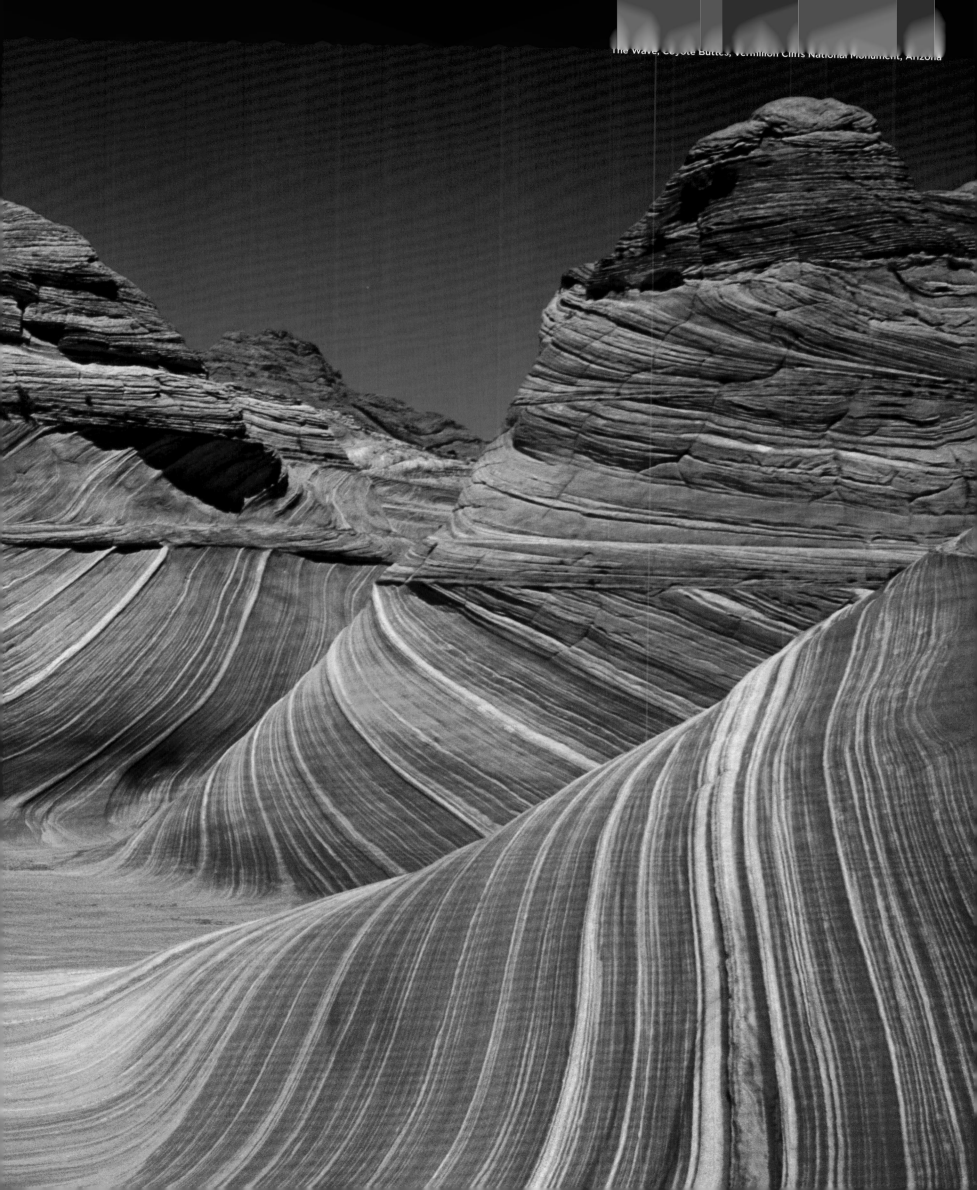

The Wave, Coyote Buttes, Vermilion Cliffs National Monument, Arizona

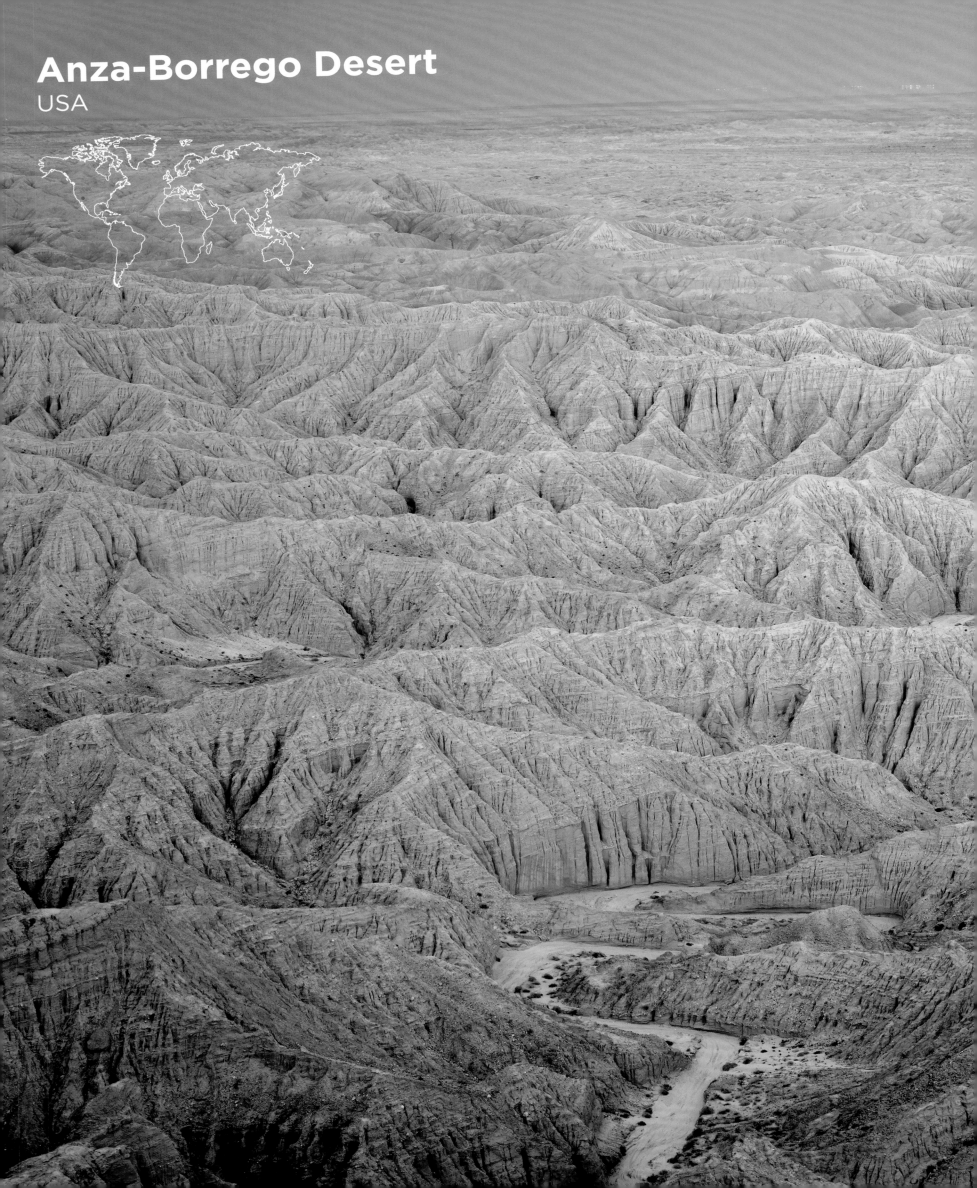

Anza-Borrego Desert
USA

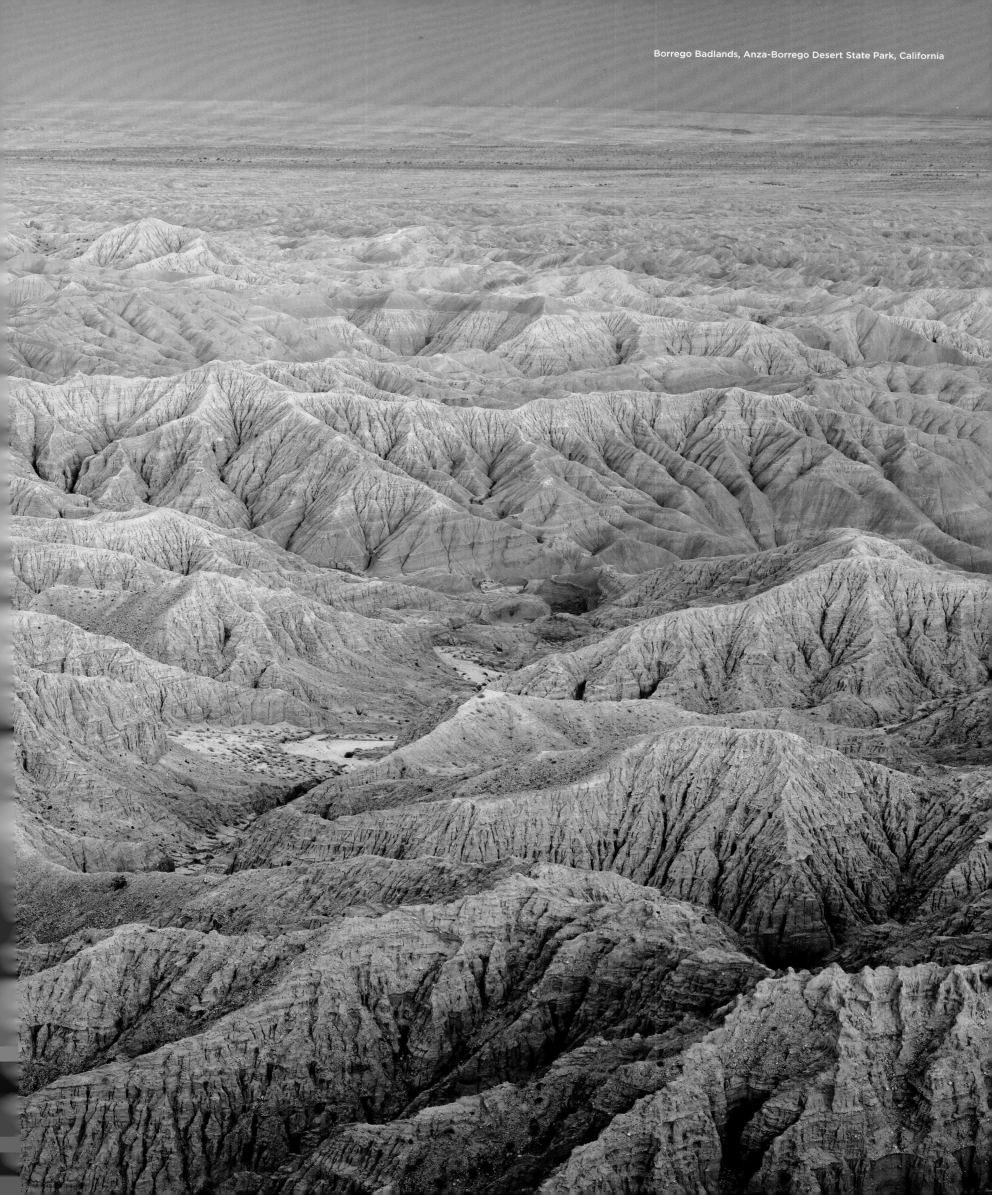

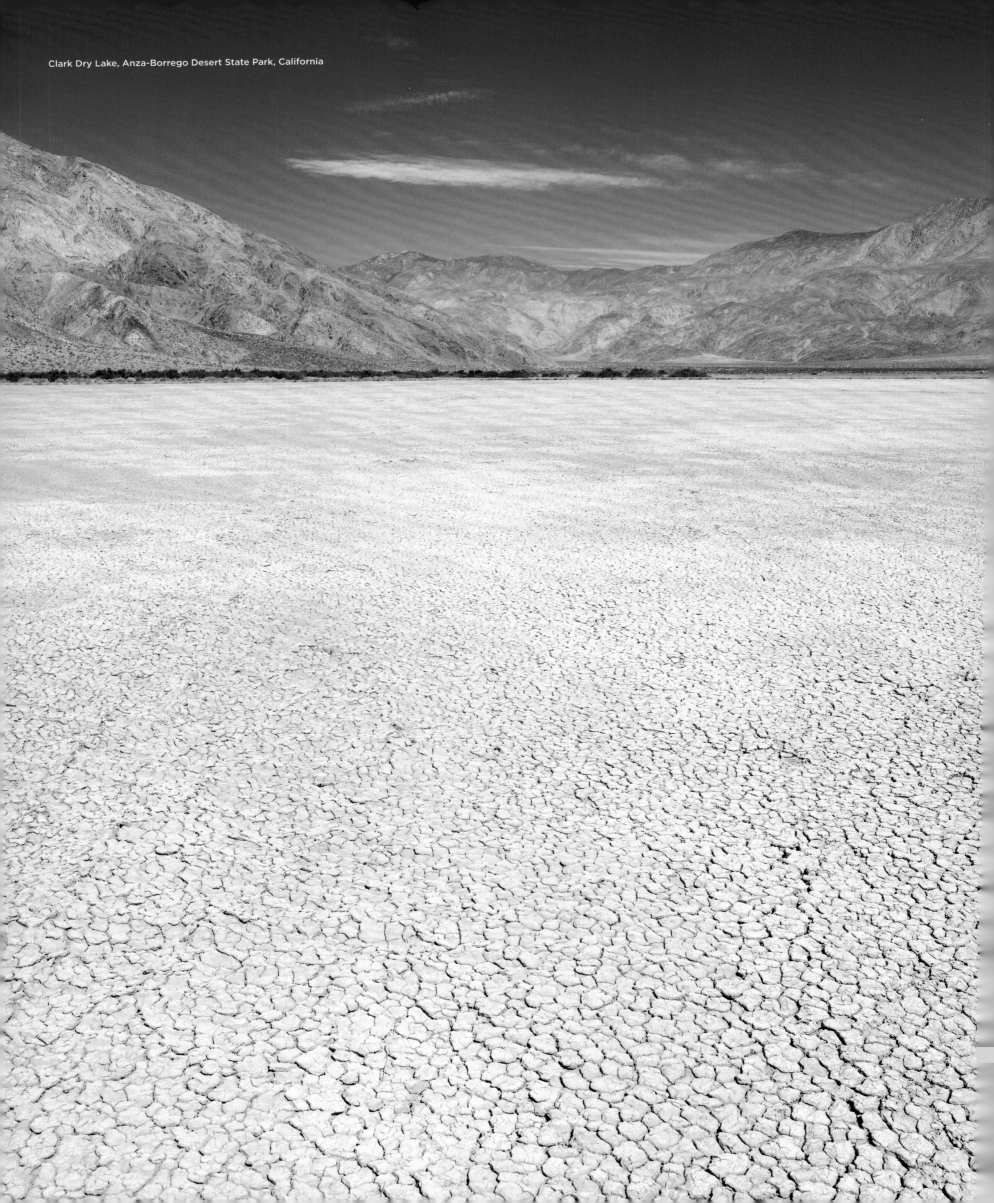

Clark Dry Lake, Anza-Borrego Desert State Park, California

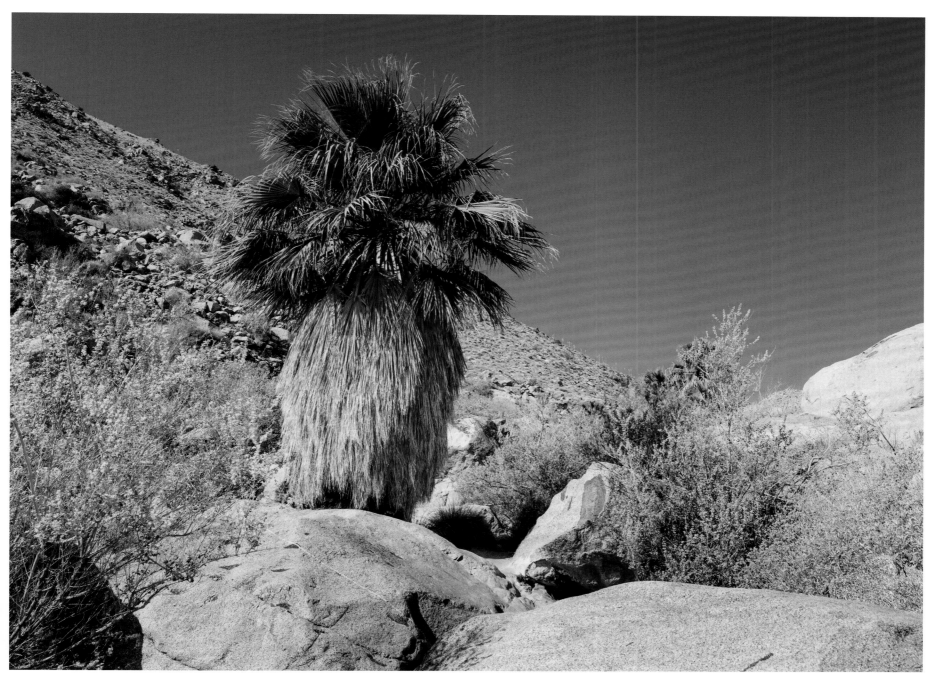

California fan palm, Hellhole Canyon, Anza-Borrego Desert State Park, California

Anza-Borrego Desert

The Anza-Borrego Desert lies in southern California and is known for its arid plains and mountains interspersed with springs that enable a proliferation of cacti and colourful wildflowers close to the oases whenever rain falls. These oases protect mountain lions, coyotes, rattlesnakes and desert bighorn sheep.

Désert d'Anza-Borrego

Situé au sud de la Californie, le désert d'Anza-Borrego est connu pour ses plaines arides et ses montagnes ponctuées de sources, qui permettent aux cactus et aux fleurs sauvages colorées de proliférer près des oasis chaque fois que la pluie tombe. Ces oasis abritent des lions des montagnes, des coyotes, des crotales et des mouflons du désert.

Anza-Borrego-Wüste

Die Anza-Borrego-Wüste liegt in Südkalifornien und ist bekannt für ihre trockenen Ebenen und Berge, die von Quellen durchsetzt sind, die Kakteen und bunten Wildblumen Wachstum in der Nähe der Oasen ermöglichen, wenn Regen fällt. Die Oasen liefern auch Trinkwasser für Berglöwen, Kojoten, Klapperschlangen und Wüstendickhornschafe.

Desierto de Anza-Borrego

El desierto de Anza-Borrego habita en el sur de California y es conocido por sus áridas llanuras y montañas intercaladas con manantiales que permiten la proliferación de cactus y coloridas flores silvestres cerca de los oasis cada vez que llueve. Estos oasis protegen a los pumas, coyotes, serpientes de cascabel y borrego cimarrones del desierto.

Deserto de Anza-Borrego

O deserto Anza-Borrego habita o sul da Califórnia e é conhecido por suas planícies áridas e montanhas intercaladas com nascentes que permitem a proliferação de cactos e flores silvestres coloridas perto dos oásis sempre que chove. Estes oásis protegem leões da montanha, coiotes, cascavéis e carneiros selvagens do deserto.

Anza-Borrego Desert

Het Anza-Borrego Desert State Park ligt in het zuiden van Californië en staat bekend om zijn droge vlakten en bergen die worden afgewisseld met bronnen. Hierdoor kunnen bij regenval cactussen en kleurige wilde bloemen in de buurt van de oases groeien. Deze oases leveren ook water aan bergleeuwen, coyotes, ratelslangen en dikhoornschapen.

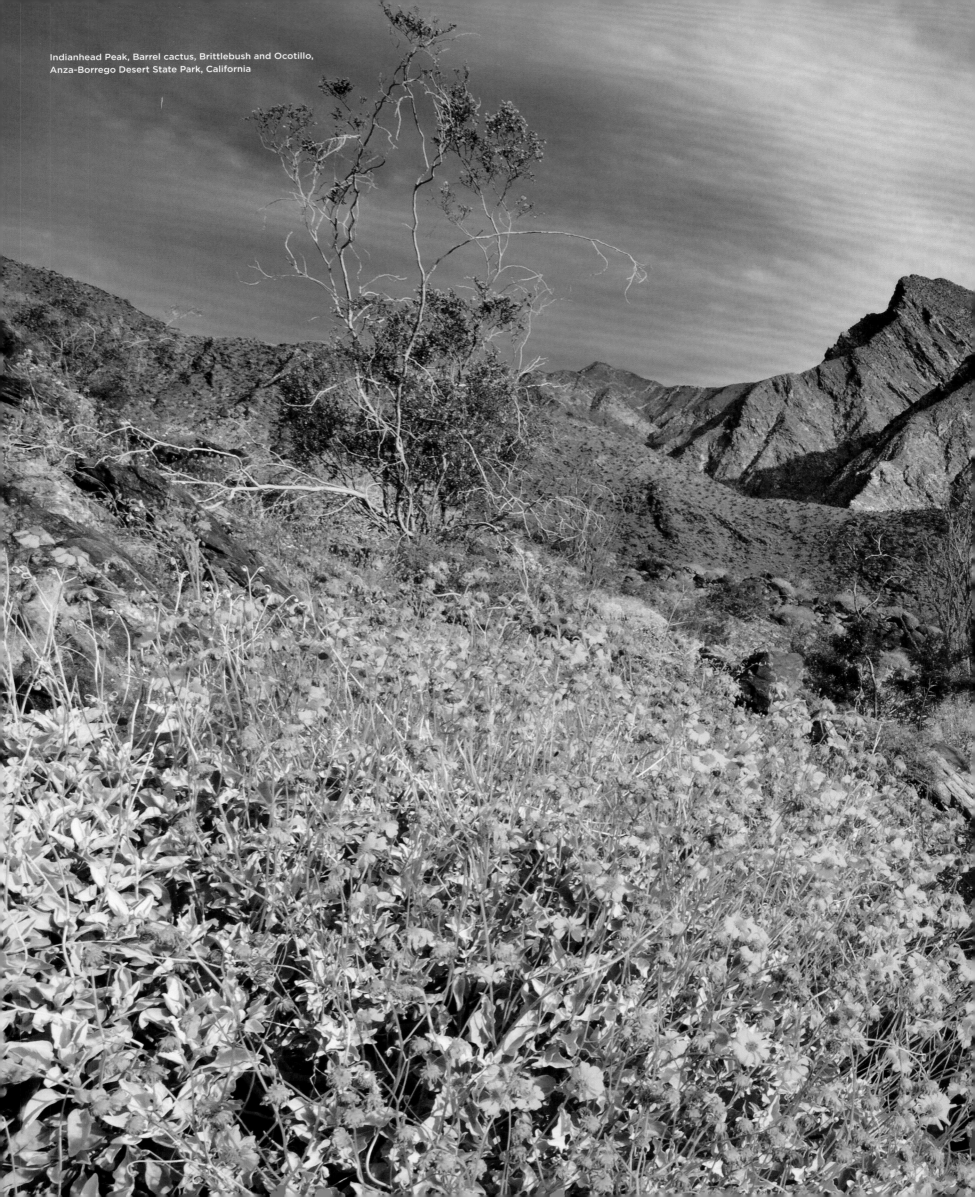

Indianhead Peak, Barrel cactus, Brittlebush and Ocotillo,
Anza-Borrego Desert State Park, California

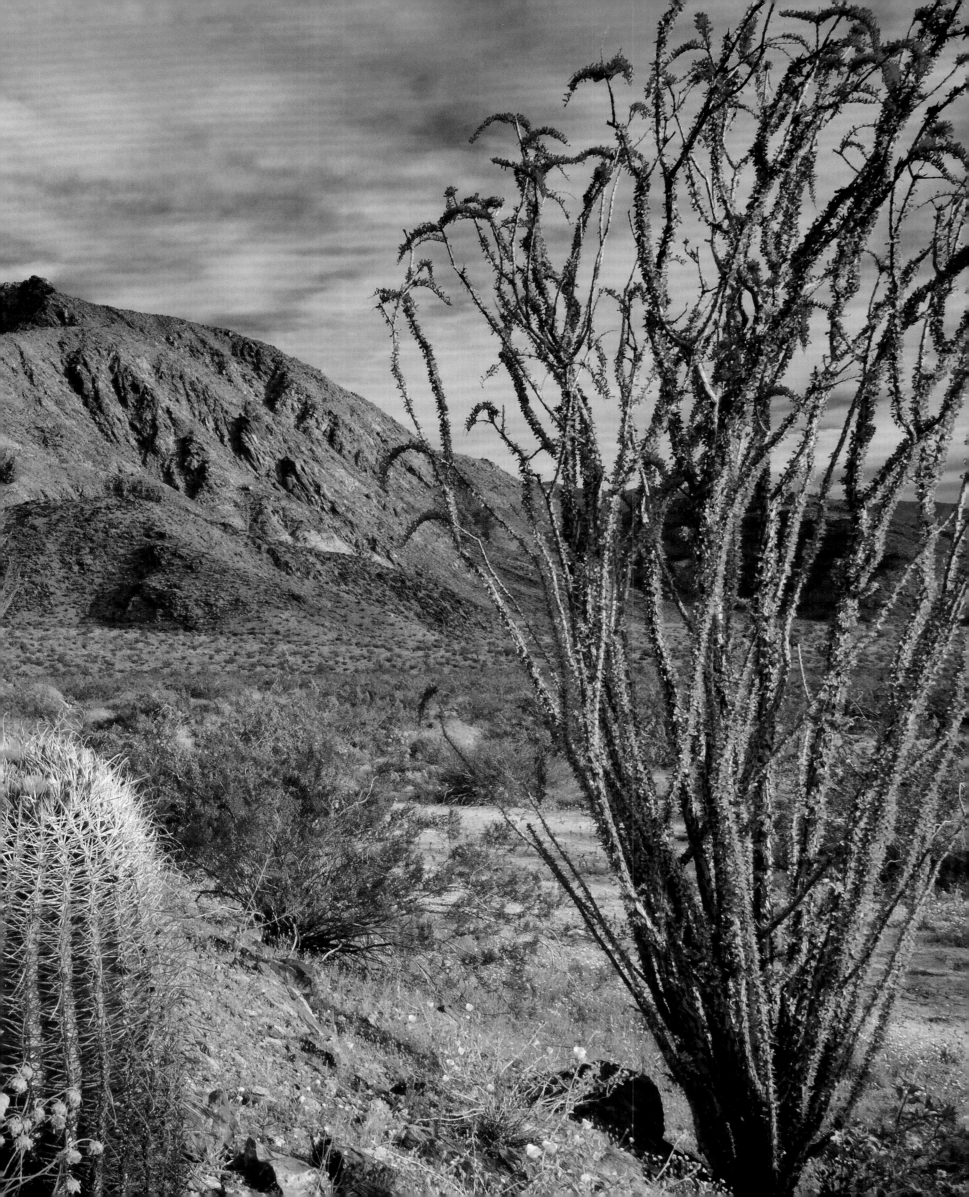

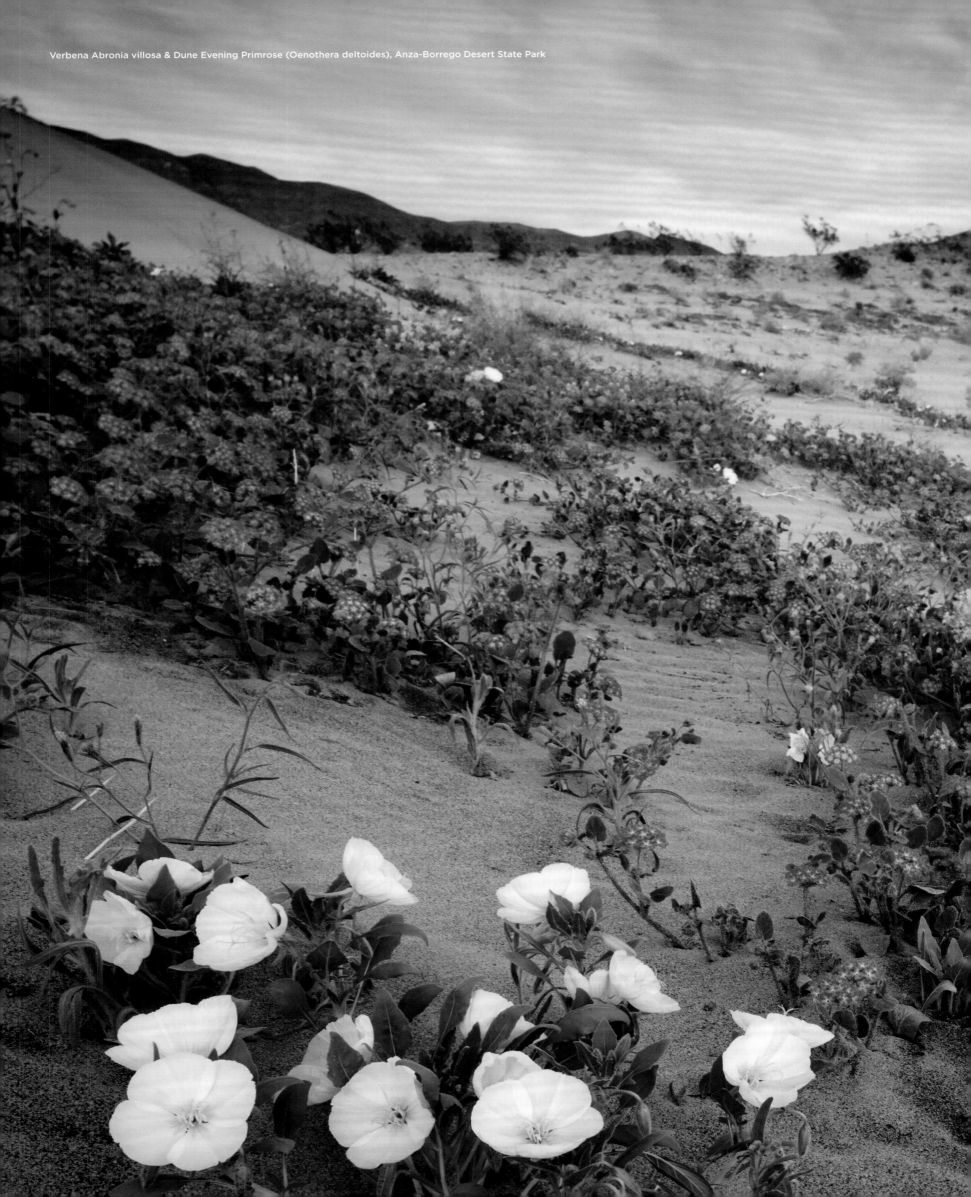

Verbena Abronia villosa & Dune Evening Primrose (Oenothera deltoides), Anza-Borrego Desert State Park

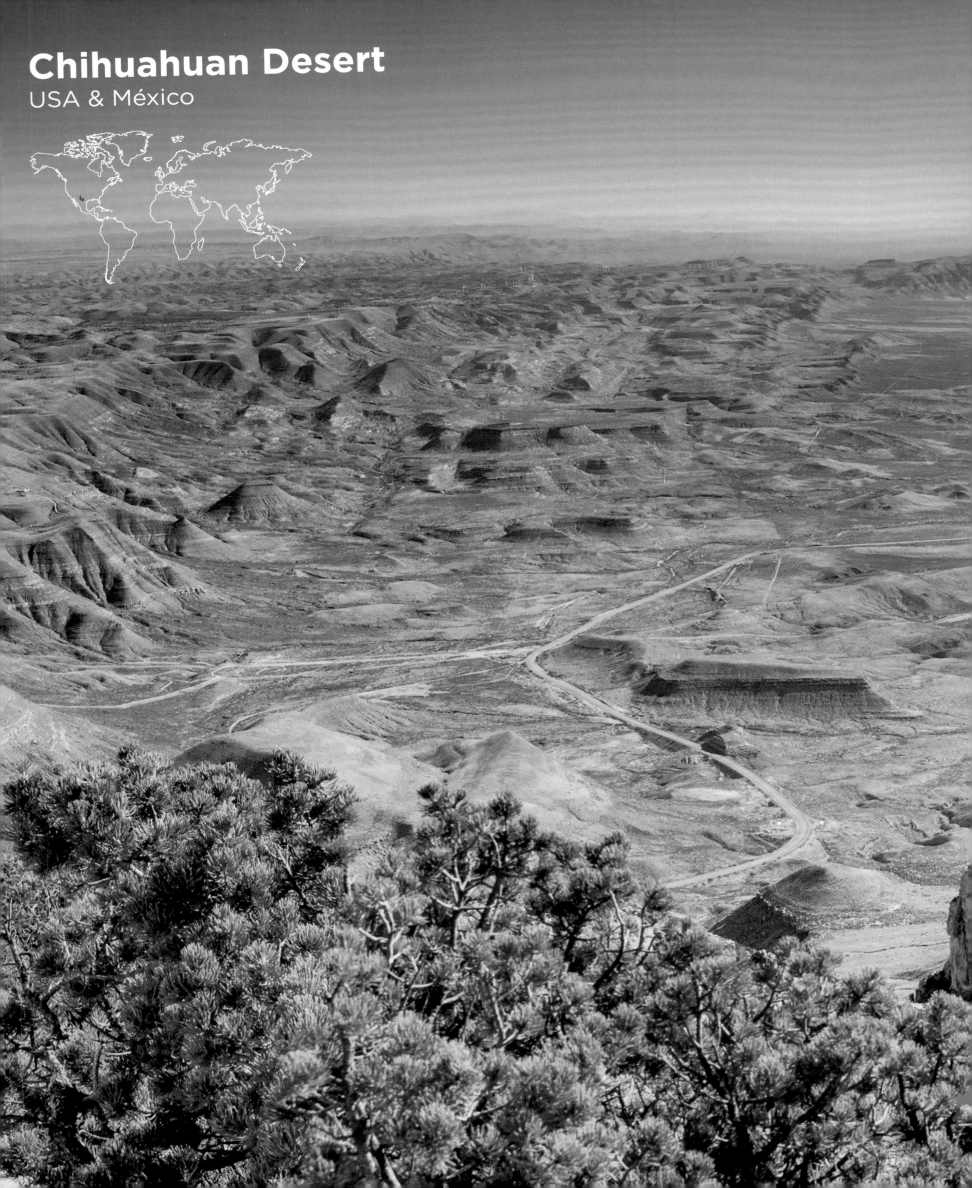

Chihuahuan Desert
USA & México

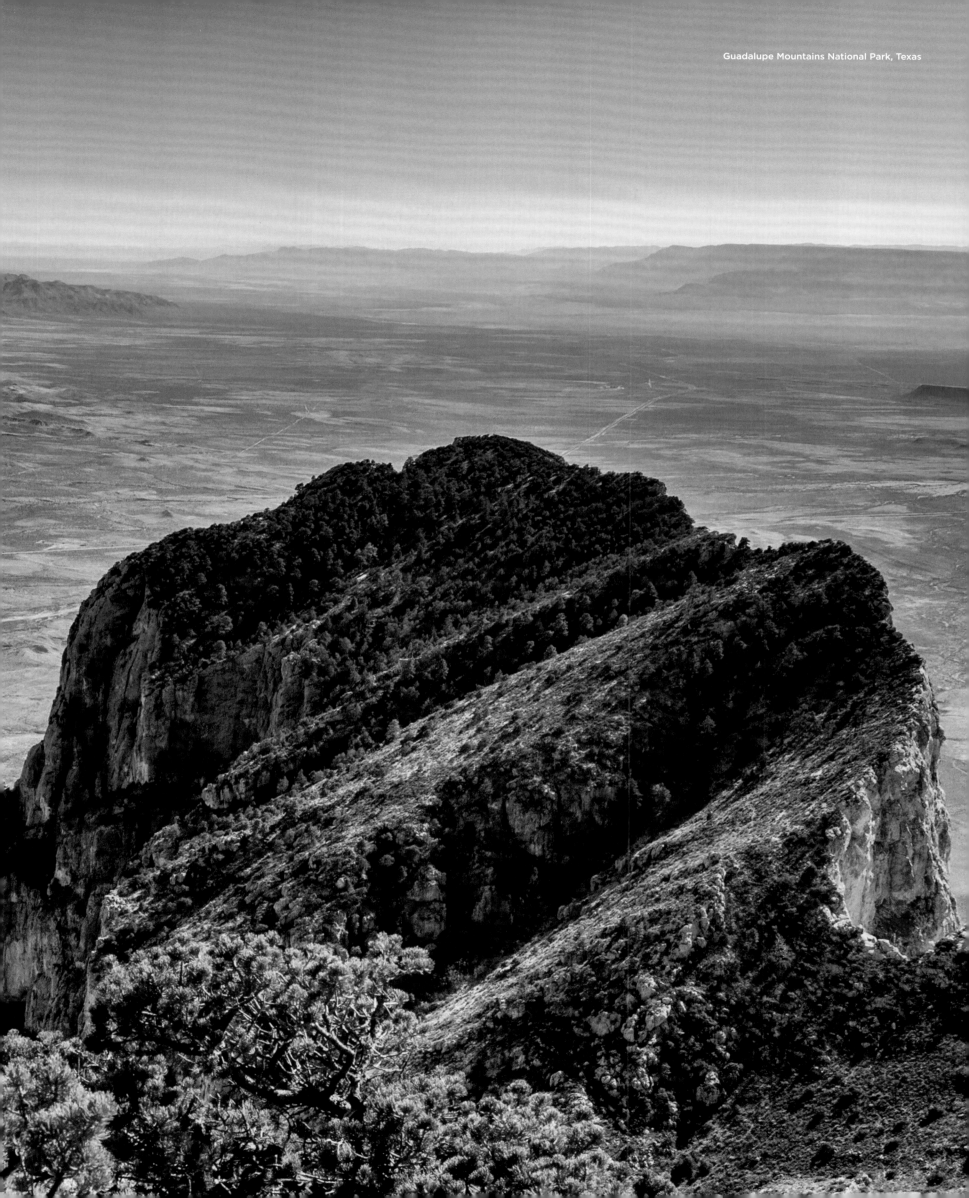

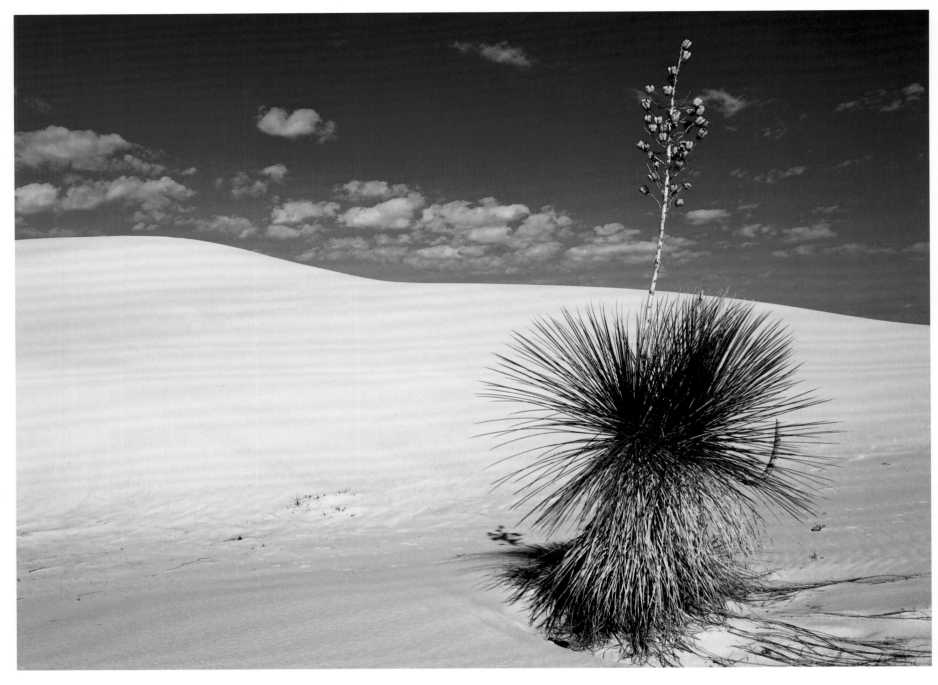

Yucca, White Sands National Monument, New Mexico

Chihuahuan Desert

The Chihuahuan Desert, one of North America's largest deserts, covers 175 000 km². It stretches from the southern reaches of the US state of New Mexico deep into Mexico, as far south as the state of San Luis Potosi. Unlike most North American deserts, the Chihuahuan Desert is subject to monsoonal conditions and can experience bitterly cold winters. On the US side of the border, the unusually white sand dunes of the White Sands National Monument are caused by the presence of gypsum, an unusual occurrence that dates back 250 million years when gypsum settled upon the floor of an inland sea. The dunes are known to move up to nine meters every year.

Le désert de Chihuahua

Comptant parmi les plus grands déserts d'Amérique du Nord, le désert de Chihuahua couvre une surface de 175 000 km². Il s'étend des zones septentrionales de l'État du Nouveau-Mexique jusqu'au cœur du Mexique, dans l'État de San Luís Potosí. À la différence de la plupart des déserts nord-américains, le Chihuahua connaît des moussons et des hivers particulièrement rigoureux. Du côté américain de la frontière, les dunes de sable du White Sands National Monument doivent leur blanc rare à la présence de gypse dans le sable, un fait inhabituel survenu voici deux cent cinquante millions d'années, à l'époque où le gypse s'est déposé sur le sol d'une mer intérieure. Les dunes grandiraient de neuf mètres chaque année.

Chihuahua-Wüste

Die Chihuahua-Wüste, eine der größten nordamerikanischen Wüsten, umfasst 175 000 km². Sie erstreckt sich vom südlichen Teil des US-Bundesstaates New Mexico bis hin zum mexikanischen Bundesstaat San Luis Potosi. Im Gegensatz zu den meisten nordamerikanischen Wüsten ist sie monsunähnlichen Klimabedingungen ausgesetzt und hat bitterkalte Winter. Die weißen Dünen des White Sands National Monument auf der US-Seite gehen auf den Gips im Sand zurück. Ein ungewöhnliches Zusammentreffen, das vor 250 Millionen Jahre stattfand, als sich Gips auf dem Boden eines Binnenmeeres absetzte. Die Dünen bewegen sich jedes Jahr um bis zu neun Meter.

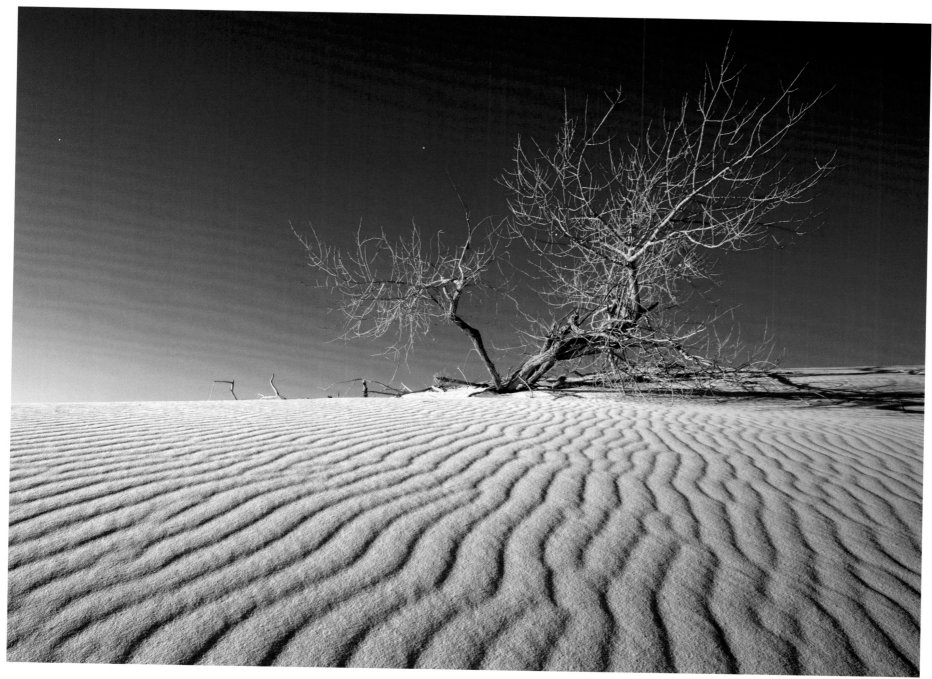

White Sands National Monument, New Mexico

Desierto de Chihuahua

El desierto de Chihuahua, uno de los desiertos más grandes de América del Norte, tiene una superficie de 175 000 km². Se extiende desde el extremo sur del estado de Nuevo México en los EE. UU. hasta México, tan al sur como el estado de San Luis Potosí.
A diferencia de la mayoría de los desiertos de América del Norte, el desierto de Chihuahua está sujeto a condiciones monzónicas y puede experimentar inviernos amargamente fríos. En el lado norteamericano de la frontera, las inusuales dunas de arena blanca del Monumento Nacional de las Arenas Blancas están causadas por la presencia de yeso en la arena, un hecho inusual que data de hace 250 millones de años, cuando el yeso se asentó en el suelo de un mar interior. Se sabe que las dunas se mueven hasta nueve metros cada año.

Deserto de Chihuahua

O Deserto de Chihuahua, um dos maiores desertos da América do Norte, cobre 175 000 km². Ela se estende do sul do estado americano do Novo México até o México, até o sul do estado de San Luis Potosí. Ao contrário da maioria dos desertos norte-americanos, o Deserto de Chihuahua está sujeito a condições de monções e pode experimentar invernos rigorosamente frios. No lado norte-americano da fronteira, as dunas de areia raramente brancas do Monumento Nacional de White Sands são causadas pela presença de Gesso na areia, uma ocorrência incomum que remonta a 250 milhões de anos quando o gesso assente no solo de um mar interior. Sabe-se que as dunas se movem até nove metros por ano.

Chihuahuawoestijn

De Chihuahuawoestijn, een van de grootste woestijnen van Noord-Amerika, beslaat 175 000 km². Hij strekt zich uit van het zuiden van de Amerikaanse staat New Mexico tot San Luis Potosi, een staat diep in Mexico. Anders dan in de meeste Noord-Amerikaanse woestijnen heersen er moessonachtige omstandigheden in de Chihuahua en kan het hier 's winters bitterkoud zijn. De ongewoon witte zandduinen van het White Sands National Monument aan de VS-kant van de grens worden veroorzaakt door de aanwezigheid van gips in het zand, dat 250 miljoen jaar geleden heel ongebruikelijk op de bodem van een binnenzee werd afgezet. Van de duinen is bekend dat ze elk jaar wel 9 meter opschuiven.

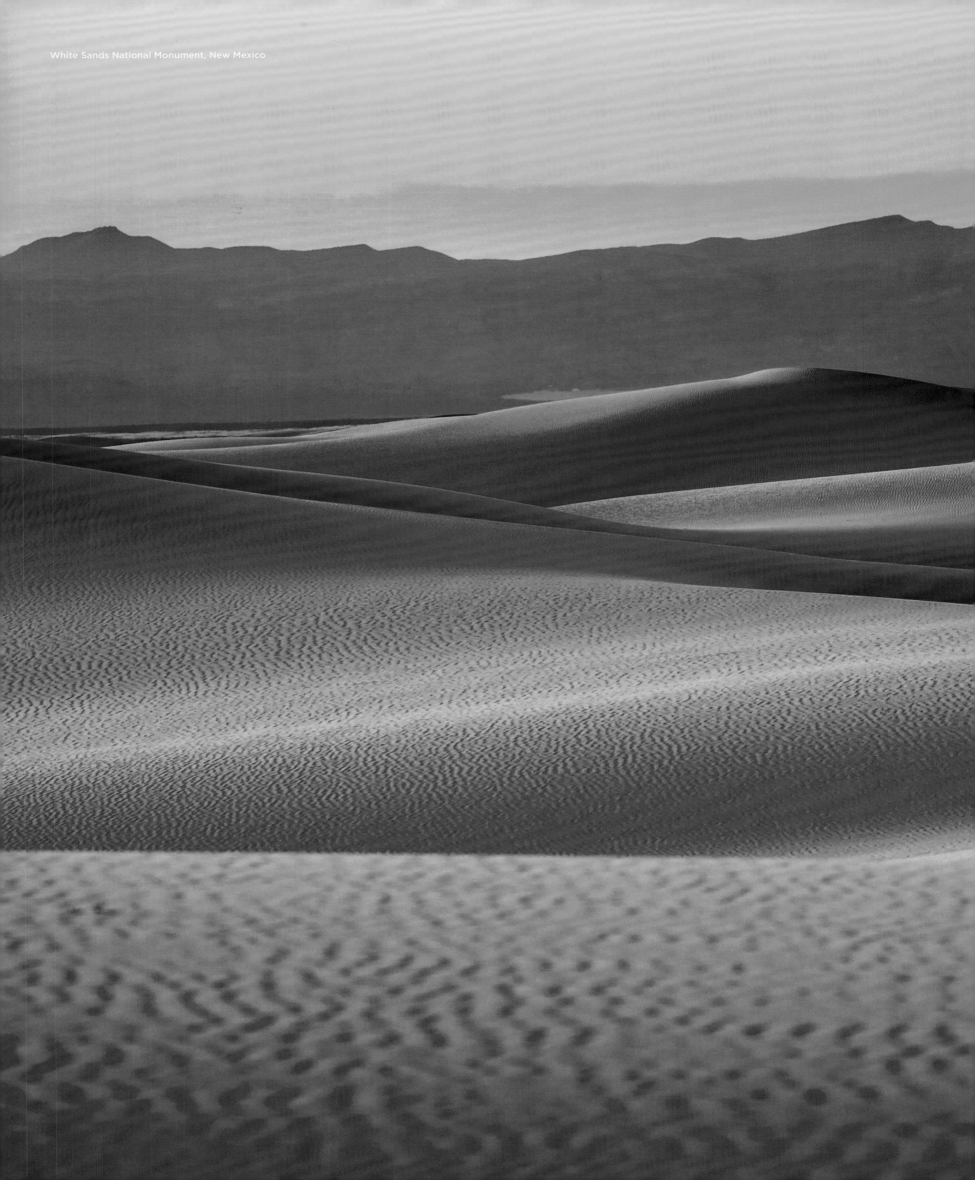

White Sands National Monument, New Mexico

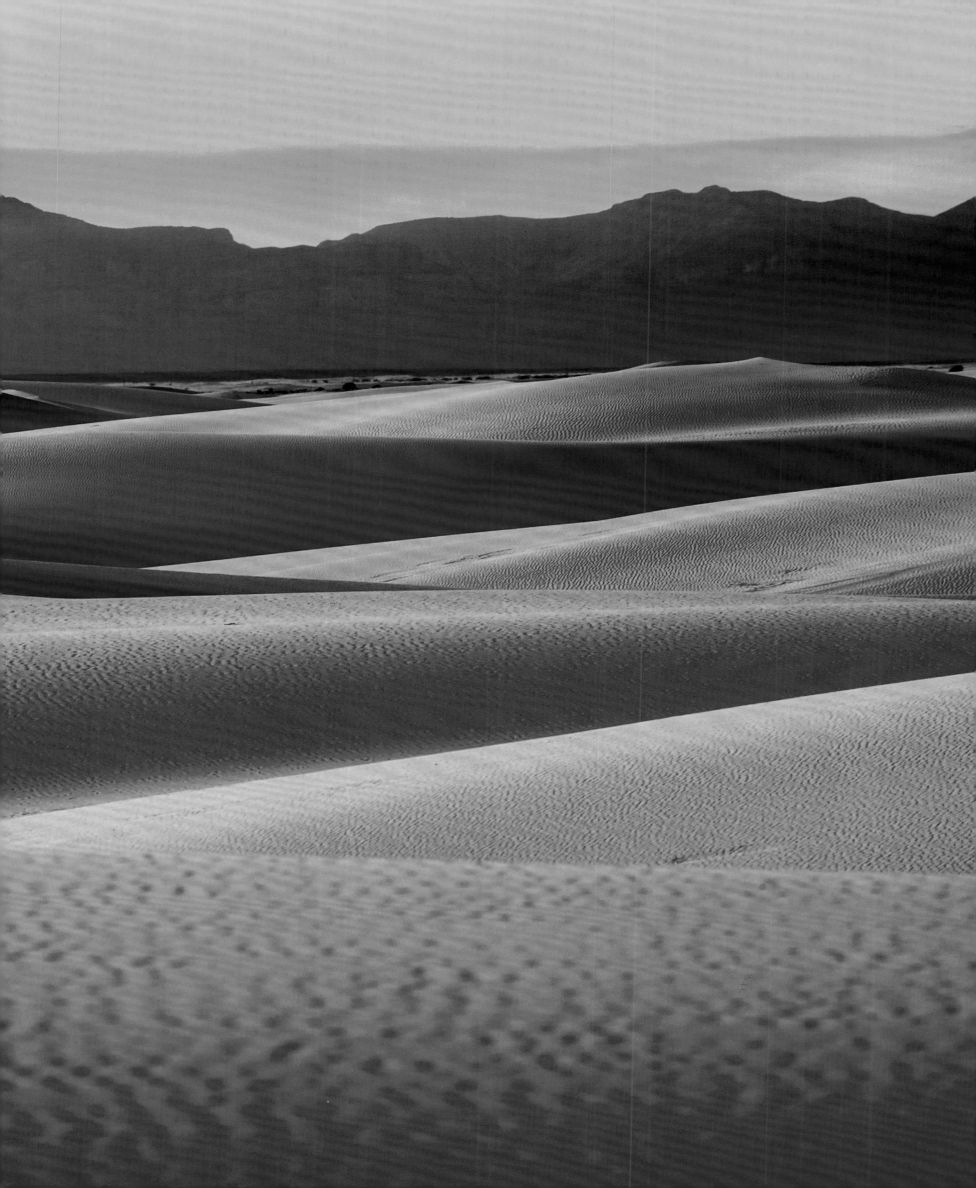

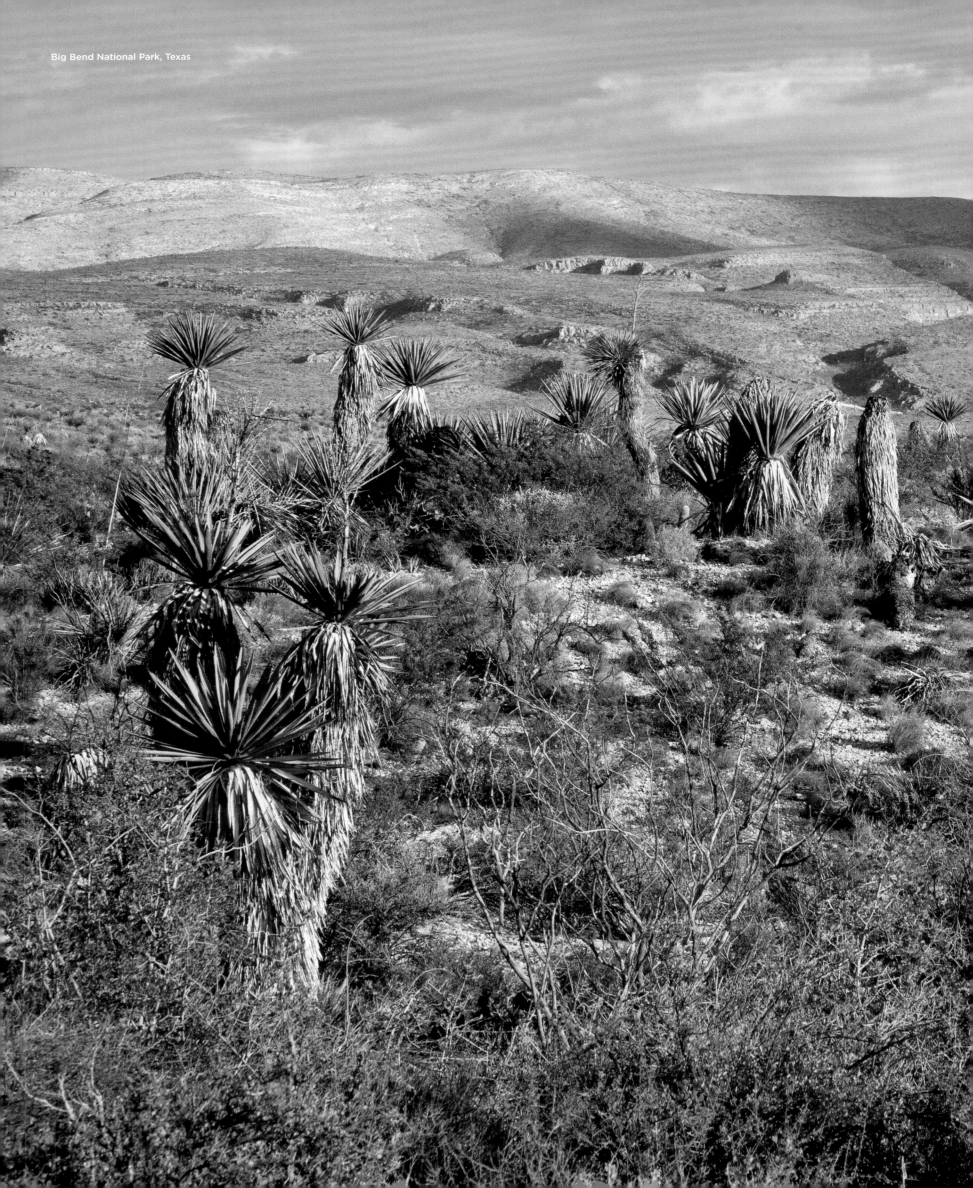

Big Bend National Park, Texas

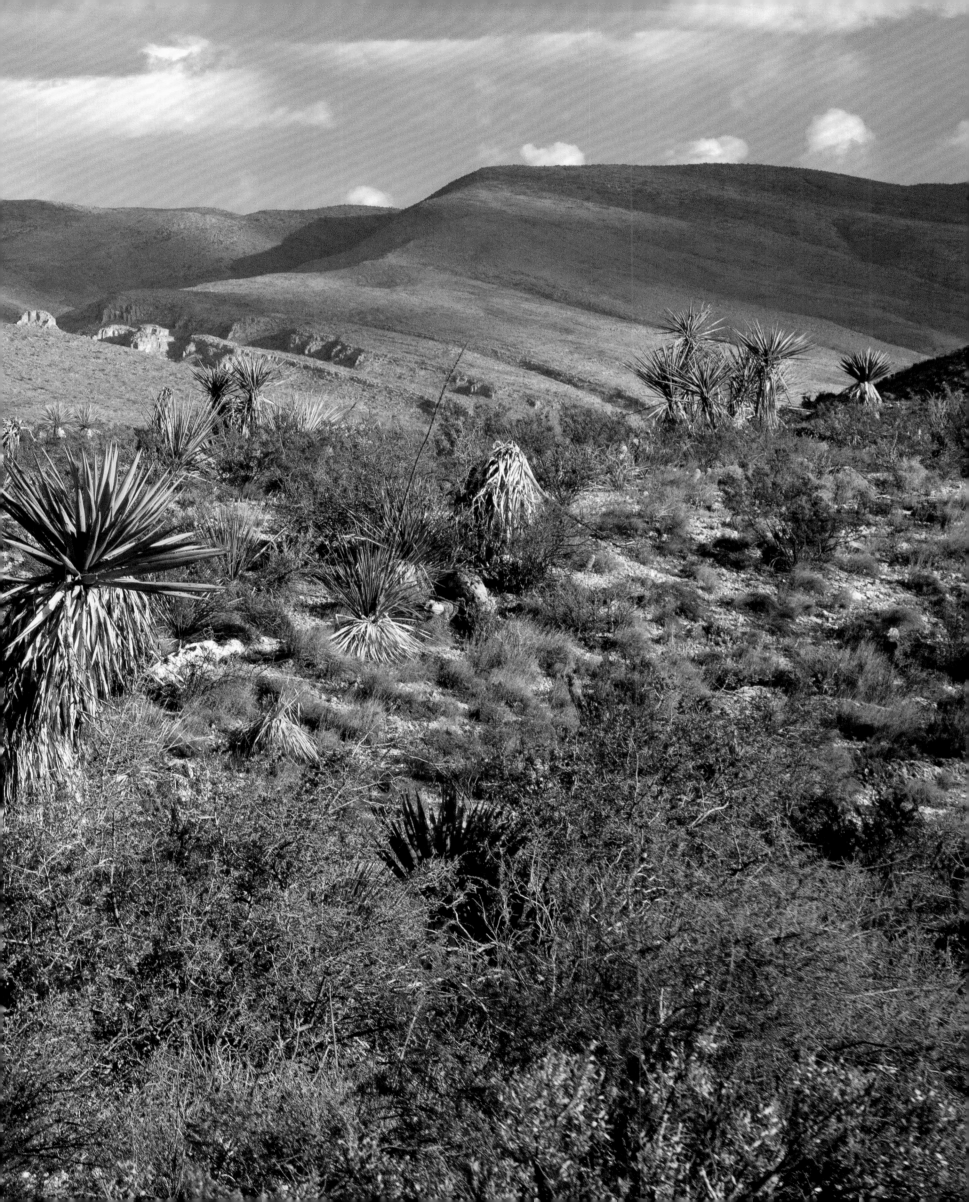

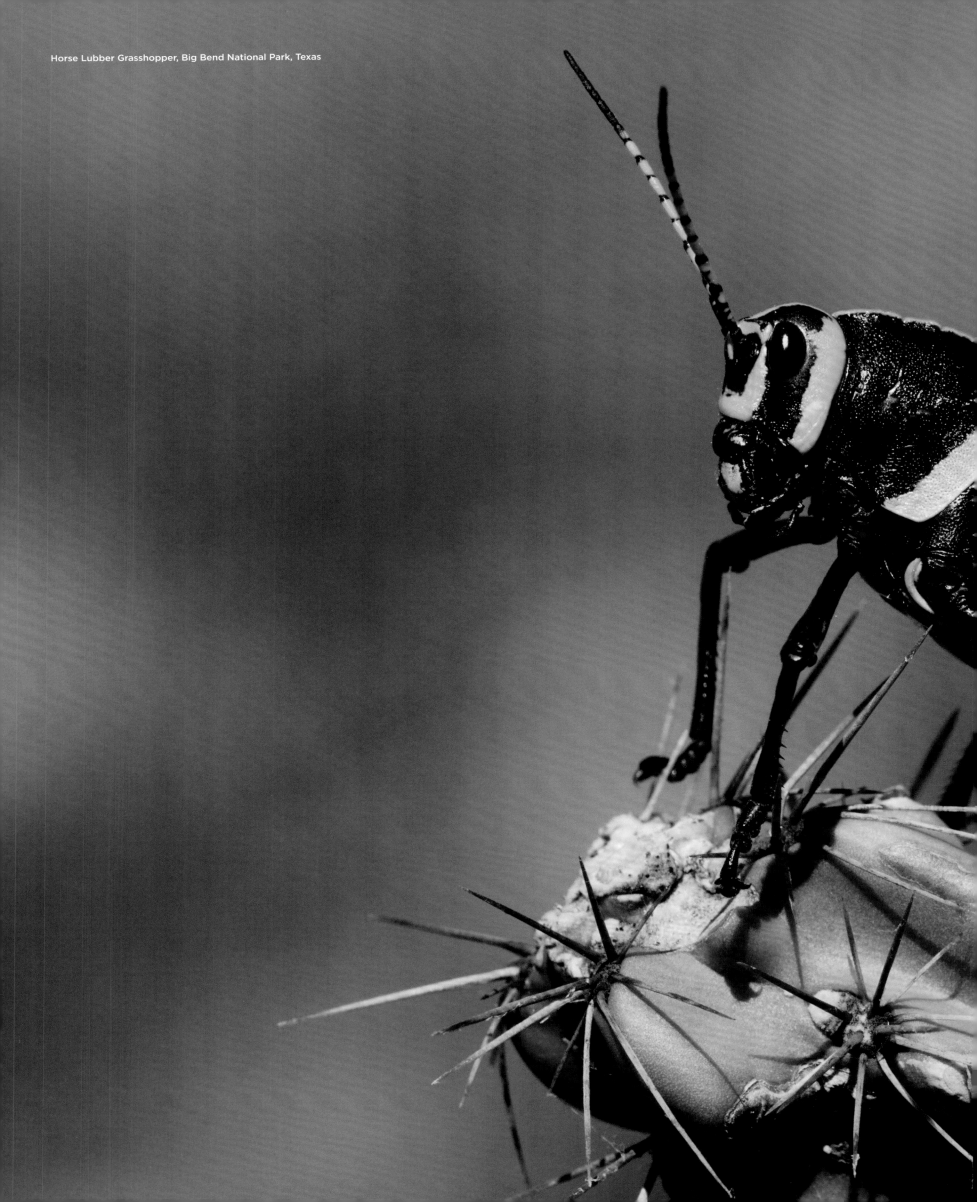

Horse Lubber Grasshopper, Big Bend National Park, Texas

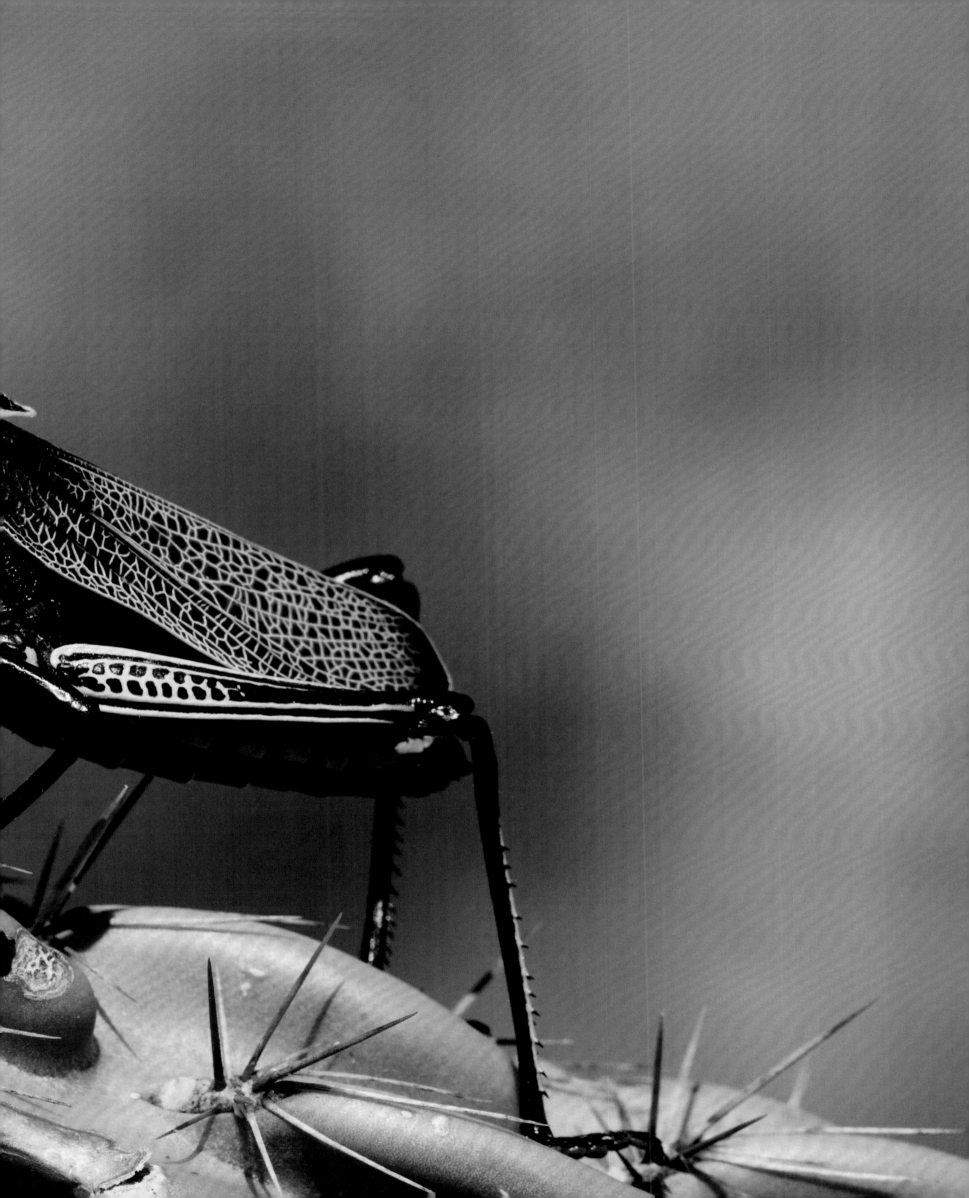

Desierto de Baja California
México

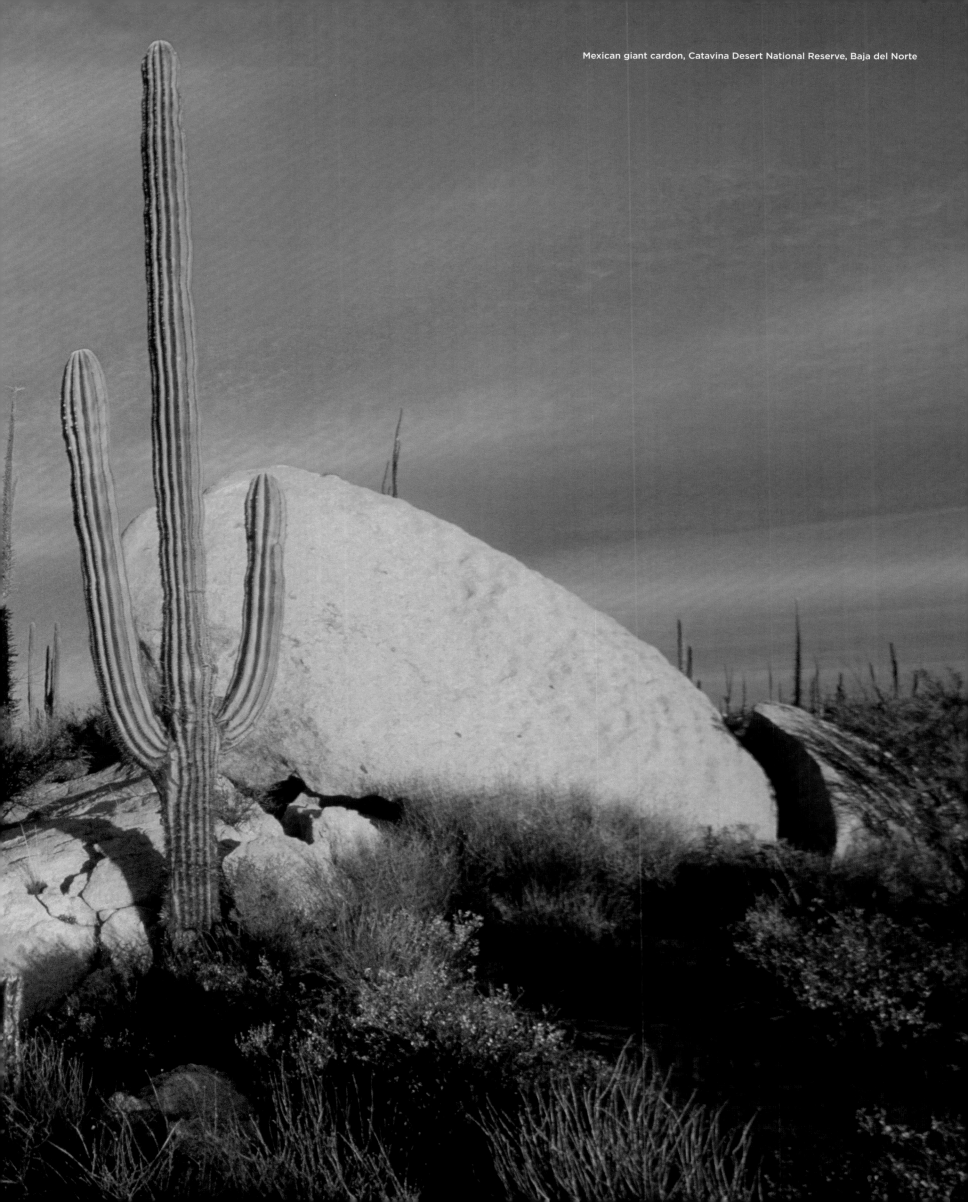

Mexican giant cardon, Catavina Desert National Reserve, Baja del Norte

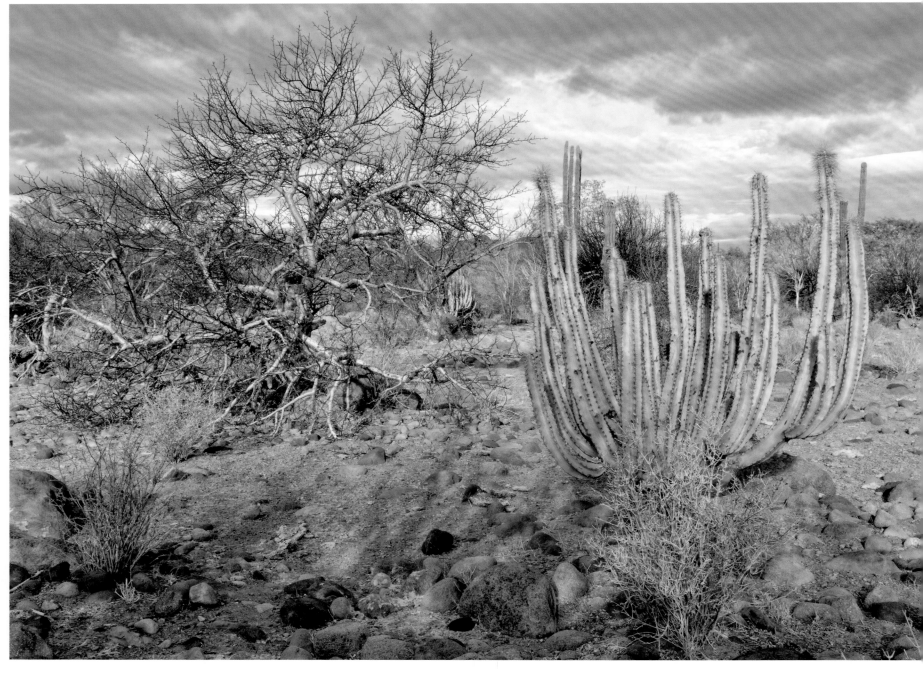

Organ Pipe Cactus, Sierra de la Giganta, Baja California Sur, México

Desierto de Baja California

Wedged between the Pacific Ocean and the Peninsular Ranges of Mexico's Baja Peninsula, the Baja California Desert is an unusual mix of dry and subtropical climate systems. This combination of dry air and humidity has given rise to an unusual proliferation of more than 500 vascular plants. The desert's coastal sand dunes run right to the edge of the ocean, and on colder mornings are sometimes enveloped in mist which can leave behind a thin coating of dew. Elsewhere, erosion has created striated landforms and white-sand beaches that are very often deserted.

Le désert de Baja, en Californie

Calé entre l'océan Pacifique et les chaînes de montagnes de la péninsule de Baja, au Mexique, le désert californien de Baja présente un climat inhabituel à la fois sec et subtropical. Le mélange d'air sec et d'humidité a permis à plus de 500 espèces de plantes vasculaires de proliférer. Les dunes de sable du désert courent jusqu'au bord de l'océan. Lors de froids matins, de la brume les enveloppe parfois, laissant sur elles une fine pellicule de rosée. À d'autres endroits, l'érosion a créé des reliefs striés et des plages de sable blanc la plupart du temps désertes.

Baja-California-Wüste

Die Baja California Desert, die zwischen dem Pazifik und den Peninsular Ranges der mexikanischen Baja-Halbinsel liegt, ist eine ungewöhnliche Mischung aus trockenen und subtropischen Klimasystemen. Diese Kombination aus trockener Luft und Feuchtigkeit hat zu einer außerordentlichen Ansammlung von mehr als 500 Gefäßpflanzenarten geführt. Die küstennahen Sanddünen der Wüste erstrecken sich bis an den Rand des Ozeans, und an kalten Morgen können sie von Nebel eingehüllt sein, der eine dünne Tauschicht hinterlässt Andernorts hat die Erosion gestreifte Landschaftsformen und weiße Sandstrände geschaffen, die sehr oft vollkommen menschenleer sind.

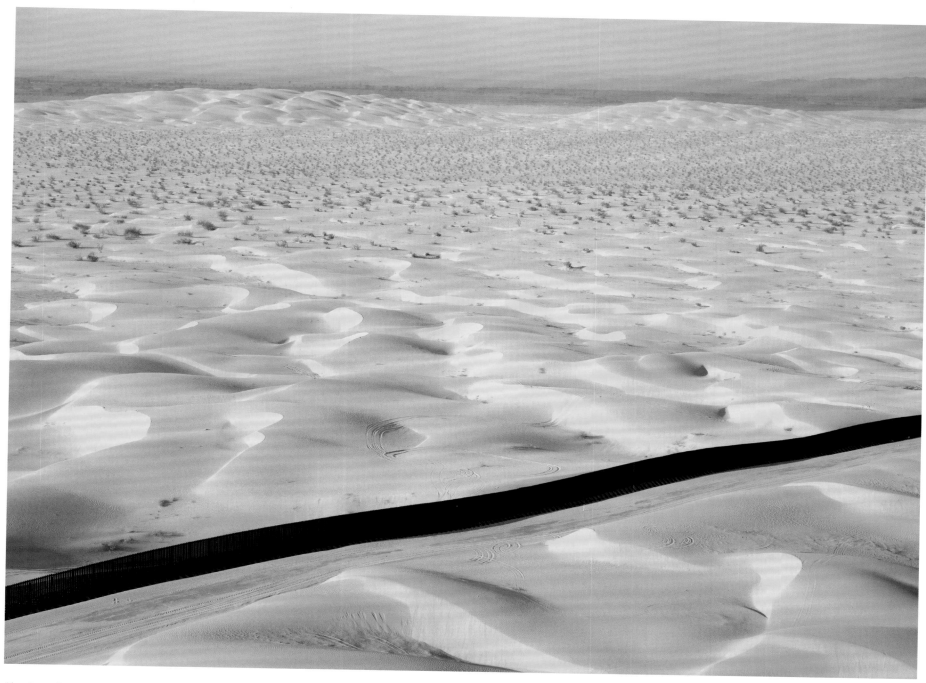

Algodones Dunes, International Border Mexico – United States of America

Desierto de Baja California

Enclavado entre el Océano Pacífico y la Cordillera Peninsular de la Península de Baja California en México, el Desierto de Baja California es una mezcla inusual de sistemas de clima seco y subtropical. Esta combinación de aire seco y humedad ha dado lugar a una proliferación inusual de más de 500 plantas vasculares. Las dunas costeras del desierto se extienden hasta el borde del océano y en las mañanas más frías pueden estar envueltas en niebla, lo que puede dejar una fina capa de rocío. En otros lugares, la erosión ha creado formas de tierra estriadas y playas de arena blanca que a menudo están desiertas.

Desierto de Baja California

Encravado entre o Oceano Pacífico e as Cordilheiras Peninsulares da Península de Baja, no México, o Deserto de Baja California é uma mistura incomum de sistemas climáticos secos e subtropicais. Esta combinação de ar seco e umidade deu origem a uma proliferação incomum de mais de 500 plantas vasculares. As dunas costeiras do deserto correm até a beira do oceano, e nas manhãs mais frias pode ser envolto em névoa que pode deixar para trás uma fina camada de orvalho. Em outros lugares, a erosão criou formas de relevo estriadas e praias de areias brancas, muitas vezes desertas.

Desierto de Baja California

De Woestijn van Neder-Californië, die ligt ingeklemd tussen de Grote Oceaan en de Peninsular Ranges van het Mexicaanse schiereiland Baja, is een ongewone mix van droge en subtropische klimaatsystemen. Door de combinatie van droge lucht en luchtvochtigheid groeien hier meer dan 500 soorten vasculaire planten. De zandduinen in de buurt van de kust lopen door tot aan de rand van de oceaan, en op koudere ochtenden kunnen ze gehuld zijn in de mist, die een dun dauwlaagje achterlaat. Elders heeft erosie gestreepte landschapsvormen en witte zandstranden gecreëerd, die vaak verlaten zijn.

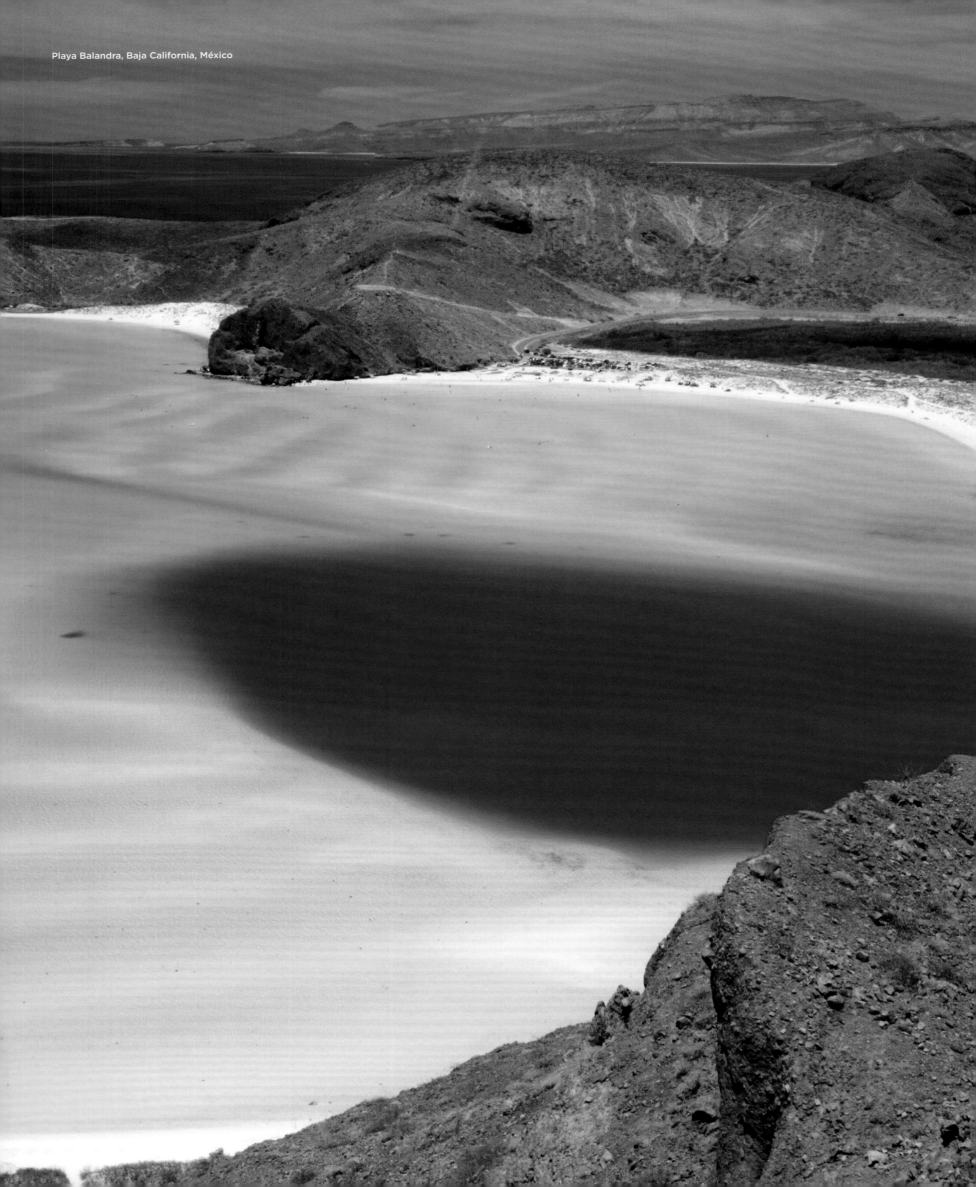

Playa Balandra, Baja California, México

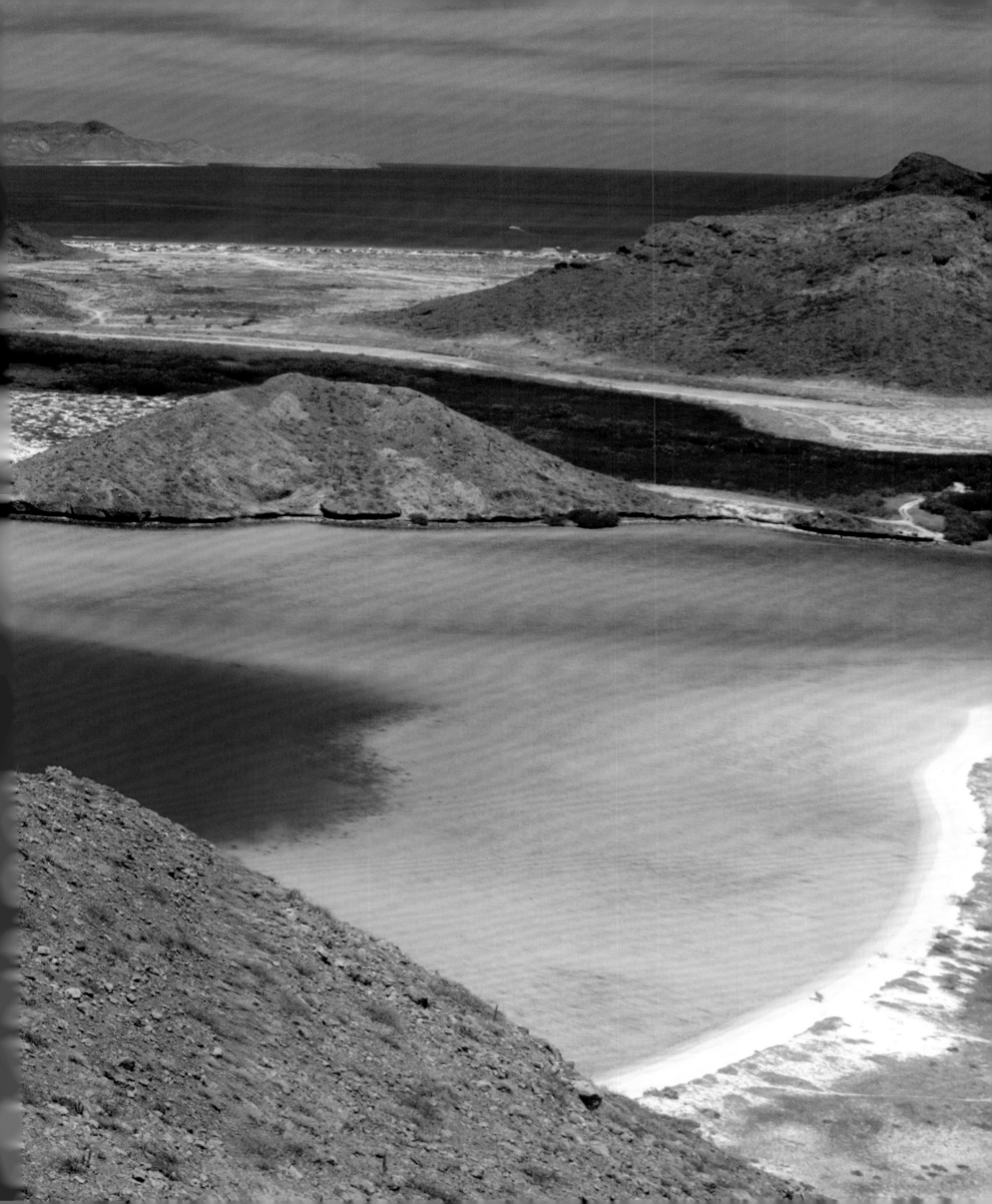

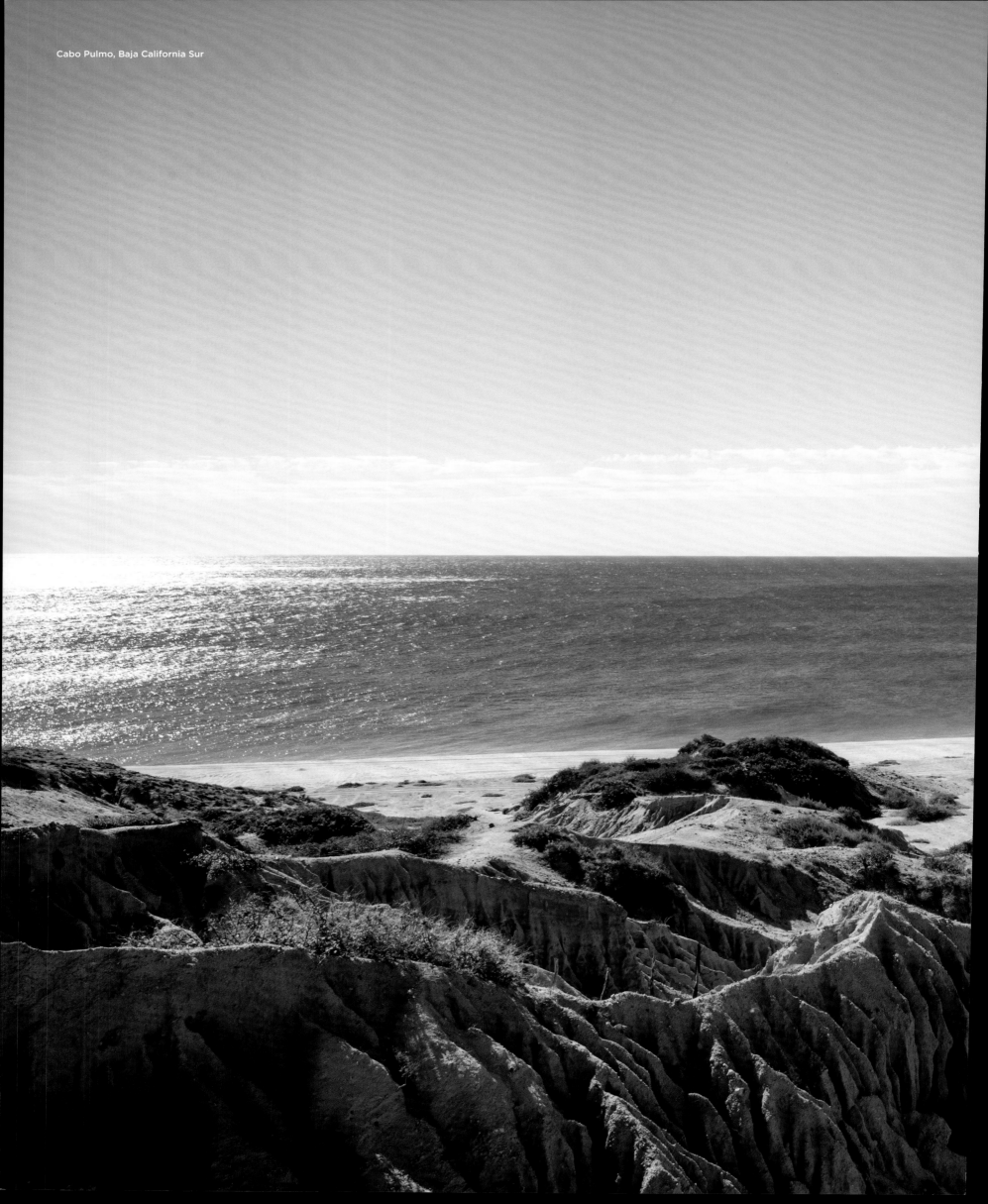

Cabo Pulmo, Baja California Sur

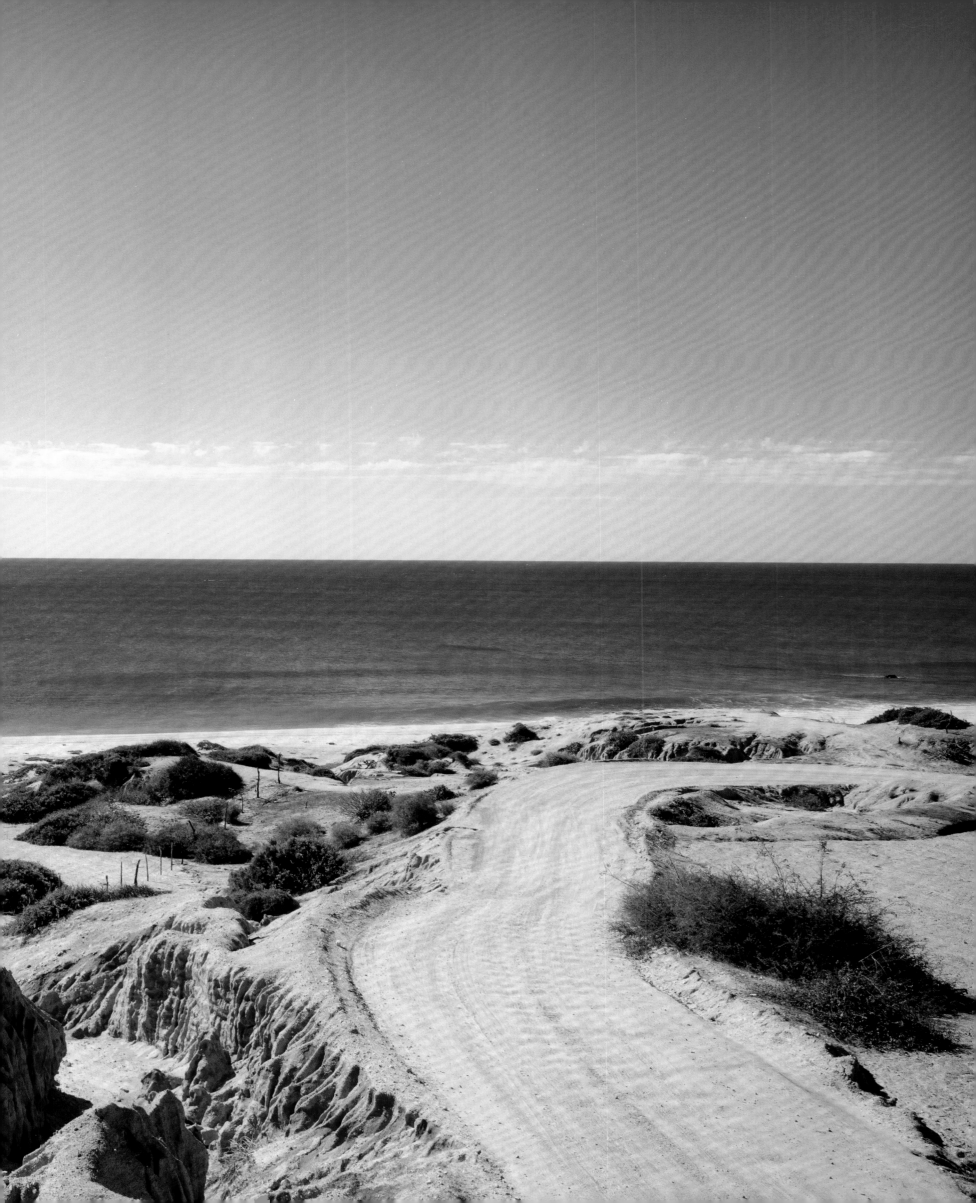

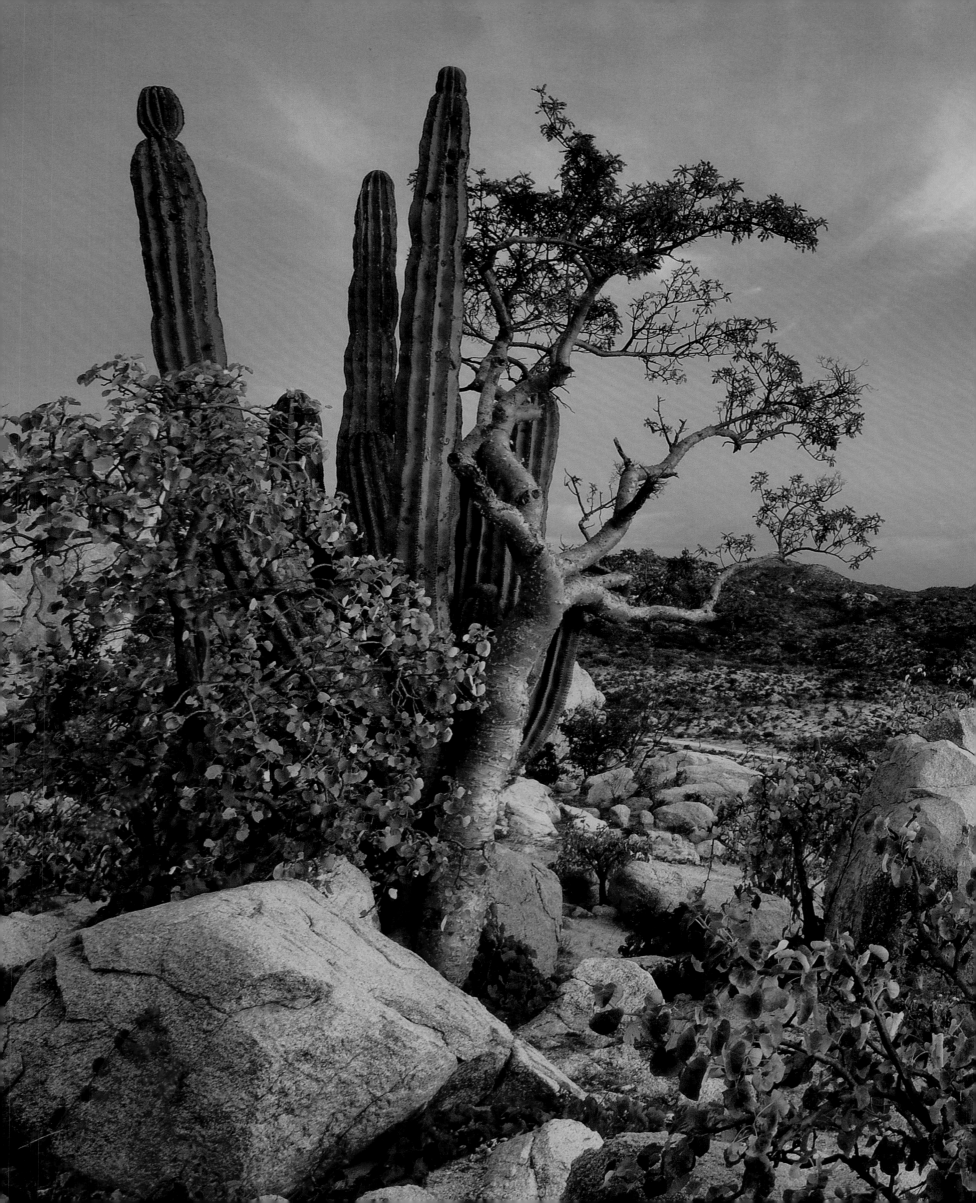

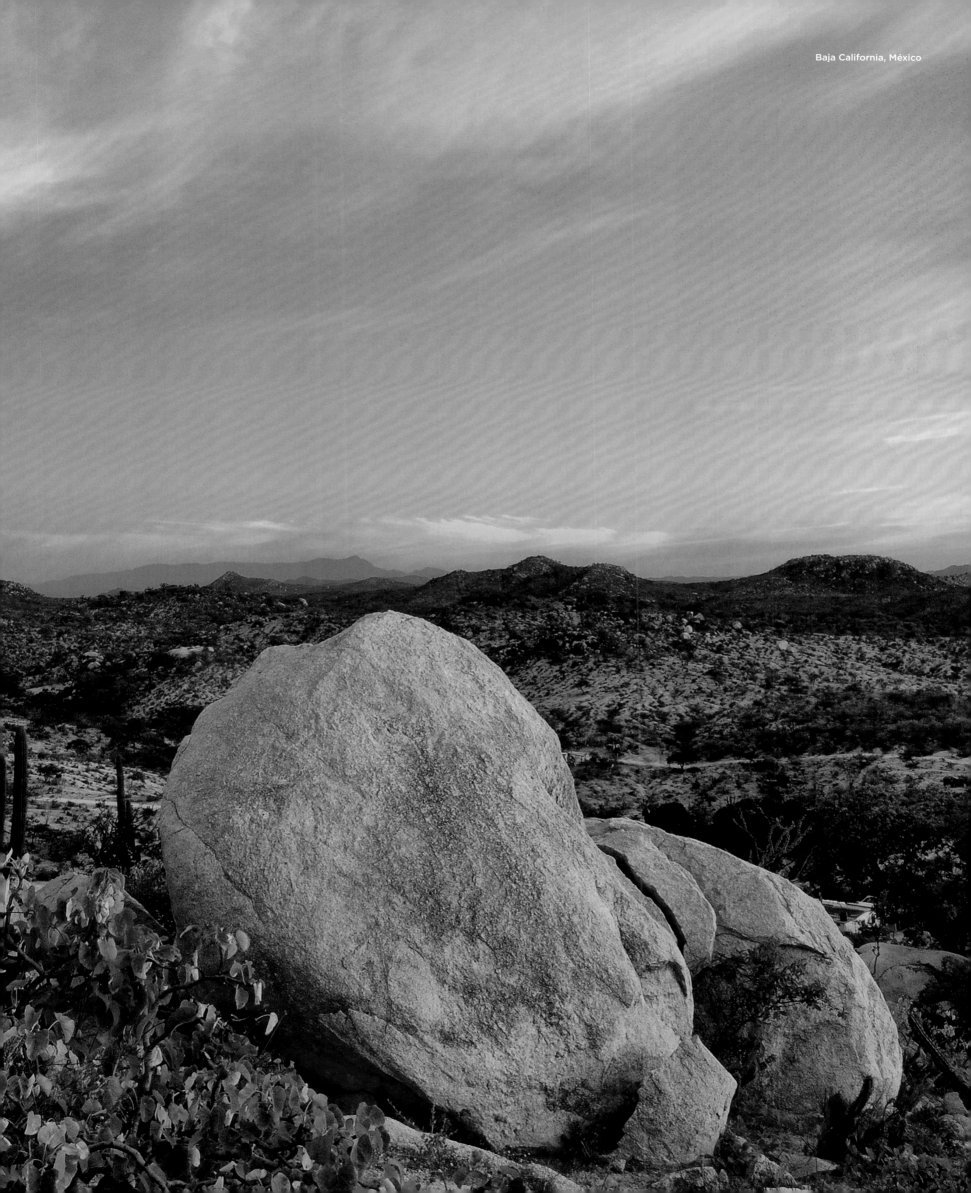

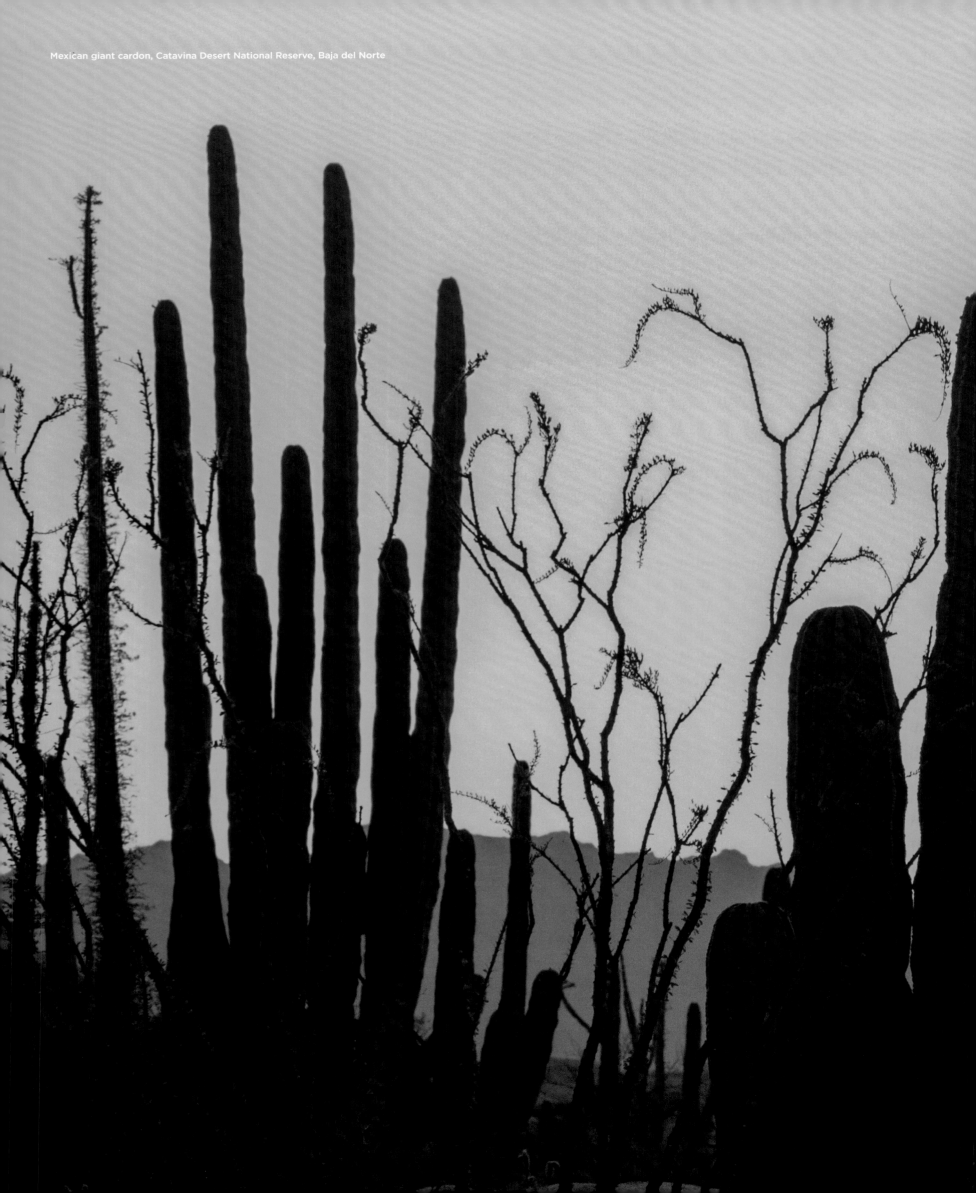

Mexican giant cardon, Catavina Desert National Reserve, Baja del Norte

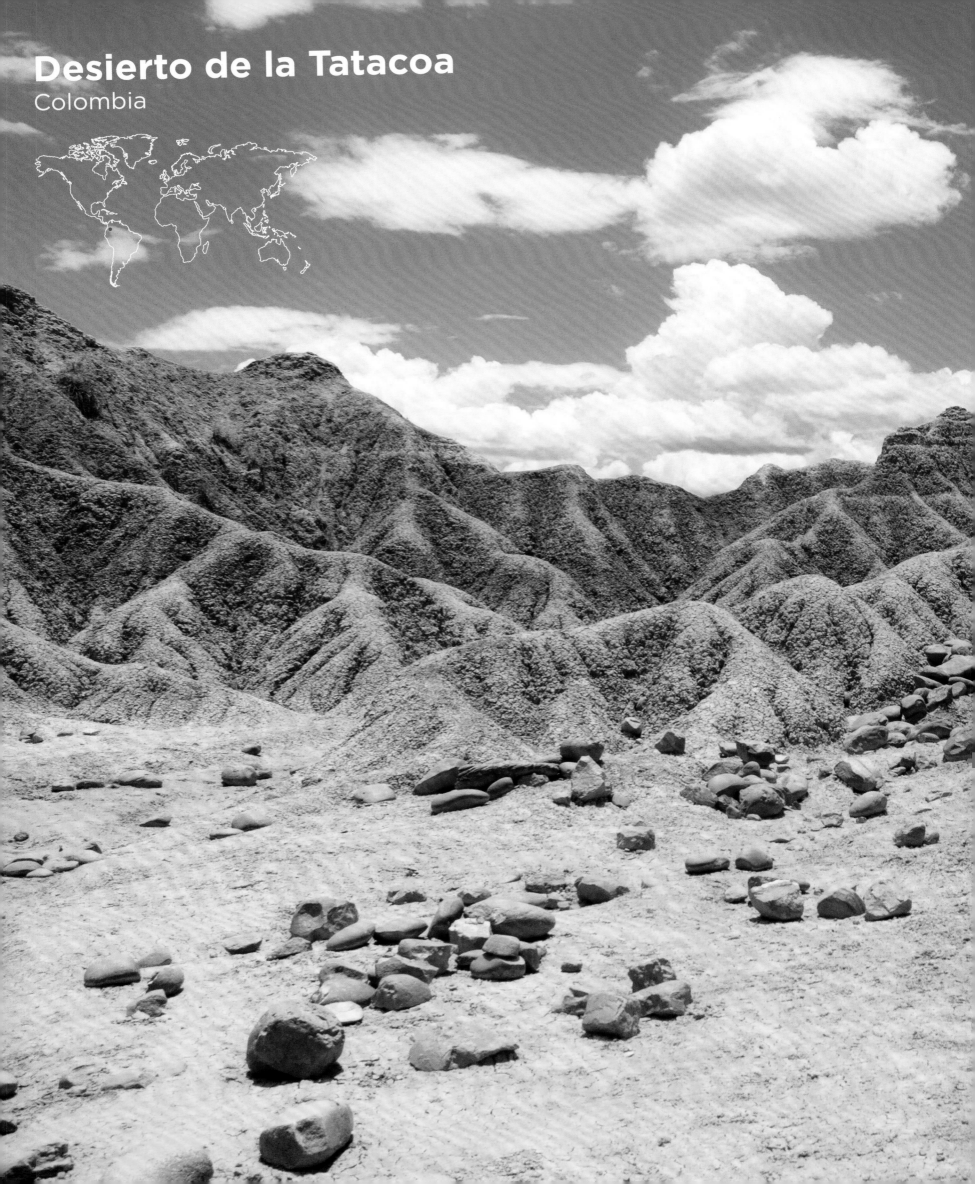

Desierto de la Tatacoa
Colombia

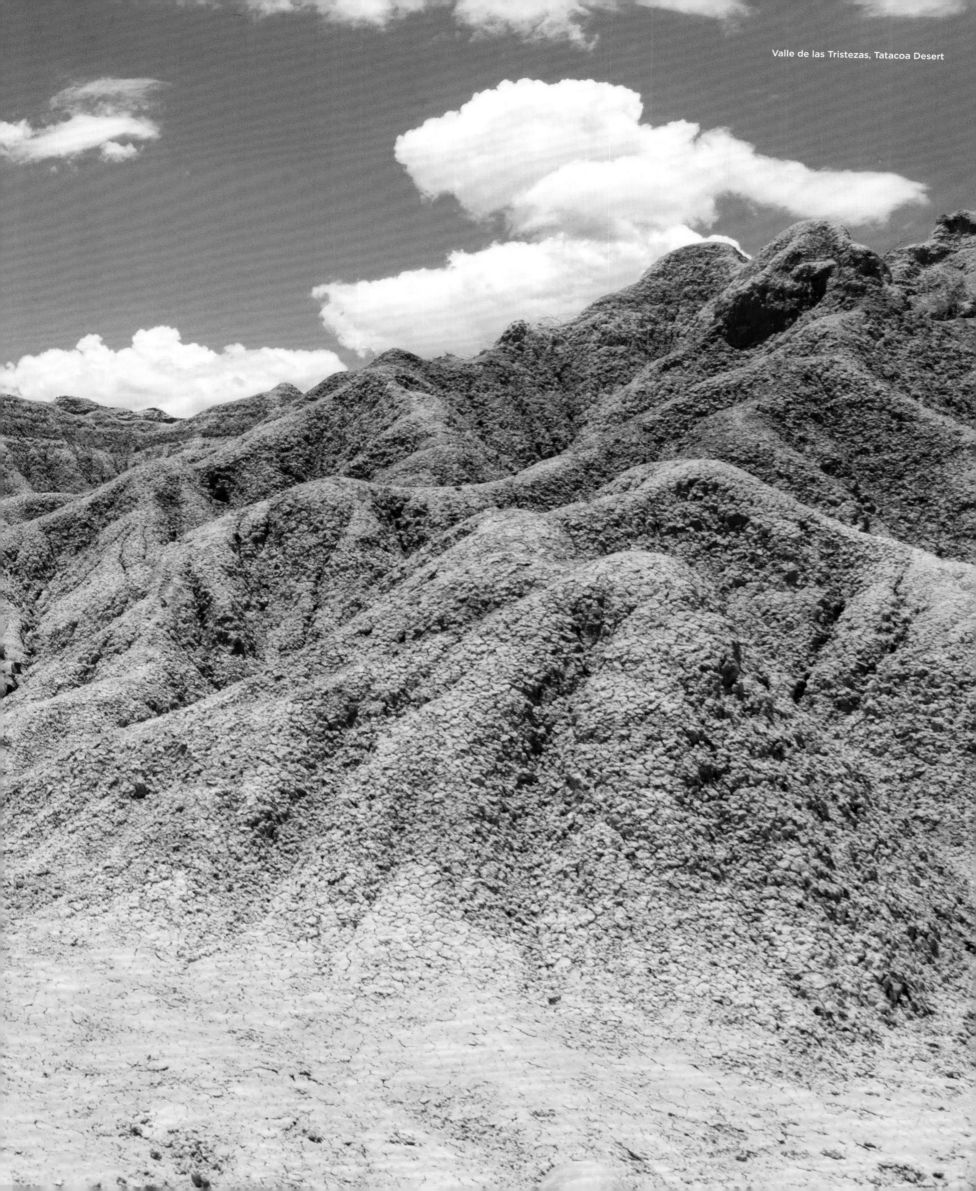

Valle de las Tristezas, Tatacoa Desert

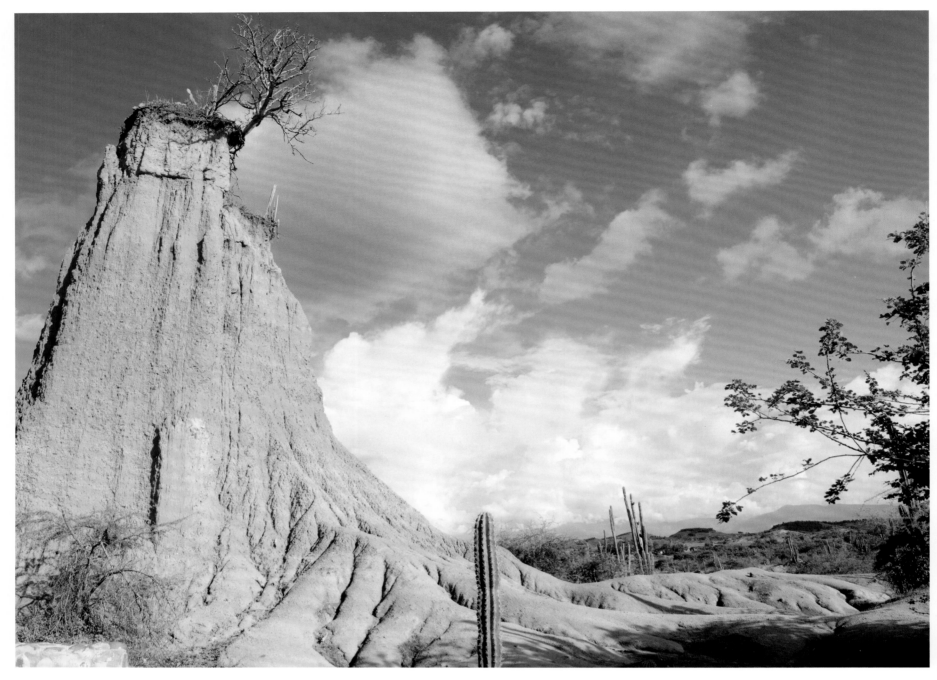

Erosion in Tatacoa Desert

Tatacoa Desert

The Tatacoa Desert – 'tatacoa' means rattlesnake in Colombian Spanish – covers just 330 km² close to Neiva and is known for its changing colours: ocher around Cuzco and gray around Los Hoyos. Like many of the world's deserts, it has been drying out throughout recent millennia, a far cry from its history during the Tertiary Era when it was a fertile land of forests and abundant plant life. Traces of wetter periods can still be seen from the eroded rock formations, caused by water, but now dry. When the Spanish conquistador Gonzalo Jiménez de Quesada passed this way in 1538, he gave this desert its other name: Valley of Sorrows.

Le désert de Tatacoa

Le désert de Tatacoa – « tatacoa » signifiant serpent à sonnette, en espagnol colombien – couvre à peine 330 km² près de Neiva. Il est connu pour ses couleurs changeantes : ocre du côté de Cuzco, gris vers Los Hoyos. Comme de nombreux déserts de la planète, il s'est asséché au cours des derniers millénaires, un destin bien différent de celui qu'il a connu à l'époque tertiaire, lorsqu'il abondait de forêts et de vie végétale. Des traces de périodes plus chaudes sont encore visibles aux formations rocheuses érodées par l'eau, mais désormais sèches. Lorsque le conquistador espagnol Gonzalo Jiménez de Quesada le traversa en 1538, il lui donna son autre nom : la vallée des douleurs.

Tatacoa-Wüste

Die Tatacoa-Wüste – ‚tatacoa' bedeutet im kolumbianischem Spanisch Klapperschlange – dehnt sich auf nur 330 km² in der Nähe der Stadt Neiva aus und ist wegen ihrer wechselnden Farben bekannt: Ocker um Cuzco und Grau um Los Hoyos. Wie viele der Wüsten der Welt ist sie in den letzten Jahrtausenden ausgetrocknet, während sie im Tertiär ein fruchtbares Land mit Wäldern und üppiger Pflanzenwelt war. Vergangene feuchtere Perioden lassen sich an den erodierten Gesteinsformationen erkennen, die einst Wasser ausgesetzt gewesen sein müssen, und jetzt trocken sind. Als der spanische Konquistador Gonzalo Jiménez de Quesada 1538 die Wüste durchquerte, gab er ihr einen weiteren Namen: Valley of Sorrows.

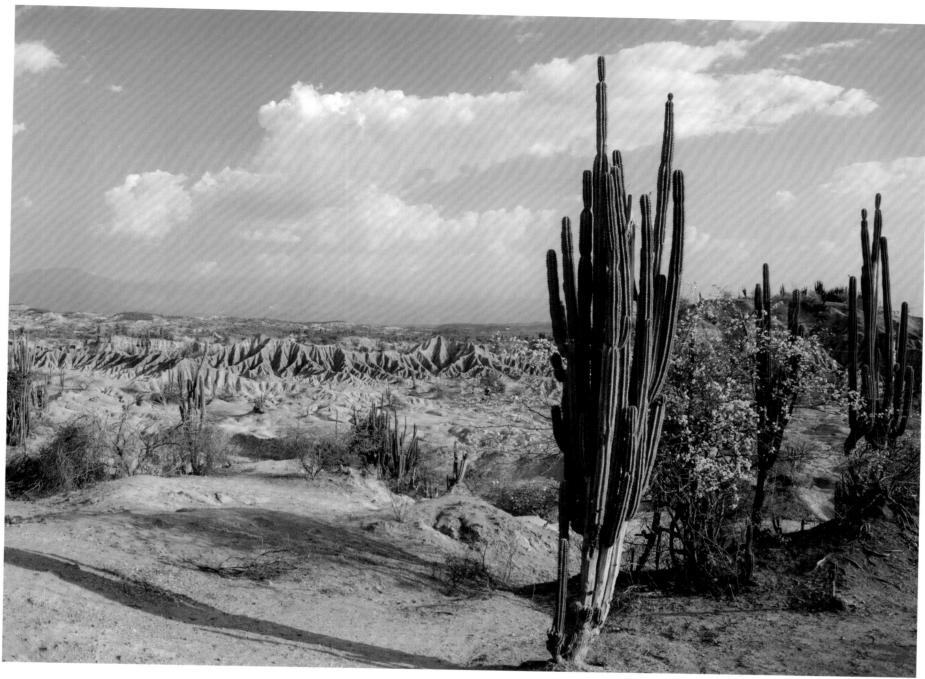

Tatacoa Desert

Desierto de la Tatacoa

El desierto de la Tatacoa («tatacoa» significa serpiente de cascabel en español colombiano) cubre solo 330 km² cerca de Neiva y es conocido por sus colores cambiantes: ocre alrededor de Cuzco y gris alrededor de Los Hoyos. Como muchos de los desiertos del mundo, se ha ido secando a lo largo de los últimos milenios, muy lejos de su historia durante la Era Terciaria, cuando era una tierra fértil llena de bosques y abundante vida vegetal. En las formaciones rocosas erosionadas, causadas por el agua, pero ahora secas, todavía se pueden ver rastros de períodos más húmedos. Cuando el conquistador español Gonzalo Jiménez de Quesada pasó por aquí en 1538, dio a este desierto su otro nombre: Valle de las Tristezas.

Deserto Tatacoa

O deserto de Tatacoa – "tatacoa" significa cascavel em espanhol colombiano – cobre apenas 330 km² perto de Neiva e é conhecido por suas cores mutáveis: ocre em torno de Cuzco e cinza em torno de Los Hoyos. Como muitos dos desertos do mundo, tem secado ao longo dos últimos milênios, muito longe de sua história durante a Era Terciária, quando era uma terra fértil de florestas e vida vegetal abundante. Traços de períodos mais húmidos ainda podem ser vistos a partir das formações rochosas erodidas, causadas pela água, mas agora secas. Quando o conquistador espanhol Gonzalo Jiménez de Quesada passou por ali em 1538, ele deu a esse deserto seu outro nome: Vale das Dores.

Tatacoa-woestijn

De Tatacoa-woestijn – *tatacoa* betekent ratelslang in het Colombiaanse Spaans – strekt zich uit over slechts 330 km2 in de buurt van de stad Neiva. Hij staat bekend om zijn veranderende kleuren: oker rond Cuzco en grijs rond Los Hoyos. Net als veel andere woestijnen is hij in de afgelopen millennia uitgedroogd – hoe anders dan tijdens het tertiair, toen dit nog vruchtbaar land met bossen en een overdaad aan planten was. Sporen van nattere tijden zijn nog te zien aan de geërodeerde rotsformaties, die ooit werden veroorzaakt door water, maar nu droog zijn. Toen de Spaanse veroveraar Gonzalo Jiménez de Quesada in 1538 door deze woestijn trok, gaf hij hem zijn andere naam: Valley of Sorrows.

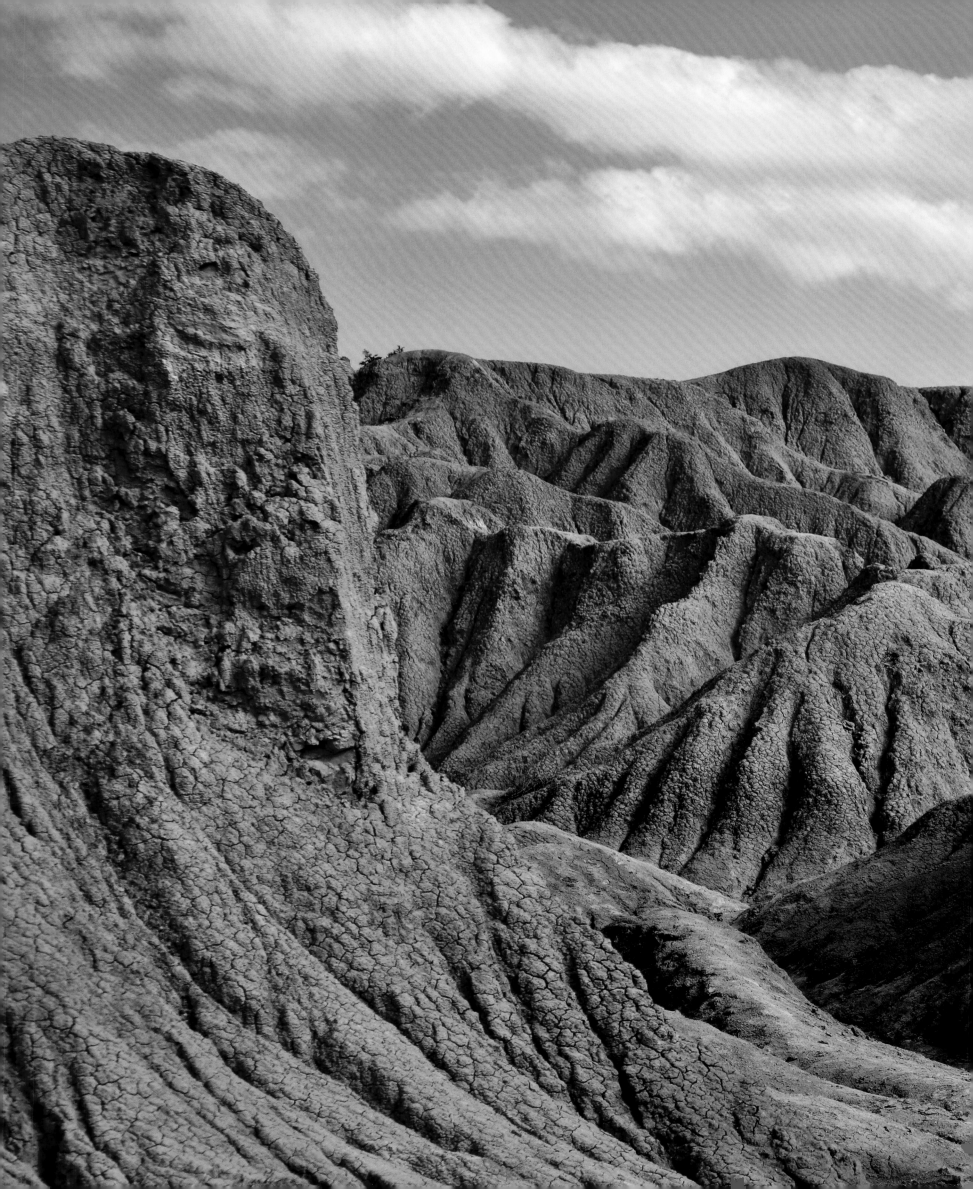

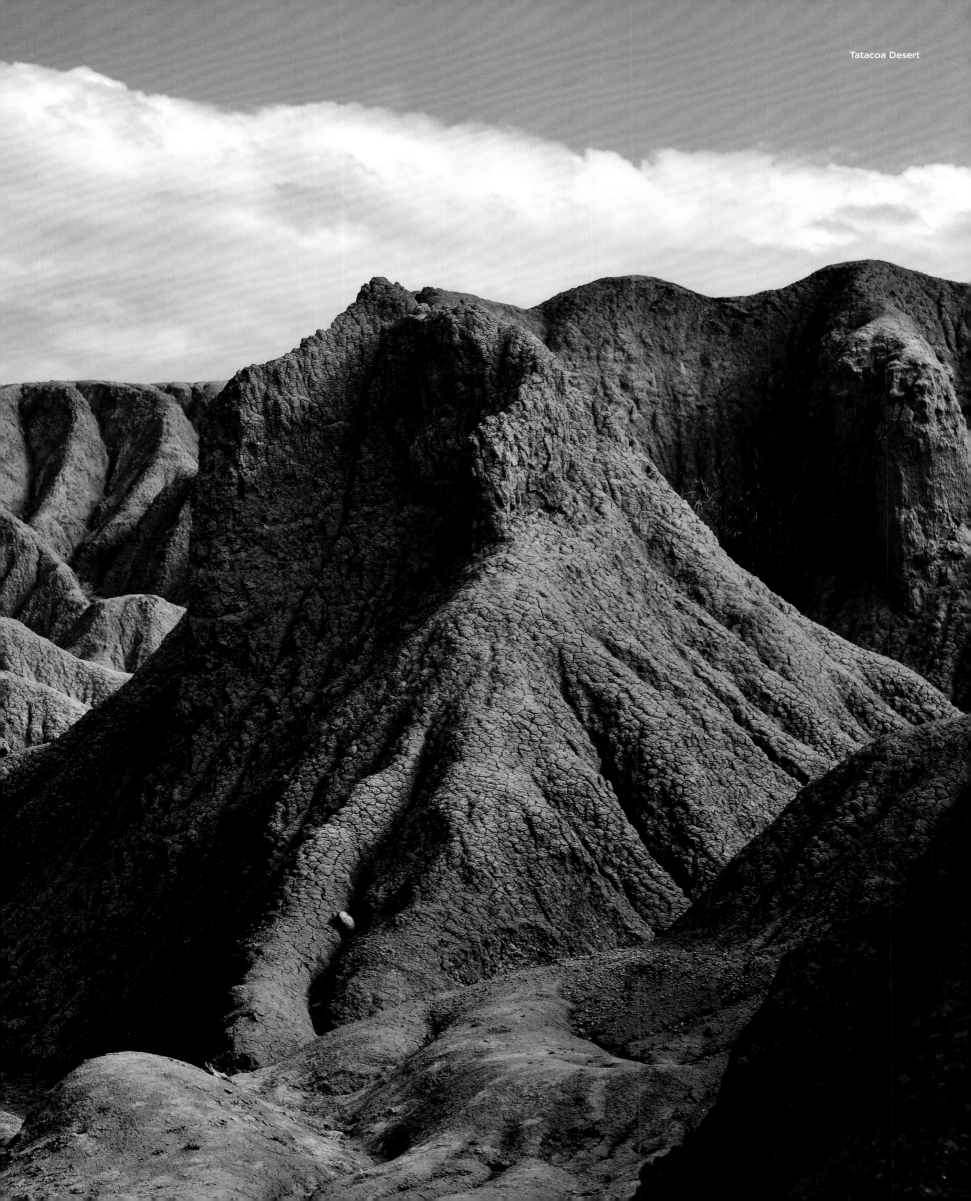

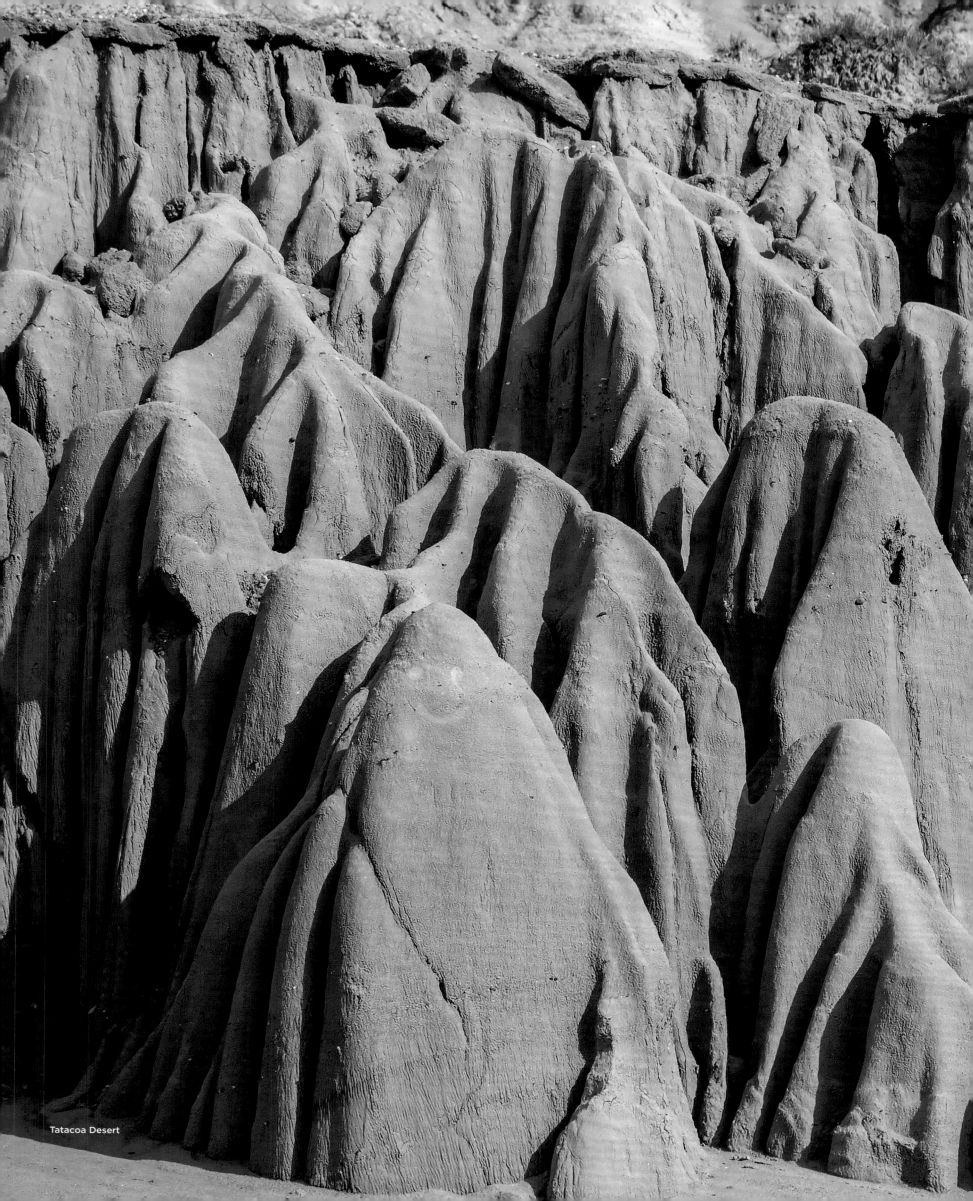

Tatacoa Desert

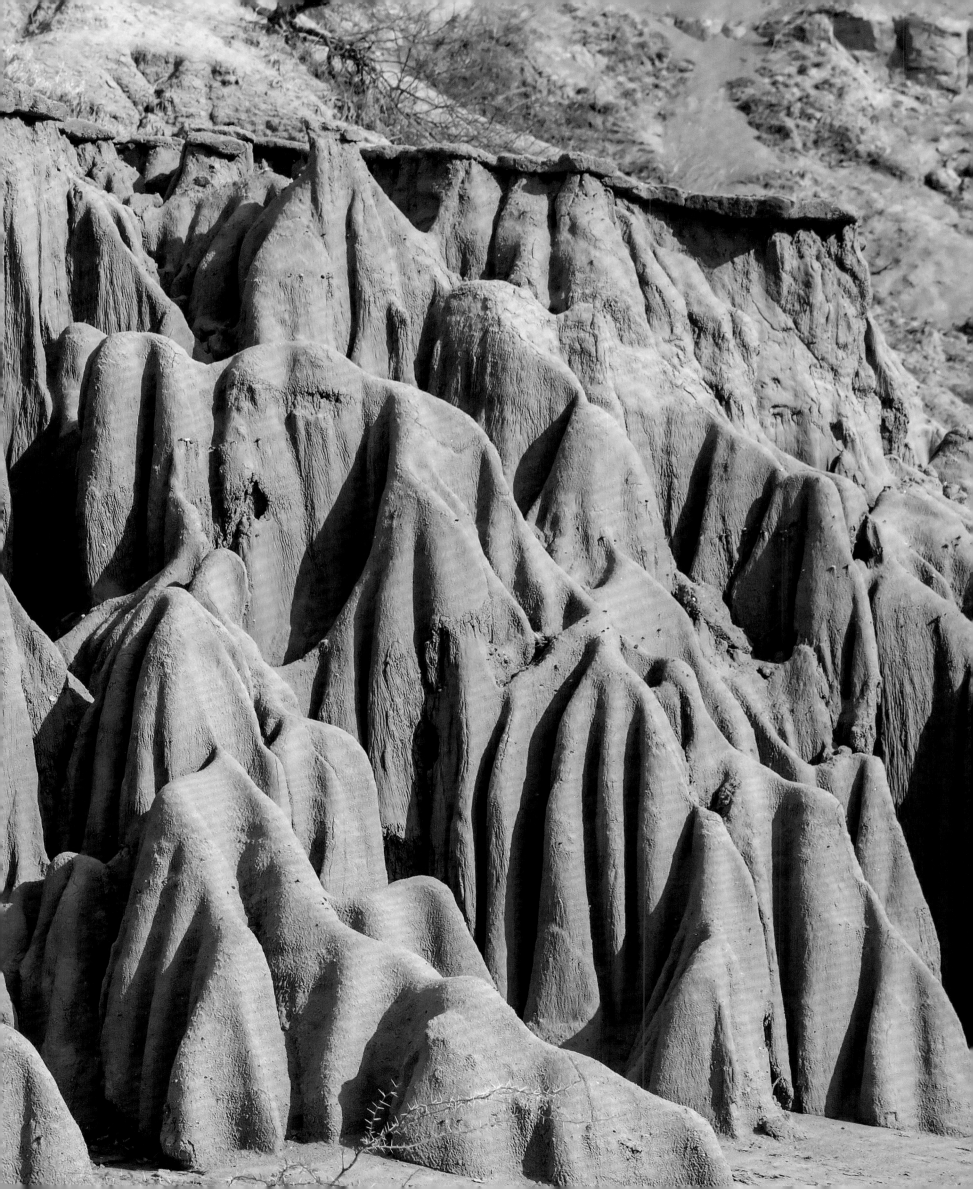

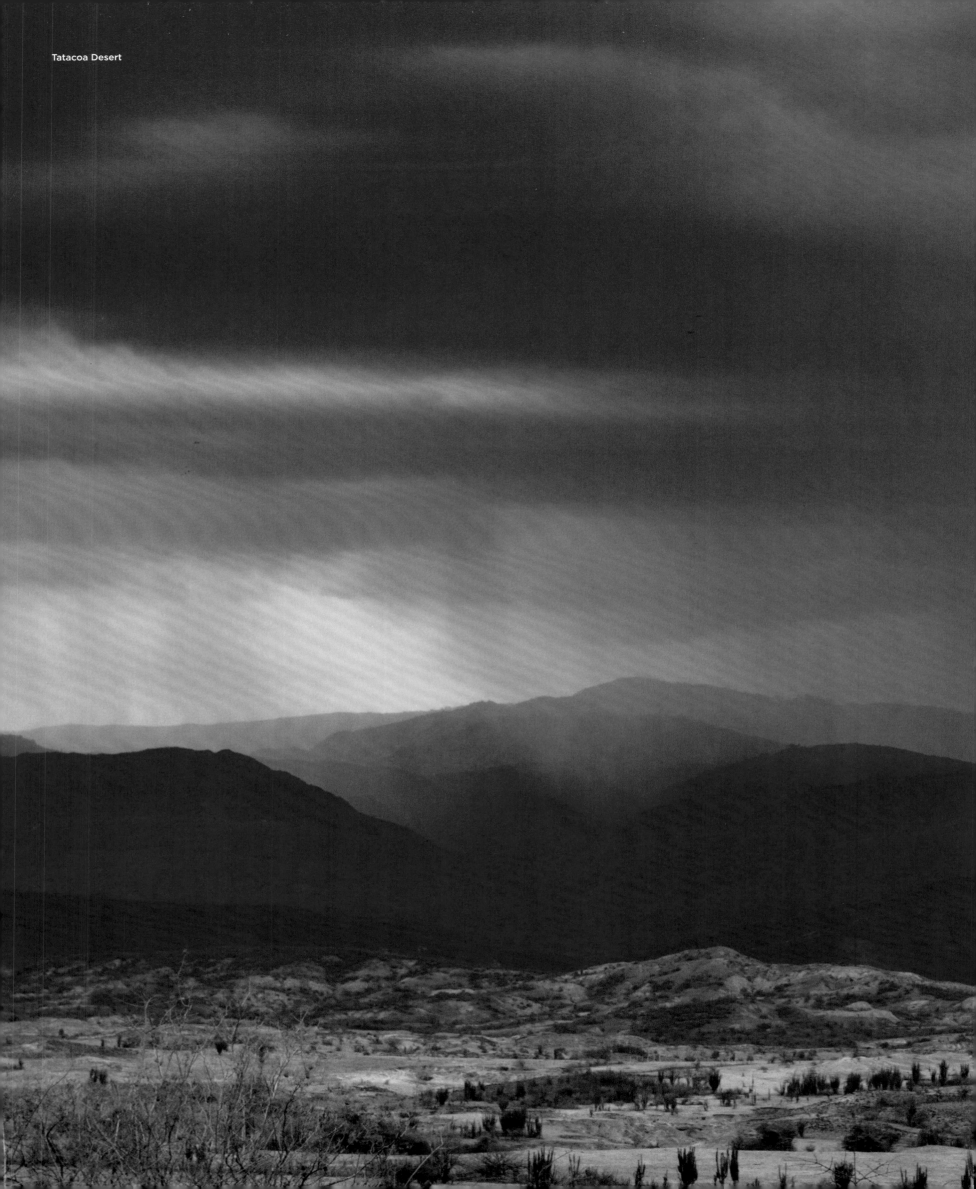

Tatacoa Desert

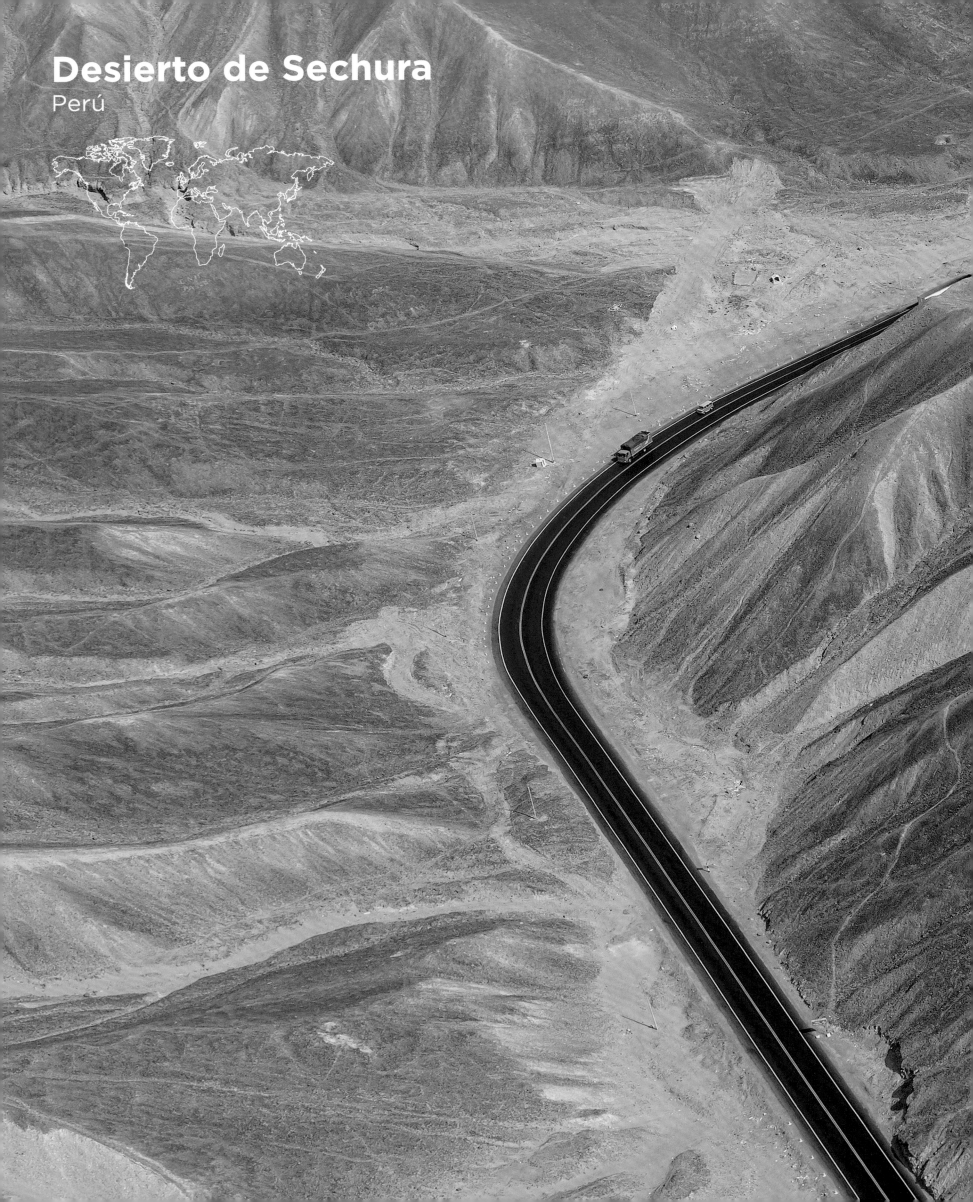

Desierto de Sechura
Perú

Nazca Lines & Carretera Panamericana Sur, Nazca

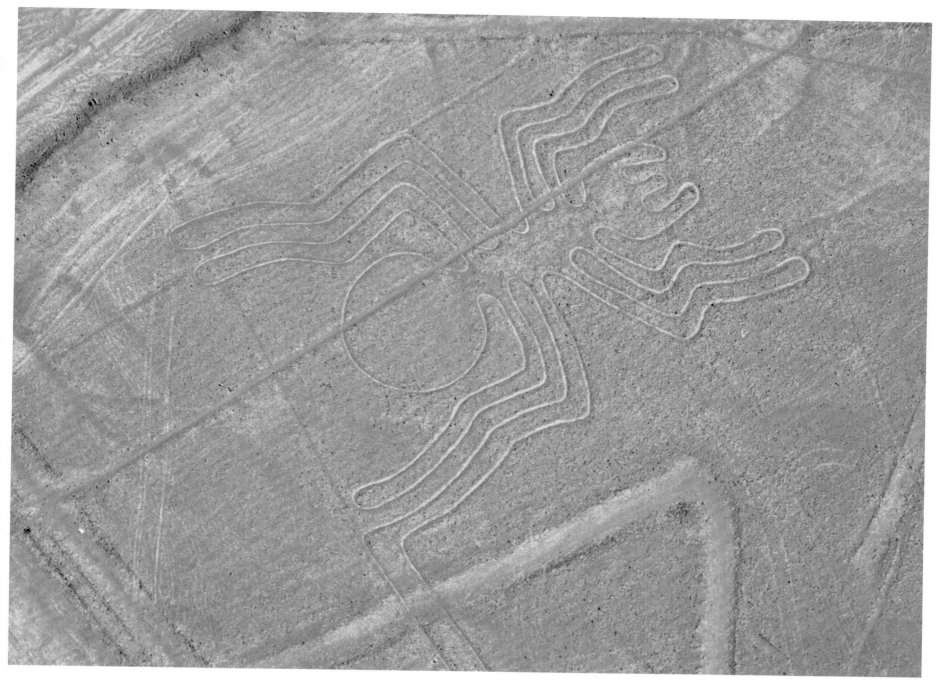

The Spider, Lines and Geoglyphs of Nazca

Sechura Desert

Ridgelines that run parallel to the coast are the main distinguishing natural feature of the Sechura Desert, but it's in the plains and valleys between the mountains that Sechura guards its secrets – the Nazca Lines. Best seen from the air, these man-made lines border on countless river channels formed over the centuries by run-off from the Andes.

Désert de Sechura

Les lignes de crêtes qui courent parallèlement à la côte forment la caractéristique naturelle la plus notable du désert de Sechura. Mais c'est dans ses plaines et ses vallées nichées entre les montagnes que le Sechura cache son secret : les lignes de Nazca. Vu depuis le ciel, dans leur entièreté, ces lignes faites de main d'homme escamotent les innombrables lits de rivières formés par le ruissellement des Andes au fil des siècles.

Sechura-Wüste

Die parallel zur Küste verlaufenden Höhenkämme sind das wichtigste natürliche Merkmal der Sechura-Wüste, ihre Geheimnisse verbirgt sie aber in den Ebenen und Tälern zwischen den Bergen – die Nazca-Linien. Diese Scharrbilder, die am besten aus der Luft zu sehen sind, umgeben unzählige Flussbetten, die im Laufe der Jahrhunderte durch den Abfluss aus den Anden entstanden sind.

Desierto de Sechura

Las cordilleras que corren en paralelo a la costa son el principal rasgo natural que distingue al desierto de Sechura, pero es en las llanuras y valles entre las montañas donde Sechura guarda sus secretos: las Líneas de Nazca. Estas líneas artificiales, que como mejor se ven es desde el aire, ensombrecen incontables canales de ríos formados a lo largo de los siglos por la escorrentía de los Andes.

Deserto de Sechura

As linhas rigidas que correm paralelas à costa são a principal característica natural distintiva do Deserto Sechura, mas é nas planícies e vales entre as montanhas que Sechura guarda seus segredos – as Linhas de Nazca. Melhor vista do ar, essas linhas artificiais penetram inúmeros canais de rios formados ao longo dos séculos pelo escoamento dos Andes.

Sechura Desert

Bergkammen die parallel aan de kust lopen, zijn de belangrijkste natuurlijke kenmerken van de Sechura Desert. Zijn geheimen bewaart hij echter op de vlakten en in de dalen tussen de bergen: de Nazca-lijnen. Deze door de mens gemaakte lijnen, die het best vanuit de lucht te zien zijn, omzomen talloze riviergeulen die door de eeuwen heen zijn uitgesleten door de afvloeiing van de Andes.

Geoglyphs of Nazca

The Unesco World Heritage-listed Nazca Lines in Peru's Sechura Desert rank among South America's most persistent mysteries. Only described in full after aerial surveys in the early to mid-20th century, many date from the Nazca era (100 BC to 800 AD), showing extraordinarily sophisticated images, some of which suggest knowledge of celestial cycles.

Les géoglyphes de Nazca

Situées dans le désert péruvien de Sechura (ou de Nazca), les lignes de Nazca, classées au patrimoine mondial de l'Unesco, font partie des mystères les plus tenaces d'Amérique du Sud. Décrites dans leur ensemble depuis le ciel à partir du début jusqu'au milieu du XXᵉ siècle, plusieurs d'entre elles datent de la période nazca (100 avant J.-C. à 800 après J.-C.), et montrent des images aussi extraordinaires que sophistiquées, dont certaines suggèrent une connaissance de l'astronomie.

Geoglyphen von Nazca

Die zum Unesco-Weltkulturerbe gehörenden Nazca-Linien in der peruanischen Sechura-Wüste gehören zu den dauerhaftesten Geheimnissen Südamerikas. Erst Anfang bis Mitte des 20. Jahrhunderts vollständig aus der Luft aufgenommen, stammen viele aus der Nazca-Zeit (100 v. Chr. bis 800 n. Chr.) und zeigen außergewöhnlich anspruchsvolle Bilder, von denen einige auf astronomische Kenntnisse hinweisen.

Geoglifos de Nazca

Las Líneas de Nazca, Patrimonio de la Humanidad de la UNESCO, en el desierto de Sechura en Perú, se encuentran entre los misterios más perdurables de Sudamérica. Descritas en su totalidad únicamente desde el aire entre principios y mediados del siglo XX, muchas de ellas datan de la época de Nazca (de 100 a.C. a 800 d.C.), mostrando imágenes extraordinariamente sofisticadas, algunas de las cuales sugieren el conocimiento de los ciclos celestes.

Geoglifos de Nazca

As linhas de Nazca, classificadas como Patrimônio da Humanidade pela Unesco, no deserto Sechura, no Peru, estão entre os mistérios mais duradouros da América do Sul. Apenas descritos na íntegra do ar no início até meados do século 20, muitos datam da era de Nazca (100 aC a 800 dC), mostrando imagens extraordinariamente sofisticadas, algumas das quais sugerem conhecimento dos ciclos celestes.

Geogliefen van Nazca

De op de werelderfgoedlijst van de Unesco opgenomen Nazca-lijnen in de Peruaanse Sechura Desert behoren tot de meest hardnekkige raadselen van Zuid-Amerika. Pas aan het begin van de 20e eeuw werden de beelden volledig beschreven vanuit de lucht. Ze stammen veelal uit de Nazca-tijd (100 v. Chr. tot 800 n. Chr.) en tonen buitengewoon hoogwaardige tekeningen, waarvan sommige op astronomische kennis wijzen.

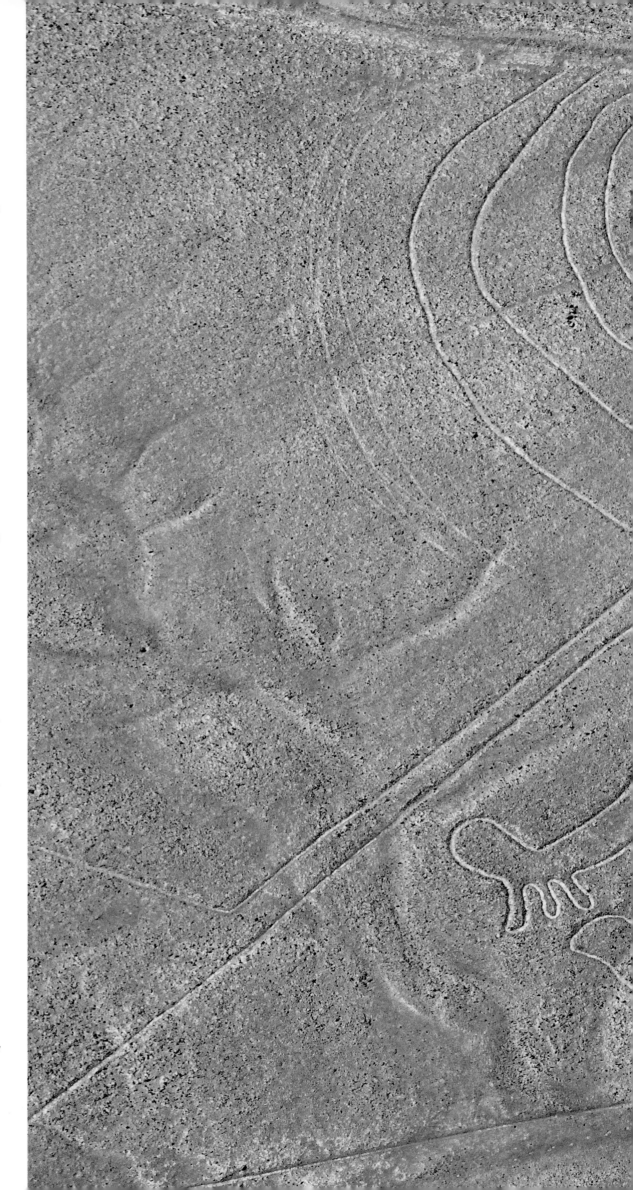

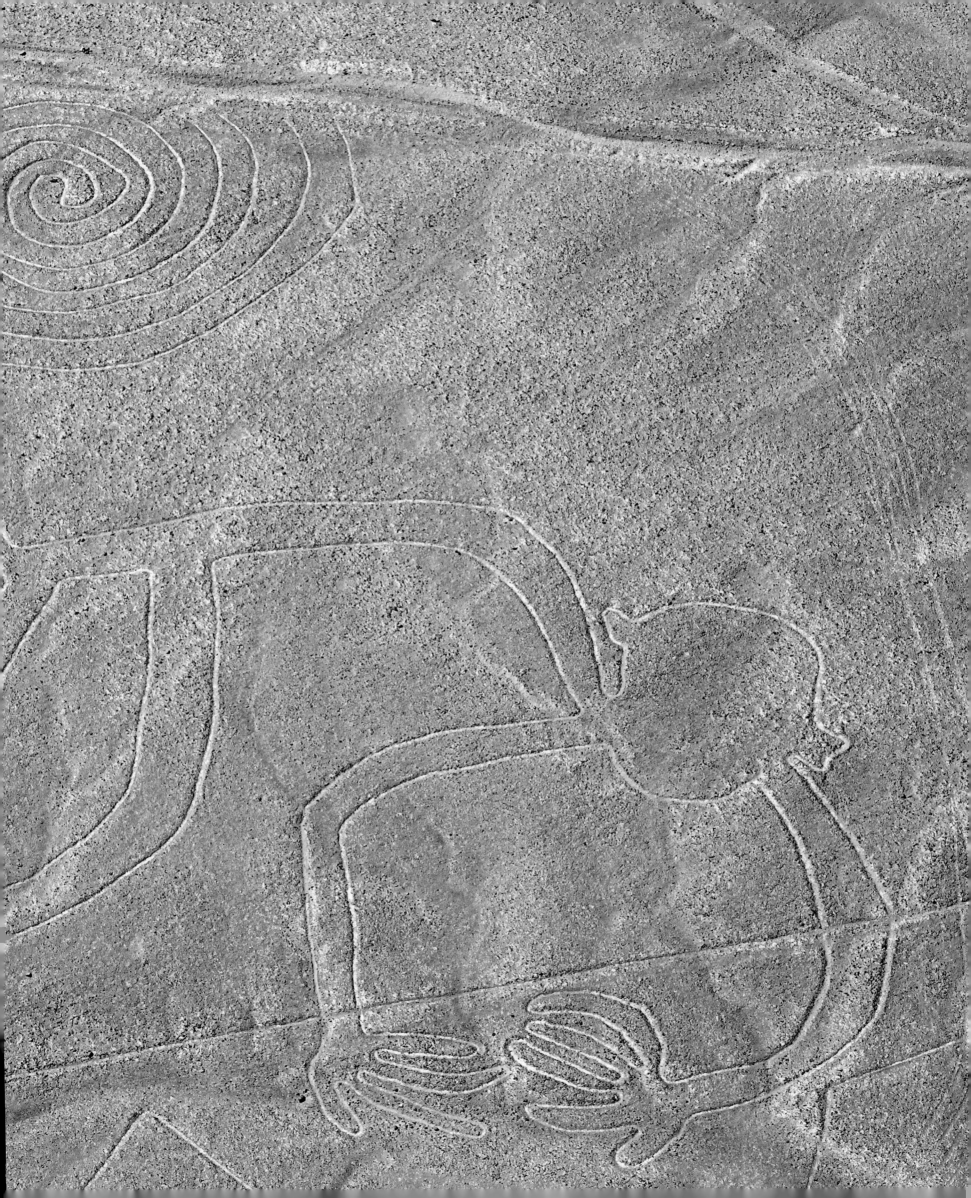

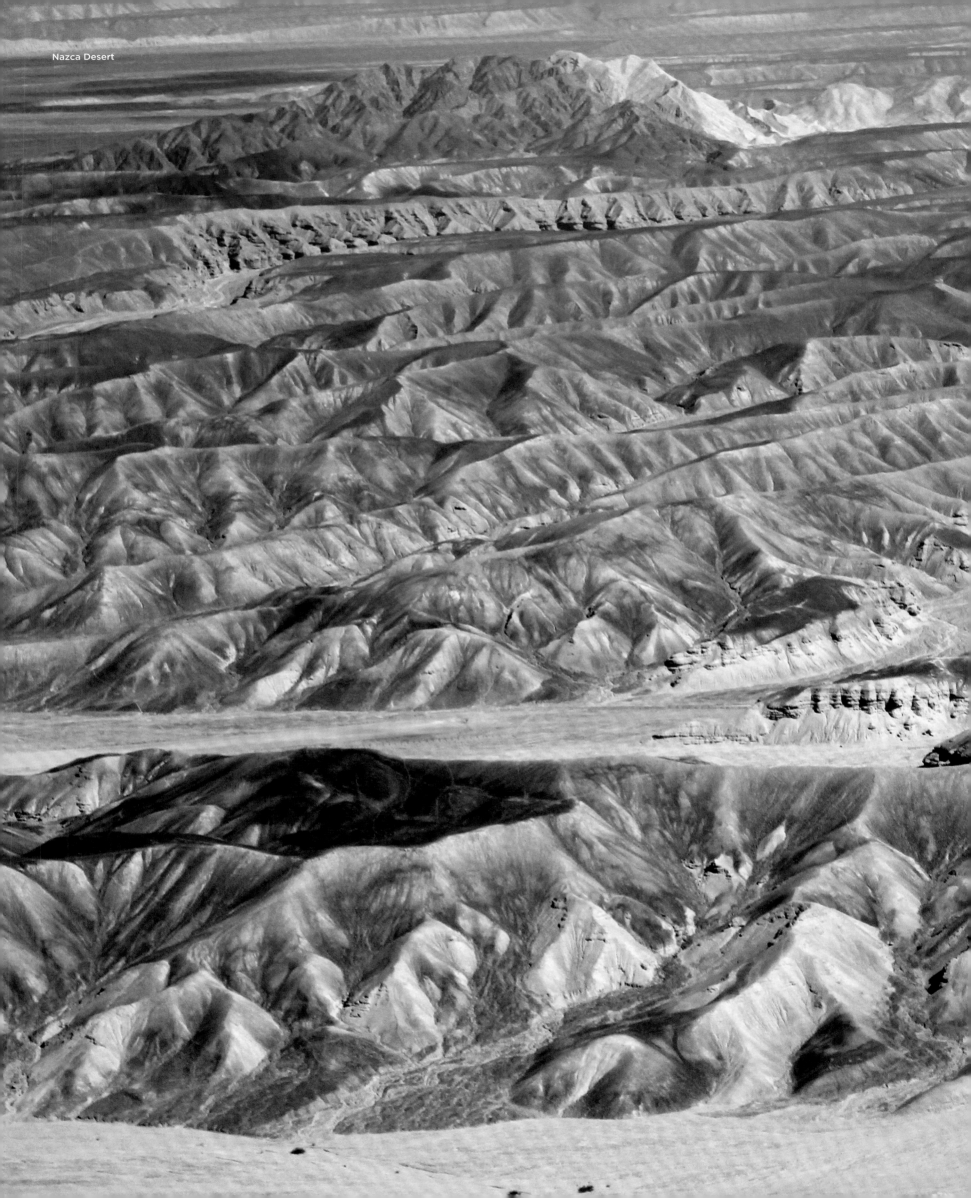
Nazca Desert

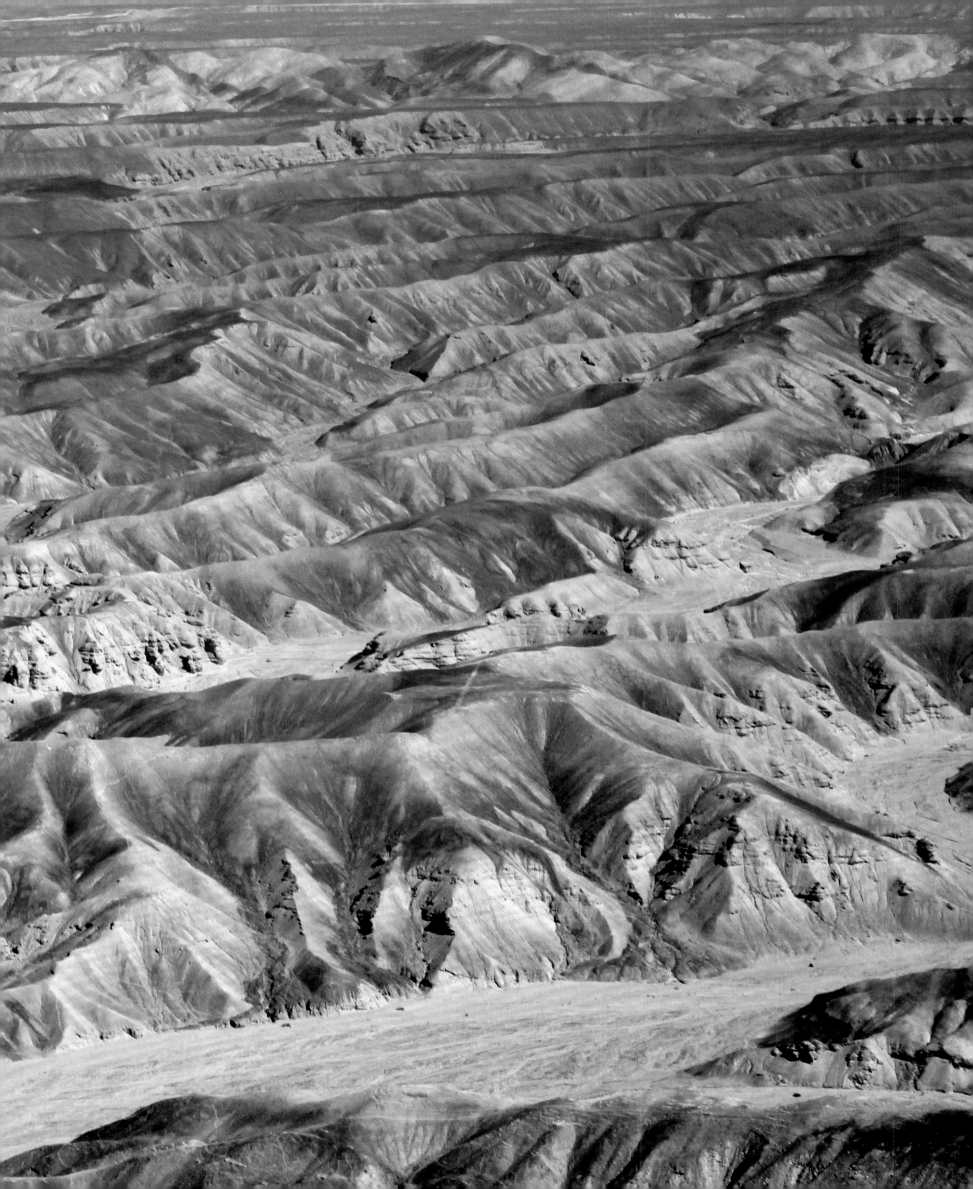

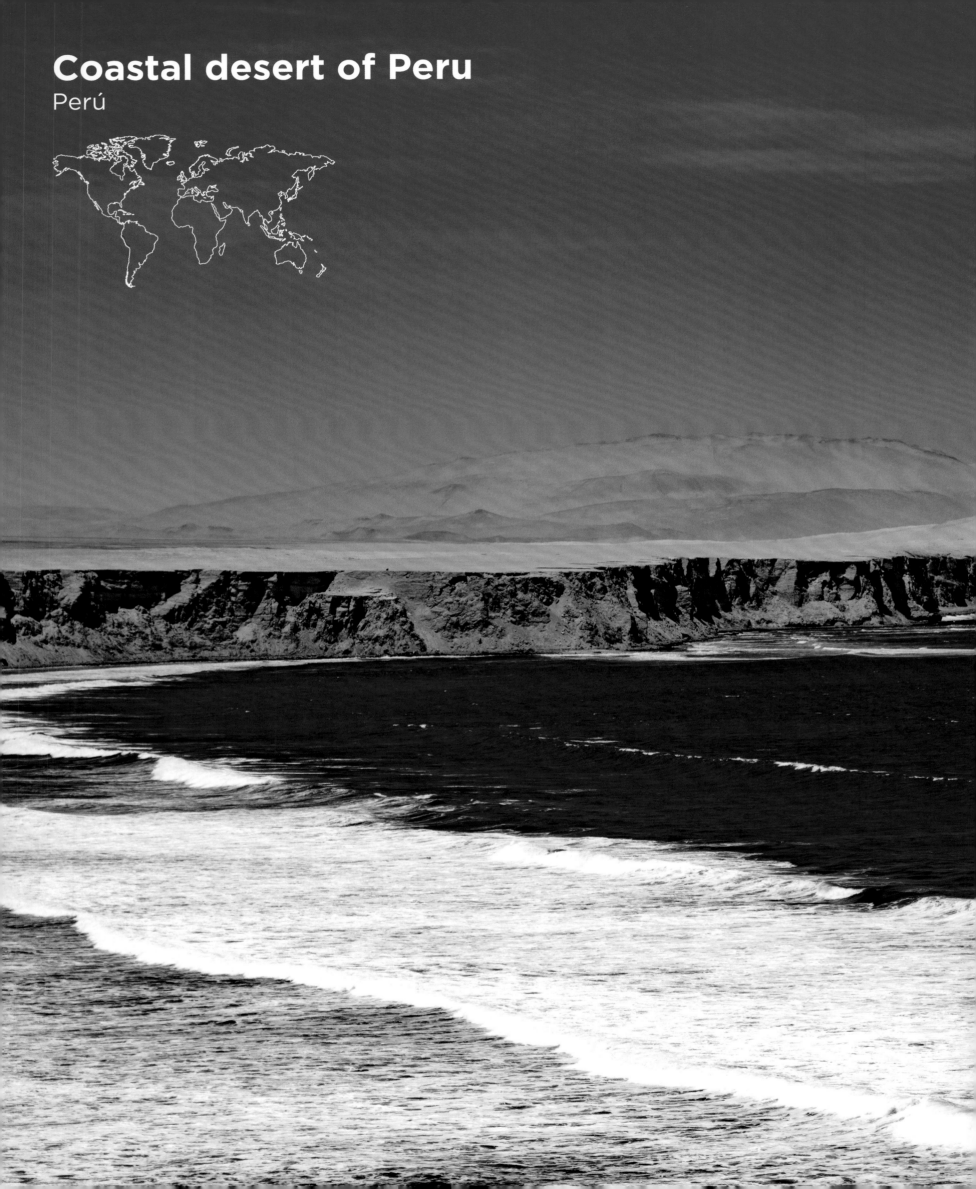

Coastal desert of Peru
Perú

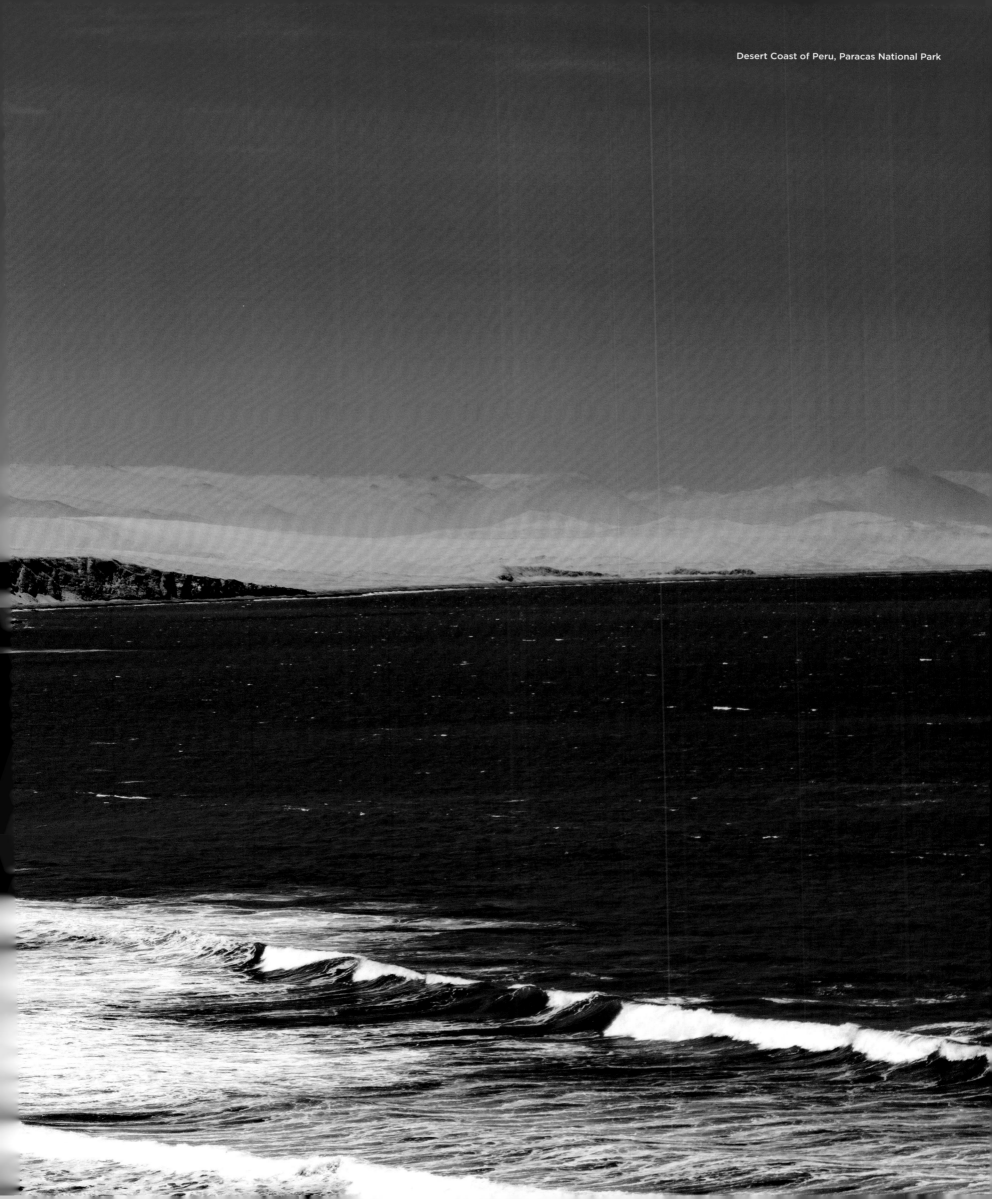

Desert Coast of Peru, Paracas National Park

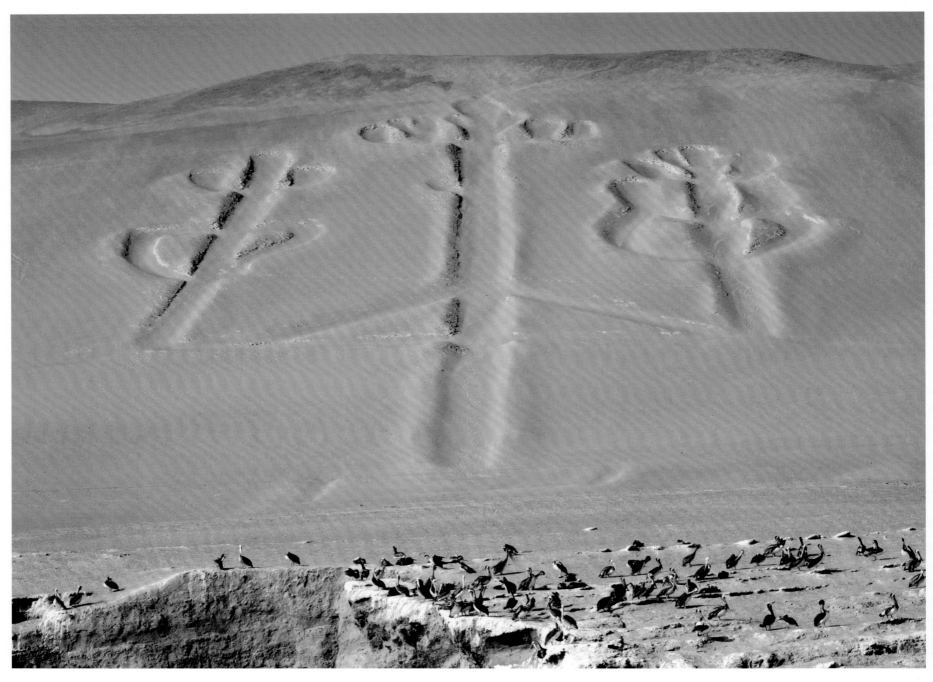

Paracas Candelabra geoglyph, Paracas National Reserve, Ica

Coastal Desert of Peru

Peru's entire coastline, from Ecuador in the north to Chile in the south is extremely arid – just 4% of the coastal plain between the Pacific and the Andes can support agriculture. Consisting of sand dunes, cliffs, and barren plains, the deserts are the complement to offshore waters where tuna supports Peru's fishing industry and vast shoals of anchovies feed astonishingly large colonies of sea birds and sea lions. But when the currents change and an El Niño weather event occurs out in the Pacific, Peru's climate once again changes, and flash flooding is possible in the desert.

Le désert côtier du Pérou

Courant de l'Équateur au nord jusqu'au Chili au sud, l'intégralité de la côte péruvienne est très aride – seuls 4% de la plaine côtière entre le Pacifique et les Andes sont propices à l'agriculture. Composés de dunes de sable, de falaises et de plaines stériles, les déserts sont les compléments des eaux côtières, dans lesquelles le thon soutient l'industrie de la pêche péruvienne et où d'immenses bancs d'anchois nourrissent des colonies d'oiseaux marins et d'otaries étonnamment peuplées. Mais lorsque les courants changent et qu'un événement climatique comme El Niño survient dans le Pacifique, le climat du Pérou varie une fois encore, et de soudaines inondations peuvent survenir en plein désert.

Küstenwüste Perus

Die gesamte Küste Perus, von Ecuador im Norden bis Chile im Süden, ist extrem trocken – nur 4% der Küstenebene zwischen Pazifik und Anden können landwirtschaftlich genutzt werden. Die Wüsten, die aus Sanddünen, Klippen und kargen Ebenen bestehen, liegen an Meeresgebieten, deren Thunfischbestände die Grundlage der peruanischen Fischereiindustrie bilden, während riesige Sardellenschwärme erstaunlich große Kolonien von Seevögeln und Seelöwen ernähren. Wenn sich aber die Meeresströmungen verschieben und im Pazifik ein El Niño-Wetterereignis stattfindet, ändert sich das Klima Perus erneut, und in der Wüste sind Sturzfluten möglich

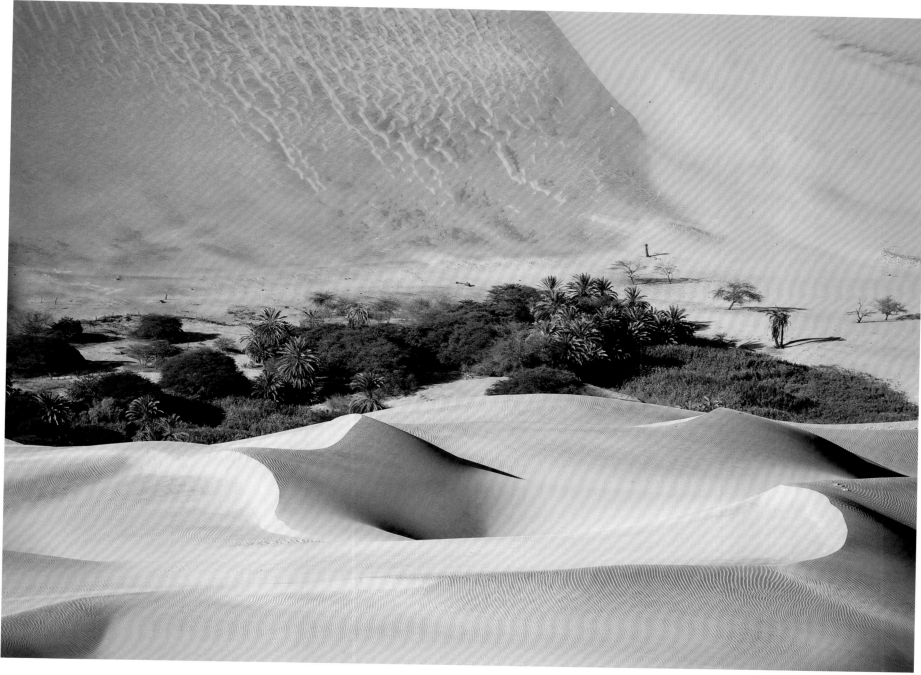

Oasis, Huacachina, Ica

Desierto costero del Perú

Toda la costa de Perú, desde Ecuador en el norte hasta Chile en el sur, es extremadamente árida (solo el 4% de la llanura costera entre el Pacífico y los Andes puede soportar la agricultura). Compuesto por dunas de arena, acantilados y llanuras áridas, los desiertos son el complemento a las aguas de la costa, donde el atún sostiene la industria pesquera de Perú y vastos bancos de anchoas sirven asombrosamente de alimento para grandes colonias de aves marinas y lobos marinos. Pero cuando las corrientes cambian y se produce un fenómeno meteorológico El Niño en el Pacífico, el clima de Perú vuelve a cambiar y es posible que se produzcan inundaciones repentinas en el desierto.

Deserto Costeiro do Peru

O litoral inteiro do Peru, da Ecuador no norte até Chile no sul, é extremamente árido – apenas 4% da planície costeira entre o Pacífico e os Andes podem sustentar a agricultura. Consistindo de dunas de areia, falésias e planícies áridas, os desertos são o complemento para as águas fora da costa onde o atum apóia a indústria pesqueira do Peru e os vastos cardumes de anchovas alimentam surpreendentemente grandes colônias de aves marinhas e leões marinhos. Mas quando as correntes mudam e ocorre um evento climático El Niño no Pacífico, o clima do Peru mais uma vez muda, e as inundações repentinas são possíveis no deserto.

Kustwoestijn van Peru

De hele kustlijn van Peru, van Ecuador in het noorden tot Chili in het zuiden, is extreem droog – op slechts 4% van de kustvlakte tussen de Grote Oceaan en de Andes is landbouw mogelijk. De woestijnen, die uit zandduinen, klippen en kale vlaktes bestaan, liggen aan de kustwateren waar het tonijnbestand de Peruaanse visindustrie ondersteunt en enorme scholen ansjovis verbazingwekkend grote kolonies zeevogels en zeeleeuwen voeden. Maar wanneer de stromingen veranderen en El Niño-weersomstandigheden heersen in de Grote Oceaan, verandert het klimaat in Peru opnieuw en zijn plotselinge overstromingen in de woestijn mogelijk.

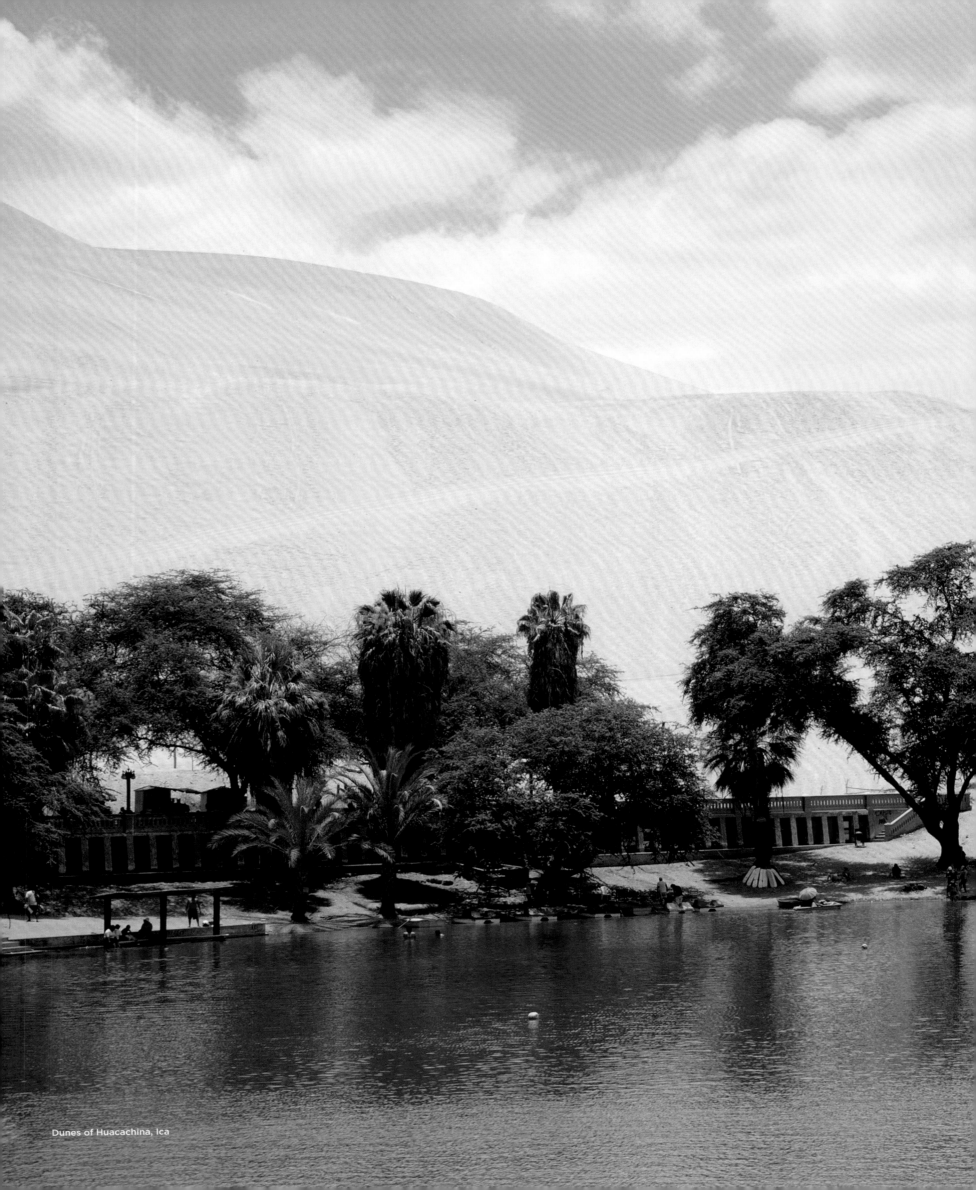

Dunes of Huacachina, Ica

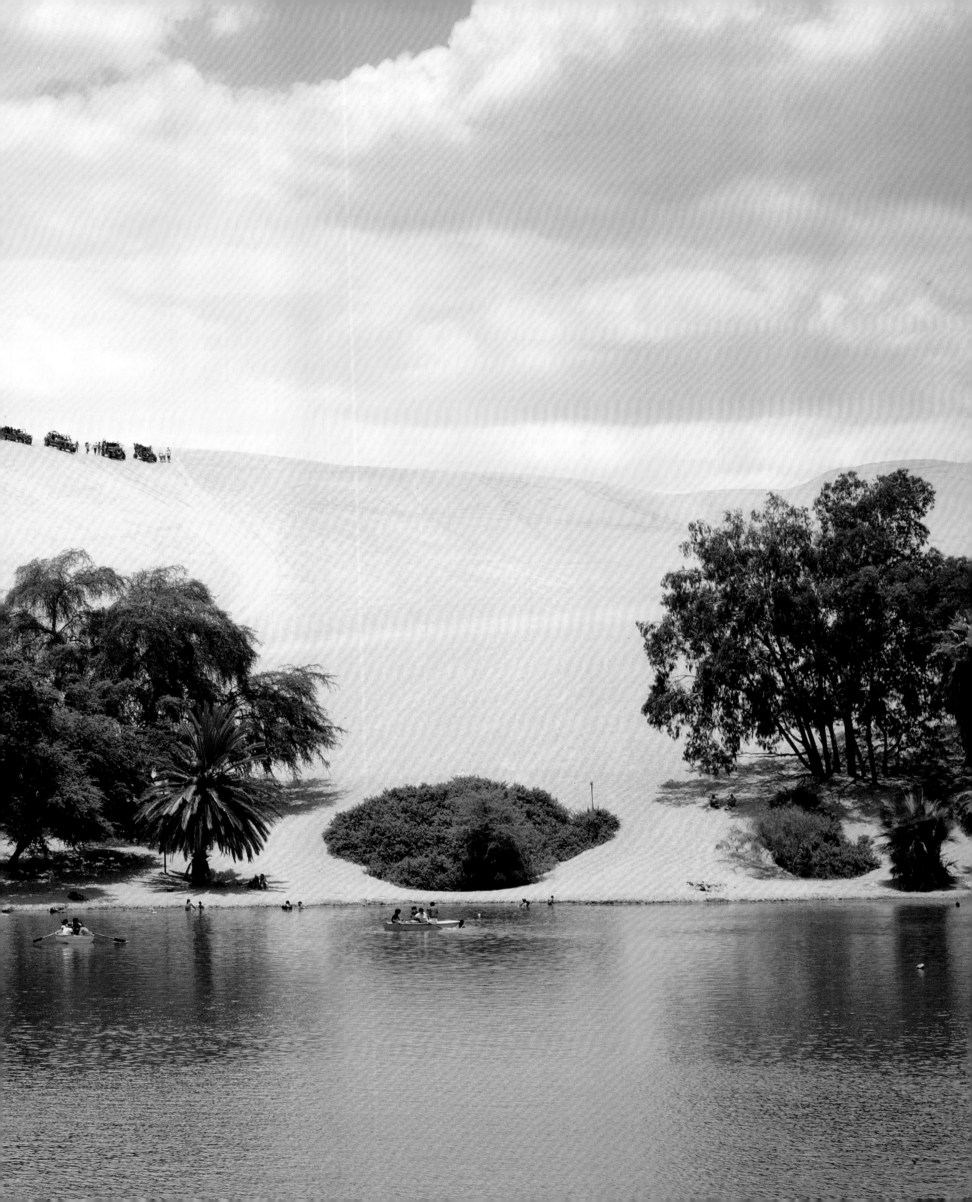

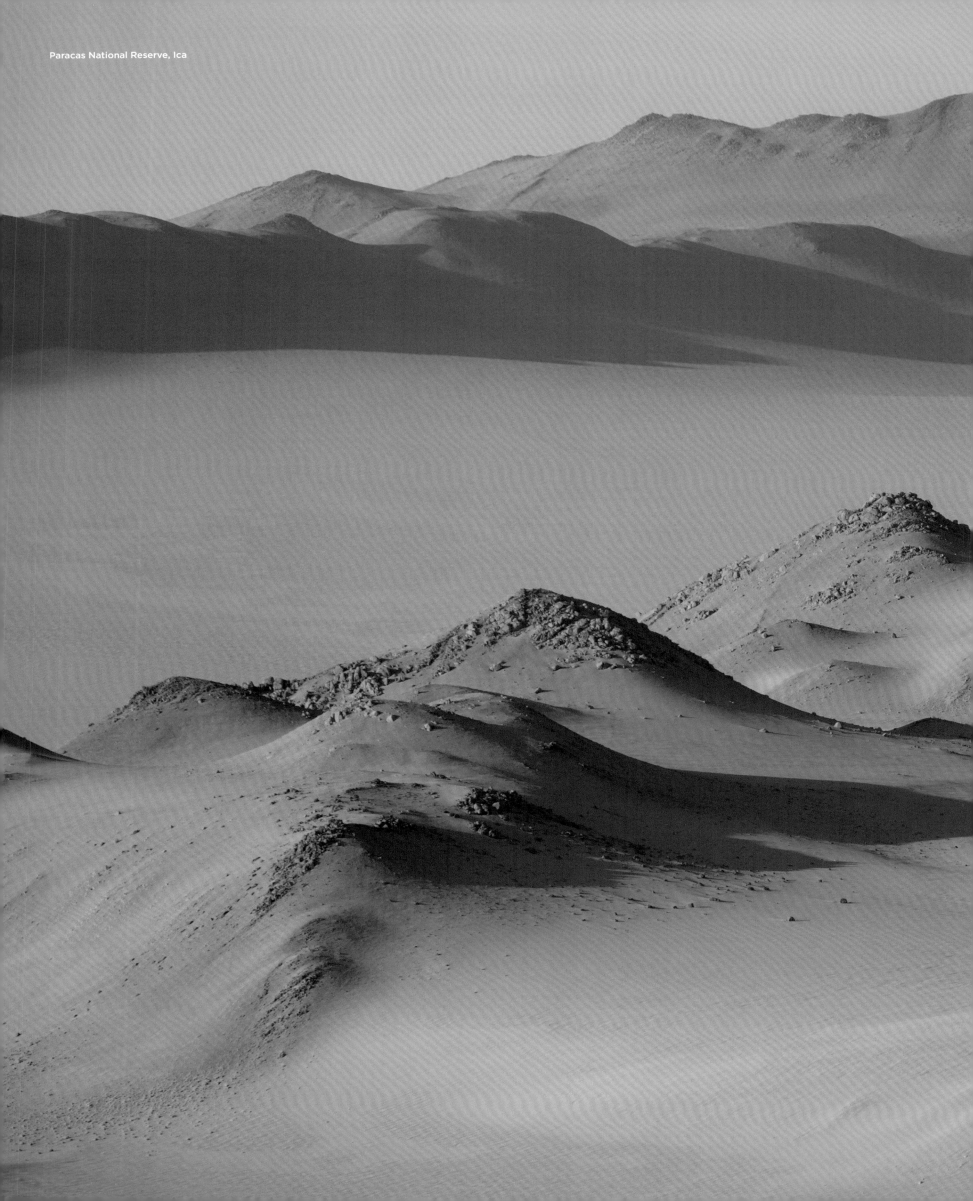
Paracas National Reserve, Ica

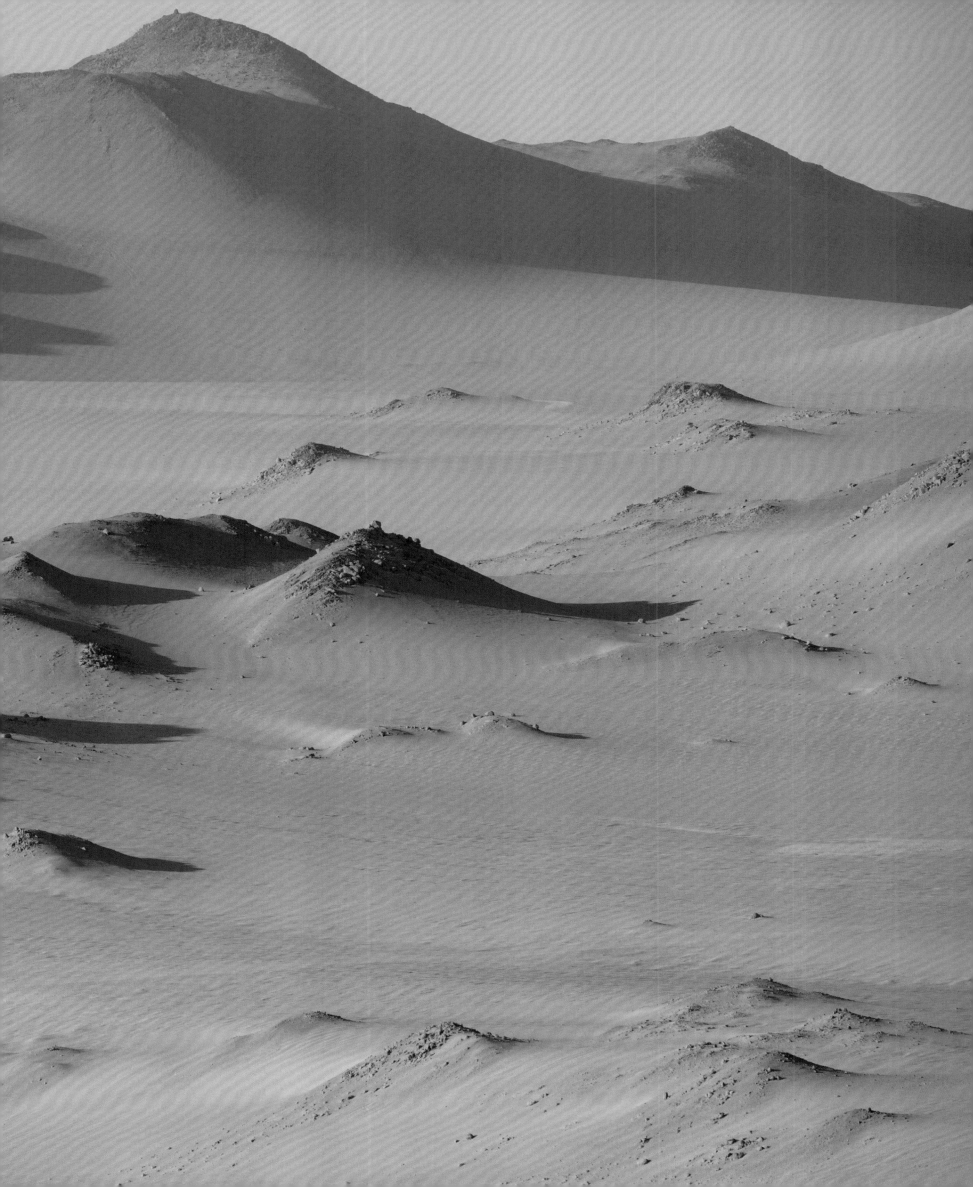

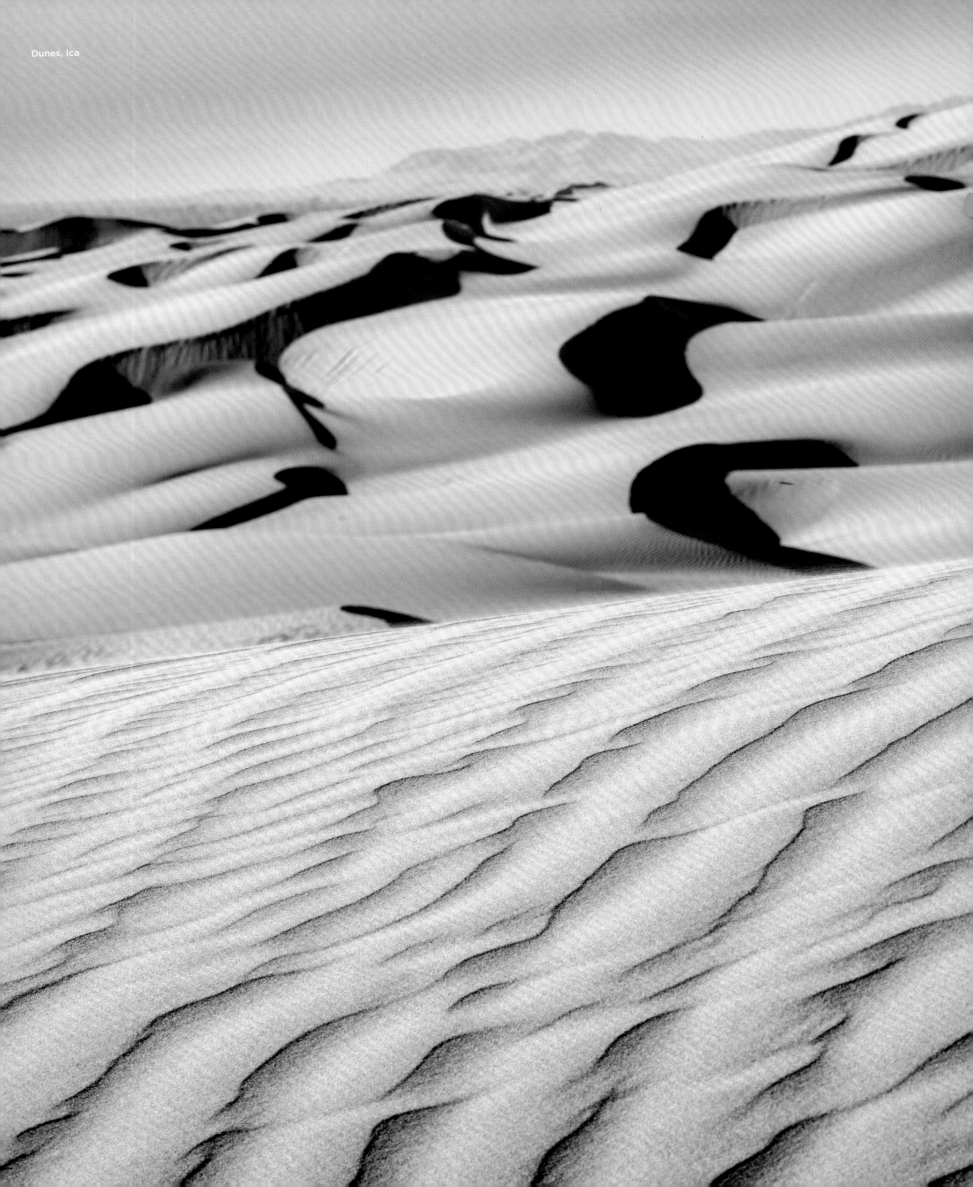

Dunes, Ica

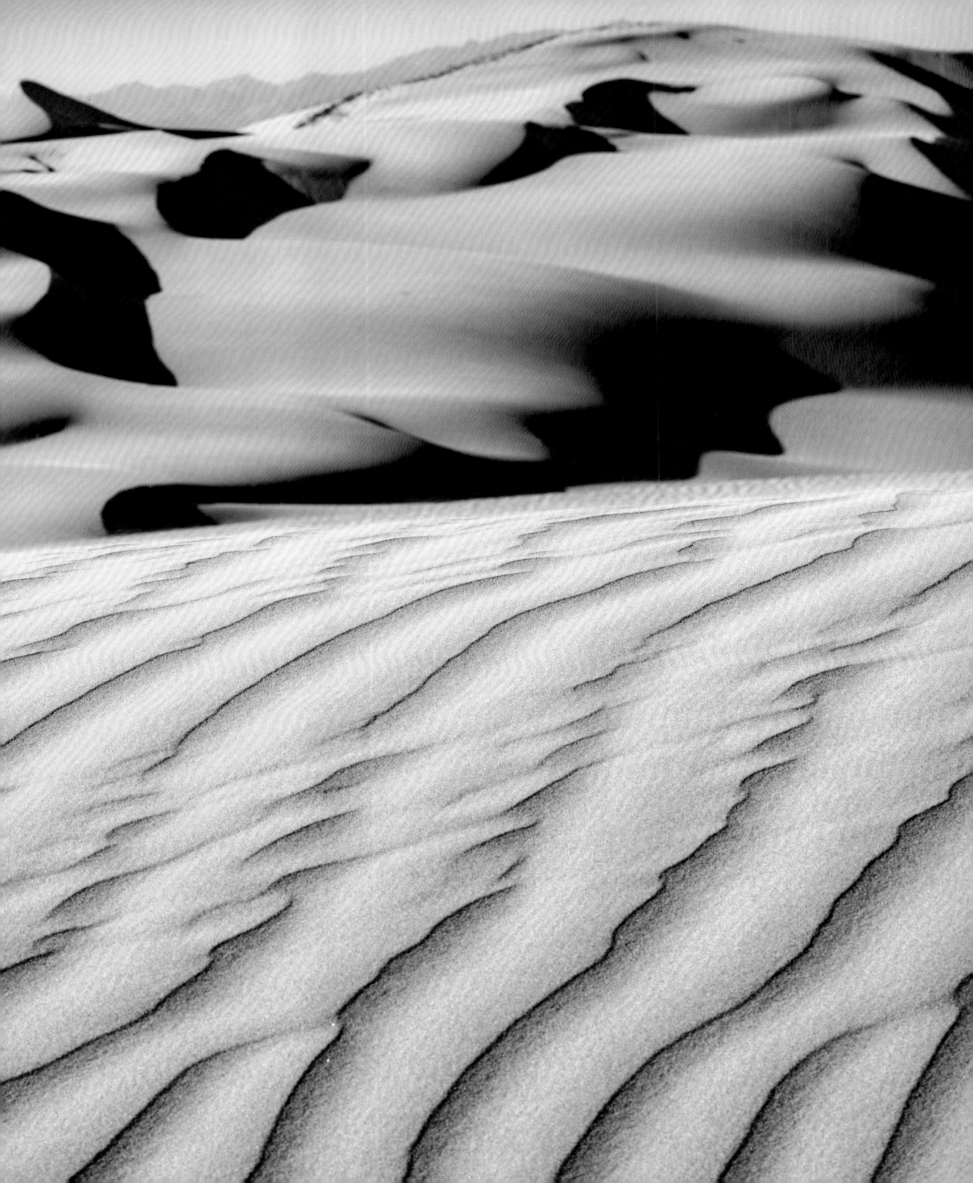

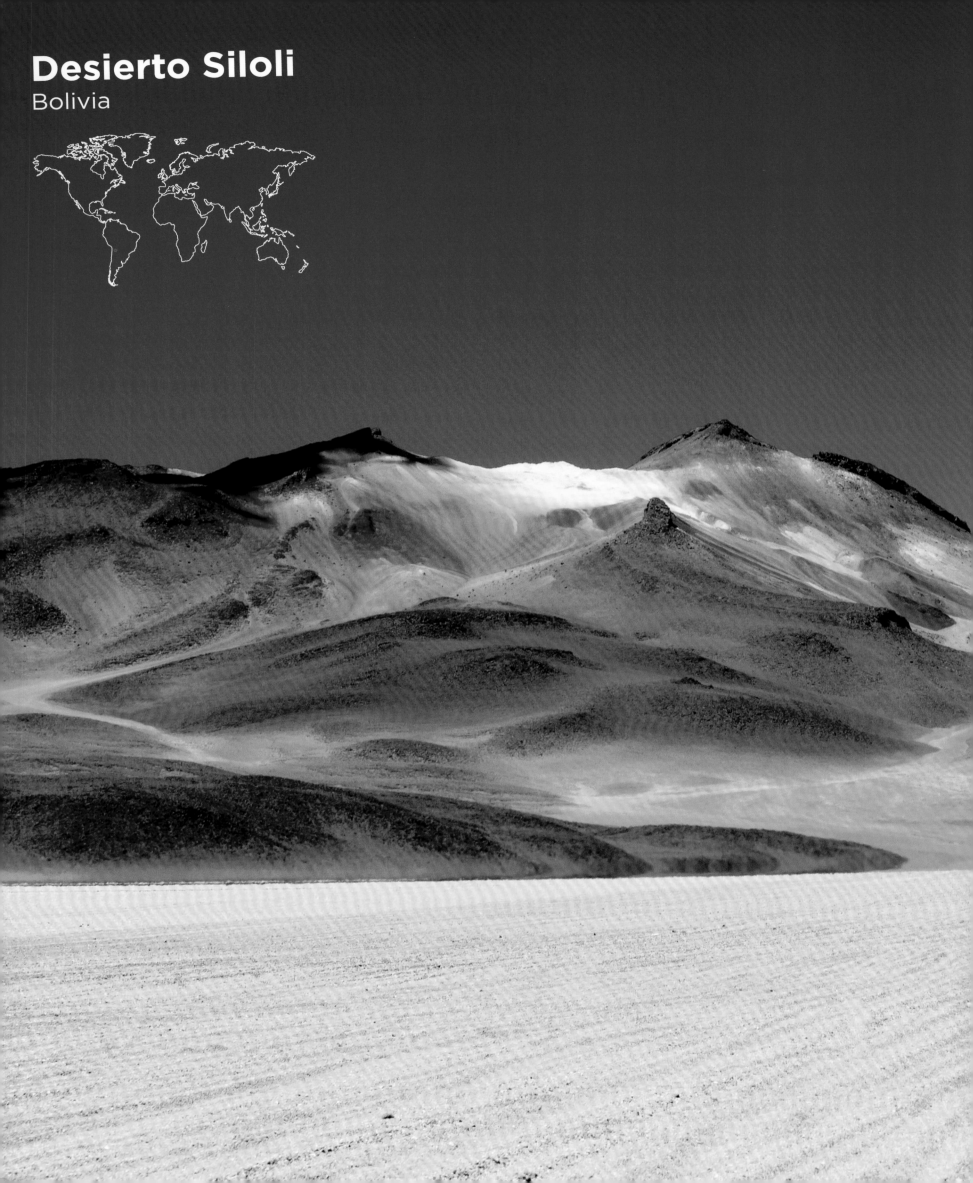

Desierto Siloli
Bolivia

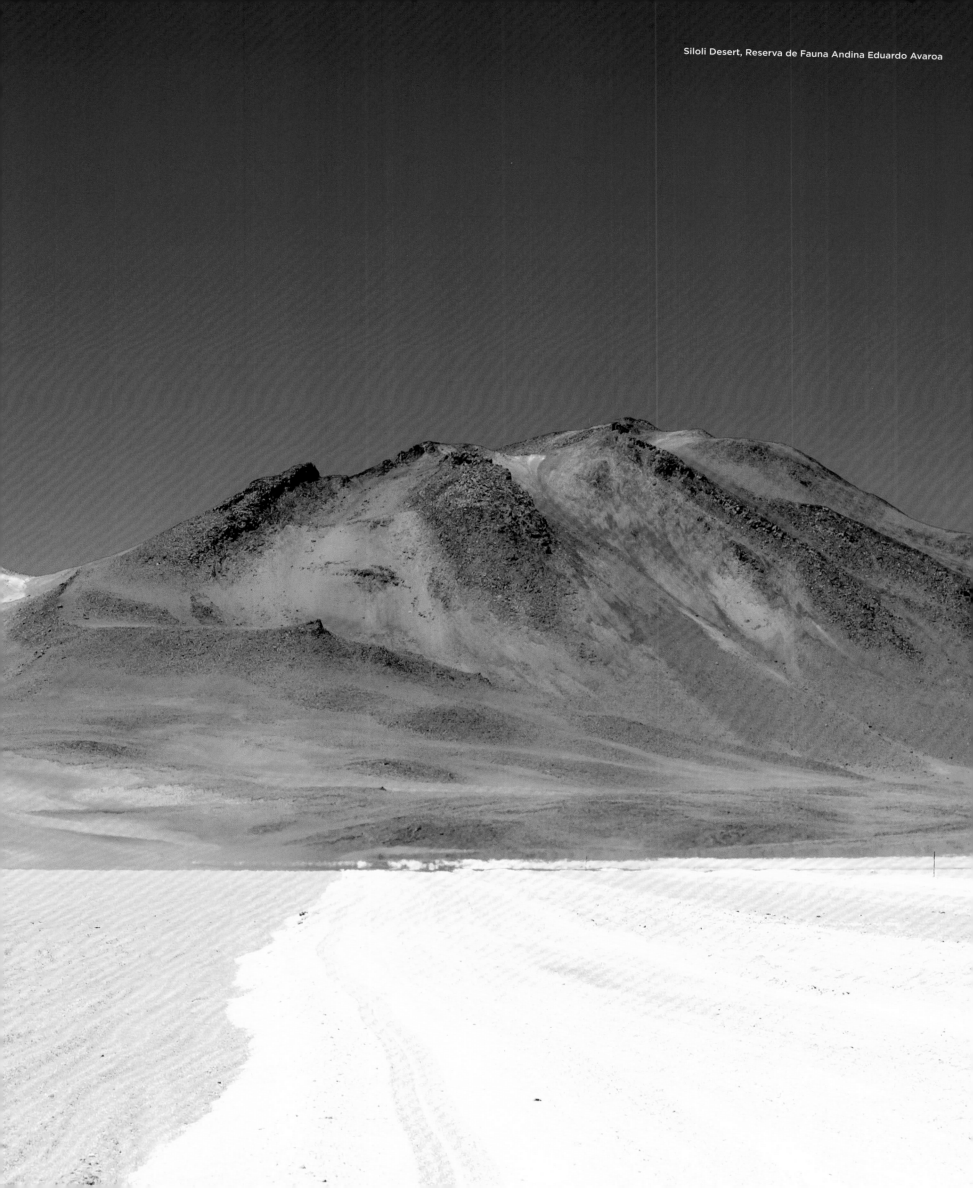

Siloli Desert, Reserva de Fauna Andina Eduardo Avaroa

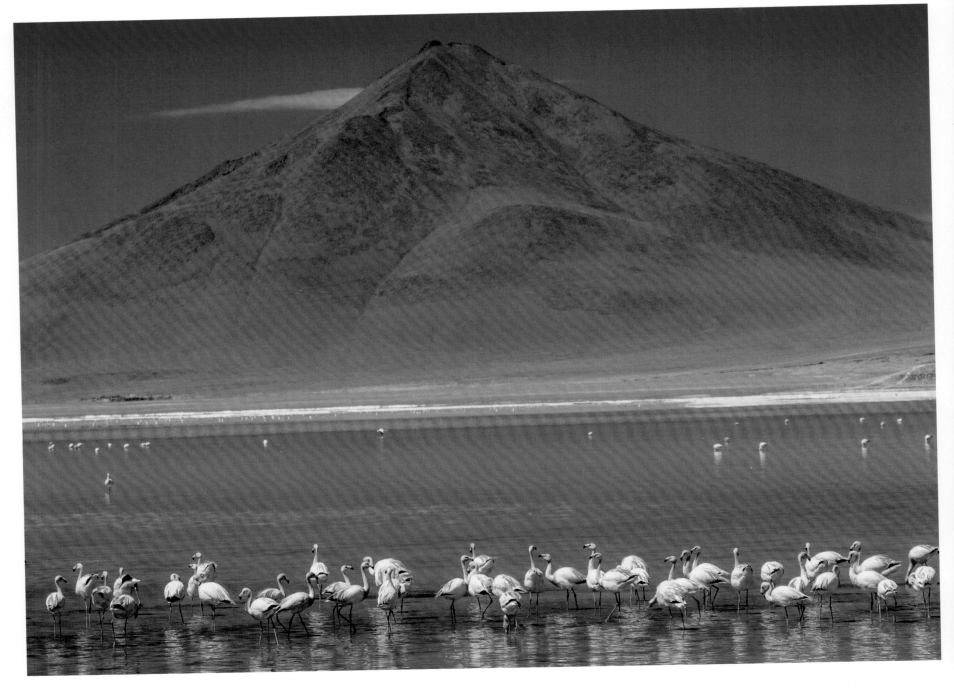

Laguna Colorada, Reserva de Fauna Andina Eduardo Avaroa

Siloli Desert

The Siloli Desert crowns Bolivia's altiplano, the country's high plateau, reaching as high as 4 500 m above sea level in places; thanks to the altitude, snowfalls in the desert are not unusual in winter. Adapted to the altitude, vicuñas and their near-relative, the llama, are found here; the former are believed to be the wild ancestors of domesticated alpacas. Their wool is extremely fine und thus much prized, and has been so since Inca times. They graze on grasslands, and are able to survive despite the low nutritional value of much of the altiplano's grass tussocks.

Le désert de Siloli

Le désert bolivien de Siloli couronne l'altiplano, le haut plateau local culminant à plus de 4 500 mètres au-dessus du niveau de la mer par endroits. À une telle altitude, les chutes de neige ne sont pas inhabituelles. Adaptés à ces conditions, les vigognes et leurs proches parents, les lamas, vivent là ; les premiers sont considérés comme les ancêtres sauvages des alpagas domestiques. Leur laine, bien que fine, est très prisée, et l'était déjà du temps des Incas. Ces animaux se nourrissent dans les prairies environnantes et sont capables de survivre malgré le peu de valeur nutritionnelle des touffes d'herbe de l'altiplano.

Siloli Wüste

Boliviens Siloli-Wüste krönt das Altiplano, die Hochebene des Landes, die teilweise bis zu 4 500 m über dem Meeresspiegel liegt; dank der Höhe sind Schneefälle in der Wüste im Winter nicht ungewöhnlich. Angepasst an die Höhe findet man hier die Vicunjas und ihren nahen Verwandten, die Lamas, die als wilde Vorfahren der domestizierten Alpakas gelten. Ihre Wolle wird seit der Zeit der Inkas wegen ihrer Feinheit sehr geschätzt. Sie weiden auf Grasland und sind in der Lage, trotz des geringen Nährwerts vieler Gräser im Altiplano zu überleben.

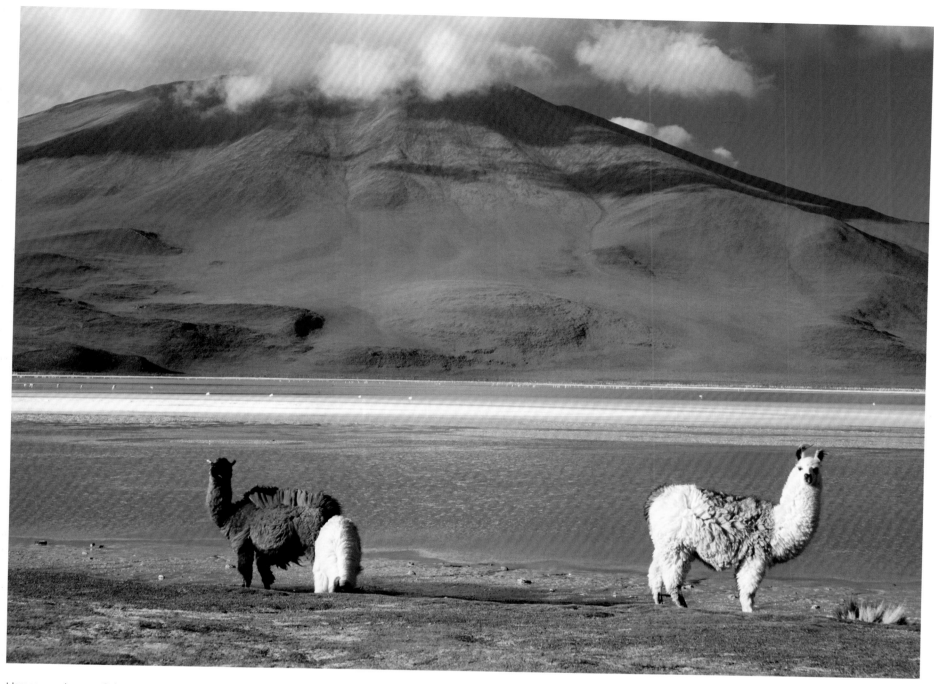

Llamas near Laguna Coloroda, Reserva de Fauna Andina Eduardo Avaroa

Desierto de Siloli

El desierto boliviano de Siloli corona el altiplano de Bolivia, la alta meseta intermontada del país, que se eleva hasta 4 500 m sobre el nivel del mar en algunos lugares. Gracias a la altitud, las nevadas en el desierto no son inusuales en invierno. Dada la altitud, aquí podemos encontrar vicuñas y su pariente cercano, la llama. Se cree que las primeras son los antepasados salvajes de las alpacas domesticadas. No es de extrañar que su lana, aunque fina, sea muy apreciada, algo que se remonta a los tiempos de los Incas. Se alimentan de pastizales y pueden sobrevivir a pesar del escaso valor nutritivo de gran parte de las mangas de hierba del altiplano.

Deserto Siloli

O deserto de Siloli, na Bolívia, coroa o altiplano da Bolívia, o planalto do país, chegando a 4 500 m acima do nível do mar em alguns pontos; Graças à altitude, as nevascas no deserto não são incomuns no inverno. Adaptado à altitude, as vicunhas e seus parentes próximos, a lhama, são encontradas aqui; Acredita-se que os primeiros sejam os ancestrais selvagens das alpacas domesticadas. Não é de surpreender que sua lã, apesar de excelente, seja muito apreciada, algo que remonta aos tempos incas. Eles se alimentam de gramados e são capazes de sobreviver apesar do baixo valor nutricional de grande parte dos tufos de capim do altiplano.

Siloli Desert

De Siloli Desert in Bolivia bekroont het Hoogland van Bolivia, dat deels 4 500 meter boven zeeniveau ligt. Door die hoogte is winterse sneeuwval niet ongebruikelijk. Aangepast aan de hoogte zijn de vicuña's en hun nauwe verwanten, de lama's; de eerste worden beschouwd als de wilde voorouders van de gedomesticeerde alpaca's. Hun fijne wol werd al ten tijde van de Inca's erg gewaardeerd. Ze voeden zich met gras en kunnen ondanks de lage voedingswaarde van het meeste gras overleven op het Hoogland.

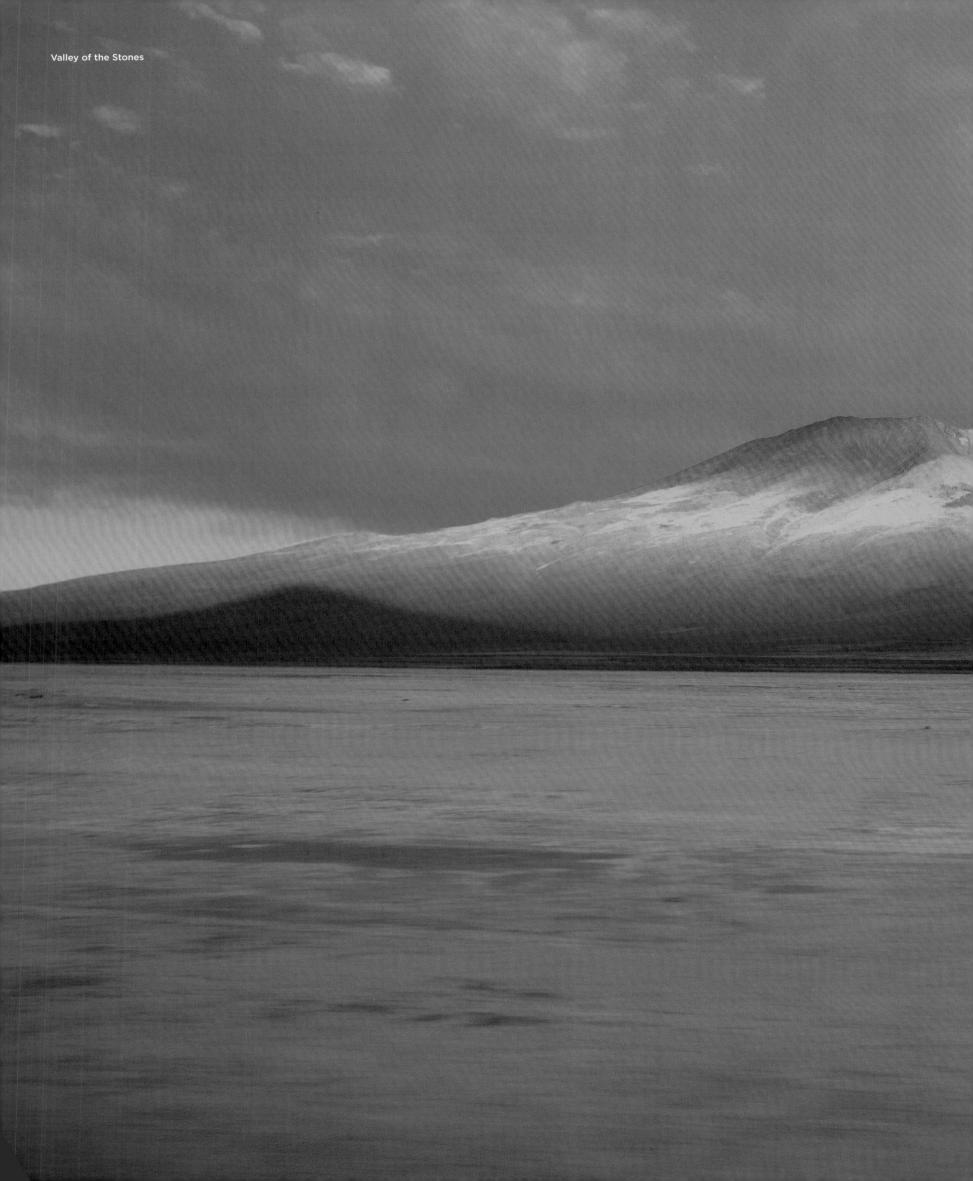

Valley of the Stones

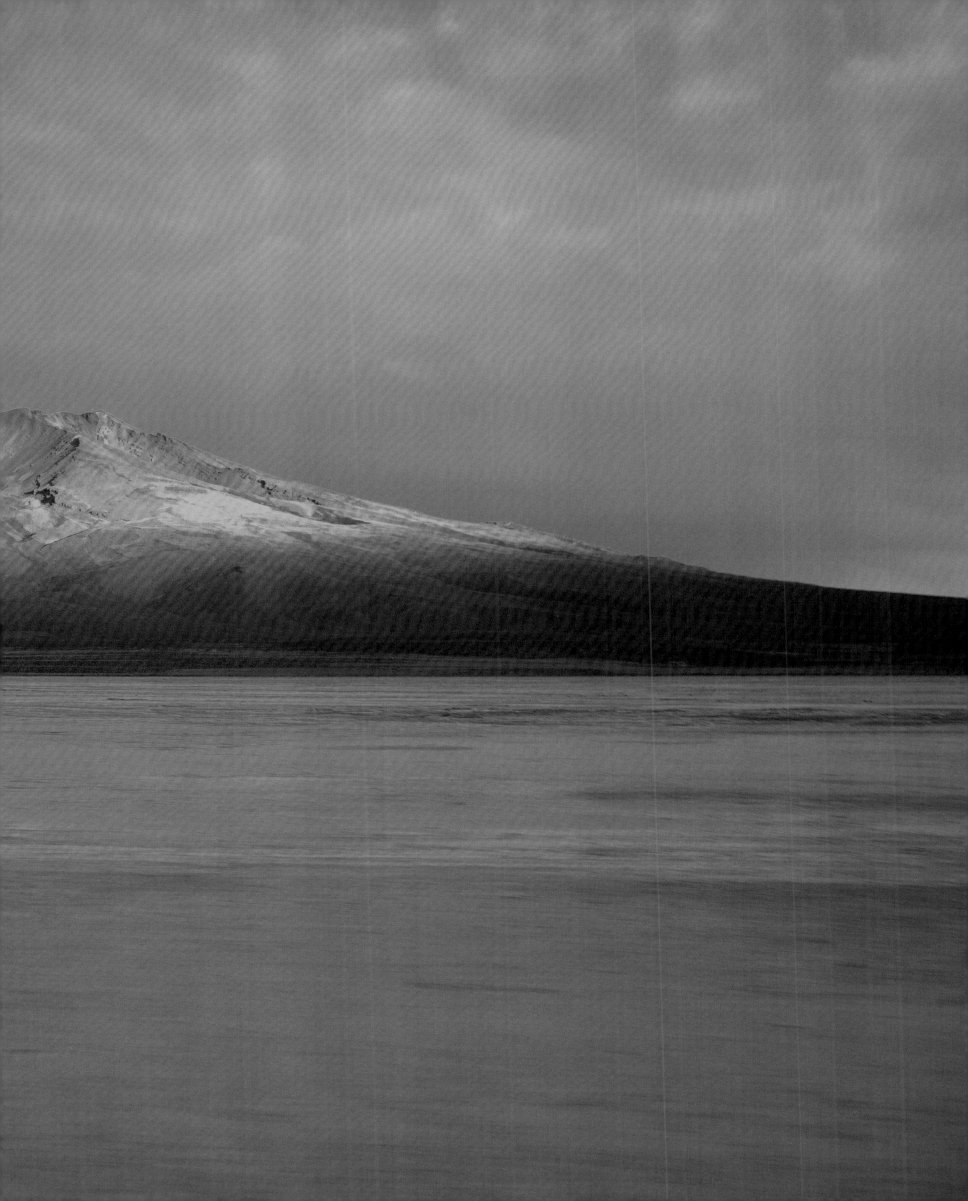

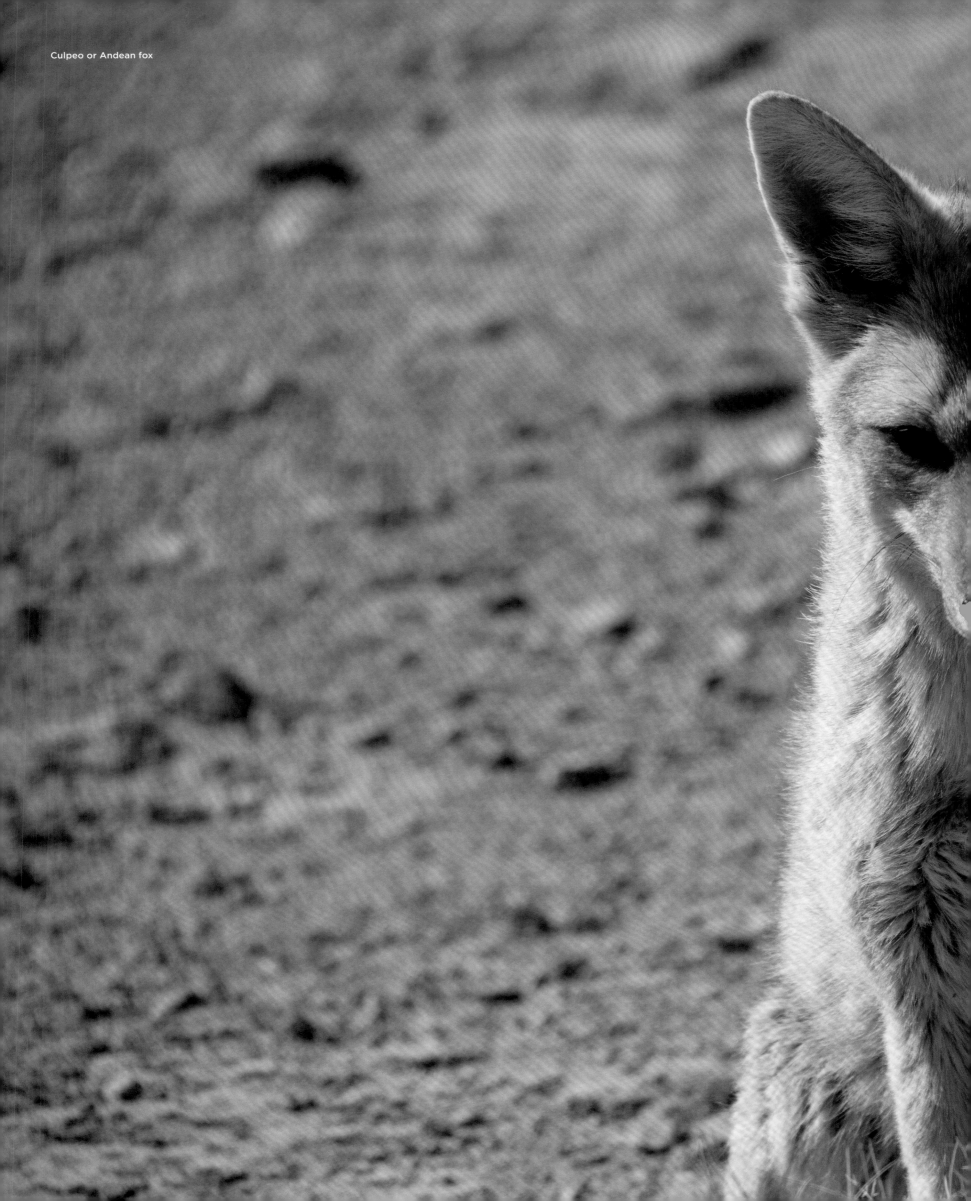

Culpeo or Andean fox

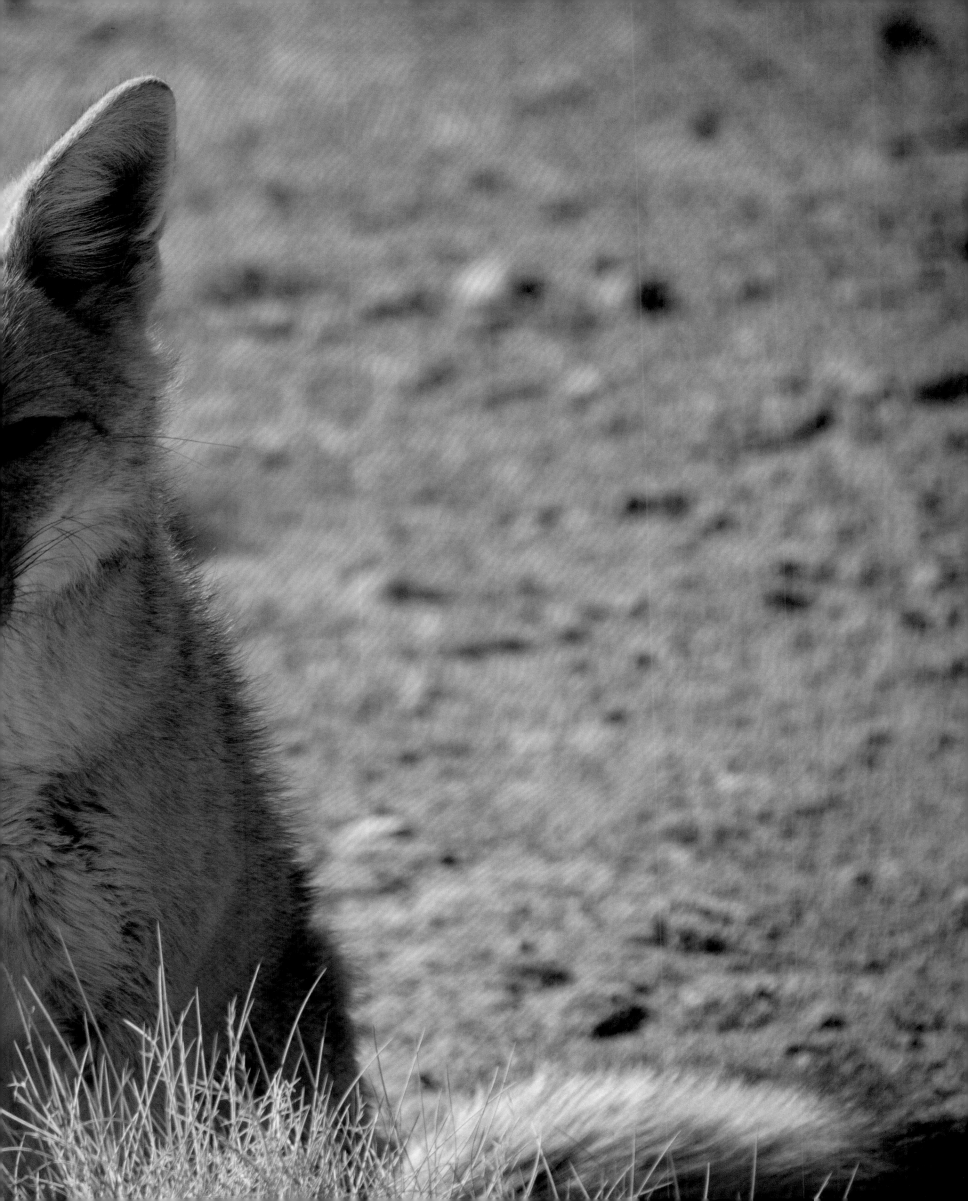

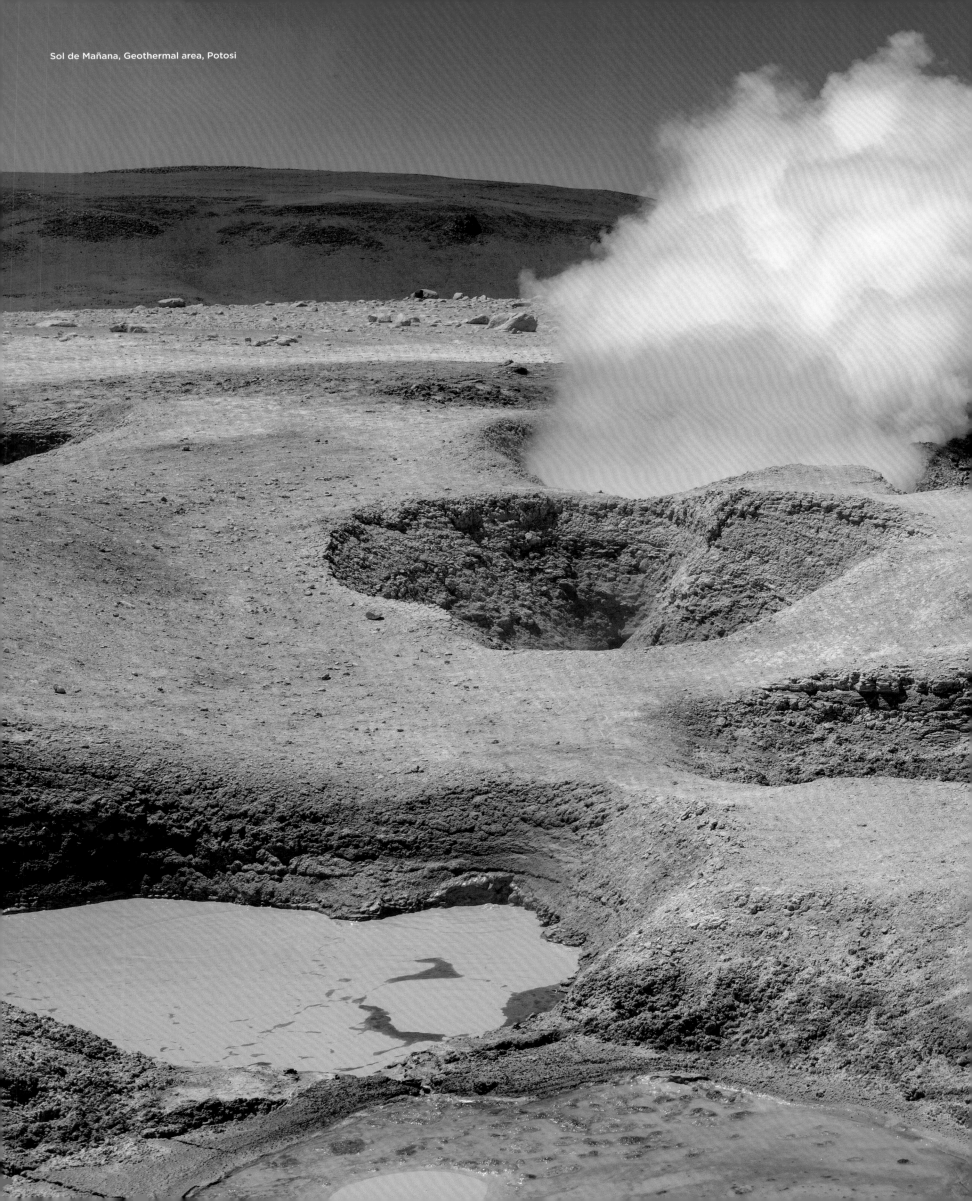

Sol de Mañana, Geothermal area, Potosi

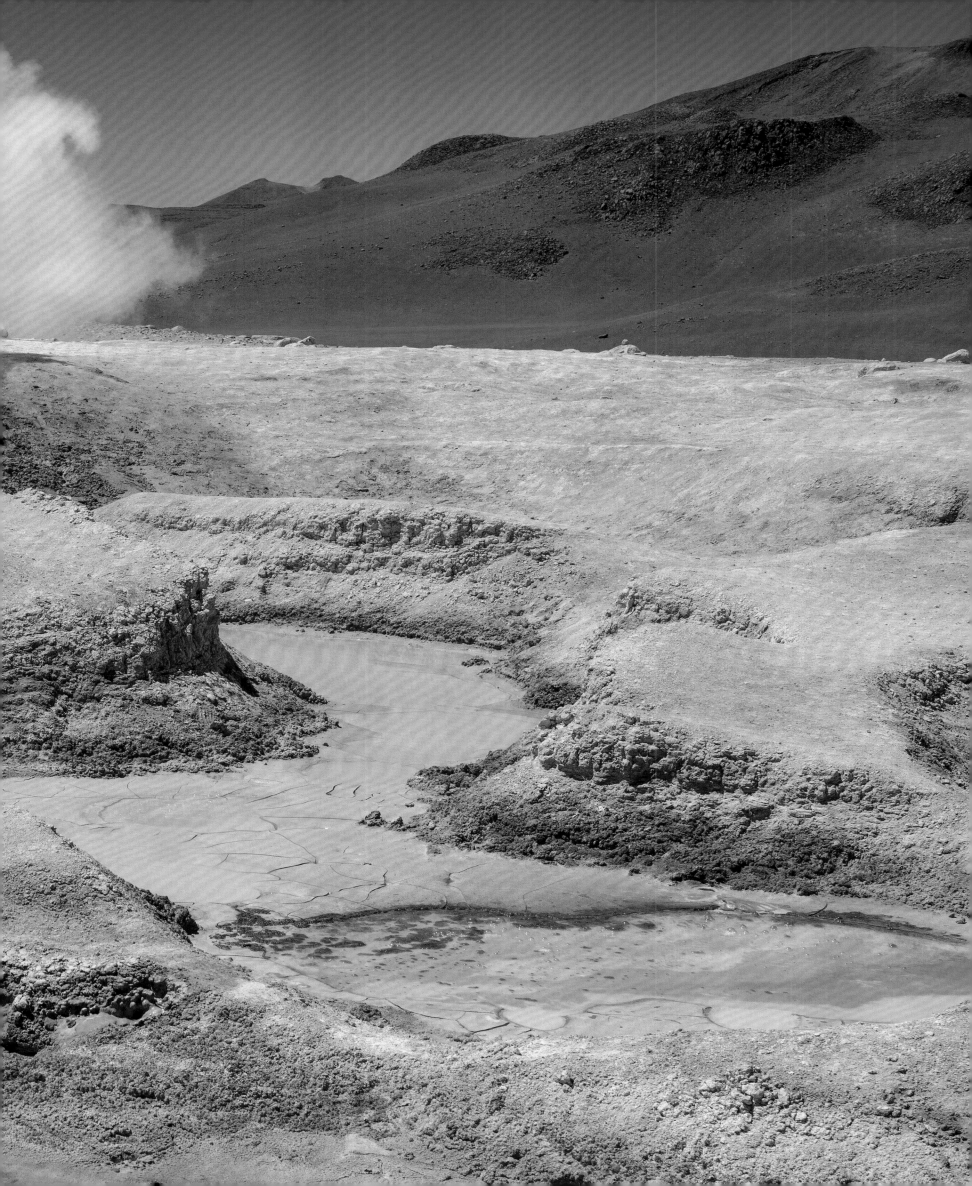

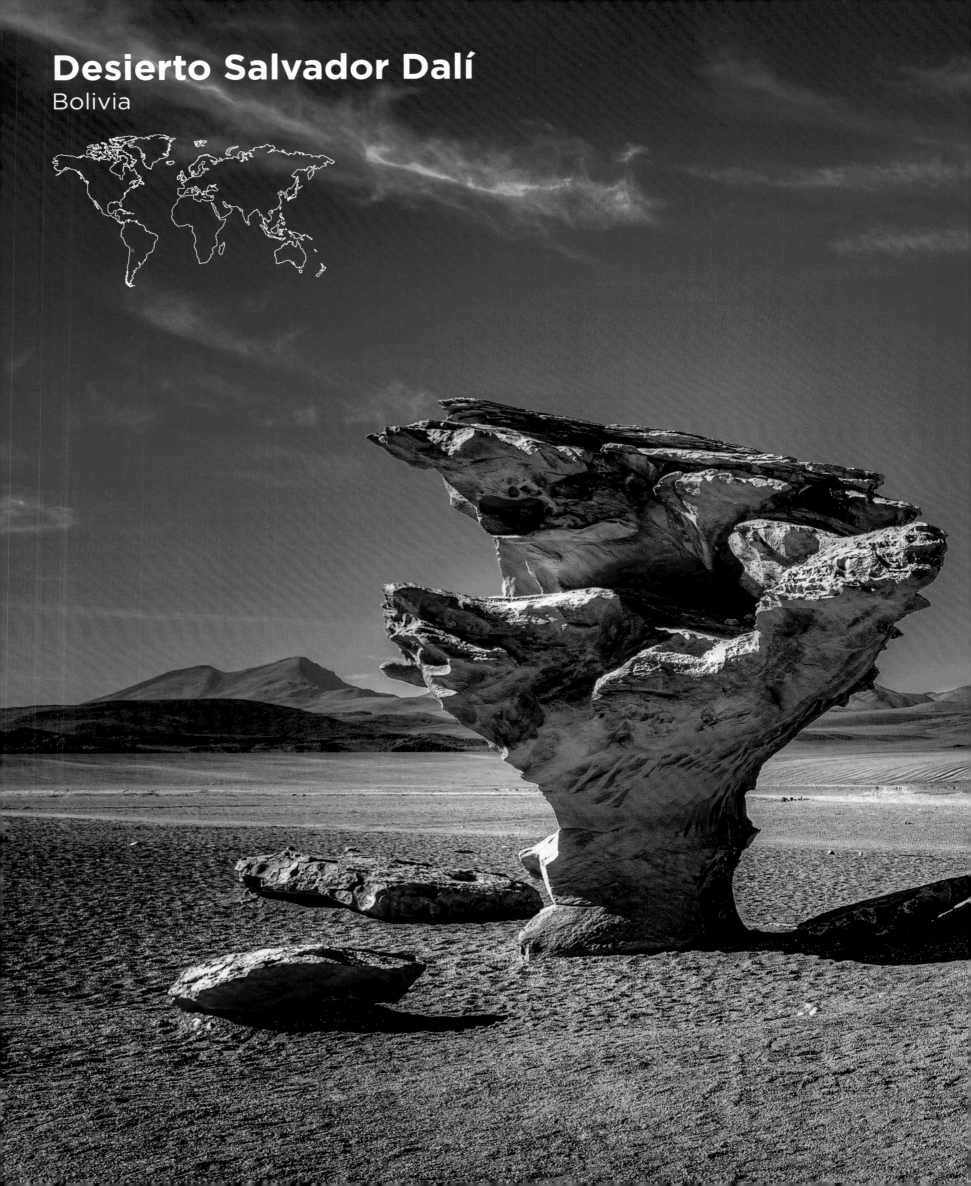

Desierto Salvador Dalí
Bolivia

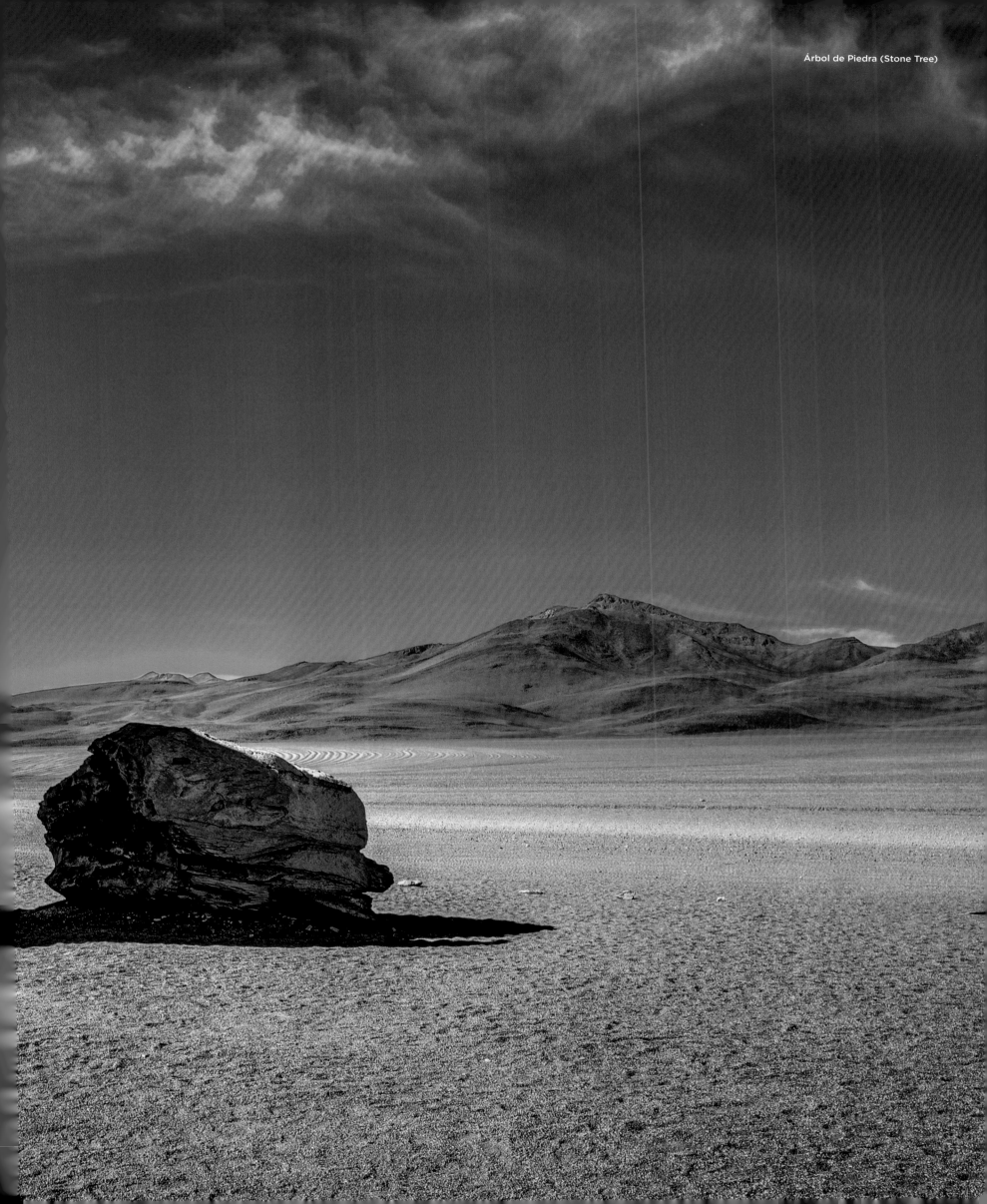

Árbol de Piedra (Stone Tree)

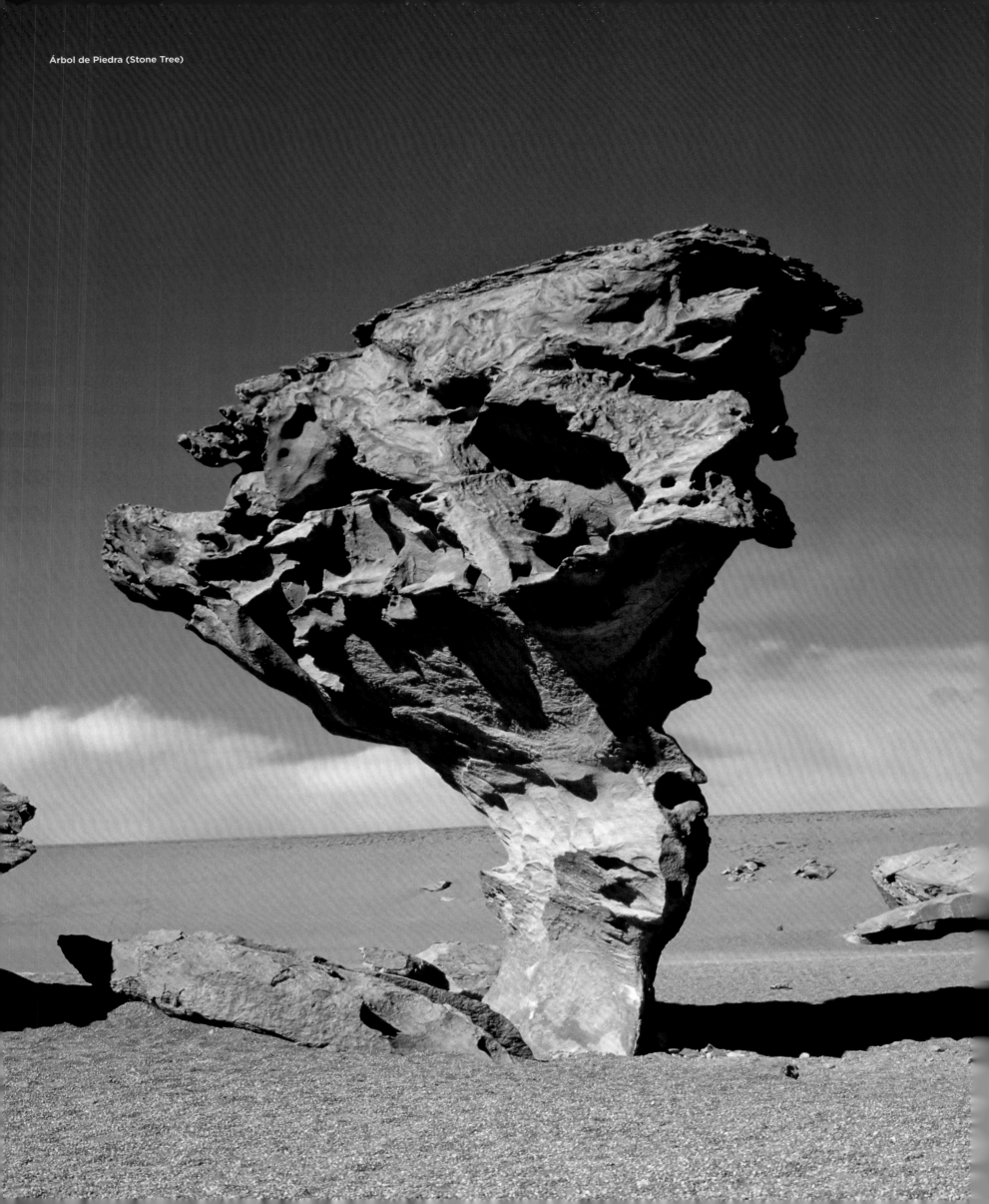

Árbol de Piedra (Stone Tree)

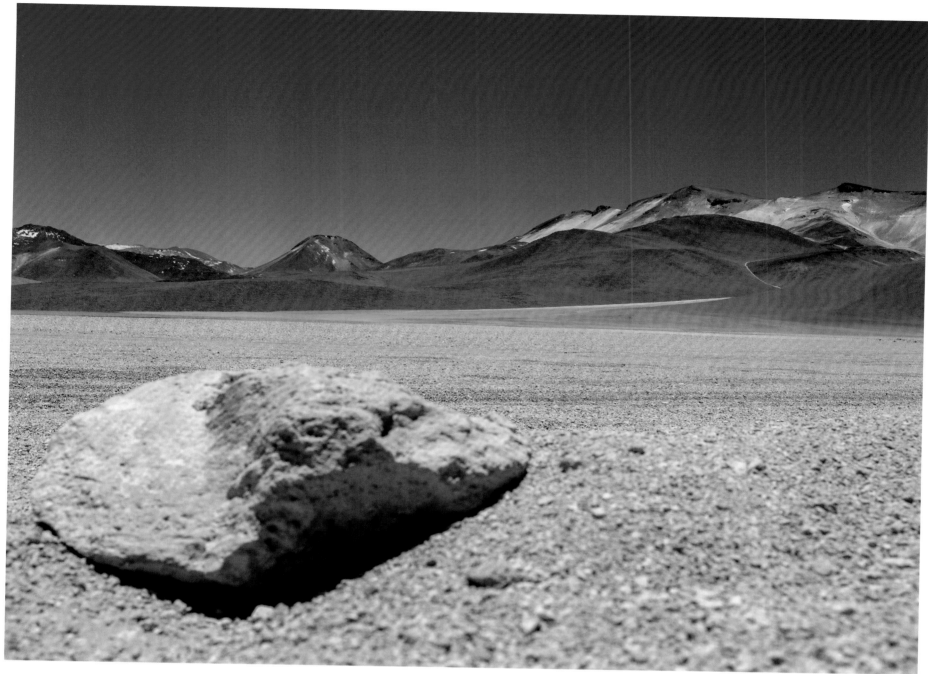

Salvador Dalí Desert

Salvador Dali Desert

In southwestern Bolivia, the Salvador Dalí Desert, or Valle de Dalí, is an arid valley that forms part of the much larger Eduardo Avaroa Andean Fauna National Reserve. Its name comes from the surrealist rock formations, sand-blasted by winds for thousands of years until they resembled artworks springing from the fevered imagination of Salvador Dalí.

Désert Salvador Dalí

Situé au sud-ouest de la Bolivie, le désert Salvador Dalí, ou vallée de Dalí, est une vallée aride qui fait partie de la réserve nationale de faune andine Eduardo Avaroa. Il tient son nom à des formations rocheuses surréalistes, que les vents ont sculptées au fil des millénaires jusqu'à ce qu'elles ressemblent à des œuvres d'art tout droit sorties de l'imagination exaltée de Salvador Dalí.

Salvador-Dali-Wüste

Im Südwesten Boliviens liegt die Salvador-Dalí-Wüste (das Valle de Dalí), ein trockenes Tal, das Teil des größeren Nationalparks Reserva Nacional de Fauna Andina Eduardo Avaroa ist. Der Name der Wüste verweist auf die surrealistischen Felsformationen, die seit Jahrtausenden von Wind und Sand geformt wurden, bis sie Kunstwerken ähneln, die der fieberhaften Fantasie von Salvador Dalí entstammen könnten.

Desierto de Salvador Dalí

En el suroeste de Bolivia, el desierto de Salvador Dalí o Valle de Dalí es un valle árido que forma parte de la Reserva Nacional de Fauna Andina Eduardo Abaroa, que es mucho más grande. Su nombre proviene de las surrealistas formaciones rocosas, arenadas por los vientos durante miles de años hasta llegar a asemejarse a obras de arte propias de la febril imaginación de Salvador Dalí.

Deserto de Salvador Dali

No sudoeste da Bolívia, o Deserto de Salvador Dalí, ou Valle de Dalí, é um vale árido que faz parte da muito maior Reserva Nacional da Fauna Andina de Eduardo Avaroa. Seu nome vem das formações rochosas surrealistas, arrasadas pelos ventos por milhares de anos até se assemelharem às obras de arte que brotam da febril imaginação de Salvador Dalí.

Salvador Dalí Desert

In het zuidwesten van Bolivia ligt de Salvador Dalí Desert of Valle de Dalí. Het is een dorre vallei die deel uitmaakt van het veel grotere Eduardo Avaroa Andean Fauna National Reserve. De naam komt van de surrealistische rotsformaties, die duizenden jaren zijn gezandstraald door de wind, tot ze op kunstwerken leken die ontsproten hadden kunnen zijn aan de fantasie van Salvador Dalí.

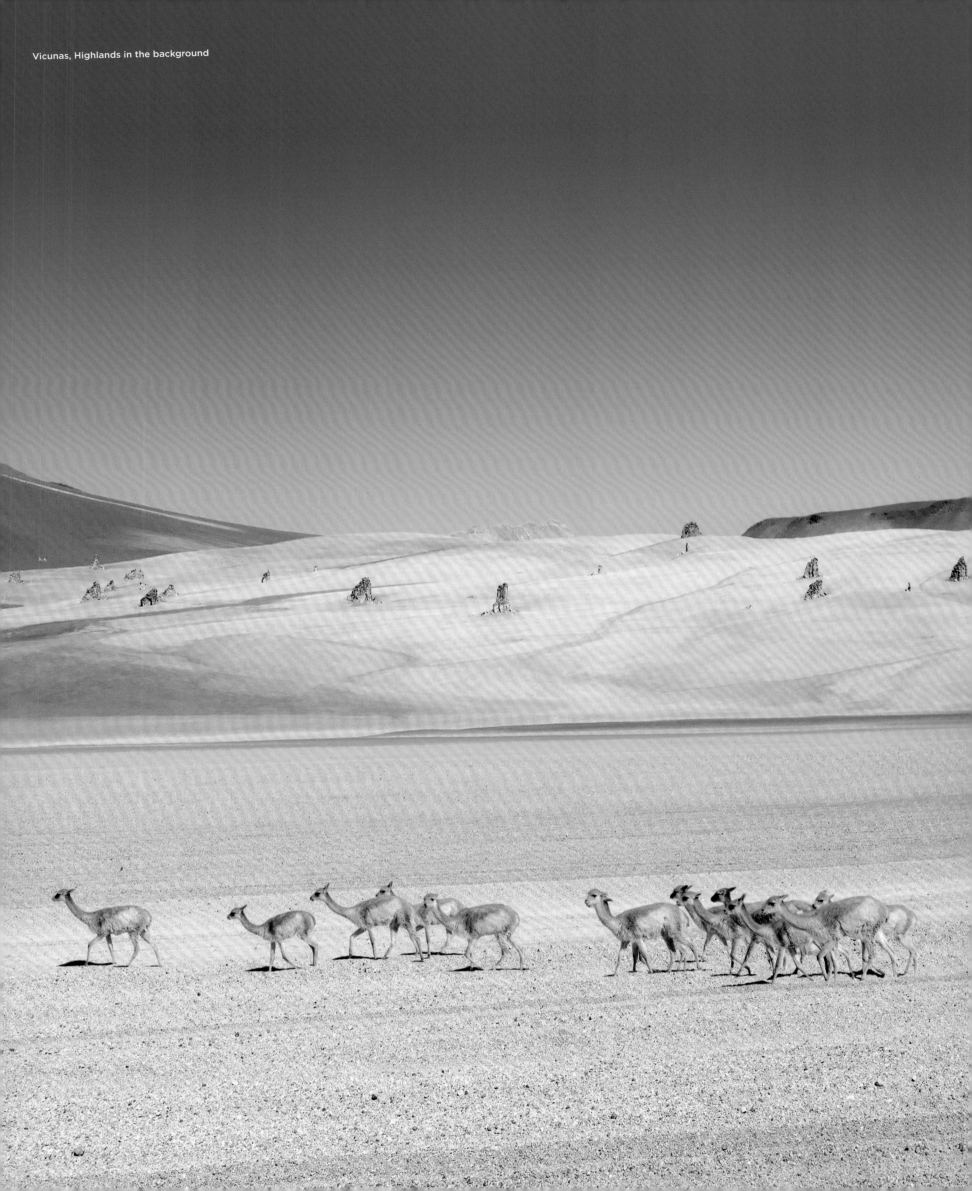

Vicunas, Highlands in the background

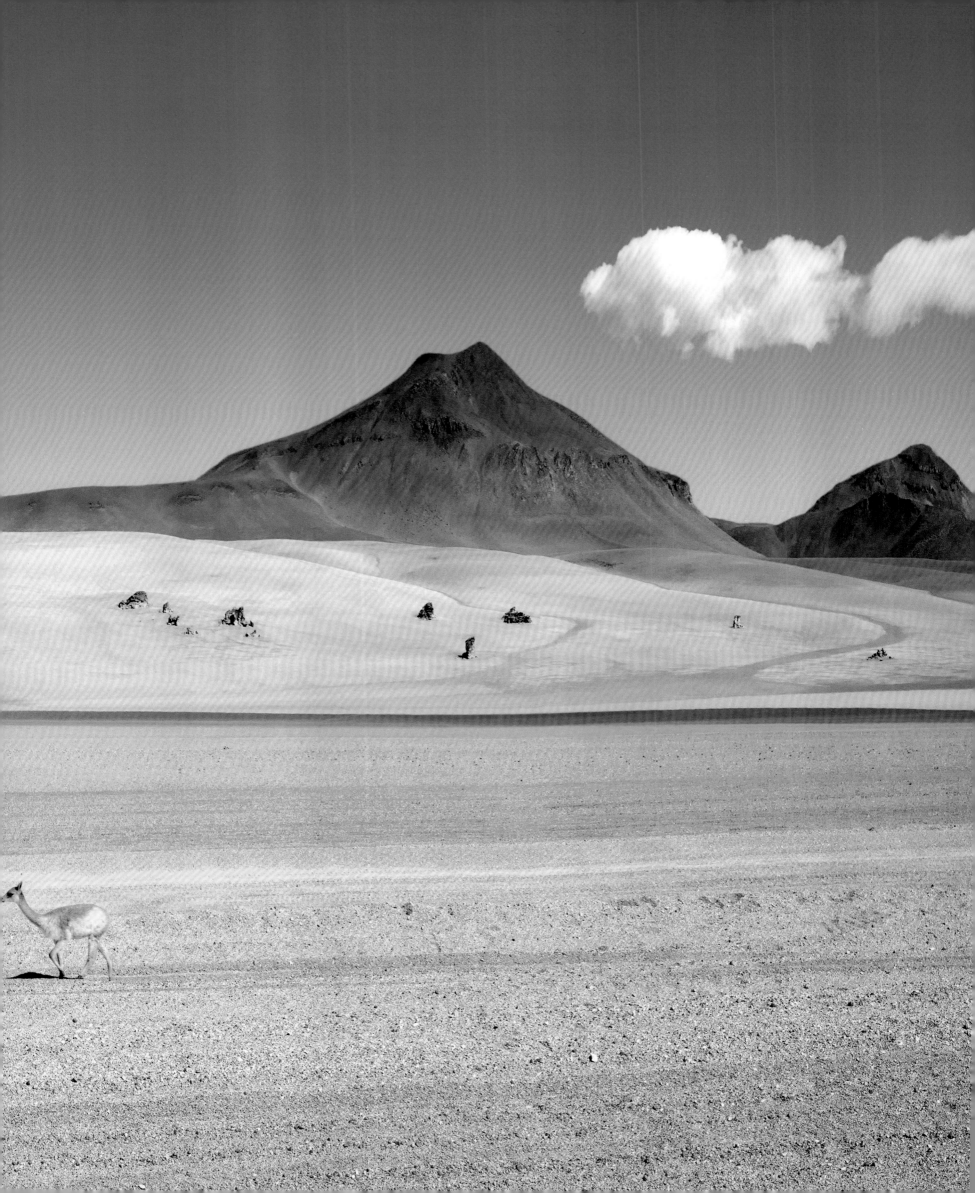

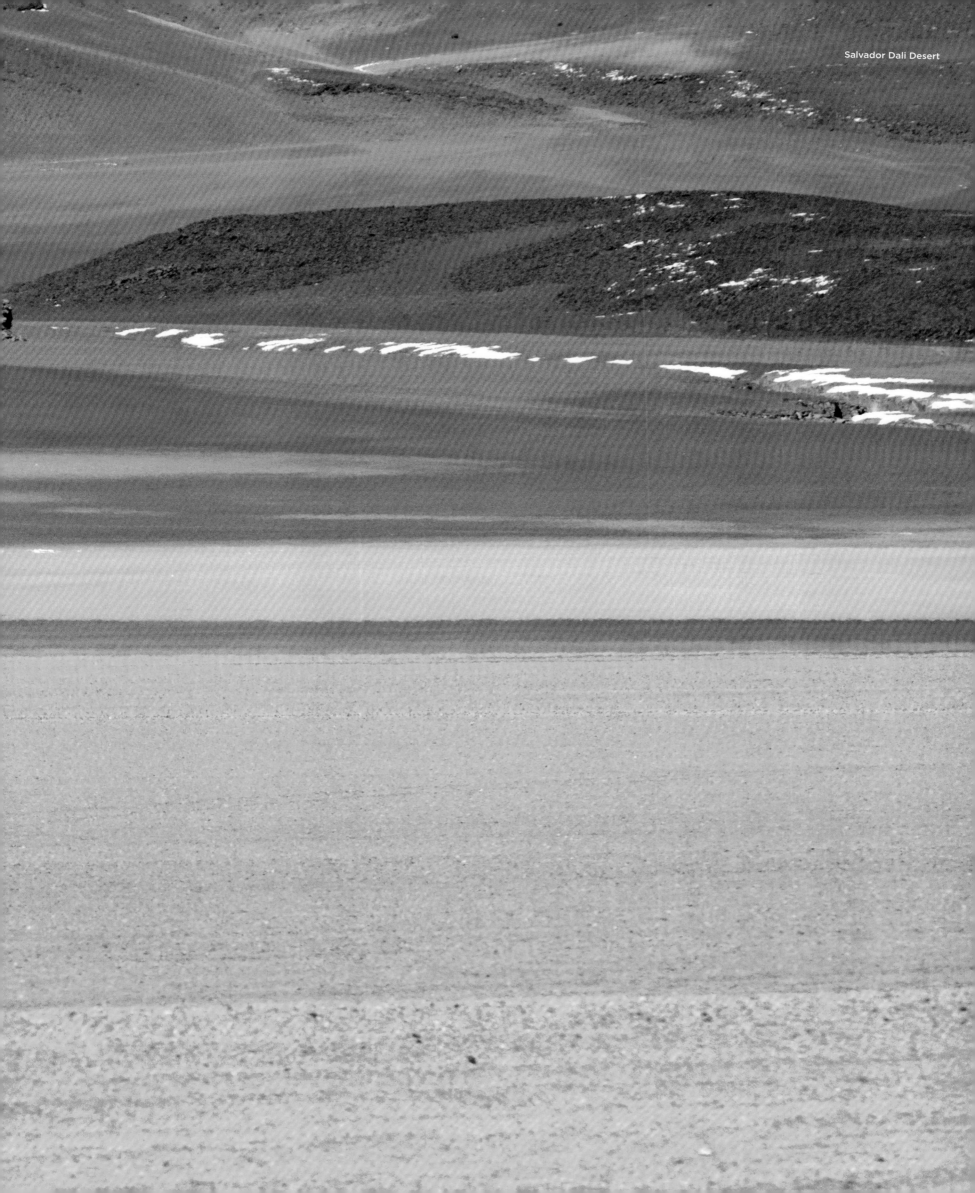
Salvador Dali Desert

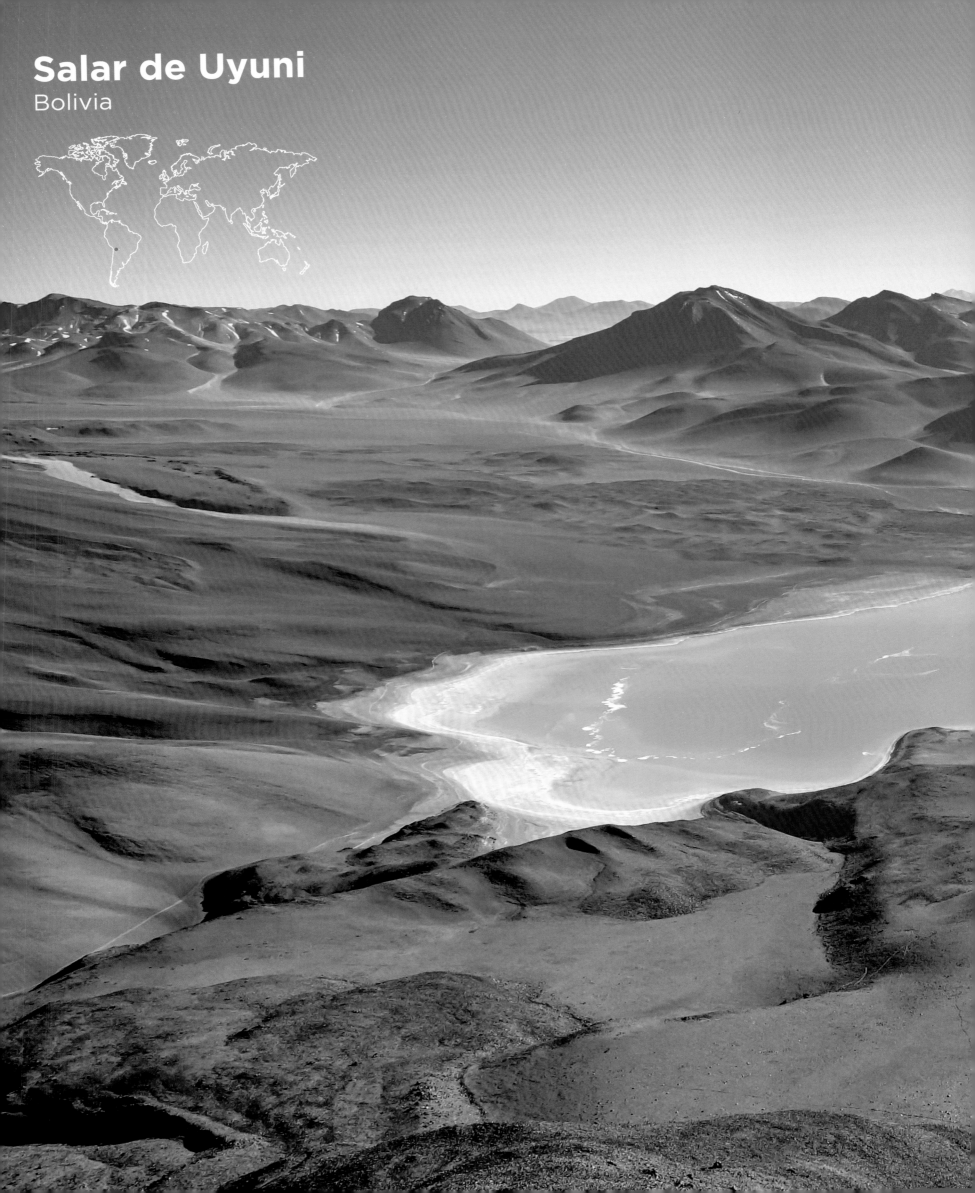

Salar de Uyuni
Bolivia

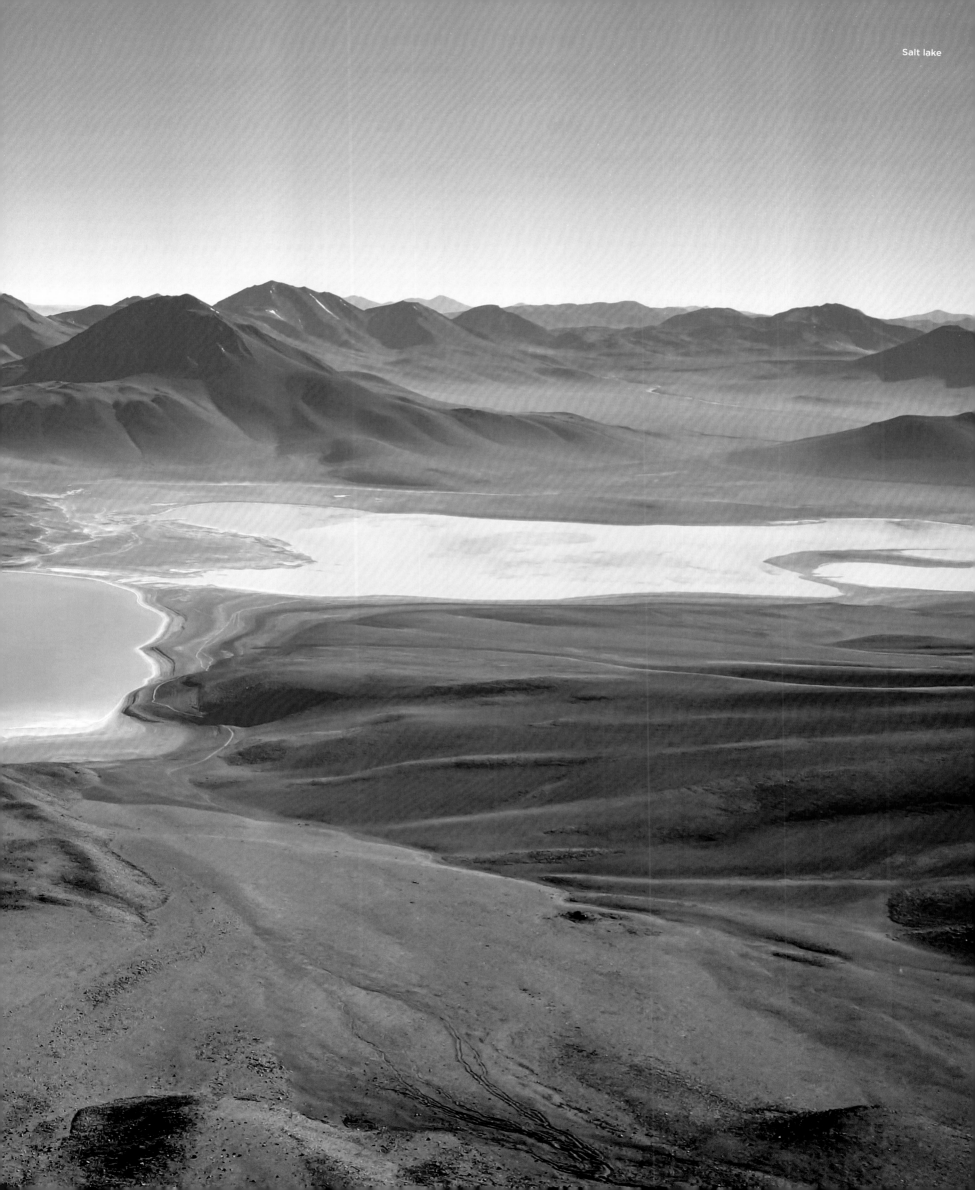
Salt lake

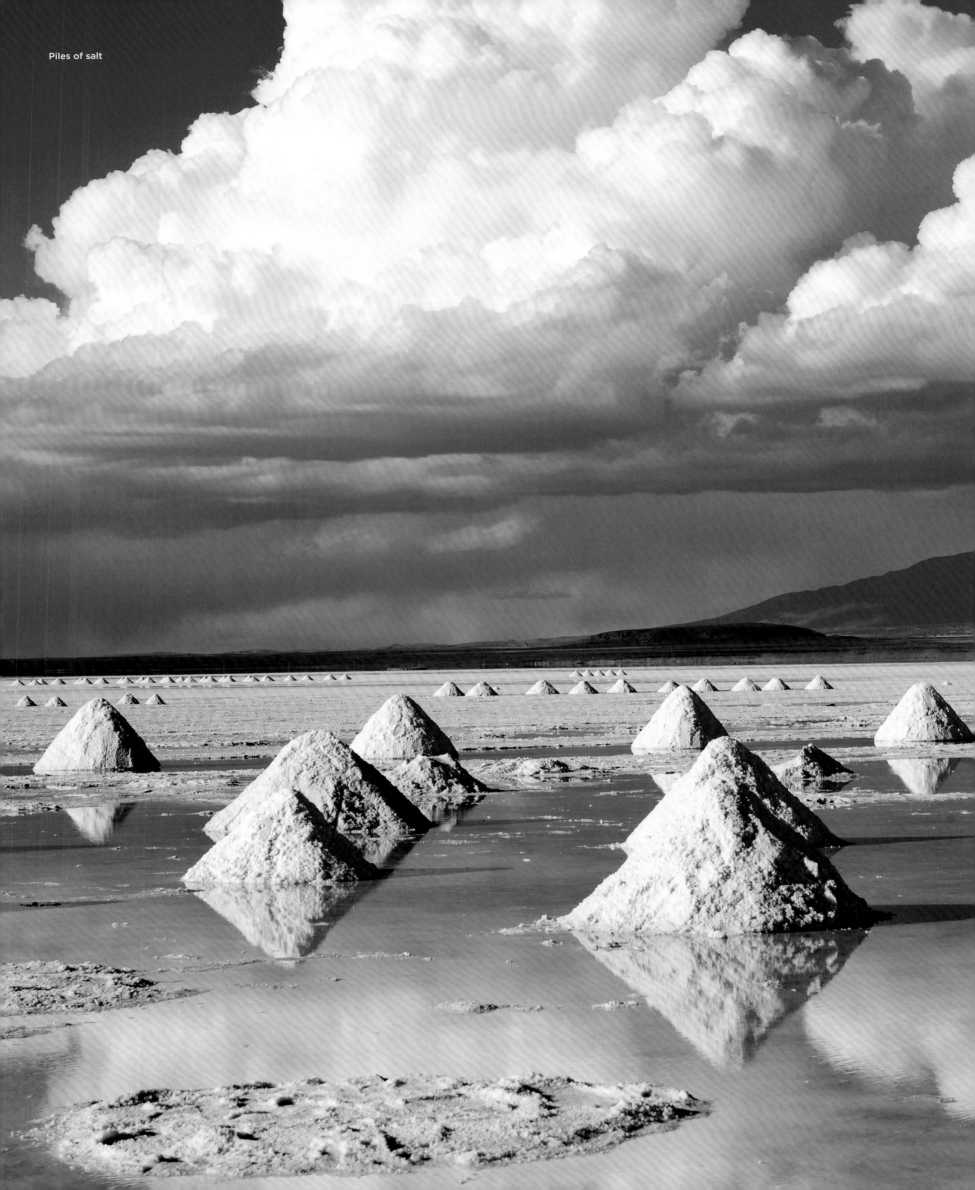

Piles of salt

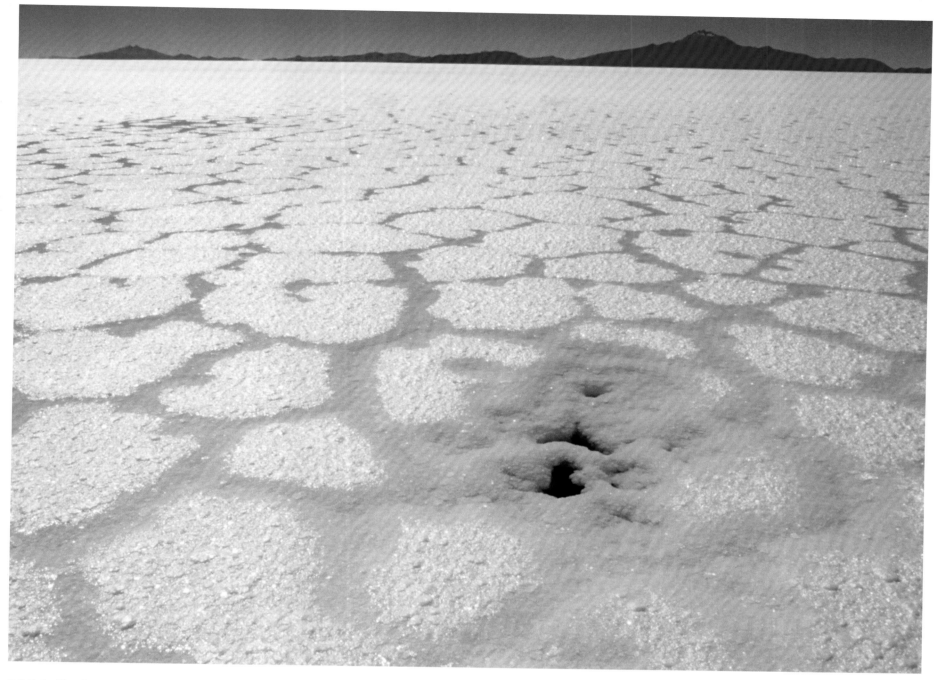

Salt Flat with salt source

Salar de Uyuni

The world's largest salt lake covers 10 582 km² and sits at 3 636 m near the ridgeline of the Andes. The lake's surface altitude varies by just one meter, so that satellites use it to calibrate their measuring instruments. The Salar de Uyuni hosts huge flocks of breeding flamingos and is an important source of lithium (it holds up to 70% of the world's reserves).

Salar d'Uyuni

Le plus grand lac salé du monde occupe une surface de 10 582 km² et se situe à 3 636 mètres près de la ligne de crête des Andes. L'altitude du lac fluctuant d'un mètre à peine, les satellites s'en servent pour calibrer leurs instruments de mesure. Salar de Uyuni regorge de flamants roses et de lithium (environ 70% des réserves mondiales).

Salar de Uyuni

Die größte Salzpfanne der Welt umfasst 10 582 km² und liegt auf 3 636 m Höhe in der Nähe des Andenkamms. Die Höhe der Salzpfanne variiert um nur einen Meter, sodass Satelliten damit ihre Messgeräte kalibrieren können. Der Salar de Uyuni ist die Heimat riesiger Flamingoschwärme. Sein Salz enthält große Mengen an Lithium (bis zu 70% der weltweiten Reserven).

Salar de Uyuni

El lago salado más grande del mundo tiene una superficie de 10 582 km² y se encuentra a 3 636 m cerca de la cordillera de los Andes. La altitud del lago varía en solo un metro, lo que significa que los satélites lo utilizan para calibrar sus instrumentos de medición. El Salar de Uyuni es rico tanto en flamencos reproductores como en litio (hasta el 70% de las reservas mundiales).

Salar de Uyuni

O maior lago salgado do mundo cobre 10 582 km² e fica a 3 636 m perto da cordilheira dos Andes. A altitude do lago varia em apenas um metro, o que significa que os satélites o usam para calibrar seus instrumentos de medição. O Salar de Uyuni é rico em flamingos reprodutores e lítio (até 70% das reservas do mundo).

Salar de Uyuni

Het grootste zoutmeer ter wereld beslaat 10 582 km² en ligt op 3 636 meter hoogte in de buurt van de Andeskam. De hoogte van het meer schommelt slechts 1 meter: satellieten gebruiken het daarom om hun meetinstrumenten te kalibreren. Salar de Uyuni is rijk aan flamingo's en lithium (tot 70% van de wereldreserves).

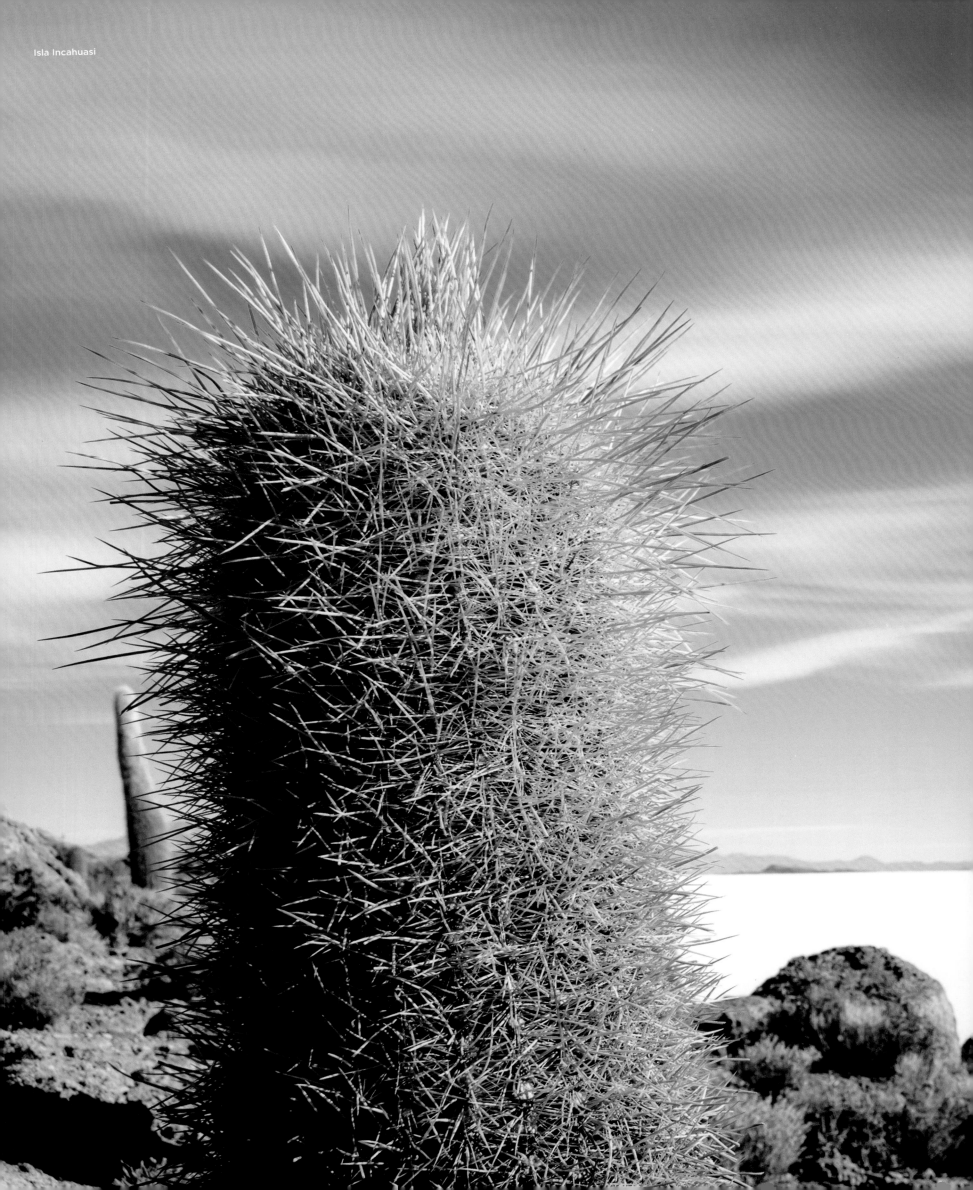

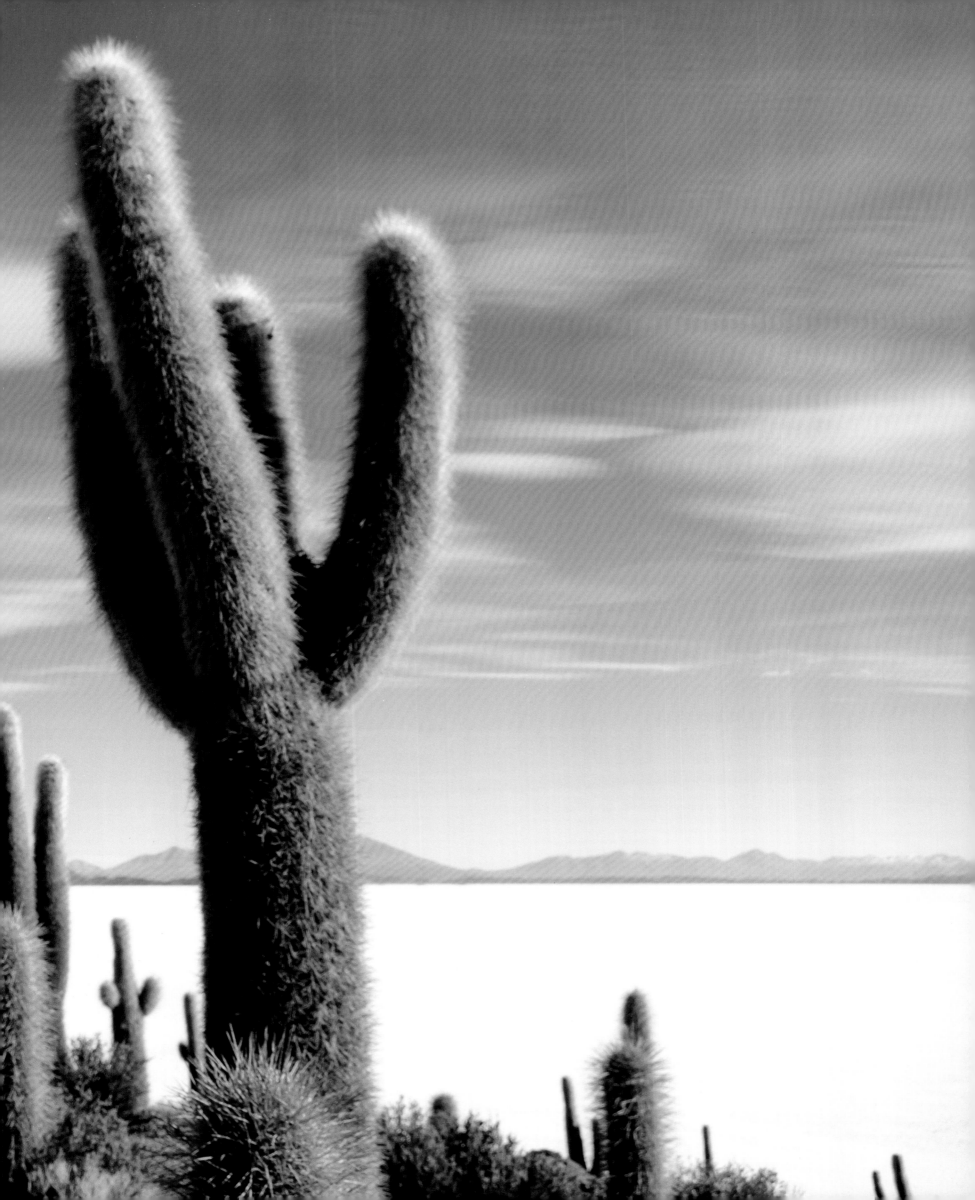

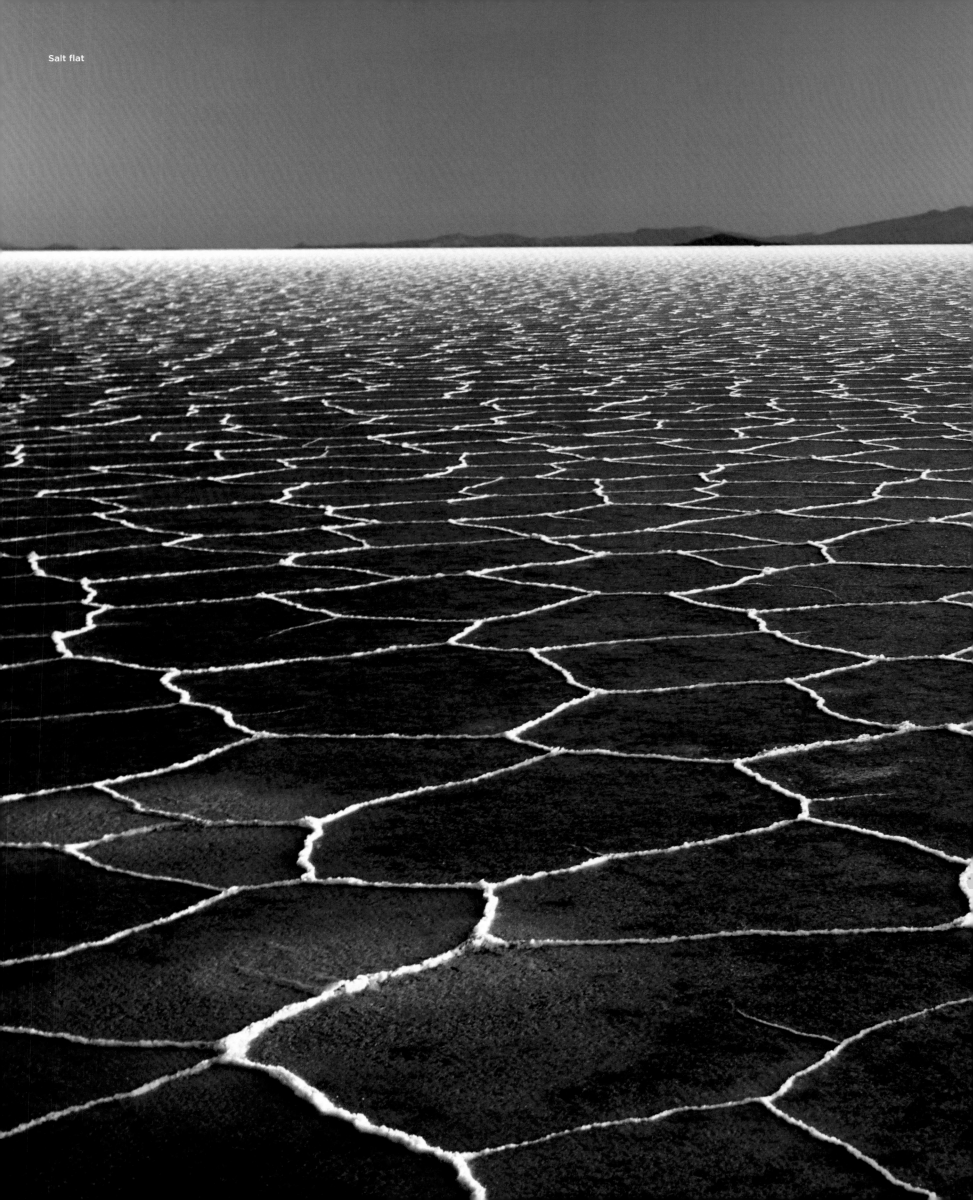

Salt flat

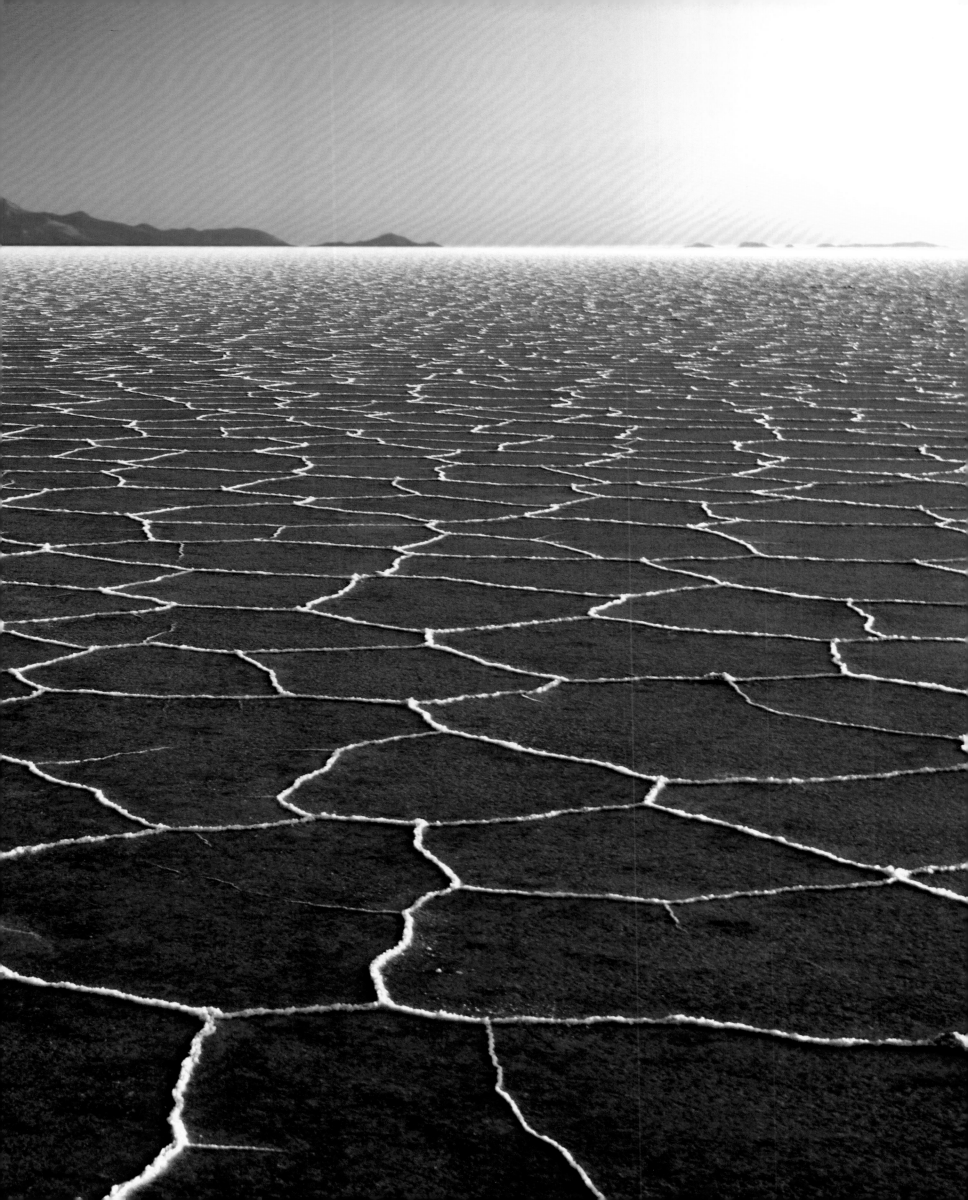

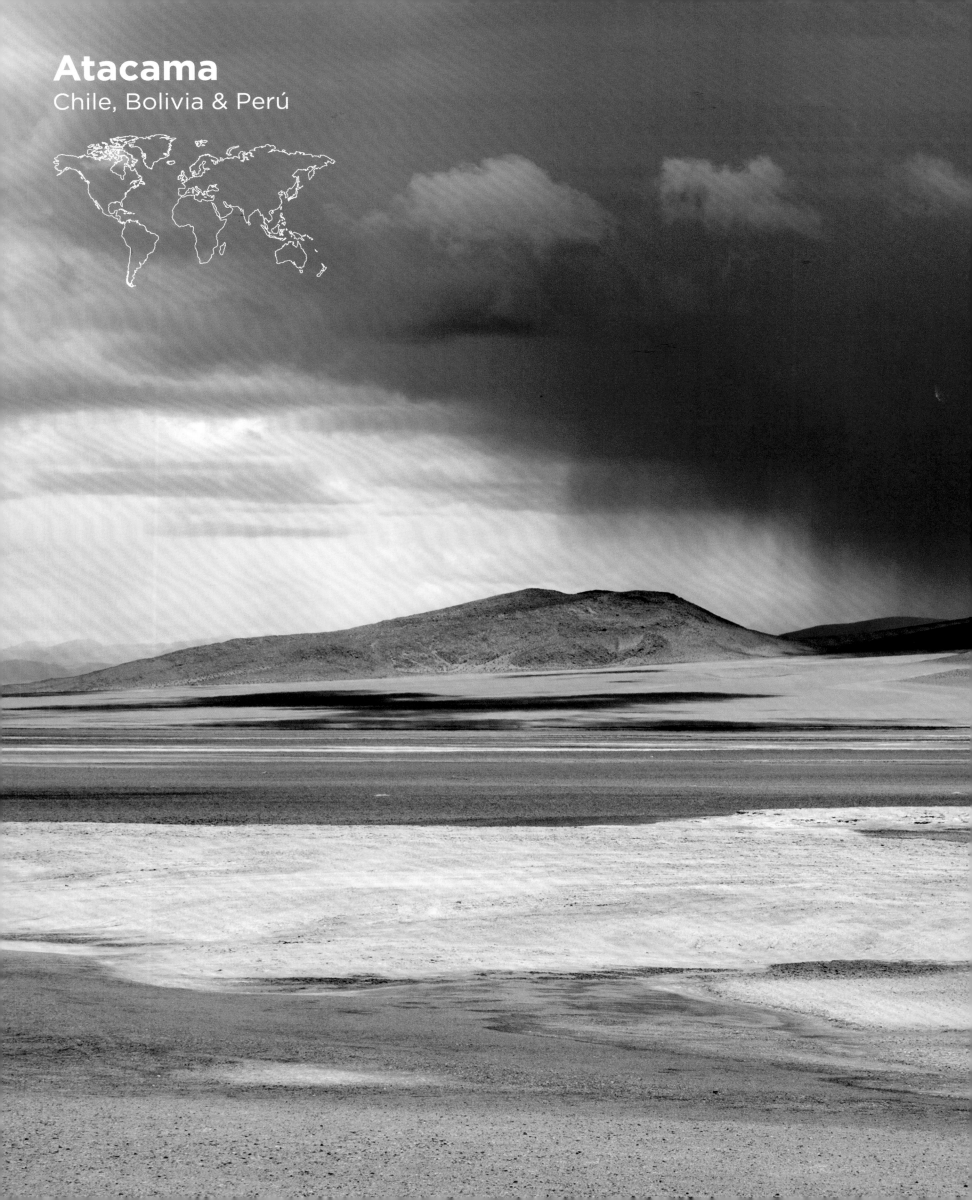

Atacama
Chile, Bolivia & Perú

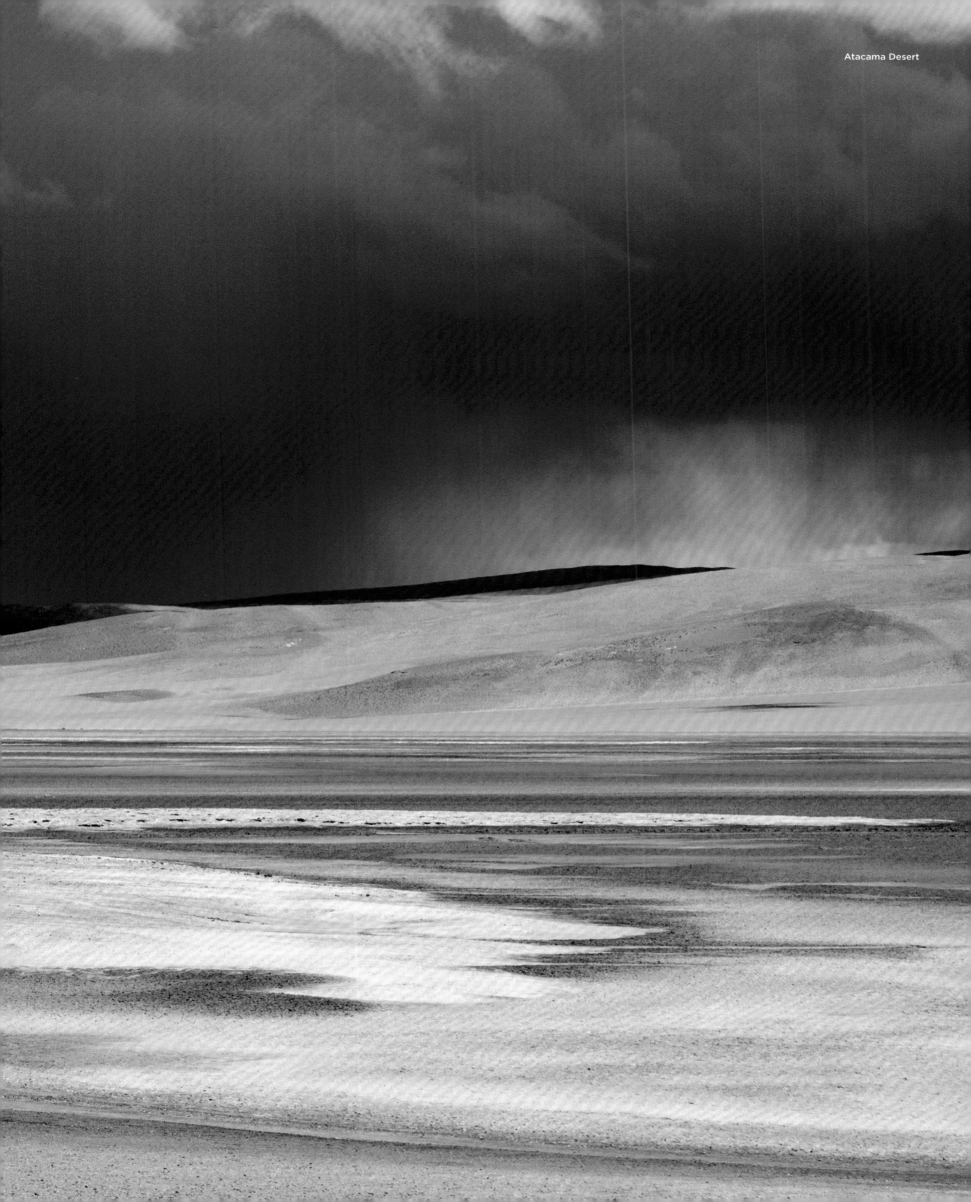

Atacama Desert

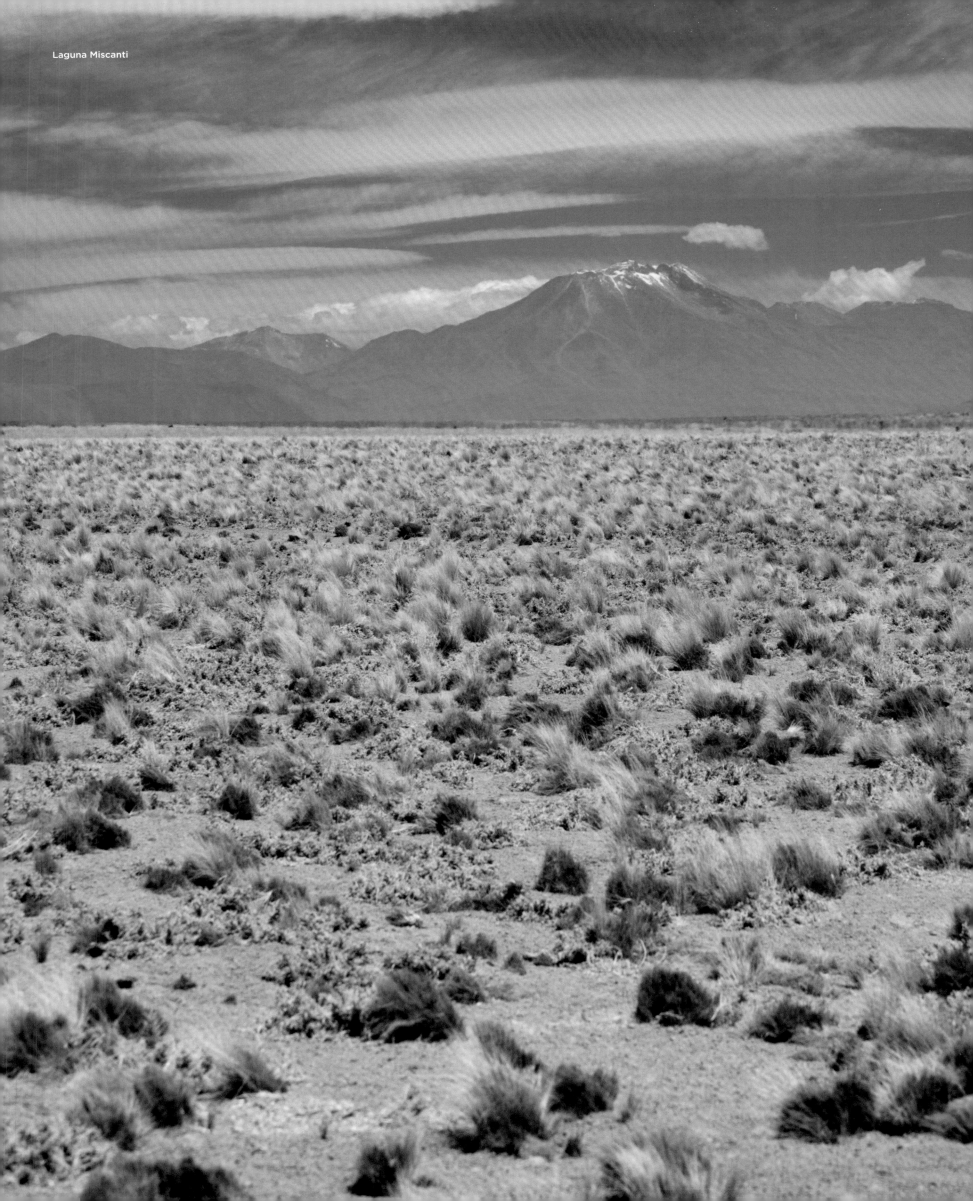

Laguna Miscanti

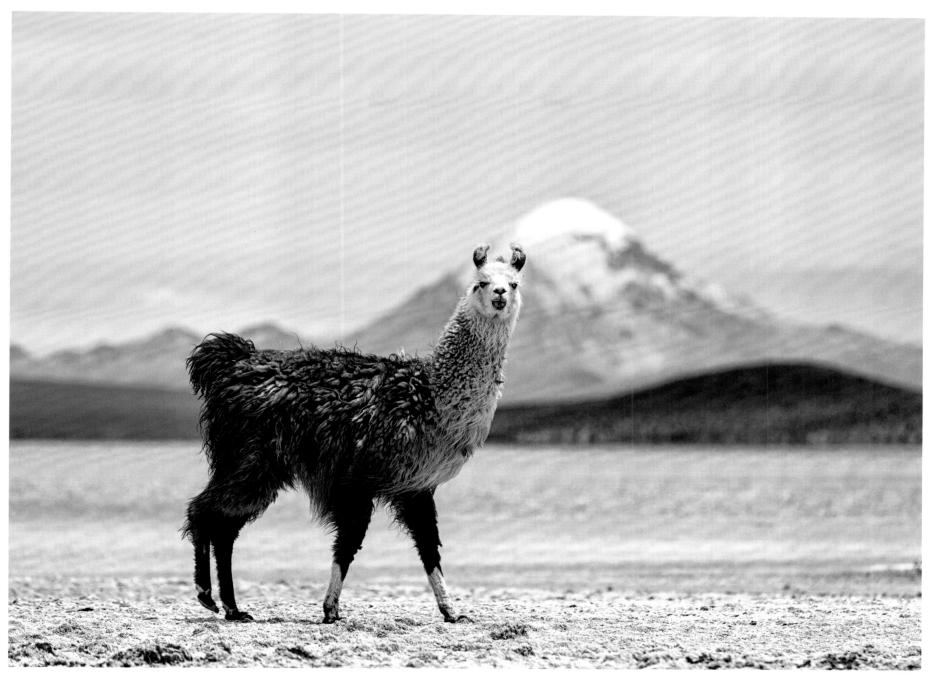
Llama

Atacama Desert

The Atacama runs for 1000 km to 1600 km along the west coastal strip of South America, passing through Peru, Argentina and Chile. The offshore Humboldt Ocean Current creates conditions that have made the Atacama the driest desert on the planet (apart from the polar deserts). Some places of the Atacama have never seen rain in recorded history.

Desierto de Atacama

El Atacama recorre de 1000 km a 1600 km a lo largo de la franja costera occidental de Sudamérica, pasando por Perú, Argentina y Chile. La Corriente Oceánica de Humboldt crea condiciones que han convertido a Atacama en el desierto más seco del planeta (aparte de los desiertos polares). Algunos lugares de Atacama nunca han visto lluvias en la historia.

Le désert d'Atacama

L'Atacama couvre environ 1000 à 1600 kilomètres de bande côtière occidentale sud-américaine à travers le Pérou, l'Argentine et le Chili. Le courant côtier océanique Humboldt est à l'origine des conditions qui font de l'Atacama le désert le plus sec de la planète (en dehors des déserts polaires). Certains endroits de l'Atacama n'auraient jamais connu la pluie.

Deserto do Atacama

O Atacama percorre 1000 km a 1600 km ao longo da costa oeste da América do Sul, passando pelo Peru, Argentina e Chile. O corrente de Humboldt cria condições que fizeram do Atacama o deserto mais seco do planeta (além dos desertos polares). Alguns lugares do Atacama nunca viram chuva na história registrada.

Atacama-Wüste

Die Atacama erstreckt sich 1000 km bis 1600 km entlang der Westküste Südamerikas und liegt in Peru, Argentinien und Chile. Der Humboldtstrom vor der Küste schafft Bedingungen, die die Atacama zur trockensten Wüste des Planeten machen (nur in den Polarwüsten fällt weniger Niederschlag). Einige Teilen der Atacama hat es seit Beginn der Aufzeichnungen noch nie geregnet.

Atacama

De Atacama loopt 1000 tot 1600 km langs de westelijke kuststrook van Zuid-Amerika, dwars door Peru, Argentinië en Chili. De Humboldtstroom voor de kust creëert omstandigheden die de Atacama tot de droogste woestijn op aarde hebben gemaakt (alleen in de poolwoestijnen valt minder neerslag). Sommige plaatsen van de Atacama hebben nog nooit regen gezien sinds er over hun geschiedenis geschreven is.

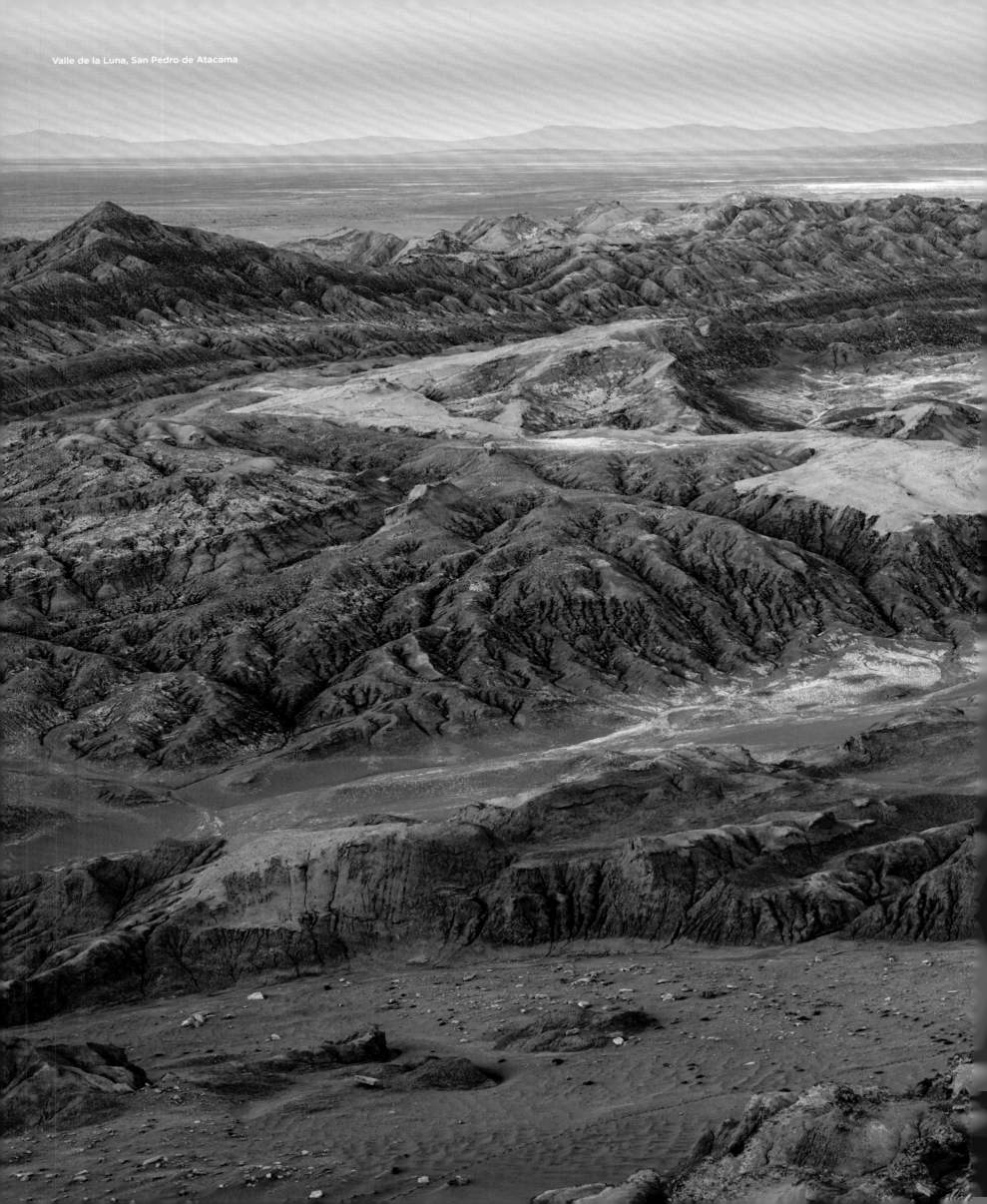

Valle de la Luna, San Pedro de Atacama

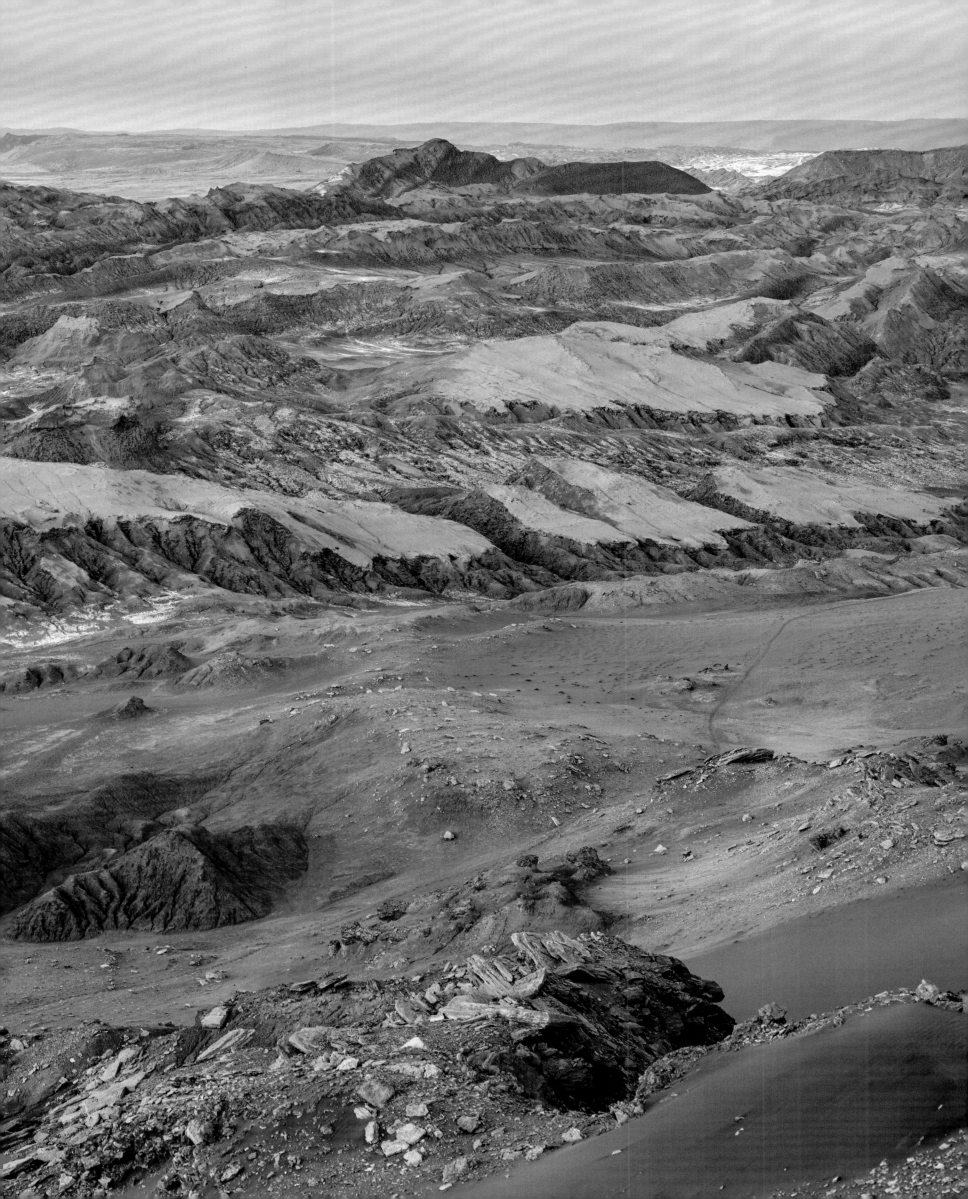

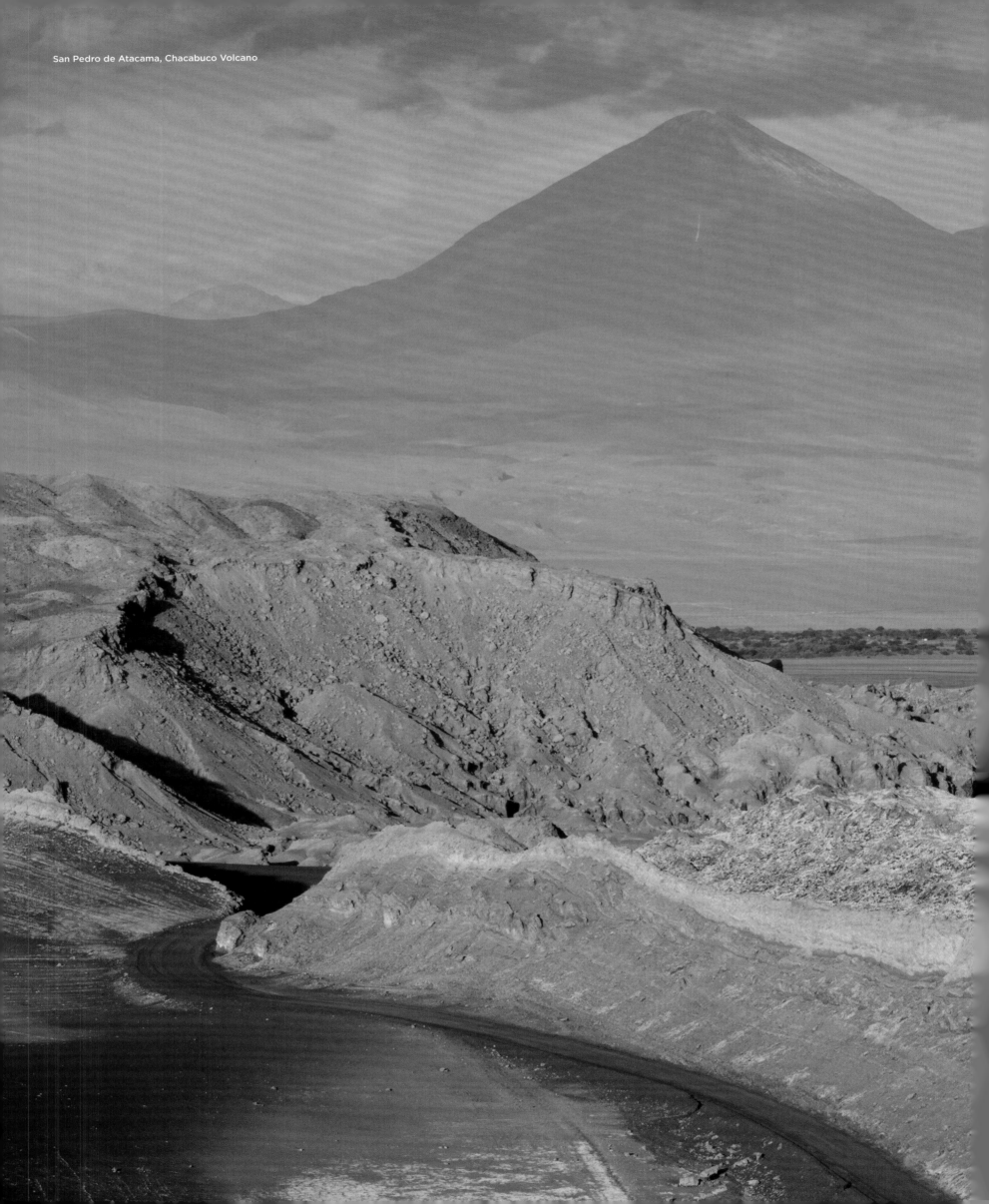

San Pedro de Atacama, Chacabuco Volcano

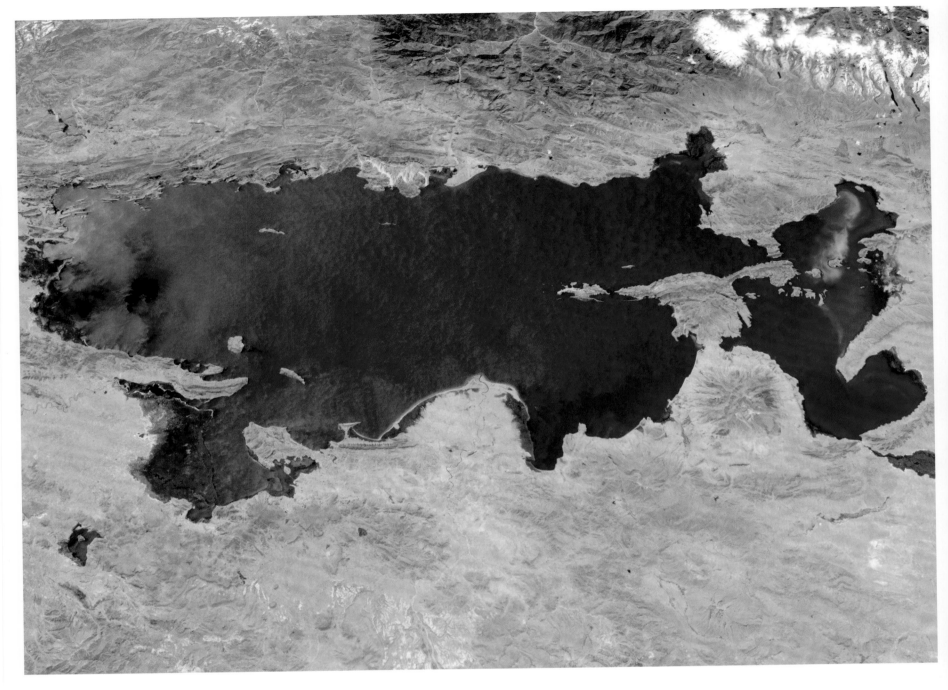

Lake Titicaca, Bolivia, Peru

Lake Titicaca

South America's largest non-tidal lake, Lake Titicaca is the highest-altitude navigable lake on earth at 3 812 m above sea level. Fed by five rivers and once the home of the Incas, Titicaca is famous as the place where Norwegian explorer Thor Heyerdahl came to learn about reed-boat construction for his numerous ocean-going expeditions. Climate change may be having an impact on the lake – with shorter rainy seasons and the run-off from melting Andean glaciers going elsewhere, lake levels are falling, including by up to a meter in 2009.

Le lac Titicaca

Plus grand lac sans marées d'Amérique du Sud, le Titicaca est le lac navigable le plus haut de la planète, avec une altitude de 3 812 mètres au-dessus du niveau de la mer. Alimenté par cinq rivières et jadis le foyer des Incas, le Titicaca est également connu pour la présence de l'explorateur norvégien, Thor Heyerdahl, venu y apprendre la construction de bateaux en roseaux en perspective de ses nombreuses expéditions sur l'océan. Le changement climatique pourrait avoir un impact sur le lac – avec des saisons des pluies plus courtes et une dérivation du ruissellement de la fonte des glaciers andins, le niveau de ses eaux ont baissé d'un mètre en 2009, par exemple. Le lac possède quarante et une îles, aux populations croissantes. La rive du lac pourrait connaître elle aussi des transformations.

Titicacasee

Der Titicacasee, Südamerikas größter Süßwassersee, ist mit 3 812 m über dem Meeresspiegel auch der höchstgelegene schiffbare See der Welt. Er wird von fünf Flüssen gespeist und war einst Heimat der Inkas. Der norwegische Forschungsreisende Thor Heyerdahl kam hierher, um für seine zahlreichen Ozean-Expeditionen mehr über den Bau von Schilfbooten zu erfahren. Möglicherweise wirkt sich der Klimawandel bereits auf den See aus – kürzere Regenzeiten und Schmelzwasser der Andengletscher, das sich andere Abflussrichtungen sucht, führen zu einem sinkenden Wasserspiegel im See – im Jahr 2009 war es knapp ein Meter.

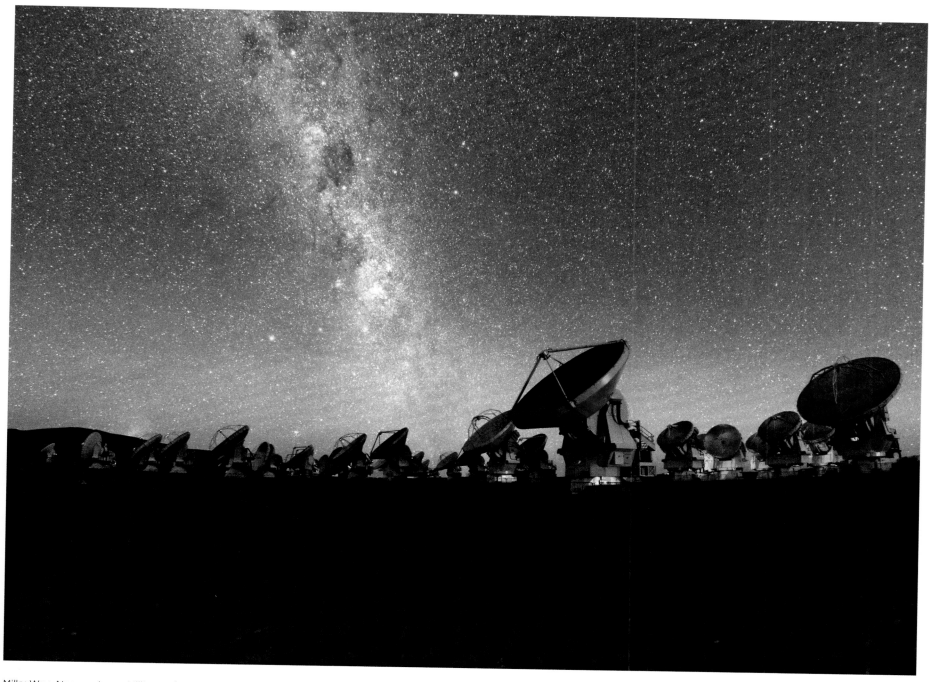

Milky Way, Atacama Large Millimeter/submillimeter Array (ALMA), Radio telescopes

Lago Titicaca

El lago no mareomotriz más grande de Sudamérica, el Titicaca, es el lago navegable de mayor altitud en la tierra, a 3 812 m sobre el nivel del mar. El Titicaca, que es alimentado por cinco ríos y una vez fue el hogar de los Incas, es famoso como el lugar donde el explorador noruego Thor Heyerdahl vino a aprender sobre la construcción de botes de caña para sus numerosas expediciones en el océano. El cambio climático puede estar afectando al lago: temporadas de lluvias más cortas y la escorrentía del derretimiento de los glaciares andinos se está desplazando a otros lugares, los niveles de los lagos están bajando, incluso hasta en un metro en 2009.

Lago Titicaca

O maior lago não-maré da América do Sul, o Lago Titicaca, é o lago navegável de maior altitude na Terra, a 3 812 m acima do nível do mar. Alimentado por cinco rios e outrora a casa dos Incas, Titicaca é famoso como o local onde o explorador norueguês Thor Heyerdahl veio aprender sobre a construção de barcos de junco para suas numerosas expedições oceânicas. A mudança climática pode estar causando um impacto no lago - com estações chuvosas mais curtas e o escoamento das geleiras andinas derretendo para outros lugares, os níveis dos lagos estão caindo, incluindo até um metro em 2009.

Titicacameer

Het Titicacameer, het grootste zoetwatermeer van Zuid-Amerika, is met 3 812 meter boven zeeniveau ook het hoogst gelegen bevaarbare meer op aarde. Het wordt gevoed door vijf rivieren en was ooit de thuisbasis van de Inca's. De Noorse ontdekkingsreiziger Thor Heyerdahl kwam hierheen om voor zijn talrijke oceaanexpedities meer te weten te komen over de bouw van een rietboot. Klimaatverandering heeft mogelijk al gevolgen voor het meer: door kortere regenseizoenen en afvloeiing van het smeltwater van de Andesgletsjers elders daalt de waterspiegel. In 2009 met bijna een meter.

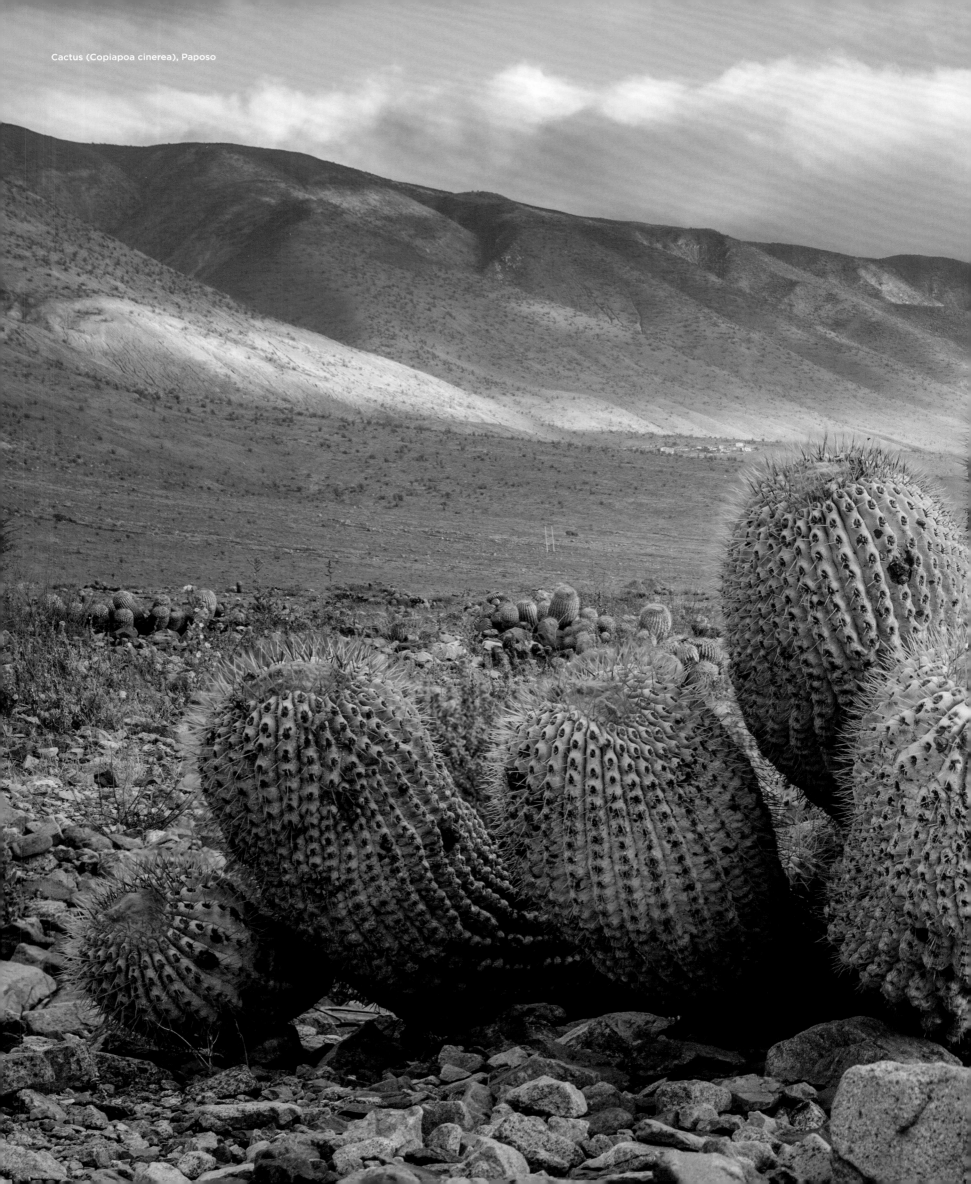

Cactus (Copiapoa cinerea), Paposo

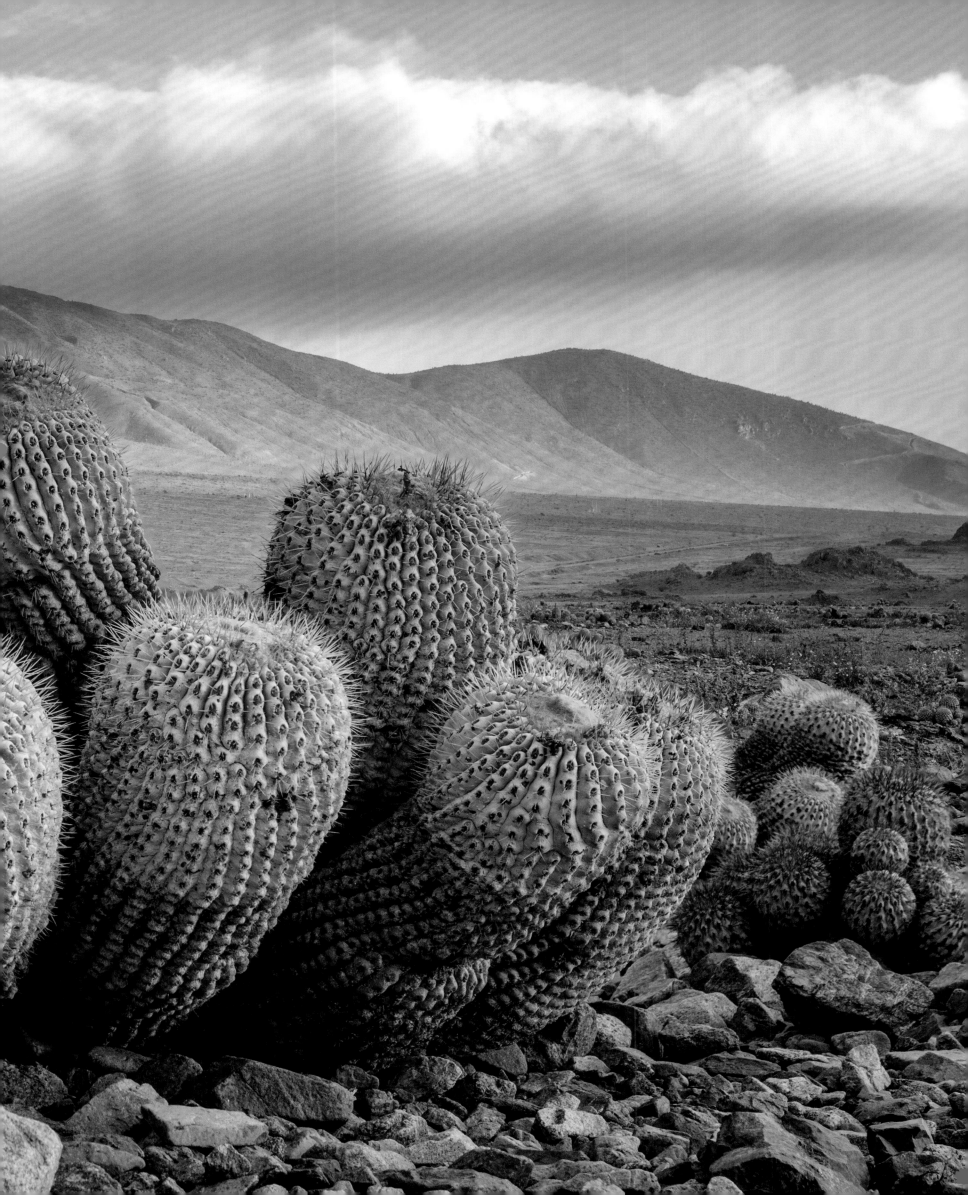

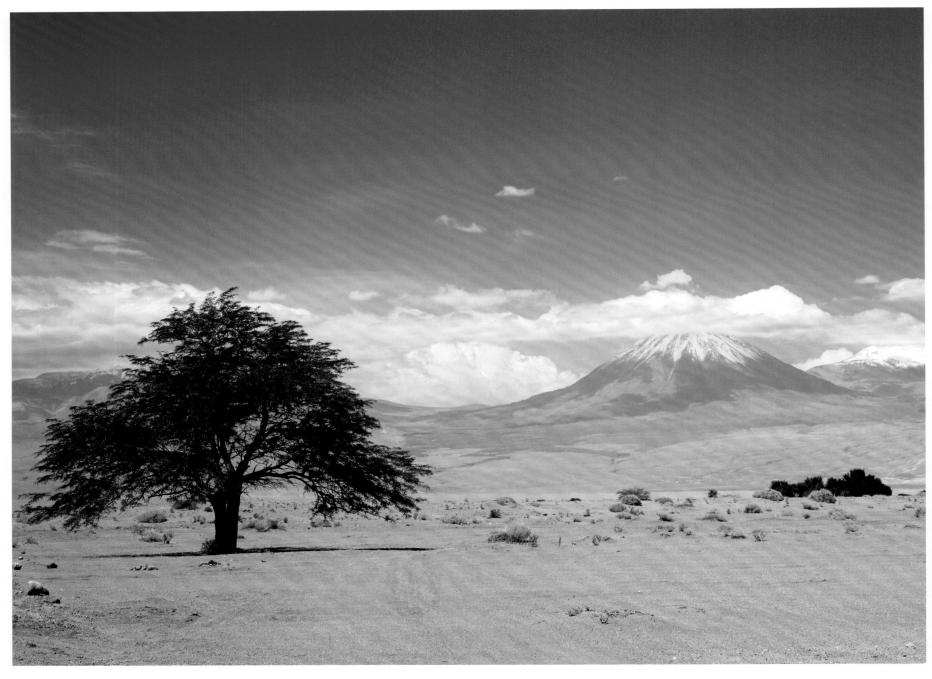

Arid landscpae & snowcapped Volcano

Atacama Volcanos

Like line drawings from a child's imagination of what real mountains look like, perfectly conical Andean volcanos appear at regular intervals along the eastern border of the Atacama Desert. Some appear marooned out on high-altitude plateaus formed by lava spills in ancient times. An estimated six still remain active, although their remote locations ensure that the risk to human life is generally considered to be small. Given that the volcanos' exterior walls were once coated in lava and some are snow-capped, the interplay of colours between the parched desert and the volcano's walls is often dramatic.

Les volcans d'Atacama

Tel un dessin au trait de montagnes réelles vues à travers l'imagination d'un enfant, les volcans andins parfaitement coniques surgissent à intervalles réguliers le long de la côte orientale du désert d'Atacama. Certains semblent avoir été abandonnés sur les plateaux de haute altitude formés par la lave déversée à une époque ancienne. Environ six d'entre eux sont encore en activité, mais leur localisation, lointaine, les rend inoffensifs pour la vie humaine. Certains volcans étant jadis couronnés de neige et leurs parois extérieures recouvertes de lave, le jeu des couleurs entre le désert desséché et les flancs des volcans peut être spectaculaire.

Atacama-Vulkane

In regelmäßigen Abständen erheben sich am Ostrand der Atacama-Wüste die konisch geformte Andenvulkane, die an Kinderzeichnungen erinnern. Einige wirken wie gestrandet auf Hochebenen, die in längst vergangenen Zeiten durch Lavaströme gebildet wurden. Schätzungsweise sechs von ihnen sind noch aktiv, allerdings stellen sie auf Grund ihrer abgelegenen Standorte nur eine geringe Gefahr für Menschen dar. Da die Hänge der Vulkane einst mit Lava bedeckt wurden und teilweise schneebedeckt sind, ist das Farbenspiel zwischen der ausgetrockneten Wüste und den Abhängen der Vulkane oft sehr beeindruckend.

Valley of the Moon

Volcanes de Atacama

Como dibujos de líneas de la imaginación de un niño sobre cómo son las verdaderas montañas, los volcanes andinos perfectamente cónicos aparecen a intervalos regulares a lo largo de la orilla oriental del desierto de Atacama. Algunos aparecen abandonados en mesetas de gran altitud formadas por derrames de lava en la antigüedad. Se estima que seis de ellos siguen activos, aunque por su ubicación remota, el riesgo para la vida humana se considera en general pequeño. Dado que las paredes exteriores de los volcanes estuvieron algún día cubiertas de lava y algunas están cubiertas de nieve, la interacción de colores entre el desierto reseco y las paredes del volcán da un aire a menudo dramático.

Vulcões do Atacama

Assim como os desenhos de linhas da imaginação de uma criança sobre as montanhas reais, vulcões andinos perfeitamente cônicos aparecem em intervalos regulares ao longo da costa leste do Deserto do Atacama. Alguns aparecem abandonados em planaltos de alta altitude formados por derrames de lava nos tempos antigos. Estima-se que seis ainda permaneçam ativos, embora suas localizações remotas garantam que o risco para a vida humana seja geralmente considerado pequeno. Dado que as paredes exteriores dos vulcões já foram revestidas de lava e algumas são cobertas de neve, a interação de cores entre o deserto árido e as paredes do vulcão é muitas vezes dramática.

Vulkanen in de Atacama

Als lijntekeningen uit de fantasie van een kind over hoe echte bergen eruitzien, verschijnen er regelmatig perfect kegelvormige vulkanen langs de oostkust van de Atacama-woestijn. Sommige lijken te zijn achtergelaten op de hoogvlakten die in een ver verleden door gemorste lava zijn gevormd. Naar schatting zijn er nog steeds zes actief, maar die leveren vanwege hun afgelegen standplaats weinig gevaar op voor mensen. Aangezien de hellingen van de vulkanen ooit bedekt waren met lava en deels bedekt zijn met sneeuw, is het kleurenspel tussen de uitgedroogde woestijn en de vulkaanhellingen vaak adembenemend.

Road crossing

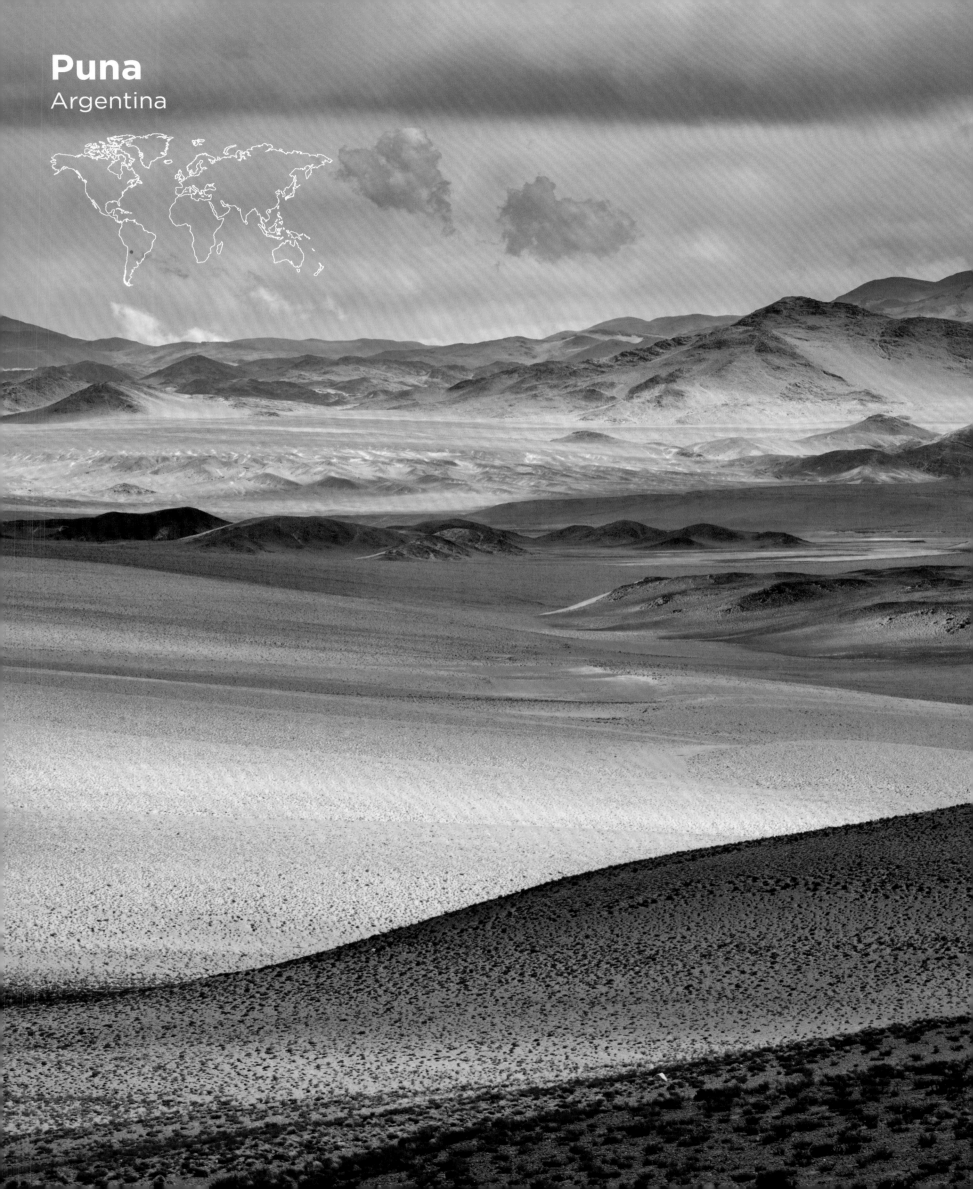

Puna
Argentina

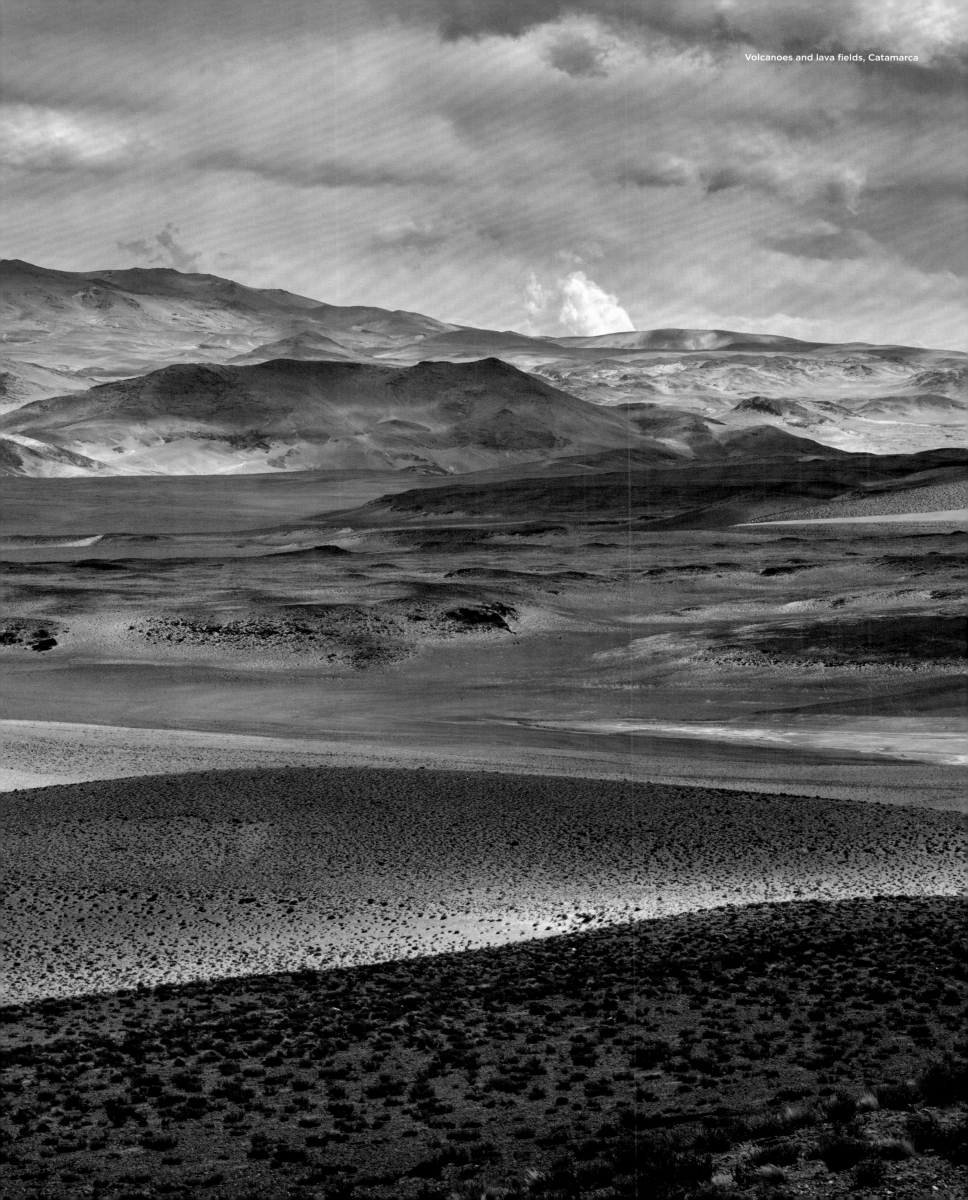

Volcanoes and lava fields, Catamarca

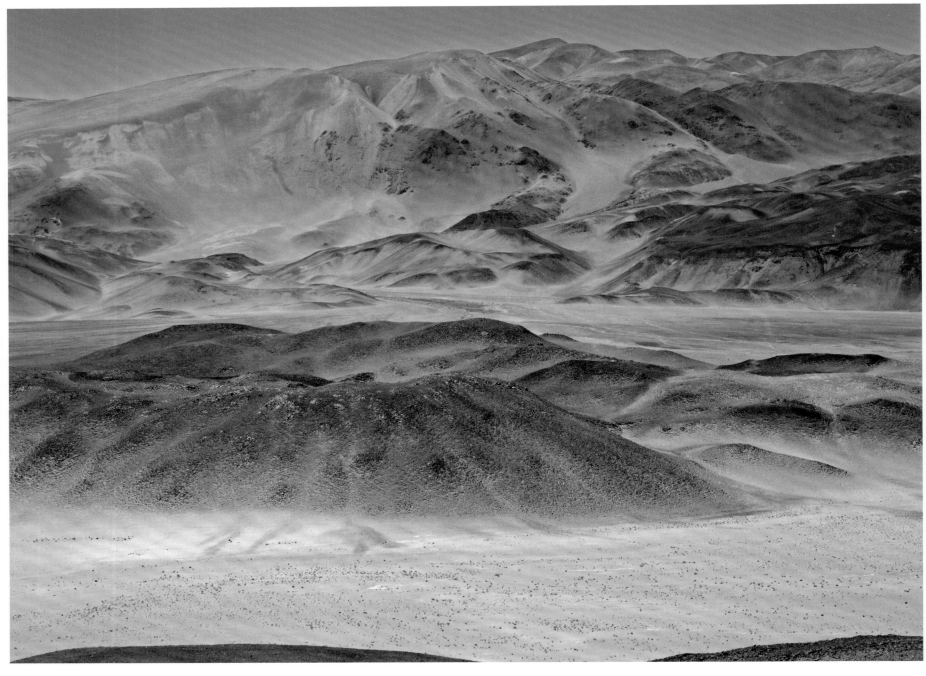

Salar de Antofalla, Catamarca

Puna Desert

This landlocked, high upland plateau forms part of the Greater Atacama region, and lies primarily in Argentina (85%) with some of the Puna Desert extending into Chile (15%). Such characterisations were once significantly more complex – for much of the 19th century belonged to Bolivia, but was surrendered to Argentina in 1898 in exchange for Tarija. Chile complained, and the current borders were finalised in 1899. The average altitude of the Puna Plateau is 4 500 m above sea level, and it covers 180 000 km².

Le désert de Puna

Ce plateau de hautes terres enclavé forme une partie de la région de l'Acatama et s'étend principalement en Argentine (85%) ainsi qu'au Chili (15%). Ces caractéristiques ont jadis été beaucoup plus complexes, le plateau ayant appartenu à la Bolivie durant une grande partie du XIXe siècle avant d'être rendu à l'Argentine, en 1898, en échange de Tarija. Suite à des plaintes de la part du Chili, les frontières actuelles ont été finalisées en 1899. Le plateau de Puna atteint une altitude moyenne de 4 500 mètres au-dessus du niveau de la mer et couvre une surface de 180 000 km².

Puna-Wüste

Diese Hochwüste ist Teil der Atacama-Region und liegt vor allem in Argentinien (85%), ein kleinerer Teil (15%) auch in Chile. Solche Zuordnungen waren in der Vergangenheit wesentlich komplexer – der Großteil gehörte im 19. Jahrhundert zu Bolivien, wurde aber 1898 im Austausch für Tarija an Argentinien abgegeben. Chile beschwerte sich über den Tausch, und 1899 wurden die derzeitigen Grenzen endgültig festgelegt. Die durchschnittliche Höhe des Puna-Plateaus beträgt 4 500 m über dem Meeresspiegel, ihre Fläche 180 000 km².

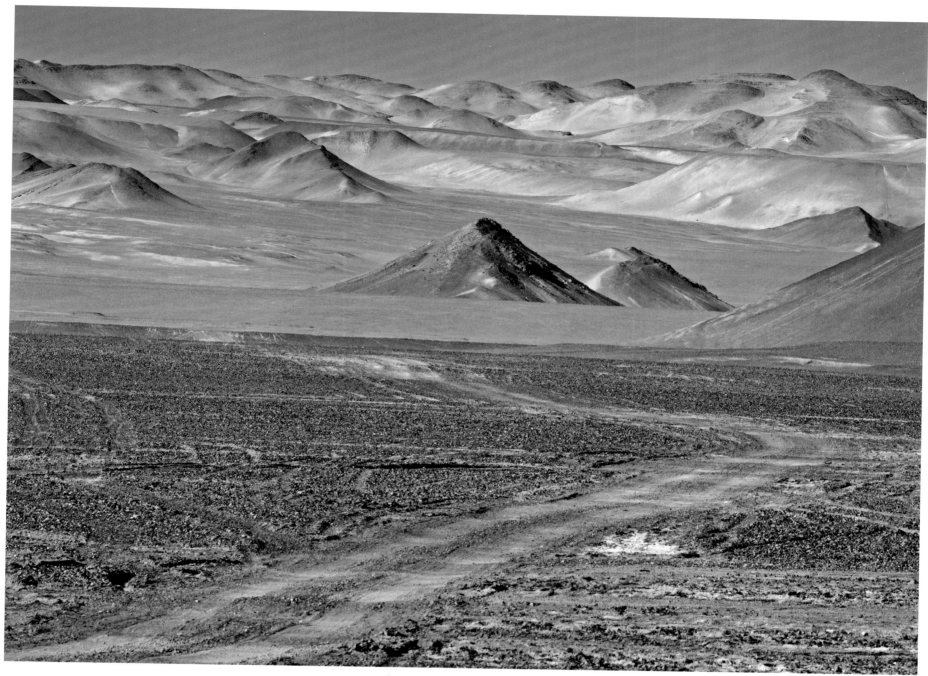

Campo de Piedra Pomez, Catamarca

Desierto de Puna

Esta meseta montañosa sin salida al mar forma parte de la región del Gran Atacama, y se encuentra principalmente en Argentina (85%), aunque parte del desierto de Puna se extiende hasta Chile (15%). Tales caracterizaciones fueron una vez considerablemente más complejas: durante gran parte del siglo XIX pertenecieron a Bolivia, pero fueron entregadas a Argentina en 1898 a cambio de Tarija. Chile se quejó y las fronteras actuales se terminaron en 1899. La altitud media de la meseta de la Puna es de 4 500 m sobre el nivel del mar y tiene una extensión de 180 000 km².

Deserto da Puna

Este planalto elevado e sem terras altas faz parte da região do Grande Atacama e encontra-se principalmente na Argentina (85%), com parte do Deserto de Puna se estendendo até o Chile (15%). Tais caracterizações foram significativamente mais complexas – durante grande parte do século 19 pertencia à Bolívia, mas foi entregue à Argentina em 1898 em troca de Tarija. O Chile reclamou, e as fronteiras atuais foram finalizadas em 1899. A altitude média do Planalto da Puna é de 4 500 m acima do nível do mar e cobre 180 000 km².

Puna de Atacama

Deze ingesloten hoogvlakte maakt deel uit van de Atacama en ligt voornamelijk in Argentinië (85%), met een kleiner deel in Chili (15%). Dit soort toewijzingen waren in het verleden aanzienlijk complexer: het grootste deel hoorde in de 19e eeuw bij Bolivia, maar werd in 1898 aan Argentinië overgedragen in ruil voor Tarija. Chili maakte bezwaar en de huidige grenzen werden in 1899 definitief vastgelegd. De Altiplano Puna ligt gemiddeld 4 500 meter boven zeeniveau en beslaat 180 000 km².

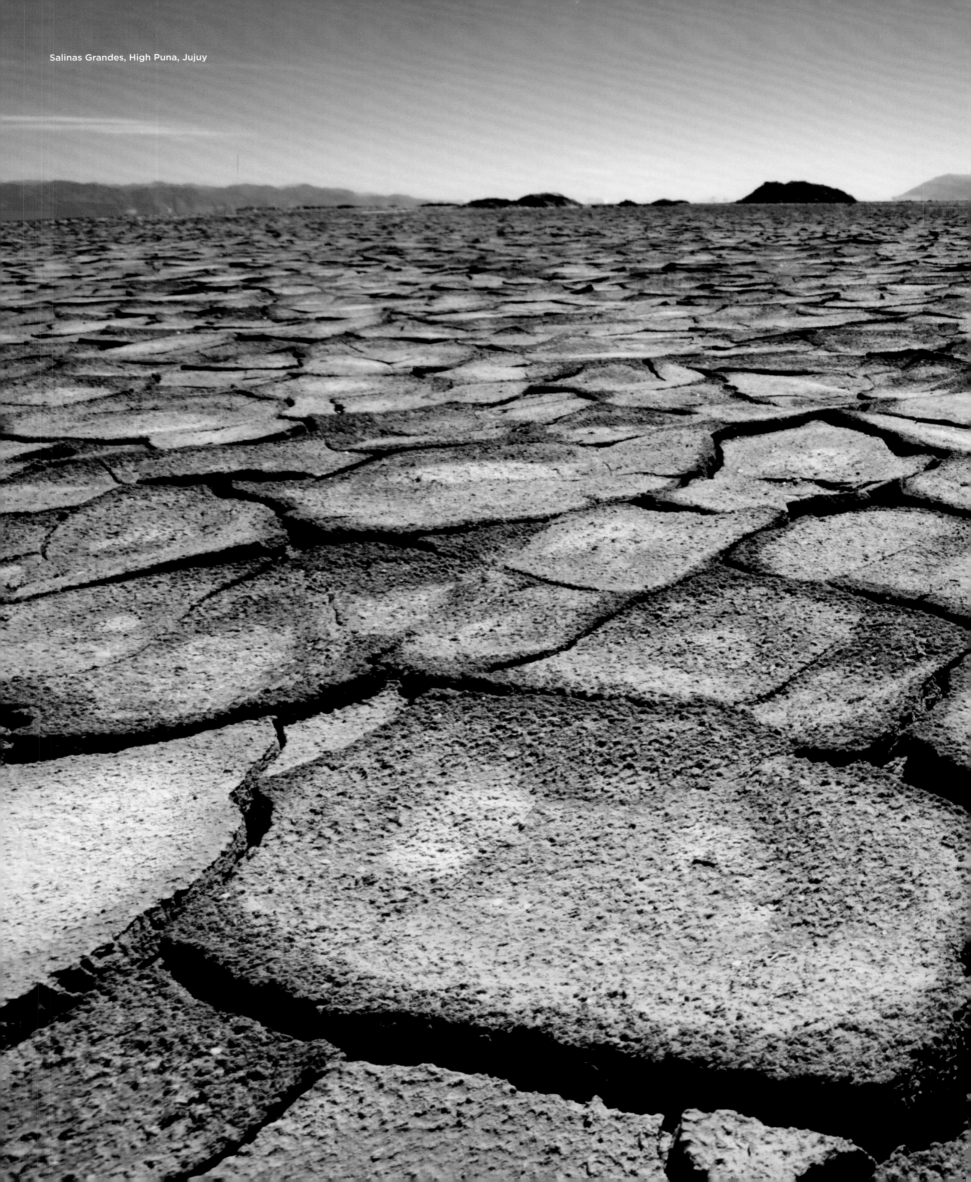

Salinas Grandes, High Puna, Jujuy

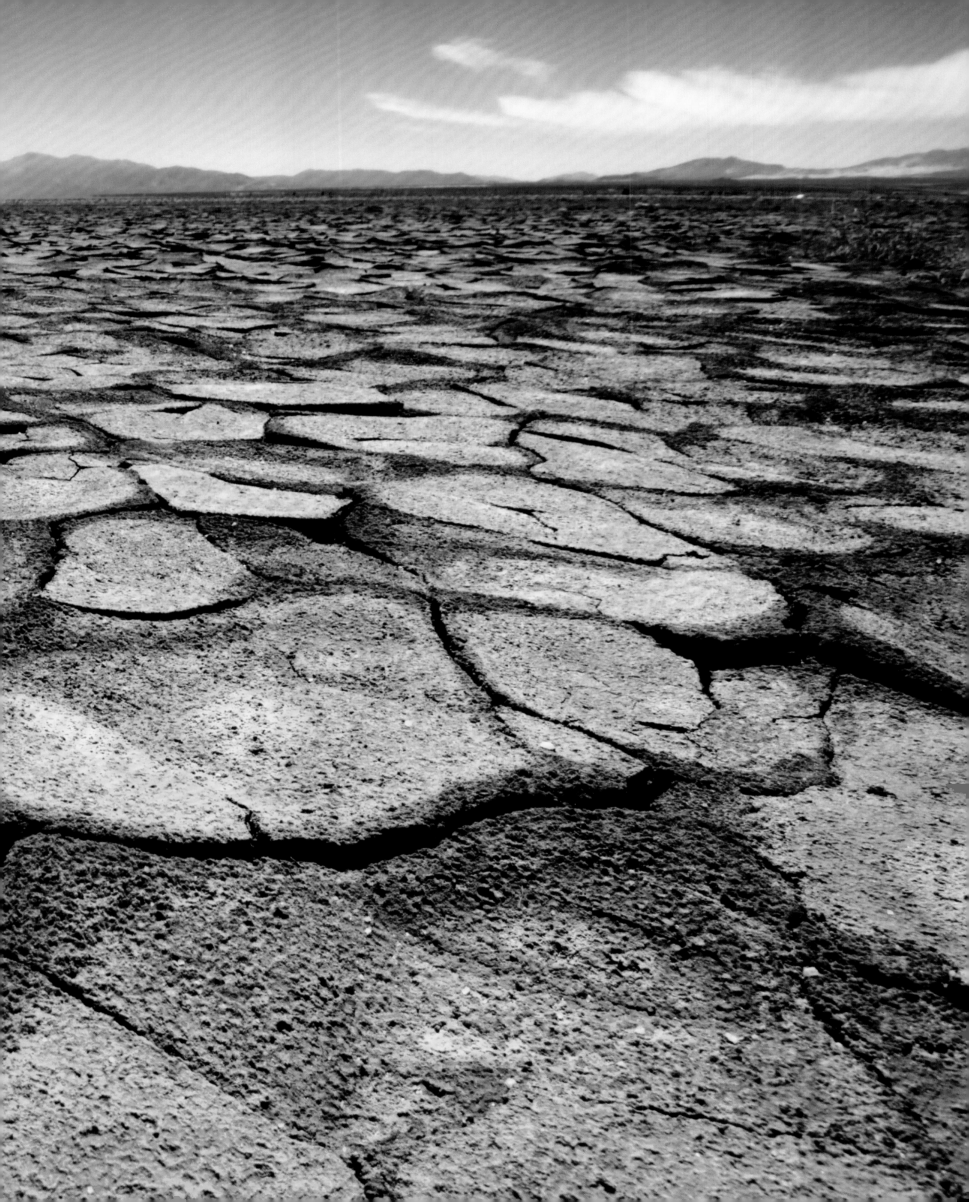

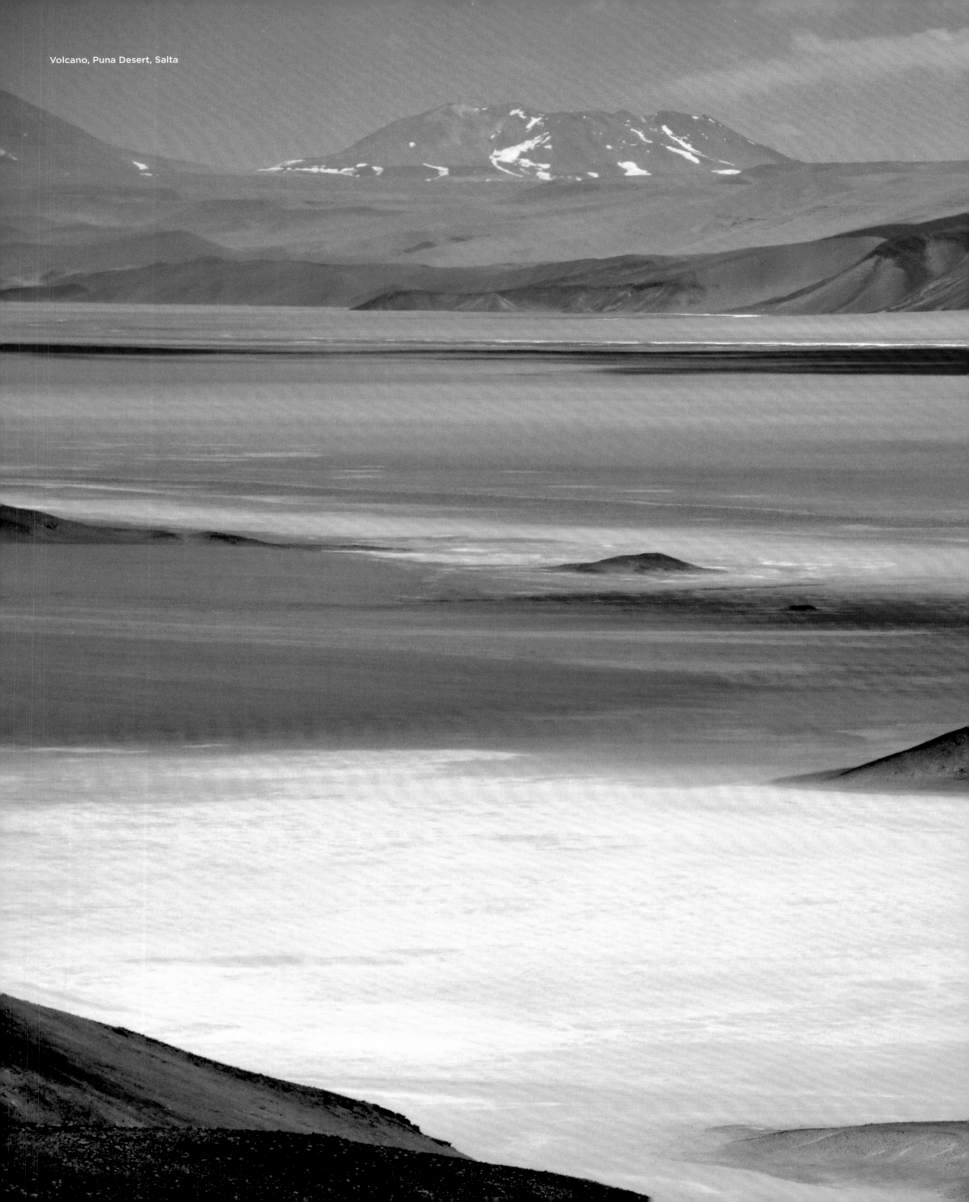

Volcano, Puna Desert, Salta

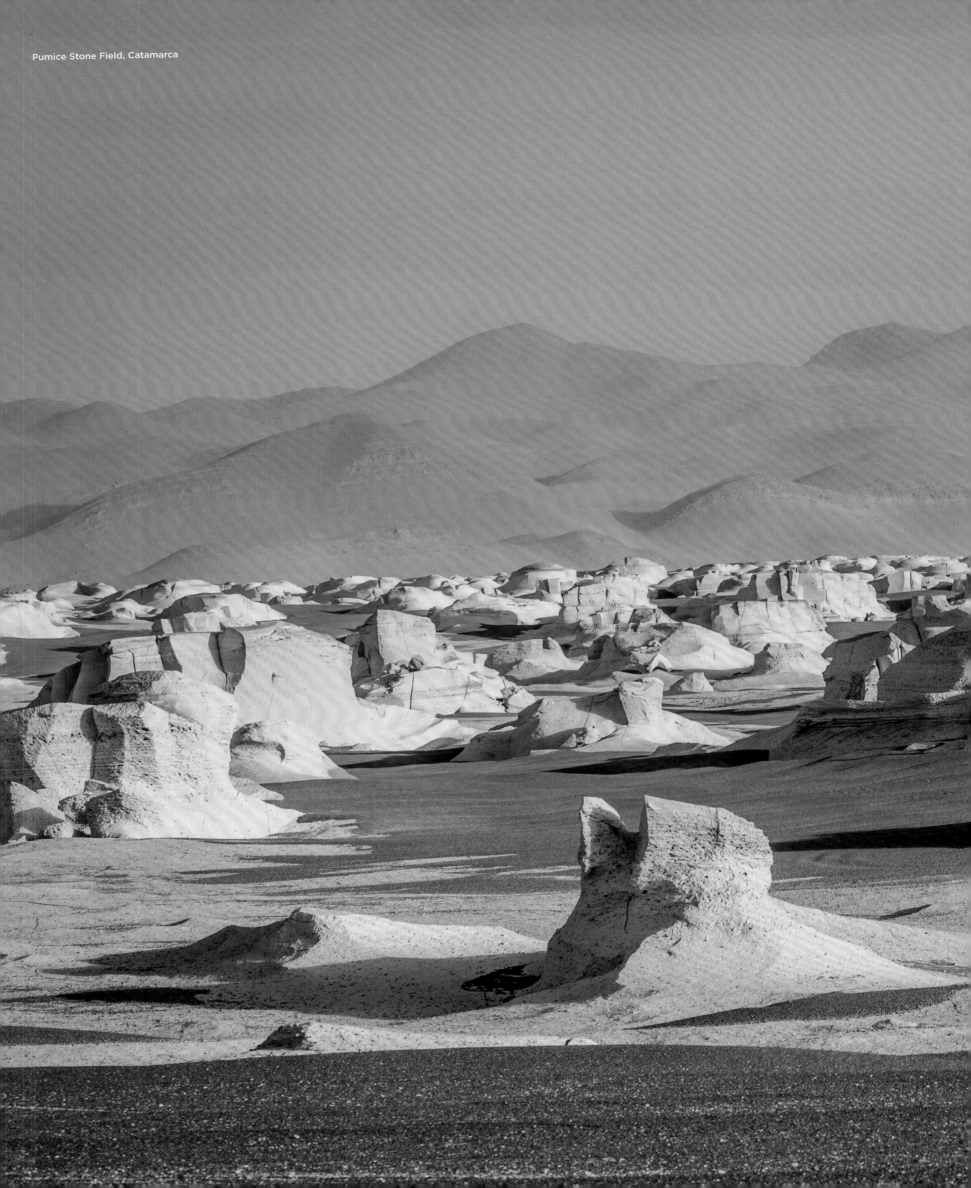

Pumice Stone Field, Catamarca

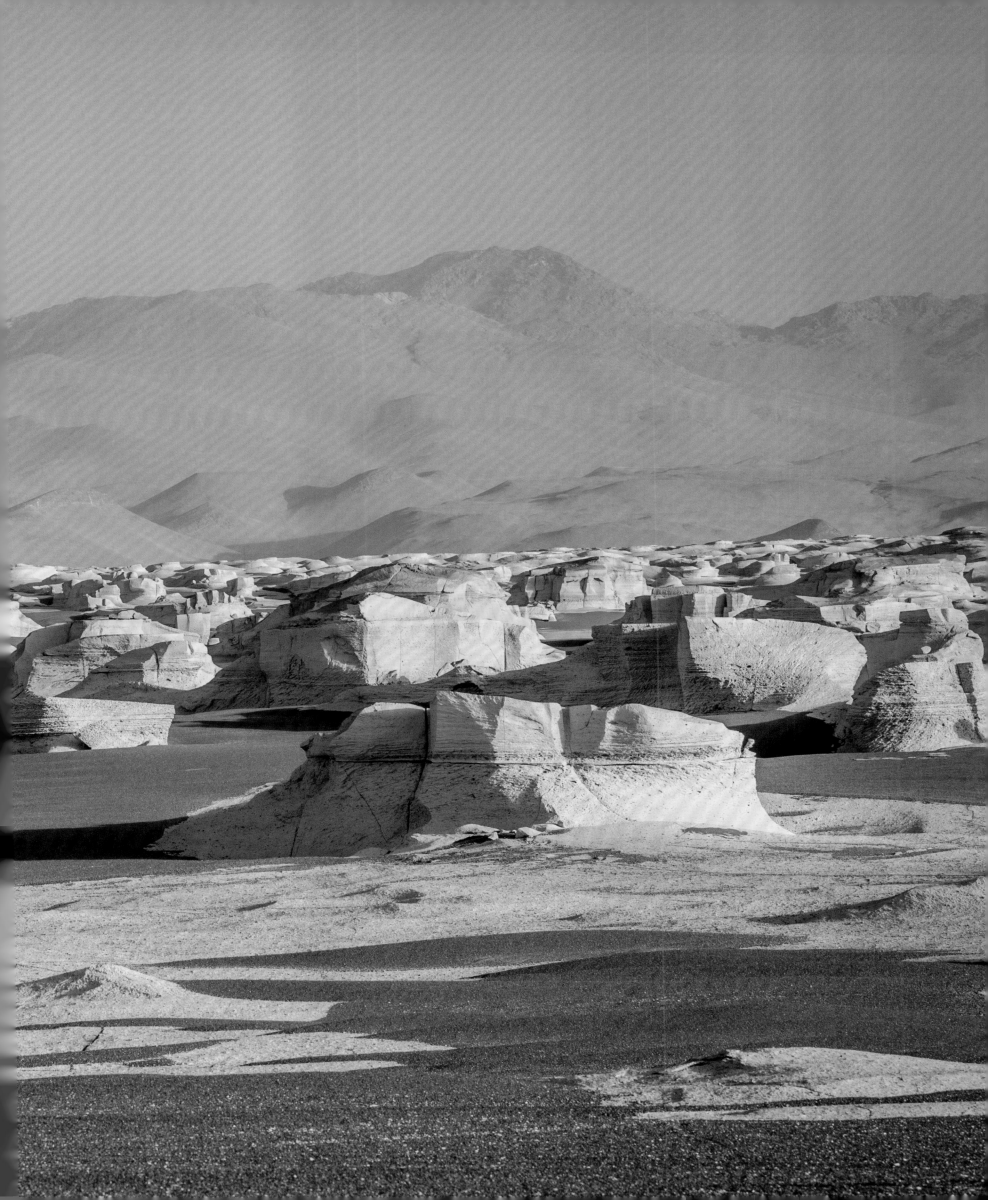

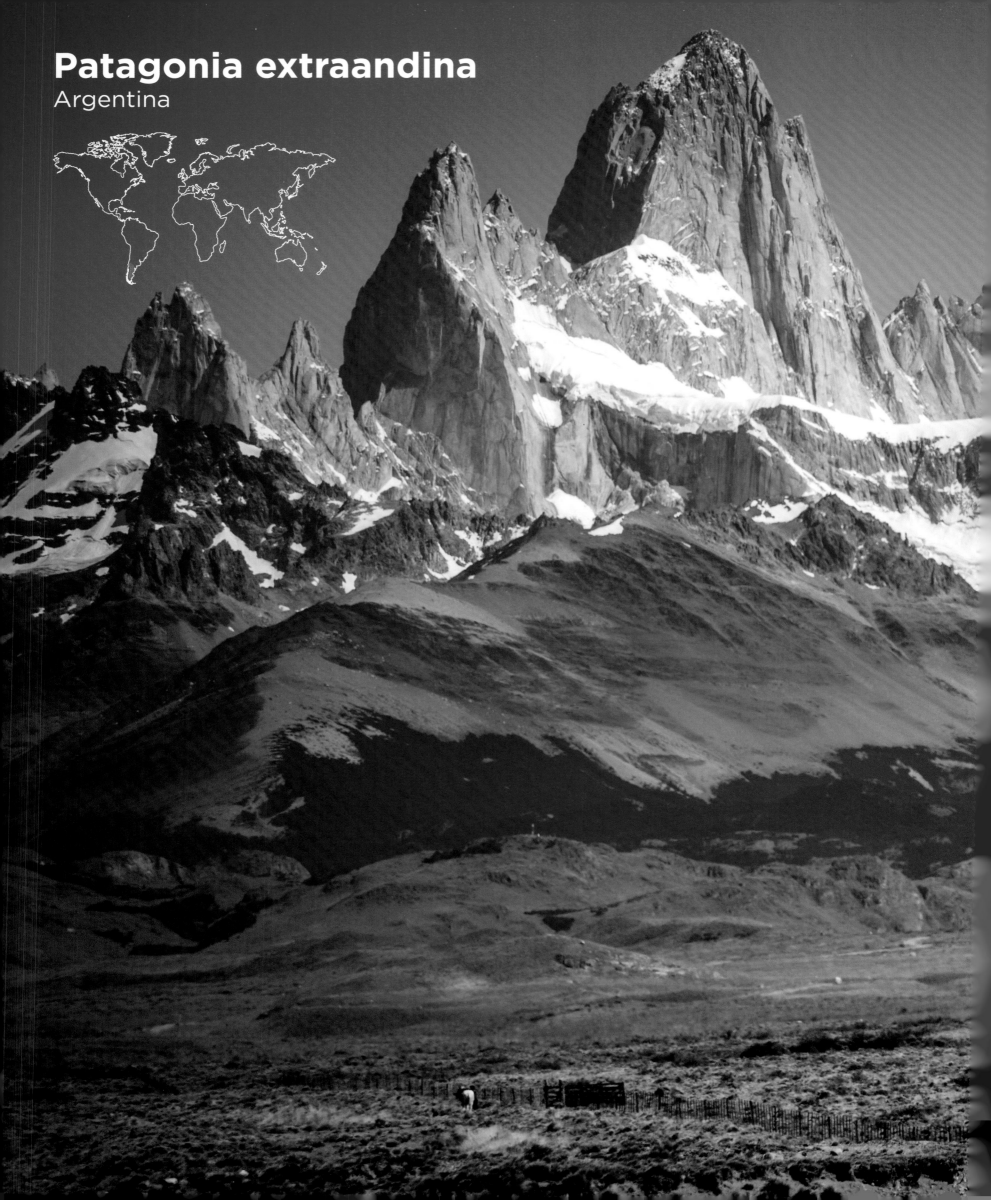

Patagonia extraandina
Argentina

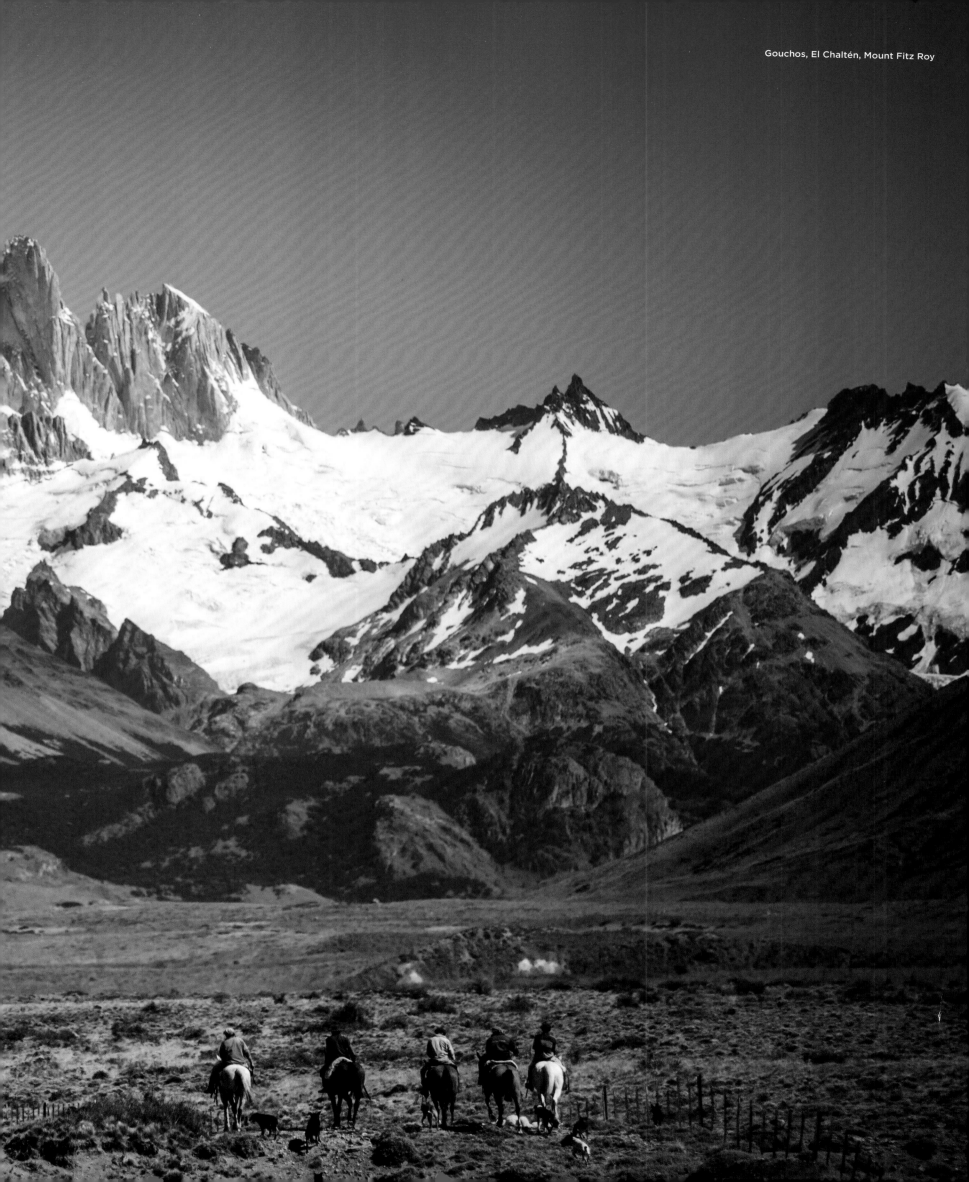

Gouchos, El Chaltén, Mount Fitz Roy

Patagonian Desert

Patagonian Desert

More often associated with snow-capped mountains and calving glaciers, Patagonia is actually home to the world's eighth-largest desert, also called the Patagonian Steppe, which lies almost entirely within Argentina. For a desert, the climate is unusual, with seven months of winter (when temperatures regularly drop below freezing and daytime temperatures rarely rise into double figures) annually and five months of summer. It owes its existence to the rain shadow formed by the Andes Mountains which lie close to the Pacific Coast here south of the 40th Parallel. In addition to the steppe, there are canyons and massifs that spread eastwards from the Andes.

Patagonie

Plus souvent associée à des montagnes couronnées de neige et à des vêlages de glaciers, la Patagonie abrite en réalité le huitième désert du monde par la taille, également appelé steppe patagonienne, presque entièrement situé en Argentine. Ce désert connaît un climat inhabituel, avec sept mois d'hiver (durant lesquels les températures descendent souvent au-dessous de zéro et atteignent rarement deux chiffres le jour) et cinq mois d'été. Il doit son existence à la région sous le vent formée par les montagnes des Andes, qui s'étirent au niveau du 40ᵉ parallèle près de la côte Pacifique. En plus des steppes, l'on y trouve des canyons et des massifs, dont on peut apercevoir des répliques à l'est des Andes.

Patagonische Wüste

Bei der Nennung Patagoniens denkt man eher an schneebedeckte Berge und kalbende Gletscher, es ist aber die Heimat der achtgrößten Wüste der Welt. Sie wird auch Patagonische Steppe genannt und liegt überwiegend in Argentinien. Für eine Wüste ist das Klima ungewöhnlich, sieben Monate im Jahr herrscht Winter (wenn die Temperaturen regelmäßig unter den Gefrierpunkt sinken und die Tagestemperaturen selten zweistellig sind) und fünf Monate ist Sommer. Die Wüste verdankt ihre Existenz der Tatsache, dass sie im Regenschatten der Anden liegt, die hier südlich des 40. Breitengrads nahe der Pazifikküste verläuft. Außer der Steppe gibt es Bergmassive und Schluchten, die sich von den Anden nach Osten ziehen.

Petrified Forest, Monumento Nacional Bosques Petrificados, Santa Cruz

Desierto Patagónico

Más a menudo asociada con montañas nevadas y glaciares que se rompen, la Patagonia es en realidad el hogar del octavo desierto más grande del mundo, también llamado la Estepa Patagónica, y se encuentra casi totalmente dentro de Argentina. Para un desierto, el clima es inusual, con siete meses de invierno (cuando las temperaturas caen regularmente bajo cero y las temperaturas diurnas raramente se elevan a dos cifras) y cinco meses de verano. Debe su existencia a la sombra de lluvia formada por la Cordillera de los Andes que se encuentra cerca de la costa del Pacífico, aquí cerca del paralelo 40. Además de la estepa, hay cañones y macizos que hacen eco hacia el este desde los Andes.

Deserto da Patagônia

Mais frequentemente associada a montanhas cobertas de neve e a geleiras que pastam, a Patagônia é, na verdade, o lar do oitavo maior deserto do mundo, também chamado de estepe patagônica e fica quase inteiramente dentro da Argentina. Para um deserto, o clima é incomum, com sete meses de inverno (quando as temperaturas regularmente caem abaixo das temperaturas de congelamento e de dia raramente aumentam em dois dígitos) e cinco meses de verão. Deve a sua existência à sombra de chuva formada pela Cordilheira dos Andes, que fica perto da costa do Pacífico, perto do 40º paralelo. Além da estepe, há cânions e maciços que ecoam para o leste dos Andes.

Patagonische woestijn

Patagonië wordt steeds vaker geassocieerd met besneeuwde bergen en afkalvende gletsjers. Patagonië herbergt echter de op zes na grootste woestijn ter wereld. Die wordt ook wel de Patagonische Steppe genoemd en ligt bijna geheel in Argentinië. Voor een woestijn is het klimaat ongebruikelijk, met zeven maanden winter (wanneer de temperatuur regelmatig onder het vriespunt komt en het overdag zelden warmer wordt dan 10 graden) en vijf maanden zomer. Hij dankt zijn bestaan aan de regenschaduw die gevormd wordt door het Andesgebergte, dat hier ten zuiden van de 40e breedtegraad vlak bij de Grote Oceaankust ligt. Behalve de steppe zijn er diepe kloven en berg-massieven, die vanuit de Andes naar het oosten lopen.

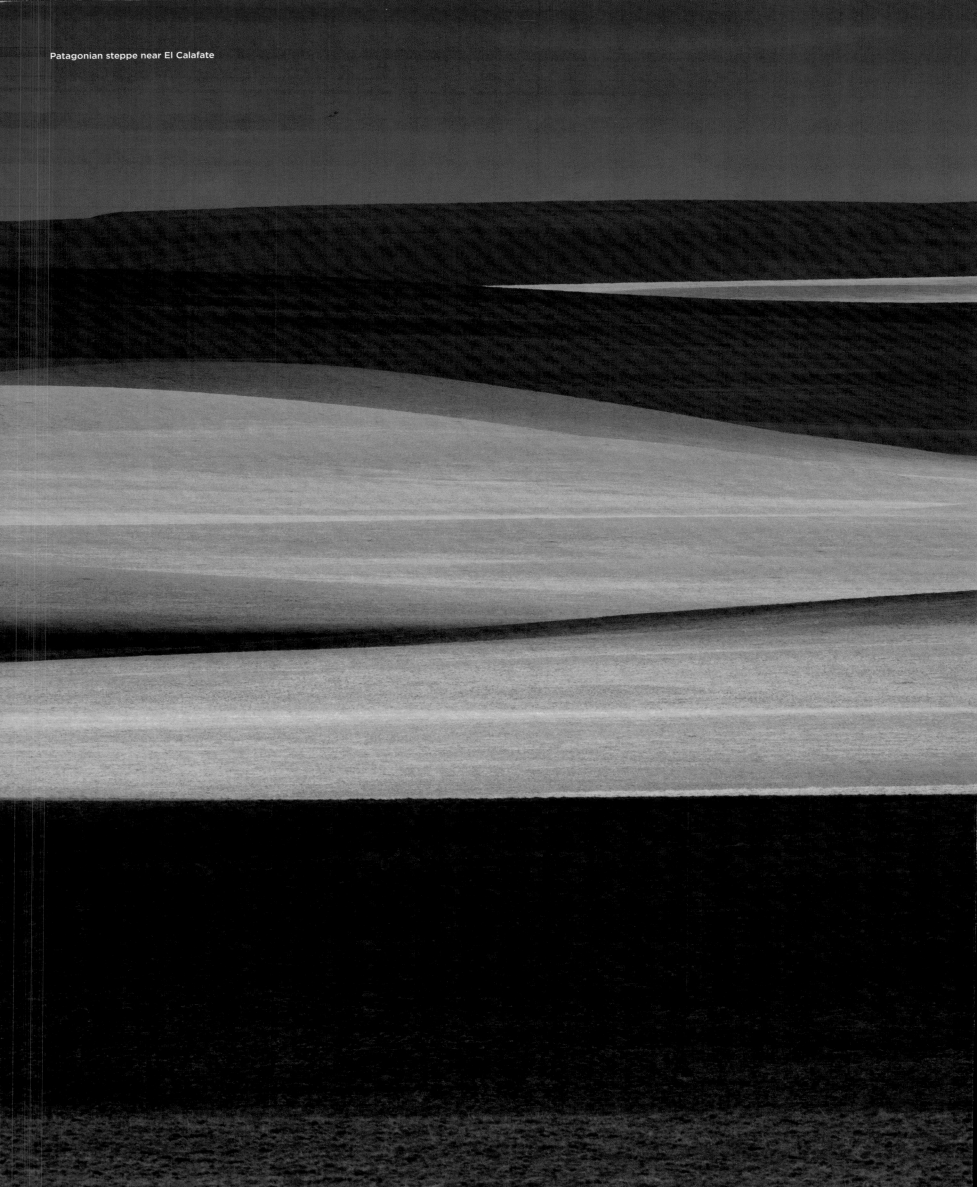

Patagonian steppe near El Calafate

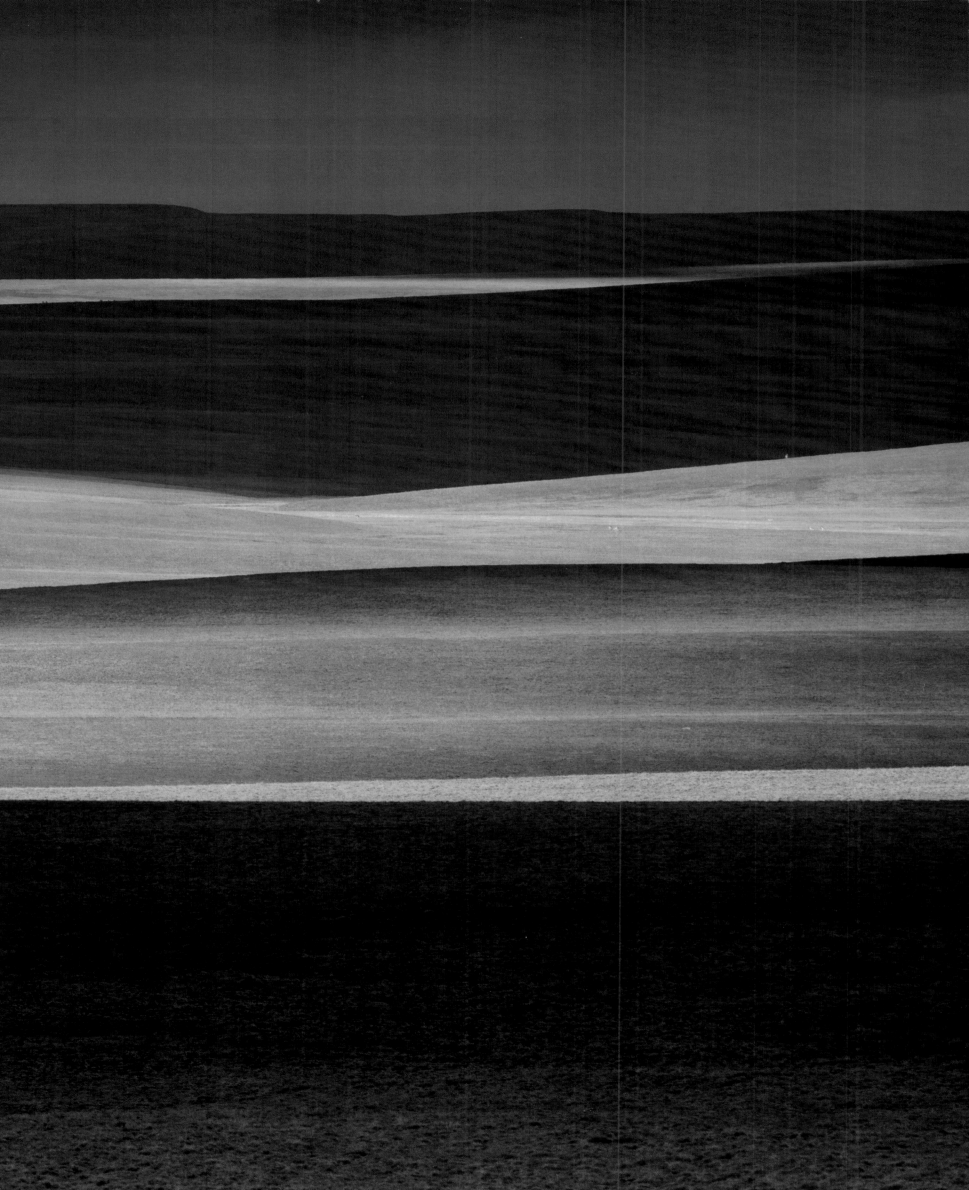

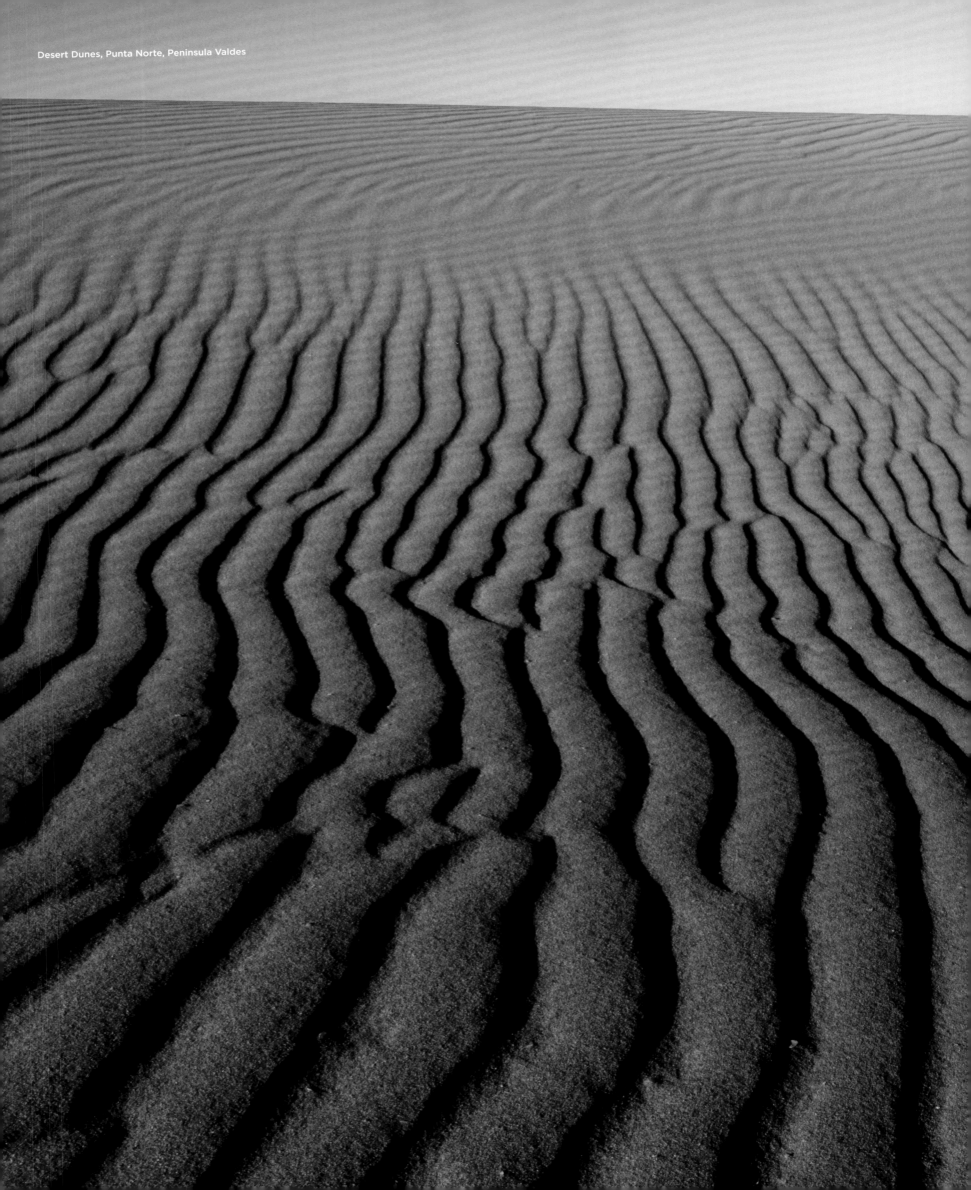
Desert Dunes, Punta Norte, Peninsula Valdes

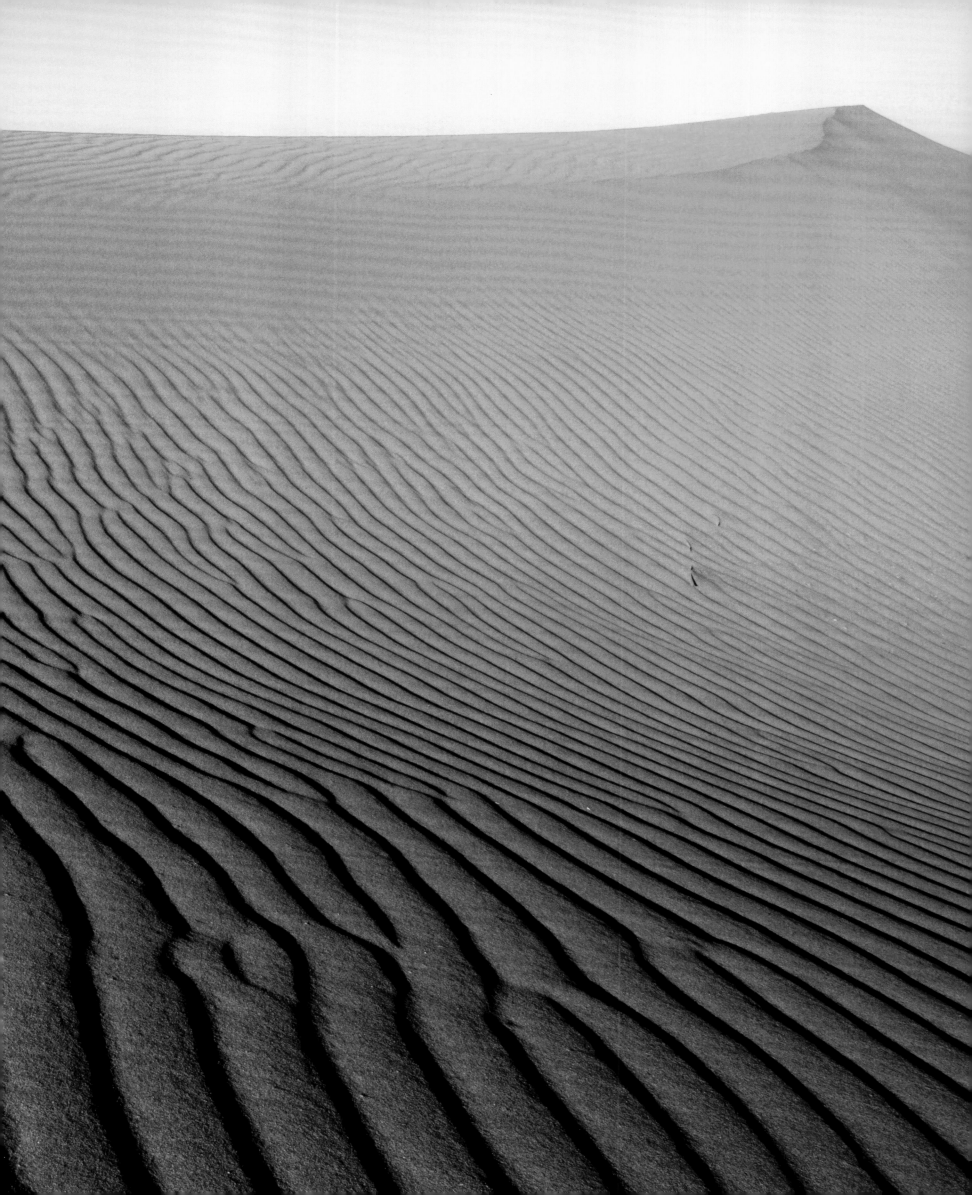

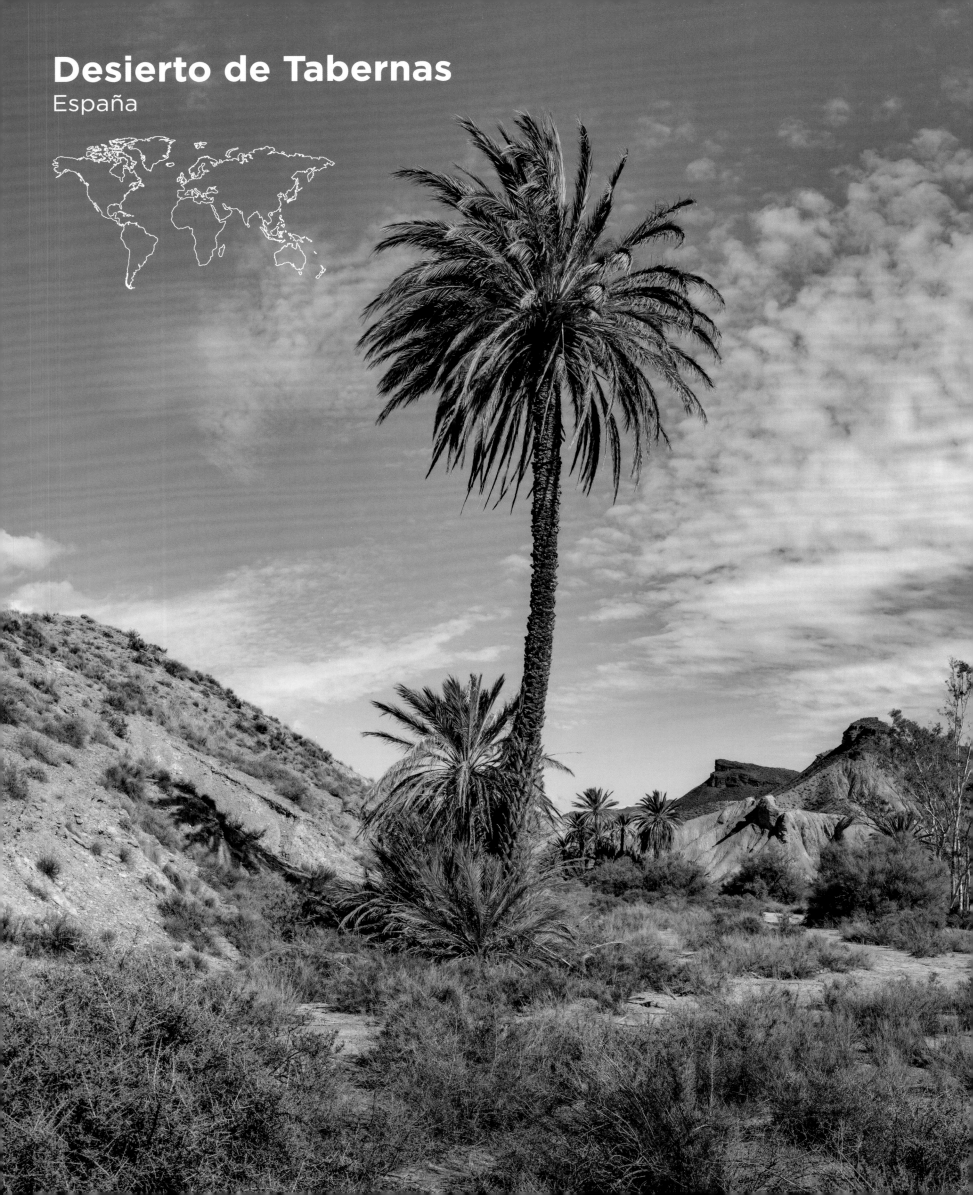

Texas Hollywood/Fort Bravo, western style theme park, Almeria

Fort Bravo Cinema Studios

Desert Cinema

Spain's Tabernas Desert, in Andalucía, has numerous film studios, and has appeared in countless spaghetti Westerns and other movies, such is its resemblance to the American West and the deserts of Arabia. Its list of credits includes *Indiana Jones and the Last Crusade (1989)*, *A Fistful of Dollars (1964)* and *Lawrence of Arabia (1962)*.

Désert de Tabernas – Désert du cinéma

Doté de nombreux studios de cinéma, le désert espagnol de Tabernas, en Andalousie, est apparu dans plusieurs westerns spaghettis, entre autres films, tant il ressemble au Far West américain et aux déserts d'Arabie. La liste des films aux génériques desquels il est crédité compte *Indiana Jones et la Dernière Croisade (1989)*, *Pour une poignée de dollars (1964)* et *Lawrence d'Arabie (1962)*.

Kinowüste

In der spanischen Tabernas-Wüste in Andalusien gibt es zahlreiche Filmstudios, in denen unzählige Italowestern und andere Filme entstanden, weil sie den Wüsten des amerikanischen Westens und Arabiens so ähnlich sieht. Die Liste umfasst neben *Indiana Jones, Der letzte Kreuzzug (1989)* und *Eine Handvoll Dollar (1964)* auch den Klassiker *Lawrence von Arabien (1962)*.

El desierto y el cine

El desierto español de Tabernas, en Andalucía, tiene numerosos estudios de cine y ha aparecido en innumerables spaghetti western y otras, tal es su parecido con el oeste americano y los desiertos de Arabia. Su lista de créditos incluye *Indiana Jones y la última cruzada (1989)*, *Un puñado de dólares (1964)* y *Lawrence de Arabia (1962)*.

O deserto e o cinema

O deserto espanhol de Tabernas, na Andaluzia, tem inúmeros estúdios cinematográficos e já apareceu em incontáveis farpas de faroeste e outros filmes, como a sua semelhança com o oeste americano e os desertos da Arábia. Sua lista de créditos inclui *Indiana Jones e a Última Cruzada (1989)*, *A Fistful of Dollars (1964)* e *Lawrence da Arábia (1962)*.

Desierto de Tabernas – Desert Cinema

In de Spaanse Tabernaswoestijn, in Andalusië, staan veel filmstudio's. De woestijn figureerde in talloze spaghettiwesterns en andere films, vanwege de gelijkenis met het Amerikaanse Westen en Arabische woestijnen. De lijst omvat *Indiana Jones and the Last Crusade (1989)*, *A Fistful of Dollars (1964)* en *Lawrence of Arabia (1962)*.

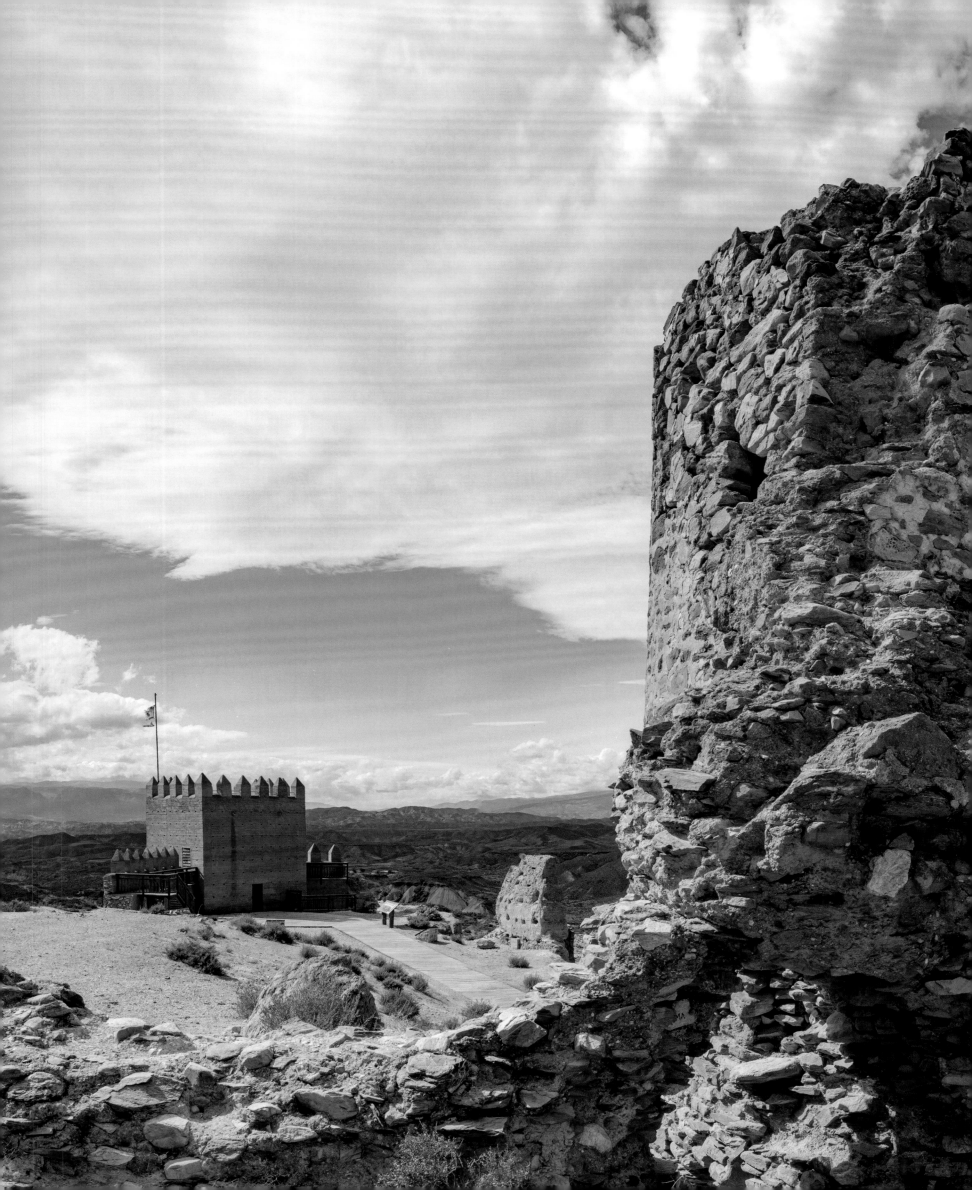

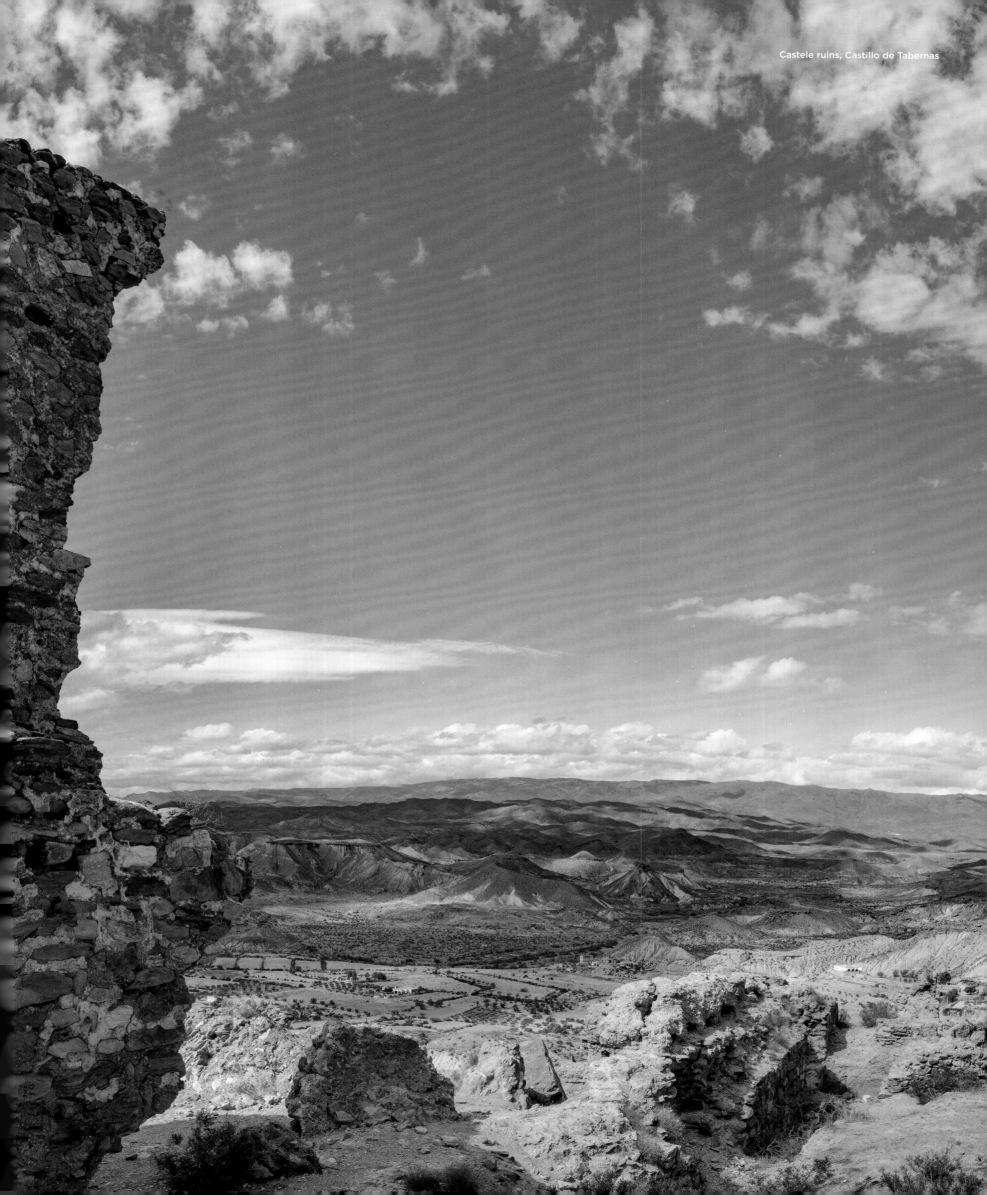
Castele ruins, Castillo de Tabernas

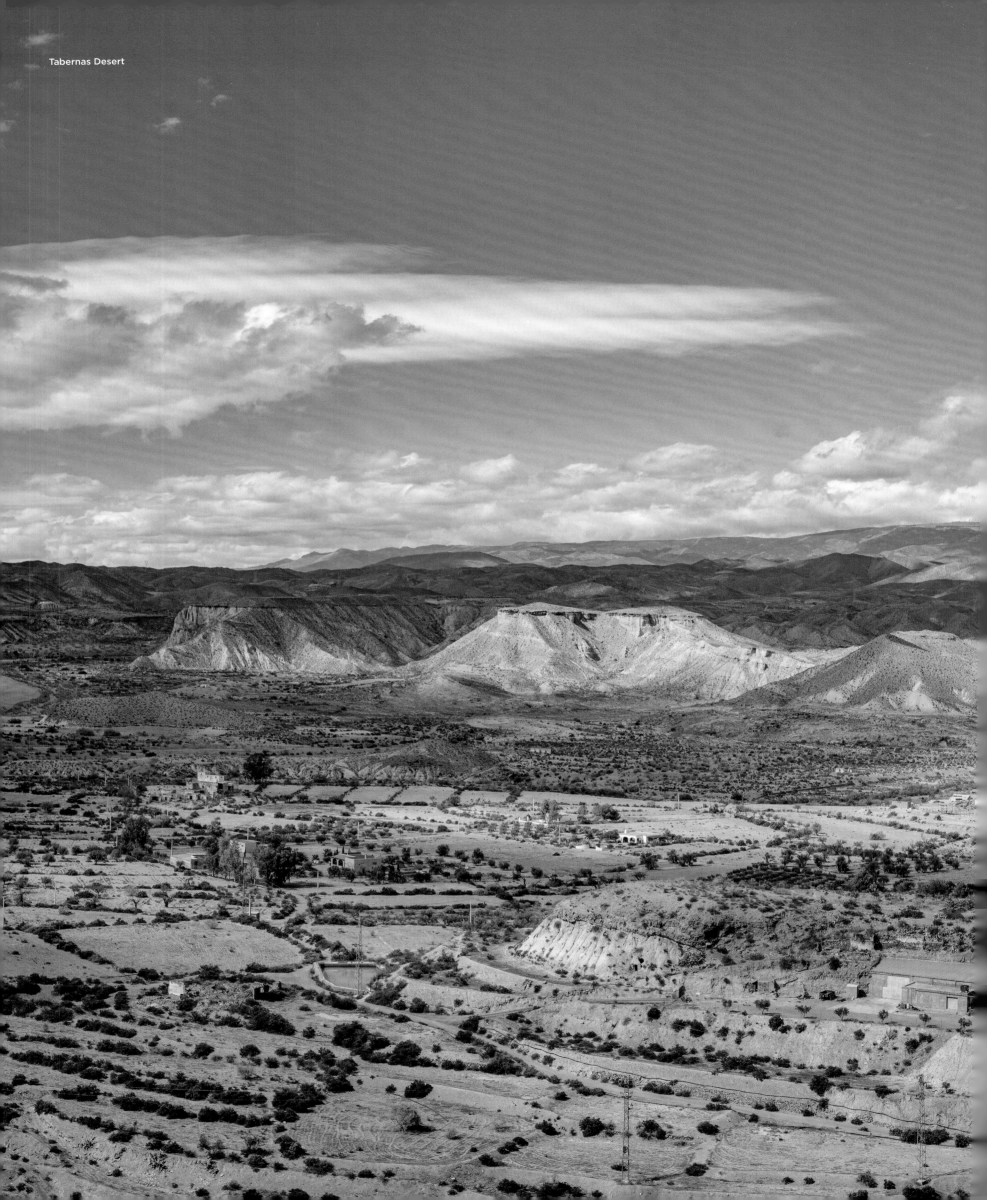

Tabernas Desert

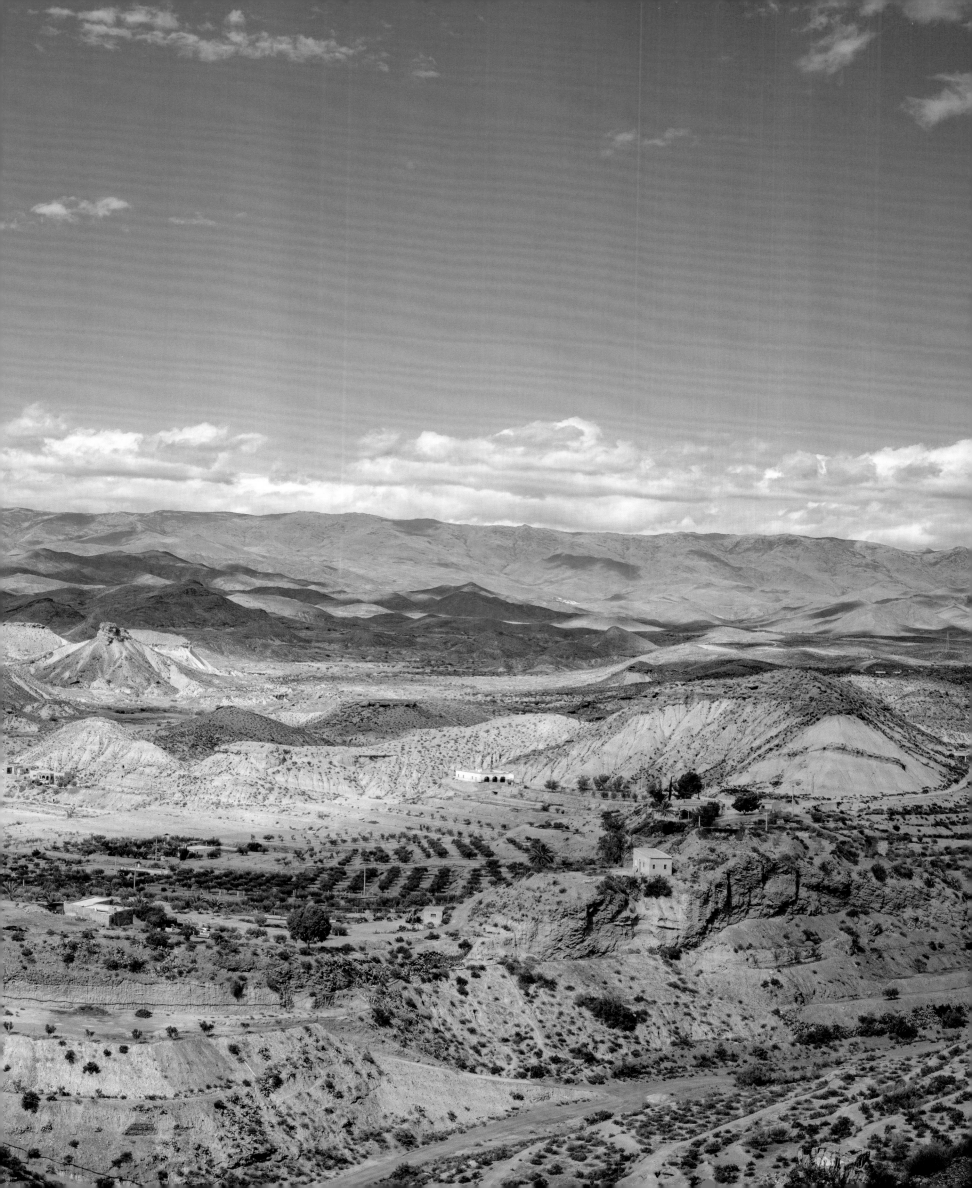

Northwestern Sahara
Tunisia, Mauritania, Morocco & Algeria

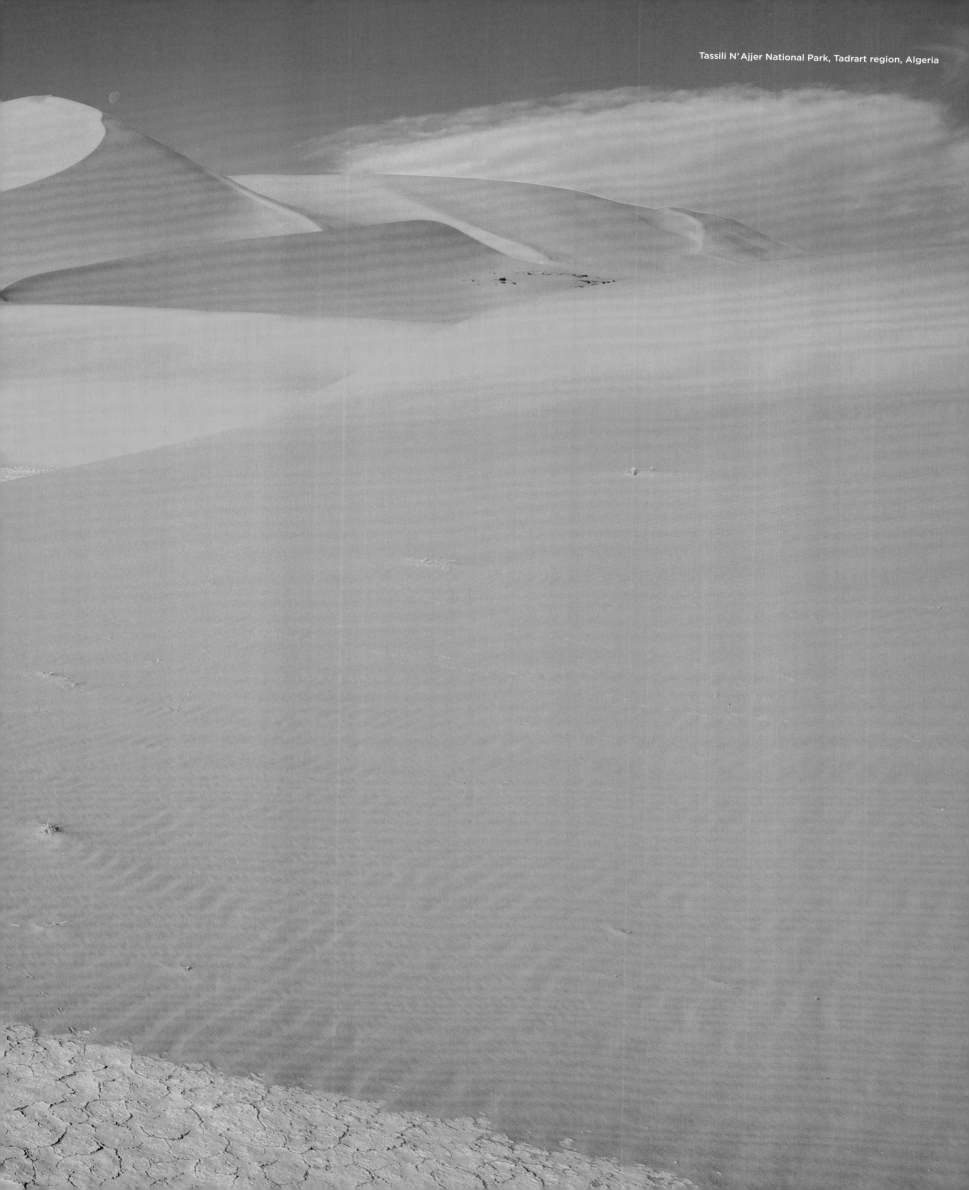

Tassili N' Ajjer National Park, Tadrart region, Algeria

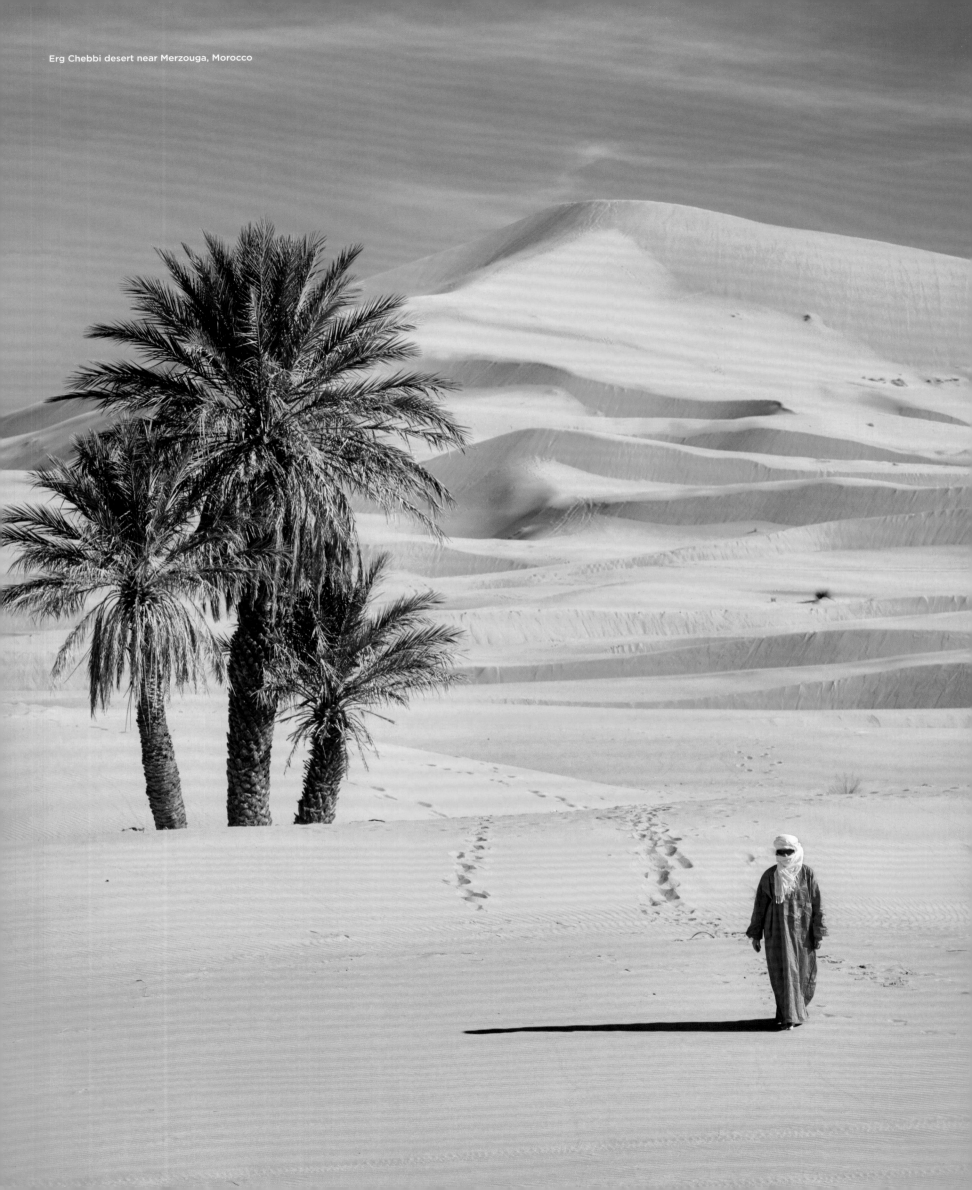

Erg Chebbi desert near Merzouga, Morocco

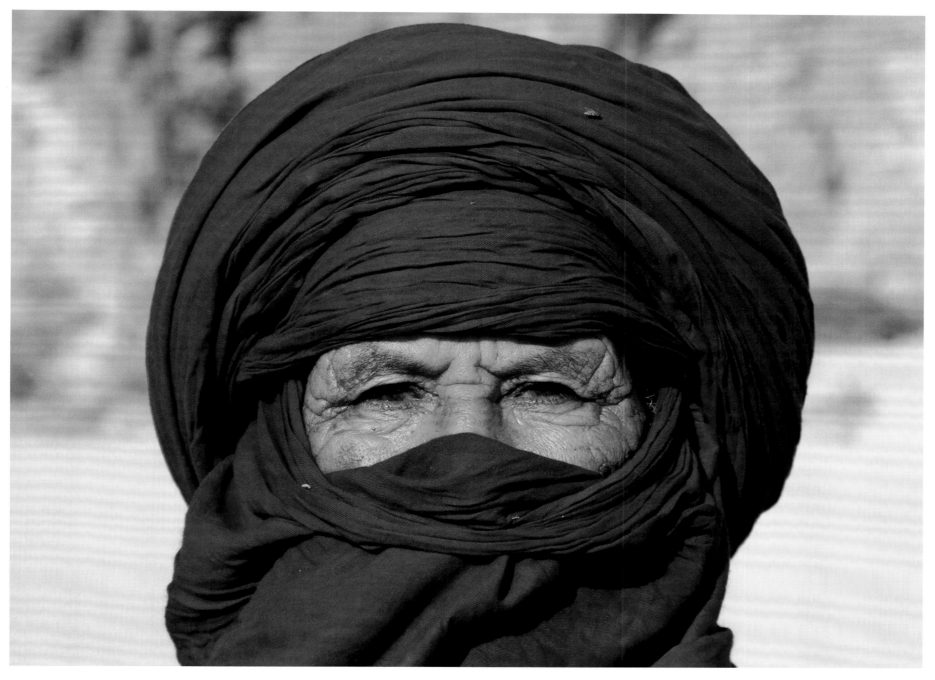

Tuareg

The Sahara's Northwest
The Sahara is the largest hot desert on earth, covering an area equivalent to the United States or to China. Vast seas of sand occupy southern Tunisia and Morocco, but the Sahara envelopes both Mauritania and Algeria, almost in their entirety. Desert massifs and seemingly endless gravel plains shelter the Tuareg of Algeria and the Moors of Mauritania.

Nord-ouest du Sahara
Le Sahara est le plus grand désert chaud de la planète et couvre une surface équivalente à celle des États-Unis ou de la Chine. Alors qu'il encercle presque entièrement la Mauritanie et l'Algérie, ses immenses mers de sable occupent le sud de la Tunisie et du Maroc. Les Touaregs d'Algérie, les Maures de Mauritanie et les Berbères vivent dans ses massifs montagneux et ses plaines de graviers courant à perte de vue.

Der Nordwesten der Sahara
Die Sahara ist die größte „heiße" Wüste der Welt, ihre Fläche entspricht derjenigen der USA oder Chinas. Weite Sandmeere bedecken den Süden Tunesiens und Marokkos, und fast ganz Mauretanien und Algerien gehören zur Sahara. In den Wüstengebirgen und scheinbar endlose Kiesebenen leben in Algerien die Tuareg und die Mauerer in Mauretanien.

El noroeste del Sahara
El Sahara es el desierto caliente más grande de la Tierra, con un tamaño equivalente al de Estados Unidos o China. Los vastos mares de arena ocupan el sur de Túnez y Marruecos, pero el Sahara envuelve a Mauritania y Argelia casi en su totalidad. Los macizos desérticos y las llanuras de grava aparentemente interminables albergan a los tuaregs de Argelia y los moros de Mauritania.

O noroeste do Saara
O Saara é o maior deserto quente da Terra, cobrindo um tamanho equivalente aos Estados Unidos ou à China. Vastos mares de areia ocupam o sul da Tunísia e Marrocos, mas o Saara envolve tanto a Mauritânia como a Argélia, quase na sua totalidade. Maciços desérticos e planícies de cascalho aparentemente infinitas abrigam os tuaregues da Argélia e os mouros da Mauritânia.

Het noordwesten van de Sahara
De Sahara is de grootste hete woestijn op aarde, met een omvang die overeenkomt met die van de Verenigde Staten of China. Uitgestrekte zandzeeën bedekken het zuiden van Tunesië en Marokko, maar ook bijna heel Mauritanië en Algerije horen bij de Sahara. In de woestijnmassieven en schier eindeloze grindvlaktes leven de Toearegs van Algerije, de Moren van Mauritanië en de Berbers.

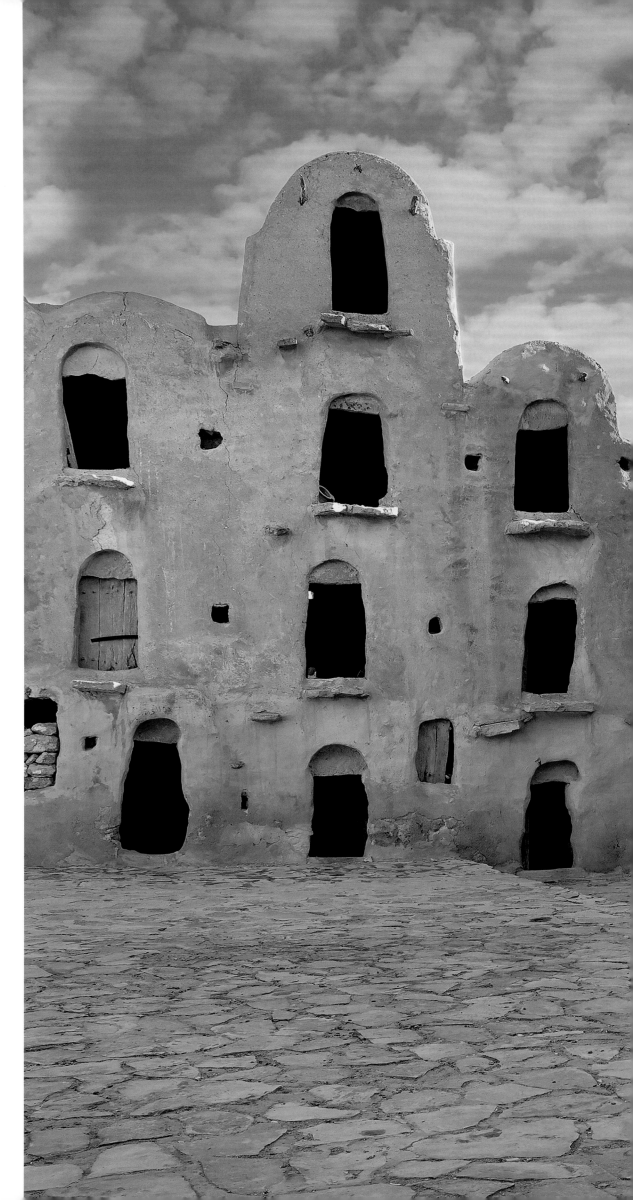

Ksar Ezzahra, Tataouine, Tunisia

Tunisia

Tunisia's south cuts into the Sahara like a wedge, and this part of the desert is almost entirely given over to sand – it was in the sand seas of Tunisia's Grand Erg Oriental that scenes from *The English Patient* were filmed. And the otherworldly Berber granary stores and hobbit-like structures have been a feature of *Star Wars* movies since the beginning.

Tunisie

Le sud de la Tunisie dessine une sorte de quartier d'orange à l'intérieur du Sahara, une partie du désert presque entièrement sablonneuse – des scènes du *Patient anglais* ont été tournées dans les mers de sable du Grand Erg oriental de Tunisie. Les greniers à grain berbères venus d'un autre monde et les structures de style hobbit sont devenus des caractéristiques de la saga *Star Wars* dès les tout premiers films.

Tunesien

Tunesiens Süden schneidet wie ein Keil in die Sahara, und in diesem Teil der Wüste gibt es kaum etwas anderes als Sand. In den Sandmeeren von Tunesiens Östlichem Großen Erg wurden Szenen des Films *Der englische Patient* gedreht. Die Berber-Korn-speicher und die Bauwerke, die von Hobbits stammen könnten, wirken so außerirdisch, dass sie von Anfang an in den *Star-Wars-Filmen* zu sehen waren

Túnez

El sur de Túnez corta el Sahara como una cuña, y esta parte del desierto está casi totalmente dedicada a la arena (fue en los mares de arena del Gran Erg Oriental de Túnez donde se filmaron escenas de *El Paciente inglés*). Y las tiendas de graneros bereberes del otro mundo y las estructuras similares a los hobbits han sido una característica de las películas de *La Guerra de las galaxias* desde el principio.

Tunísia

O sul da Tunísia corta o Saara como uma cunha, e essa parte do deserto é quase inteiramente entregue à areia - foi nos mares de areia do Grand Erg Oriental da Tunísia que cenas do The English Patient foram filmadas. E as lojas de celeiro berberes de outro mundo e estruturas semelhantes a hobbits têm sido uma característica dos filmes de *Guerra nas Estrelas* desde o começo.

Tunesië

Het zuiden van Tunesië snijdt als een wig in de Sahara, en dit deel van de woestijn bestaat bijna volledig uit zand. In de zandzeeën van de Grand Erg Oriental van Tunesië werden de opnamen voor *The English Patient* gemaakt. En de onwerkelijk aandoende Berberse graanschuren en hobbitachtige bouwsels zijn al vanaf het begin te zien in de *Star Wars-films*.

232

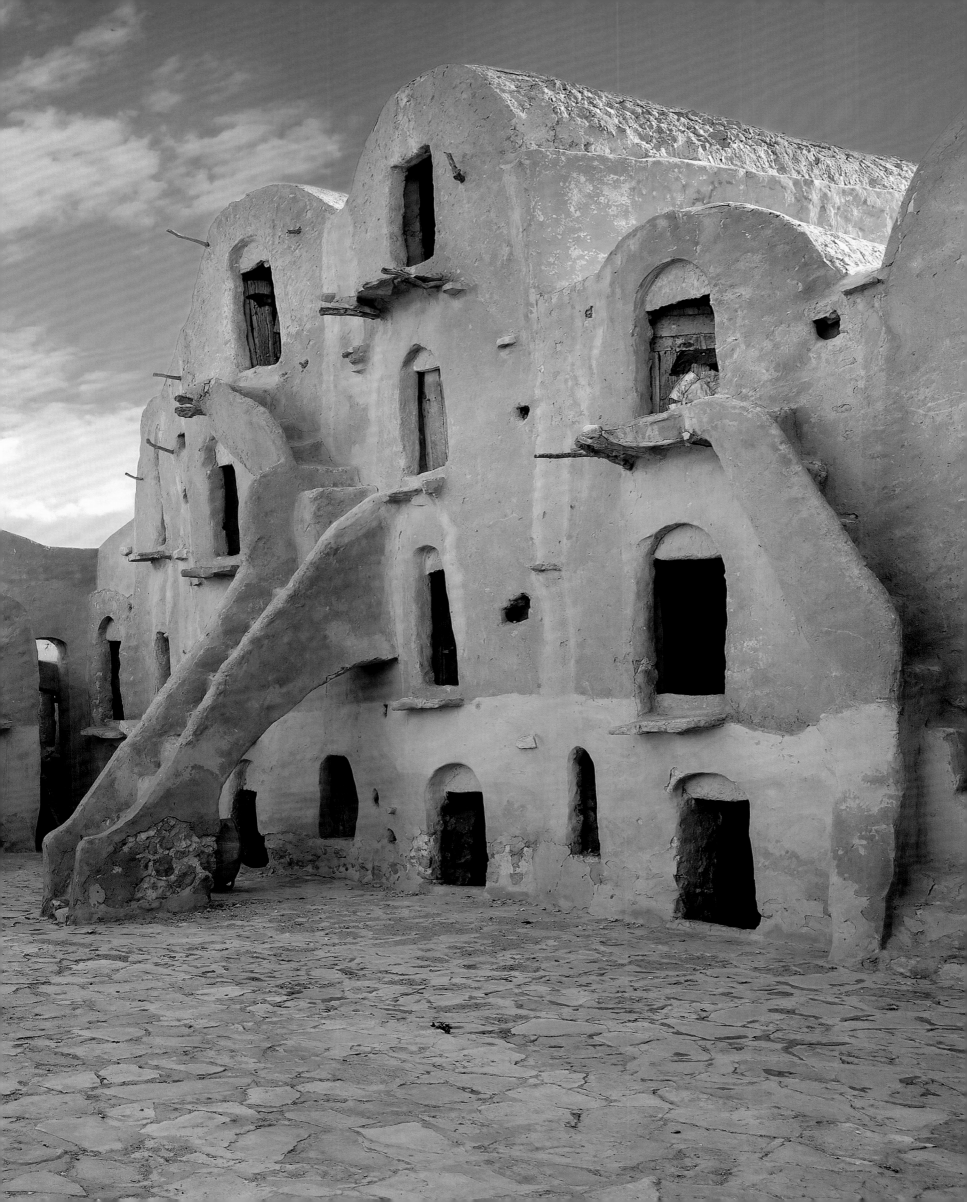

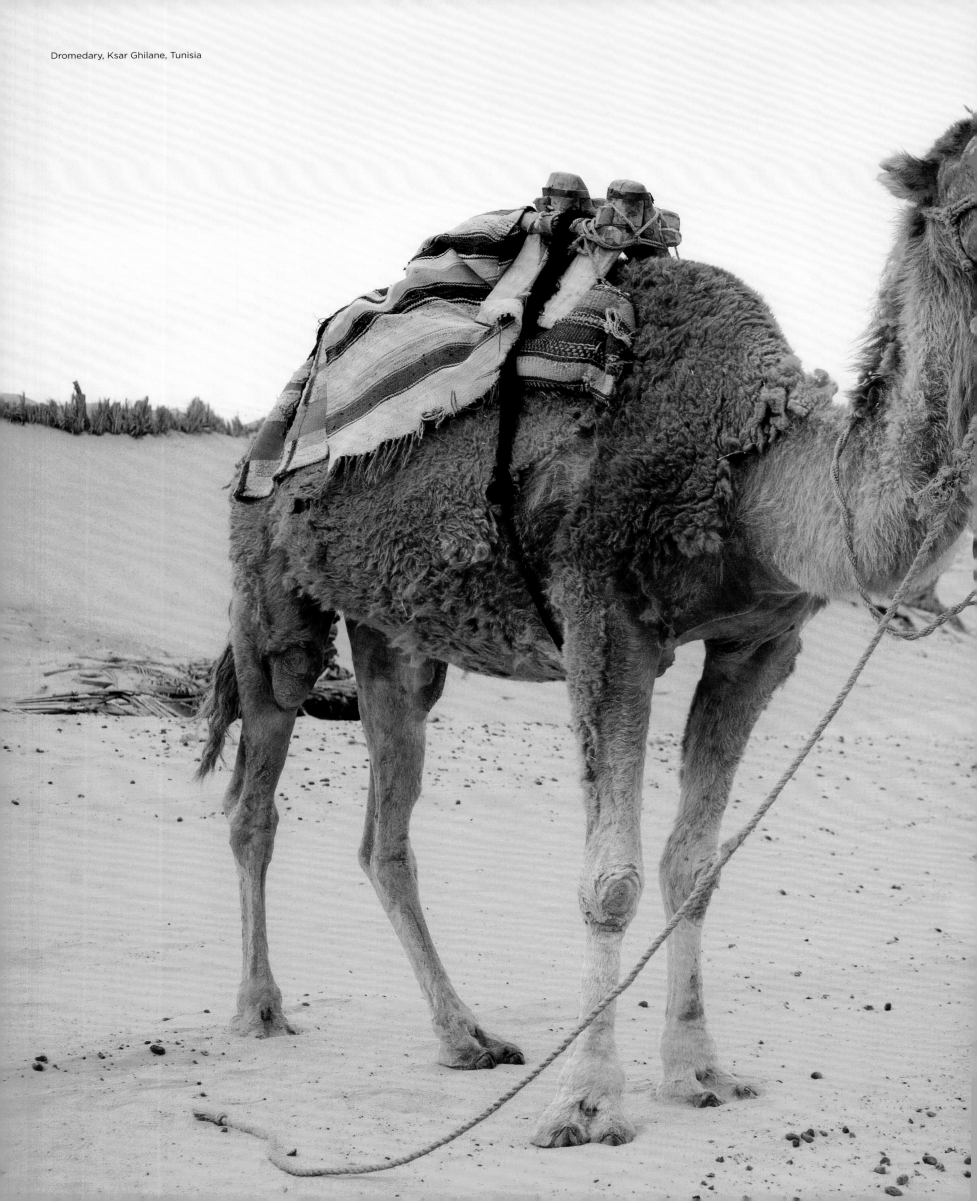

Dromedary, Ksar Ghilane, Tunisia

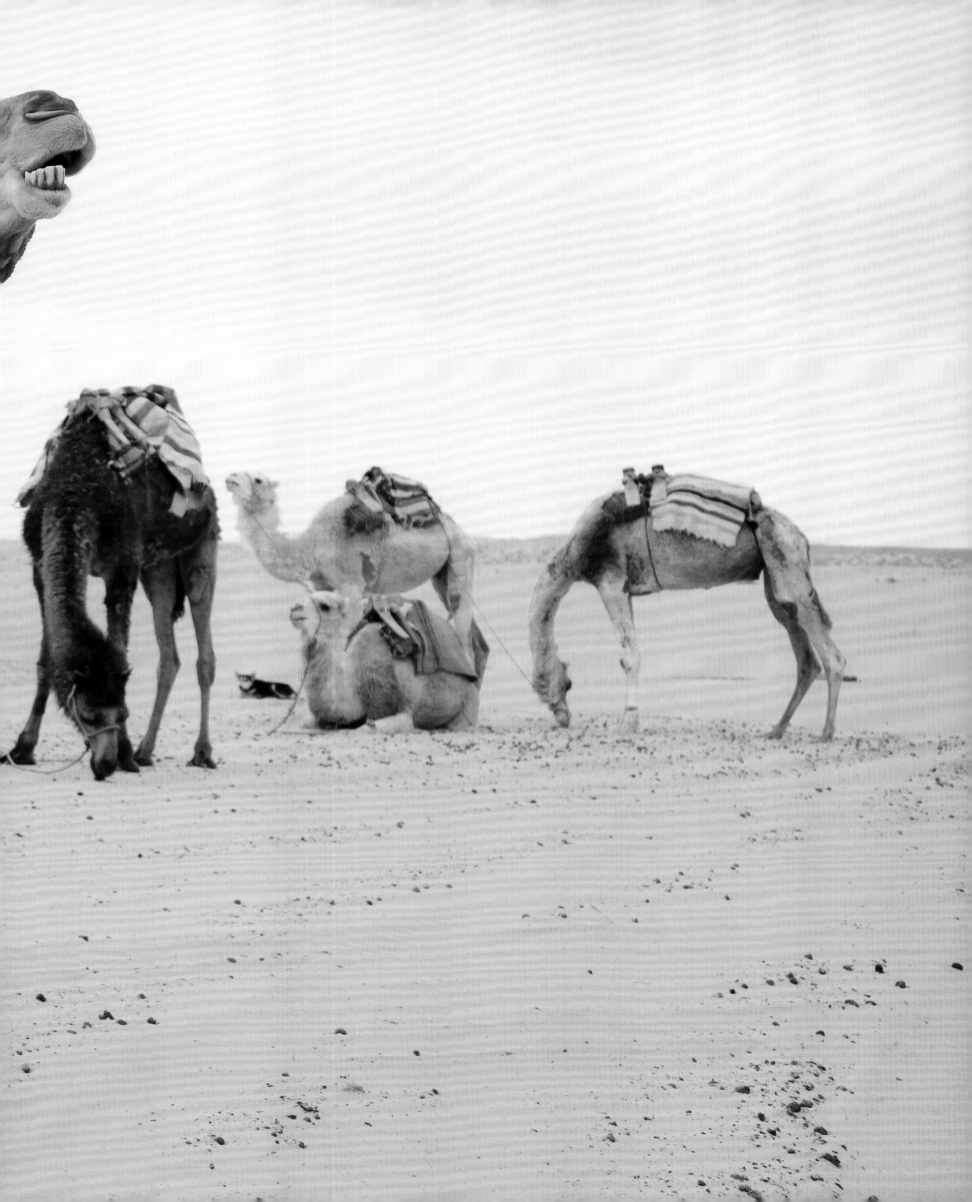

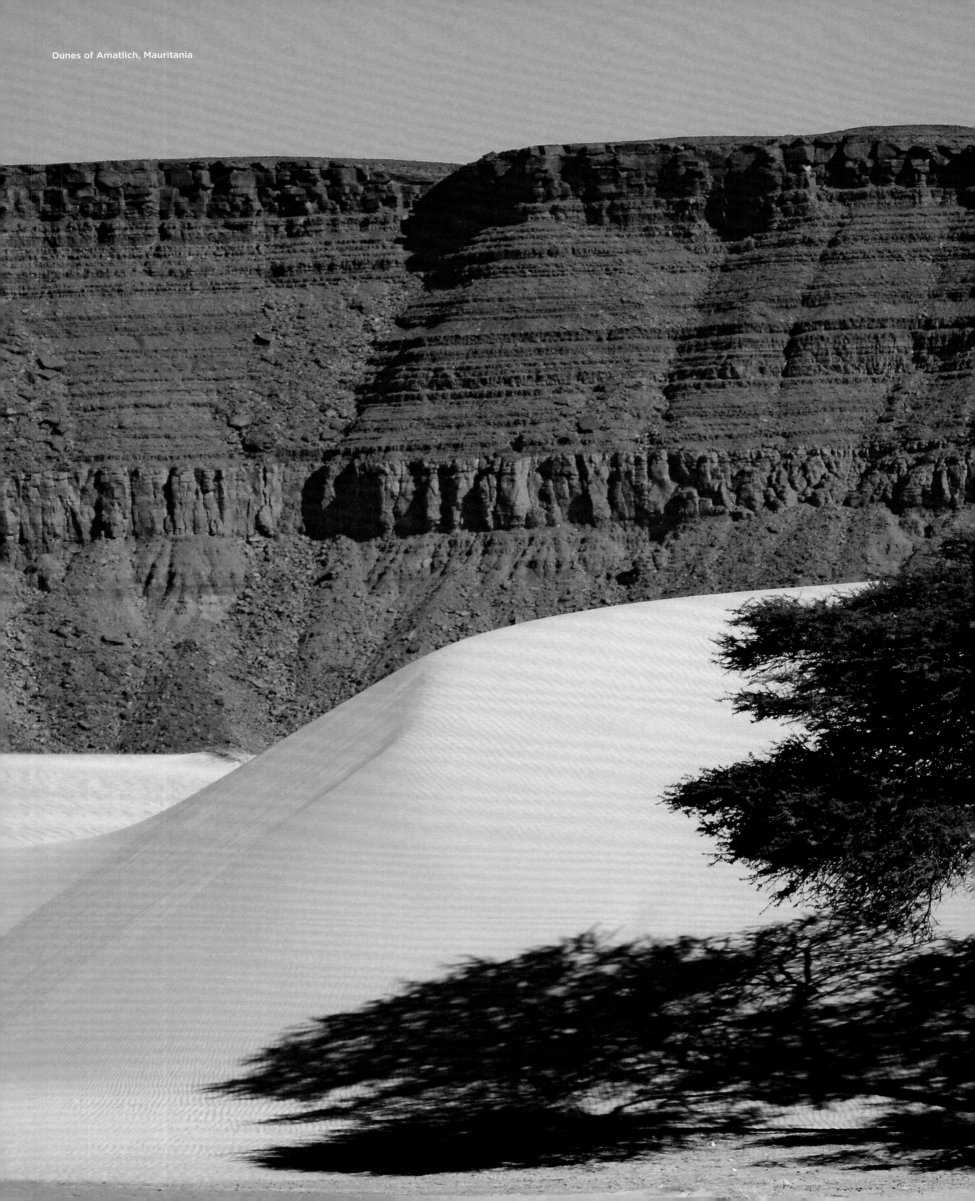

Dunes of Amatlich, Mauritania

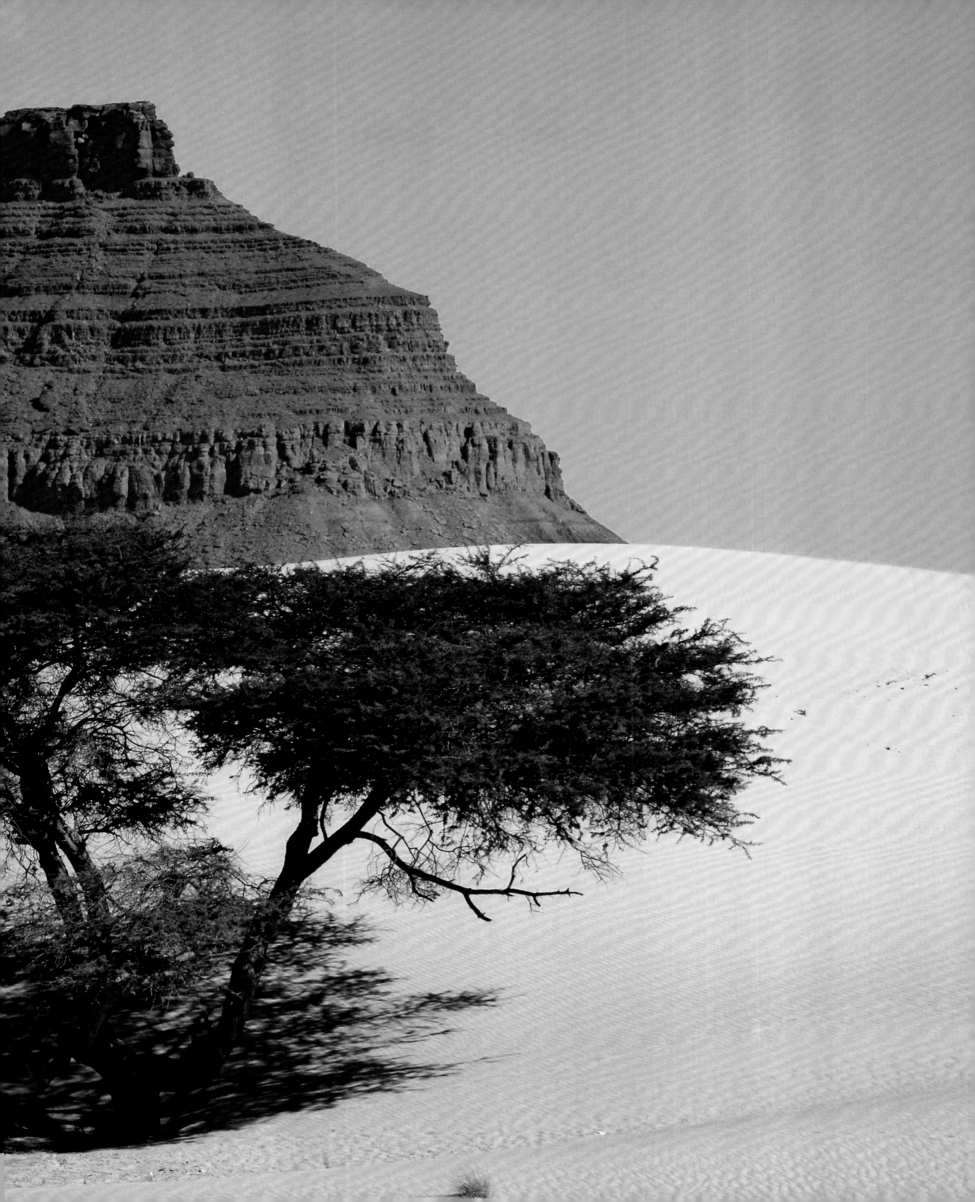

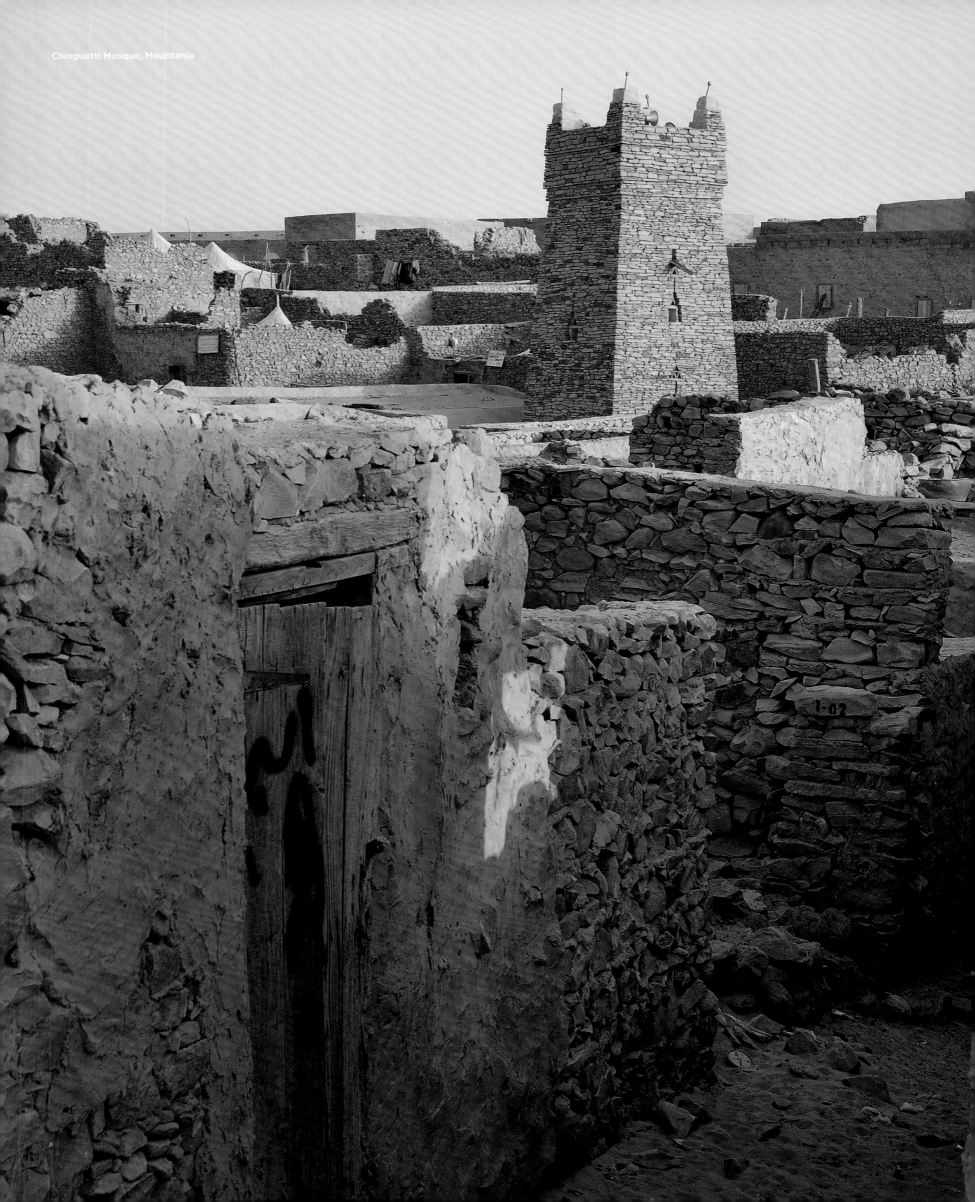

Chinguetti Mosque, Mauritania

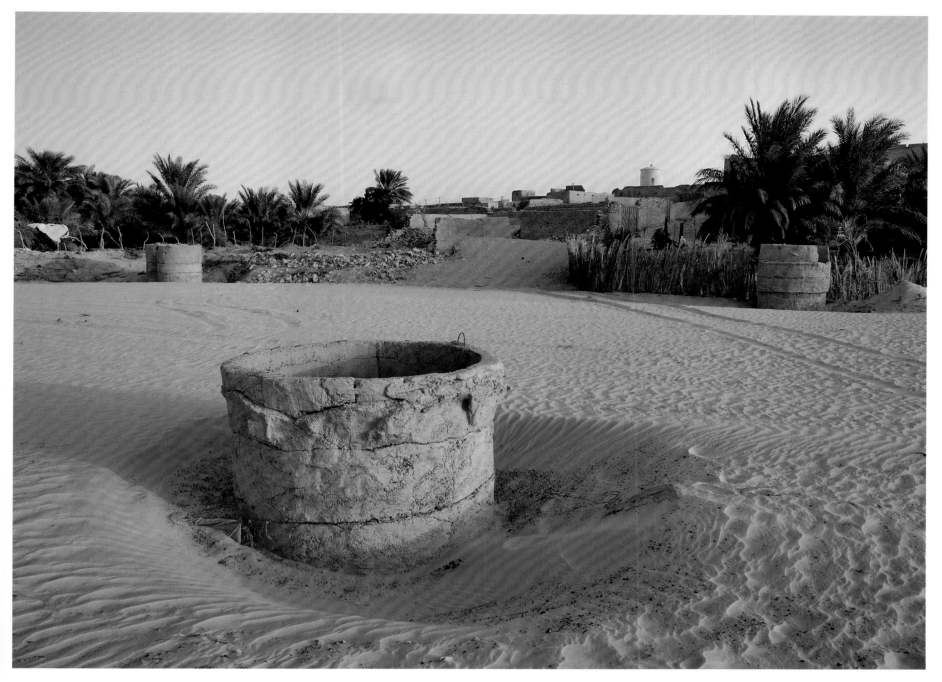

Fontaine, dry riverbed, Chinguetti, Mauritania

Mauritania

Mauritania is three-quarters Sahara, and its ancient caravan towns like Chinguetti were famed in medieval times for their Islamic scholarship; Chinguetti is Islam's seventh-holiest city and ancient Arabic manuscripts are still found here. The Mauritanian Sahara is a sun-blasted realm of oases, sand dunes, rocky plateaus and canyons.

Mauritanie

La Mauritanie occupe les trois quarts du Sahara, et ses anciennes cités caravanières telle que Chinguetti étaient célèbres à la période médiévale pour leur érudition et culture islamiques. Chinguetti est la septième ville sainte de l'Islam et d'anciens manuscrits arabes s'y trouvent toujours aujourd'hui. Le Sahara mauritanien est un royaume écrasé par le soleil d'oasis, de dunes, de plateaux rocheux et de canyons.

Mauretanien

Drei Viertel Mauretaniens liegen in der Sahara. Die alten Karawanenstädte wie Chinguetti waren im Mittelalter für ihre islamische Gelehrsamkeit berühmt; Chinguetti ist die siebtheiligste Stadt des Islam und noch immer Aufbewahrungsort kostbarer Handschriften. Die mauretanische Sahara ist ein sonnengebräuntes Reich aus Oasen, Sanddünen, Felsplätzen und Schluchten.

Mauritania

Mauritania es tres cuartas partes del Sahara, y sus antiguas ciudades caravana como Chinguetti eran famosas en la Edad Media por su erudición islámica; Chinguetti es la séptima ciudad más santa del Islam y todavía se encuentran aquí manuscritos árabes antiguos. El Sahara mauritano es un reino asediado por el sol y lleno de oasis, dunas de arena, mesetas rocosas y cañones.

Mauritânia

Mauritânia é três quartos do Saara, e suas antigas cidades de caravanas como Chinguetti eram famosas na época medieval por sua erudição islâmica; Chinguetti é a sétima cidade mais sagrada do Islã e manuscritos árabes antigos ainda são encontrados aqui. O Saara da Mauritânia é um reino repleto de sol de oásis, dunas de areia, planaltos rochosos e canyons.

Mauritanië

Mauritanië is driekwart Sahara, en de oude karavaan-stadjes zoals Chinguetti waren in de middeleeuwen beroemd om hun islamitische wetenschap. Chinguetti is de op zes na heiligste stad van islam en er zijn nog altijd oude Arabische manuscripten te vinden. De Mauritaanse Sahara is een door zon geteisterd gebied met oases, zandduinen, rotsplateaus en canyons.

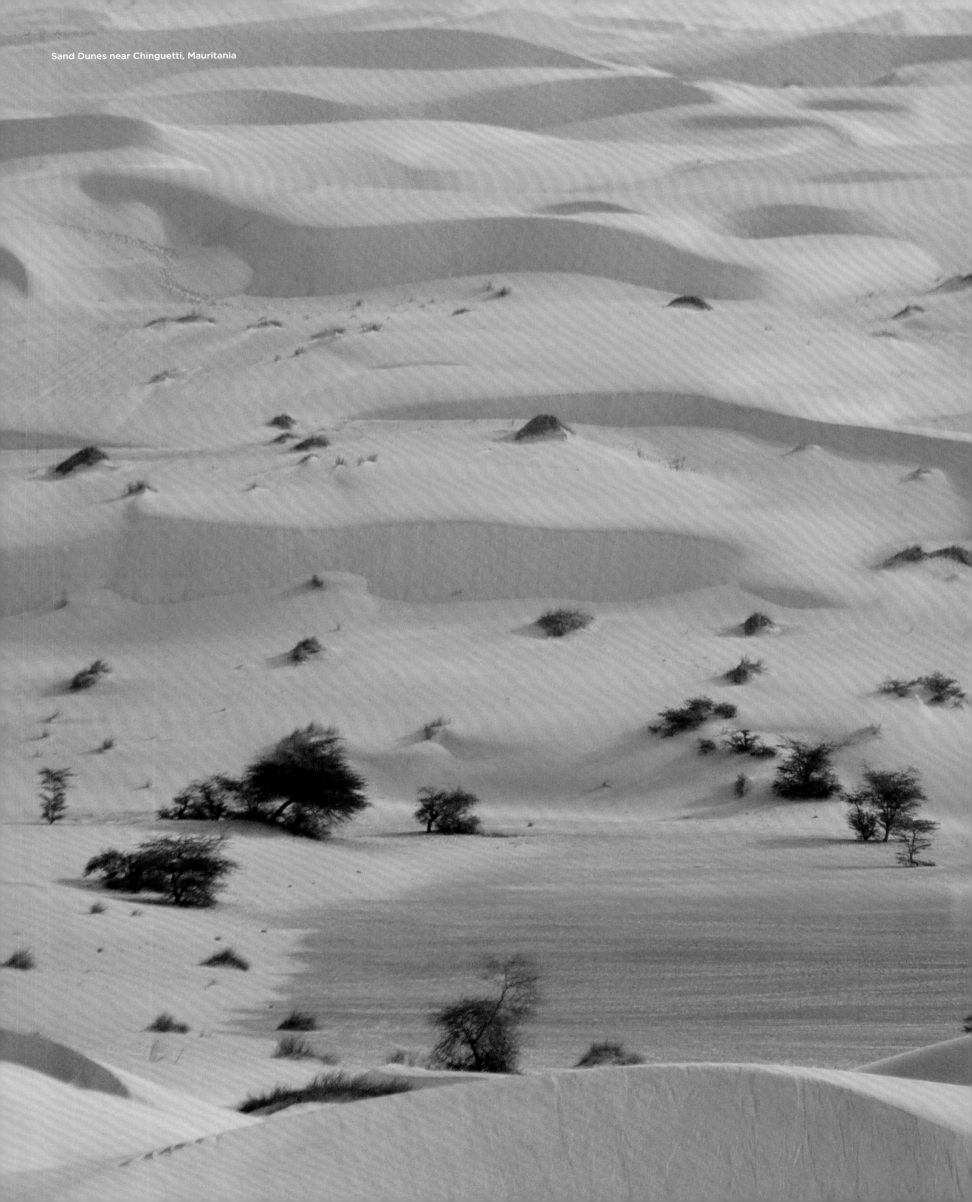

Sand Dunes near Chinguetti, Mauritania

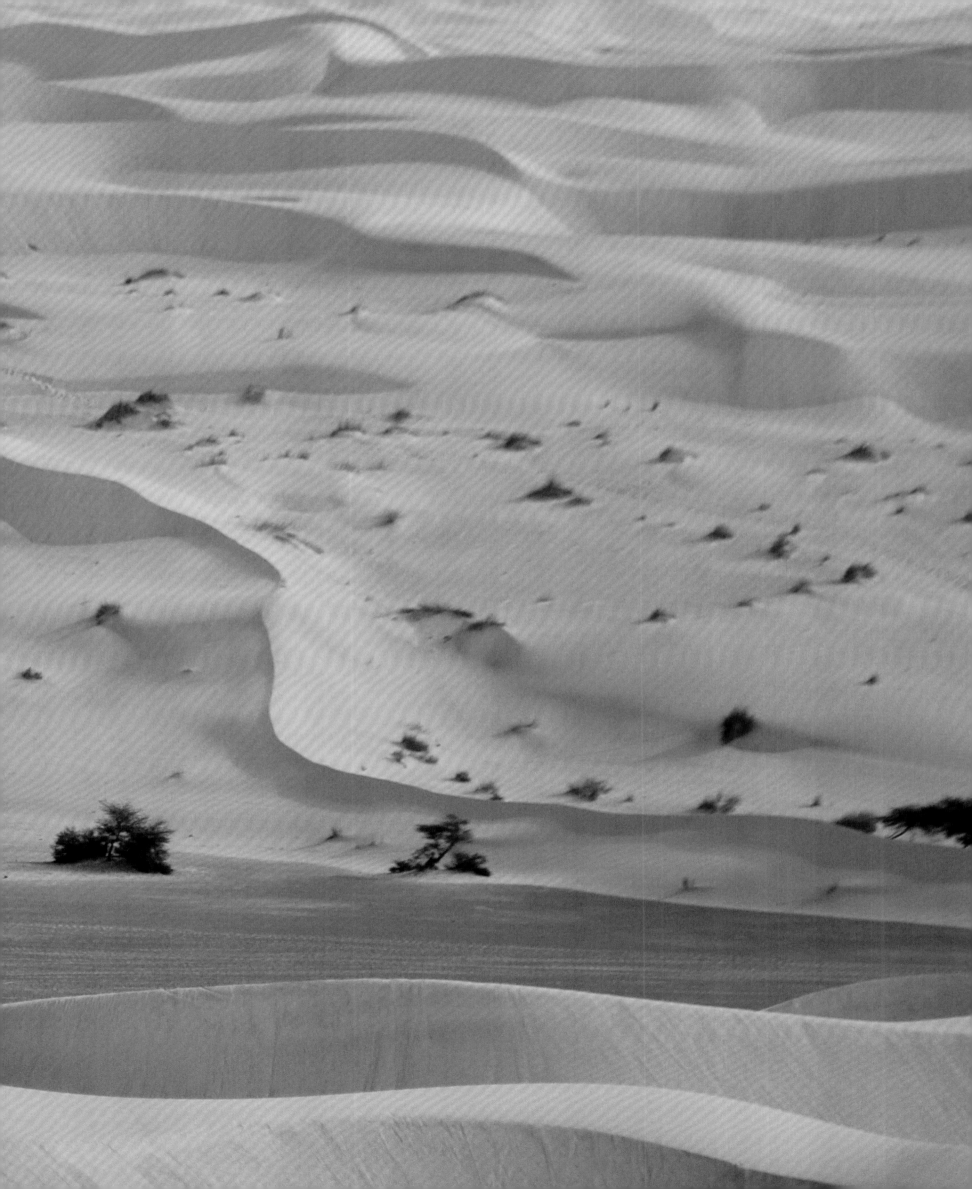

Vortex, Erg Chigaga, Morocco

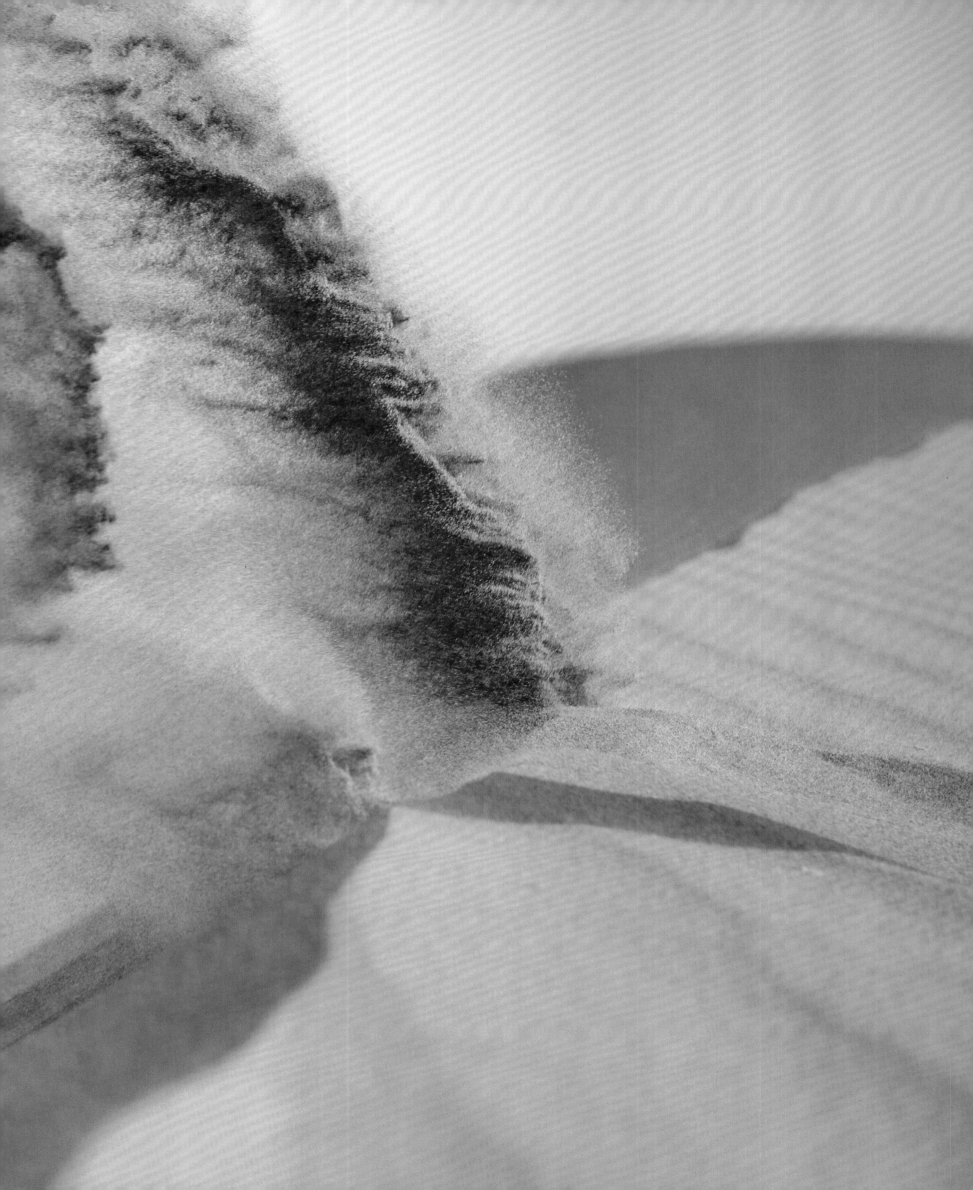

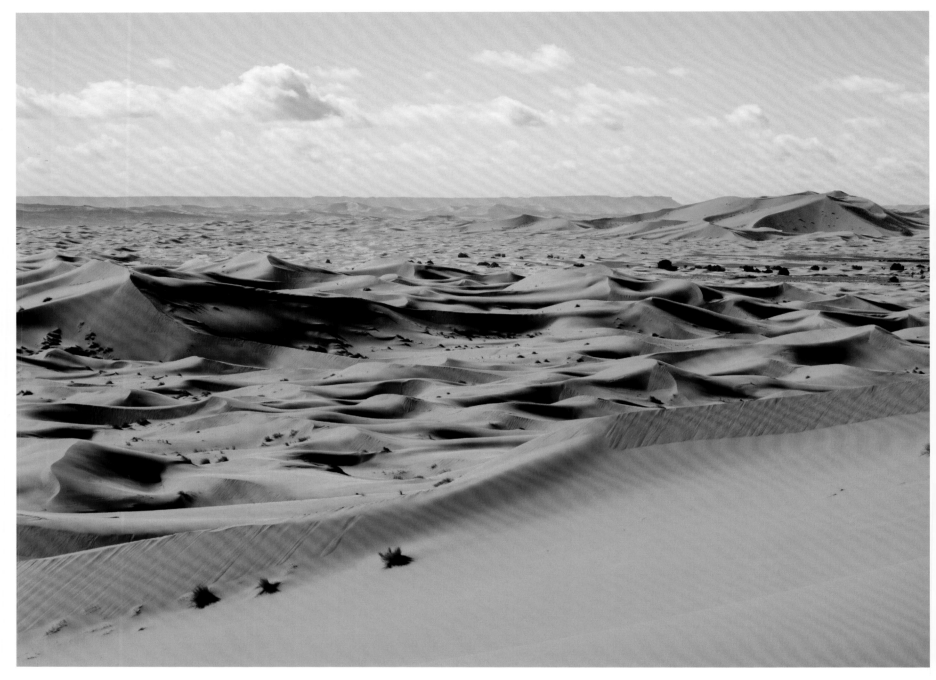

Erg Chebbi, Morocco

Morocco

The Moroccan Sahara, a day's drive from the Mediterranean Coast, is the desert's most accessible corner. In ancient times, trans-Saharan camel caravans, usually carrying salt, once took around 50 days to cross between the oases of southern Morocco to the fabled city of Timbuktu (Tombouctou). Mud-brick Berber fortress cities – used to film Hollywood blockbusters such as *Gladiator* – cling to the southern slopes of the Atlas Mountains, a vertiginous range that separates the desert from the rest of Morocco. Merzouga is the best-known desert playground, but Erg Chebbi is a genuine Saharan erg of drifting sand dunes nearly 200 m high.

Maroc

Situé à une journée de voiture de la côte méditerranéenne, le Sahara marocain est la partie la plus accessible de ce désert. Jadis, les caravanes de chameaux qui traversaient le Sahara, généralement chargées de sel, ralliaient en à peine cinquante jours la légendaire cité de Tombouctou en coupant par les oasis du Sud marocain. Les villes forteresses berbères en briques de boue – décors de films hollywoodiens à grand succès tel que *Gladiator* – sont accrochées aux versants sud de l'Atlas marocain, une chaîne de montagnes vertigineuse, qui sépare le désert du reste du Maroc. Merzouga en est le terrain de jeu le plus connu, mais Erg Chebbi est un authentique erg saharien de dunes tourbillonnantes mesurant près de 200 mètres de hauteur.

Marokko

Die marokkanische Sahara, eine Tagesfahrt von der Mittelmeerküste entfernt, ist der am leichtesten zu erreichende Teil der Wüste. In der Antike benötigten die trans-saharischen Kamelkarawanen, die meist Salz transportierten, etwa 50 Tage, um von den Oasen Südmarokkos bis in die sagenumwobene Stadt Timbuktu zu gelangen. Die Berberfestungsstädte aus Lehmziegeln, in denen Hollywood-Blockbuster wie *Gladiator* gedreht wurden, liegen an den Südhängen des Atlasgebirges, einer schwindelerregenden Gebirgskette, die die Wüste vom Rest Marokkos trennt. Merzouga ist der bekannteste Ort in diesem Teil der Sahara, aber der Erg Chebbi ist ein echtes saharisches Erg aus wandernden Sanddünen von fast 200 m Höhe.

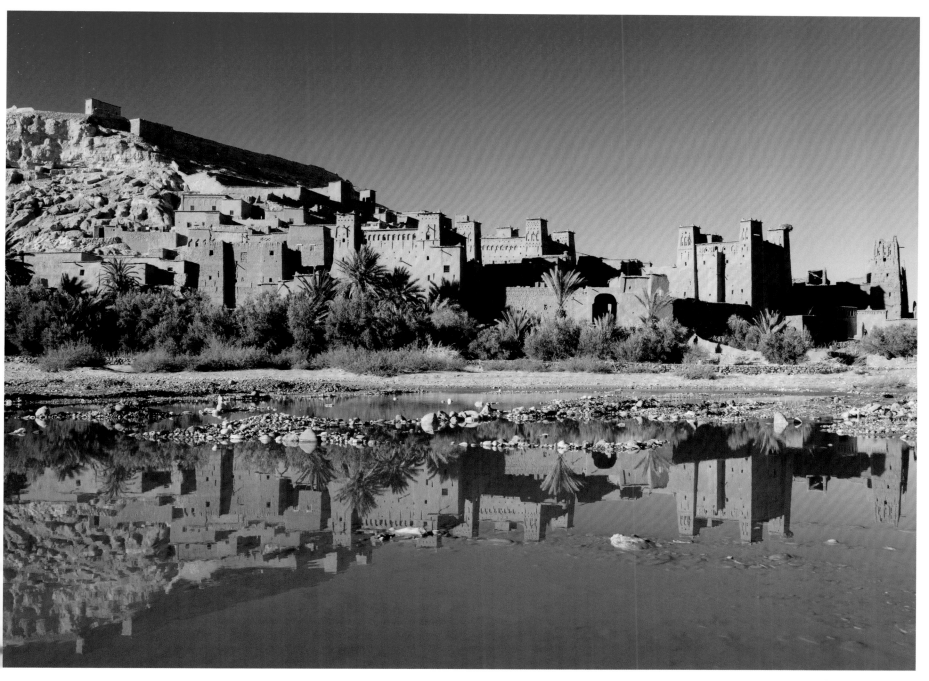

Ait Benhaddou, Souss-Massa-Draa, Morocco

Marruecos

El Sahara marroquí, a un día en coche de la costa mediterránea, es el rincón más accesible del desierto. En la antigüedad, las caravanas de camellos transaharianos, que suelen llevar sal, tardaban unos 50 días en cruzar entre los oasis del sur de Marruecos hasta la legendaria ciudad de Tombuctú (Tombouctou). Las ciudades fortaleza bereberes de ladrillo de barro (utilizadas para filmar éxitos de taquilla de Hollywood como *Gladiator*) se aferran a las laderas meridionales de la cordillera del Atlas, una cordillera vertiginosa que separa el desierto del resto de Marruecos. Merzouga es el parque infantil más conocido del desierto, pero Erg Chebbi es un auténtico erg sahariano de dunas de arena a la deriva de casi 200 m de altura.

Marrocos

O Sahara Marroquino, a um dia de carro da costa do Mediterrâneo, é o canto mais acessível do deserto. Nos tempos antigos, as caravanas transarianas de camelos, geralmente carregando sal, uma vez levou cerca de 50 dias para atravessar os oásis do sul de Marrocos para a lendária cidade de Timbuktu (Tombouctou). As cidades fortalezas berberes – usadas para filmar blockbusters de Hollywood como *Gladiator* – se agarram as encostas do sul das montanhas do Atlas, uma faixa vertiginosa que separa o deserto do resto do Marrocos. Merzouga é o parque de diversões mais conhecido do deserto, mas Erg Chebbi é um verdadeiro erg Saariano de dunas de areia de quase 200 m de altura.

Marokko

De Marokkaanse Sahara, een dagje rijden vanaf de Middellandse Zeekust, is het meest toegankelijke deel van de woestijn. In de klassieke oudheid kostte het de kamelenkaravanen, die meestal zout vervoerden, circa 50 dagen om van de oases van Zuid-Marokko naar de legendarische stad Timboektoe te reizen. De van lemen bakstenen gebouwde vestingsteden van de Berbers, waarin Hollywood-blockbusters zoals *Gladiator* werden opgenomen, klampen zich vast aan de zuidelijke hellingen van de Atlas, een duizelingwekkend gebergte dat de woestijn scheidt van de rest van Marokko. Merzouga is de bekendste plaats in dit deel van de Sahara, terwijl Erg Chebbi echt Saharaans is met zijn stuifduinen van bijna 200 meter hoog.

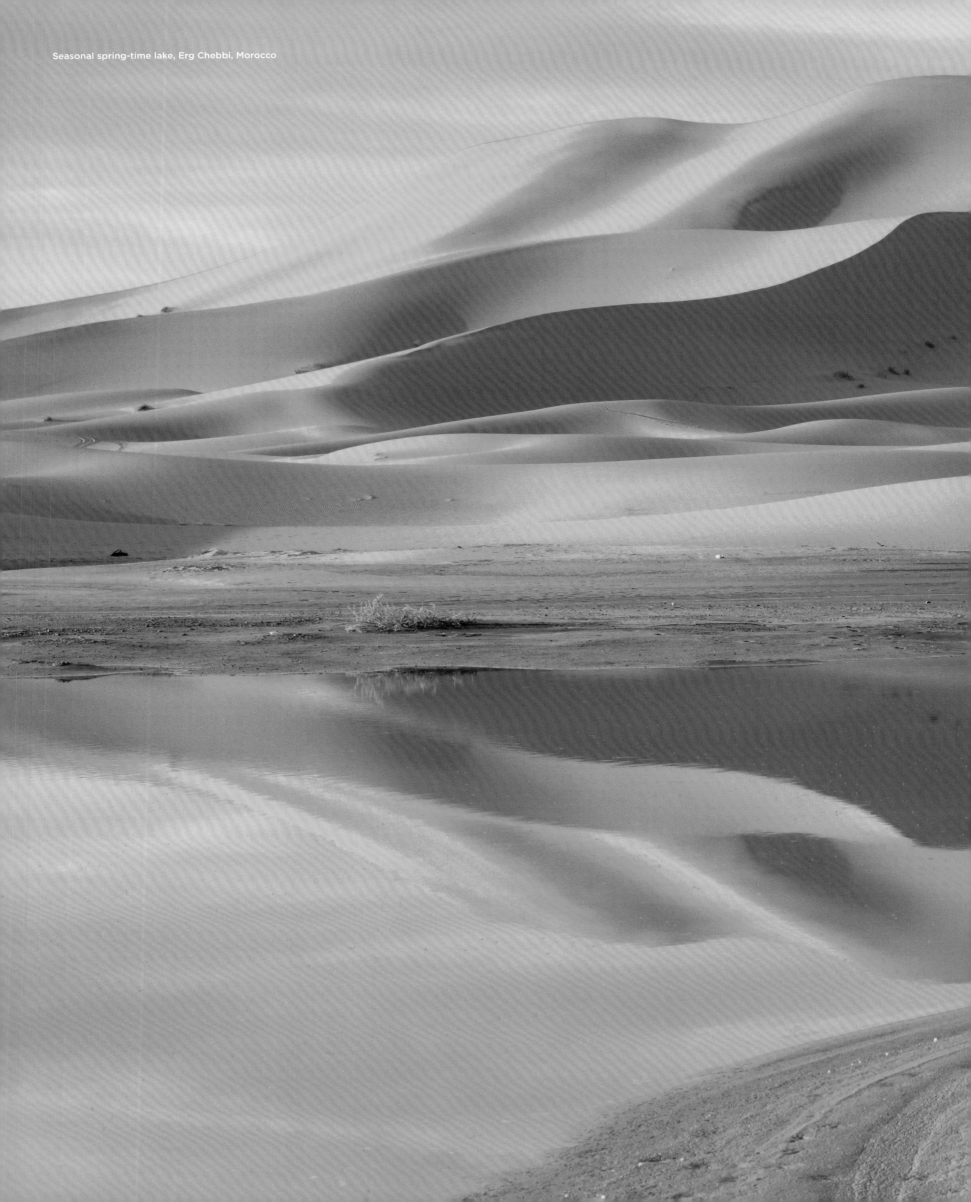

Seasonal spring-time lake, Erg Chebbi, Morocco

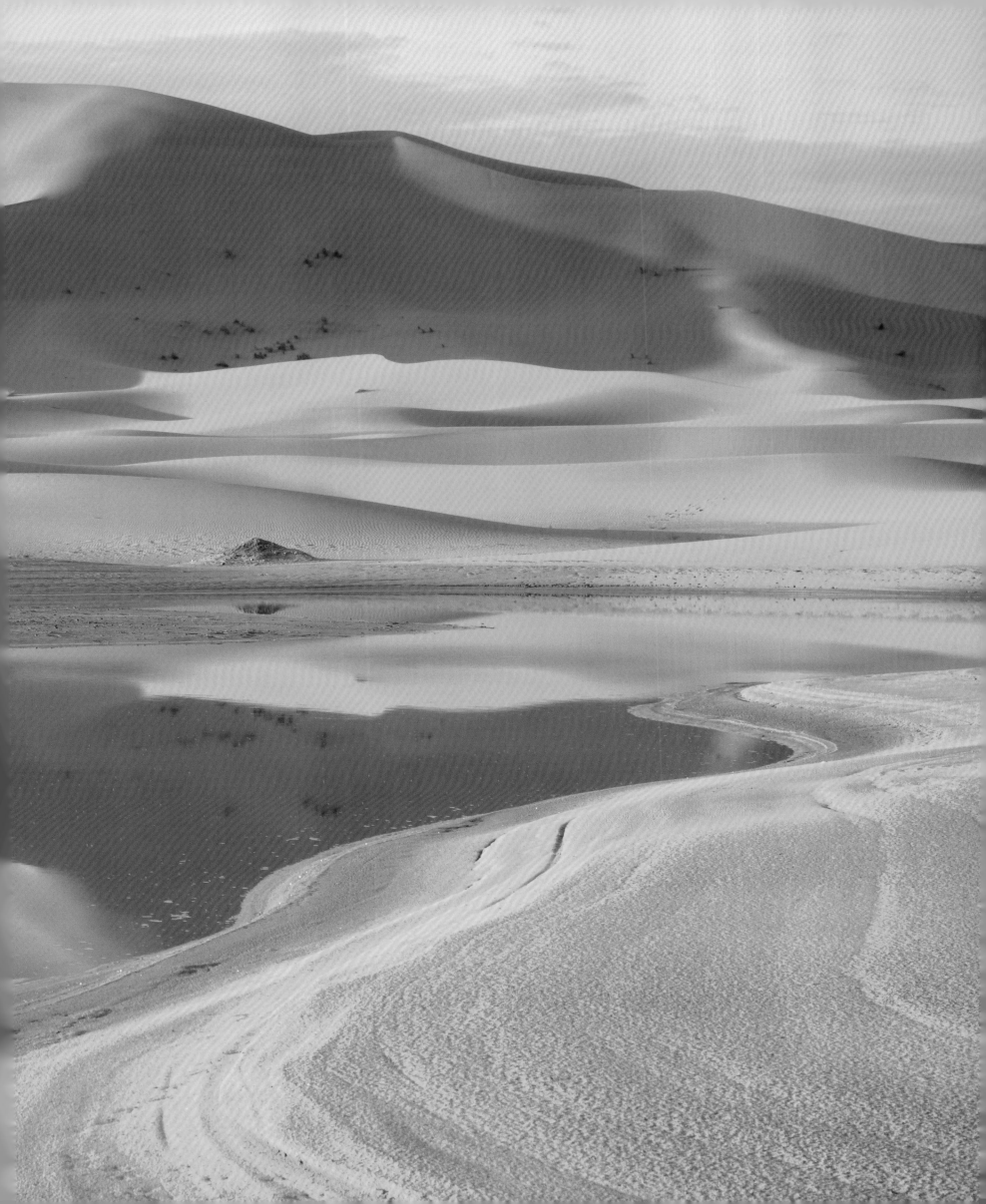

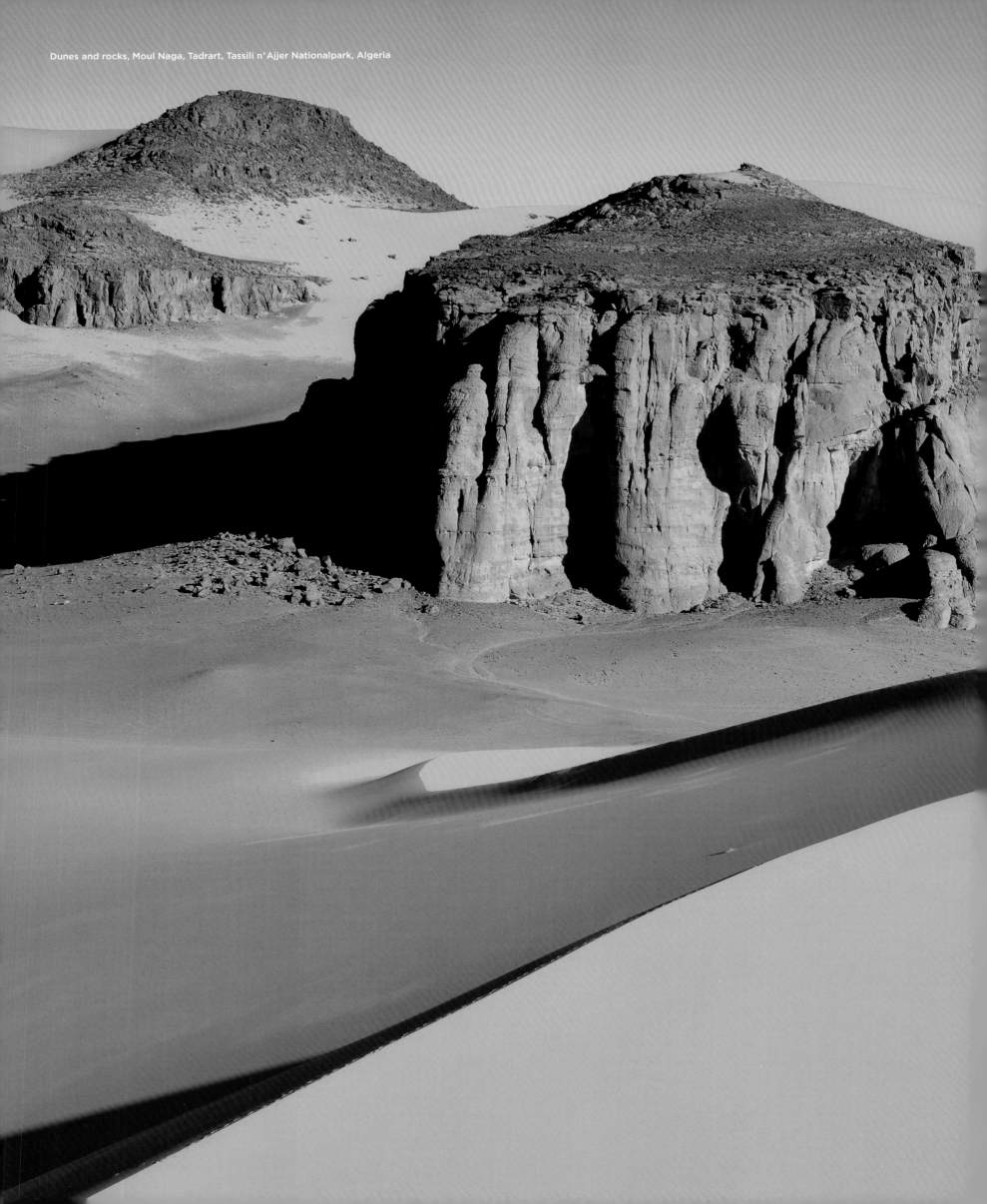

Dunes and rocks, Moul Naga, Tadrart, Tassili n' Ajjer Nationalpark, Algeria

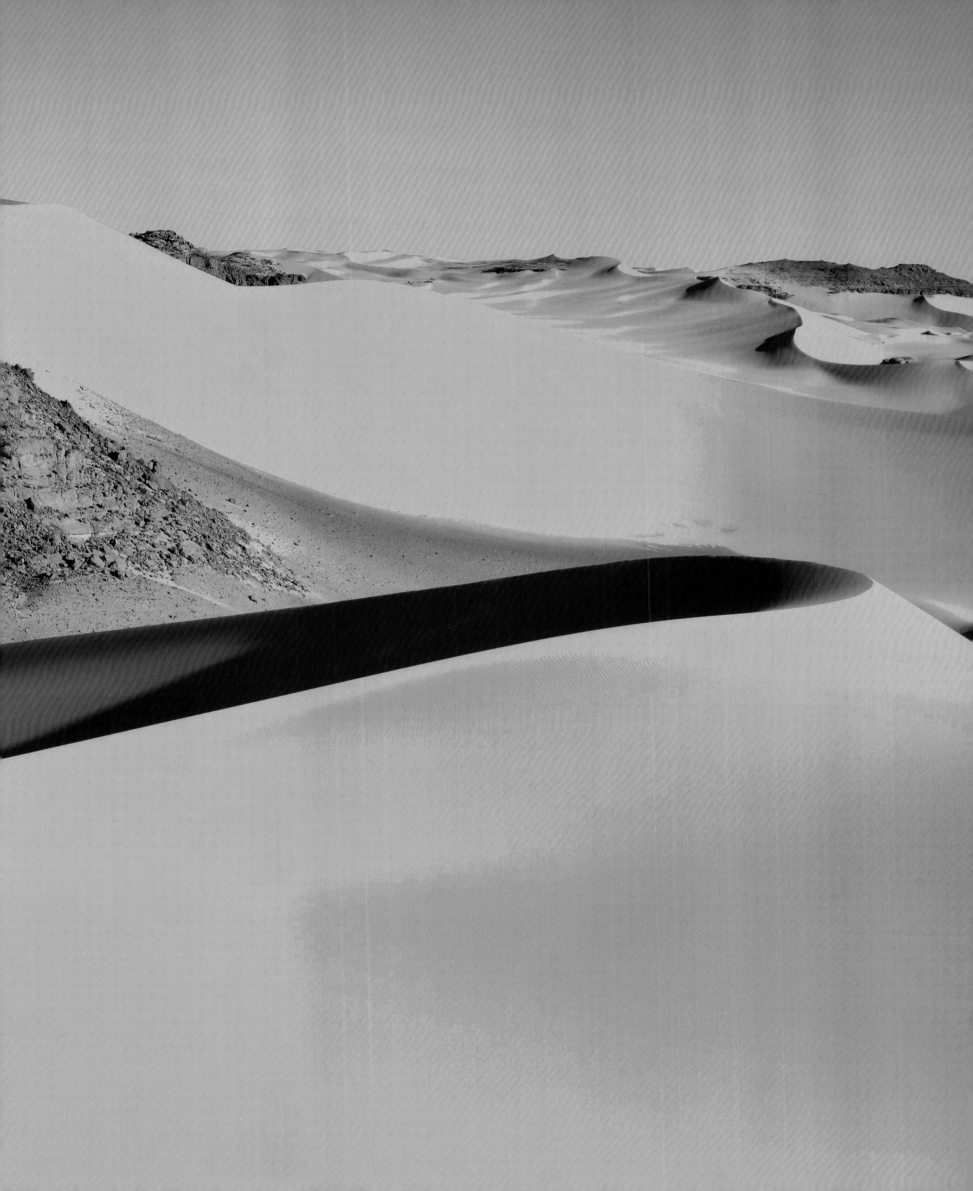

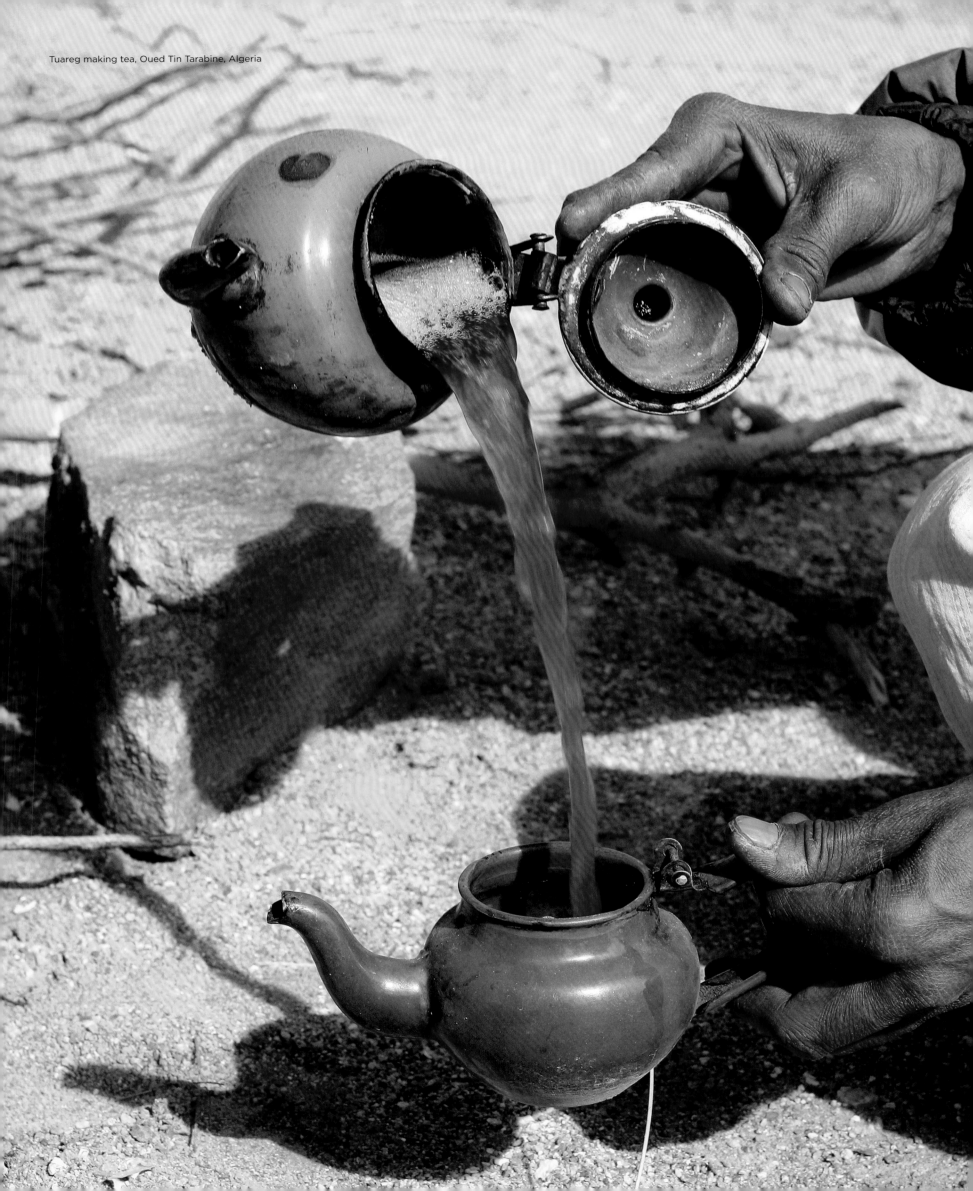

Tuareg making tea, Oued Tin Tarabine, Algeria

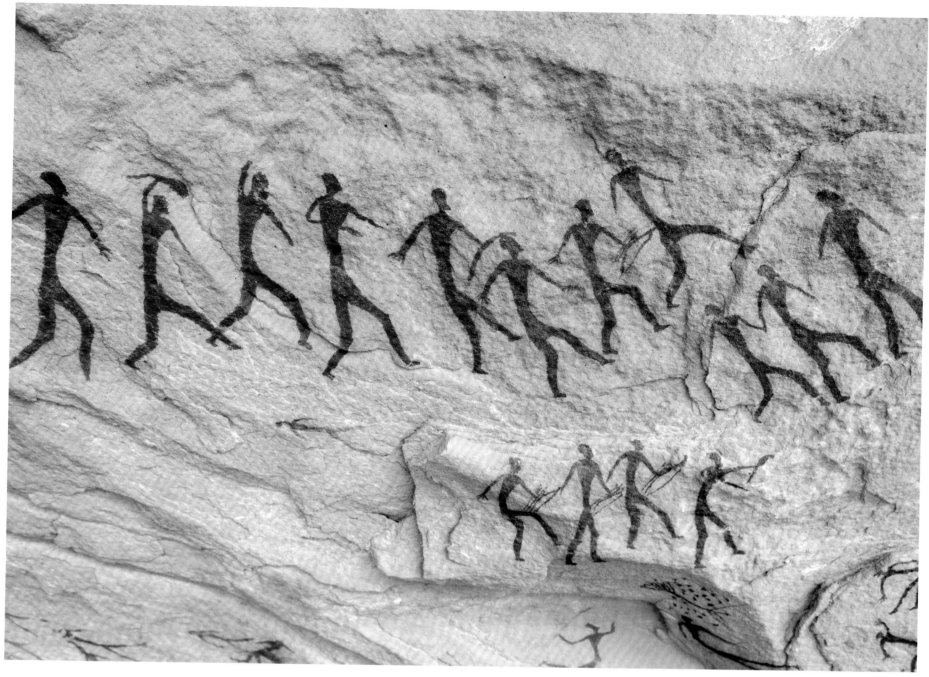

Neolithic Rock Carving, Arakokem, Adrar Tekemberet, Immidir, Algeria

Neolithic Rock Carving

Often considered the Sahara's history books, the rock paintings reveal that this is one of the youngest deserts on earth. Until around 12 000 years ago, the Sahara was fertile and enjoyed a pleasant Mediterranean climate. Through their subject matter, the remote rock paintings tell of the Sahara's transition into a desert and of its changing human population.

Art rupestre du Néolithique

Souvent considérées comme les livres d'histoire du Sahara, les peintures sur roche qui ornent les parois des grottes locales montrent que ce désert est l'un des plus jeunes du monde. Voici 12 000 ans avant notre ère, le Sahara était fertile et jouissait alors d'un agréable climat méditerranéen. À travers leurs sujets, les anciennes peintures rupestres racontent la mutation du Sahara en désert et l'évolution de sa population humaine.

Neolithische Felsbilder

Die Felsmalereien, die auch als das Geschichtsbuch der Sahara bezeichnet werden, zeigen, dass die Wüste eine der jüngsten der Welt ist. Bis vor etwa 12 000 Jahren war die Sahara fruchtbar und hatte ein mediterranes Klima. Entlegene Felsmalereien erzählen von der Verwandlung der Sahara zu einer Wüste und von den Veränderungen für die menschlichen Bevölkerung.

Talla en roca neolítica

A menudo considerados los libros de historia del Sahara, las pinturas rupestres revelan que se trata de uno de los desiertos más jóvenes de la tierra. Hasta hace unos 12 000 años, el Sahara era fértil y gozaba de un agradable clima mediterráneo. A través de su temática, las pinturas rupestres remotas hablan de la transición del Sahara a un desierto y de su cambiante población humana.

Escultura de pedra neolítica

Muitas vezes considerados livros de história do Saara, as pinturas rupestres revelam que este é um dos mais jovens desertos da Terra. Até cerca de 12 000 anos atrás, o Saara era fértil e desfrutava de um clima mediterrânico agradável. Através de seu assunto, pinturas rupestres remotas contam a transição do Saara para um deserto e sua população humana em mutação.

Neolithische rotstekeningen

De rotsschilderingen onthullen dat dit een van de jongste woestijnen op aarde is. Tot circa 12 000 jaar geleden was de Sahara vruchtbaar en heerste er een aangenaam mediterraan klimaat. Afgelegen rotsschilderingen vertellen met hun onderwerpkeuze over de verandering van de Sahara in een woestijn en de veranderingen voor de menselijke bevolking.

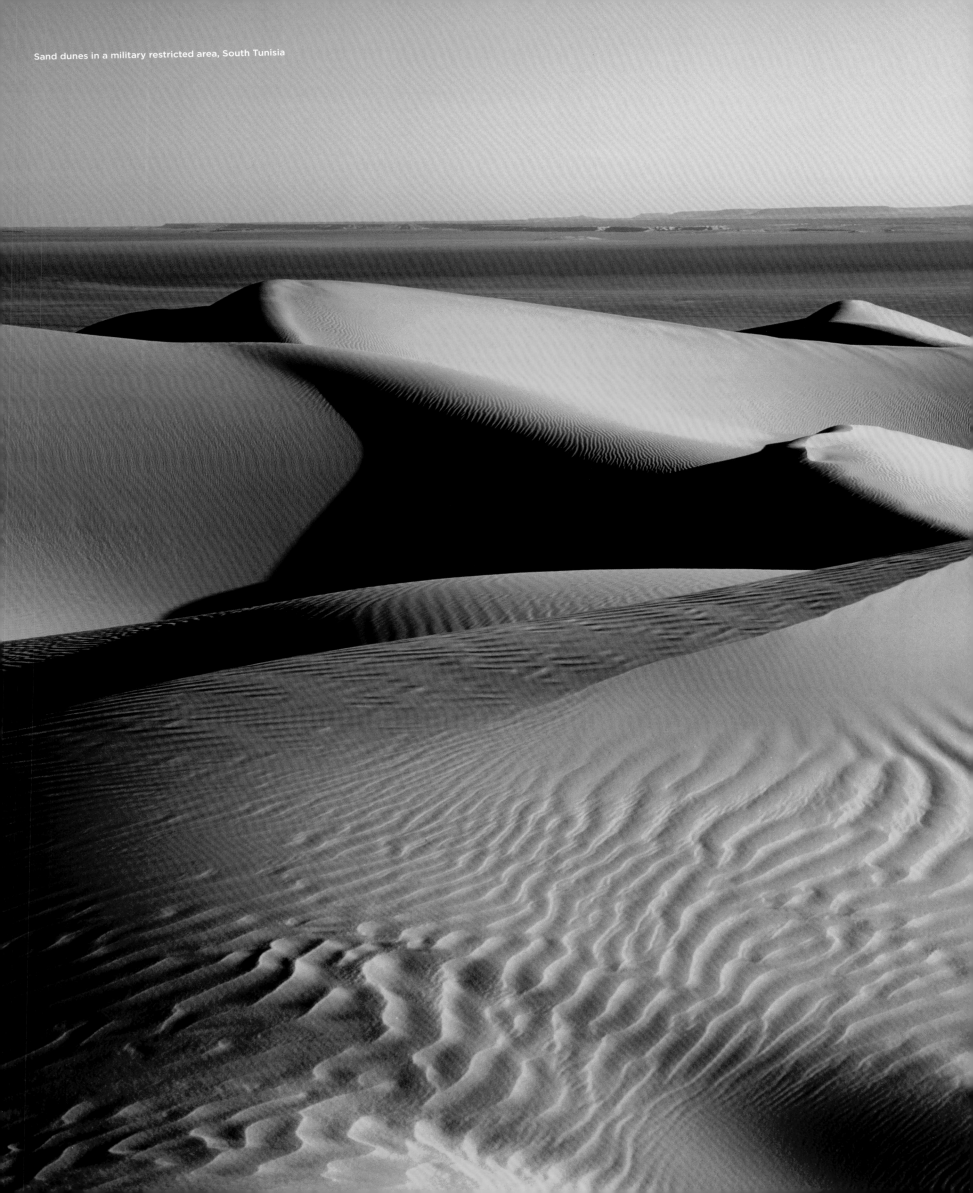

Sand dunes in a military restricted area, South Tunisia

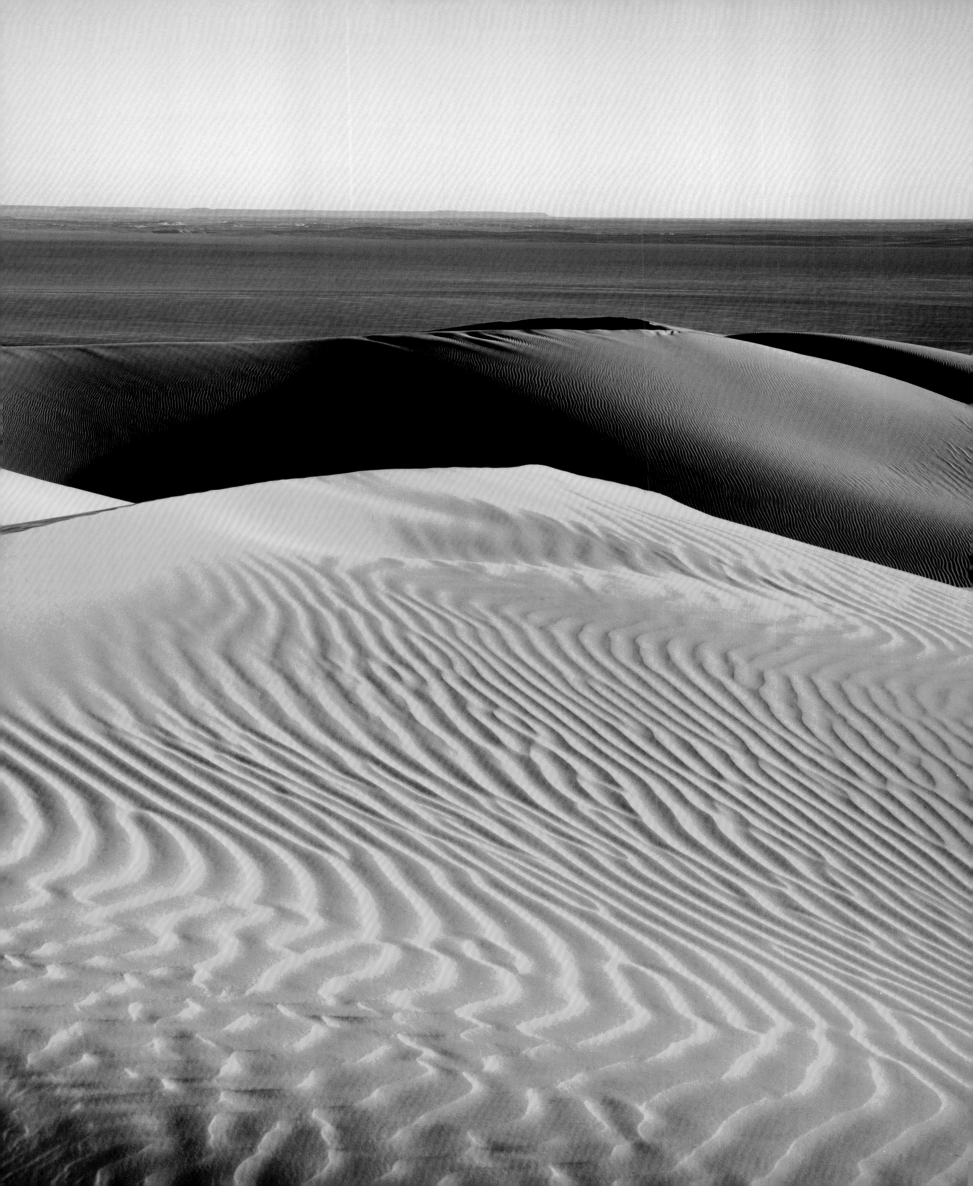

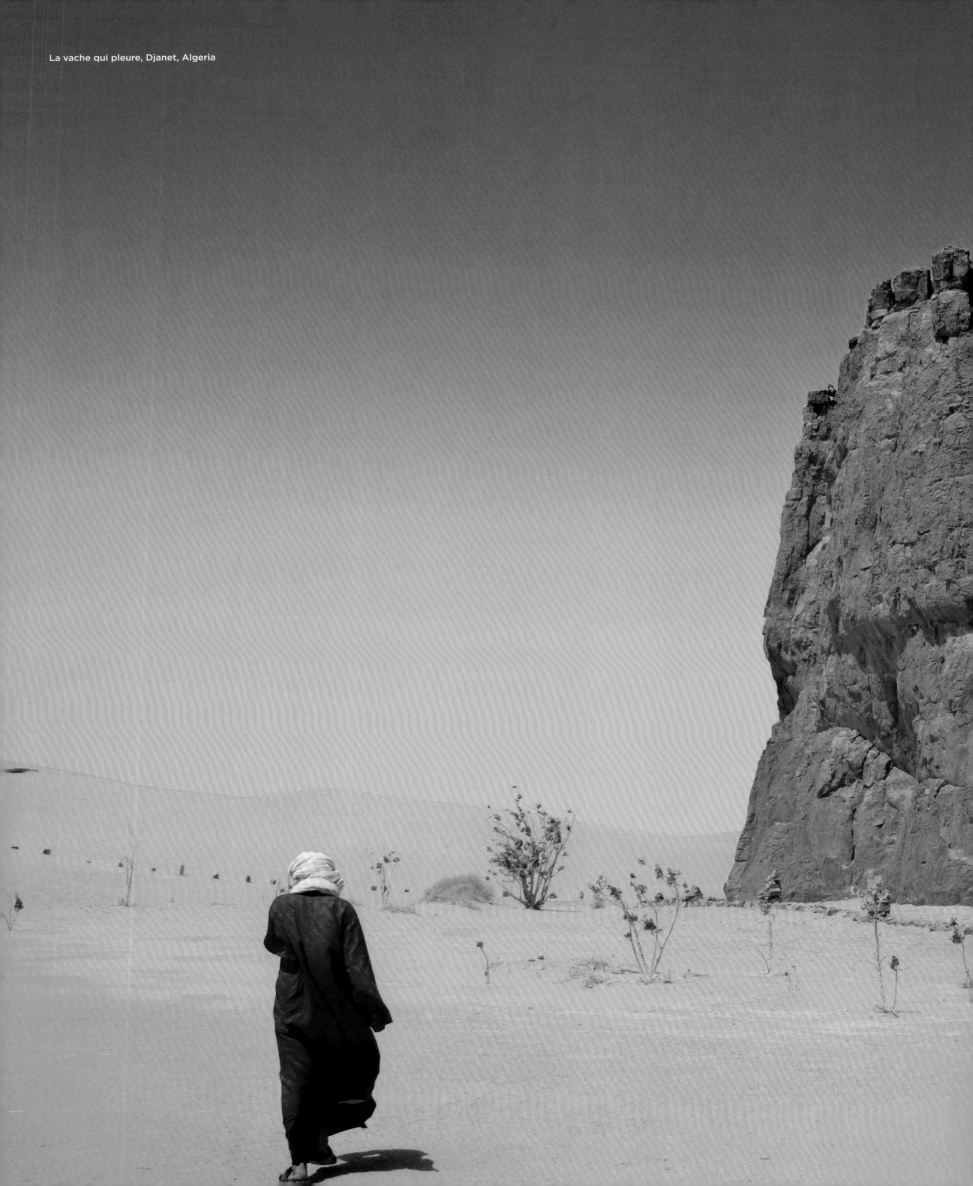

La vache qui pleure, Djanet, Algeria

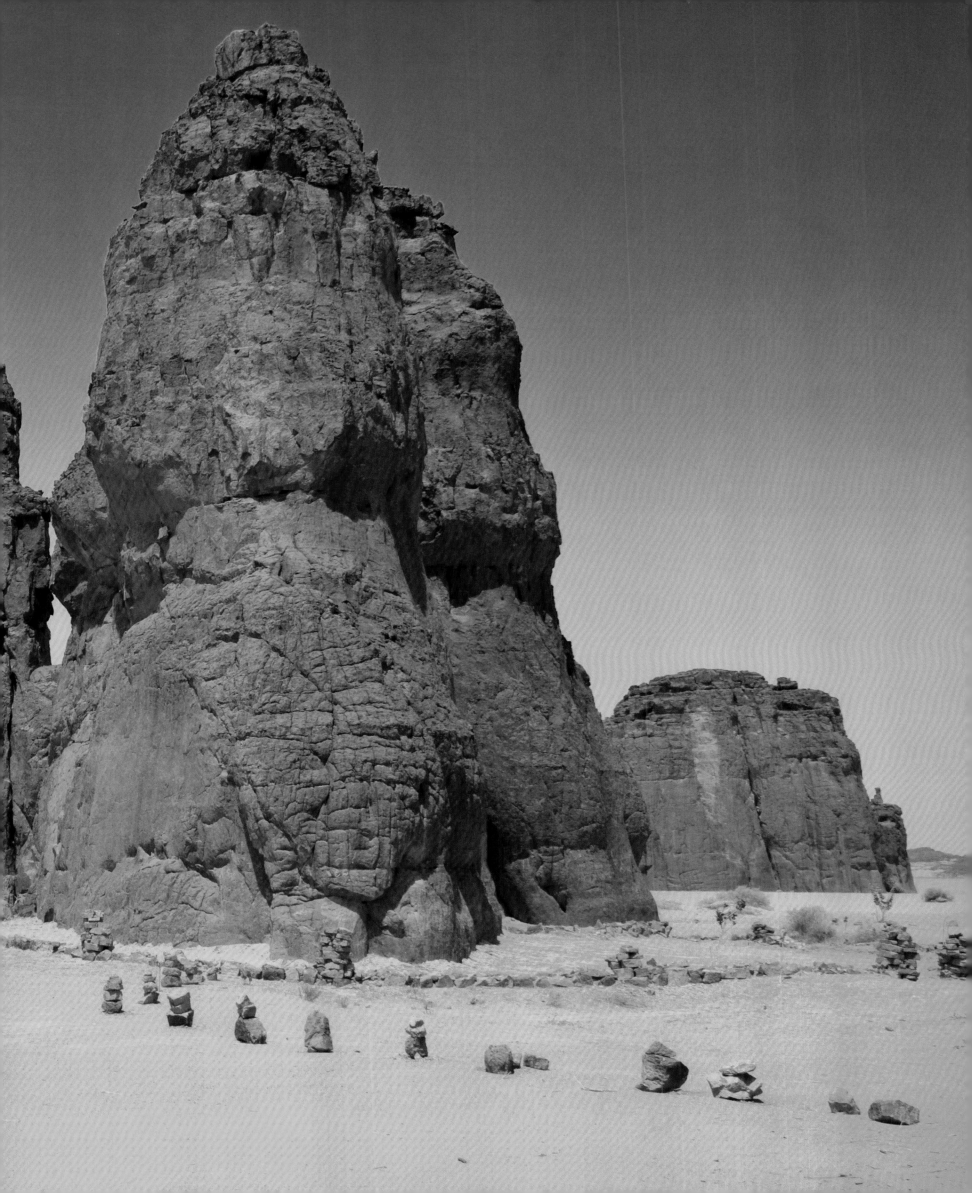

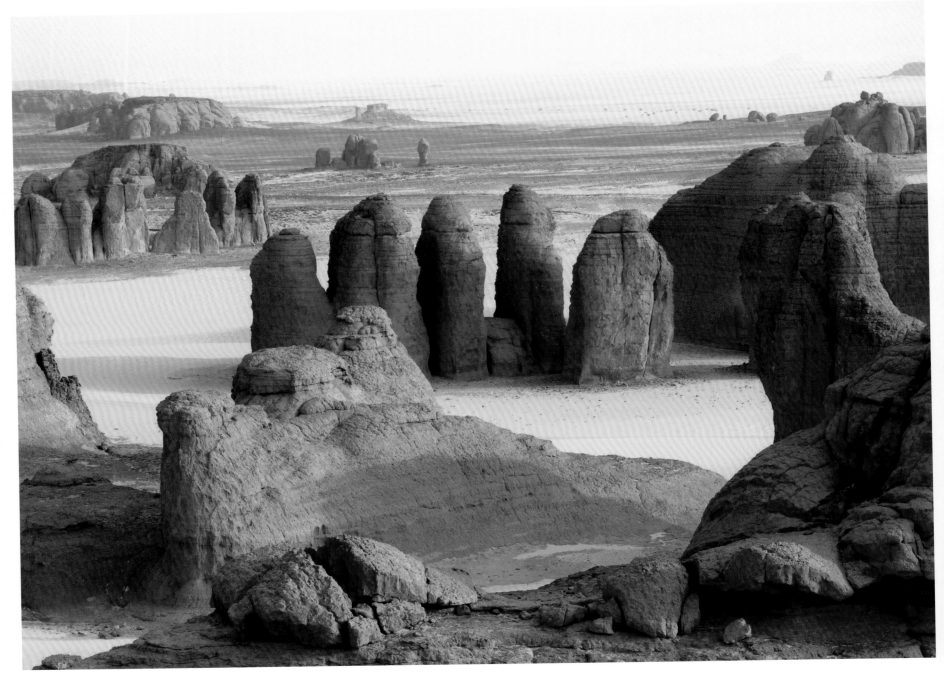

Tamanghasset, Algeria

Algeria's Desert Massifs

Desert mountain ranges, blasted by sand and hot desert winds for more than ten thousand years, lie throughout the Sahara. But it is in Algeria that they take on their most extraordinary forms. The Hoggar Mountains of Algeria's south, a fiercely defended Tuareg homeland, and outlying ranges are known for their bizarrely sculpted rocks: mushrooms, vast and craggy forests, city skylines. There is even a place called Assekrem, which means 'The End of the World' in the Tuareg language.

Massifs du désert algérien

Battues par le sable et les vents chauds du désert pendant plus de dix mille ans, les chaînes de montagnes s'étirent un peu partout à travers le Sahara. Mais c'est en Algérie que leurs formes sont les plus extraordinaires. Le Hoggar du Sud algérien, patrie touarègue farouchement protégée, et ses chaînes périphériques, sont connues pour leurs étranges rochers évoquant des champignons, d'immenses forêts escarpées et des silhouettes de gratte-ciel. Un plateau nommé Assekrem, ou « la fin du monde », en langue touarègue, est d'ailleurs implanté là. Plus improbables encore, ses massifs abritent une population « relique » de guépards sahariens, l'animal terrestre le plus rapide du monde.

Algeriens Wüstengebirge

Bergzüge, die seit mehr als zehntausend Jahren von Sand und heißen Wüstenwinden gepeitscht werden, gibt es in der gesamten Sahara. Aber gerade in Algerien nehmen die Berge außergewöhnliche Formen an. Das Hoggar-Gebirge im Süden Algeriens wird von den dort lebenden Tuareg erbittert verteidigt. Die abgelegenen Bergketten sind bekannt für ihre bizarr geformten Felsen: Pilze, riesige zerklüftete Wälder, Stadtsilhouetten. Es gibt sogar einen Ort namens Assekrem, was in der Tuareg-Sprache „Das Ende der Welt" bedeutet.

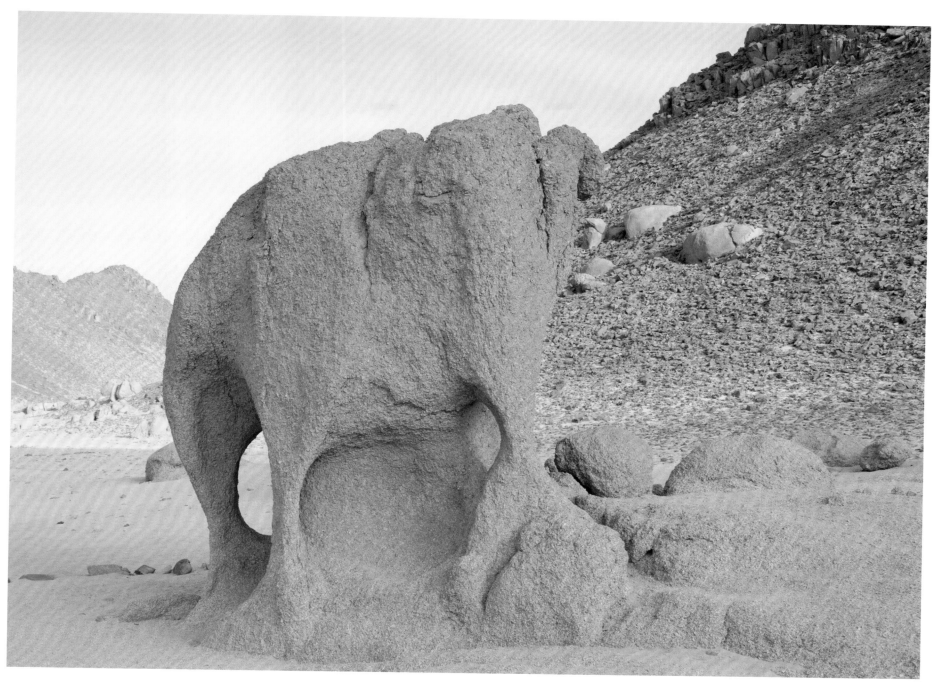
Tadrat Desert, Wadi Tasset, Algeria

Macizos del desierto de Argelia

Las cadenas montañosas del desierto, azotadas por la arena y los vientos cálidos del desierto durante más de diez mil años, se extienden por todo el Sáhara. Pero es en Argelia donde estas adquieren sus formas más extraordinarias. Las montañas Hoggar del sur de Argelia, una patria tuareg ferozmente defendida, y las cordilleras periféricas son conocidas por sus rocas extrañamente esculpidas: hongos, vastos y escarpados bosques, líneas del horizonte de la ciudad. Incluso hay un lugar llamado. Assekrem, que significa «el fin del mundo» en lengua tuareg.

Os maciços do deserto da Argélia

Cordilheiras do deserto, destruídas por areia e ventos quentes do deserto por mais de dez mil anos, estão espalhadas por todo o Saara. Mas é na Argélia que eles assumem suas formas mais extraordinárias. As montanhas de Hoggar, no sul da Argélia, uma pátria tuaregues ferozmente protegida, são conhecidas por suas rochas bizarramente esculpidas: cogumelos, vastas e íngremes florestas, skylines da cidade. Existe até um lugar chamado Assekrem, que significa "O fim do mundo" na língua tuaregue.

Algerijns woestijnmassief

Overal in de Sahara liggen woestijngebergtes, die al meer dan tienduizend jaar door zand en hete woestijnwinden worden gestraald. In Algerije nemen ze echter de bijzonderste vormen aan. Het Ahaggargeberte in het zuiden van Algerije wordt hevig verdedigd door de Toearegs. De afgelegen bergketens staan bekend om hun bizar gevormde rotsen: paddenstoelen, uitgestrekte bossen vol kloven, skylines van steden. Er is zelfs een plaats met de naam Assekrem, wat in de Toearegtaal "het einde van de wereld" betekent.

Tassili n'Ajjer, Algeria

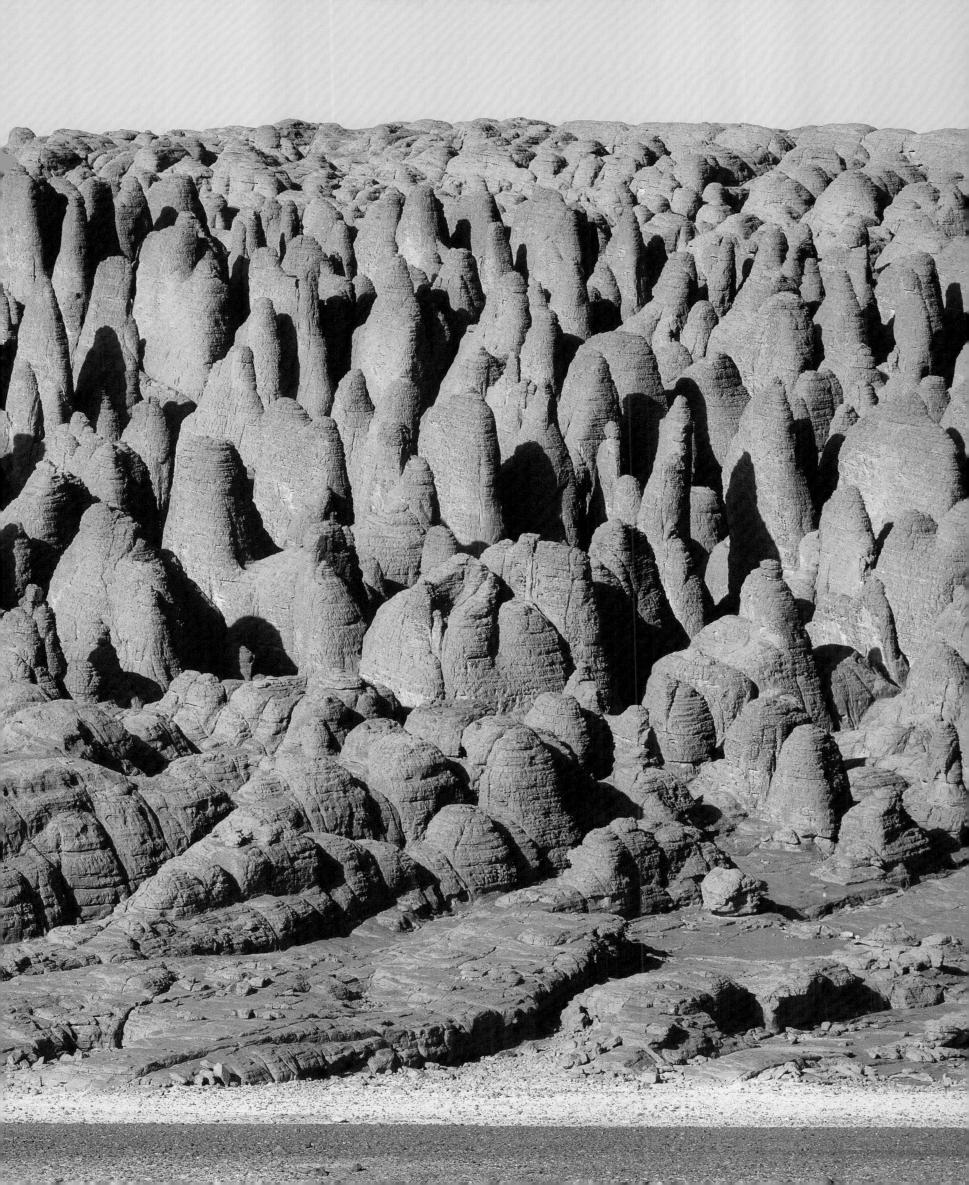

Eastern Sahara
Libya, Egypt & Sudan

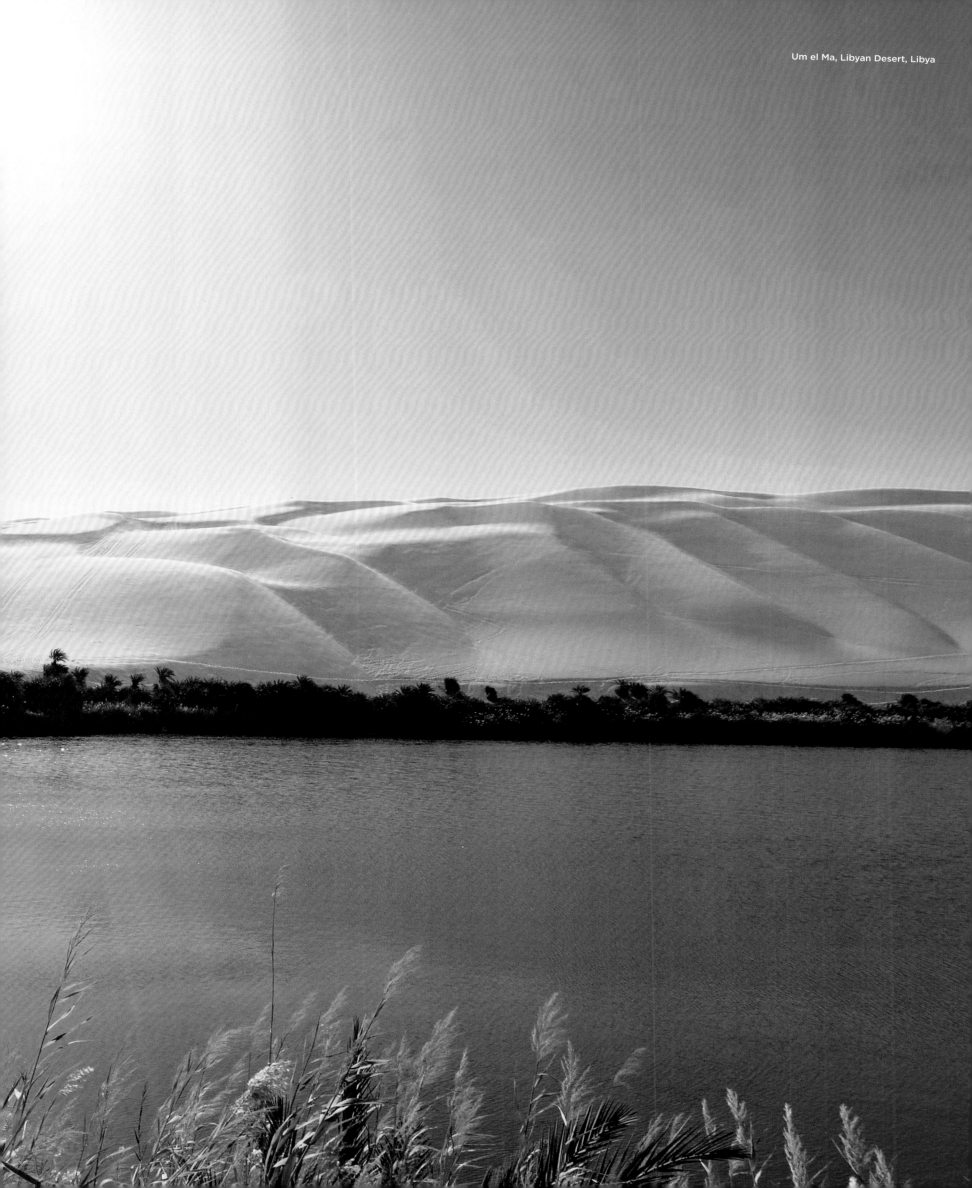

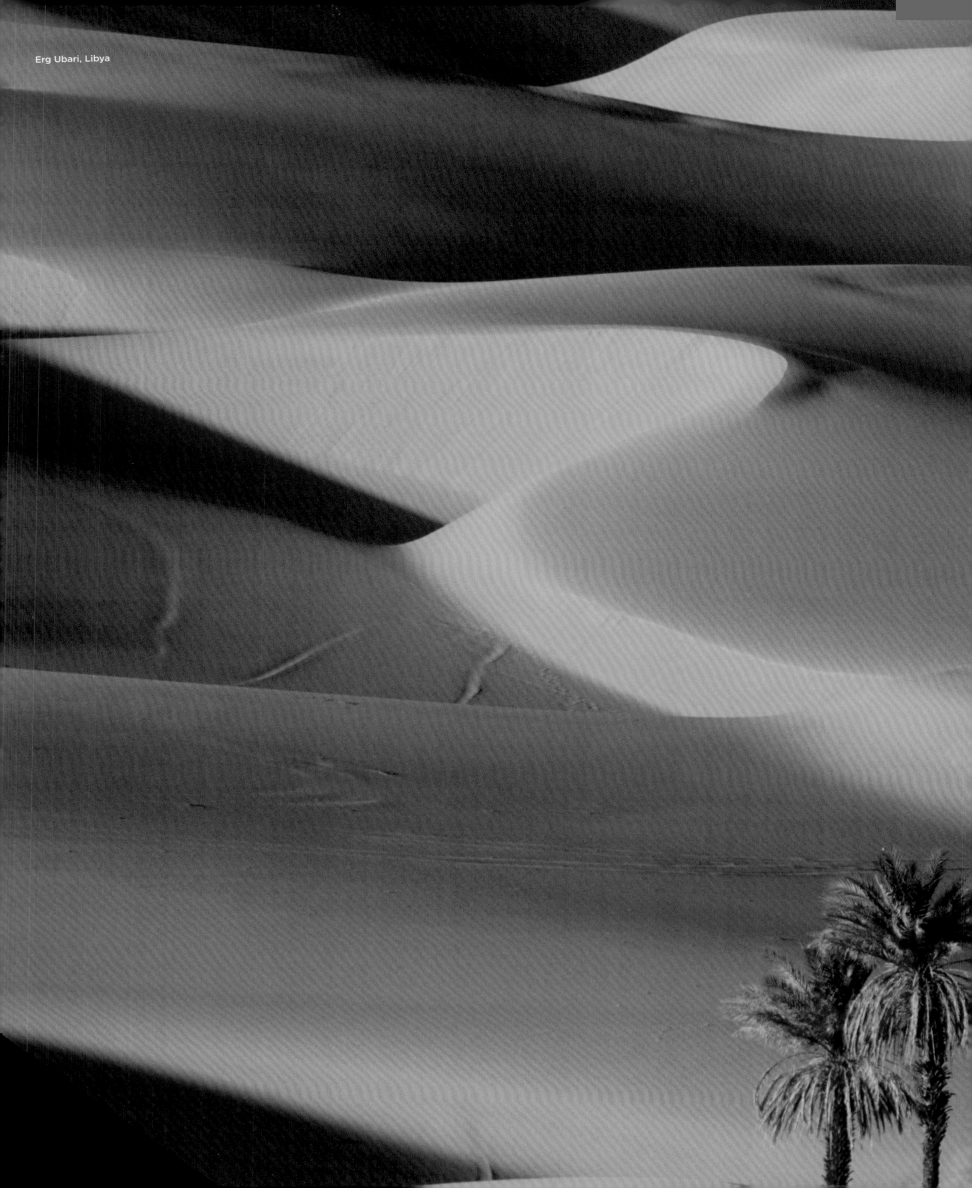

Erg Ubari, Libya

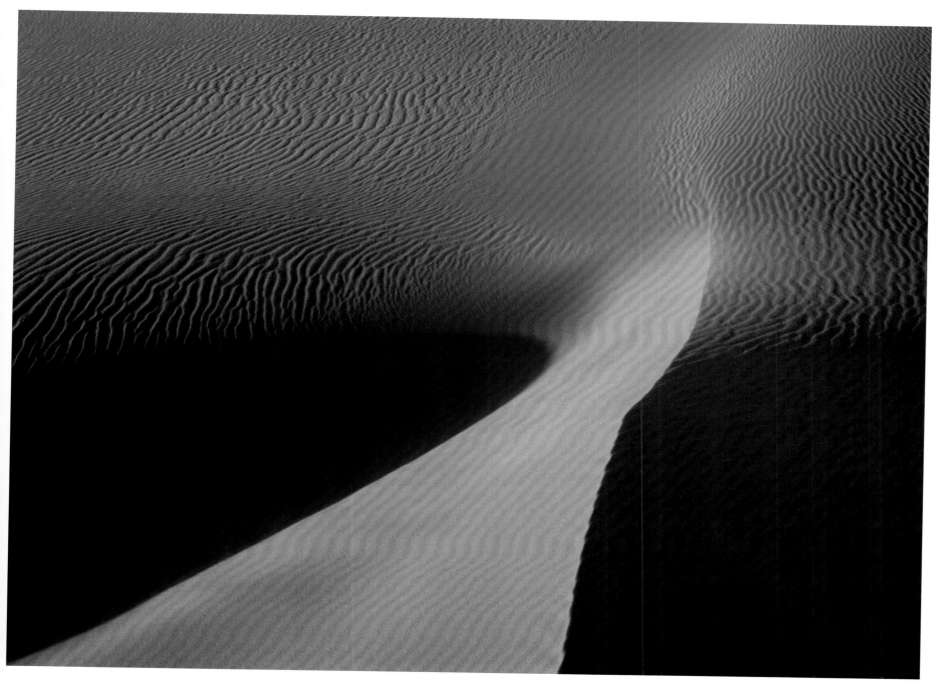

Erg Ubari, Libya

Eastern Sahara

The Sahara's east is classic Saharan terrain. Libya has the richest variety of desert landscapes, with astonishing sand seas (the Erg Ubari, with its 11 or more palm-fringed lakes surrounded by high dunes is roughly the same size as Switzerland), as well as the Jebel Acacus massif and Waw an-Namus black-sand volcanic crater.

Sahara oriental

L'est du Sahara présente un terrain saharien classique. La Libye possède la plus riche variété de paysages désertiques, avec d'étonnantes mers de sable – l'Erg Ubari, qui compte au moins onze lacs bordés de palmiers cernés de hautes dunes fait environ la même superficie que la Suisse –, le massif de Jebel Acacus ainsi que le cratère de sable noir volcanique de Waw an Namus.

Ost-Sahara

Der Osten der Sahara zeigt klassische Saharalandschaften. Libyen hat die größte Vielfalt an Wüstenlandschaften zu bieten: erstaunliche Sandmeere (der Erg Ubari mit seinen 11 oder mehr palmengesäumten Seen, die von hohen Dünen umgeben sind), die ungefähr die gleiche Größe wie die Schweiz haben; das Dschebel-Acacus-Massiv; und der von schwarzen Sand umgebenen Vulkankrater Waw an-Namus.

Sahara Oriental

El este del Sahara es el clásico terreno sahariano. Libia tiene la más rica variedad de paisajes desérticos, con asombrosos mares de arena (el Erg Ubari, con sus 11 o más lagos bordeados de palmeras y rodeados de altas dunas, es aproximadamente del mismo tamaño que Suiza), así como el macizo de Jebel Acacus y el cráter volcánico de arena negra de Waw an Namus.

Saara Oriental

O leste do Saara é um terreno clássico do Saara. A Líbia tem a mais rica variedade de paisagens desérticas, com surpreendentes mares de areia (o Erg Ubari, com seus 11 ou mais lagos cercados de palmeiras cercados por altas dunas) é aproximadamente do mesmo tamanho da Suíça), assim como o maciço de Jebel Acacus e Waw cratera vulcânica an-Namus preto-areia.

Oostelijke Sahara

Het oosten van de Sahara is klassiek Saharaans terrein. Libië heeft de rijkste verscheidenheid aan woestijnlandschappen, met verbazingwekkende zandzeeën (Erg Ubari, met zijn elf of meer met palmbomen omzoomde meren die door hoge duinen worden omgeven), het massief Tadrart Acacus en Waw-an-Namus, een vulkaanveld en krater met zwart zand.

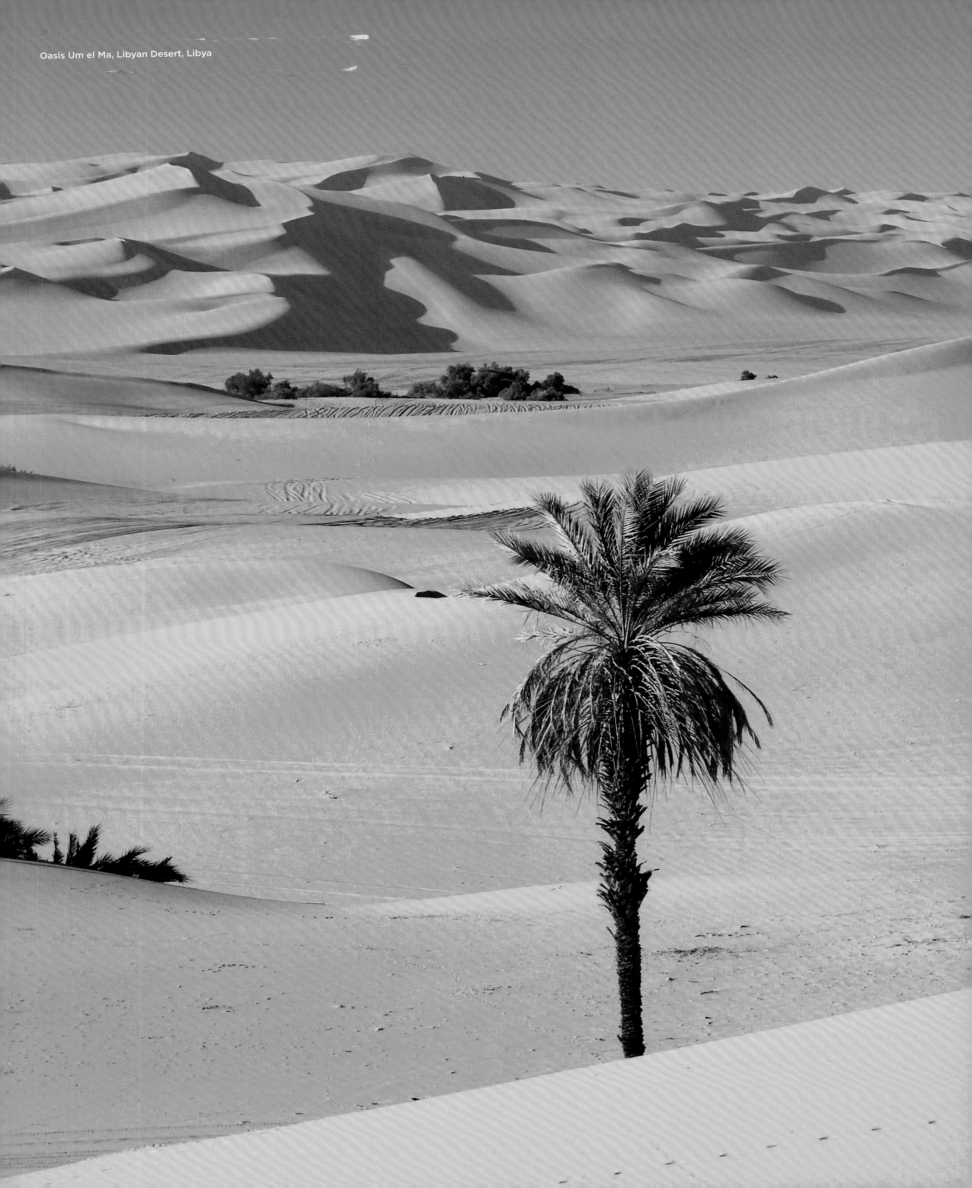

Oasis Um el Ma, Libyan Desert, Libya

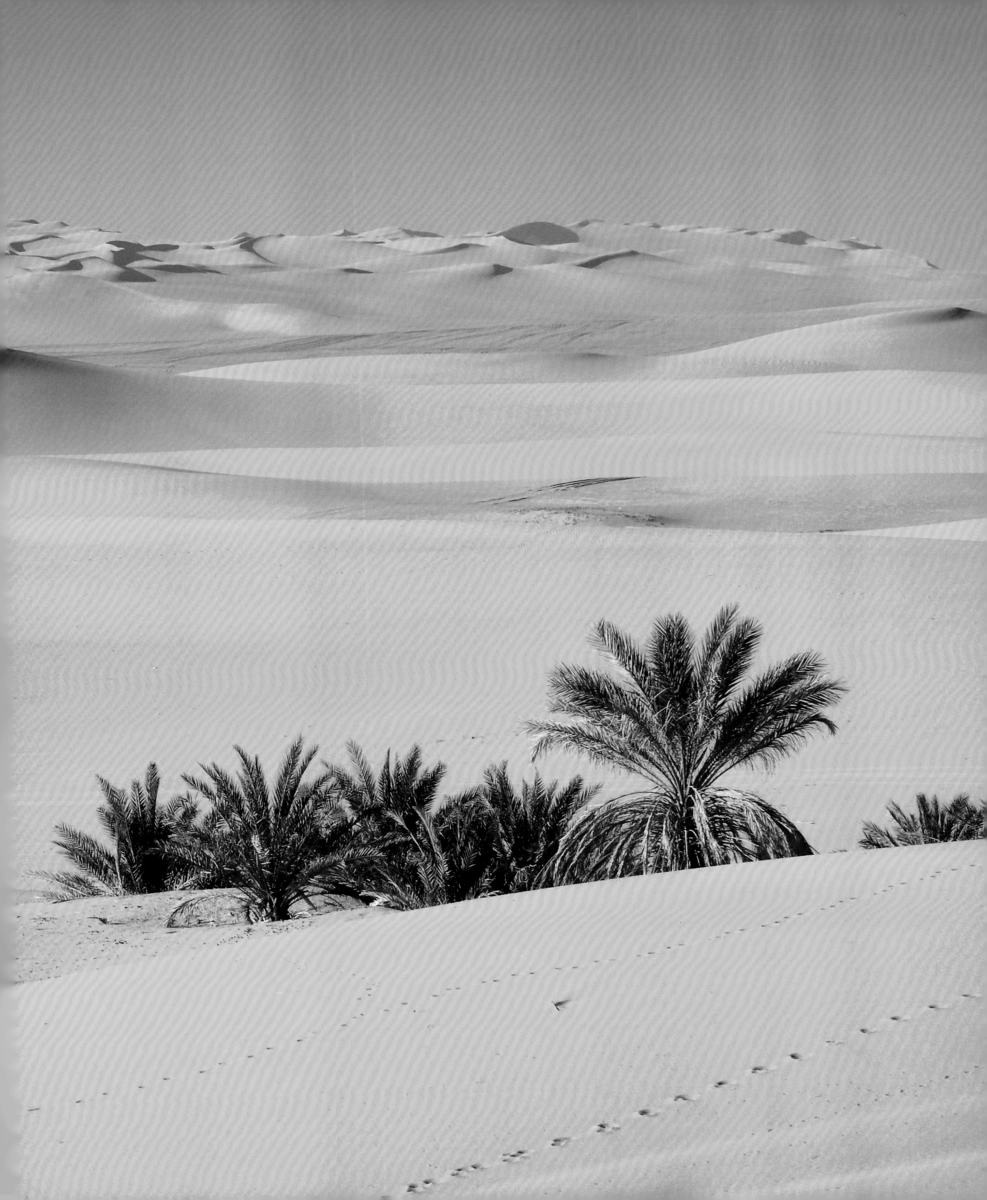

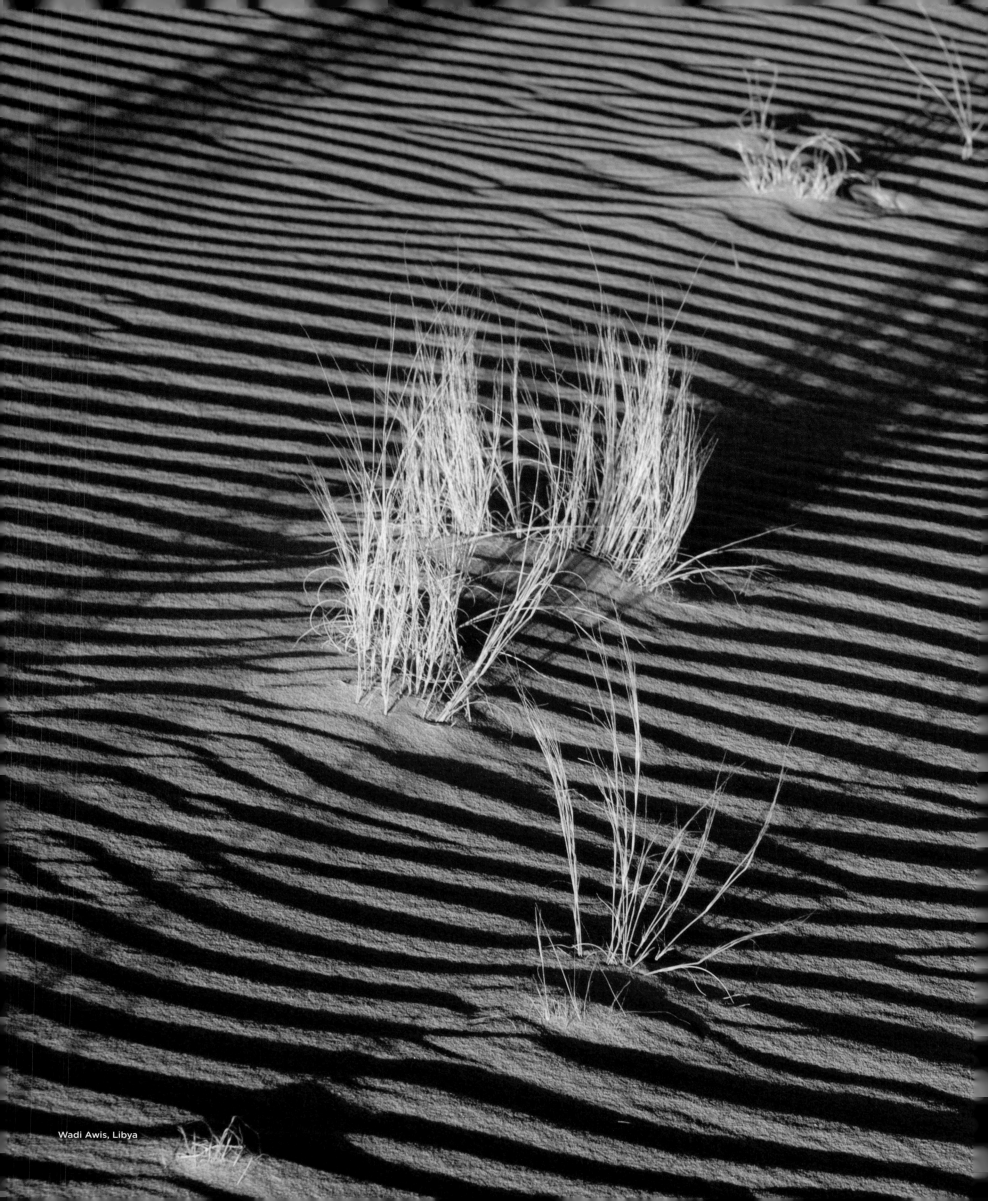

Wadi Awis, Libya

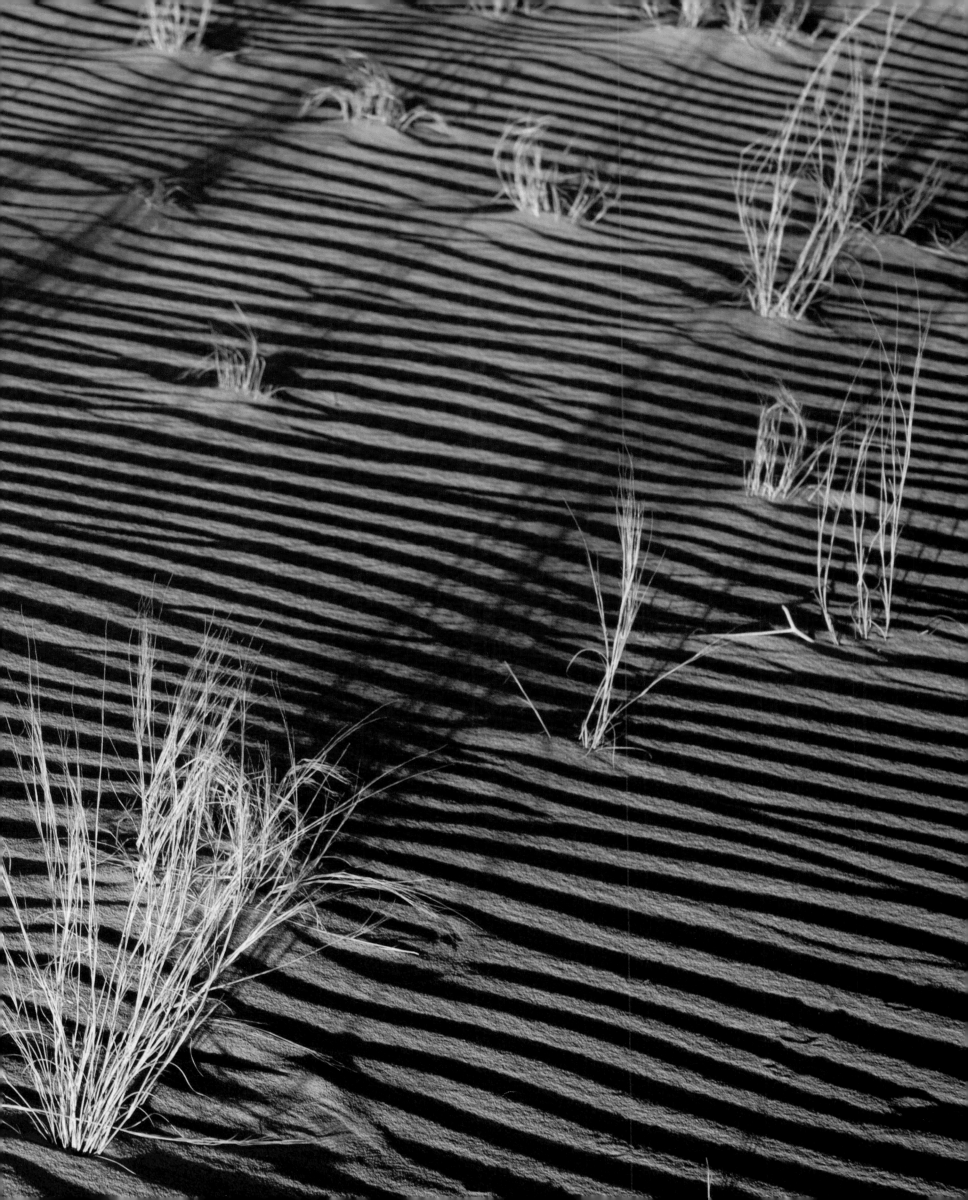

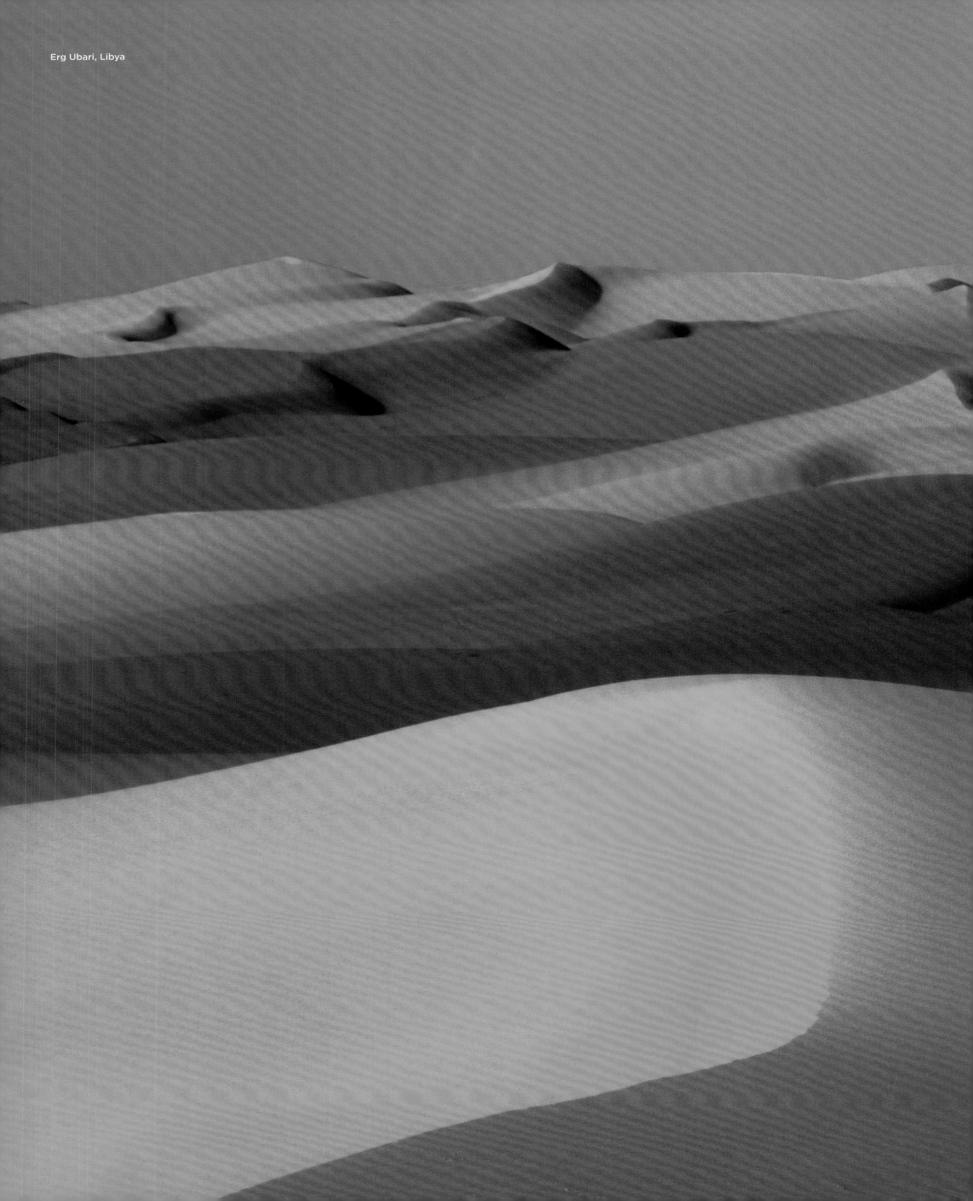

Erg Ubari, Libya

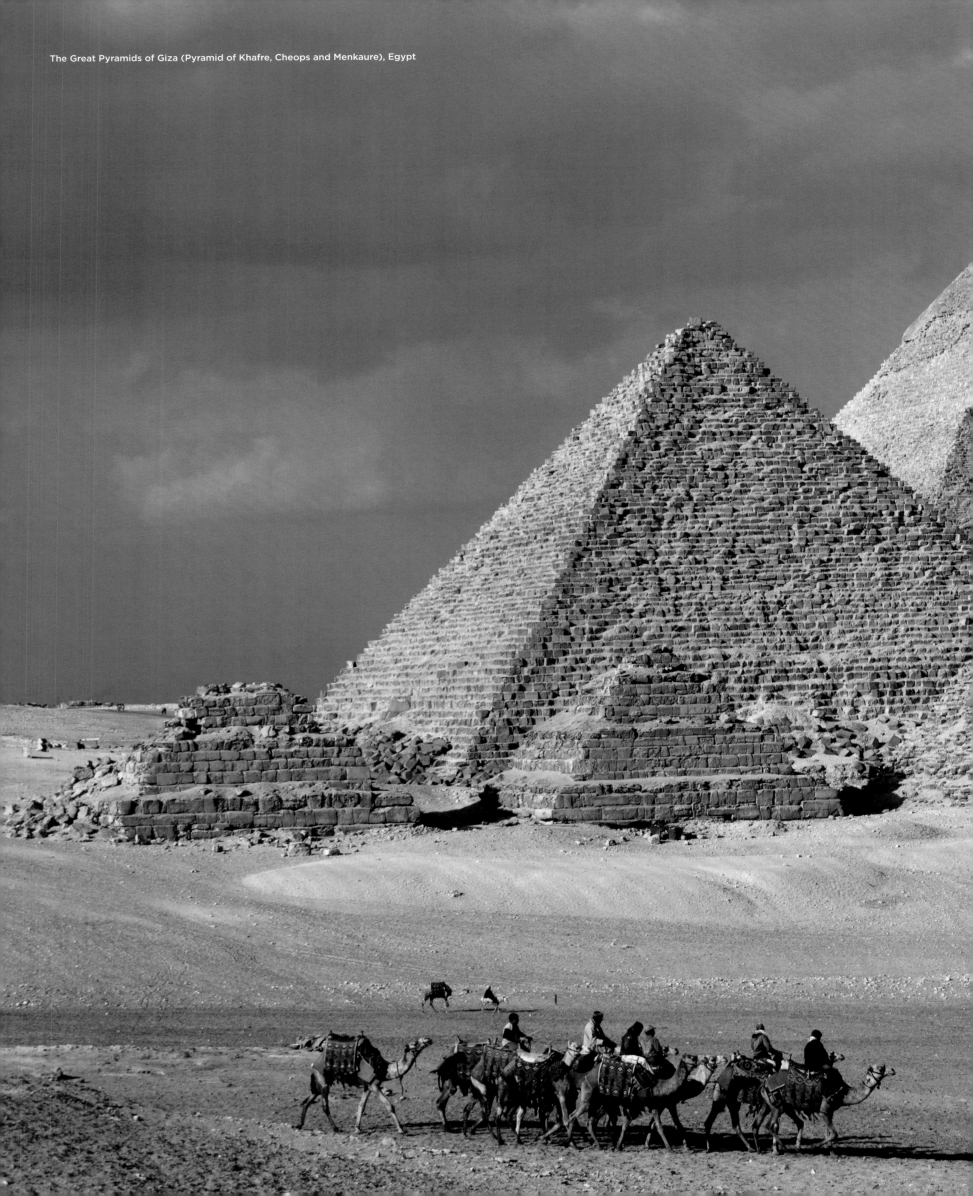

The Great Pyramids of Giza (Pyramid of Khafre, Cheops and Menkaure), Egypt

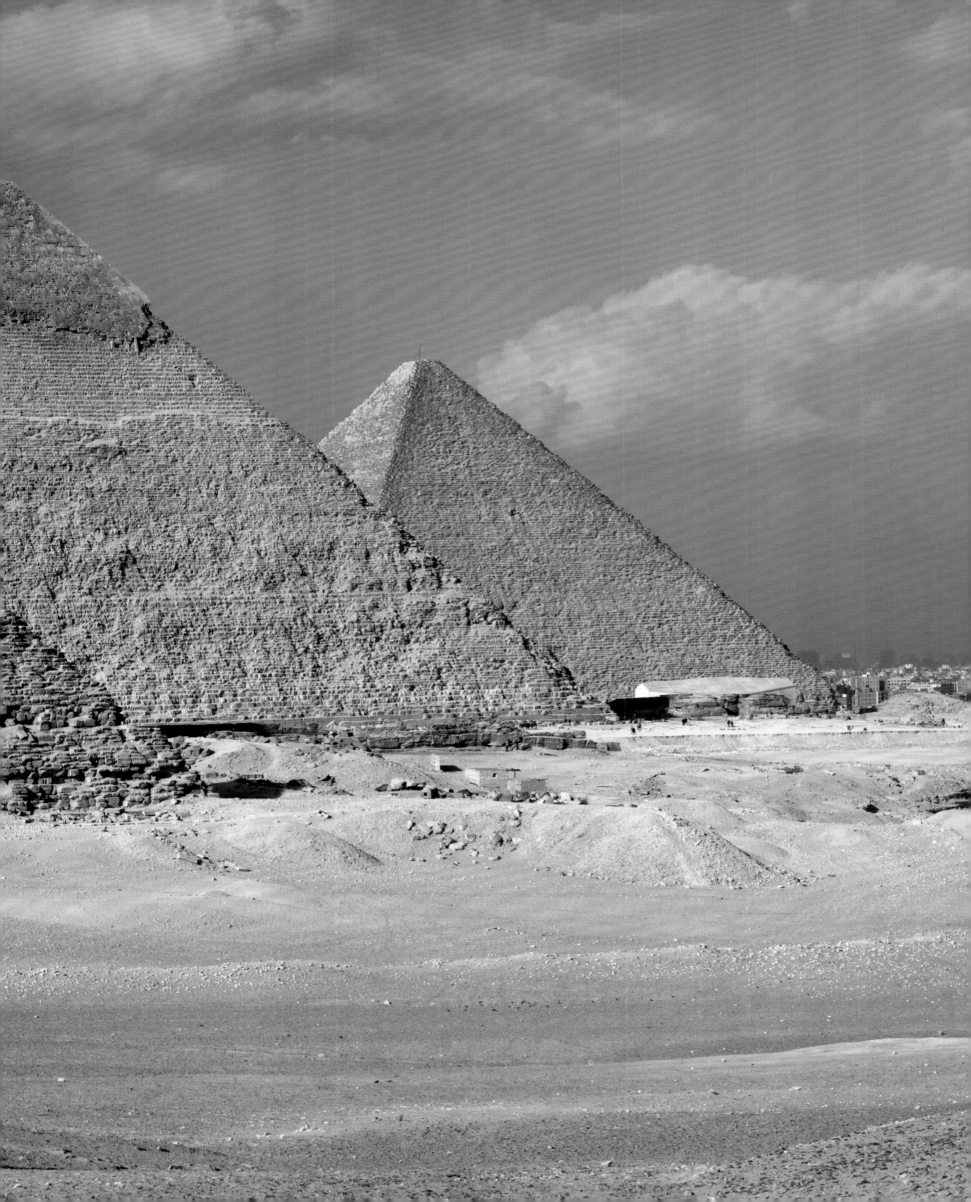

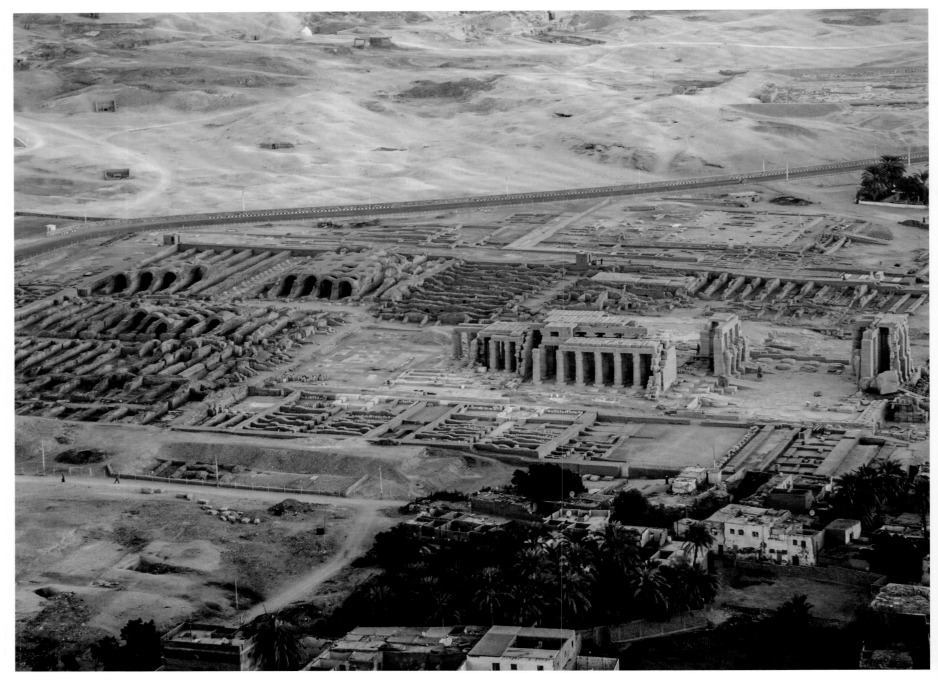

Ramesseum, West Bank of the Nile, Egypt

Valley of the Kings

Close to where the Sahara meets the Nile lies one of the most treasured sites of Ancient Egypt: The Valley of the Kings is an extraordinarily rich world of rock-hewn tombs where the pharaohs were buried until the 11th century BC. Close to modern-day Luxor (ancient Thebes) on the West Bank of the Nile, the valley celebrates the excess and elaborate ritual that lay at the heart of Ancient Egypt, and is also a reminder that were it not for the Nile the Sahara would reach from the Atlantic to the Red Sea. It therefore stands at a critical geographical and historical crossroads, a role to which its grandeur is eminently well suited.

Vallée des Rois

Proche de l'endroit où le Sahara rejoint le Nil et l'un des sites les plus chéris de l'ancienne Égypte, la vallée des Rois est un monde extraordinairement riche de tombes taillées dans la roche où les pharaons ont été enterrés jusqu'au XIe siècle avant notre ère. Proche de la moderne Louxor (l'ancienne Thèbes) sur la rive ouest du Nil, la vallée symbolise les excès et les rituels au cœur de l'ancienne Égypte, et rappelle que sans le Nil, le Sahara s'étendrait de l'Atlantique à la mer Rouge. Ainsi situé à un carrefour historique et géographique déterminant, il joue un rôle fondamental auquel sa grandeur est parfaitement adaptée.

Tal der Könige

Dort, wo die Sahara fast bis an den Nil reicht, liegt eine der bedeutendsten Stätten des alten Ägypten: Im Tal der Könige gibt es außerordentlich viele Felsengräbern, wo bis zum 11. Jahrhundert v. Chr. die Pharaonen begraben wurden. In der Nähe des heutigen Luxor (das einstige Theben) am Westufer des Nils erinnert das Tal an die Exzesse und die aufwendigen Rituale, die Herz und Seele des alten Ägypten ausmachten. Darüber hinaus wird klar, dass die Sahara ohne den Nil vom Atlantik bis zum Roten Meer reichen würde. Es liegt somit an einem wichtigen geografischen und historischen Knotenpunkt, dem seine Großartigkeit durchaus angemessen ist.

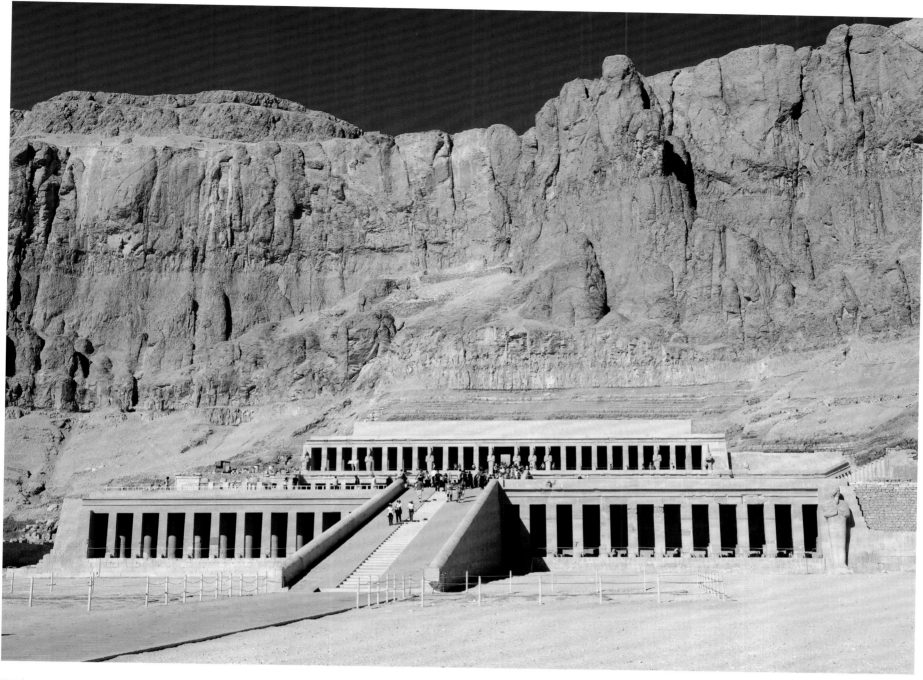

Hatshepsut's Mortuary Temple, Valley of the Kings, Egypt

Valle de los Reyes

Cerca de donde el Sahara se encuentra con el Nilo y uno de los lugares más preciados del Antiguo Egipto, el Valle de los Reyes es un mundo extraordinariamente rico de tumbas excavadas en la roca donde los faraones fueron enterrados hasta el siglo XI antes de Cristo. Cerca de la actual Luxor (antigua Tebas) en la ribera occidental del río Nilo, el valle celebra a la vez el exceso y el elaborado ritual que yacía en el corazón del Antiguo Egipto, y un recordatorio de que, si no fuera por el Nilo, el Sahara llegaría desde el Atlántico hasta el Mar Rojo. Por lo tanto, se encuentra en una encrucijada geográfica e histórica crítica, un papel para el que su grandeza es eminentemente adecuada.

Vale dos Reis

Perto de onde o Saara encontra o Nilo e um dos locais mais preciosos do Antigo Egito, o Vale dos Reis é um mundo extraordinariamente rico de tumbas talhadas de pedra, onde os faraós foram enterrados até o século 11 aC. Perto da moderna Luxor (antiga Tebas), na margem ocidental do Nilo, o vale celebra o excesso e o elaborado ritual que se encontra no coração do antigo Egito, e um lembrete de que, se não fosse pelo Nilo, o Saara alcance do Atlântico para o Mar Vermelho. Portanto, ele está em uma encruzilhada geográfica e histórica crítica, um papel para o qual sua grandeza é eminentemente adequada.

Dal van de koningen

Vlak bij de plek waar de Sahara op de Nijl stuit, ligt een van de geliefdste plekken van het oude Egypte: het Dal der koningen. Dit is een buitengewoon rijke wereld van uit rotsen gehouwen graftombes waar de farao's tot in de 11e eeuw v.Chr. begraven werden. Dicht bij het huidige Luxor (het oude Thebe), op de westoever van de Nijl, herinnert het dal meteen aan de overdaad en uitgebreide rituelen die het hart en de ziel van het oude Egypte voorstelden. Niet in de laatste plaats herinnert het dal eraan dat de Sahara zonder de Nijl zou reiken van de Atlantische Oceaan tot de Rode Zee. Het dal ligt dus op een belangrijk geografisch en historisch knooppunt, een rol waarvoor de grootsheid ervan zich uitstekend leent.

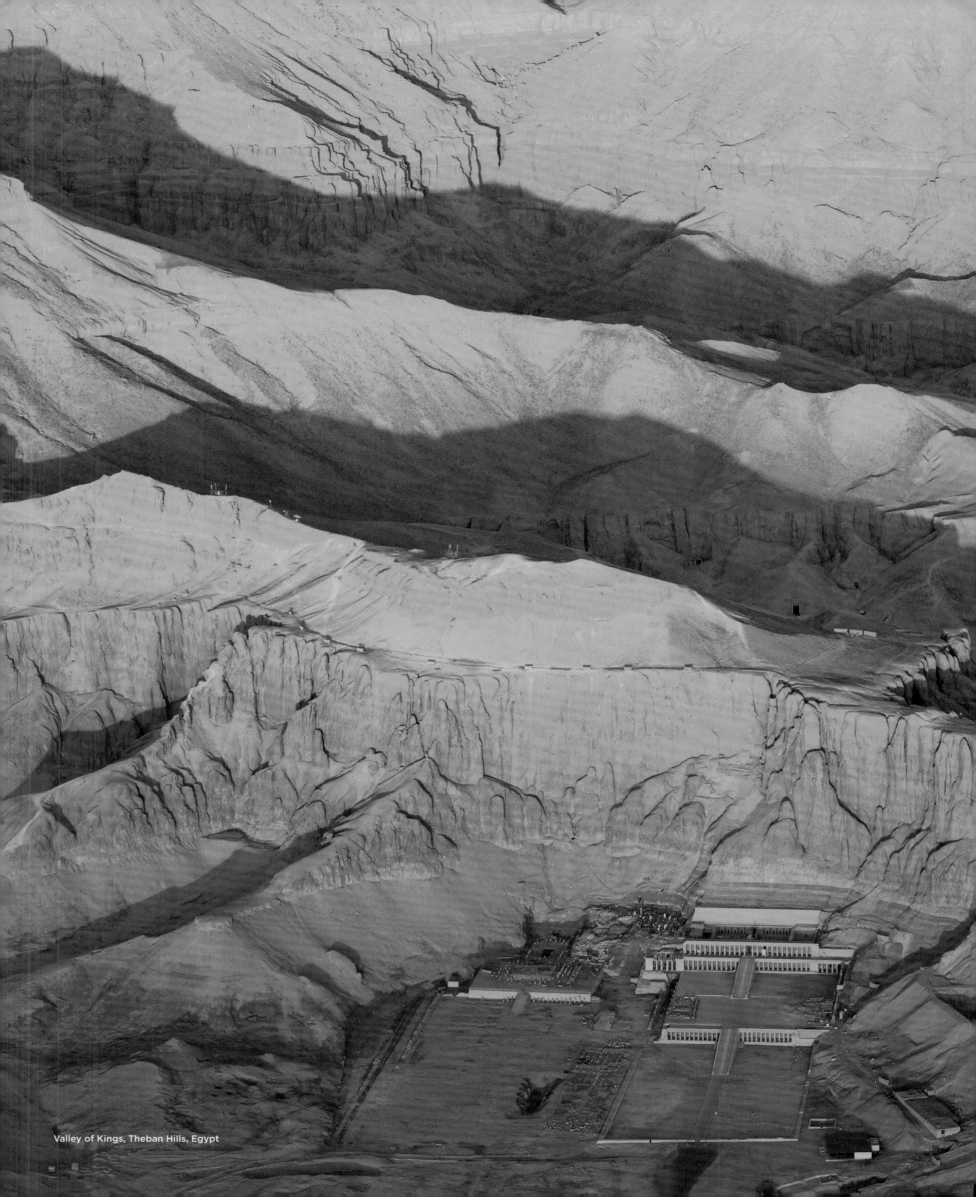

Valley of Kings, Theban Hills, Egypt

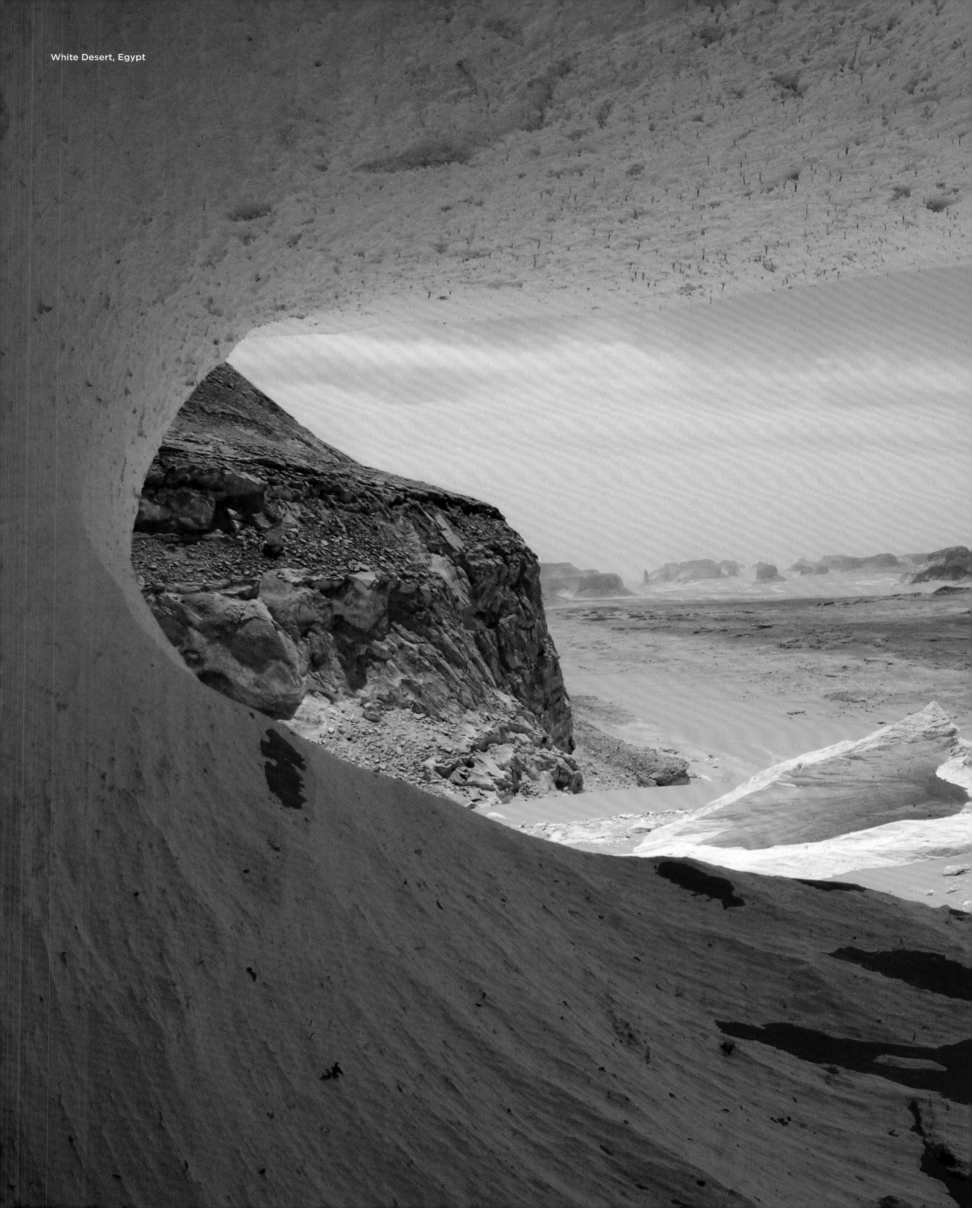

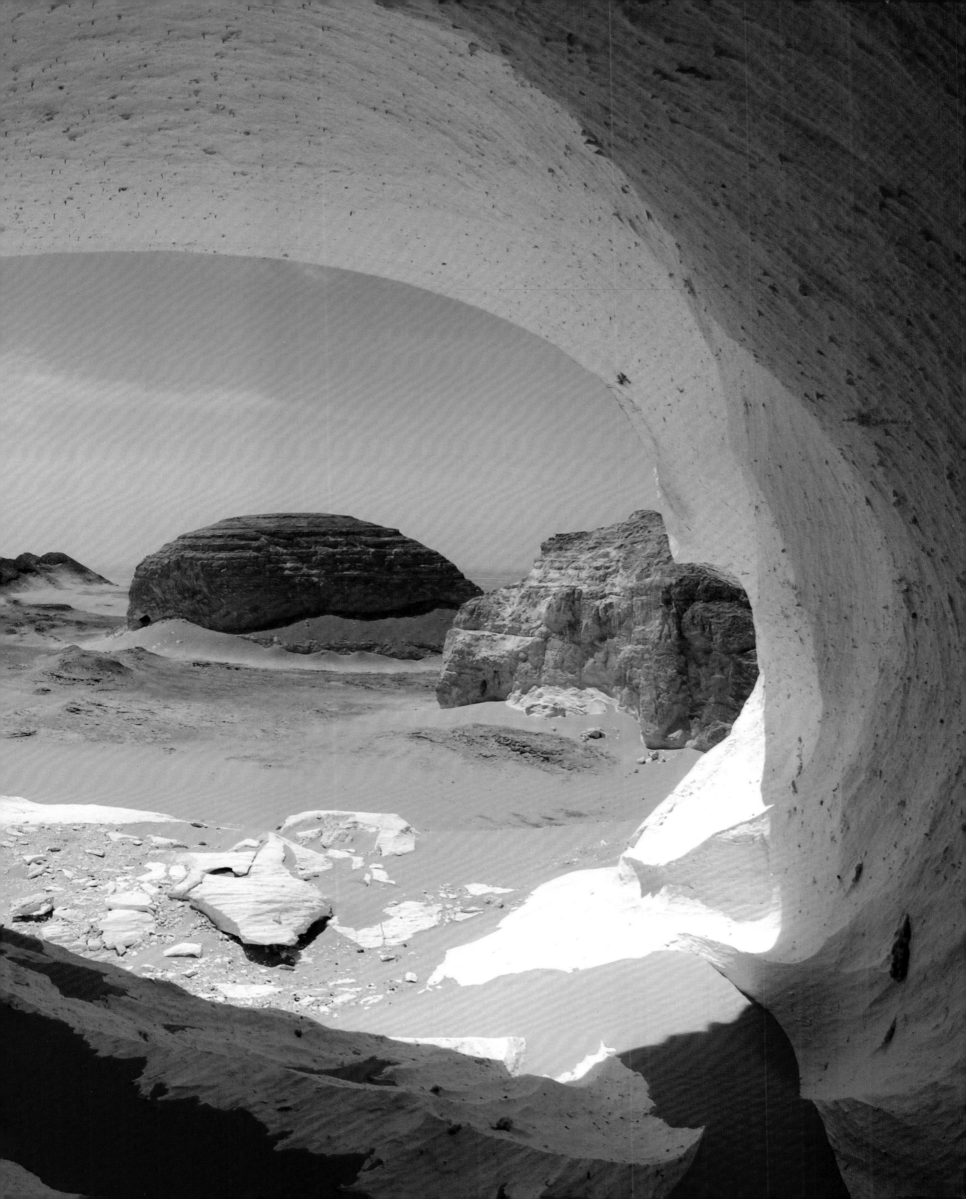

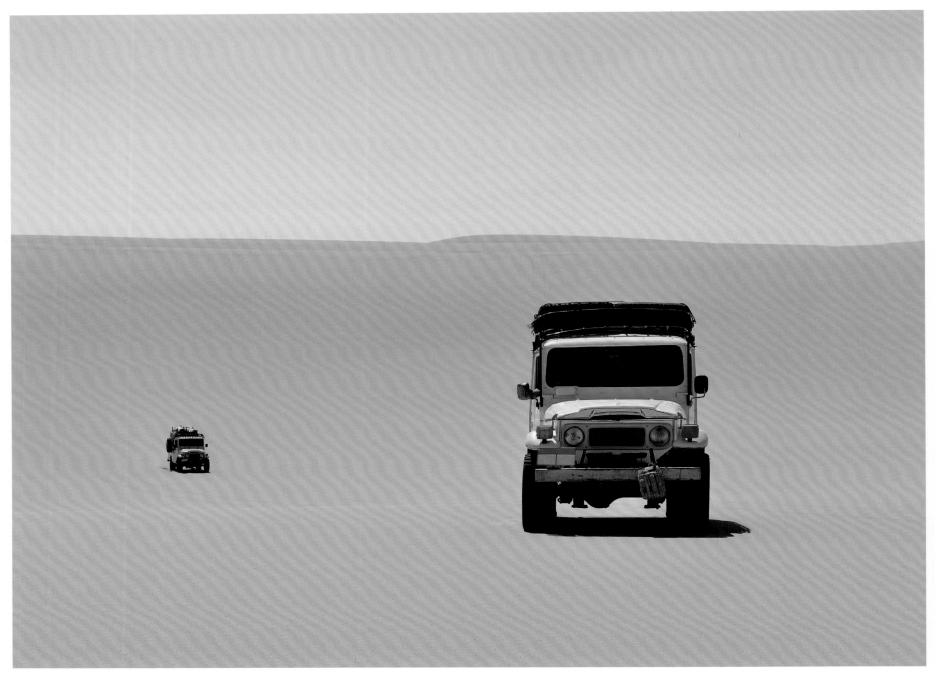

Western Desert, Egypt

Saharan Life

There are numerous touchstones to life in the desert. Modes of transport – donkeys for short distances, or, traditionally camels with their long-distance stamina and ability to go long periods without water, later 4WDs – are crucial to life out here. The oases themselves, without which life would be impossible, are symbols of the need for the water that sustains life. Life here is also dictated by the sun and wind – activity, including travel, is rare during most daylight hours, and the hotter months can be unbearable. Family ties and religious faith, too, are considered equally important in sustaining life in many desert communities.

Vie saharienne

La vie dans le désert a plusieurs pierres de touche. Les modes de transport – des ânes pour les courtes distances et, traditionnellement pour les autres, des chameaux endurants capables de se passer d'eau durant de très longues périodes, puis, plus tard, des véhicules à quatre roues motrices – sont cruciaux pour la vie locale. Les oasis, sans lesquelles la vie serait impossible, symbolisent le besoin d'eau pour vivre. Elle est également régie par le soleil et le vent – les activités, dont se déplacer, se font rares aux heures les plus chaudes de la journée, et les mois les plus arides peuvent être insupportables. Les liens familiaux et la croyance religieuse jouent pour beaucoup dans la persistance de la vie au sein de nombreuses communautés du désert.

Leben in der Sahara

Es gibt zahlreiche Prüfsteine für das Leben in der Wüste. Transportmittel – Esel für kurze Distanzen oder traditionell Kamele mit ihrer Langstreckenausdauer und der Fähigkeit, lange Zeit ohne Wasser auszudauern, später Allradfahrzeuge – sind für das Leben hier draußen entscheidend. Die Oasen selbst, ohne die ein Überleben unmöglich wäre, sind Symbole für die Notwendigkeit des Wassers, das das Leben erhält. Das Leben hier wird auch von der Sonne und dem Wind bestimmt – menschliche Aktivität, einschließlich Reisen, ist am Tag meist selten, und die heißeren Monate können unerträglich sein. Der Familienzusammenhalt und der religiöse Glaube gelten als ebenso wichtig für das Leben in vielen Wüstengemeinden.

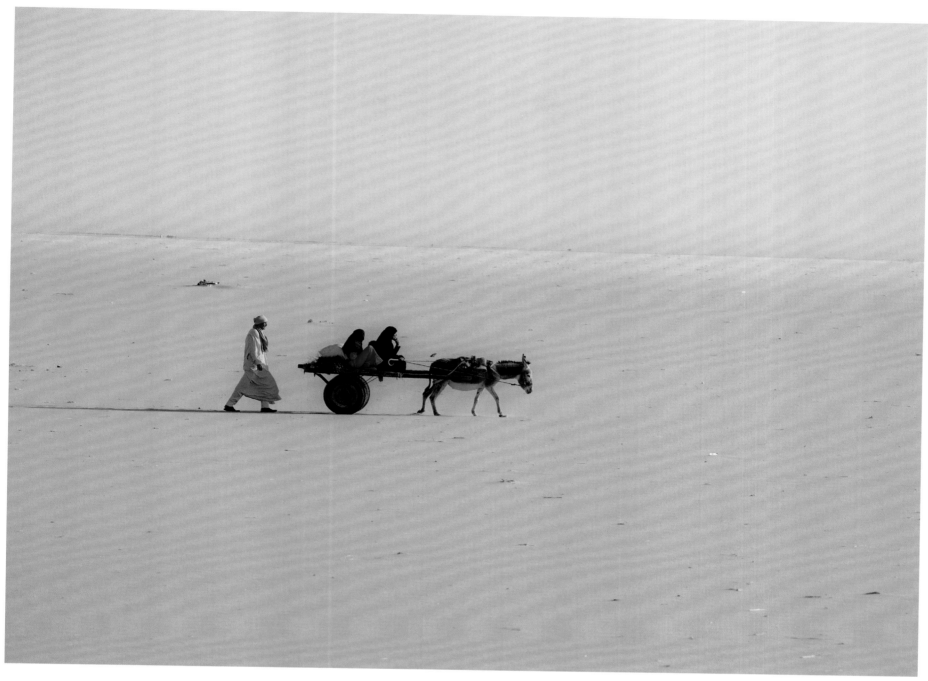

Western Desert, Egypt

La vida en el Sahara

Hay numerosos referentes para la vida en el desierto. Los modos de transporte (burros para distancias cortas o, tradicionalmente, camellos con su resistencia para las largas distancias y la capacidad de pasar largos períodos sin agua, y más tarde los 4x4) son cruciales para la vida aquí fuera. Los propios oasis, sin los cuales la vida sería imposible, son símbolos de la necesidad del agua que sostiene la vida. La vida aquí también se rige por el sol y el viento (la actividad, incluidos los viajes, es rara durante la mayoría de las horas del día, y los meses más calurosos pueden ser insoportables). La vida familiar y la fe religiosa también se consideran igualmente importantes para mantener la vida en muchas comunidades desérticas.

Vida do Saara

Existem numerosas referências à vida no deserto. Modos de transporte - burros para curtas distâncias, ou tradicionalmente camelos com resistência a longa distância e capacidade de passar longos períodos sem água, depois 4WDs – são cruciais para a vida aqui. Os próprios oásis, sem os quais a vida seria impossível, são símbolos da necessidade da água que sustenta a vida. A vida aqui também é ditada pelo sol e pelo vento – a atividade, incluindo as viagens, é rara durante a maioria das horas do dia, e os meses mais quentes podem ser insuportáveis. A vida familiar e a fé religiosa também são consideradas igualmente importantes para sustentar a vida em muitas comunidades do deserto.

Leven in de Sahara

Het leven in de woestijn kent veel toetsstenen. Transportmiddelen – ezels voor korte afstanden of, traditiegetrouw, kamelen met hun enorme uithoudingsvermogen en het vermogen lange tijd zonder water te kunnen, later terreinwagens – zijn cruciaal voor het leven hier. De oases zelf, waarzonder geen leven mogelijk zou zijn, zijn symbolen van de behoefte aan het leven voedende water. Het leven hier wordt ook bepaald door de zon en de wind. Menselijke activiteit, inclusief reizen, is overdag uitzonderlijk, en de warmere maanden kunnen onverdraaglijk zijn. Het gezinsleven en geloof zijn van even groot belang om in veel woestijngemeenschappen te overleven.

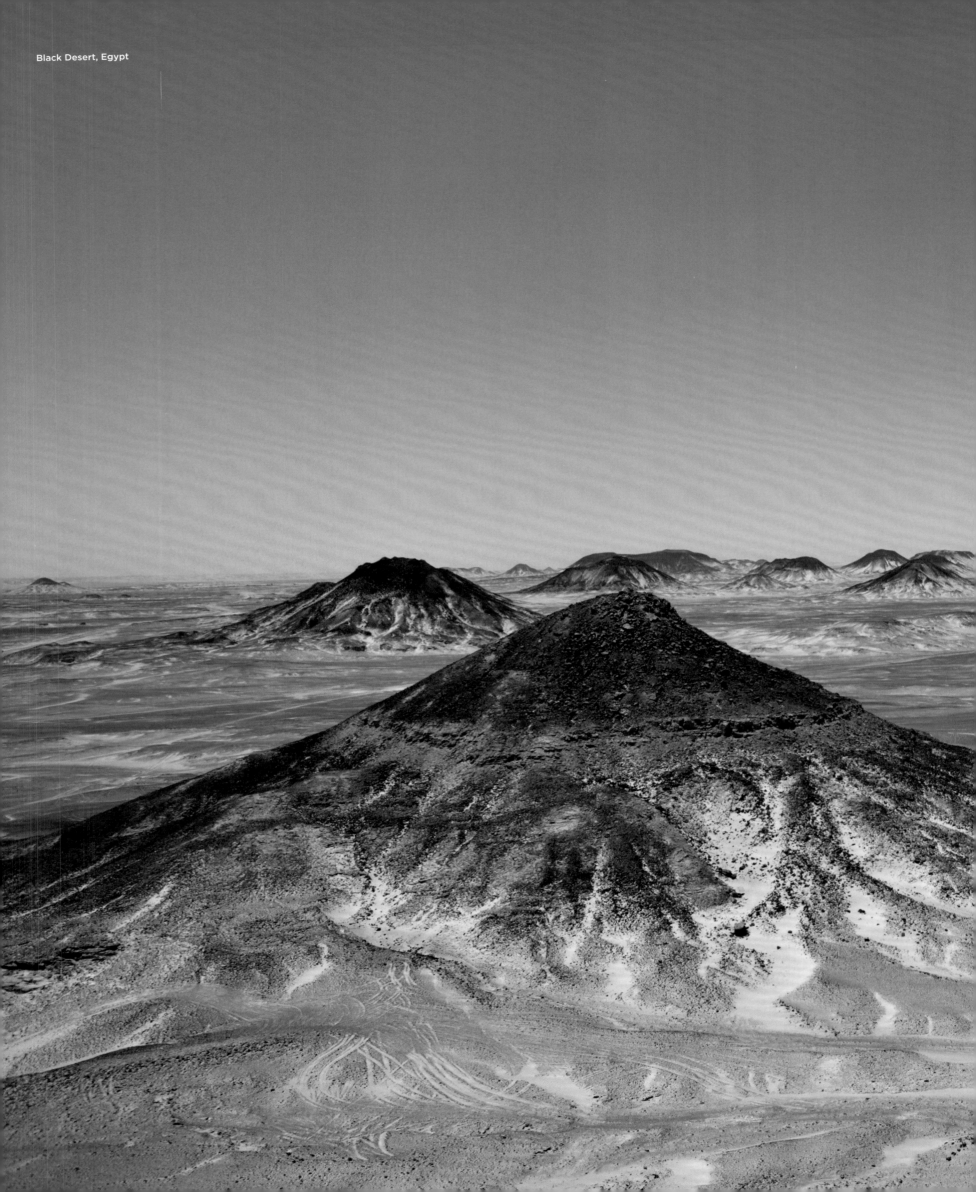

Black Desert, Egypt

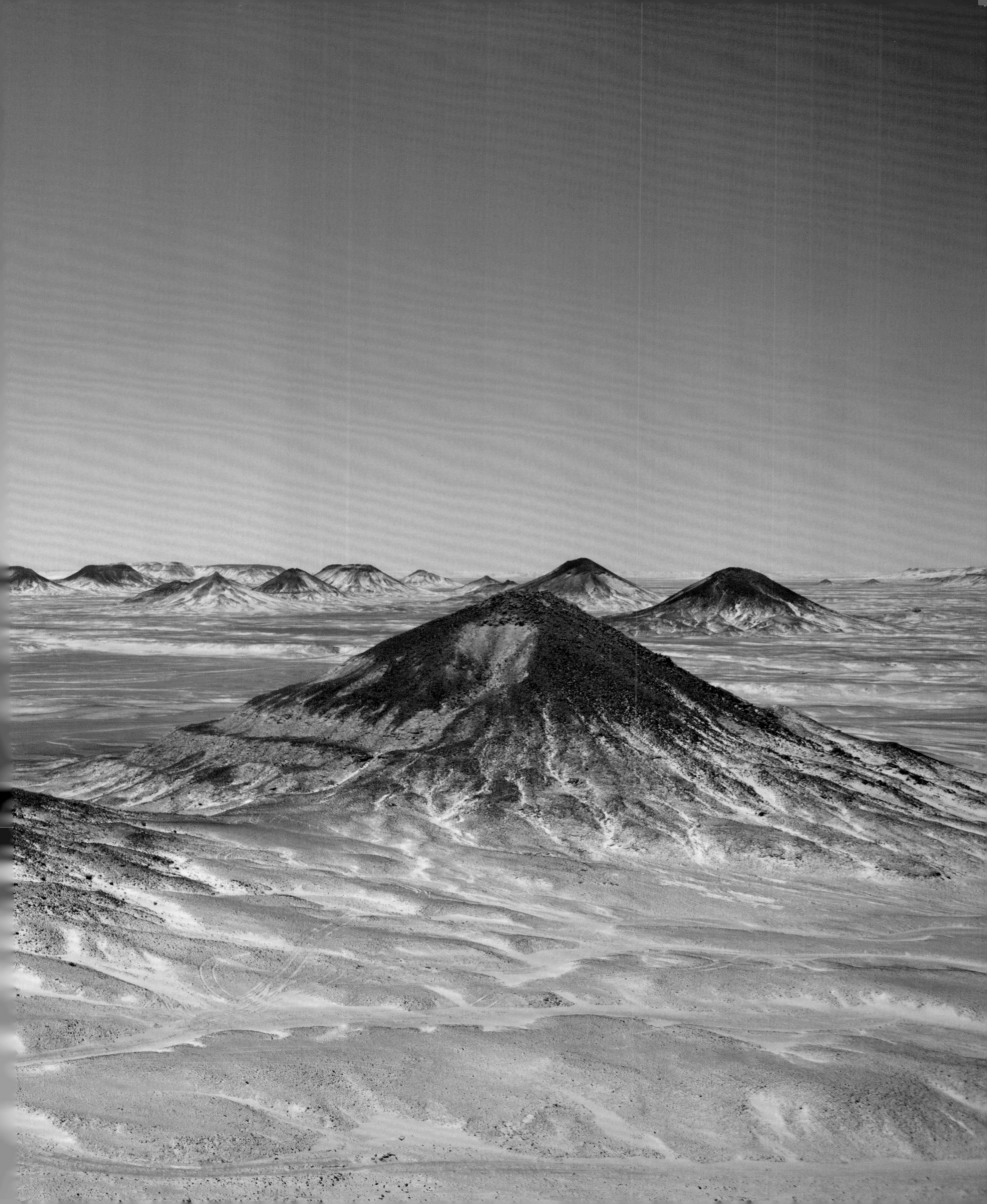

Village of Kosha, Northern Sudan

Sudan

Shut away from the outside world by war and isolation for decades, the Sahara of Sudan is one of the desert's least-known corners. The Unesco World Heritage-listed pyramids of Meroë, in the country's north, date back to the rule of the Kingdom of Kush, with more than 200 pyramids spread across the desert sands. Kush rose in the 8th century BC and ruled Egypt for a time. The kingdom and its capital Meroë survived until the 4th century AD, when it was destroyed by invaders from south of the Sahara, the Kingdom of Aksum from Ethiopia. French explorers rediscovered Meroë in 1821 and the first excavations began 13 years later.

Soudan

Coupé du reste de la planète durant des décennies à cause de la guerre et de l'enclavement, le Sahara du Soudan est l'une des zones les moins connues de ce désert. Les pyramides de Méroé figurent sur la liste du patrimoine mondial de l'UNESCO. Situées au nord du pays, elles datent de l'époque du royaume de Koush. Elles sont plus de deux cents à ponctuer les déserts de sable. Koush est apparu au VIIIe siècle avant notre ère et a régné sur l'Égypte pendant un temps. Le royaume et sa capitale, Méroé, ont survécu jusqu'au IVe siècle après J.-C., période à laquelle ils ont été détruits par des envahisseurs venus du sud du Sahara, précisément du royaume d'Aksoum, en Éthiopie. Des explorateurs français ont redécouvert Méroé en 1821, puis des premières fouilles ont été lancées treize ans plus tard.

Sudan

Der im Sudan liegende Teil der Sahara, jahrzehntelang durch Krieg isoliert, ist eine der am wenigsten bekannten Regionen der Wüste. Die zum Weltkulturerbe der Unesco gehörenden Pyramiden von Meroë im Norden gehen auf die Zeit des Königreichs Kusch zurück – mit mehr als 200 Pyramiden. Das Reich Kusch entstand im 8. Jahrhundert v. Chr. und beherrschte eine Zeit lang Ägypten. Das Reich mit der Hauptstadt Meroë überlebte bis ins 4. Jahrhundert n. Chr., als es von Eindringlingen aus dem Süden der Sahara, dem Königreich Aksum in Äthiopien, zerstört wurde. Französische Forscher entdeckten Meroë 1821 wieder, und die ersten Ausgrabungen begannen 13 Jahre später.

Nubian Wadi Halfa, Lake Nasser, Northern Sudan

Sudán

Alejado del mundo exterior por la guerra y el aislamiento durante décadas, el Sahara de Sudán es uno de los rincones menos conocidos del desierto. Las pirámides de Meroë, en el norte del país, que forman parte del Patrimonio de la Humanidad de la UNESCO, se remontan al reinado del Reino de Kush – con más de 200 pirámides. Kush se levantó en el siglo VIII a.C. y gobernó Egipto durante un tiempo. El reino, con su capital en Meroë, sobrevivió hasta el siglo IV d. C., cuando fue destruido por invasores del sur del Sahara, el Reino de Axum de Etiopía. Los exploradores franceses redescubrieron Meroë en 1821 y las primeras excavaciones comenzaron 13 años después.

Sudão

Afastado do mundo exterior pela guerra e isolamento por décadas, o Saara do Sudão é um dos cantos menos conhecidos do deserto. As pirâmides de Meroë, listadas no Patrimônio Mundial da Unesco, no norte do país, datam do domínio do Reino de Kush – com mais de 200 pirâmides. Kush cresceu no século 8 aC e governou o Egito por um tempo. O reino, com sua capital em Meroë, sobreviveu até o século 4 dC, quando foi destruído por invasores do sul do Saara, o reino de Aksum da Etiópia. Os exploradores franceses redescobriram Meroë em 1821 e as primeiras escavações começaram 13 anos depois.

Soedan

De Sahara van Soedan, die door oorlog en isolement decennialang van de buitenwereld was afgesloten, is een van de minst bekende regio's van de woestijn. De op de werelderfgoedlijst van de Unesco opgenomen piramides van Meroë in het noorden van het land stammen uit de tijd van het koninkrijk Koesj, met meer dan 200 piramides. Koesj kwam op in de 8e eeuw v.Chr. en heerste een tijdlang over Egypte. Het koninkrijk, met de hoofdstad Meroë, overleefde tot in de 4e eeuw n.Chr., toen het door indringers uit het zuiden van de Sahara, het koninkrijk Aksoem uit Ethiopië, werd vernietigd. Franse ontdekkingsreizigers herontdekten Meroë in 1821 en de eerste opgravingen begonnen dertien jaar later.

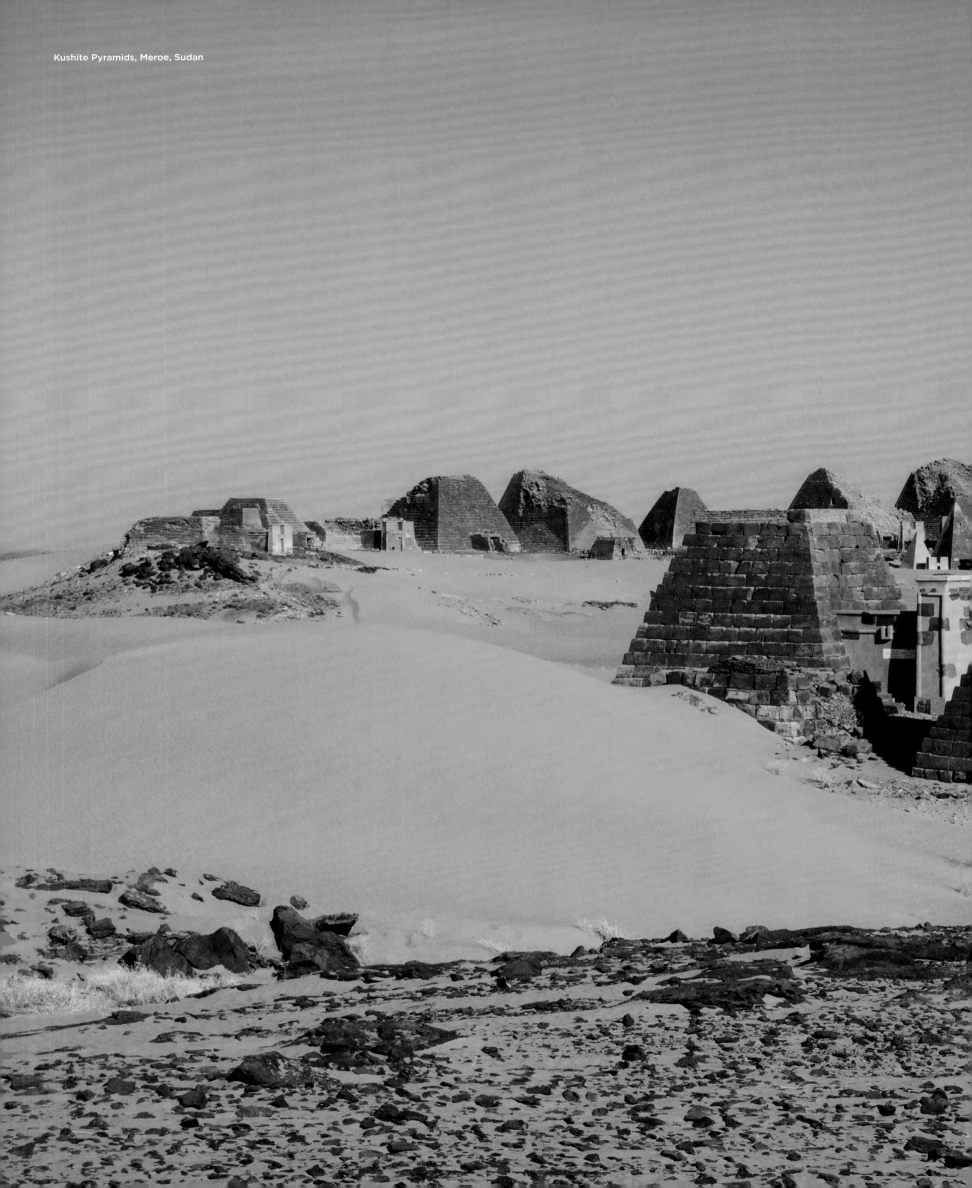

Kushite Pyramids, Meroe, Sudan

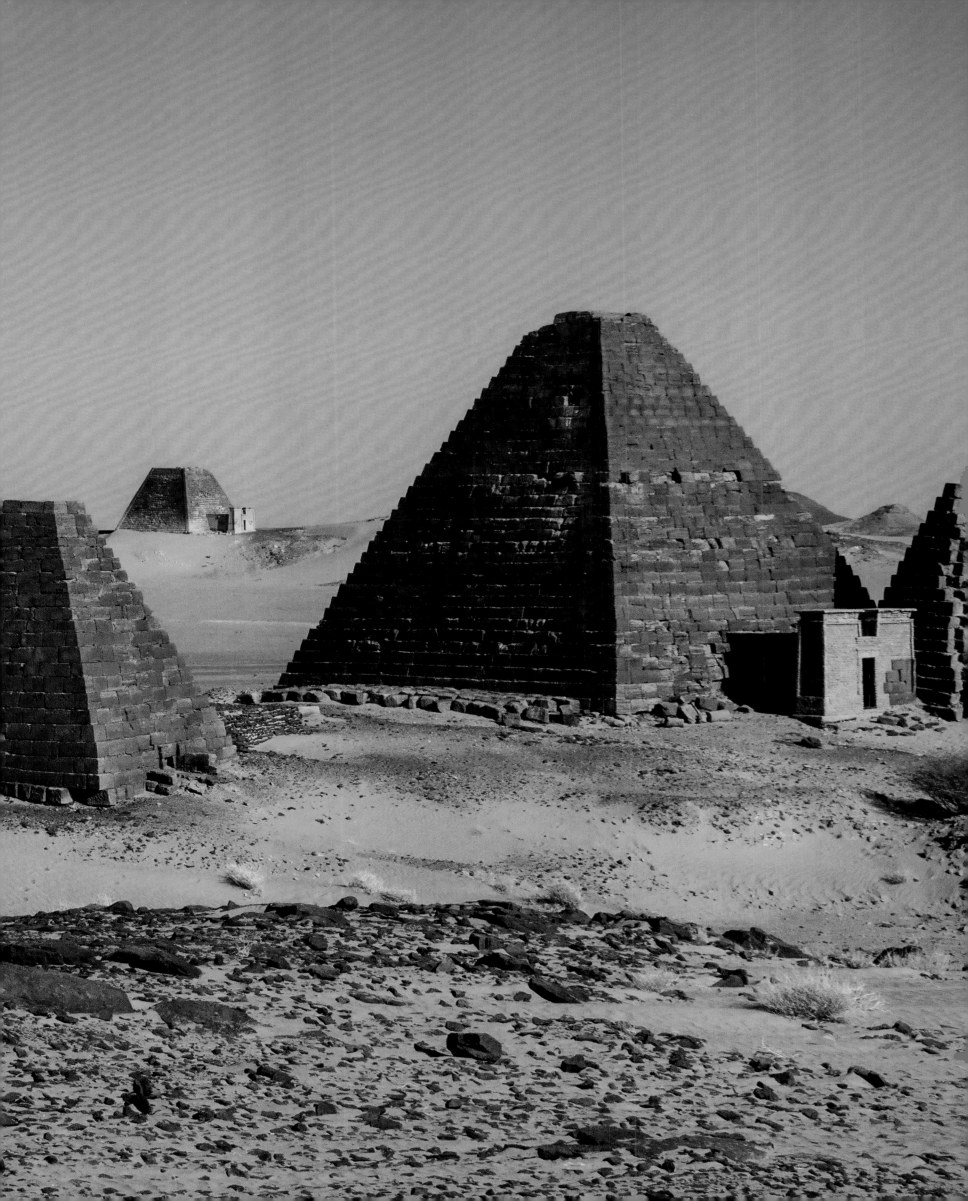

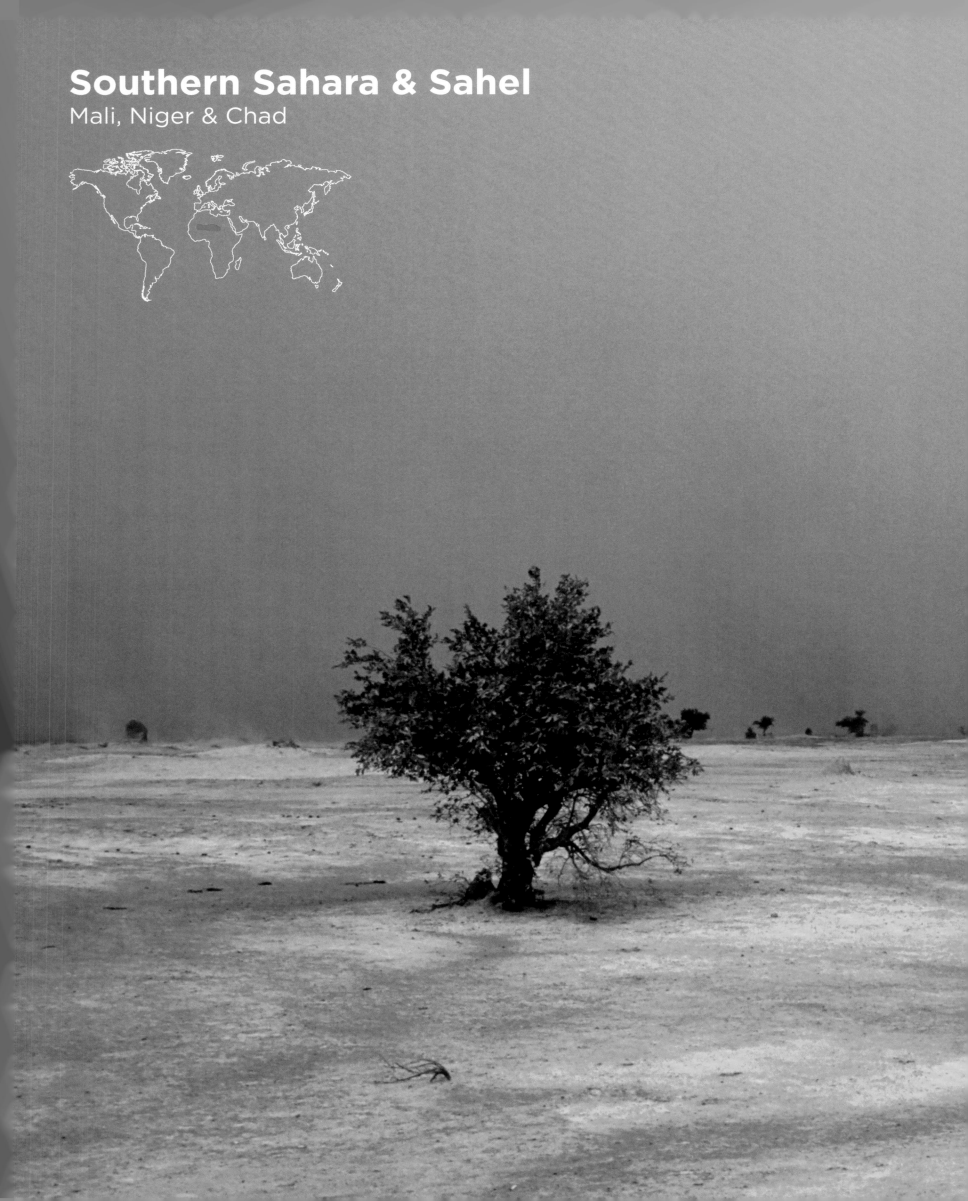

Southern Sahara & Sahel
Mali, Niger & Chad

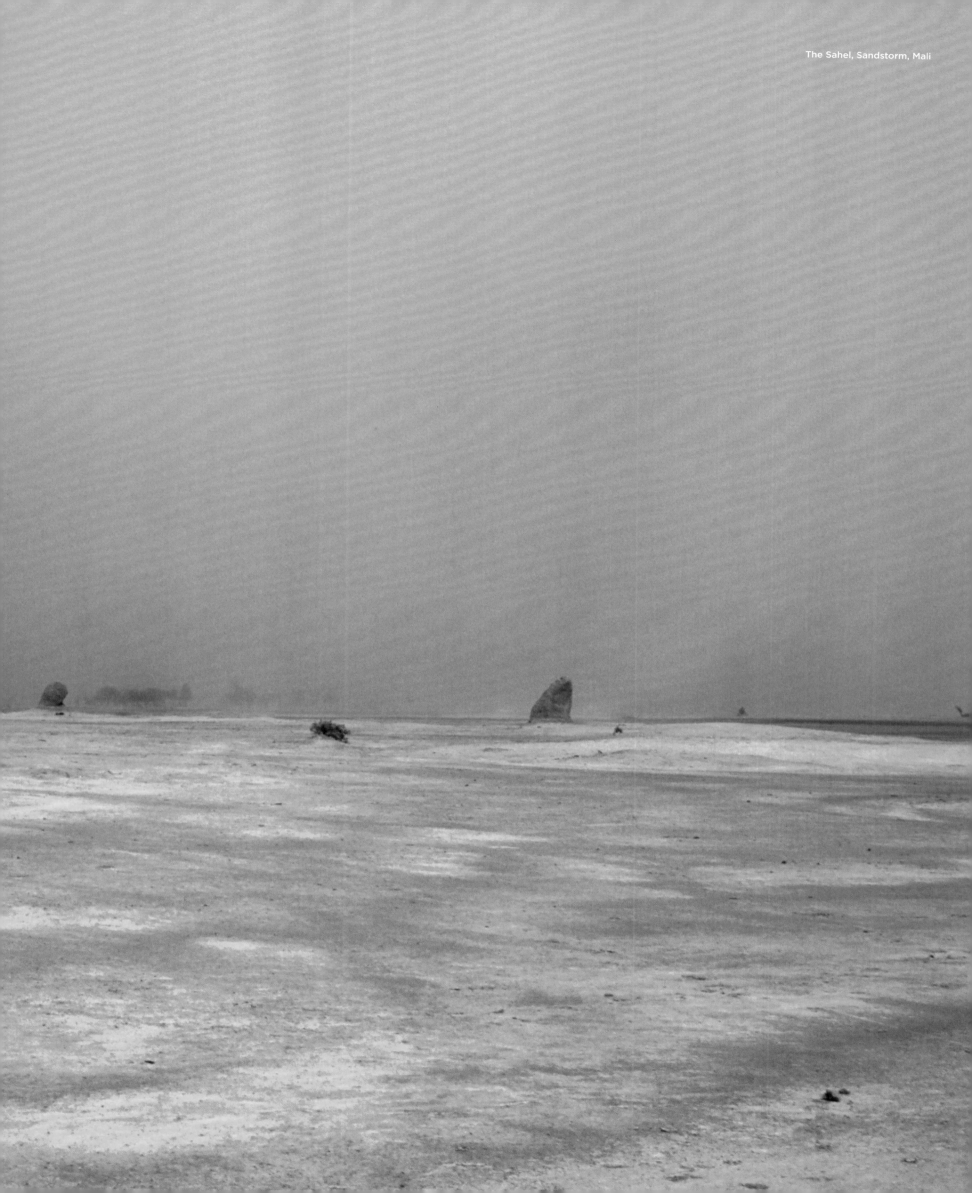

The Sahel, Sandstorm, Mali

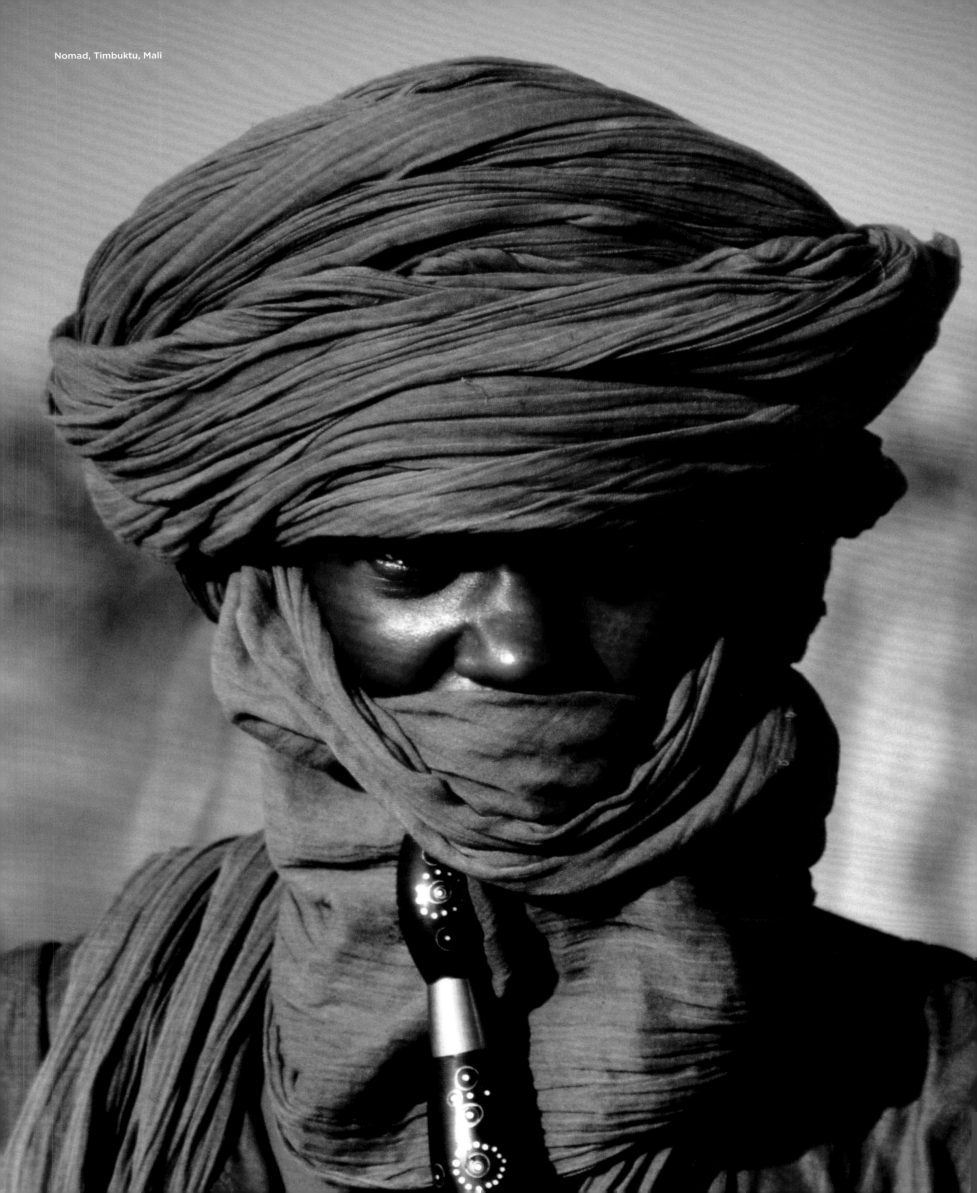

Nomad, Timbuktu, Mali

Sanga cattle, Sahel, Mali

Sahara and Sahel

Although barely distinguishable to the untrained eye, the Sahara and Sahel are two distinct ecological zones. The Sahel, a transition zone, spreads south of the Sahara from the Nile to the Atlantic. Densely populated, it faces serious environmental concerns, primary among them being desertification as the Sahara creeps south.

Sahara et Sahel

Bien qu'indistincts pour un œil non exercé, le Sahara et le Sahel présentent deux zones écologiques distinctes. Aire de transition, le Sahel ombre le sud du Sahara, du Nil jusqu'à l'Atlantique. Densément peuplé, il fait aujourd'hui face à de graves problèmes environnementaux, au premier rang desquels figure la désertification avec le glissement du Sahara vers le sud.

Sahara und Sahel

Obwohl für das ungeschulte Auge kaum unterscheidbar, sind die Sahara und der Sahel zwei verschiedene ökologische Zonen. Die Sahelzone, eine Übergangszone, folgt vom Nil bis zum Atlantik auf die südliche Sahara. Sie ist dicht besiedelt und steht vor ernsthaften Umweltproblemen, vor allem wegen der Wüstenbildung, da sich die Sahara stetig nach Süden vergrößert.

Sahara y Sahel

Aunque apenas distinguibles a simple vista, el Sahara y el Sahel son dos zonas ecológicas distintas. El Sahel, una zona de transición, cubre el sur del Sahara desde el Nilo hasta el Atlántico. Densamente poblada, se enfrenta a graves problemas medioambientales, entre los que destaca la desertificación a medida que el Sahara se extiende hacia el sur.

Saara e Sahel

Embora mal distinguível do olho destreinado, o Saara e o Sahel são duas zonas ecológicas distintas. O Sahel, uma zona de transição, ilumina o sul do Saara, do Nilo ao Atlântico. Densamente povoada, enfrenta graves preocupações ambientais, sendo a principal delas a desertificação enquanto o Saara se arrasta para o sul.

Sahara en Sahel

Hoewel ze voor het ongeoefende oog nauwelijks van elkaar te onderscheiden zijn, zijn de Sahara en de Sahel twee verschillende ecologische zones. De Sahel, een overgangsgebied, volgt de zuidelijke Sahara van de Nijl tot aan de Atlantische Oceaan. Het gebied is dichtbevolkt en kampt met ernstige milieuproblemen, voornamelijk als gevolg van woestijnvorming doordat de Sahara zich naar het zuiden blijft uitbreiden.

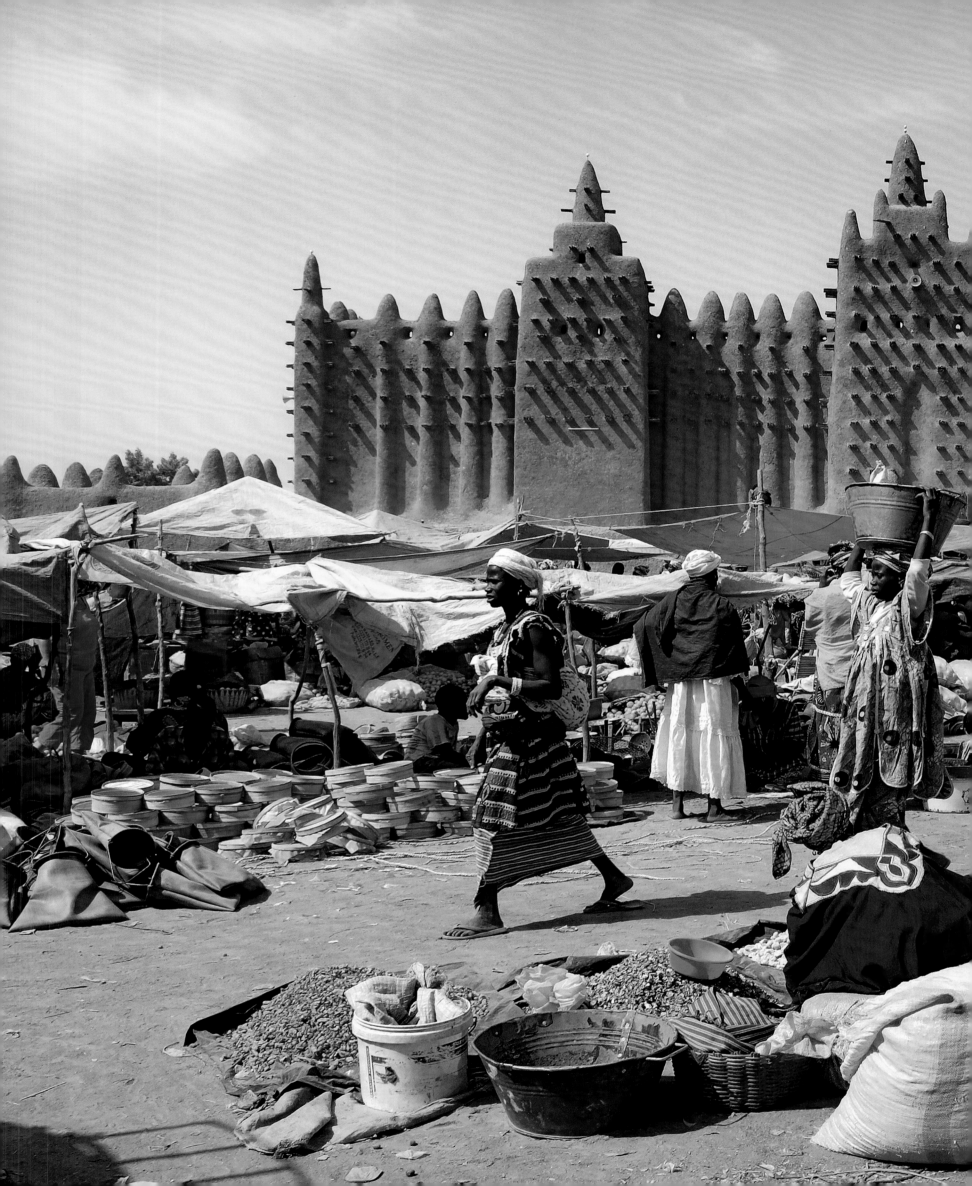

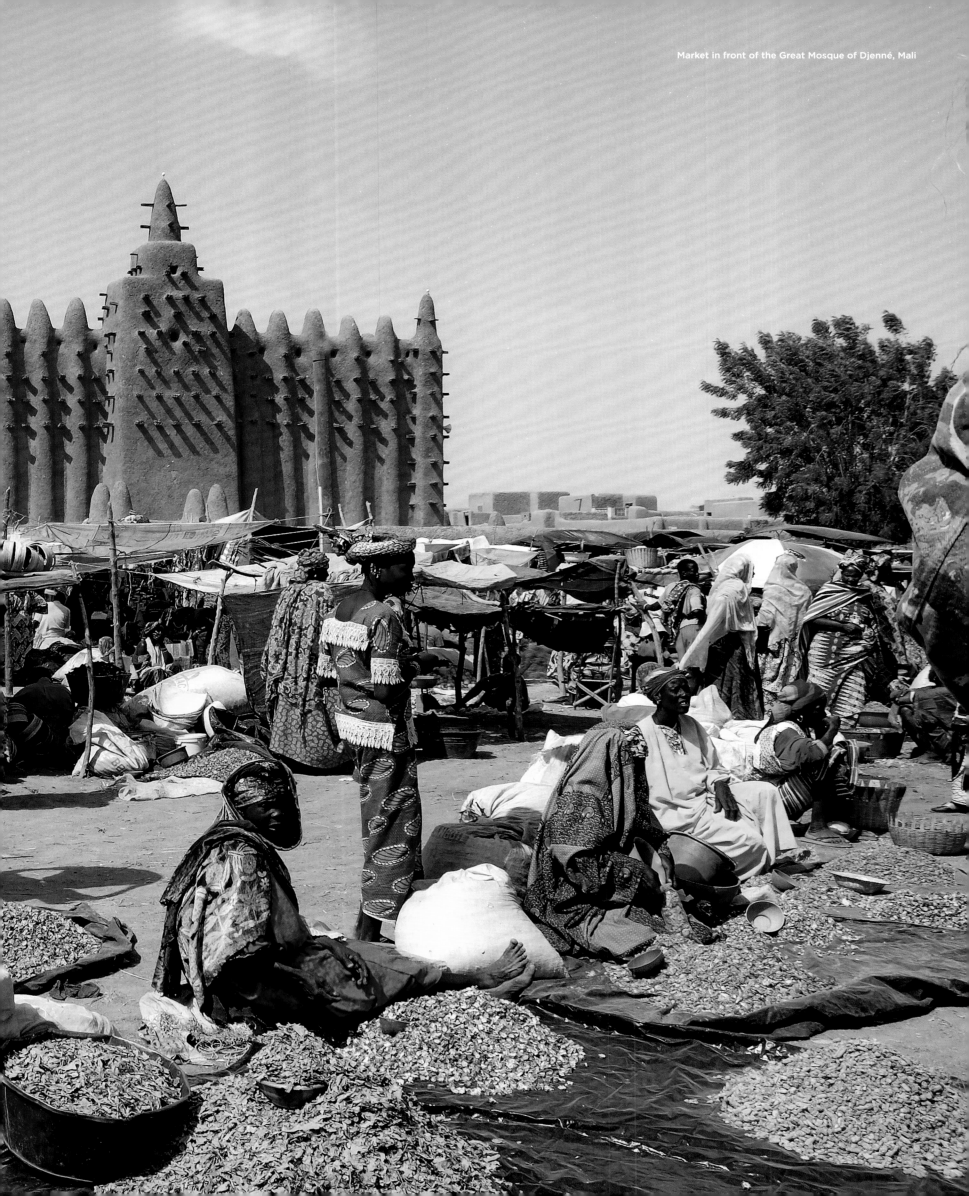

Market in front of the Great Mosque of Djenné, Mali

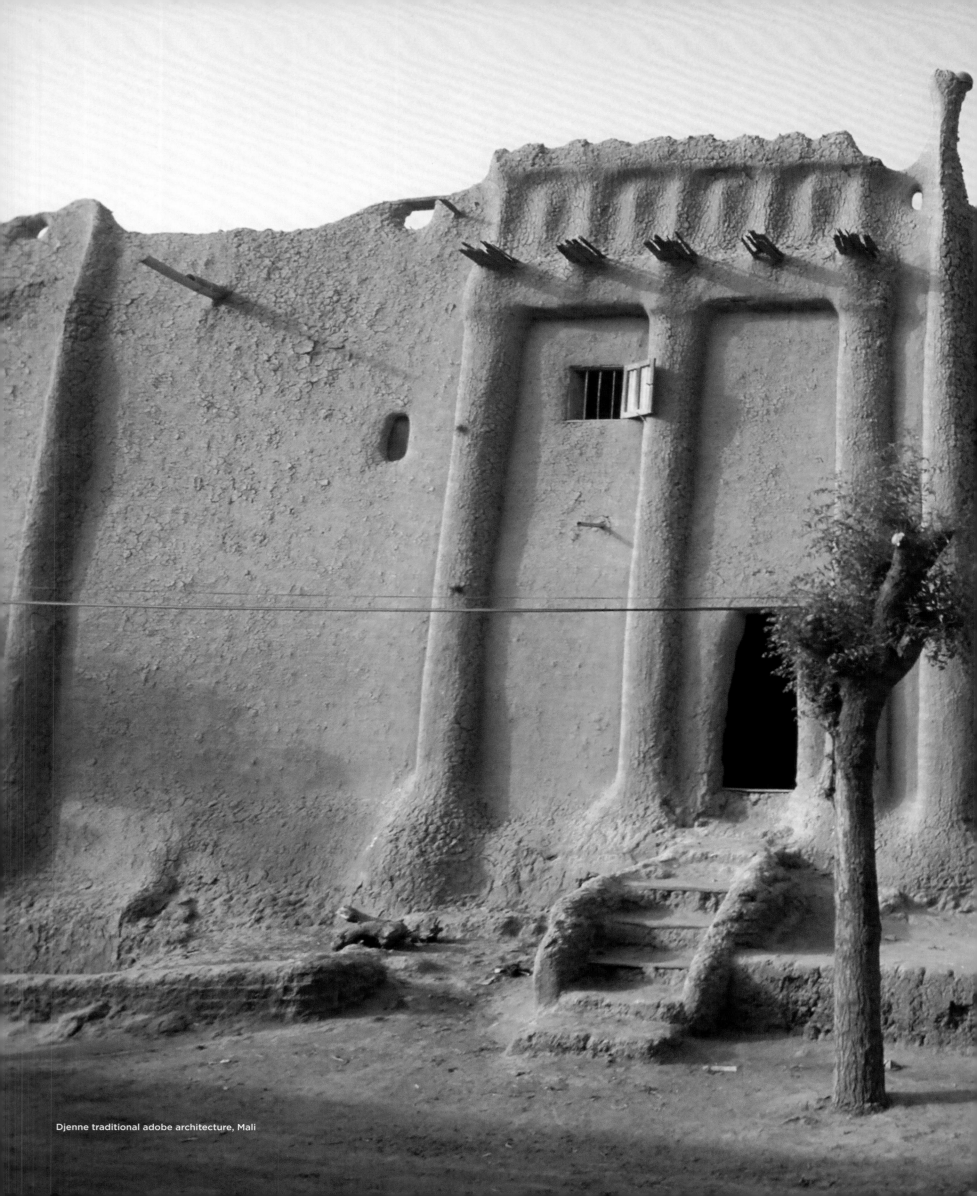

Djenne traditional adobe architecture, Mali

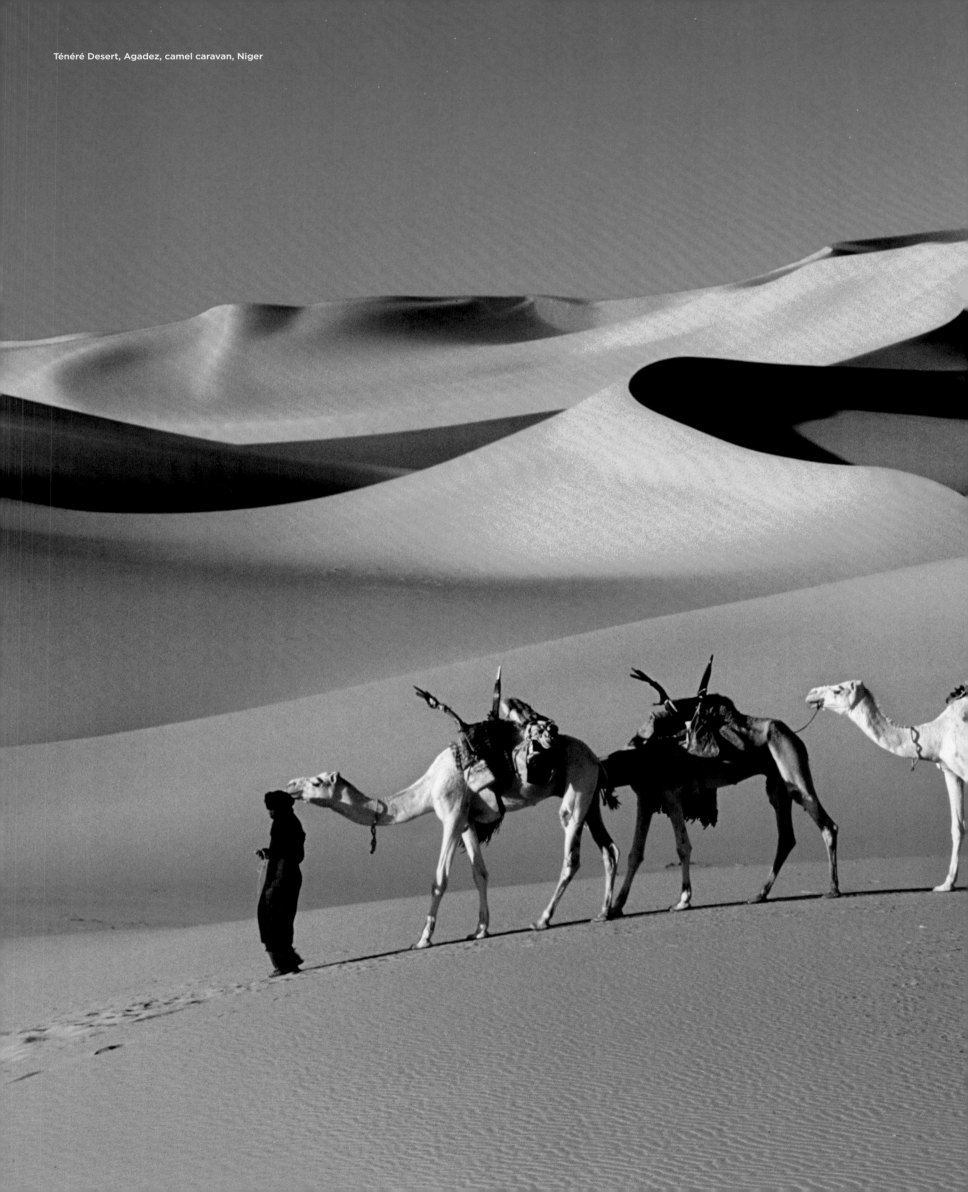

Ténéré Desert, Agadez, camel caravan, Niger

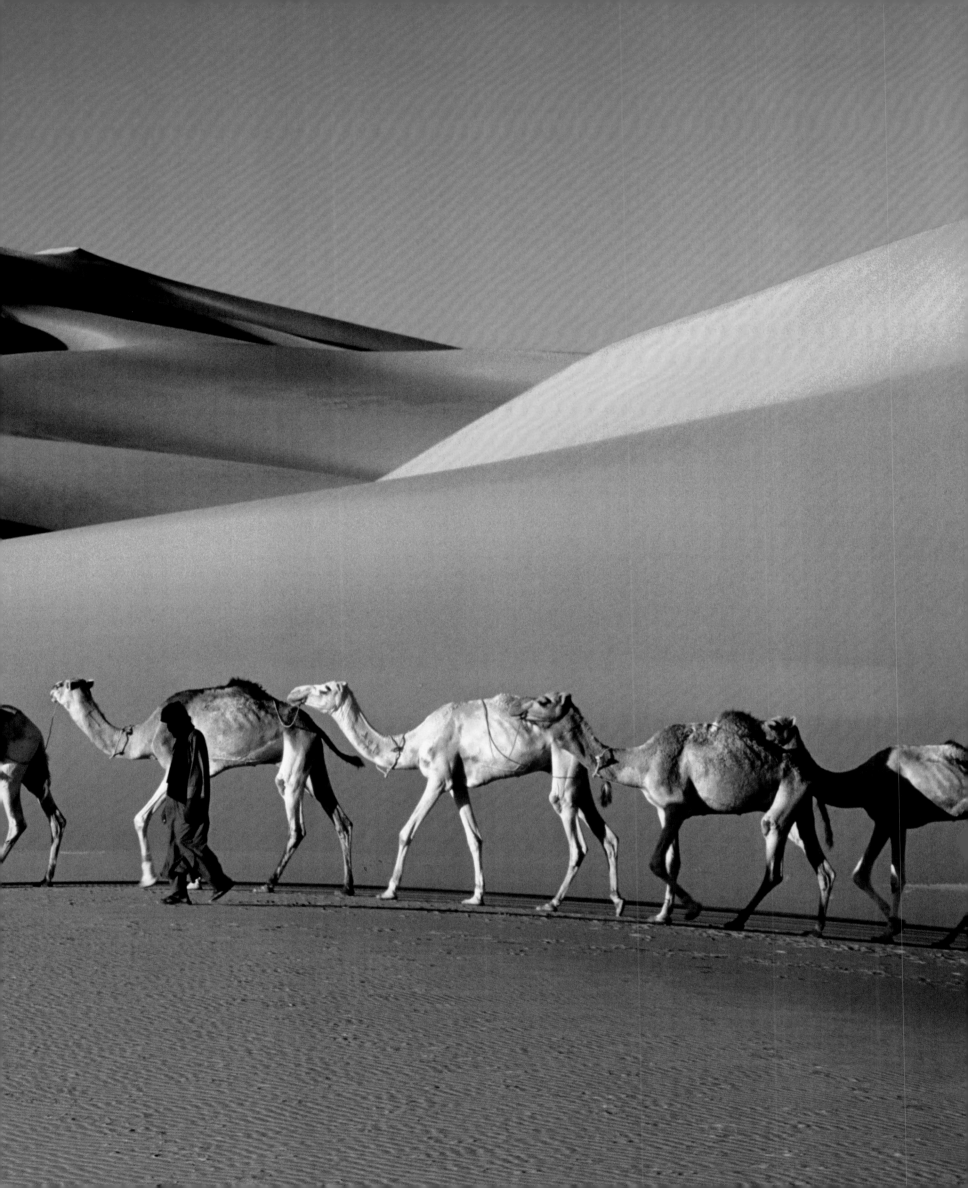

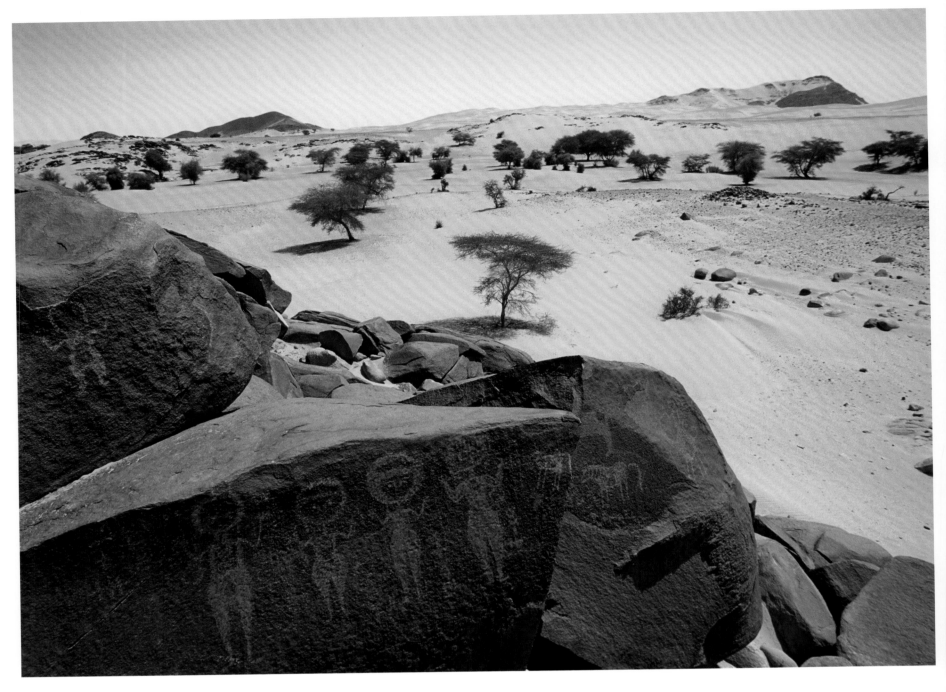

Ténéré Desert, Petroglyphs, Niger

Mali and Niger

Two of the poorest countries on the planet are steeped in Saharan lore; Mali is evenly divided between Sahara and Sahel, while the latter engulfs an estimated 80% of Niger. Ancient caravan and trading towns – Timbuktu (Tombouctou) and riverside Djenné in Mali, and Agadez in Niger – are built almost entirely from mud and remain important gateway towns to the Sahara. Djenné's Great Mosque is the largest mud-built structure in the world and serves as a backdrop for its world-famous Monday market; the wooden struts are used annually for artisans to reapply the mud render to the façade.

Mali et Niger

Comptant parmi les pays les plus pauvres de la planète, le Mali et le Niger sont pétris de traditions sahariennes. Si le Mali se répartit équitablement entre Sahara et Sahel, ce dernier embrasse environ 80% du Niger. D'anciennes caravanes et villes commerçantes – Tombouctou et Djenné la riveraine, au Mali, et Agadès, au Niger – se dressent au milieu ou presque et demeurent d'incontournables portes d'accès au Sahara. La grande mosquée de Djenné est la plus importante construction en boue de la planète et sert de toile de fond au célèbre marché local du lundi. Chaque année, les artisans utilisent les étais en bois pour renduire sa façade de boue.

Mali und Niger

Zwei der ärmsten Länder der Welt sind von der Geschichte der Sahara geprägt; Mali ist gleichmäßig zwischen der Sahara und der Sahelzone aufgeteilt, während der Sahel schätzungsweise 80% der Fläche des Niger einnimmt. Alte Karawanen- und Handelsstädte – Timbuktu und das am Fluss liegende Djenné in Mali und Agadez in Niger – sind fast vollständig aus Lehm erbaut und heute noch wichtige Torstädte zur Sahara. Die Große Moschee von Djenné ist das größte Lehmbauwerk der Welt, vor ihre Kulisse findet der weltberühmte Montagsmarkt statt; die Holzstreben werden von Handwerkern verwendet, um alljährlich wieder Lehmputz auf die Fassade aufzutragen.

Thunderstorm, Zinder, Niger

Malí y Níger

Dos de los países más pobres del planeta están impregnados de la tradición sahariana; Malí está dividido en partes iguales entre el Sahara y el Sahel, mientras que este último engloba aproximadamente el 80 % de Níger. Antiguas caravanas y ciudades comerciales (Timbuktu [Tombouctou] y el río Djenné en Malí, y Agadez en Níger) están construidas casi en su totalidad desde la mitad y siguen siendo importantes ciudades de entrada al Sahara. La Gran Mezquita de Djenné es la estructura de barro más grande del mundo y sirve como telón de fondo para su mundialmente famoso mercado de los lunes; los puntales de madera se utilizan anualmente para que los artesanos vuelvan a aplicar el enlucido de barro a la fachada.

Mali e Níger

Dois dos países mais pobres do planeta estão mergulhados no folclore saariano; O Mali é dividido igualmente entre o Saara e o Sahel, enquanto o segundo engloba cerca de 80% do Níger. Antigas caravanas e cidades comerciais – Timbuktu (Tombouctou) e Djenné às margens do rio, no Mali, e Agadez, no Níger - são construídas quase inteiramente a partir de meados e continuam a ser importantes cidades de acesso ao Sahara. A Grande Mesquita de Djenné é a maior estrutura de barro do mundo e serve como pano de fundo para o mundialmente famoso mercado de segunda-feira. os suportes de madeira são utilizados anualmente pelos artesãos para reaplicar o reboco de lama na fachada.

Mali en Niger

Twee van de armste landen ter wereld, zitten boordevol traditionele kennis over de Sahara. Mali is gelijkelijk verdeeld over de Sahara en Sahel, terwijl de Sahel naar schatting 80% van het oppervlak van Niger beslaat. Oude karavaan- en handelssteden – Timboektoe en het aan de rivier gelegen Djenné in Mali, en Agadez in Niger – zijn bijna volledig van leem gebouwd en zijn nog altijd belangrijke toegangspoorten tot de Sahara. De Grote Moskee van Djenné is het grootste lemen gebouw ter wereld en dient als decor voor de wereldberoemde maandagmarkt. De houten steunen worden jaarlijks gebruikt door ambachtslieden om nieuwe modder aan te brengen op de gevels.

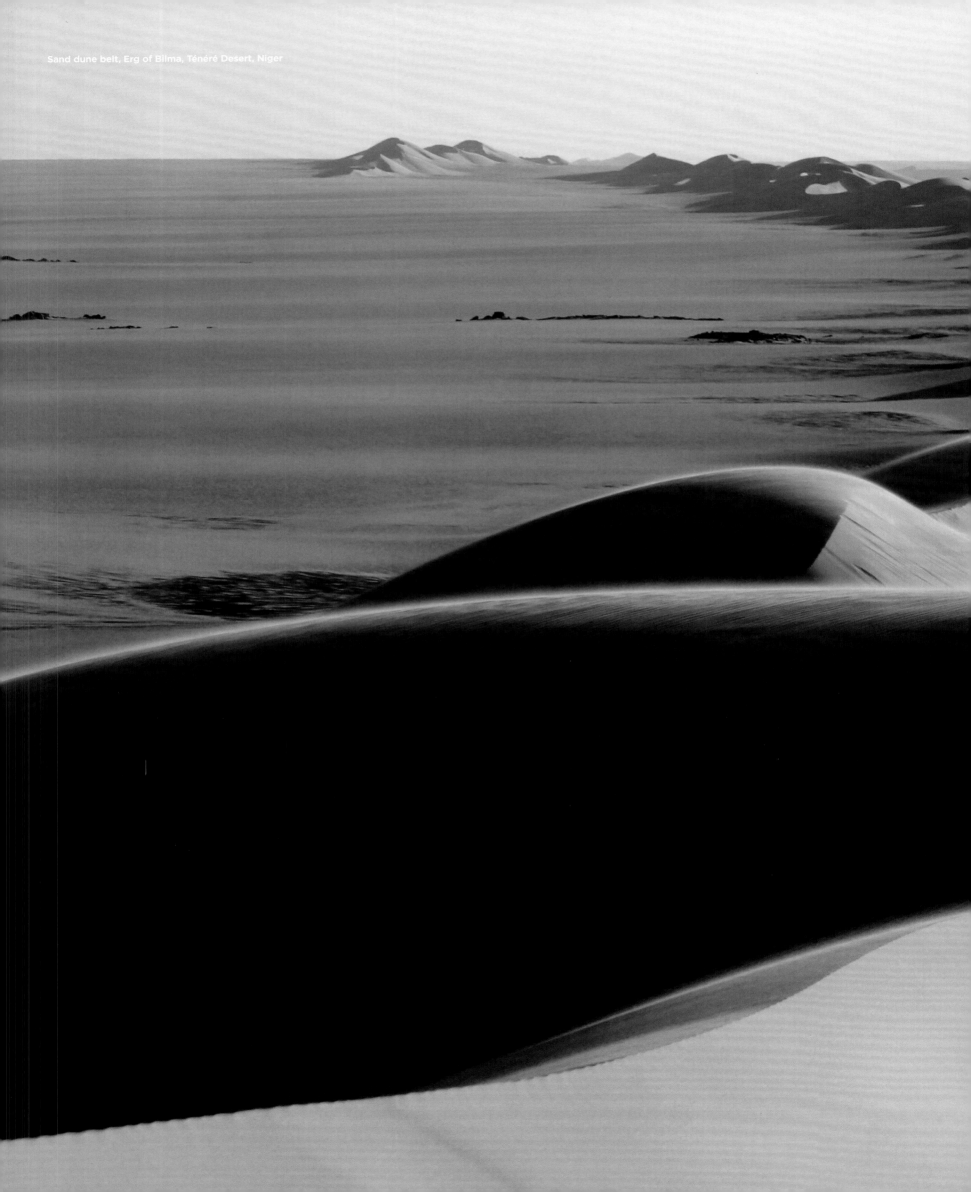

Sand dune belt, Erg of Bilma, Ténéré Desert, Niger

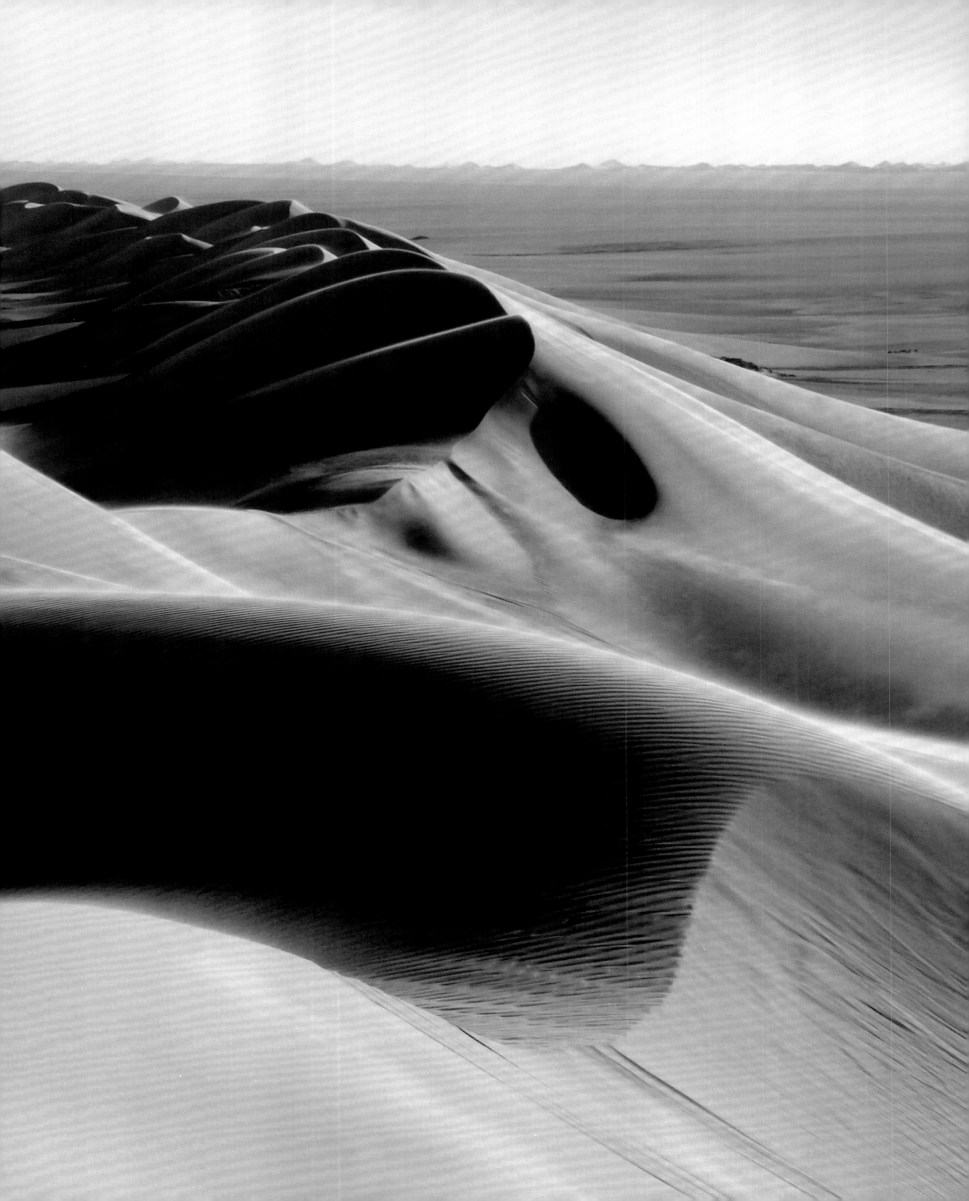

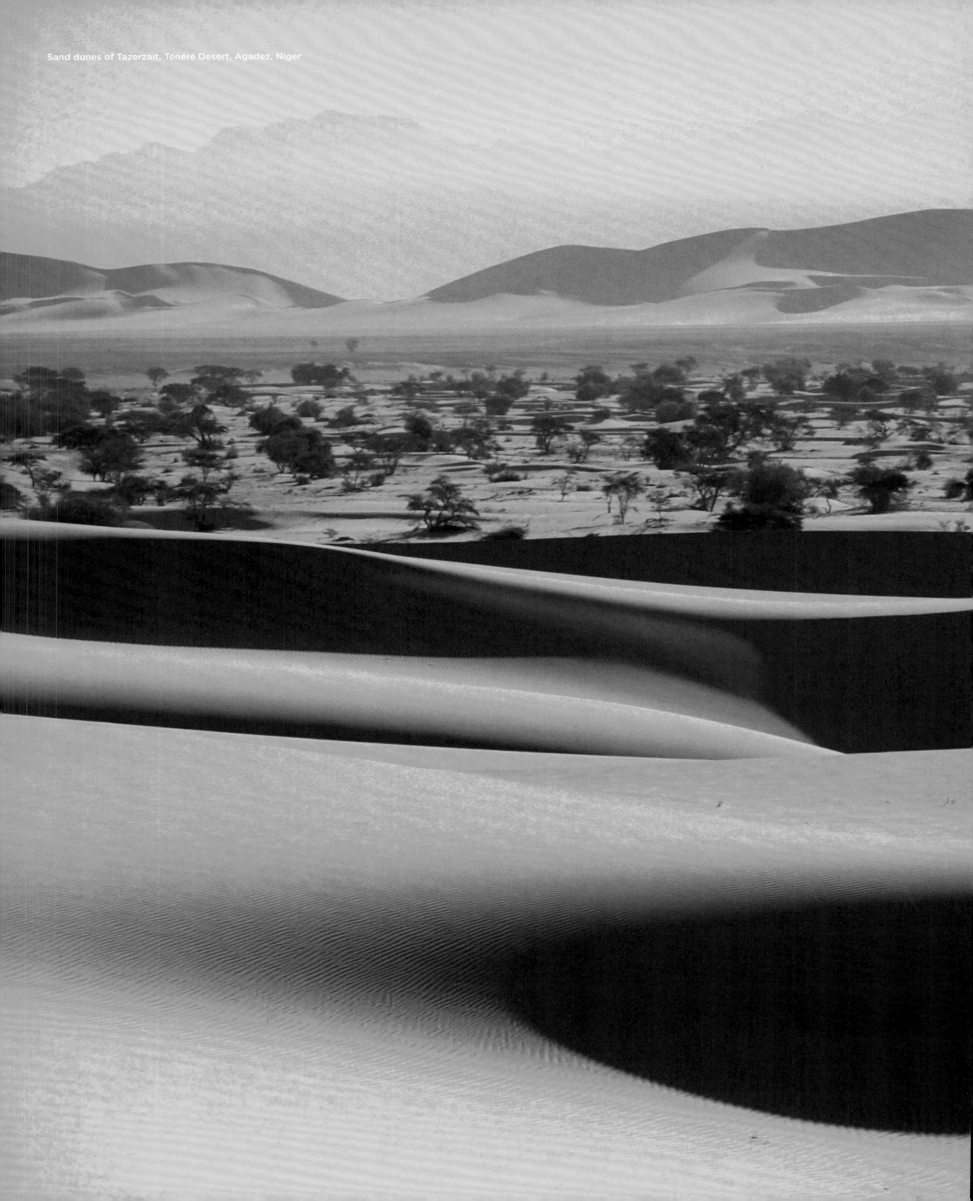
Sand dunes of Tazerzait, Ténéré Desert, Agadez, Niger

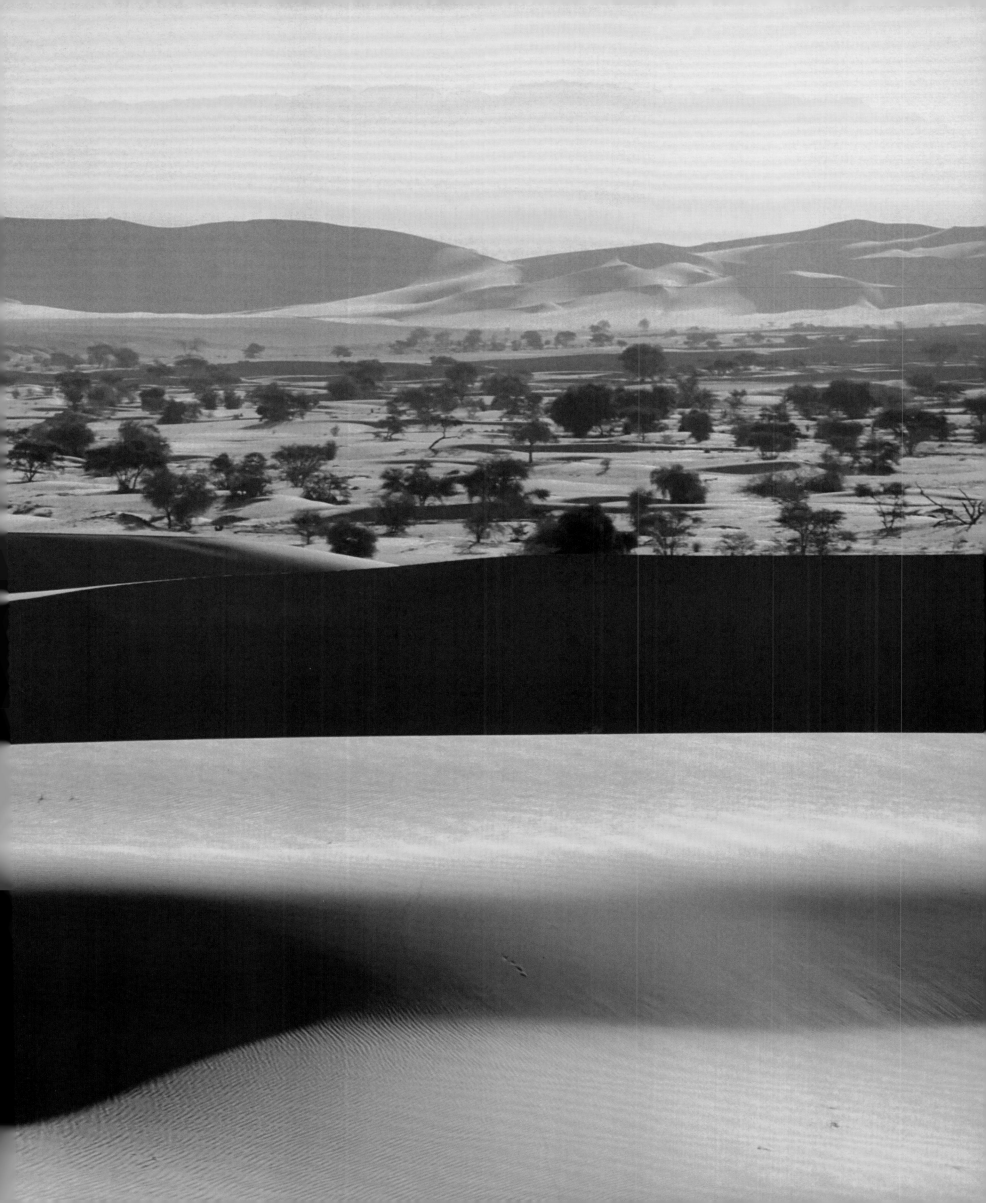

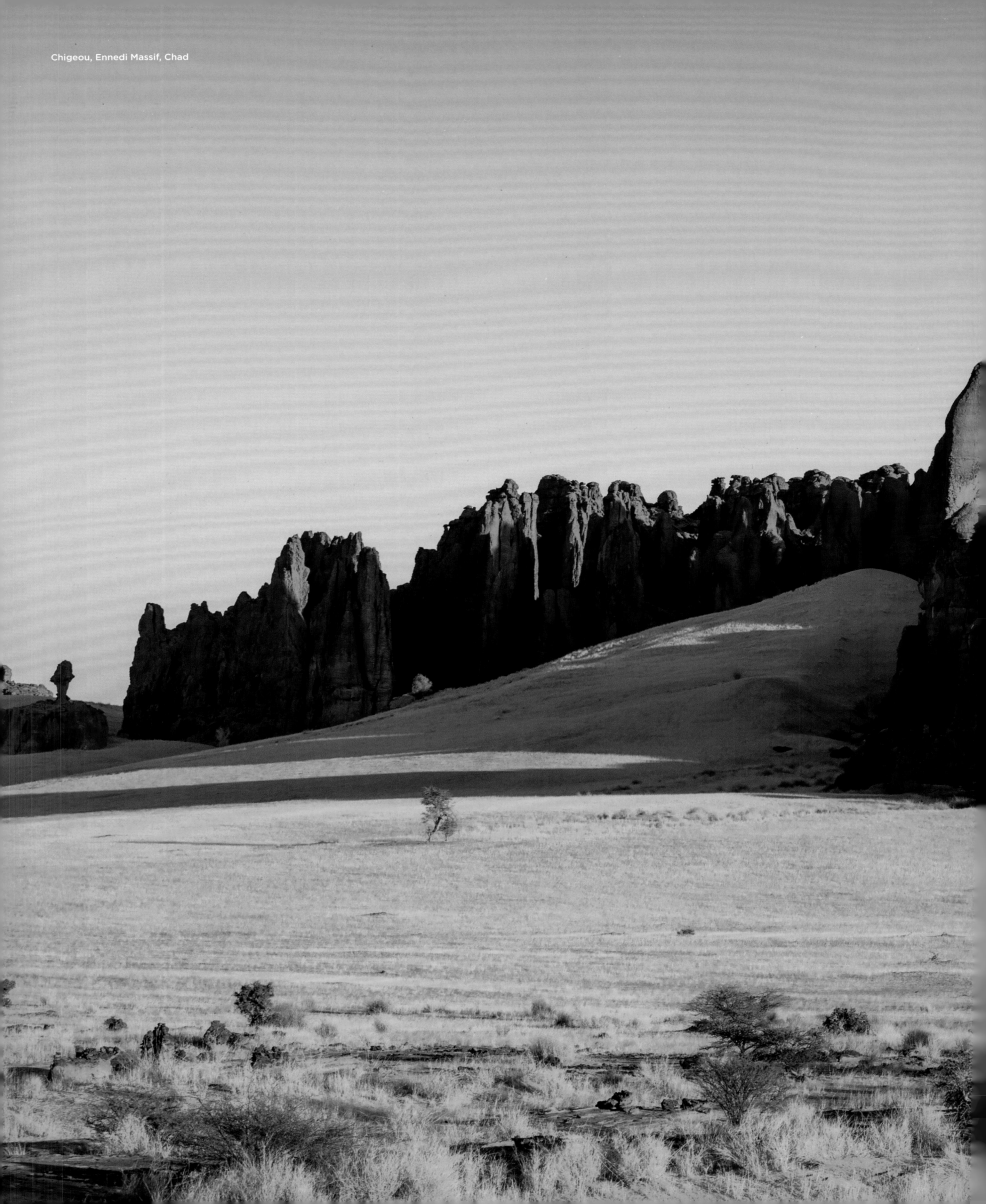

Chigeou, Ennedi Massif, Chad

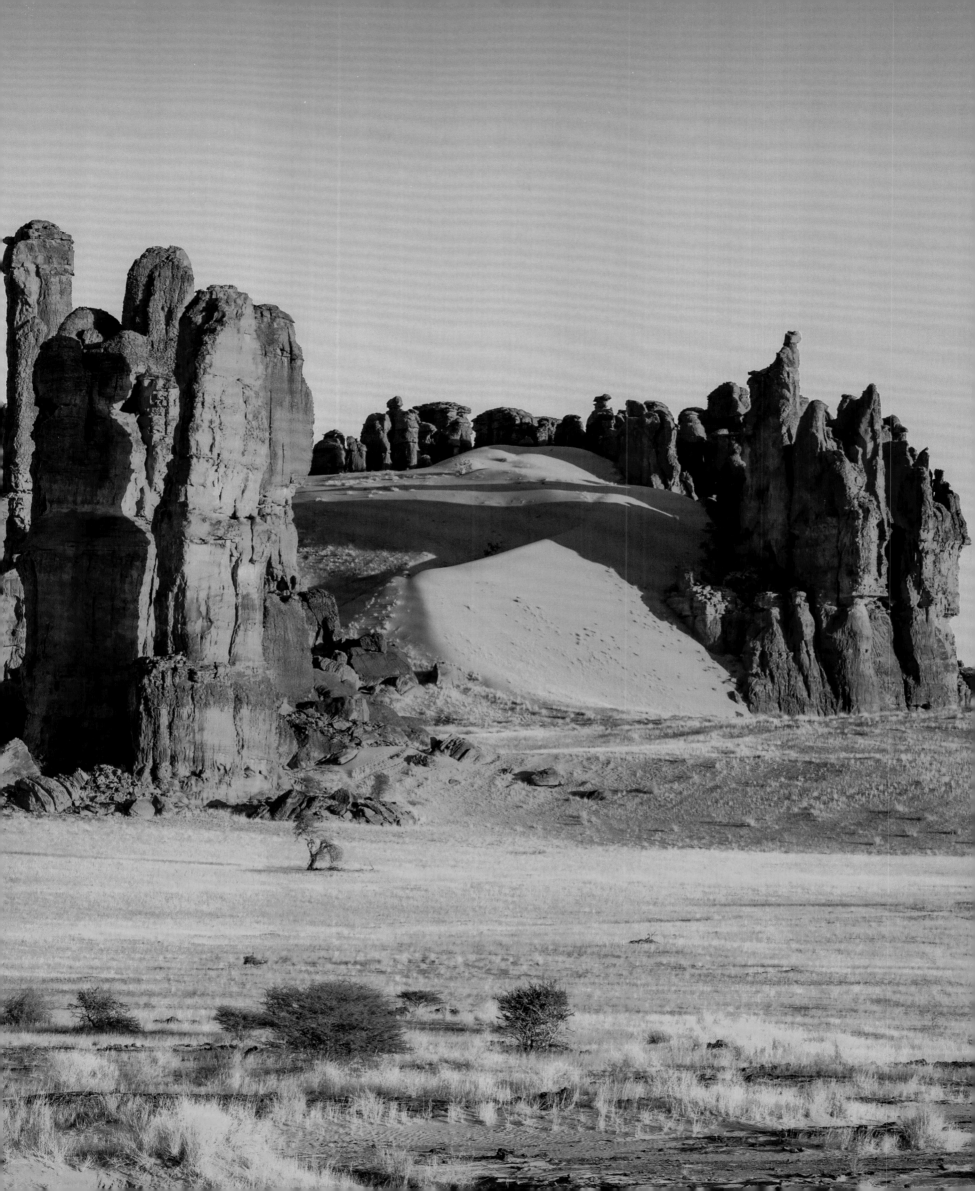

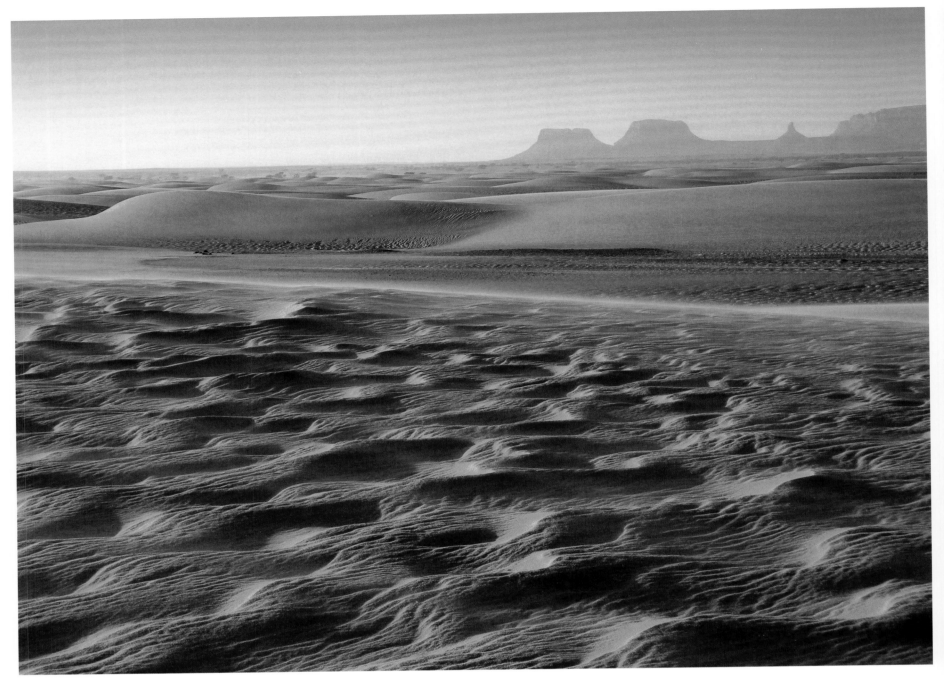

Mourdi region, Chad

Chad

Like Mali, Chad is divided neatly in two by Sahara and
Sahel. This is reflected in the country's ethnic mix,
with a population split between people of northern,
Arab origin and Black Africans from the south. In the
far north, the Tibesti Mountains rank among the
desert's most dramatic sights. Riven with canyons and
rising to the highest point in the Sahara (Emi Koussi,
at 3445 m), the Tibesti is an unlikely human realm –
the name means 'the place where mountain people
live', but this is the domain of the Toubou who have
lived here for 2500 years and use the Tibesti's oases
to water their livestock and camels.

Tchad

Comme le Mali, le Tchad est soigneusement divisé
en deux par le Sahara et le Sahel. Cette séparation
se reflète au niveau de l'ethnicité du pays, dont la
population se divise entre les gens du nord, d'origine
arabe, et les Noirs d'Afrique, au sud. Dans le nord
du Tchad, le massif du Tibesti se classe parmi les
panoramas désertiques les plus spectaculaires.
Fendu par des canyons et culminant au point le plus
haut du Sahara (le volcan Emi Koussi, à 3445 mètres
d'altitude), le Tibesti forme un improbable royaume
humain – son nom signifie « l'endroit où les
montagnards vivent » – au sein duquel les Toubous
vivent depuis 2500 ans, profitant des oasis locales
pour faire boire leurs animaux d'élevage et leurs
chameaux.

Tschad

Wie Mali wird der Tschad von Sahara und Sahelzone
in zwei Teile geteilt. Dies spiegelt sich in der ethnischen
Zusammensetzung des Landes wider: Die Bevölkerung
im Norden ist arabischer Herkunft, im Süden leben
Schwarzafrikaner. Im hohen Norden gehören die
Tibesti-Berge zu den dramatischsten Sehenswürdig-
keiten der Wüste. Von Schluchten durchzogen und
bis zum höchsten Punkt der Sahara (Emi Koussi,
3445 m) aufsteigend, ist der Tibesti ein unwirtlicher
Lebensraum für Menschen, aber er ist das Reich der
Toubou – der Name Tibesti bedeutet „der Ort, an dem
die Bergbewohner leben" –, die hier seit 2500 Jahren
leben und die Oasen nutzen, um ihr Vieh und ihre
Kamele zu tränken.

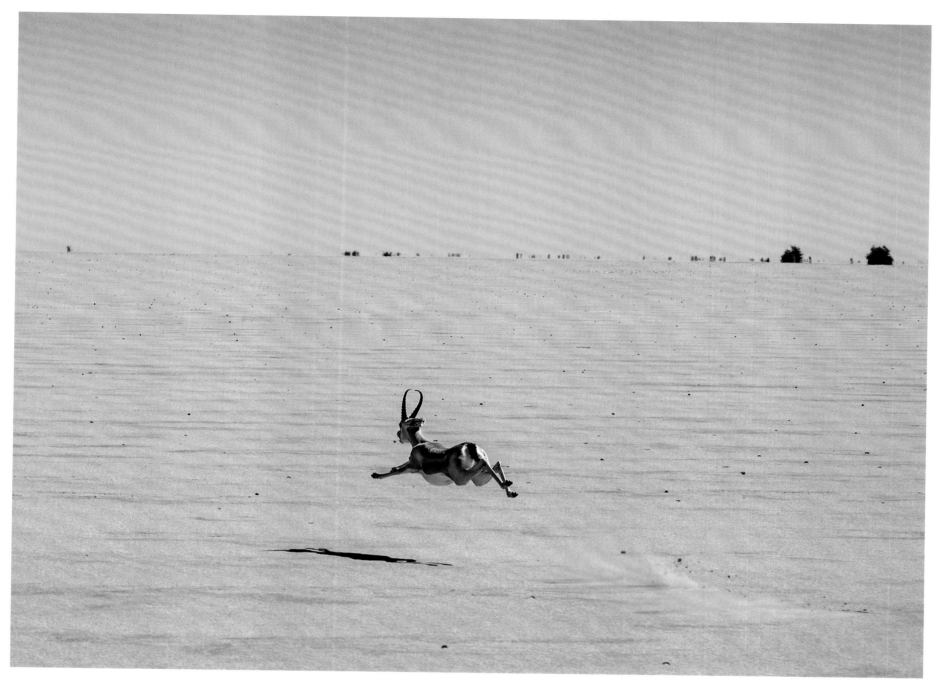

Dorcas gazelle, Chad

Chad

Al igual que Malí, Chad está dividido claramente en
dos por el Sahara y el Sahel. Esto se refleja en la
mezcla étnica del país, con una población dividida
entre personas del norte, de origen árabe y africanos
negros del sur. En el extremo norte, el Tibesti es
uno de los lugares de interés más espectaculares del
desierto. Rodeado de cañones y elevándose hasta el
punto más alto del Sahara (Emi Koussi, a 3 445 m), el
Tibesti es un reino humano poco probable, su nombre
significa «el lugar donde viven los montañeses» y este
es el dominio del Toubou, que ha vivido aquí durante
2 500 años y utiliza los oasis tibetanos para regar su
ganado y sus camellos.

Chade

Como o Mali, Chad é dividido ordenadamente em dois
por Sahara e Sahel. Isso se reflete na mistura étnica
do país, com uma população dividida entre pessoas
do norte, de origem árabe e negros africanos do sul.
No extremo norte, as Montanhas Tibesti estão entre
as atrações mais impressionantes do deserto.
Rasgado com cânions e subindo ao ponto mais alto
do Saara (Emi Koussi, a 3 445 m), o Tibesti é um reino
humano improvável - o nome significa "o lugar onde
as pessoas da montanha vivem", e este é o domínio
dos Toubou que moram aqui há 2 500 anos e usam
os oásis do Tibesti para regar o gado e os camelos.

Tsjaad

Net als Mali wordt Tsjaad netjes in tweeën gedeeld
door de Sahara en Sahel. Deze tweedeling wordt
weerspiegeld in de etnische samenstelling van het
land: de bevolking in het noorden is van Arabische
afkomst en in het zuiden leven zwarte Afrikanen. In het
hoge noorden van Tsjaad behoort het Tibestigebergte
tot de spectaculairste bezienswaardigheden van de
woestijn. Doorkruist door kloven en opklimmend
tot het hoogste punt van de Sahara (Emi Koussi,
3 445 meter) is de Tibesti een onwaarschijnlijke
verblijfplaats voor mensen. Toch is dit het rijk van de
Toeboe (de naam Tibesti betekent "plaats waar de
bergbewoners wonen"), die hier al 2 500 jaar wonen
en hun vee en kamelen in de oases laten drinken.

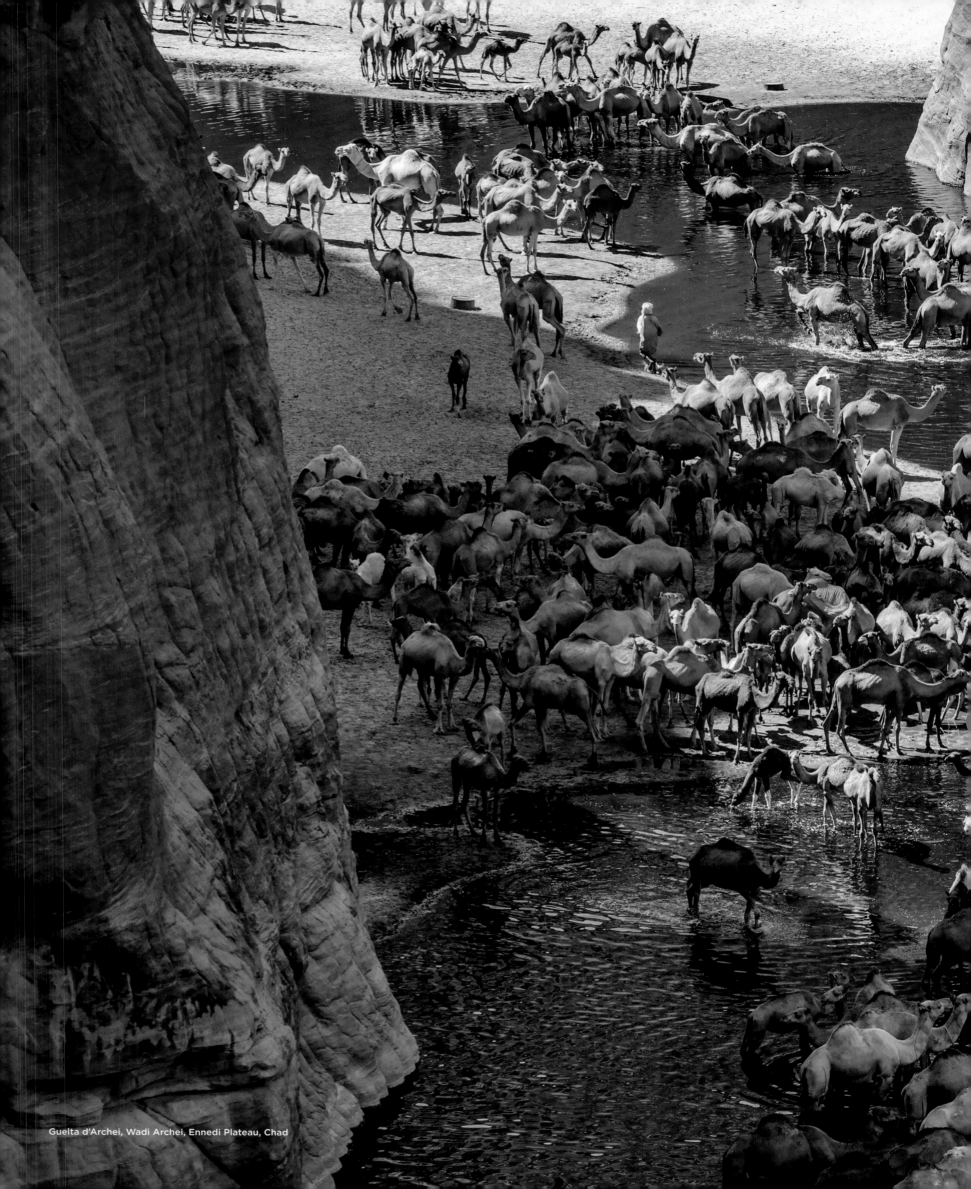

Guelta d'Archei, Wadi Archei, Ennedi Plateau, Chad

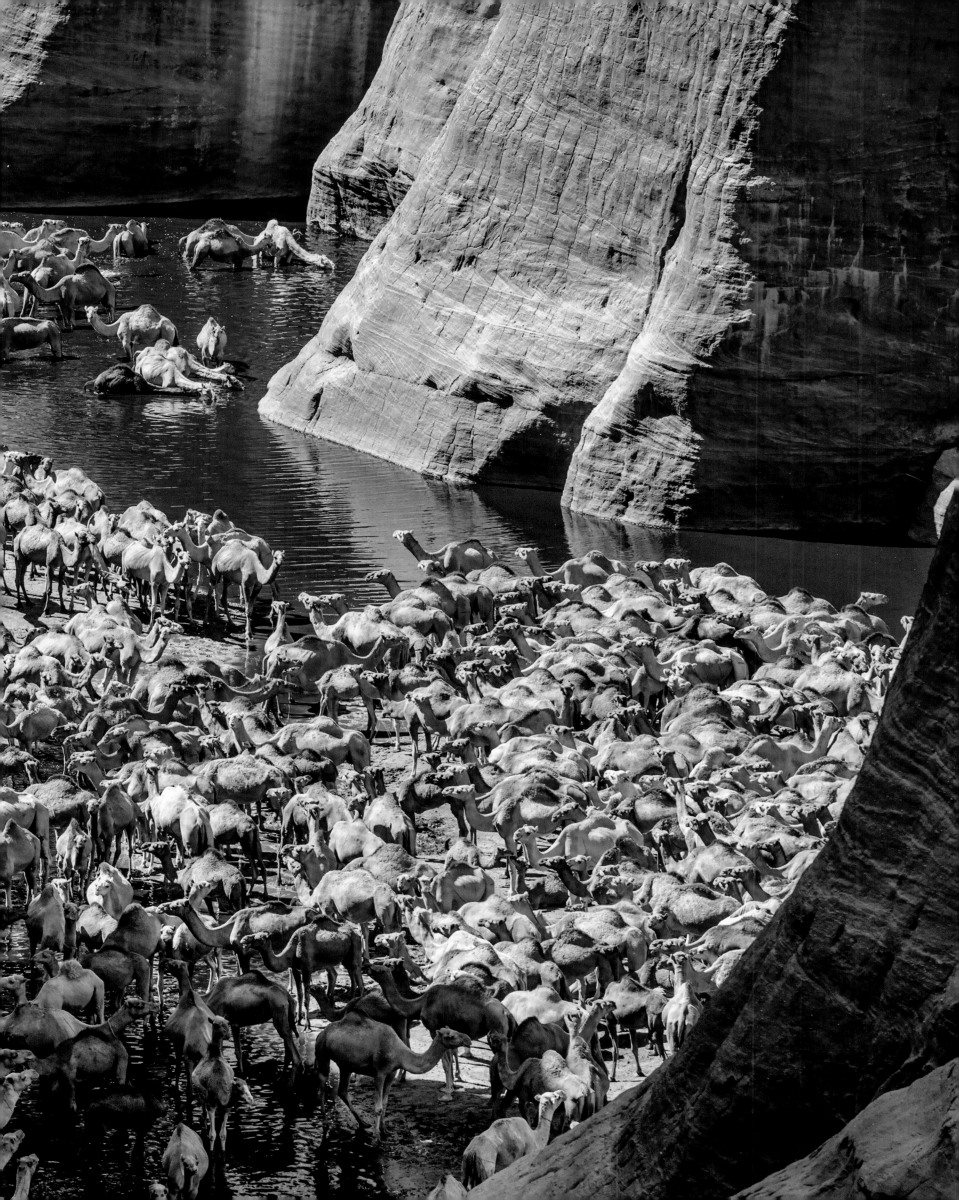

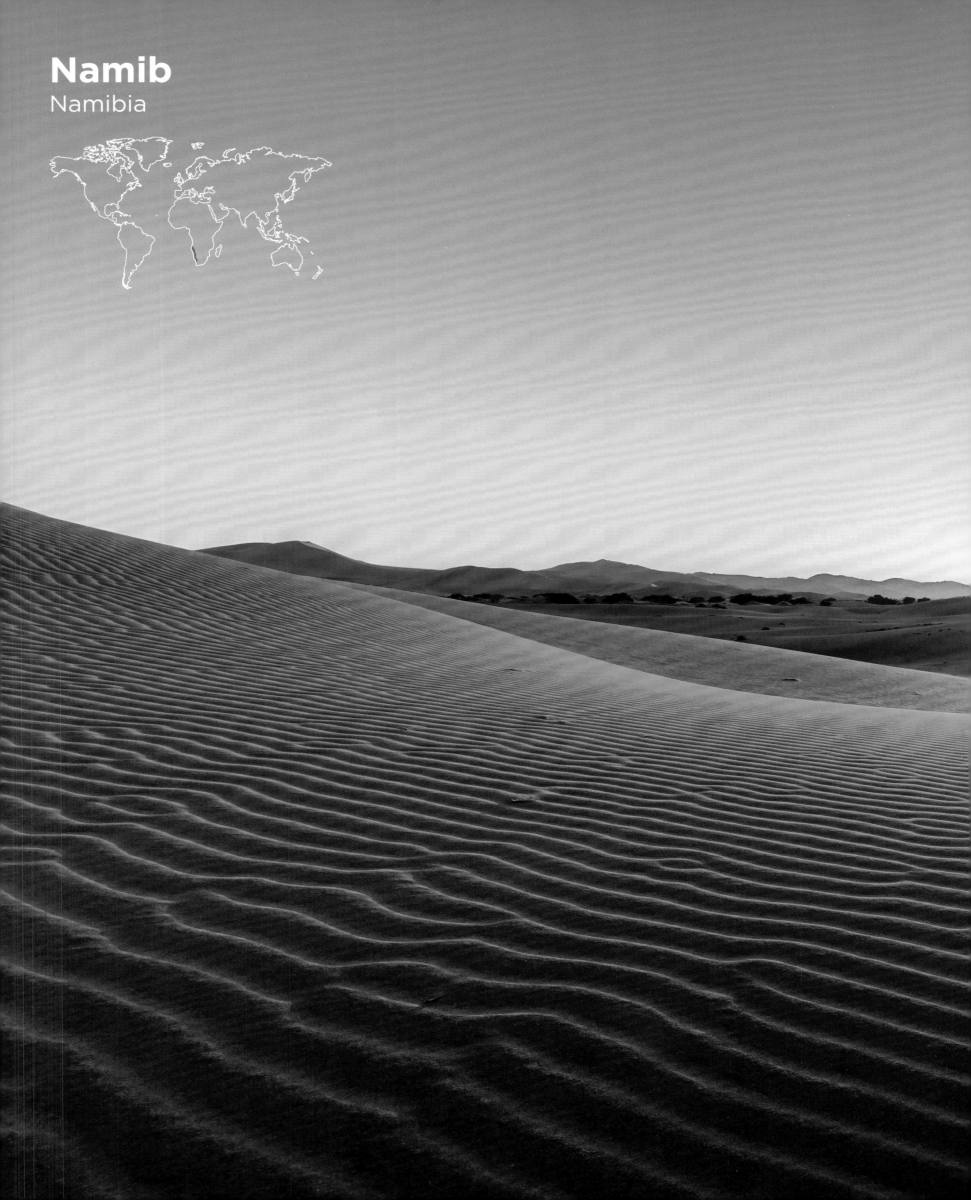

Namib
Namibia

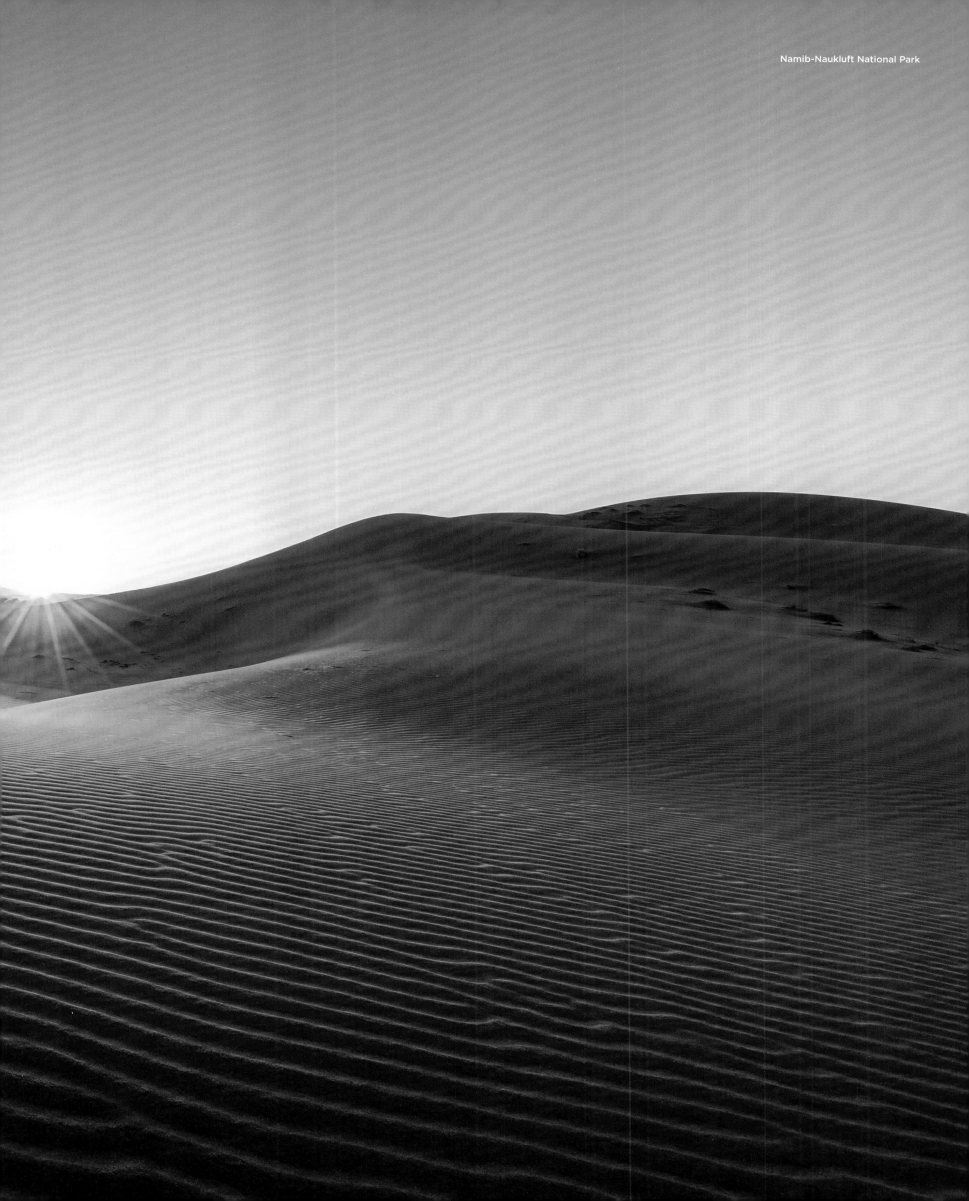

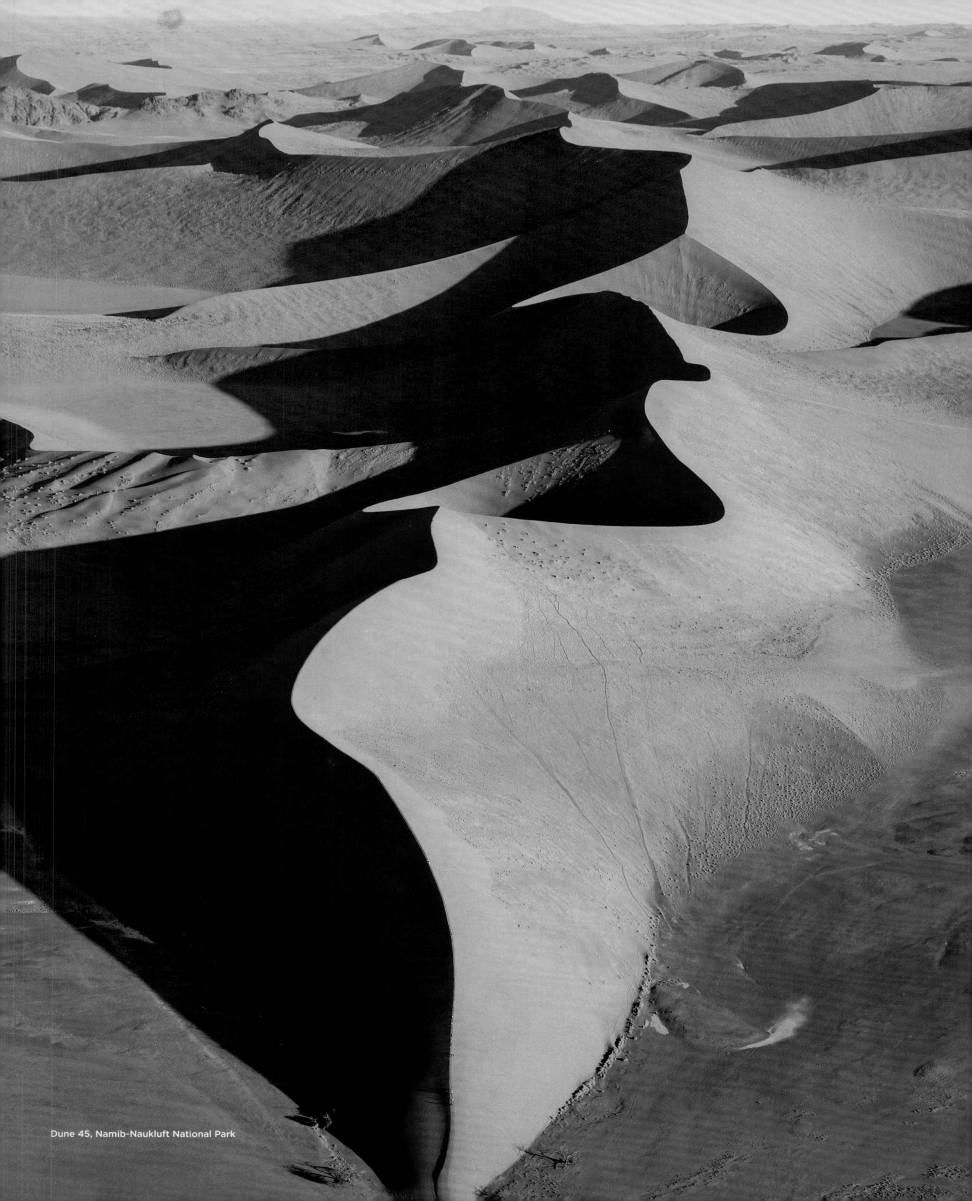

Dune 45, Namib-Naukluft National Park

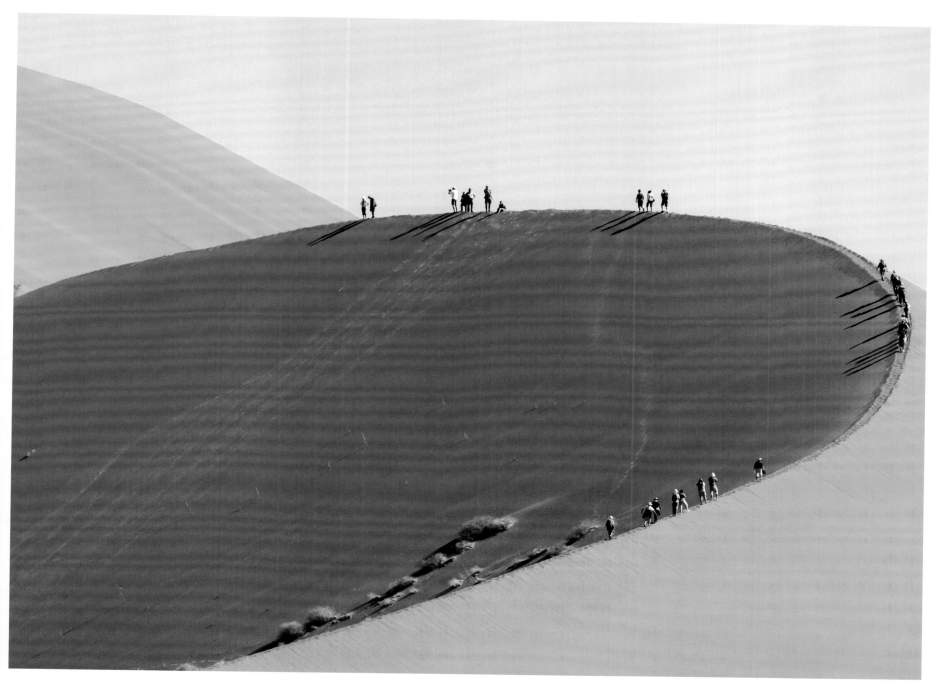

Elim Dune, Namib-Naukluft National Park, Sossusvlei

Namib

Scientists believe that the Namib is the oldest desert on the planet, and may date back more than 100 million years. It is also responsible for making Namibia the driest country in Africa south of the Sahara. Its coastal sand dunes are known as the Skeleton Coast, a reference to the shipwrecks that litter the shoreline here.

Désert du Namib

Les scientifiques considèrent le Namib comme le plus vieux désert de la planète, le datant de plus de 100 millions d'années. C'est également à lui que la Namibie doit son statut de pays le plus sec de l'Afrique subsaharienne. Ses dunes côtières sont connues sous le nom de côte des Squelettes, une référence aux épaves jonchant la côte locale.

Namib

Wissenschaftlern zur Folge ist die Namib die älteste Wüste der Welt und ihre Entstehung liegt mehr als 100 Millionen Jahre zurück. Die Wüste ist auch dafür verantwortlich, dass Namibia das trockenste Land Afrikas südlich der Sahara ist. Die Gegend mit ihren Sanddünen wird Skelettküste genannt, ein Hinweis auf die vielen Schiffswracks, die hier vor der Küste liegen.

Namib

Los científicos creen que el Namib es el desierto más antiguo del planeta y que puede datar de hace más de 100 millones de años. También es responsable de hacer de Namibia el país más seco de África al sur del Sahara. Sus dunas costeras de arena son conocidas como la Costa del Esqueleto, una referencia a los naufragios que ensucian la costa.

Namib

Os cientistas acreditam que o Namibe é o deserto mais antigo do planeta e pode ter mais de 100 milhões de anos. É também responsável por tornar a Namíbia o país mais seco da África a sul do Saara. Suas dunas costeiras são conhecidas como a Costa dos Esqueletos, uma referência aos naufrágios que cobrem a costa aqui.

Namib

Wetenschappers geloven dat de Namib de oudste woestijn op aarde is – misschien wel meer dan 100 miljoen jaar oud. Door de woestijn is Namibië ook het droogste land van Afrika ten zuiden van de Sahara. Het kustgebied met zijn zandduinen staat bekend als de Geraamtekust, vanwege de scheepswrakken die hier langs de kustlijn liggen.

African Elephant, Hoarusib River

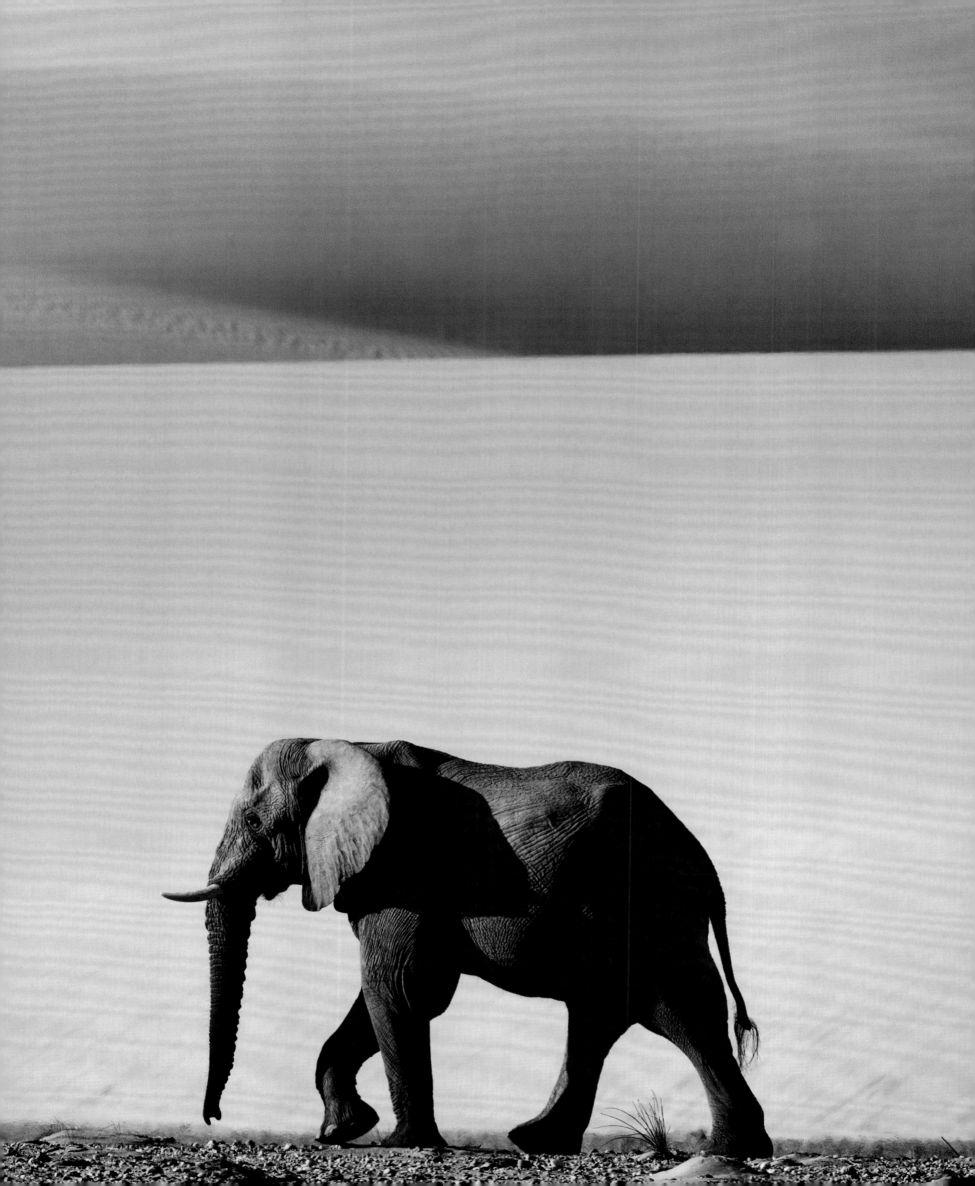

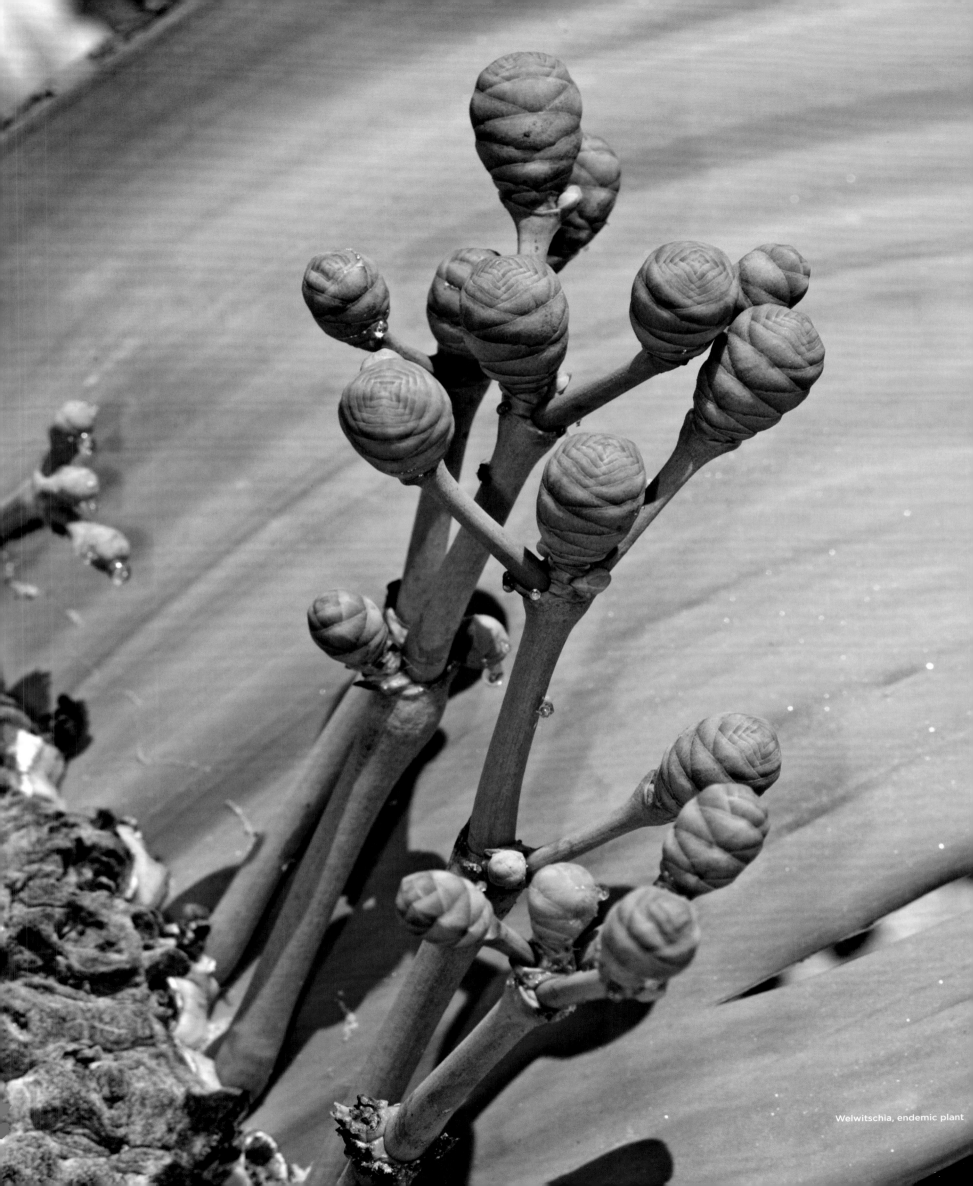

Welwitschia, endemic plant

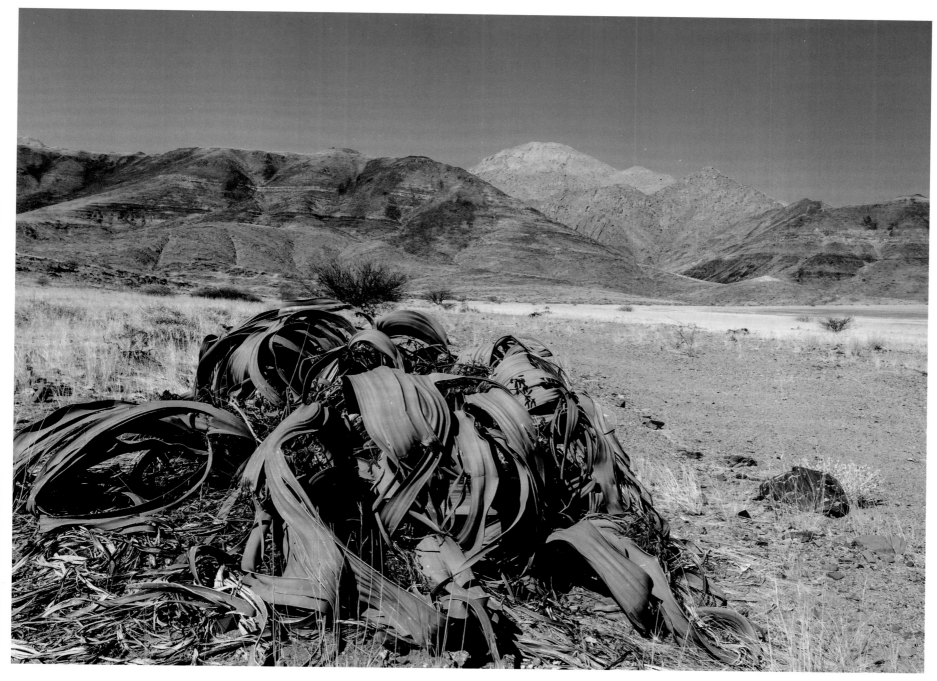

Welwitschia, Brandberg Mountain, Erongo

Flora

The Namib's climate is determined as much by the Atlantic as the African interior. On around 180 days of the year, fog (created by a collision of warm onshore air with cold air from the Benguela Current) sweeps across the coast, wreaking havoc for shipping in the area but providing ideal conditions for an unusual variety of desert flora.

Flore

Le climat du Namib est autant déterminé par l'Atlantique que par l'intérieur de l'Afrique. Durant pratiquement la moitié de l'année, le brouillard (créé par une collision entre l'air terrestre chaud et l'air froid dû au courant du Benguela) balaie la côte, ravageant les navires de la zone, mais prodiguant des conditions de développement idéales pour une flore du désert variée et rare.

Flora

Das Klima der Namib wird durch den Atlantik und das afrikanische Inland bestimmt. An rund 180 Tagen im Jahr zieht Nebel (der durch das Zusammentreffen von warmer Landluft mit der kalten Luft über der Benguela-Meeresströmung entsteht) über die Küste. Er stellt eine ungeheure Gefahr für die Schifffahrt dar, bietet aber ideale Bedingungen für eine ungewöhnlich vielfaltige Wüstenflora.

Flora

El clima de Namib está determinado tanto por el Atlántico como por el interior de África. Alrededor de 180 días al año, la niebla (creada por una colisión de aire caliente en tierra con aire frío de la corriente de Benguela) se extiende a través de la costa, causando estragos para el transporte marítimo, pero proporcionando las condiciones ideales para una variedad inusual de flora desértica.

Flora

O clima da Namíbia é determinado tanto pelo Atlántico quanto pelo interior africano. Em cerca de 180 dias do ano, o nevoeiro (criado por uma colisão de ar quente em terra com ar frio da Corrente de Benguela) varre a costa, causando estragos na navegação mas proporcionando condições ideais para uma variedade incomum de flora do deserto.

Flora

Het klimaat van de Namib wordt evenzeer door de Atlantische Oceaan als door het Afrikaanse binnenland bepaald. Op ca. 180 dagen van het jaar trekt er mist (ontstaan door een botsing van warme aanlandige lucht met koude lucht van de Benguelastroom) over de kust. Hij is desastreus voor de scheepvaart in het gebied, maar biedt ideale omstandigheden voor een ongewone verscheidenheid aan woestijnflora.

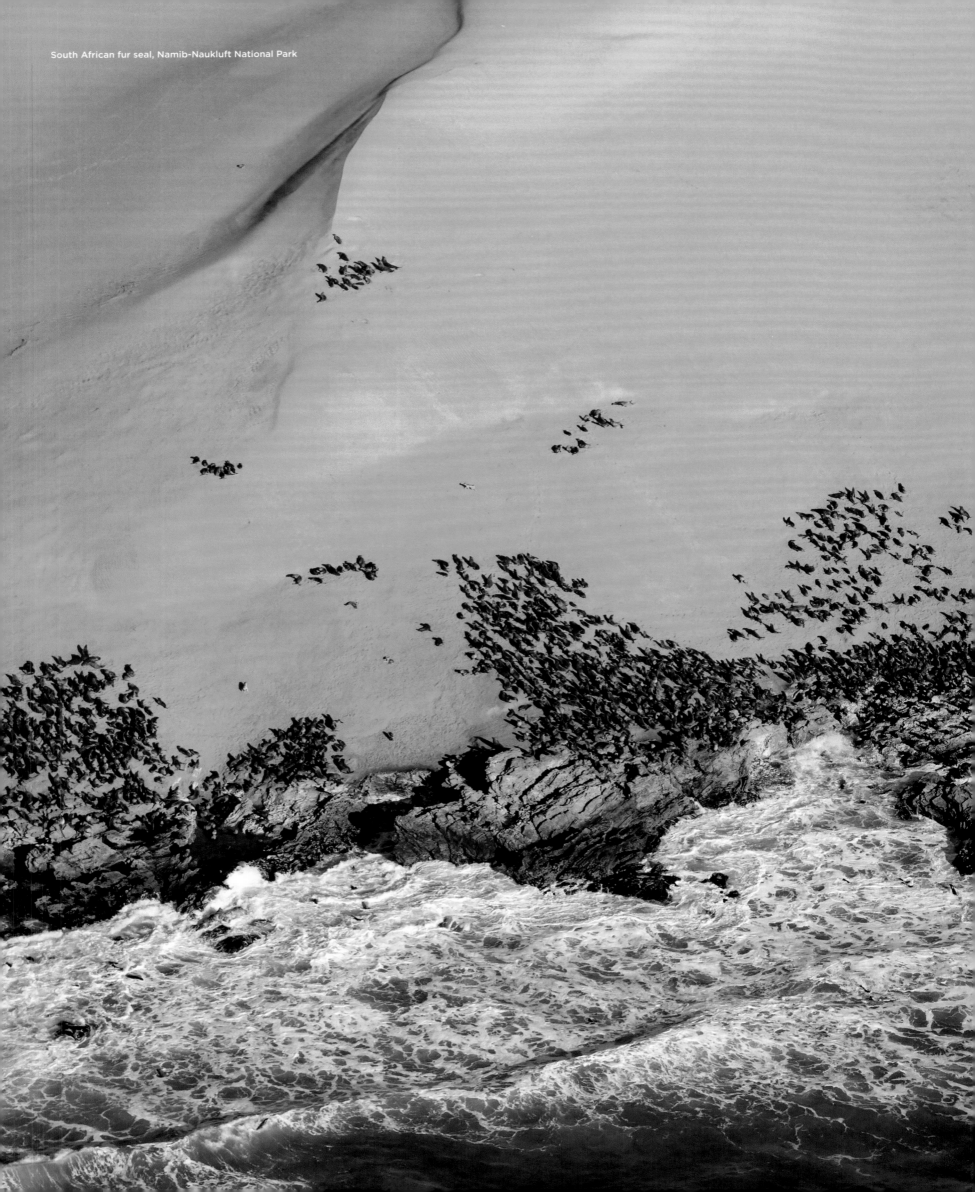

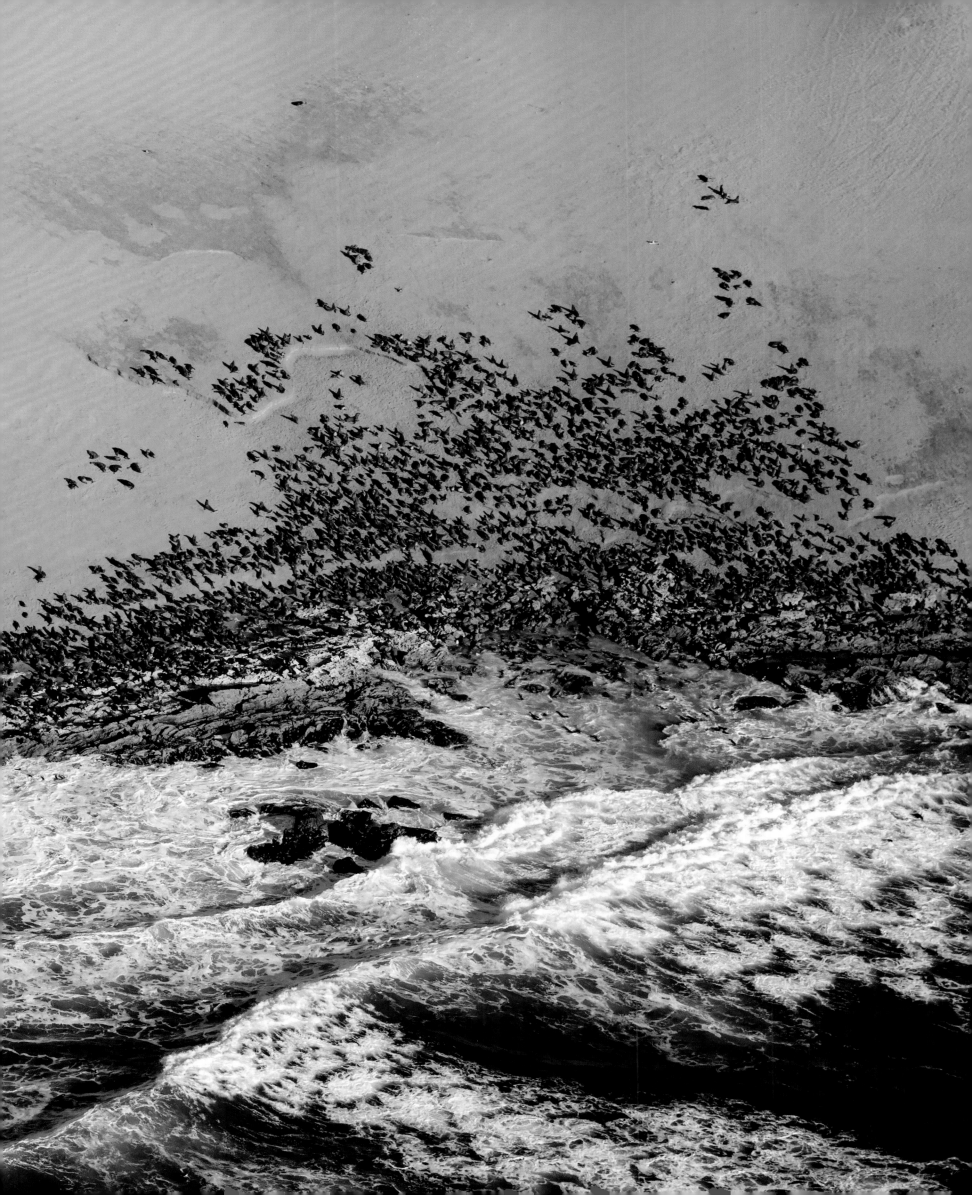

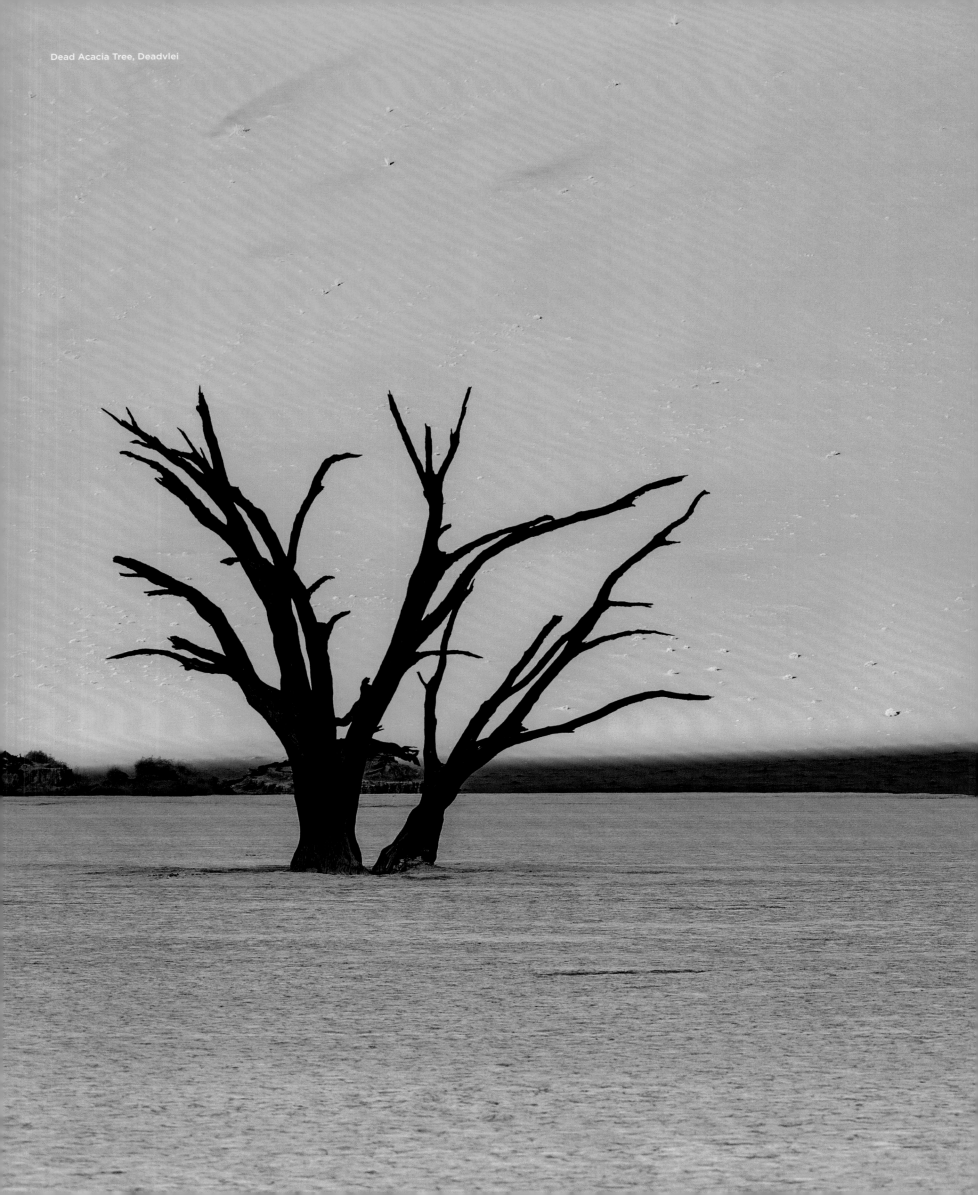

Dead Acacia Tree, Deadvlei

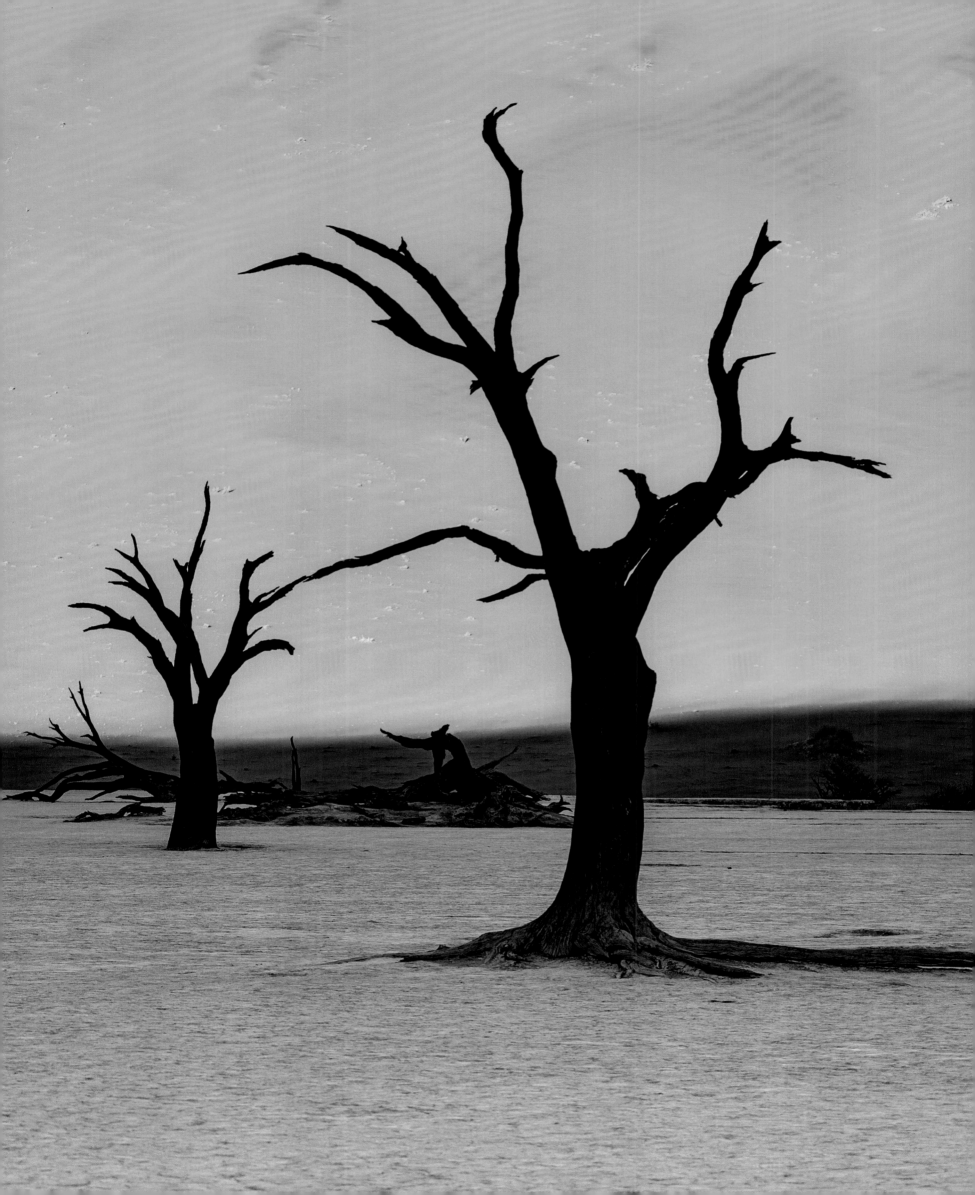

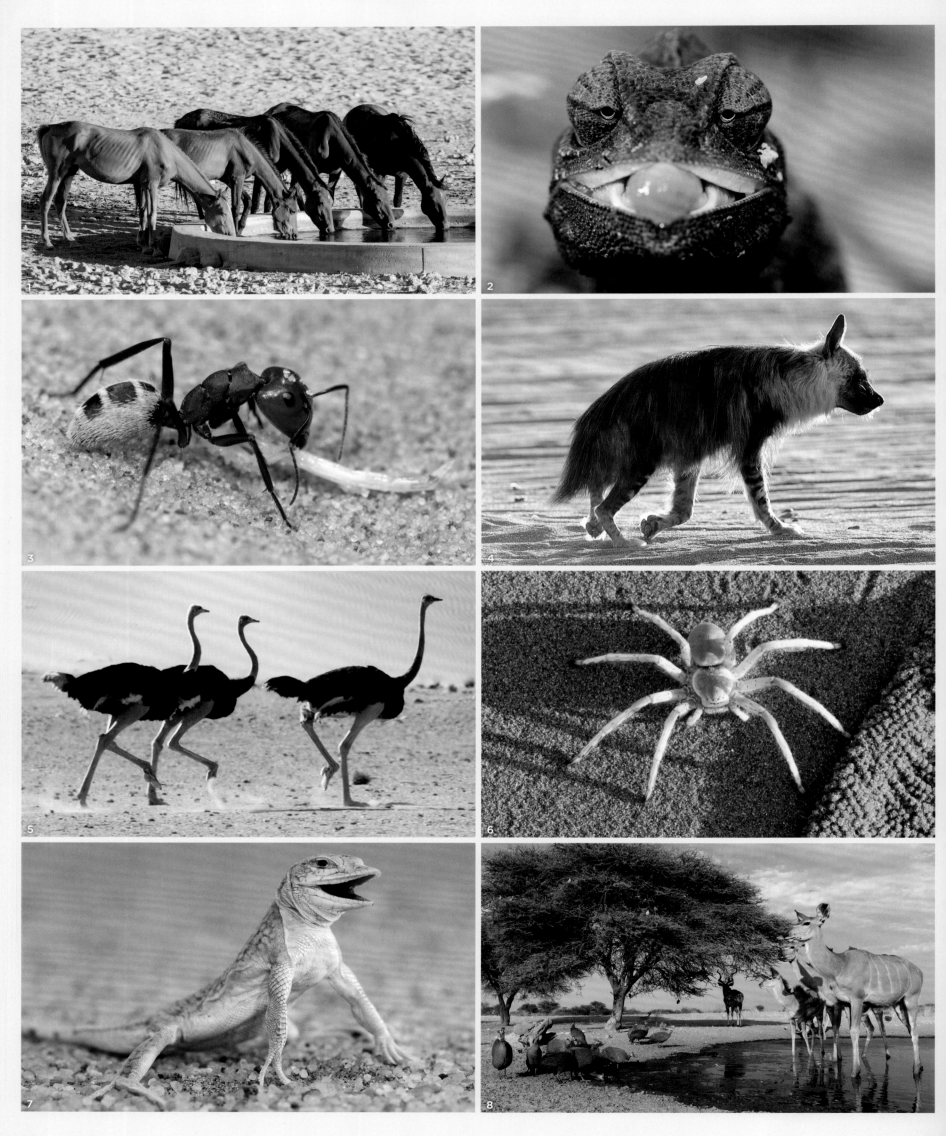

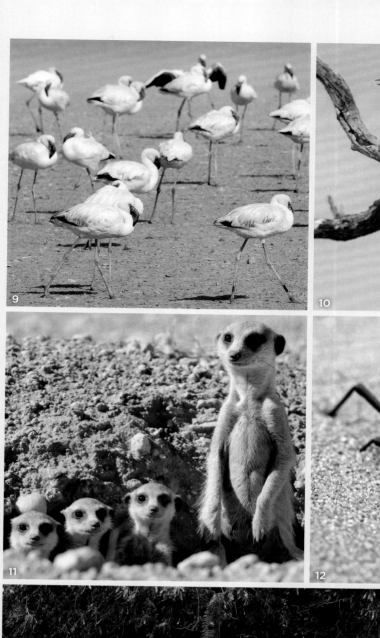

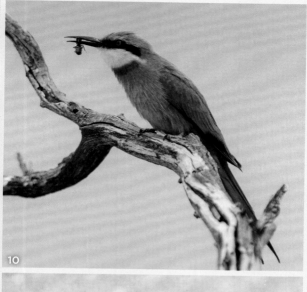

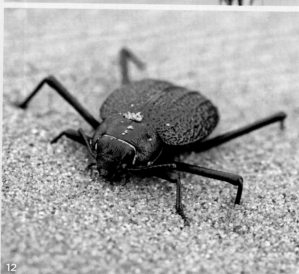

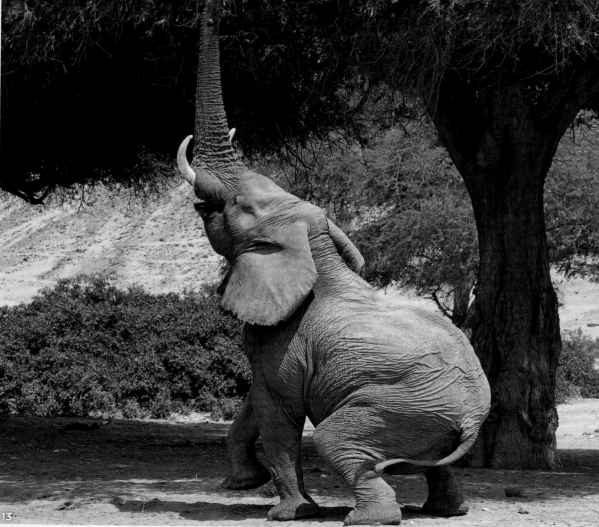

Namibian Animals

1 Wild Horses; Chevaux sauvages; Wildpferde; Caballos salvajes; Cavalos selvagens; Wilde paarden

2 Namaqua Chameleon; Chamaeleo namaquensis; Wüstenchamäleon; Camaleón de Namaqua; Camaleão Namaqua; Kameleon

3 Namib Desert Dune Ant; Fourmi de dunes du désert; du Namib Namib-Dünenameise; Hormiga camponotus detritus; Formiga do Deserto do Namibe; Mier

4 Brown Hyena; Hyène brune; Braune Hyäne; Hiena parda; Hiena castanha; Bruine hyena

5 Ostriches; Autruches; Strauße; Avestruces; Avestruzes; Struisvogels

6 White Lady Spider; Araignée dame blanche; Weiße Damen-Spinne; Araña dama blanca; Aranha senhora branca; Spin

7 Shovel-snouted Lizard or Namib Sanddiver; Gecko de sable; Anchietas-Düneneidechse; Lagarto meroles anchieae; Lagarto cabeça de Pá; Hagedis

8 Greater Kudus; Grands koudous; Großkudus; Kudús mayores; Kudus maiores; Grote koedoes

9 Greater Flamingos; Flamants roses; Rosaflamingos; Flamencos mayores; Flamingos maiores; Flamingo's

10 Swallow-tailed Bee-eater; Guêpier à queue d'aronde; Schwalbenschwanzspint; Abejaruco golondrina; Abelharuco-de-cauda-de-andorinha; Zwaluwstaartbijeneter

11 Meerkats; Suricates; Erdmännchen; Suricatos; Suricatos; Stokstaartjes

12 Head-stander Beetle; Coléoptère Onymacris unguiculari; Nebeltrinker-Käfer; Escarabajo onymacris unguicularis; Besouro Cabeça-Stander; Zwartlijfkever

13 African Bush Elephant; Éléphant de savane d'Afrique; Afrikanischer Elefant; Elefante africano de sabana; Elefante-africano; Savanneolifant

Kalahari
Namibia, South Africa & Botswana

Central Kalahari Game Reserve, Botswana

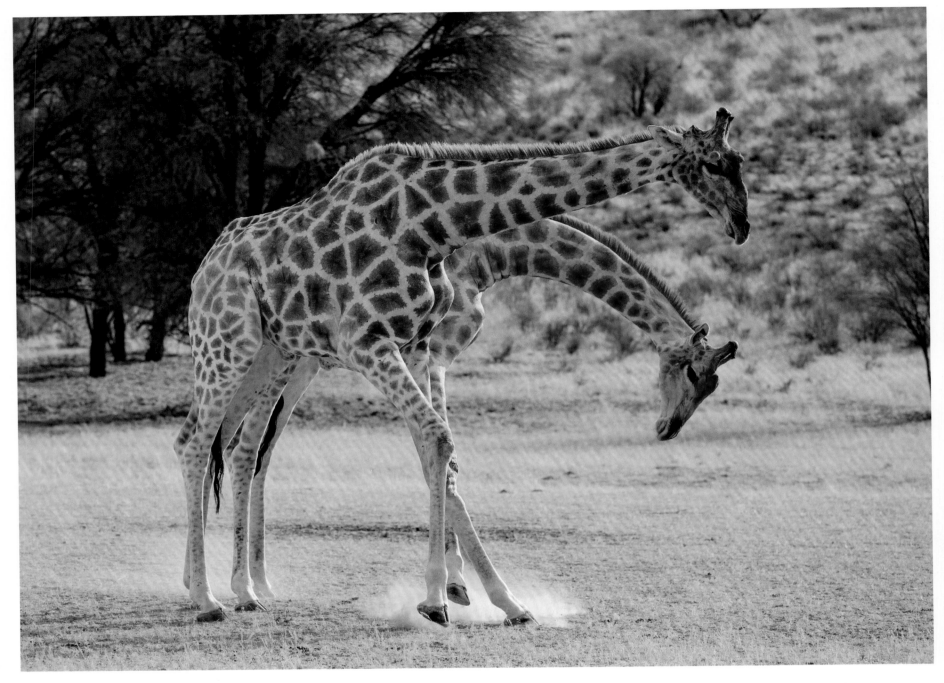

Giraffes, Kgalagadi Transfrontier National Park, South Africa

Kalahari

Covering nearly a million square kilometres in southern Africa, the red-sand Kalahari gets its name from local words that mean 'the great thirst' or 'waterless place'. In the northern Kalahari, the Makgadikgadi Pans form part of a vast network of salt lakes, one of the largest on the planet, that in past millennia formed the floor of an inland sea. The Kalahari has been inhabited by the indigenous San people for tens of thousands of years, who lived a semi-nomadic lifestyle until the 1990s. Major national parks here include the Central Kalahari Game Reserve, Etosha National Park, and the Kgalagadi Transfrontier Park.

Kalahari

Couvrant pratiquement un million de kilomètres carrés au sud de l'Afrique, le Kalahari au sable rouge tient son nom d'un dérivé de mots locaux signifiant « la grande soif » ou « lieu sans eau ». Au nord, le pan de Makgadikgadi fait partie d'un vaste réseau de lacs salés, l'un des plus grands de la planète, qui, au cours des derniers millénaires, a formé le fond d'une mer intérieure. Le Kalahari a été habité durant dix mille ans par le peuple indigène San, qui a connu un mode de vie semi-nomadique jusque dans les années 1990. Parmi les parcs nationaux les plus importants de la région, l'on compte la réserve de chasse du Kalahari central, le parc national d'Etosha et le parc transfrontalier de Kgalagadi.

Kalahari

Der Name der fast eine Million Quadratkilometer großen Kalahari im südlichen Afrika stammt von den dort lebenden Völkern und bedeutet „der große Durst" oder „der wasserlose Ort". In der nördlichen Kalahari sind die Makgadikgadi-Salzpfannen Teil eines riesigen Netzwerks von Salzseen, einem der größten der Welt, das in vergangenen Jahrtausenden den Boden eines Binnenmeeres bildete. Die Kalahari wird seit Zehntausenden von Jahren von den indigenen San bewohnt, die hier bis in die 1990er Jahre einen halbnomadischen Lebensstil führten. Zu den wichtigsten Nationalparks gehören das Central Kalahari Game Reserve, der Etosha Nationalpark und der Kgalagadi Transfrontier Park.

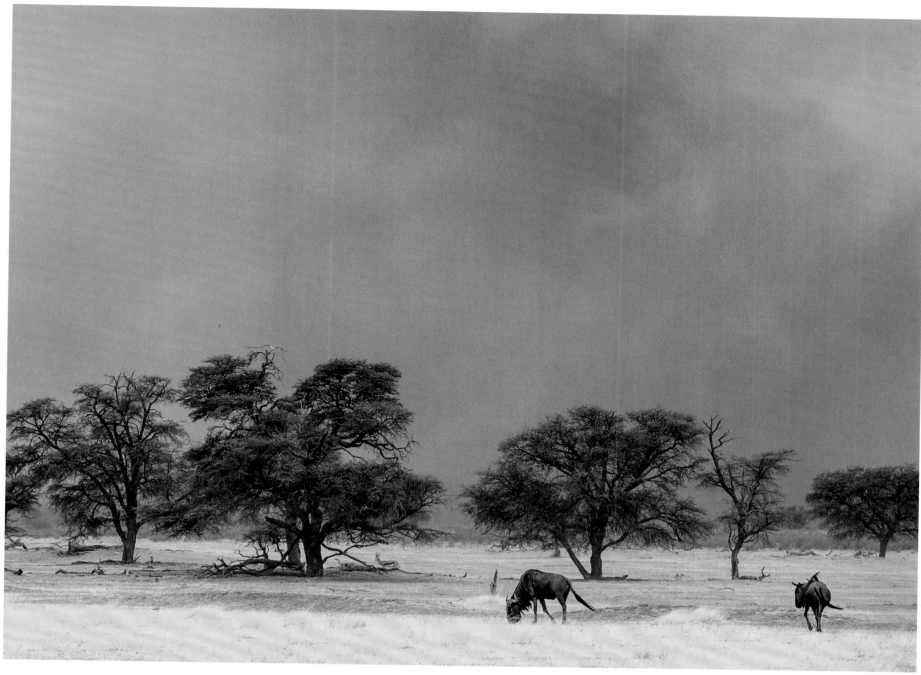

Sandstorm in dry Nossob riverbed, Blue Wildbeest, Camel Thorn Tree

Kalahari

Cubriendo casi un millón de kilómetros cuadrados en el sur de África, el Kalahari de arena roja recibe su nombre de palabras locales que significan «la gran sed» o «lugar sin agua». En el Kalahari septentrional, los salares de Makgadikgadi forman parte de una vasta red de lagos salados, uno de los más grandes del planeta, que en milenios pasados formaron el fondo de un mar interior. El Kalahari ha sido habitado por el pueblo indígena San durante decenas de miles de años y vivió un estilo de vida seminómada hasta la década de 1990. Entre los principales parques nacionales se encuentran la Reserva de Caza del Kalahari Central, el Parque Nacional de Etosha y el Parque Transfronterizo de Kgalagadi.

Kalahari

Cobrindo quase um milhão de quilômetros quadrados no sul da África, o Kalahari, de areia vermelha, recebe esse nome de palavras locais que significam "a grande sede" ou "lugar sem água". No Kalahari do norte, as Makgadikgadi Pans fazem parte de uma vasta rede de lagos salgados, uma das maiores do planeta, que no passado milênio formava o solo de um mar interior. O Kalahari foi habitado pelo povo indígena San por dezenas de milhares de anos e viveu um estilo de vida semi-nômada até a década de 1990. Os principais parques nacionais incluem a Reserva de Caça Central do Kalahari, o Parque Nacional Etosha e o Parque Transfronteiriço Kgalagadi.

Kalahari

Met een oppervlak van bijna 1 miljoen vierkante kilometer in zuidelijk Afrika ontleent de Kalahari zijn naam aan lokale woorden die "de grote dorst" of "waterloze plaats" betekenen. In de noordelijke Kalahari maken de Makgadikgadizoutvlaktes deel uit van een uitgebreid netwerk van zoutmeren, een van de grootste ter wereld, die in de afgelopen millennia de bodem van een binnenzee vormden. De Kalahari wordt al tienduizenden jaren bewoond door het inheemse Sanvolk, dat er tot in de jaren negentig een seminomadische levensstijl op nahield. Tot de grote nationale parken hier behoren het Central Kalahari Game Reserve, nationaal park Etosha en het Kgalagadi Transfrontier Park.

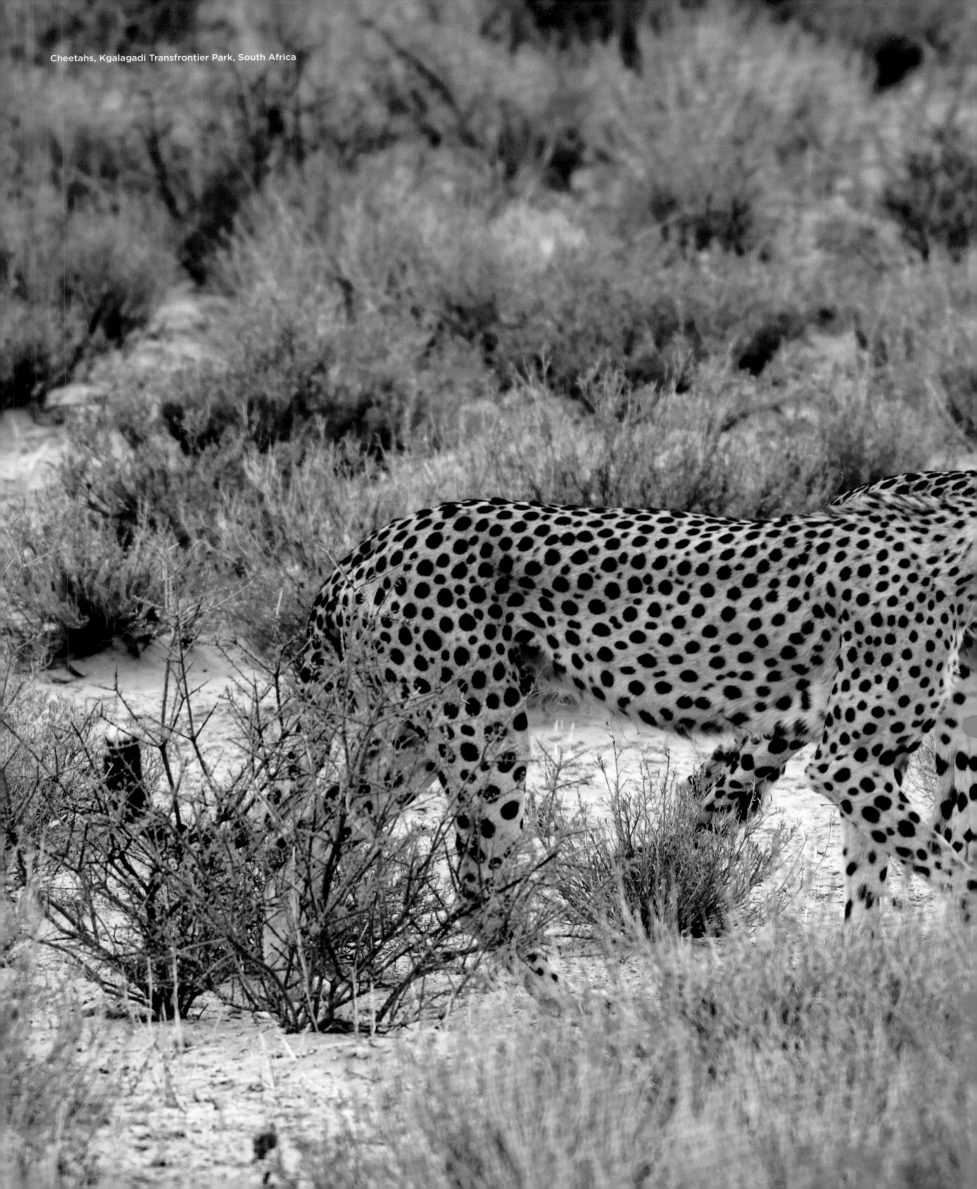

Cheetahs, Kgalagadi Transfrontier Park, South Africa

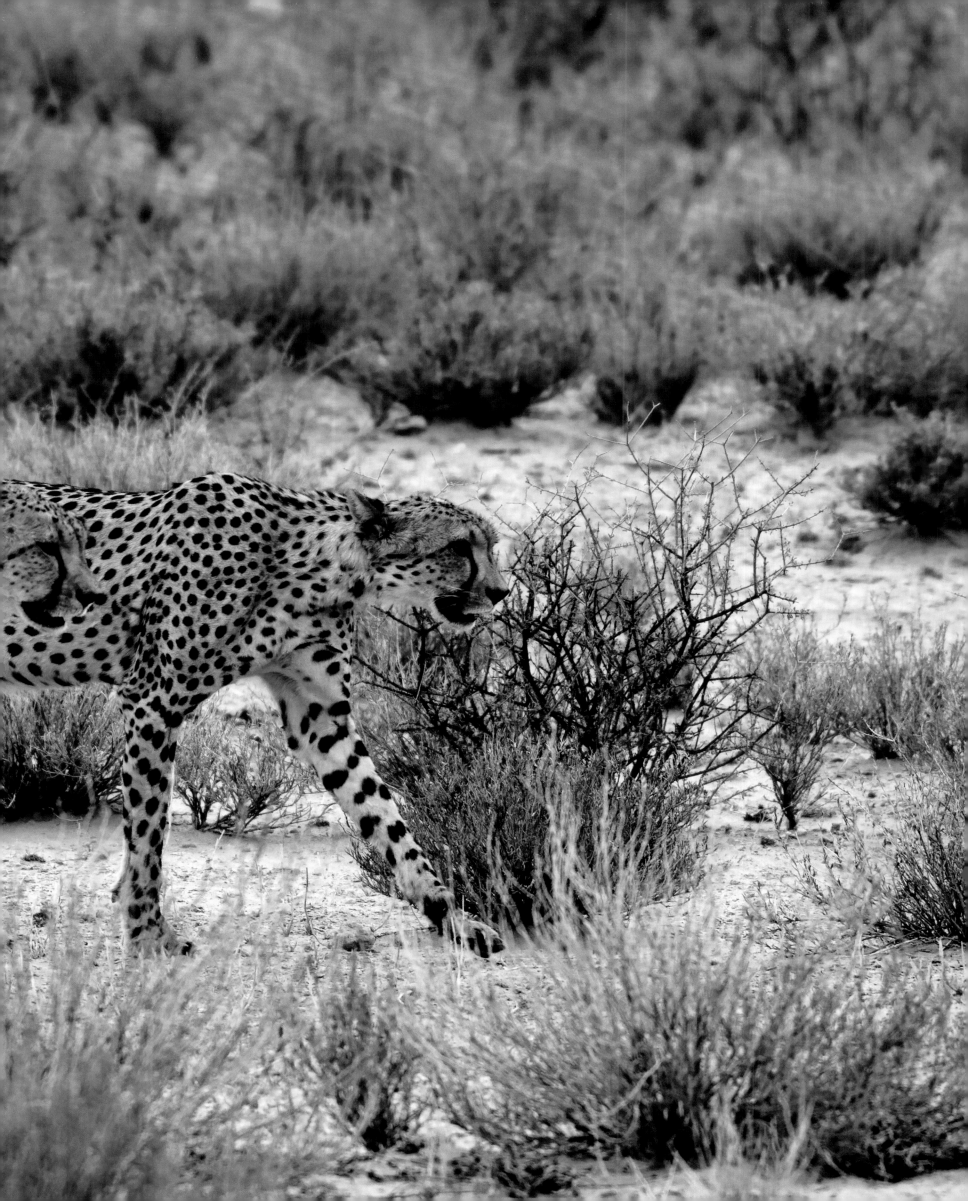

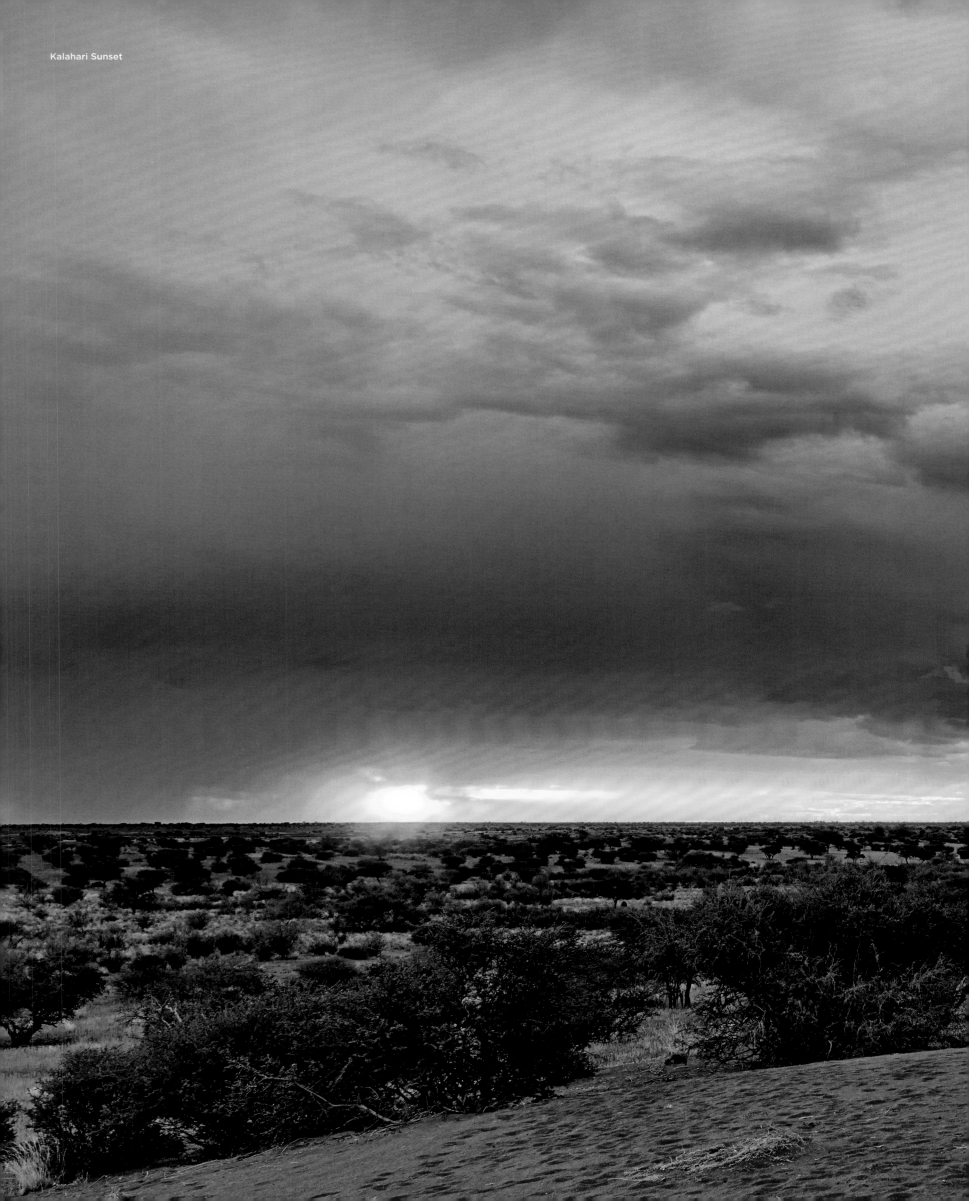

Kalahari Sunset

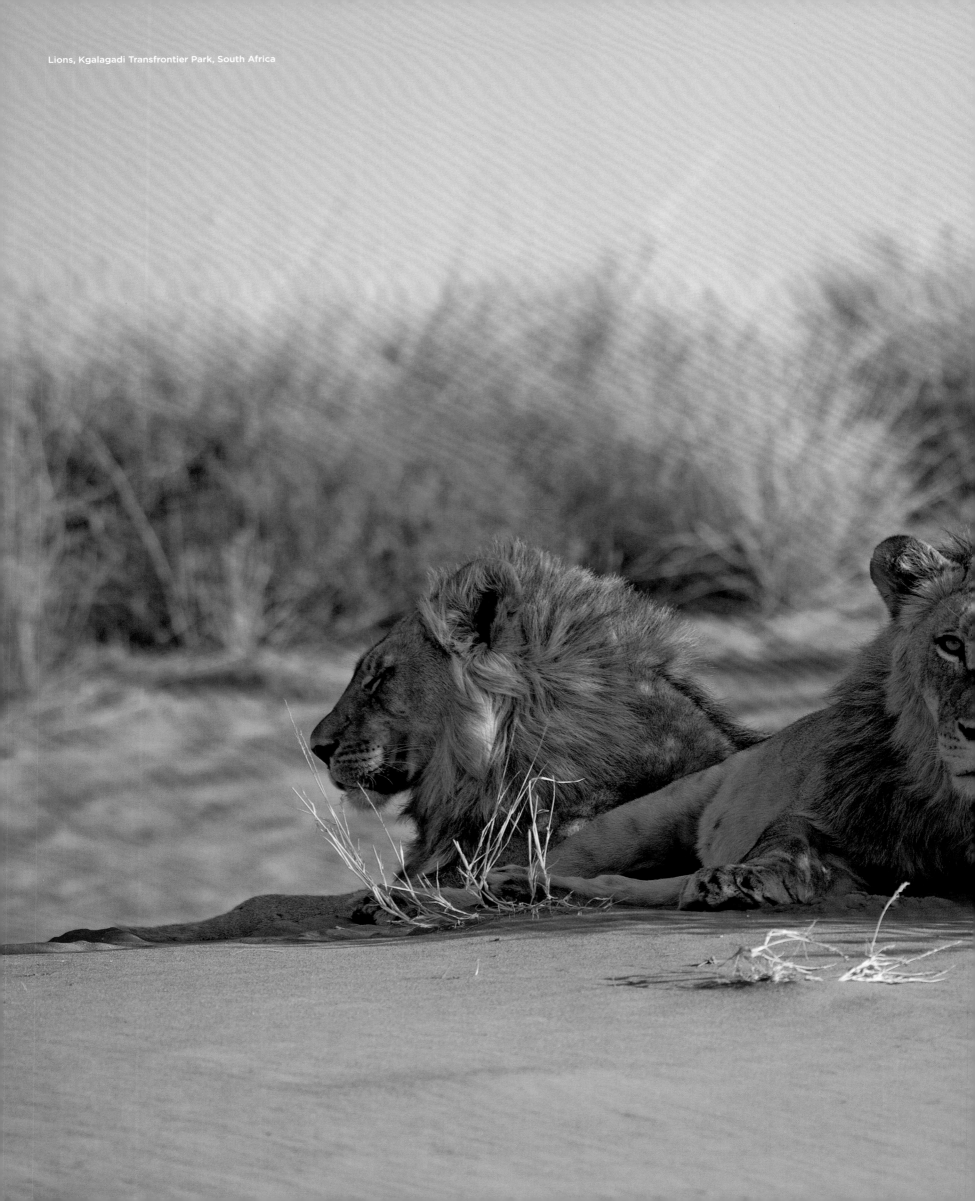

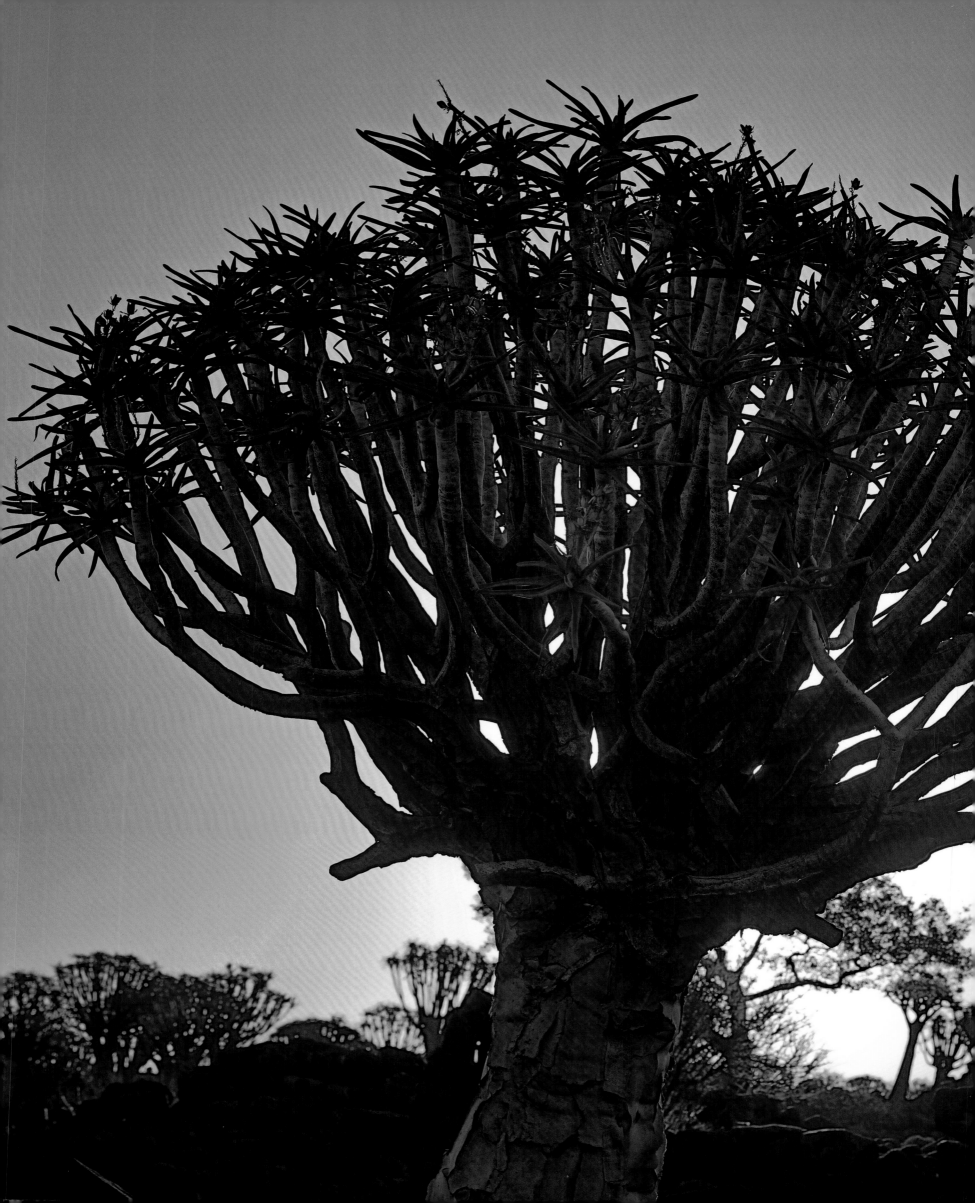

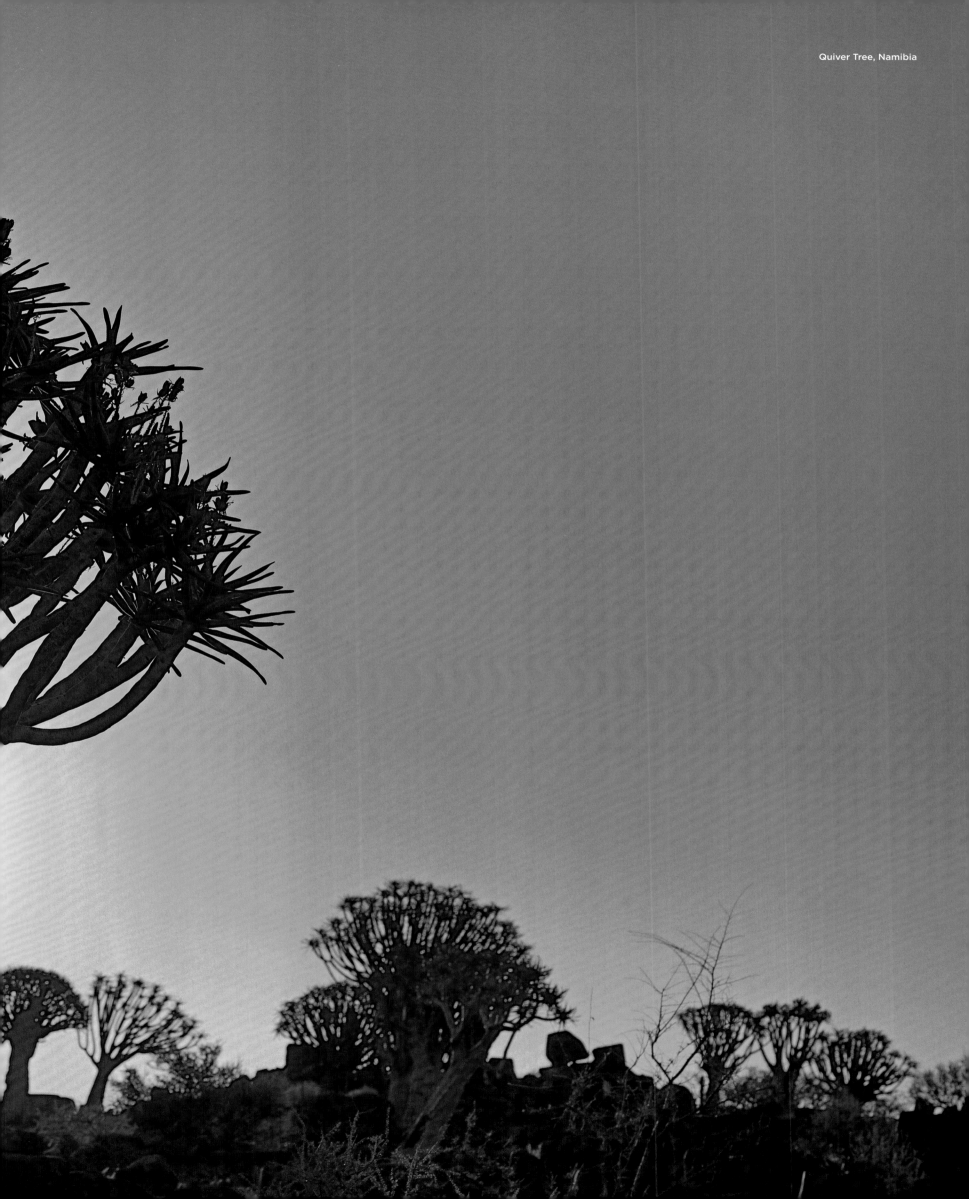

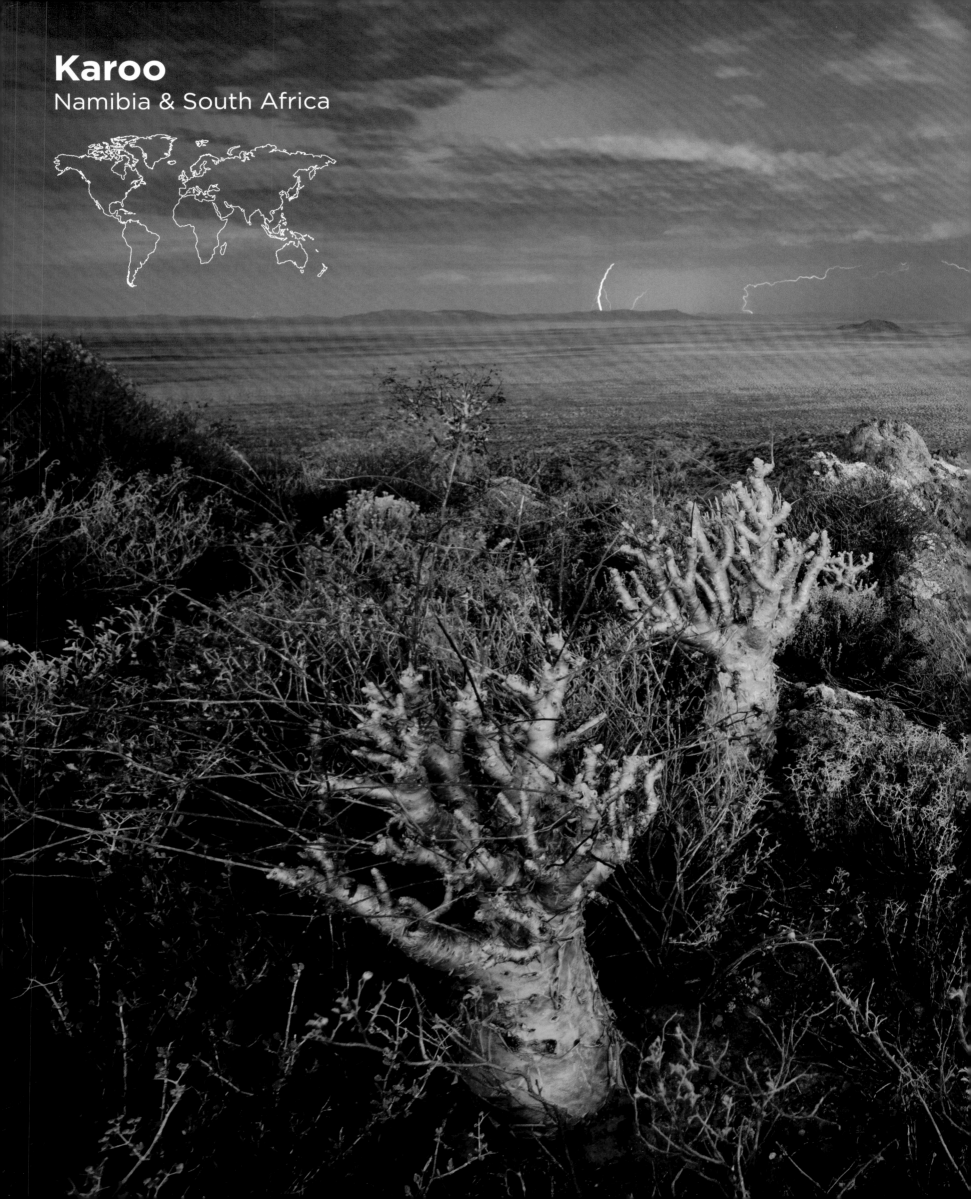

Karoo
Namibia & South Africa

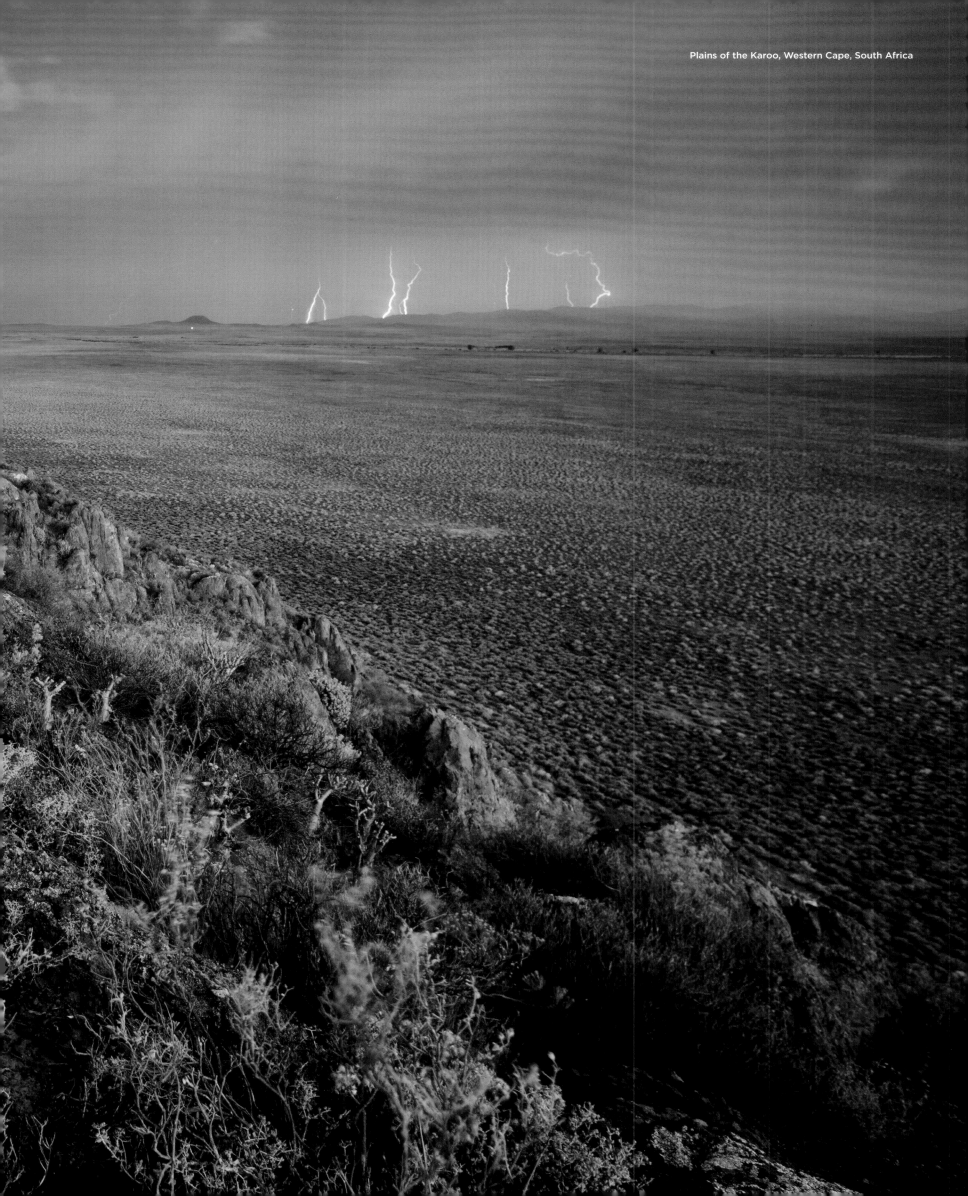

Plains of the Karoo, Western Cape, South Africa

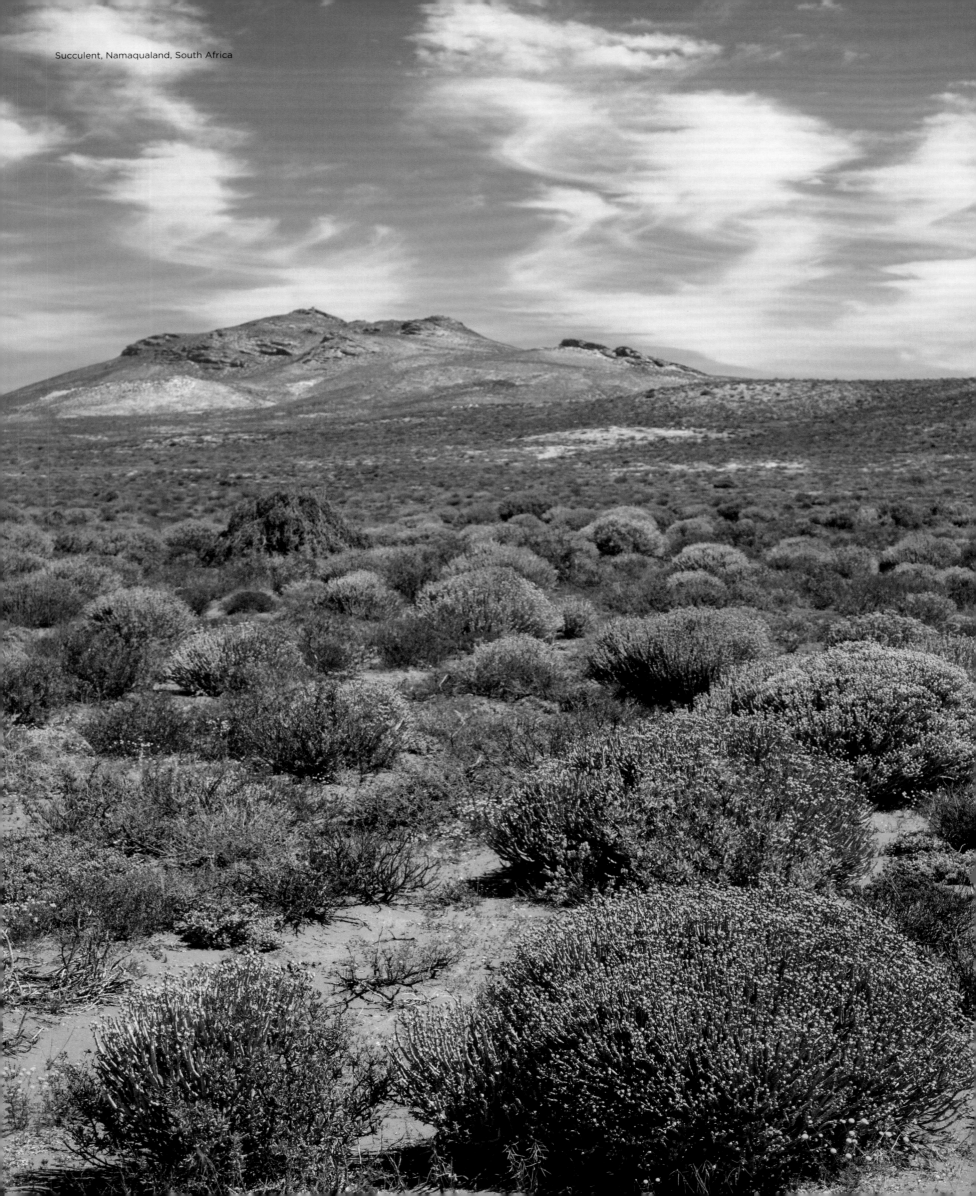

Succulent, Namaqualand, South Africa

Little Karoo, South Africa

Karoo

The Karoo spans the transition zone between the Kalahari Desert in the north and South Africa's coastal hinterland. In the 17th. century, the Karoo prevented settlers expanding white settlement from Cape Town. In modern times sudden rainfall episodes produce vast plains filled with wildflowers, while springbok, zebra and leopard all live here. ·

Karoo

Le Karoo couvre la zone de transition entre le désert du Kalahari au nord et l'arrière-pays côtier d'Afrique du Sud. Au cours du XVIIᵉ siècle, le Karoo a empêché les colons d'étendre la colonisation blanche depuis Le Cap. De nos jours, de brusques épisodes de pluie donnent naissance à une multitude de fleurs sauvages dans de vastes plaines, où vivent des springboks, des zèbres et des léopards.

Karoo

Die Karoo erstreckt sich über die Übergangszone zwischen der Kalahari-Wüste im Norden und dem Küstenhinterland Südafrikas. Im 17. Jahrhundert hinderte die Karoo Siedler daran, das weiße Siedlungsgebiet von Kapstadt aus zu erweitern. In der heutigen Zeit führen plötzliche Regenfälle zu einer Wildblumenblüte auf den weiten Ebenen, in denen Spießböck, Zebras und Leoparden leben.

Karoo

El Karoo abarca la zona de transición entre el desierto de Kalahari, en el norte, y el interior de la costa sudafricana. En el siglo XVII, los Karoo impidieron que los colonos expandieran los asentamientos blancos de Ciudad del Cabo. En los tiempos modernos, los episodios repentinos de lluvias producen vastas llanuras llenas de flores silvestres, mientras que aquí viven la gacela saltarina, la cebra y el leopardo.

Karoo

O Karoo abrange a zona de transição entre o deserto de Kalahari, no norte, e o interior do litoral da África do Sul. No século XVII, o Karoo impediu que os colonos expandissem os assentamentos brancos da Cidade do Cabo. Nos tempos modernos, os episódios repentinos de chuvas produzem vastas planícies repletas de flores silvestres, enquanto o springbok, a zebra e o leopardo vivem todos aqui.

Karoo

De Karoo strekt zich uit van de overgangszone tussen de Kalahariwoestijn in het noorden en het achterland van Zuid-Afrika. In de 17e eeuw verhinderde de Karoo de kolonisten de blanke nederzetting van Kaapstad uit te breiden. Tegenwoordig leveren plotselinge regenbuien uitgestrekte vlaktes vol wilde bloemen op, terwijl springbokken, zebra's en luipaarden hier allemaal leven.

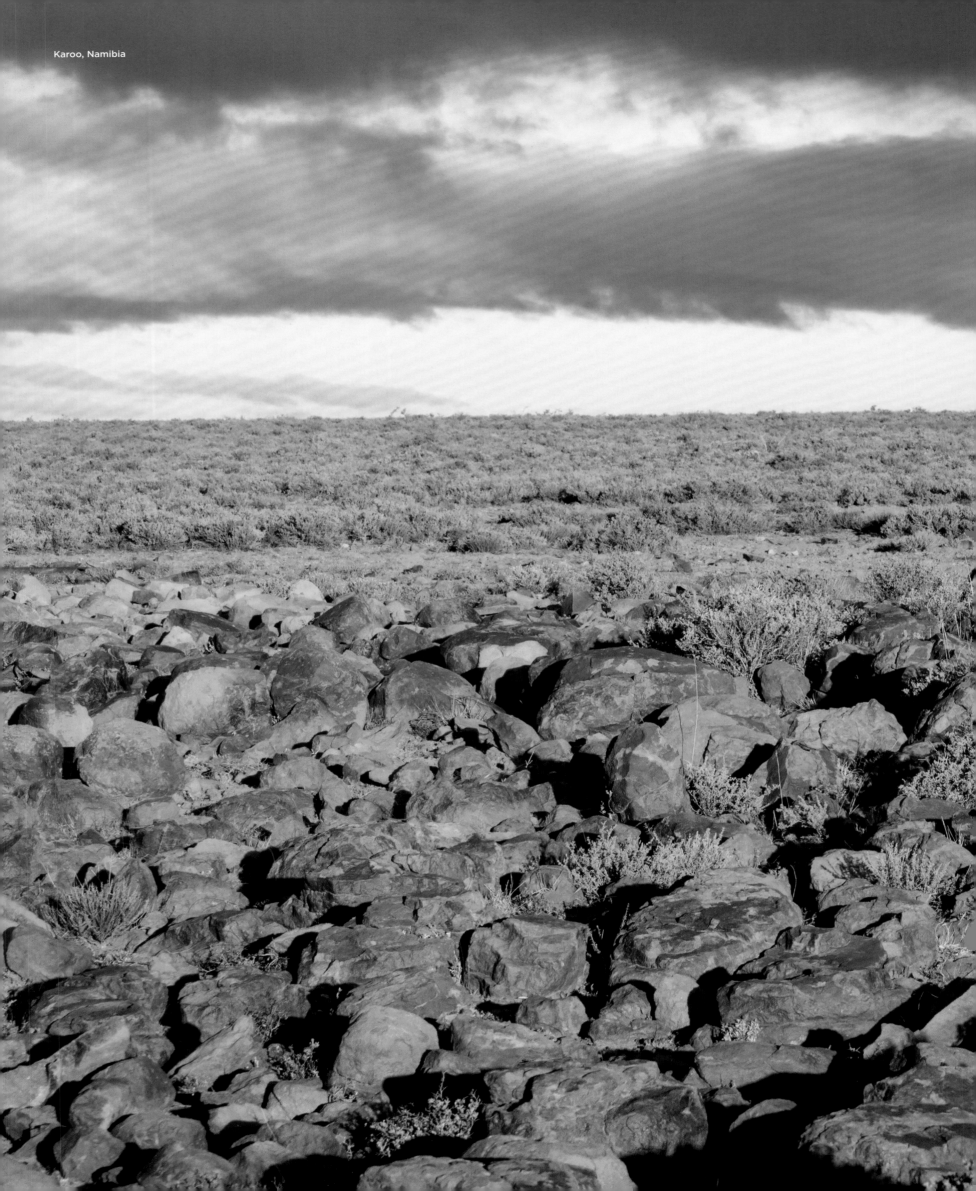

Karoo, Namibia

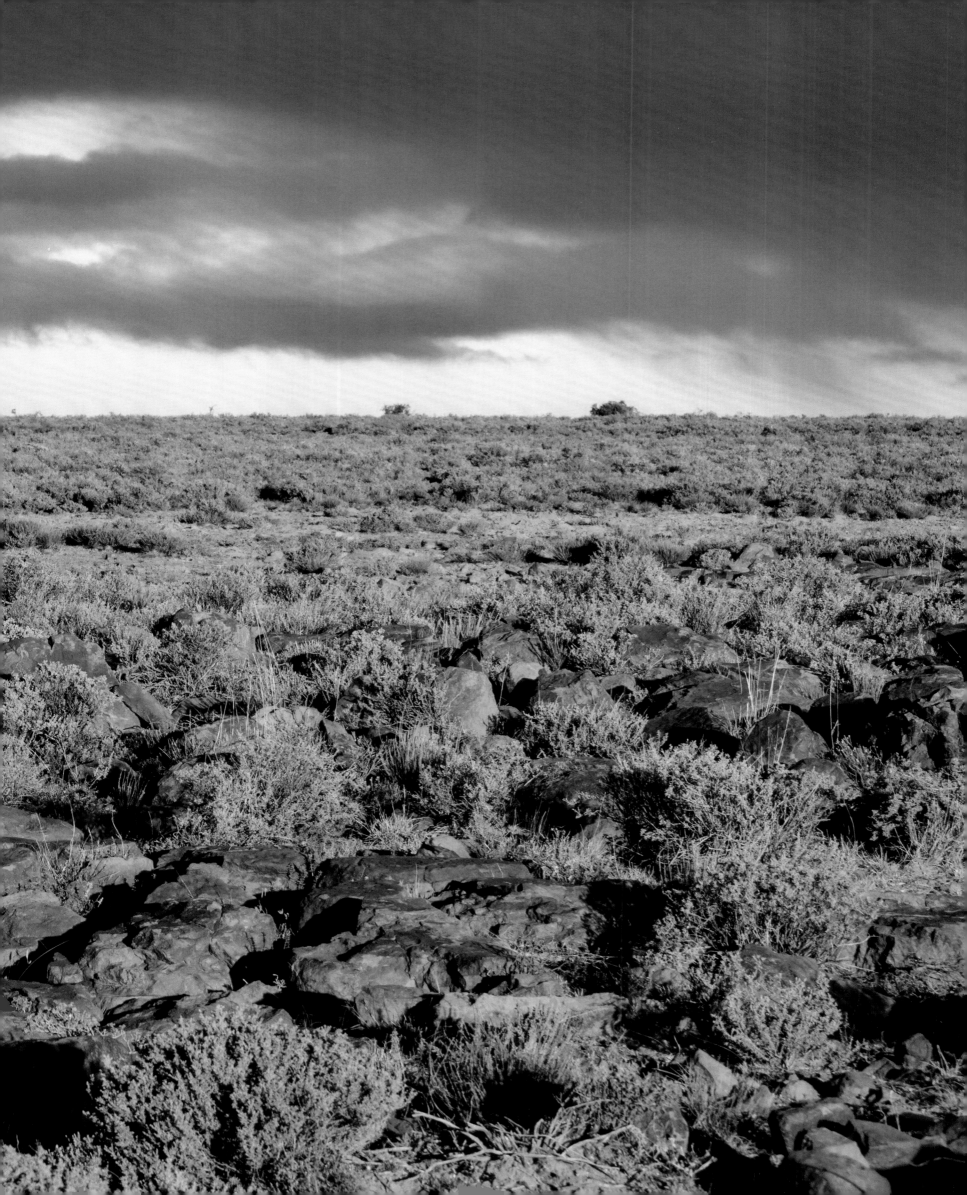

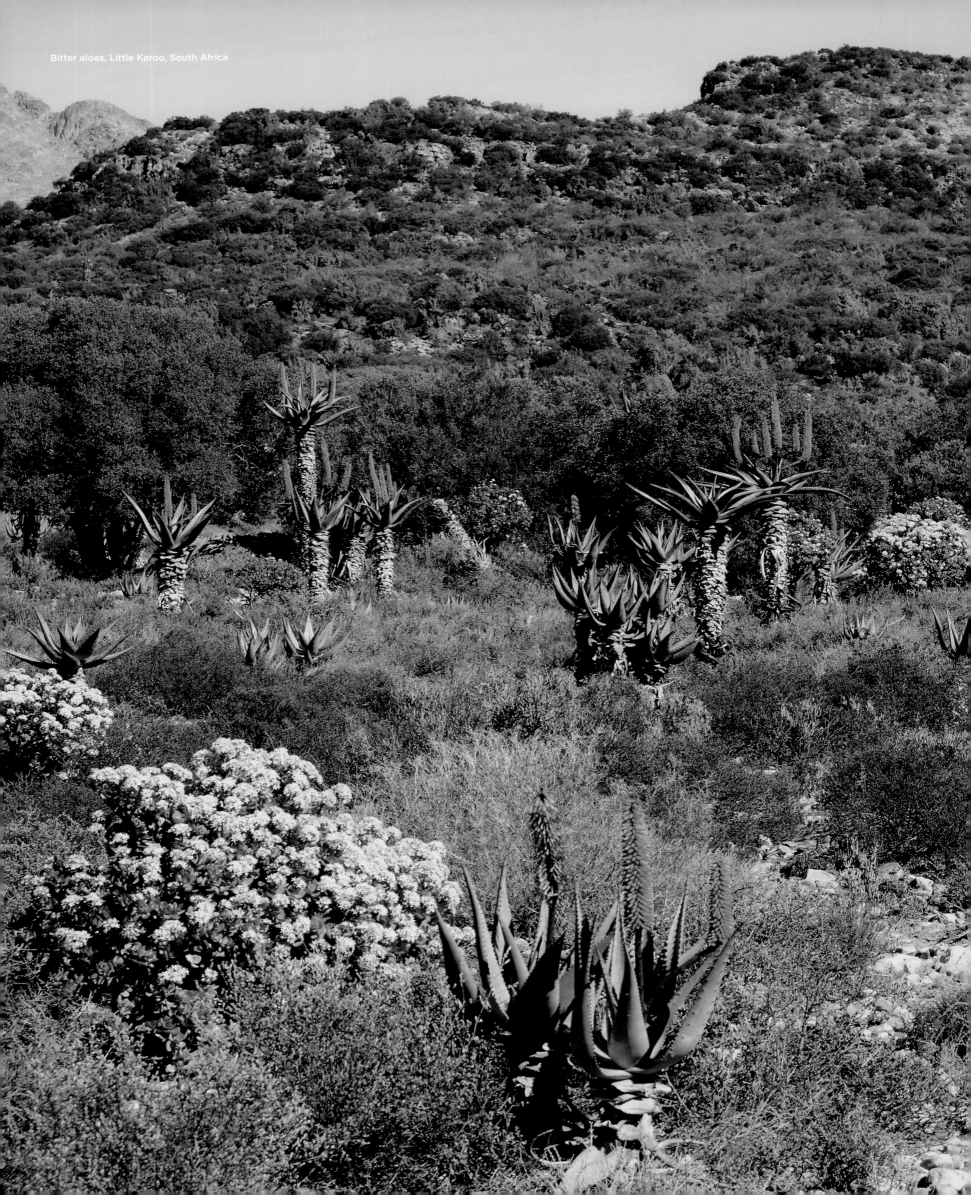

Bitter aloes, Little Karoo, South Africa

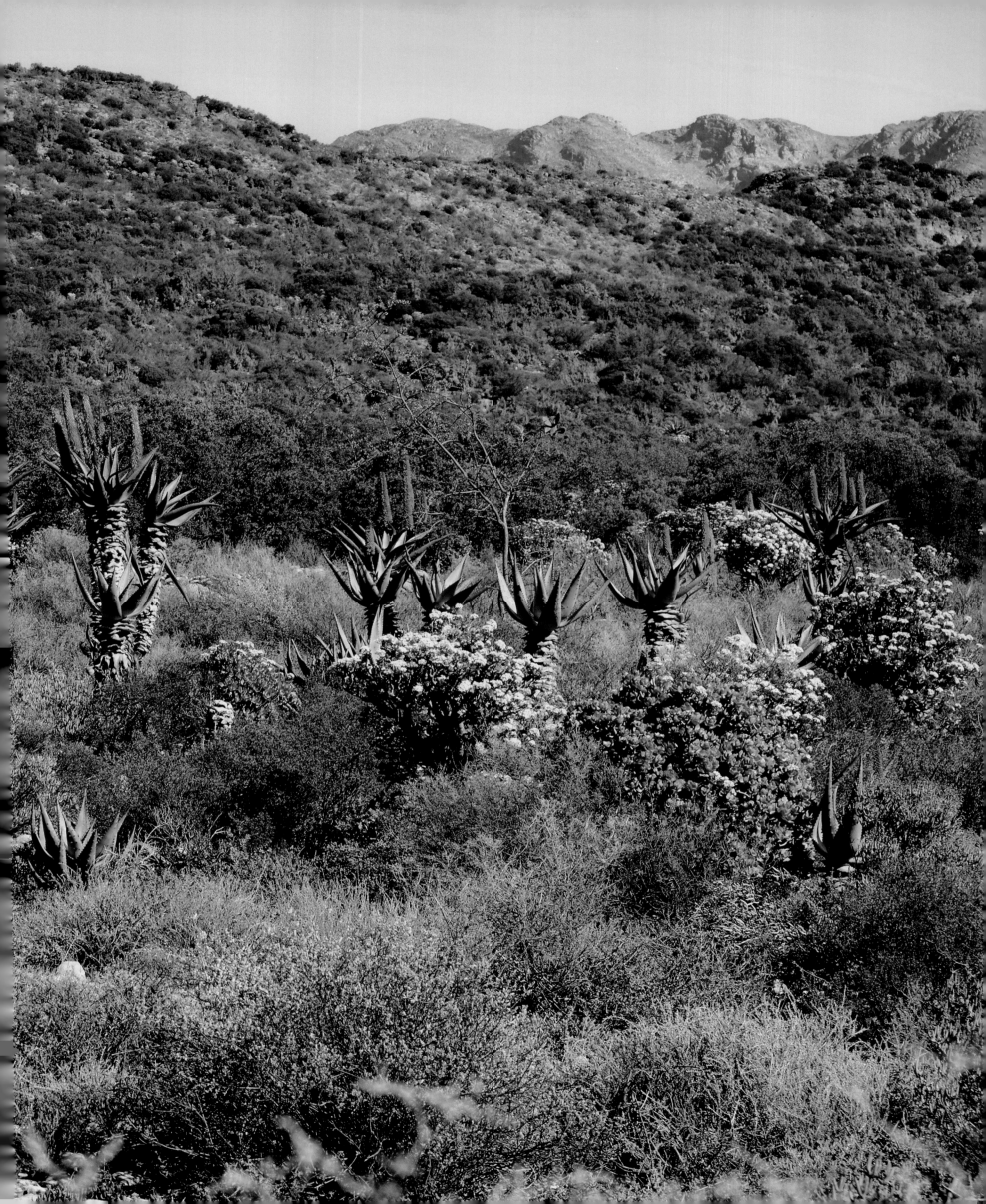

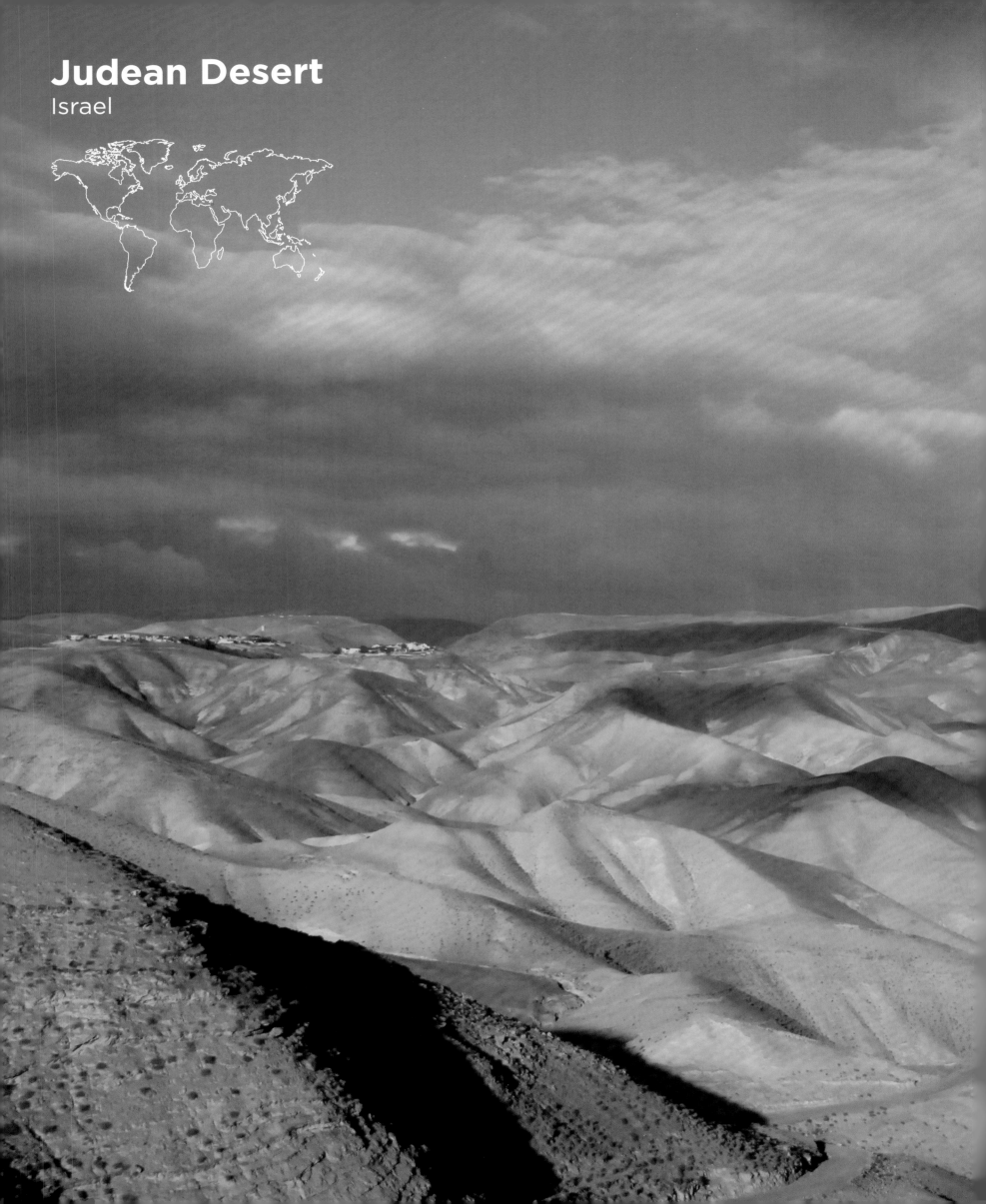

Judean Desert

Israel

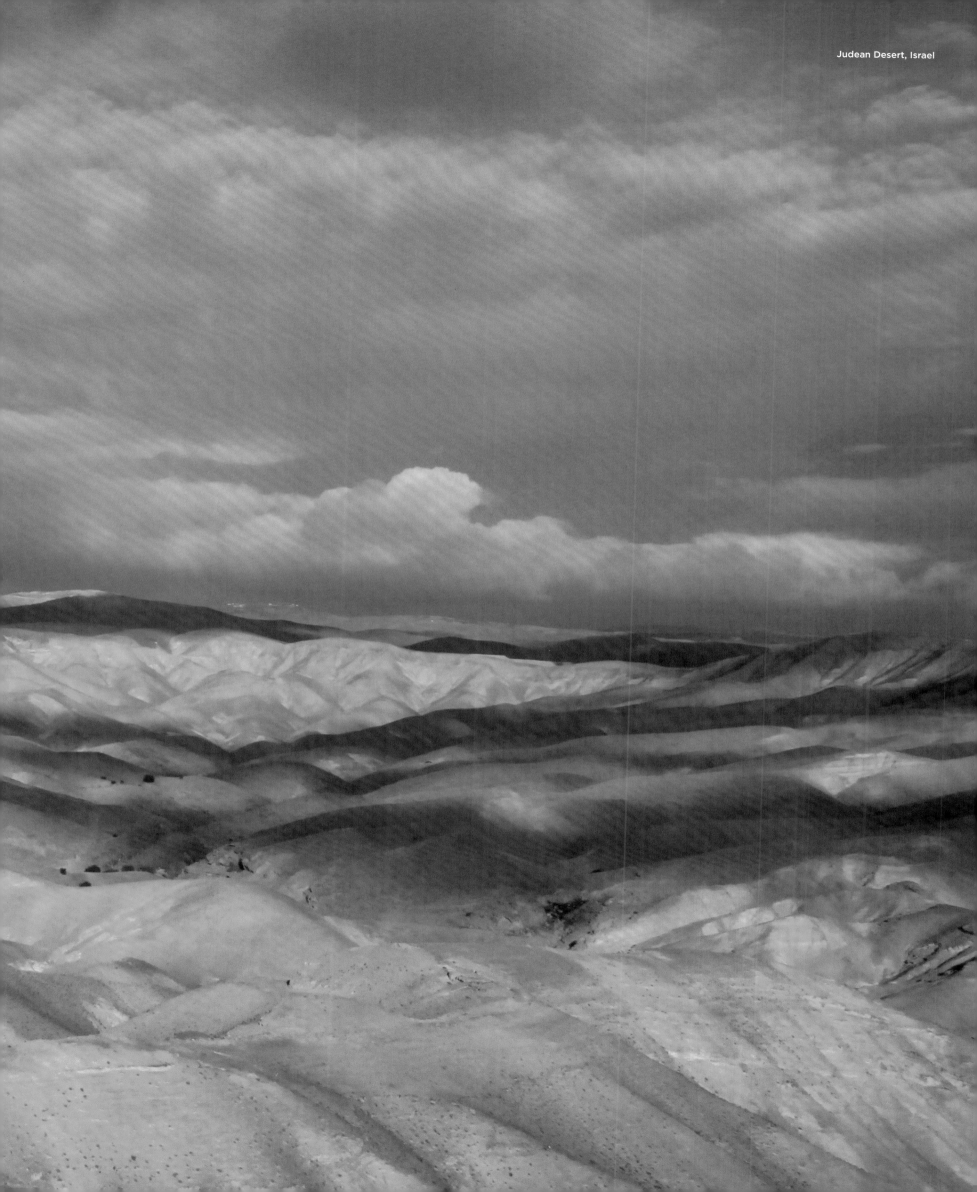

Judean Desert, Israel

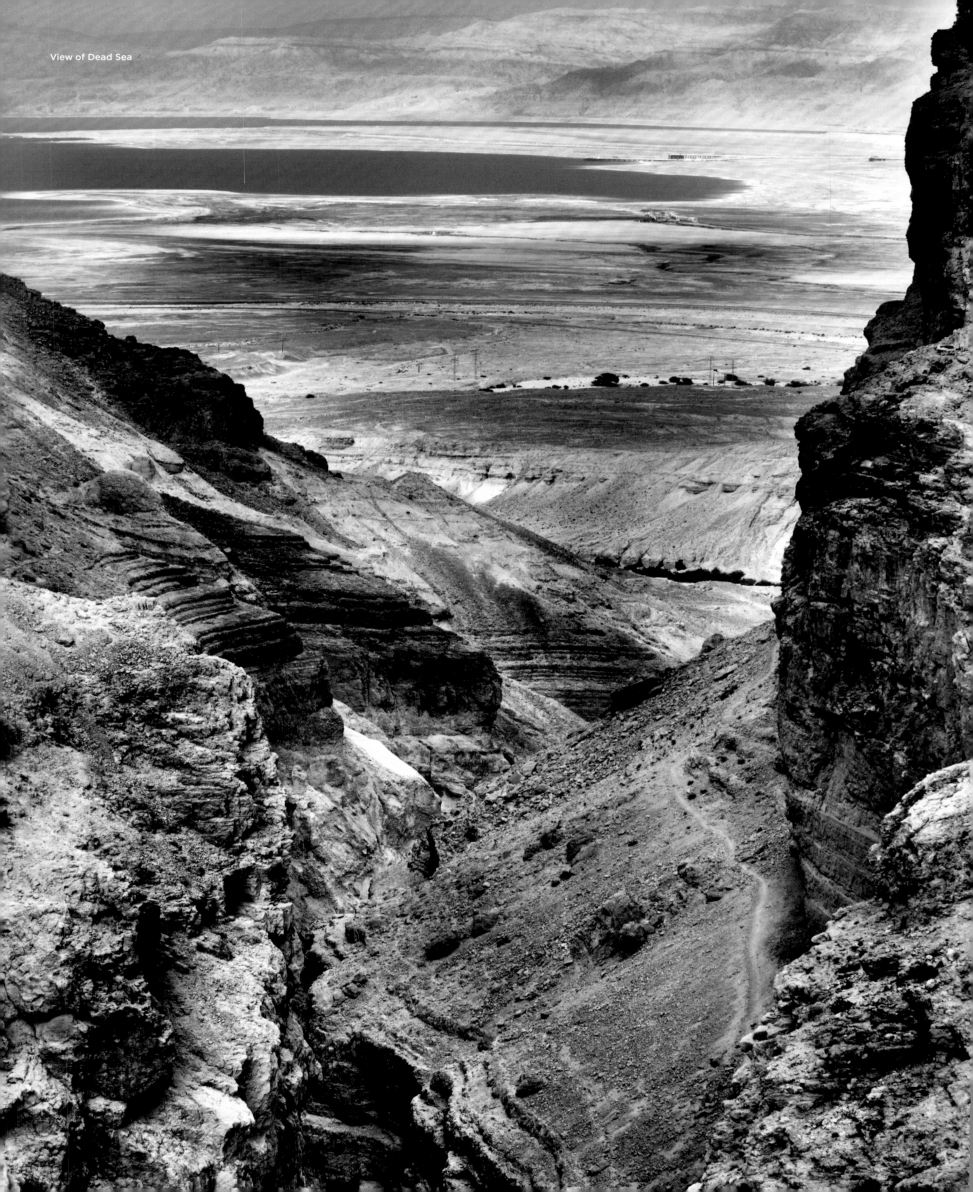

View of Dead Sea

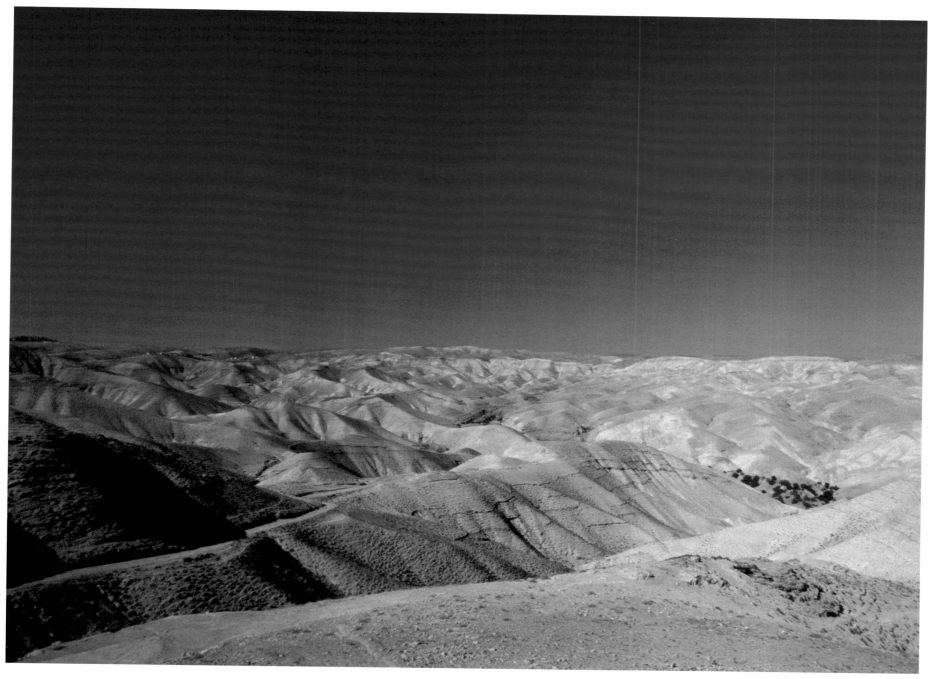

Judean Desert

Judean Desert

The Judean Desert traverses both Israel and the West Bank, beginning west of Jerusalem before dropping steeply down to the Dead Sea in a series of canyons or escarpments. Unlike most deserts, it consists primarily of terraces and barren hills. Beneath it lies one of Israel's largest underground aquifers, a potential source of water in the future.

Désert de Judée

Commençant à l'ouest de Jérusalem avant de descendre en pente raide jusqu'à la mer Morte via une série de canyons et d'escarpements, le désert de Judée traverse Israël et la Cisjordanie. À la différence de la plupart des déserts, il se constitue essentiellement de terrasses et de collines arides. L'un des plus grands aquifères d'Israël s'étend en dessous, une future source d'eau potentielle.

Judäische Wüste

Die Judäische Wüste zieht sich durch Israel und das Westjordanland. Sie beginnt westlich von Jerusalem, bevor sie in einer Reihe von Canyons und Steilhängen steil zum Toten Meer hin abfällt. Im Gegensatz zu den meisten Wüsten besteht sie hauptsächlich aus Terrassen und kargen Hügeln. Darunter befindet sich einer der größten unterirdischen Grundwasserleiter Israels, eine potenzielle Wasserquelle der Zukunft.

Desierto de Judea

El Desierto de Judea atraviesa tanto Israel como Cisjordania, comenzando al oeste de Jerusalén antes de descender abruptamente hasta el Mar Muerto en una serie de cañones o escarpaduras. A diferencia de la mayoría de los desiertos, se compone principalmente de terrazas y colinas estériles. Debajo se encuentra uno de los acuíferos subterráneos más grandes de Israel, una fuente potencial de agua en el futuro.

Deserto da Judeia

O deserto da Judeia atravessa Israel e a Cisjordânia, começando a oeste de Jerusalém antes de descer abruptamente até o Mar Morto, em uma série de canyons ou escarpas. Ao contrário da maioria dos desertos, consiste principalmente em terraços e colinas estéreis. Abaixo dele, encontra-se um dos maiores aquíferos subterrâneos de Israel, uma fonte potencial de água no futuro.

Woestijn van Judea

De woestijn van Judea loopt door Israël en de Westelijke Jordaanoever. Hij begint ten westen van Jeruzalem en daalt dan in een reeks ravijnen en steile hellingen steil af naar de Dode Zee. Anders dan de meeste woestijnen bestaat hij voornamelijk uit terrassen en kale heuvels. Daaronder ligt een van Israëls grootste waterhoudende grondlagen, een toekomstige potentiële bron van water.

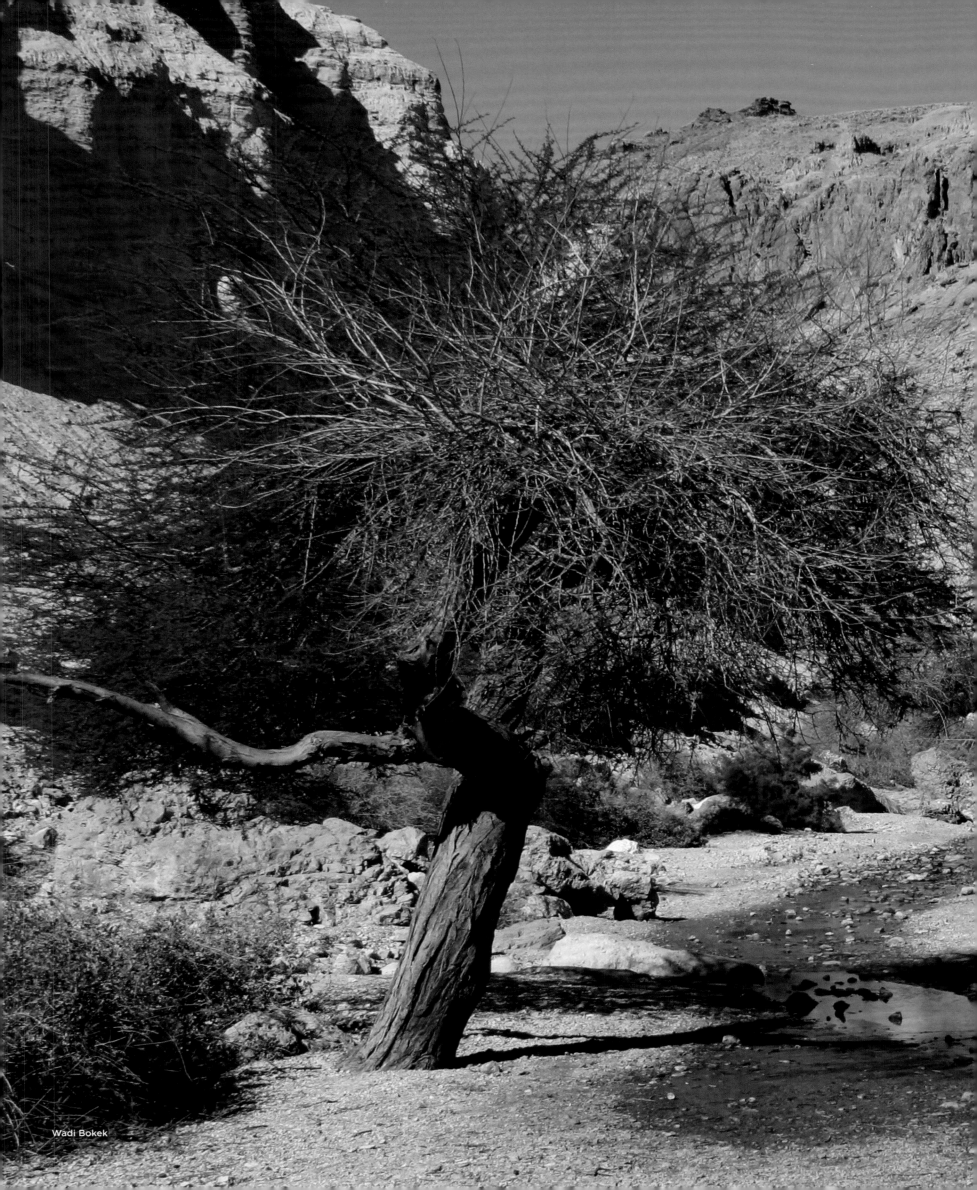

Wadi Bokek

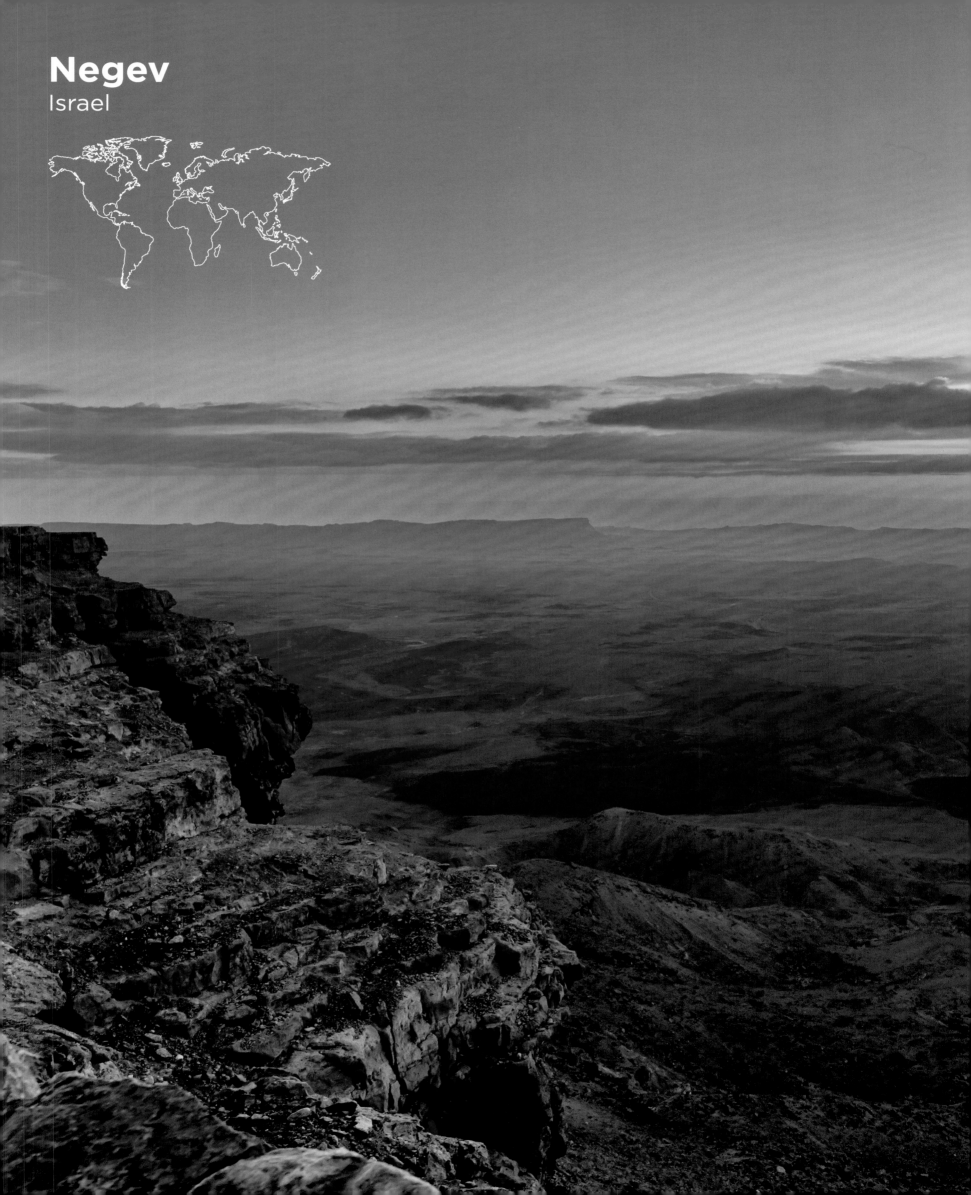

Negev
Israel

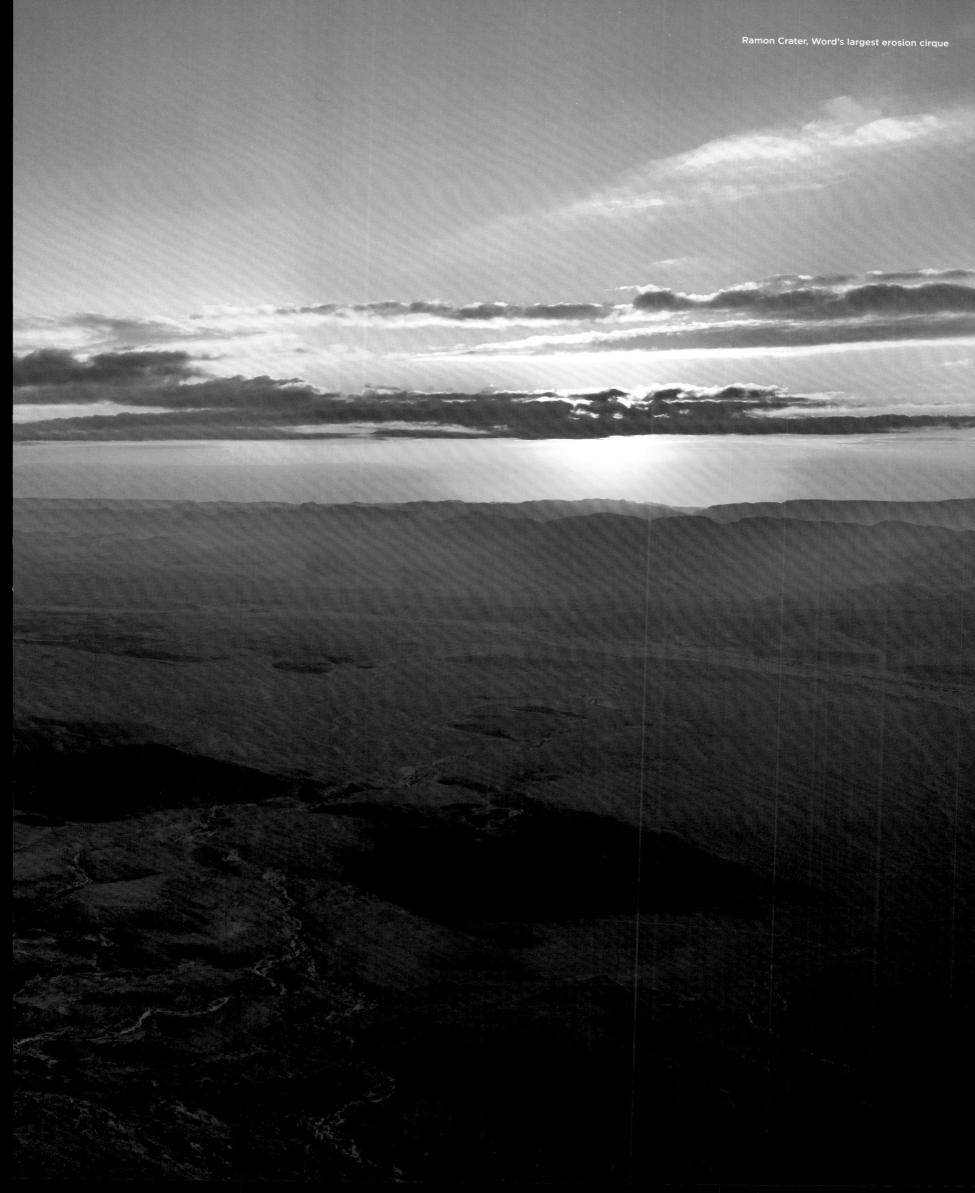

Ramon Crater, Word's largest erosion cirque

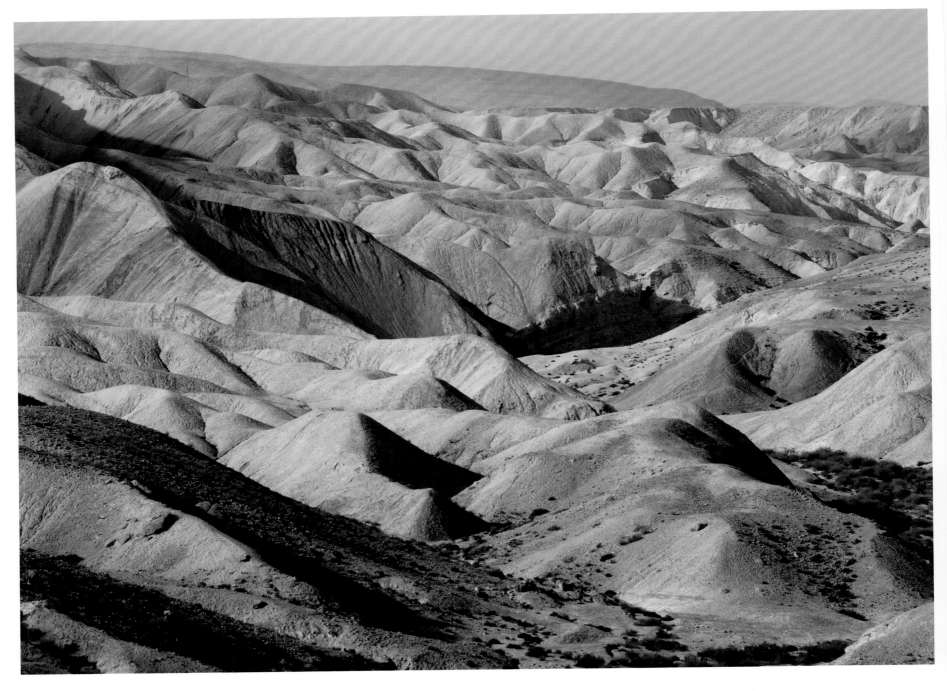

Ein Avdat Canyon

Negev

Israel's largest desert occupies the country's southern
half, ending at the Gulf of Aqaba. It is a traditional
homeland of the Bedouins, and is now home to a
number of cities, among them Beersheba and Eilat.
The desert's name comes from the Hebrew root for
'dry' while Negev in the Bible is often a synonym for
south; in Arabic, the name for the desert is al-Naqab,
which means 'the mountain pass'. The Negev's
defining characteristics are rocky plains and hills,
craters, the unusual *makhteshim* (box canyons) and,
in places, sand dunes.

Néguev

Le plus grand désert d'Israël occupe la moitié sud du
pays jusqu'au golfe d'Aqaba. C'est la terre ancestrale
traditionnelle des Bédouins, et aujourd'hui la zone
d'implantation d'un grand nombre de villes, parmi
lesquelles Bersabée et Eilat. Le désert doit son nom
à une racine hébraïque signifiant « sec » tandis que le
Néguev de la Bible est souvent un synonyme de Sud ;
en arabe, le désert se dit al-Naqab, et se traduit par «
col de montagne ». Des plaines et des collines
rocailleuses, des cratères, d'inhabituels *makhteshim*
(canyons en cul-de-sac) et, à certains endroits, des
dunes, caractérisent le Néguev. C'est également
là que se développent les palmiers les plus
septentrionaux de la planète, les doums, et des
tortues du Néguev, menacées d'extinction.

Negev

Die größte Wüste Israels nimmt die südliche Hälfte
des Landes ein und endet am Golf von Akaba. Sie ist
die Heimat der Beduinen und beherbergt heute einige
Städte, darunter Beersheba und Eilat. Der Name der
Wüste kommt von der hebräischen Wortwurzel für
„trocken", während in der Bibel Negev oft ein
Synonym für Süden ist. Im Arabischen ist der Name
für die Wüste al-Naqab, was „der Bergpass" bedeutet.
Die charakteristischen Merkmale der Negev sind
felsige Ebenen und Hügel, Krater, die ungewöhnlichen
Machteschs (Kasten-Canyons) und auch Sanddünen.

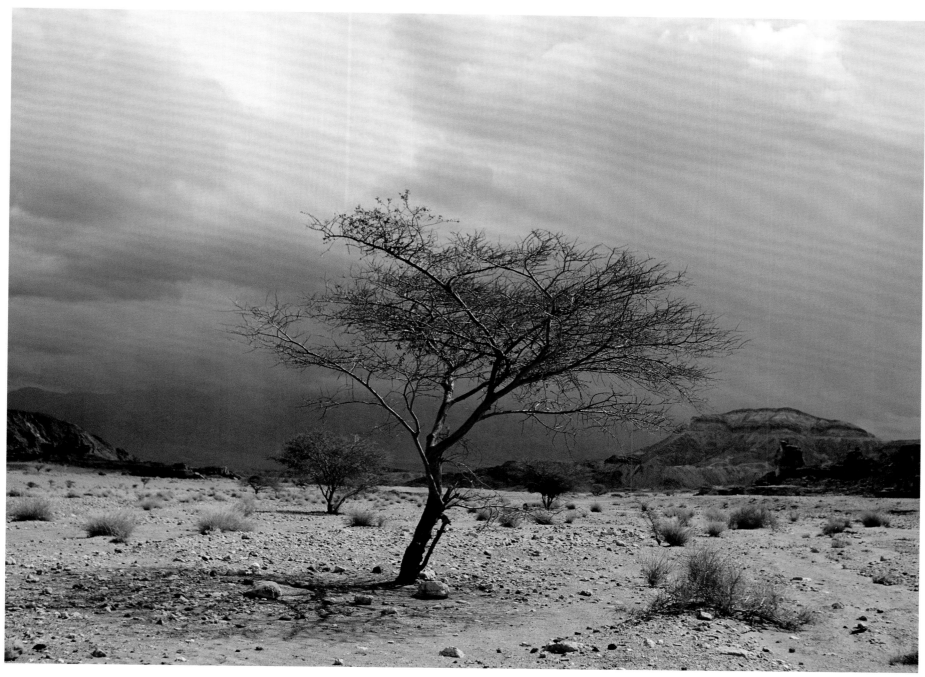

Negev Desert

Néguev

El desierto más grande de Israel ocupa la mitad sur del país y termina en el Golfo de Áqaba. Es una patria tradicional de los beduinos y en la actualidad alberga varias ciudades, entre ellas Beersheba y Eilat.
El nombre del desierto proviene de la raíz hebrea de «seco», mientras que Negev en la Biblia es a menudo sinónimo de sur; en árabe, el nombre del desierto es al-Naqab, que significa «el paso de la montaña». Las características que definen el Néguev son las llanuras rocosas y las colinas, los cráteres, el inusual *makhteshim* (cañones de caja) y, en algunos lugares, las dunas de arena.

Negev

O maior deserto de Israel ocupa a metade sul do país, terminando no Golfo de Aqaba. É uma terra natal tradicional dos beduínos, e é agora o lar de várias cidades, entre elas Beersheba e Eilat. O nome do deserto vem da raiz hebraica para "seco", enquanto Negev na Bíblia é muitas vezes um sinônimo para o sul; em árabe, o nome do deserto é al-Naqab, que significa "a passagem da montanha". As características definidoras do Negev são planícies rochosas e colinas, crateras, os *makhteshim* incomuns (desfiladeiros de caixa) e, em alguns lugares, dunas de areia.

Negev

De grootste woestijn van Israël beslaat de zuidelijke helft van het land en eindigt aan de Golf van Akaba. Het is een traditioneel thuisland van bedoeïenen en bezit een aantal steden, waaronder Beër Sjeva en Eilat. Zijn naam heeft de woestijn van de Hebreeuwse wortel voor 'droog', terwijl Negev in de Bijbel vaak synoniem is voor het zuiden. In het Arabisch heet de woestijn al-Naqab, 'de bergpas'. De Negev wordt gekenmerkt door rotsachtige vlaktes en heuvels, kraters, de ongewone *machteshim* (kraters) en hier en daar zandduinen.

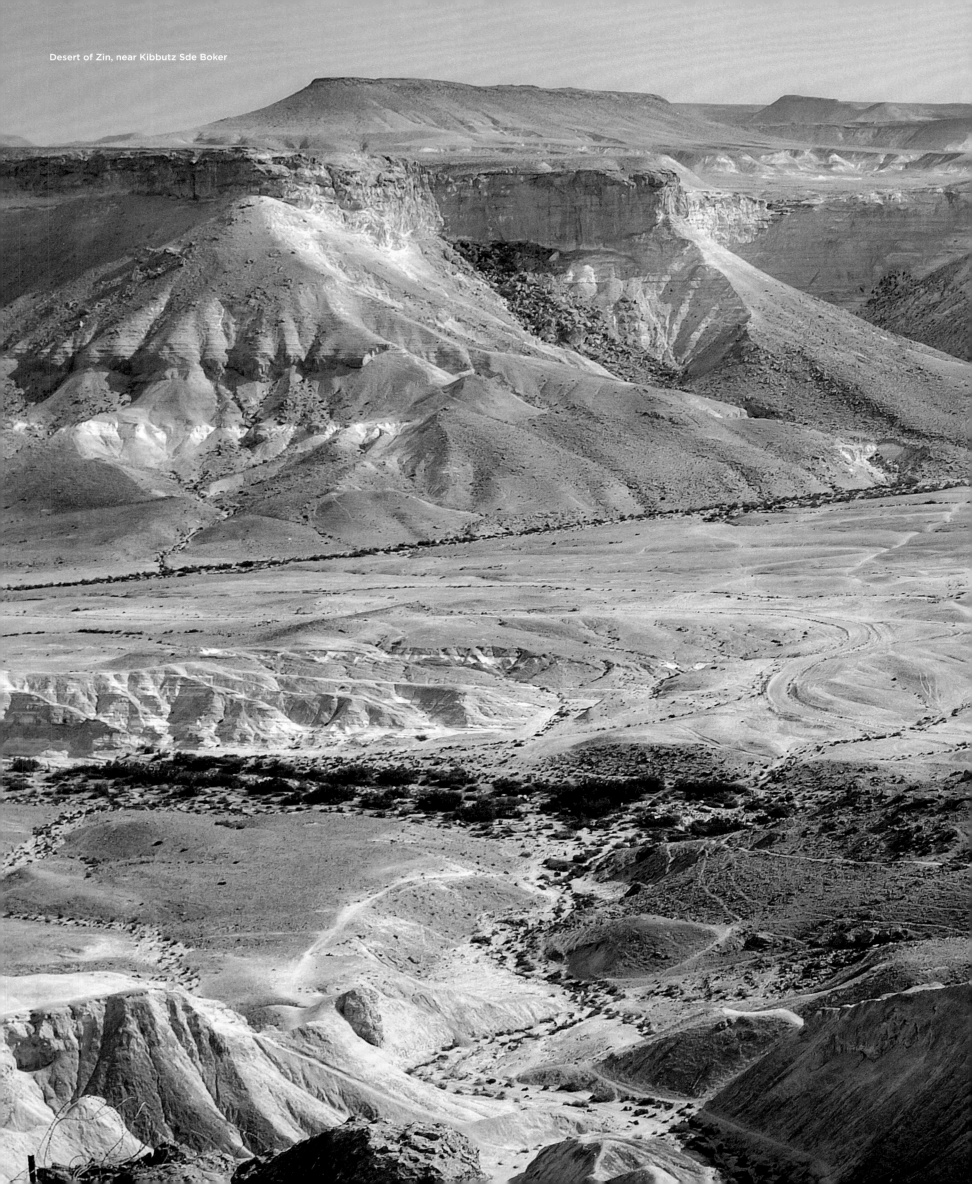

Desert of Zin, near Kibbutz Sde Boker

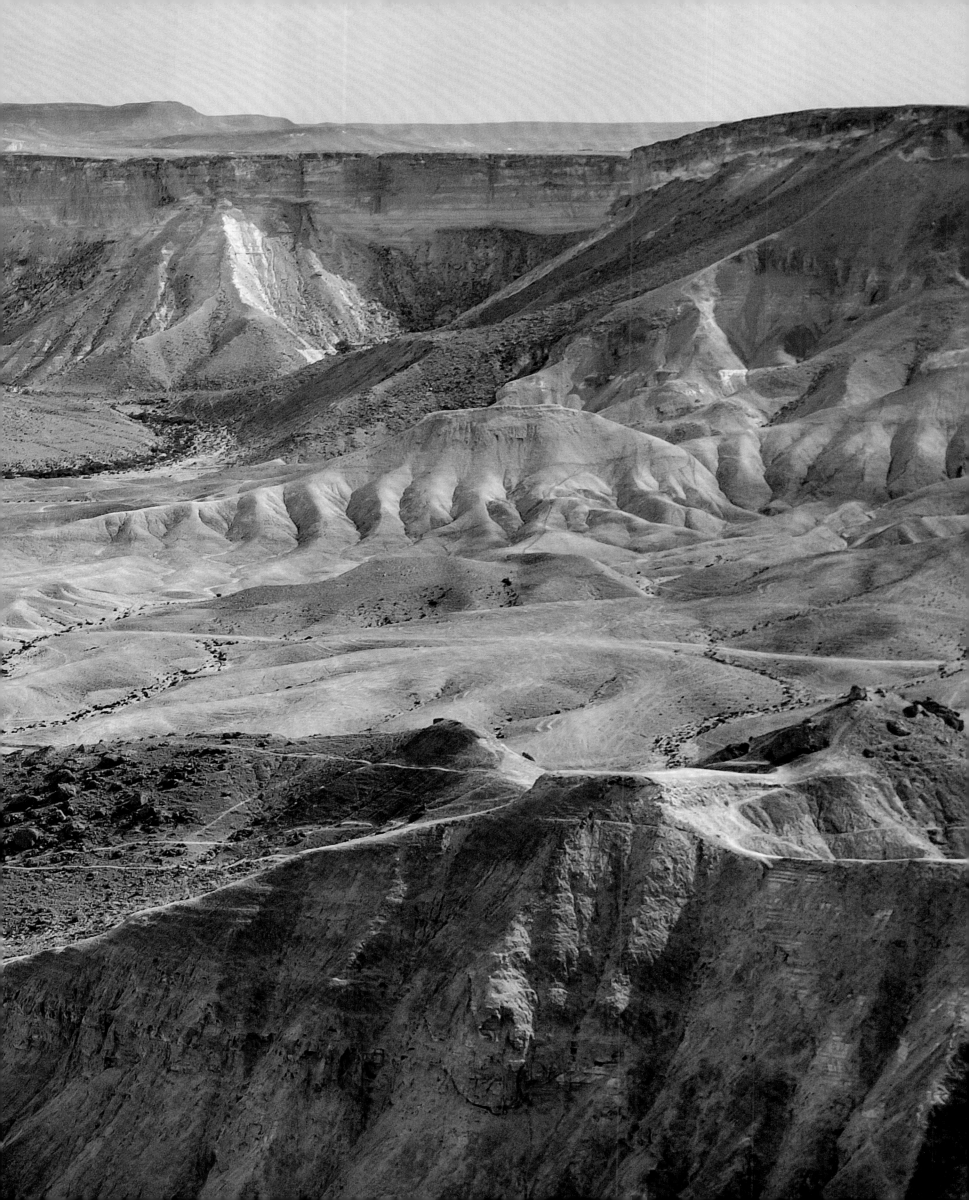

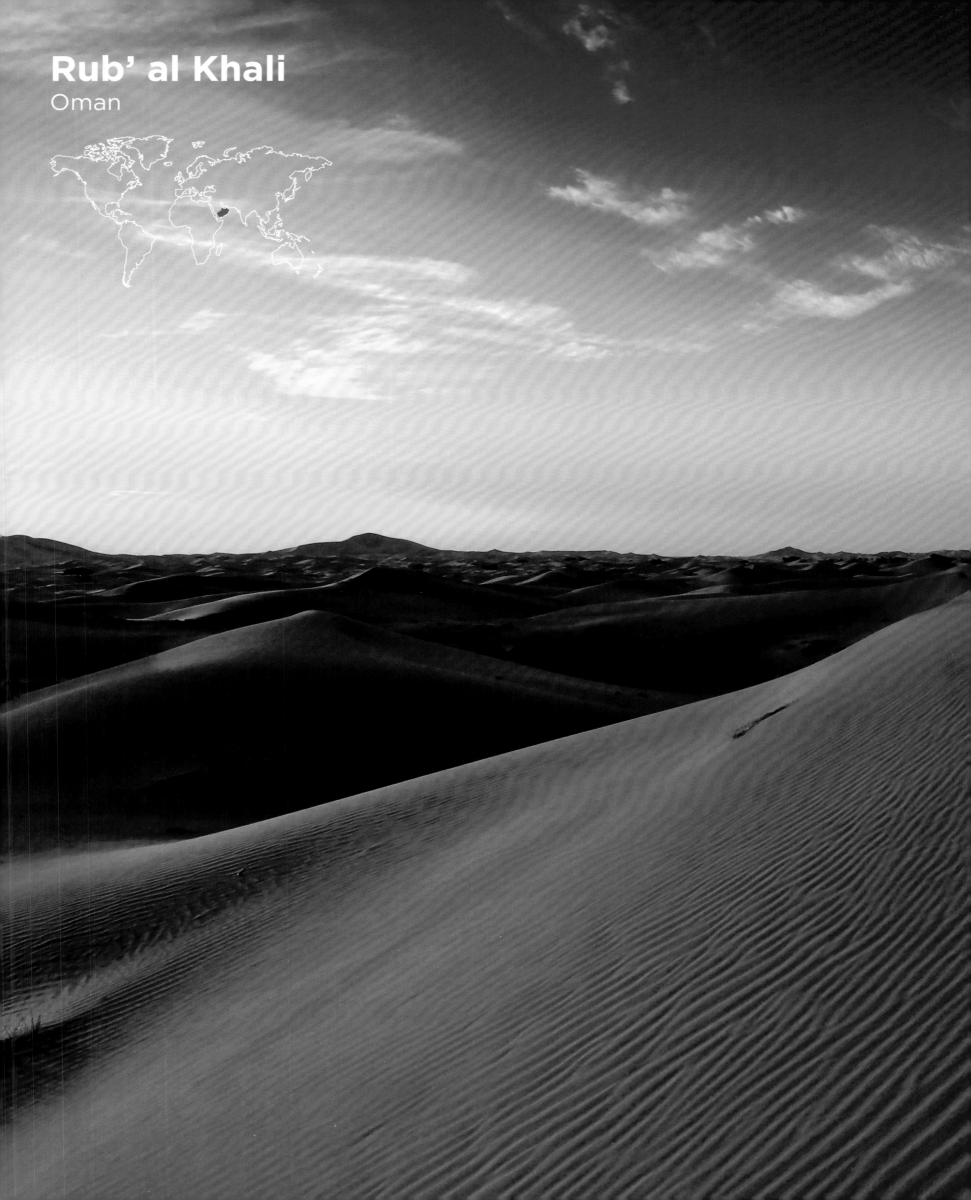

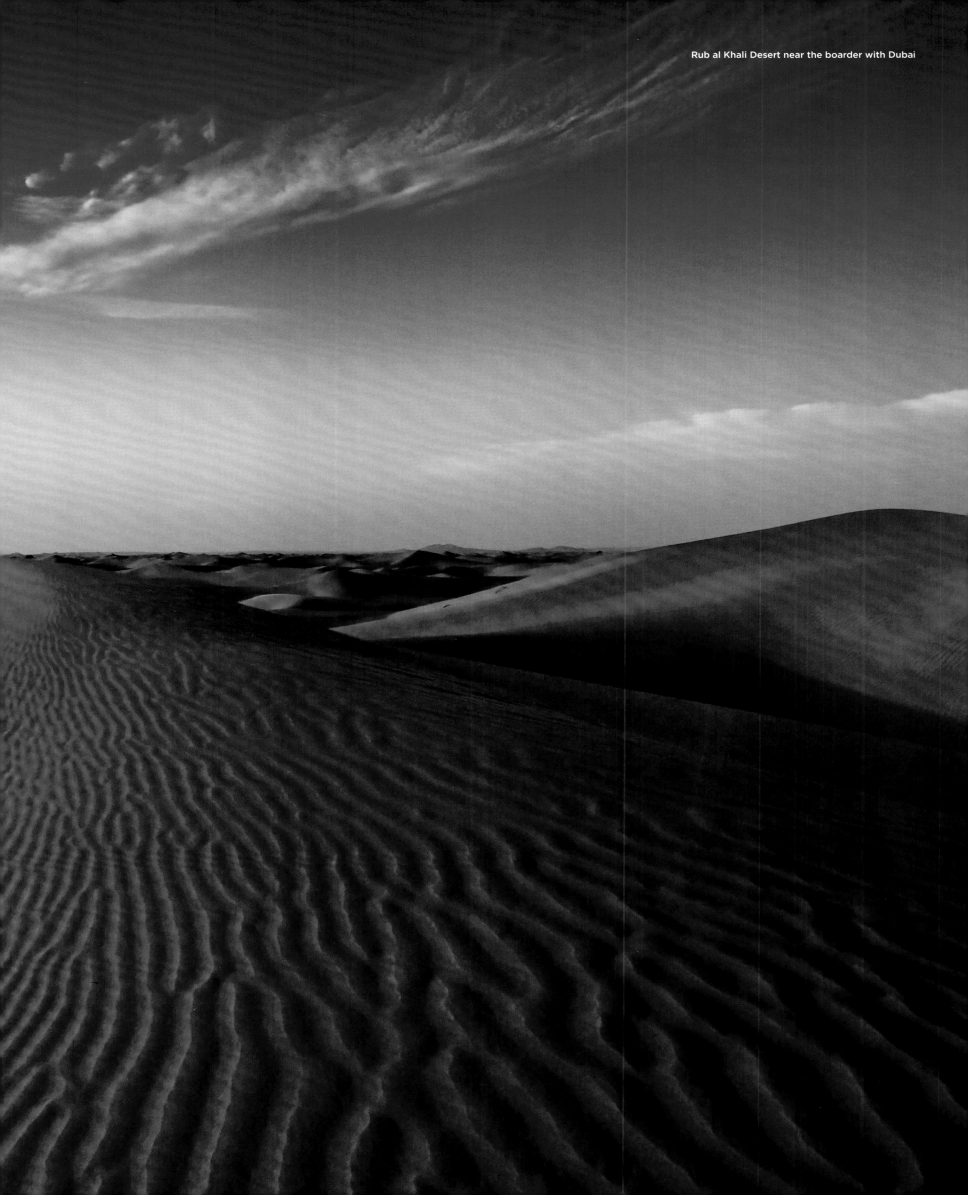

Rub al Khali Desert near the boarder with Dubai

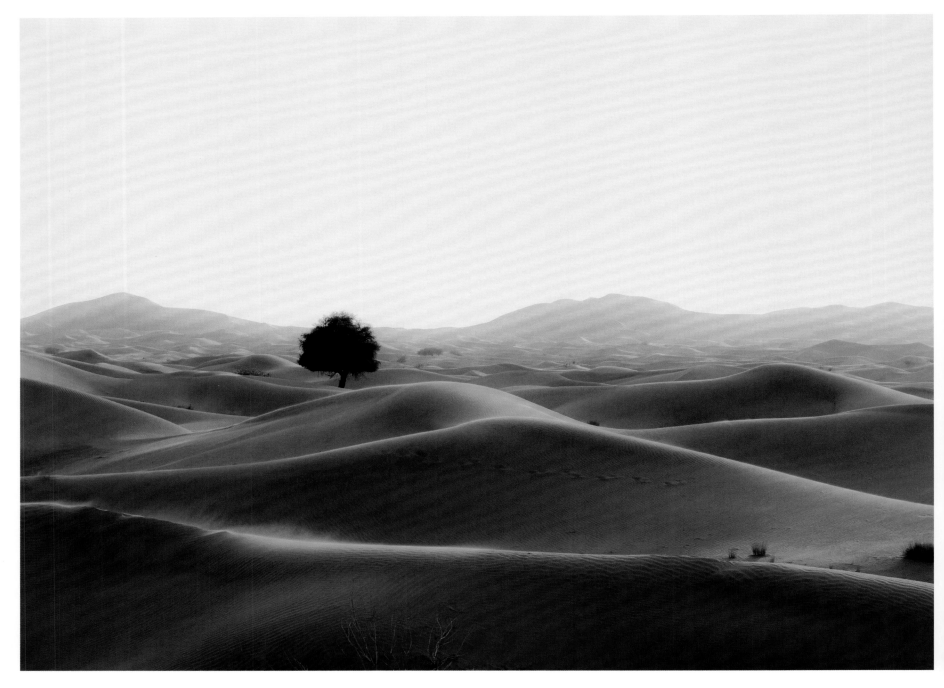

Rub Al Khali Desert near the boarder with Dubai

Rub al-Khali

The vast Rub al-Khali (the Empty Quarter, the Abode of Silence) is the largest continuous stretch of sand in the world, covering 655 000 km², one-third of the Arabian Peninsula and an area larger than France. Immortalised by explorer Wilfred Thesiger in his classic of desert exploration, *Arabian Sands,* the Rub al-Khali is known for its sand dunes, some of which rise 300 m high and can move 30 m in a year, and gravel plains that underlie the sand. The realm of Bedouin nomads, the desert is home to iconic species such as the Arabian wolf, sand cat and the reintroduced Arabian oryx.

Rub al-Khali

Couvrant 655 000 km², un tiers de la péninsule arabique et une zone plus vaste que la France, l'immense Rub al-Khali (surnommé le « Quart Vide » ou « Demeure du Silence ») est la plus grande étendue continue de sable du monde. Immortalisé par l'explorateur Wilfred Thesiger dans son étude classique du désert, *Le Désert des déserts,* le Rub al-Khali est connu pour ses dunes, qui peuvent atteindre trois cents mètres de haut et se déplacer de trente mètres par an, ainsi que pour ses plaines de graviers sous-tendant le sable. Domaine des nomades bédouins (qui l'appellent simplement « Les Sables »), ce désert est le foyer d'espèces iconiques telles que le loup d'Arabie, le chat des sables et l'oryx arabe réintroduit.

Rub al-Chali

Die riesige Rub al Chali (das Leere Viertel, der Ort der Stille) ist die größte zusammenhängende Sandfläche der Welt und umfasst 655 000 km², ein Drittel der Arabischen Halbinsel und eine Fläche, die größer ist als Frankreich. Der Forscher Wilfred Thesiger hat sie in seinem Klassiker der Wüstenreisebeschreibungen, *Arabian Sands,* verewigt. Die Rub al Chali ist bekannt für ihre Sanddünen – von denen einige 300 m hoch sind und sich bis zu 30 m im Jahr bewegen können – und die Kiesebenen, die unter dem Sand liegen. Die Wüste ist das Reich der nomadischen Beduinen und beherbergt ikonische Tierarten wie den arabischen Wolf, die Sandkatze und die wiedereingeführte Arabischen Oryx.

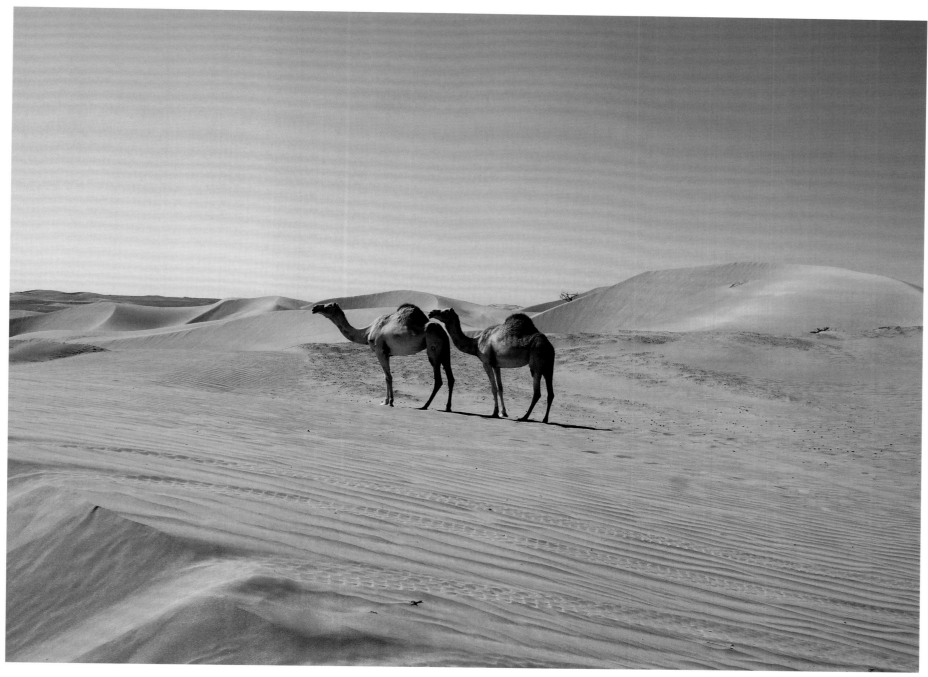

Road to Liwa Oasis

Rub al-Jali

El vasto Rub al-Jali (el cuartel vacío, la morada del silencio) es la mayor extensión continua de arena del mundo, con una superficie de 655 000 km², un tercio de la península arábiga y una superficie mayor que la de Francia. Inmortalizado por el explorador Wilfred Thesiger en su clásico de exploración del desierto, *Arabian Sands,* el Rub al-Jali es conocido por sus dunas de arena, algunas de las cuales se elevan a 300 metros de altura y pueden moverse 30 metros en un año, y por las planicies de grava que subyacen a la arena. El reino de los nómadas beduinos, el desierto es el hogar de especies icónicas como el lobo árabe, el gato de arena y el órice de Arabia reintroducido.

Rub al-Khali

O vasto Rub al-Khali (o Bairro Vazio, a Morada do Silêncio) é o maior trecho contínuo de areia do mundo, cobrindo 655 000 km², um terço da Península Arábica e uma área maior que a França. Imortalizado pelo explorador Wilfred Thesiger em seu clássico de exploração do deserto, *Arabian Sands,* o Rub al-Khali é conhecido por suas dunas de areia, algumas com 300 m de altura e 30 m por ano, e planícies de cascalho que sustentam a areia. O reino dos nômades beduínos, o deserto é o lar de espécies icônicas como o lobo árabe, o gato de areia e o órix árabe reintroduzido.

Rub al-Khali

De uitgestrekte Rub al-Khali ('het lege kwartier') is de grootste aaneengesloten zandvlakte ter wereld en beslaat met een oppervlak van 655 000 km² een derde van het Arabische schiereiland – een gebied dat groter is dan Frankrijk. De Rub al-Khali, die door ontdekkingsreiziger Wilfred Thesiger werd vereeuwigd in de klassieker van de woestijnreis-literatuur, *Arabian Sands,* staat de bekend om zijn zandduinen – waarvan sommige 300 meter hoog zijn en zich in een jaar 30 meter kunnen verplaatsen – en grindvlaktes die onder het zand liggen. De woestijn is het rijk van de bedoeïenen en herbergt iconische diersoorten zoals de Arabische wolf, de woestijnkat en de opnieuw geïntroduceerde Arabische oryx.

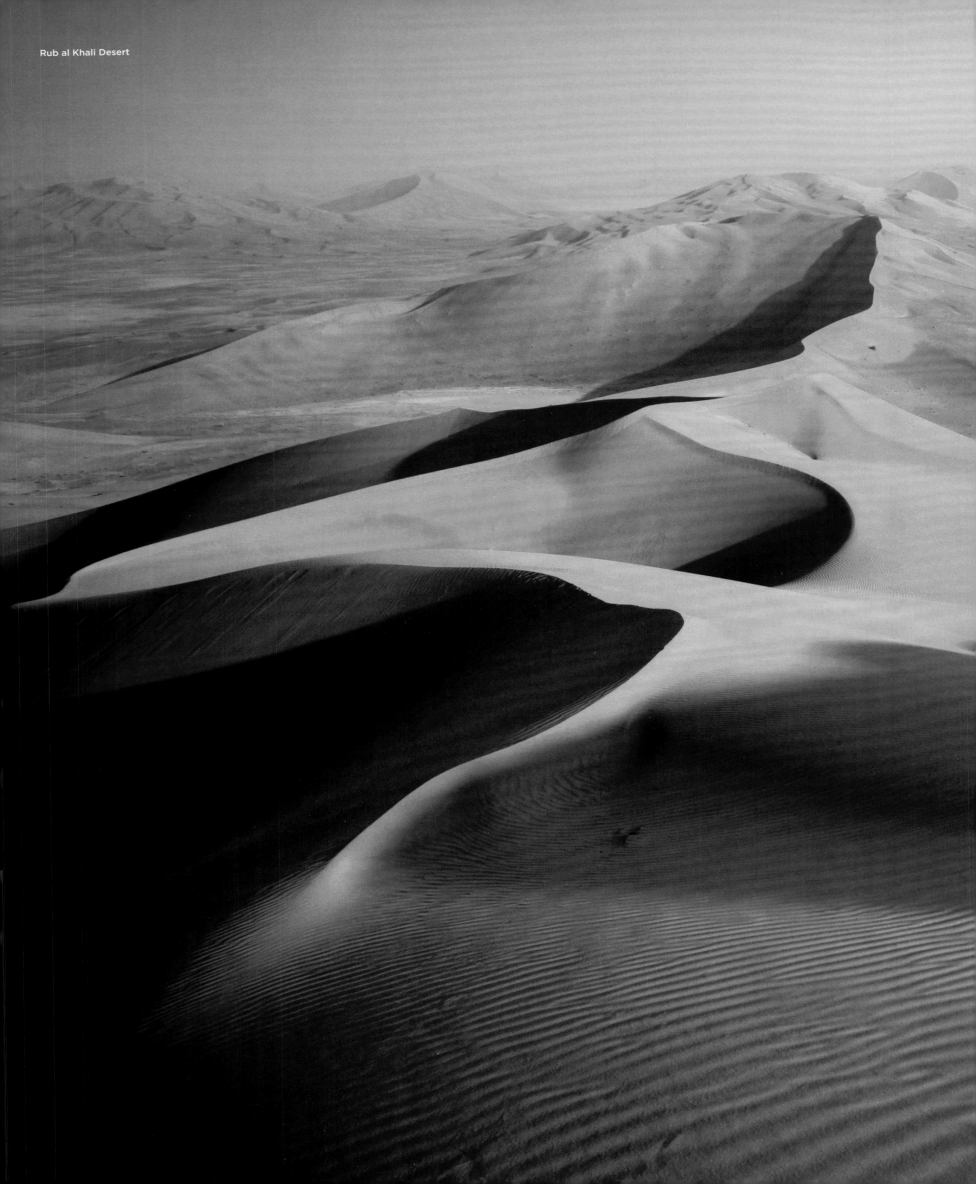
Rub al Khali Desert

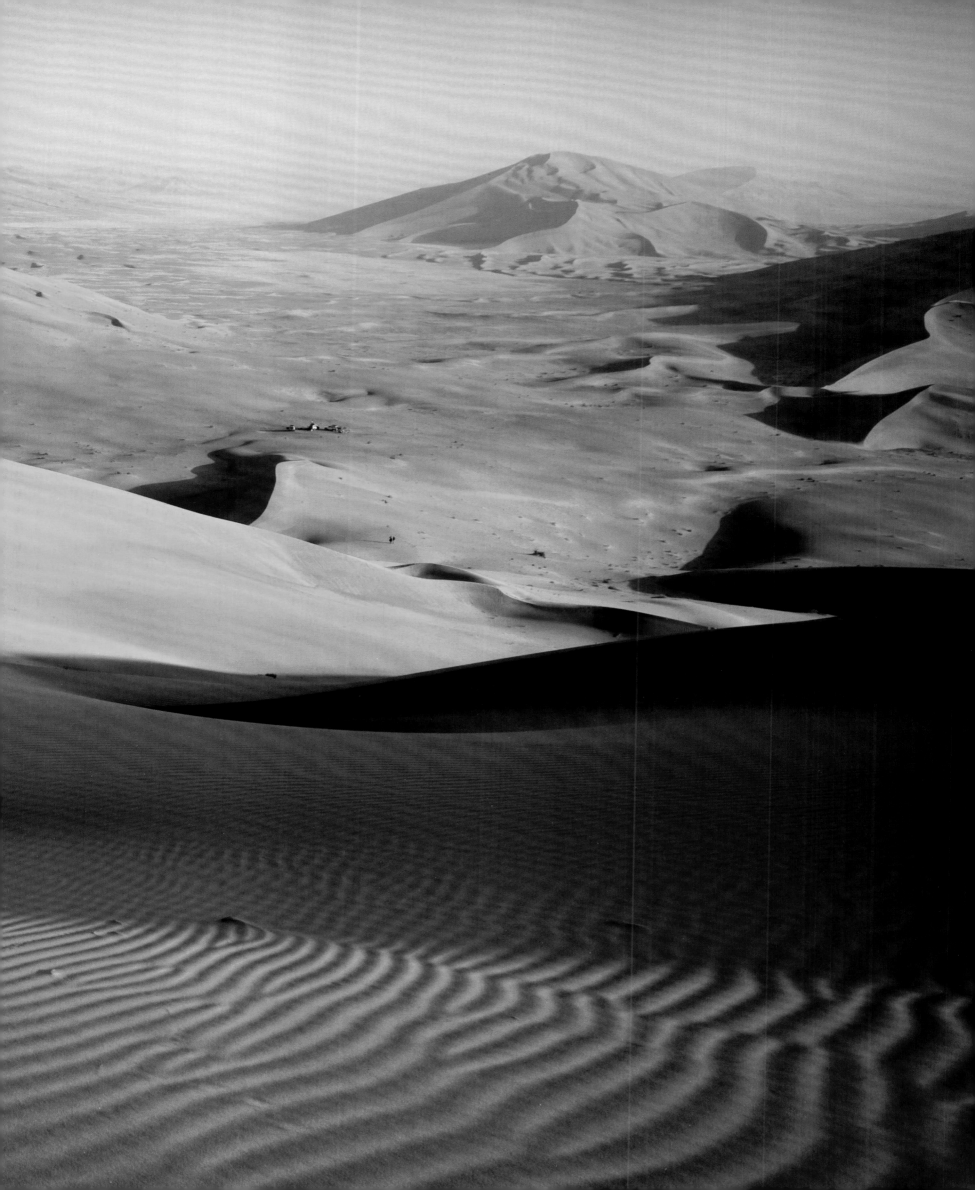

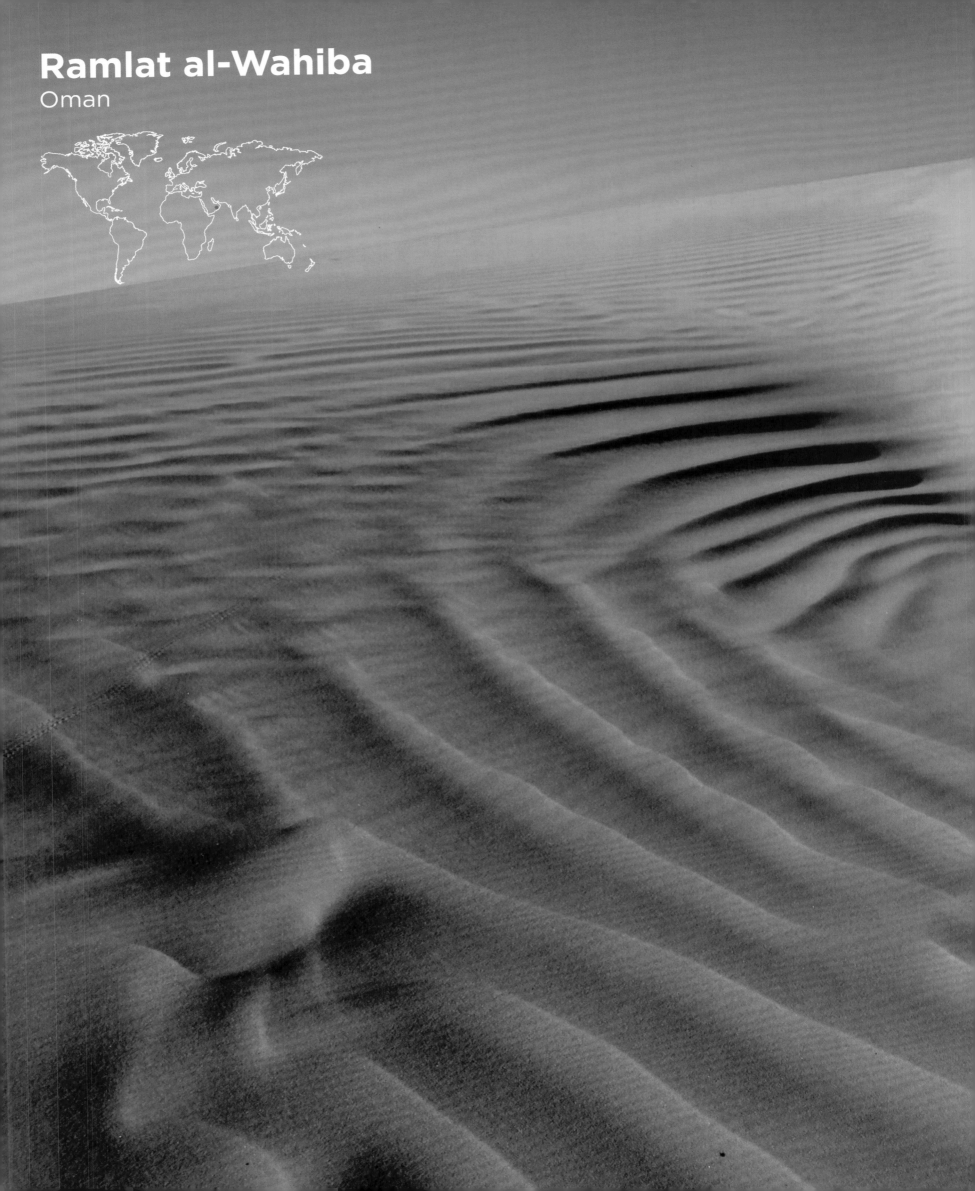
Ramlat al-Wahiba
Oman

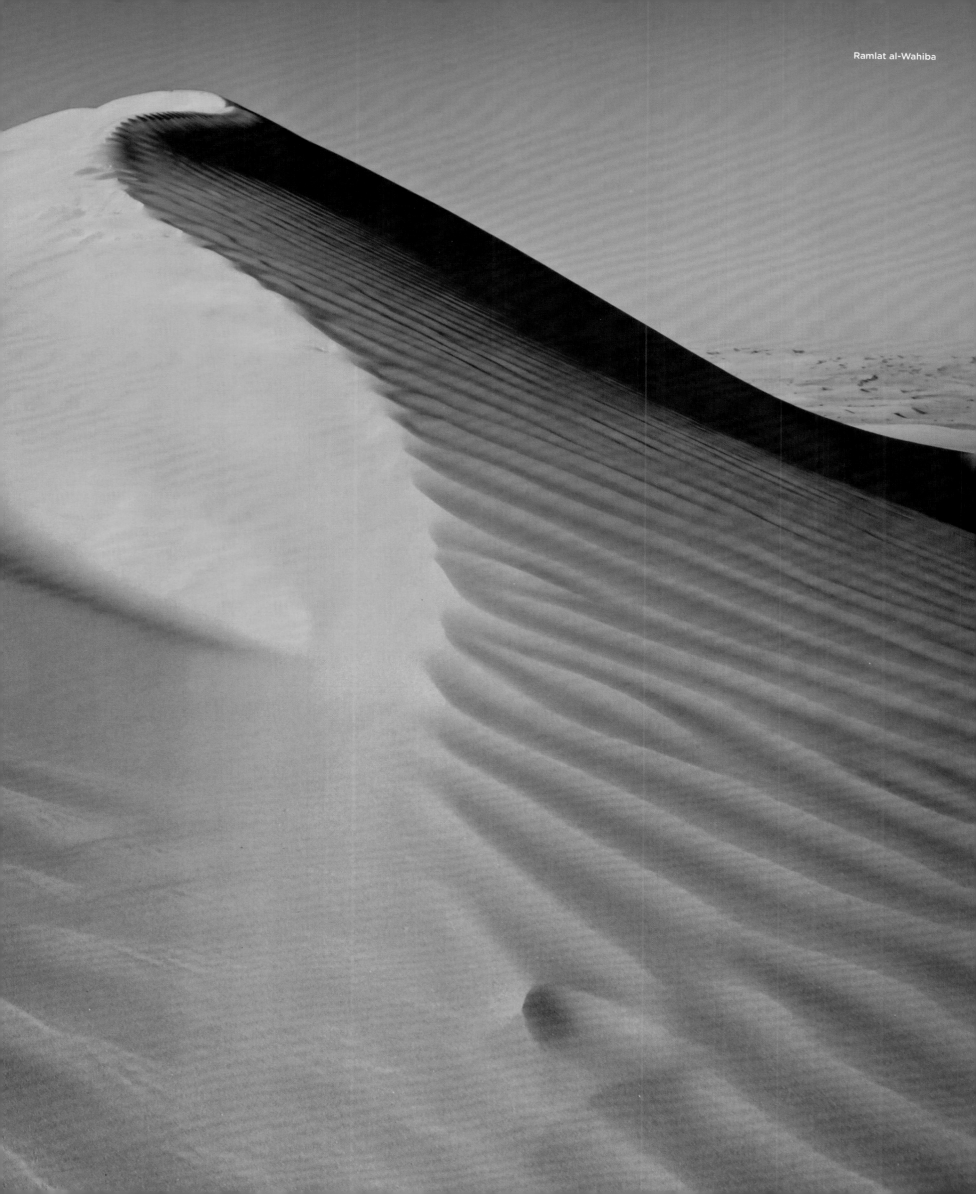

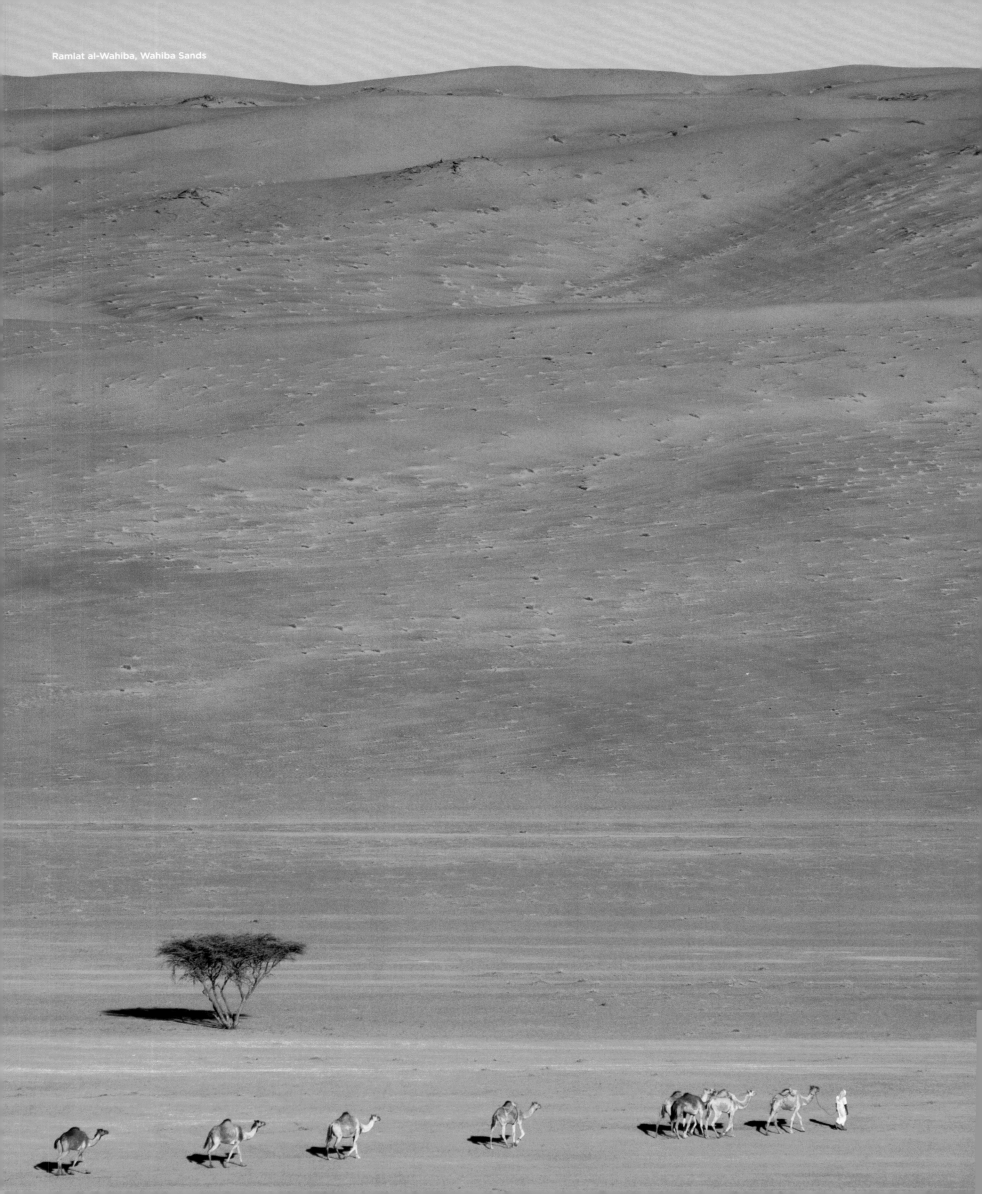

Ramlat al-Wahiba, Wahiba Sands

Ramlat al-Wahiba, Wahiba Sands

Ramlat al-Wahiba

Also known as the Sharqiya Sands, the Ramlat al-Wahiba is the traditional home of the Bani Wahiba Bedouin tribe in Oman. The sand dunes here were formed centuries ago by monsoon and trade winds, and despite its barren appearance a 1986 Royal Geographical Society found 200 wildlife species, 150 plant species, and 16 000 invertebrates.

Ramlat al-Wahiba

Également connus sous le nom de Sharqiya Sands, les Ramlat al-Wahiba sont les terres traditionnelles de la tribu bédouine Wahiba, à Oman. Leurs dunes ont été formées au fil des siècles par les moussons et les alizés. Malgré leur apparente aridité, la Royal Geographical Society y a répertorié en 1986 200 espèces fauniques, 150 espèces de plantes, et 16 000 invertébrés.

Rimla al-Wahiba

Die Rimla al-Wahiba (auch als Sharqiya Sands bezeichnet) ist das traditionelle Land des Beduinenstammes Bani Wahiba im Oman. Die Sanddünen hier wurden vor Jahrhunderten durch Monsun- und Passatwinde geformt, und trotz ihres kargen Aussehens fand die Royal Geographical Society 1986 hier 200 Wildtierarten, 150 Pflanzenarten und 16 000 Wirbellose.

Ramlat al-Wahiba

Conocido también como Sharqiya Sands, el Ramlat al-Wahiba es la tierra tradicional de la tribu beduina Bani Wahiba en Omán. Las dunas de arena se formaron hace siglos por el monzón y los vientos alisios y, a pesar de su apariencia estéril, la Royal Geographical Society de 1986 encontró 200 especies de vida silvestre, 150 especies de plantas y 16 000 invertebrados.

Ramlat al-Wahiba

Também conhecido como o Sharqiya Sands, o Ramlat al-Wahiba é a terra tradicional da tribo Bani Wahiba Bedouin, em Omã. As dunas de areia aqui foram formadas há séculos pelas monções e ventos alísios e, apesar de sua aparência estéril, a Royal Geographical Society de 1986 encontrou 200 espécies de animais selvagens, 150 espécies de plantas e 16 000 inverte--brados.

Ramlat al-Wahiba

De Ramlat al-Wahiba, ook bekend als de Sharqiya Sands, is het traditionele land van de bedoeïenenstam Bani Wahiba in Oman. De zandduinen hier werden eeuwen geleden gevormd door moessons en passaatwinden, en ondanks hun kale aanzien vond de Royal Geographical Society hier in 1986 200 wilde diersoorten, 150 plantensoorten en 16 000 ongewervelde dieren.

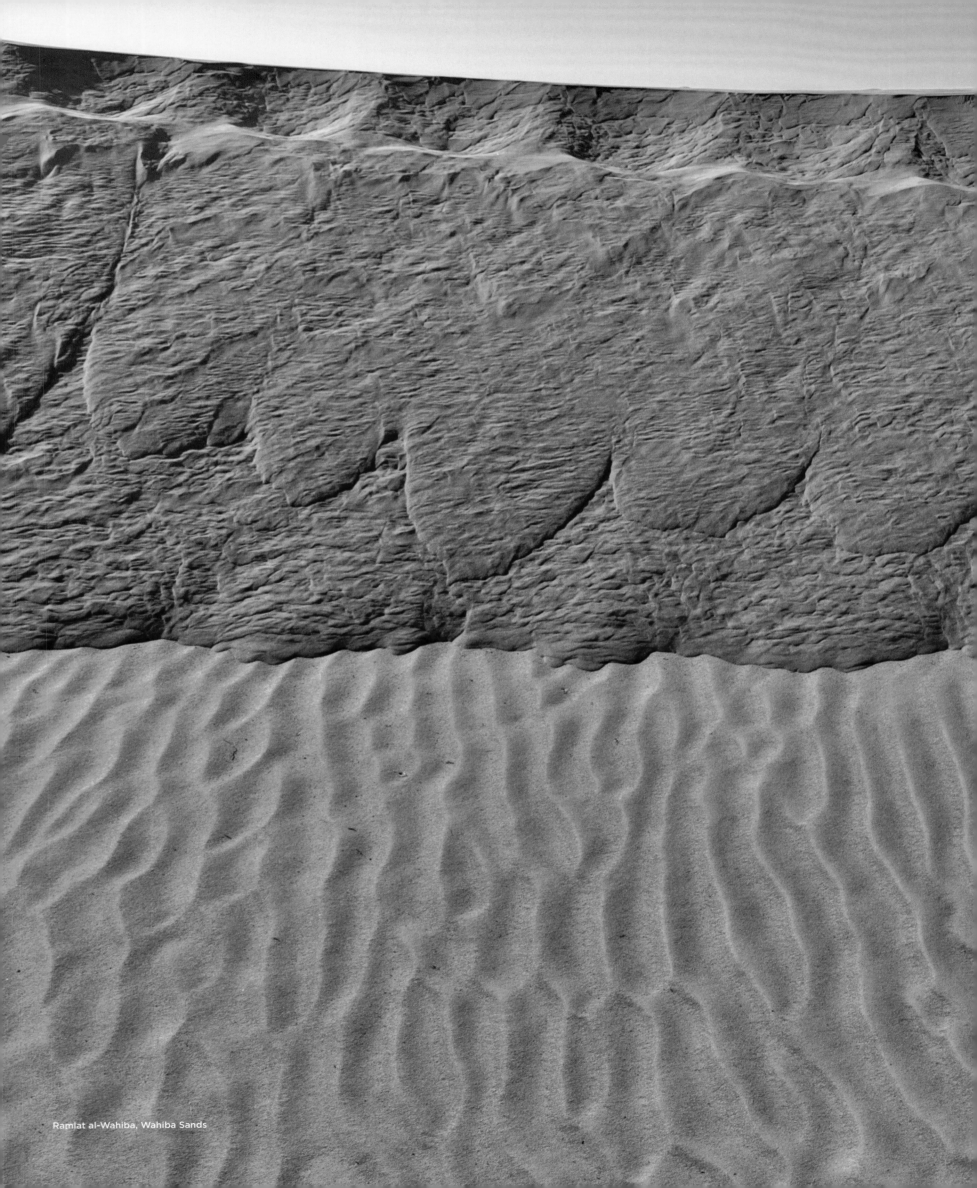

Ramlat al-Wahiba, Wahiba Sands

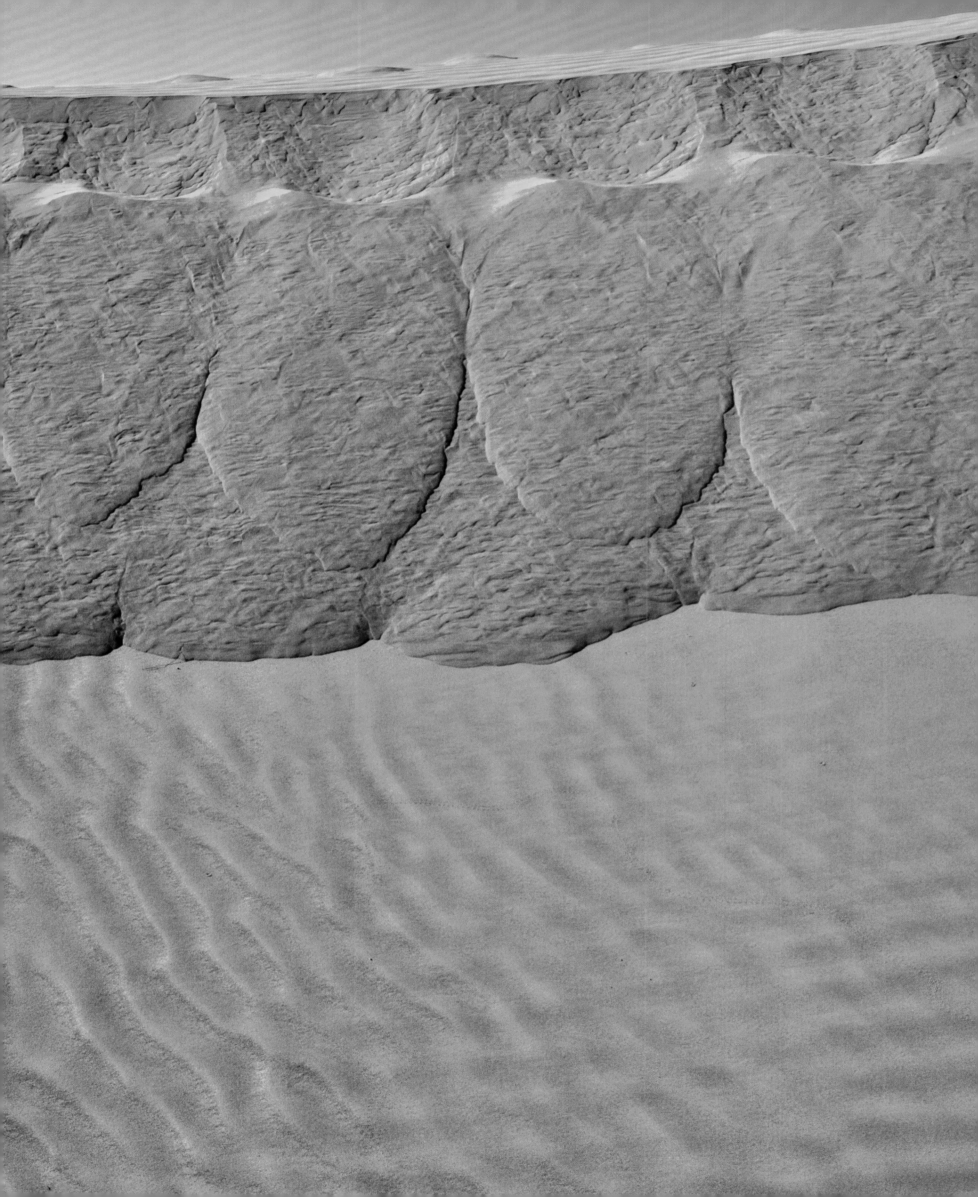

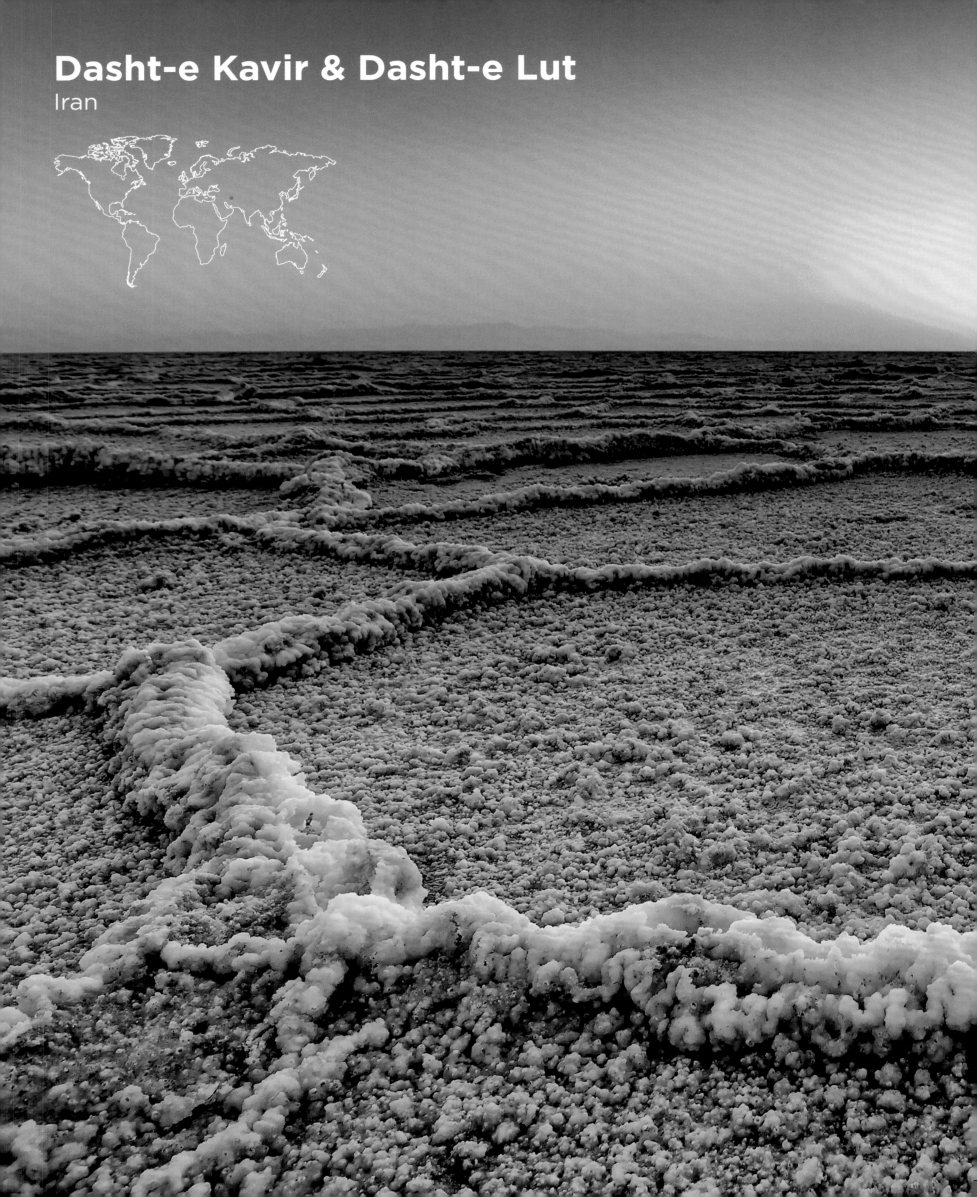

Dasht-e Kavir & Dasht-e Lut
Iran

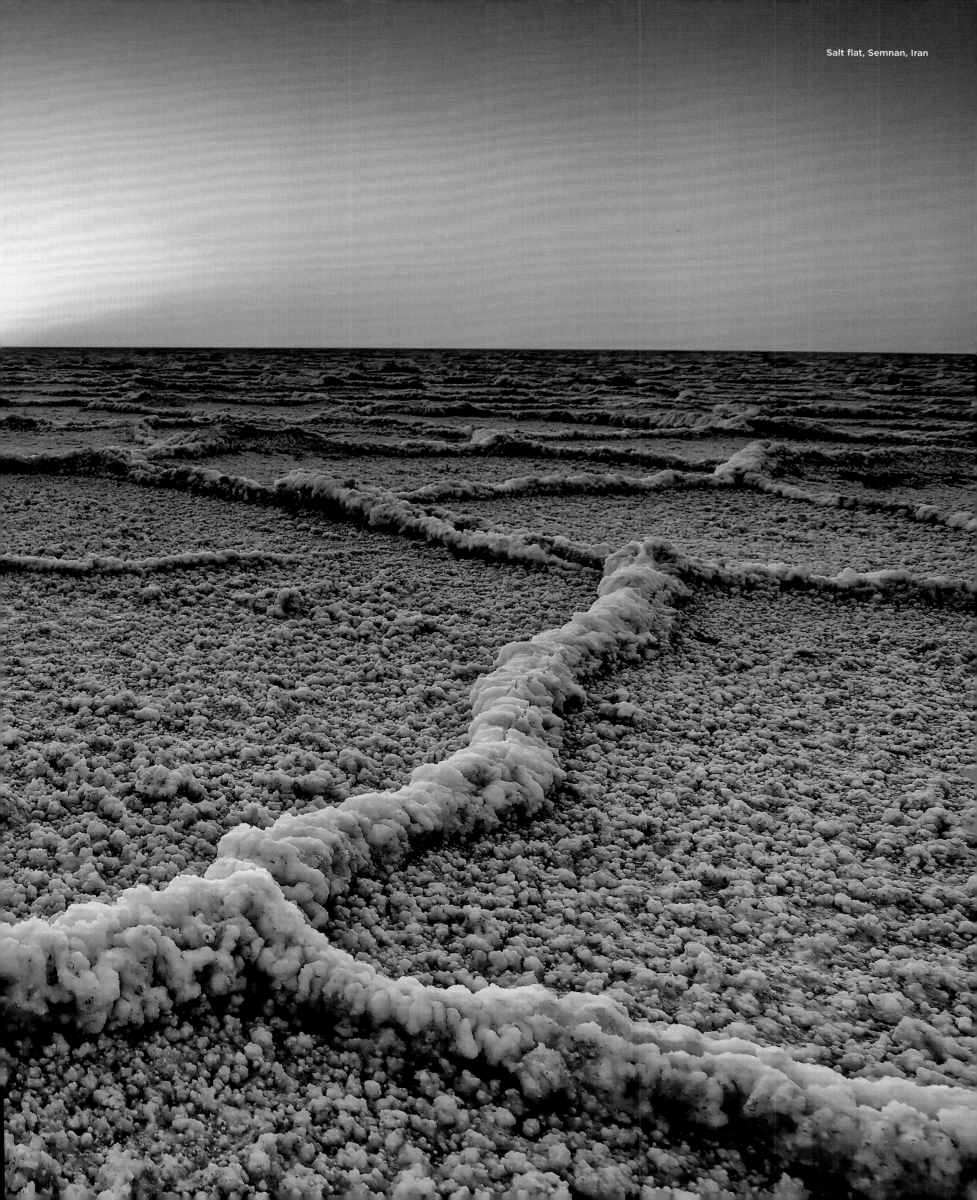

Salt flat, Semnan, Iran

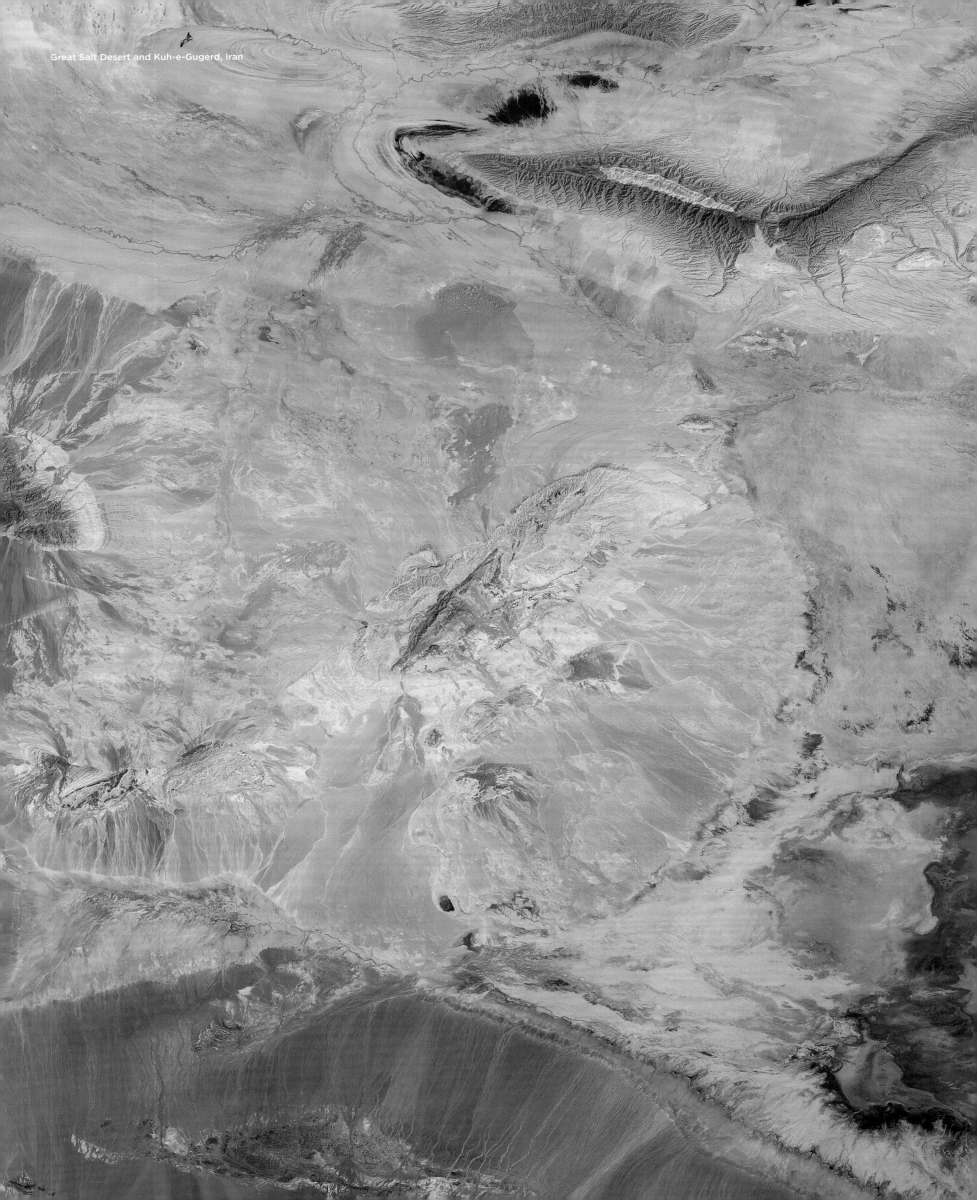

Great Salt Desert and Kuh-e-Gugerd, Iran

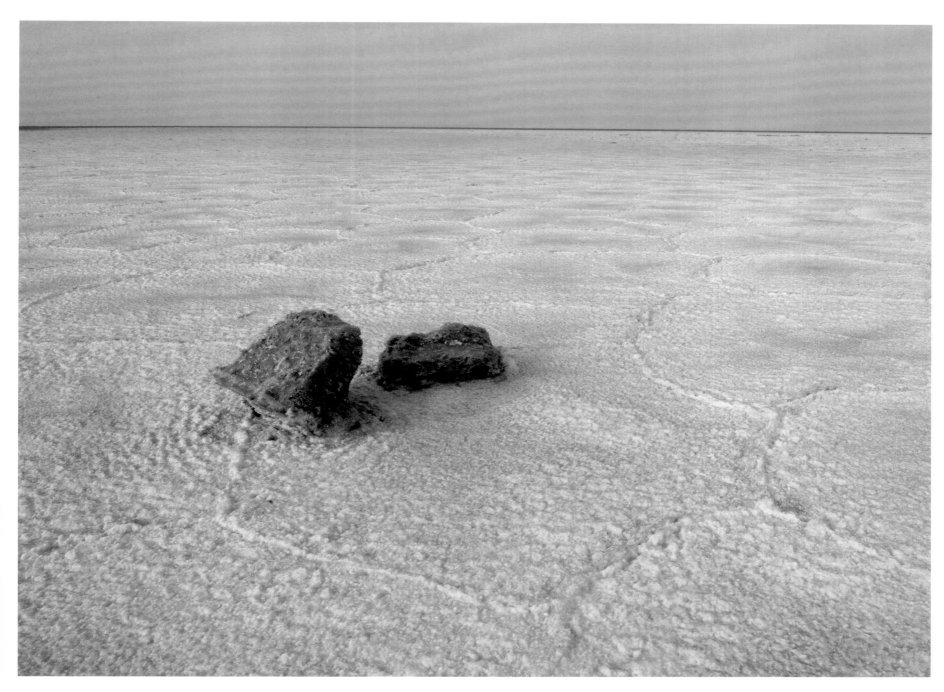

Salt flat, near Khur, Iran

Dasht-e Lut and Dasht-e Kavir
The Dasht-e Lut ('The Emptiness Plain') and the Dasht-e Kavir ('The Great Desert') are a series of plateaus, sand dunes, salt lakes and desert basins which together are considered to be among the hottest and driest places on the planet. Despite this, the deserts are home to Persian gazelles, Persian leopards and the Asiatic cheetah.

Déserts Dasht-e-Lut et Dasht-e Kavir
Dasht-e-Lut (« Désert du vide ») et Dasht-e Kavir (« Grand désert salé ») sont une série de plateaux, de dunes de sable, de lacs salés et de bassins désertiques, qui comptent parmi les endroits les plus chauds et les plus arides de la planète, pris dans leur ensemble. Malgré cela, ces déserts abritent des gazelles de Perse, des panthères de Perse et des guépards asiatiques.

Dascht-e Lut und Dascht-e Kawir
Die Dasht-e Lut („Die Wüste der Leere") und die Dasht-e Kawir („Die Große Wüste") bestehen aus einer Reihe von Plateaus, Sanddünen, Salzseen und Wüstenbecken, die zusammen zu den heißesten und trockensten Orten der Welt gehören. Dennoch sind die Wüsten die Heimat von Kropfgazellen, Persischen Leoparden und Asiatischen Geparden.

Dasht-e-Lut y Dasht-e Kavir
El Dasht-e-Lut («el desierto del Vacío») y el Dasht-e-Kavir («el gran desierto») son una serie de mesetas, dunas de arena, lagos salados y cuencas desérticas, que juntos están considerados como uno de los lugares más cálidos y secos del planeta. A pesar de ello, los desiertos son el hábitat de las gacelas persas, los leopardos persas y los guepardos asiáticos.

Dasht-e Lut & Dasht-e Kavir
O Dasht-e Lut ('O Vazio Plain') eo Dasht-e Kavir ('O Grande Deserto') são uma série de planaltos, dunas de areia, lagos salgados e bacias do deserto, que juntos são considerados entre os mais quentes e lugares mais secos do planeta. Apesar disso, os desertos abrigam as gazelas persas, os leopardos persas e as chitas asiáticas.

Dasht-e Lut en Dasht-e Kavir
De Dasht-e Lut ('woestijn van de leegte') en Dasht-e Kavir ('de grote woestijn') bestaan uit een reeks hoogvlaktes, zandduinen, zoutmeren en woestijn-bekkens, die met elkaar een van de heetste en droogste plekken op aarde uitmaken. Toch leven in deze woestijnen kropgazellen, Perzische panters en jachtluipaarden (Acinonyx jubatus venaticus).

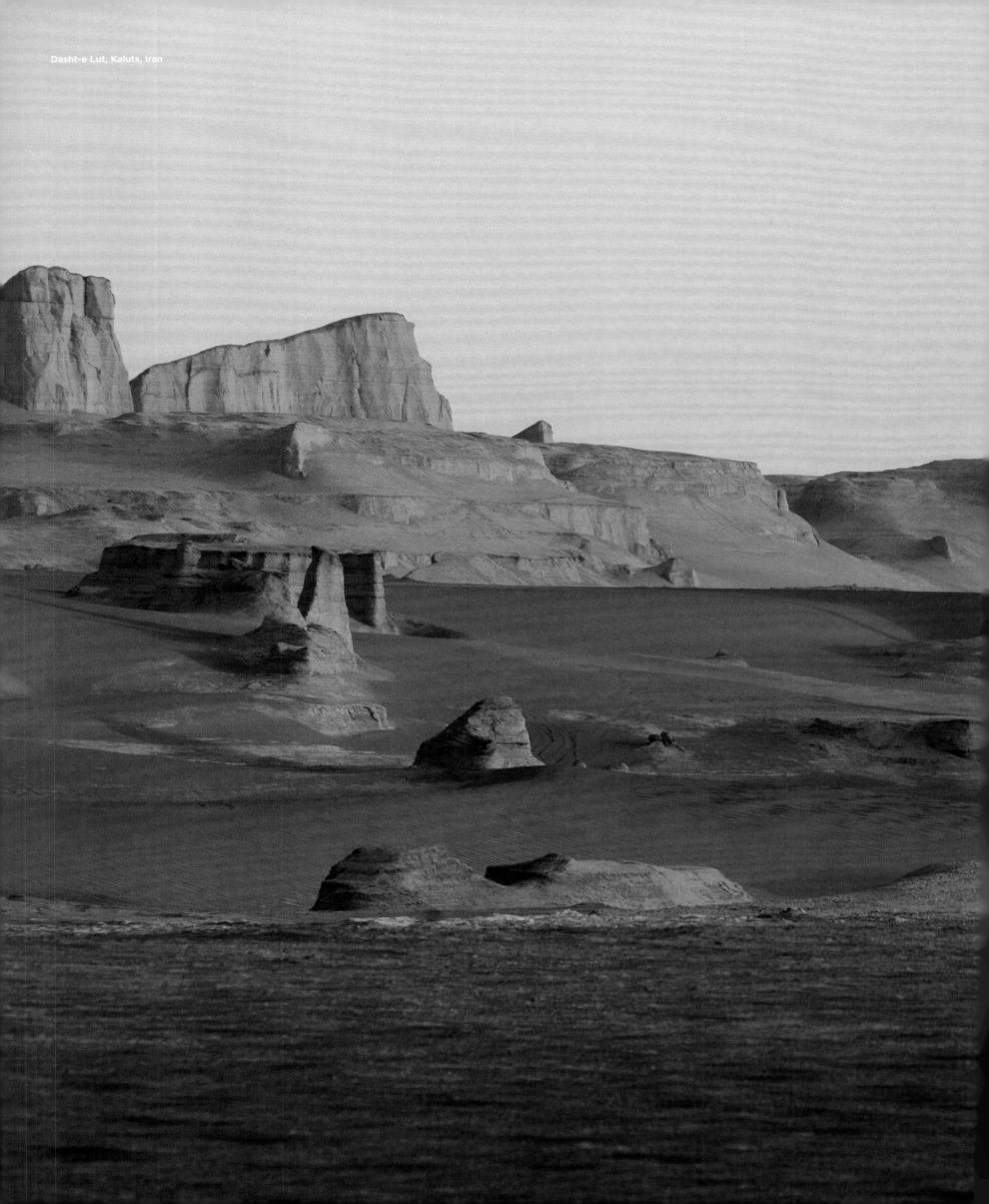

Dasht-e Lut, Kaluts, Iran

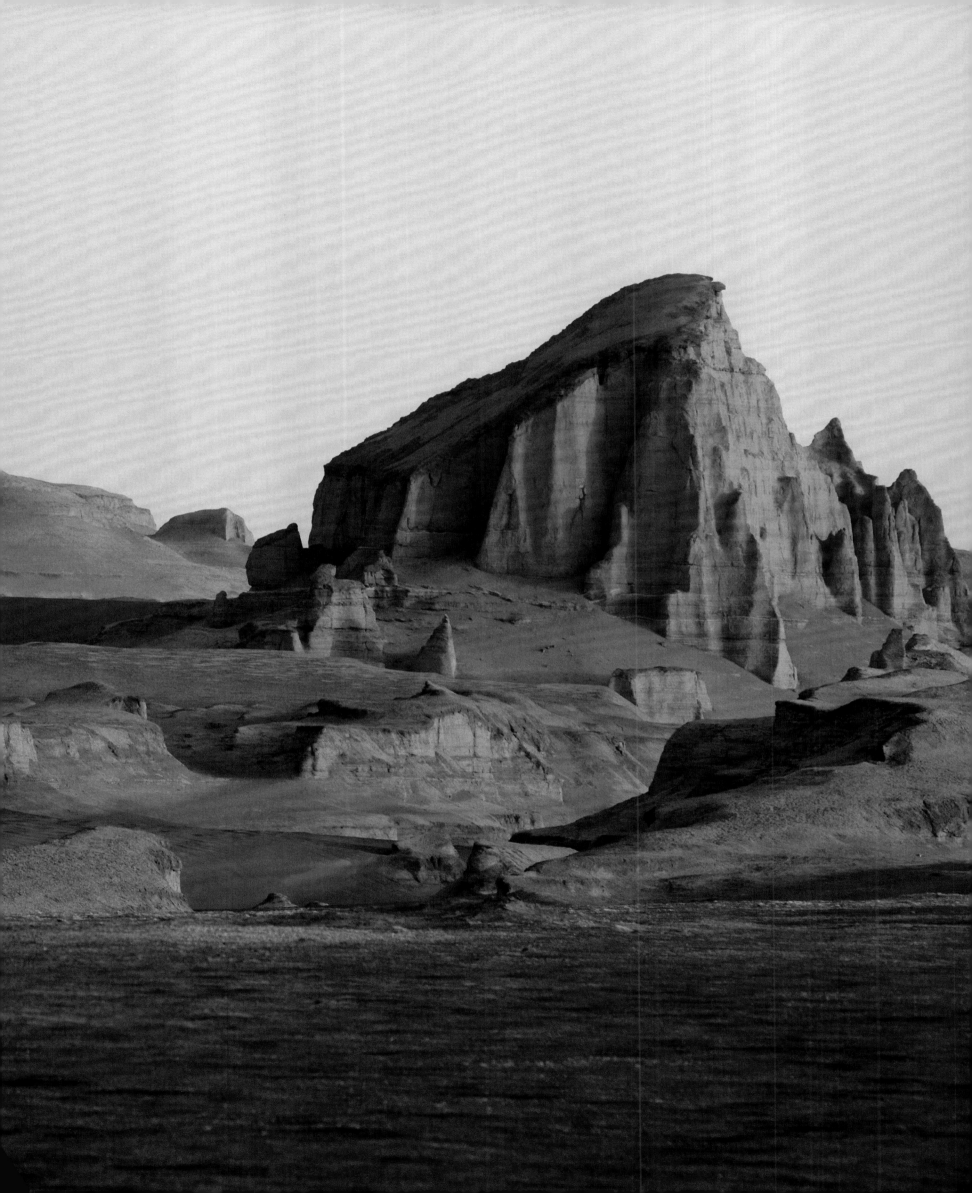

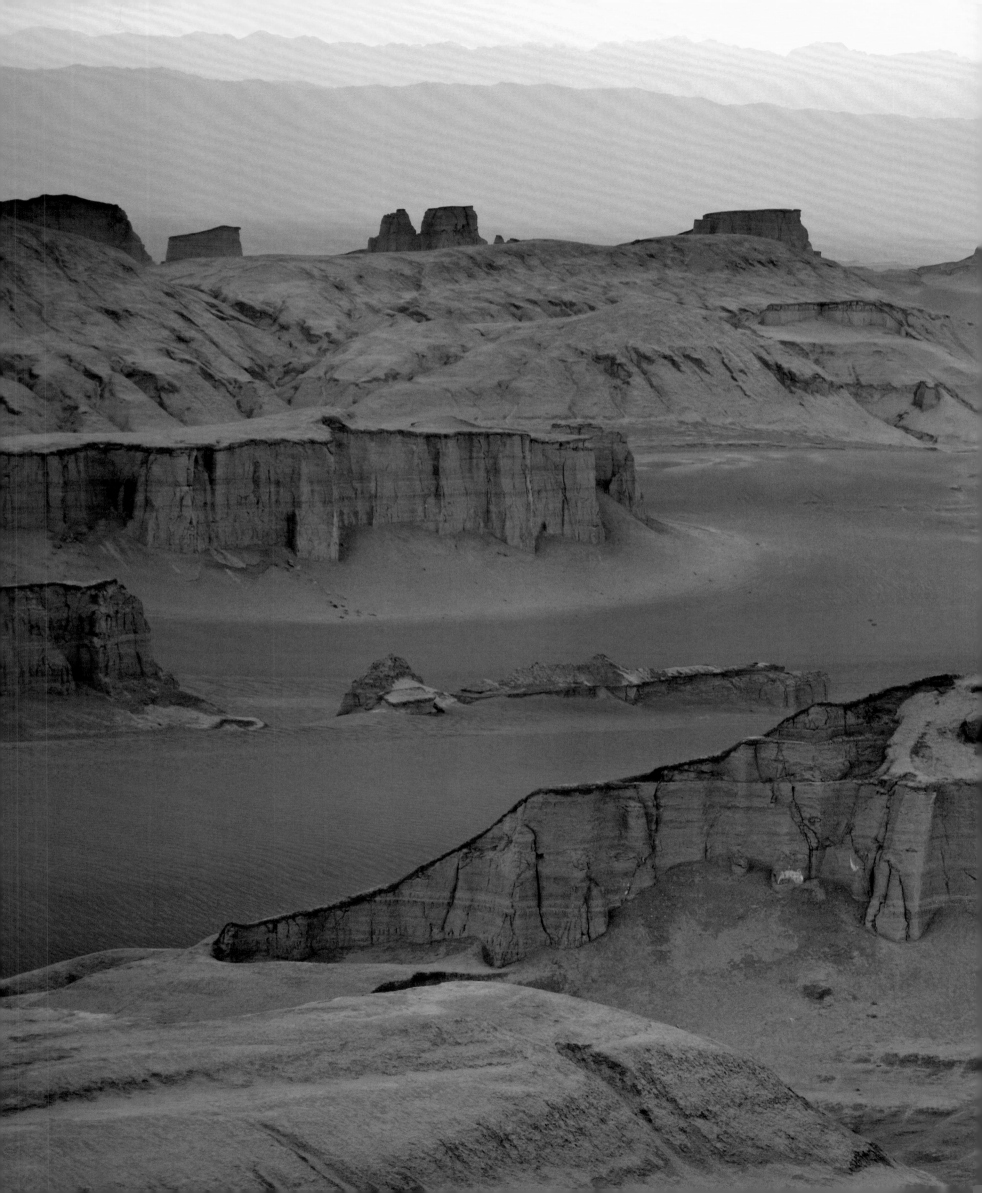

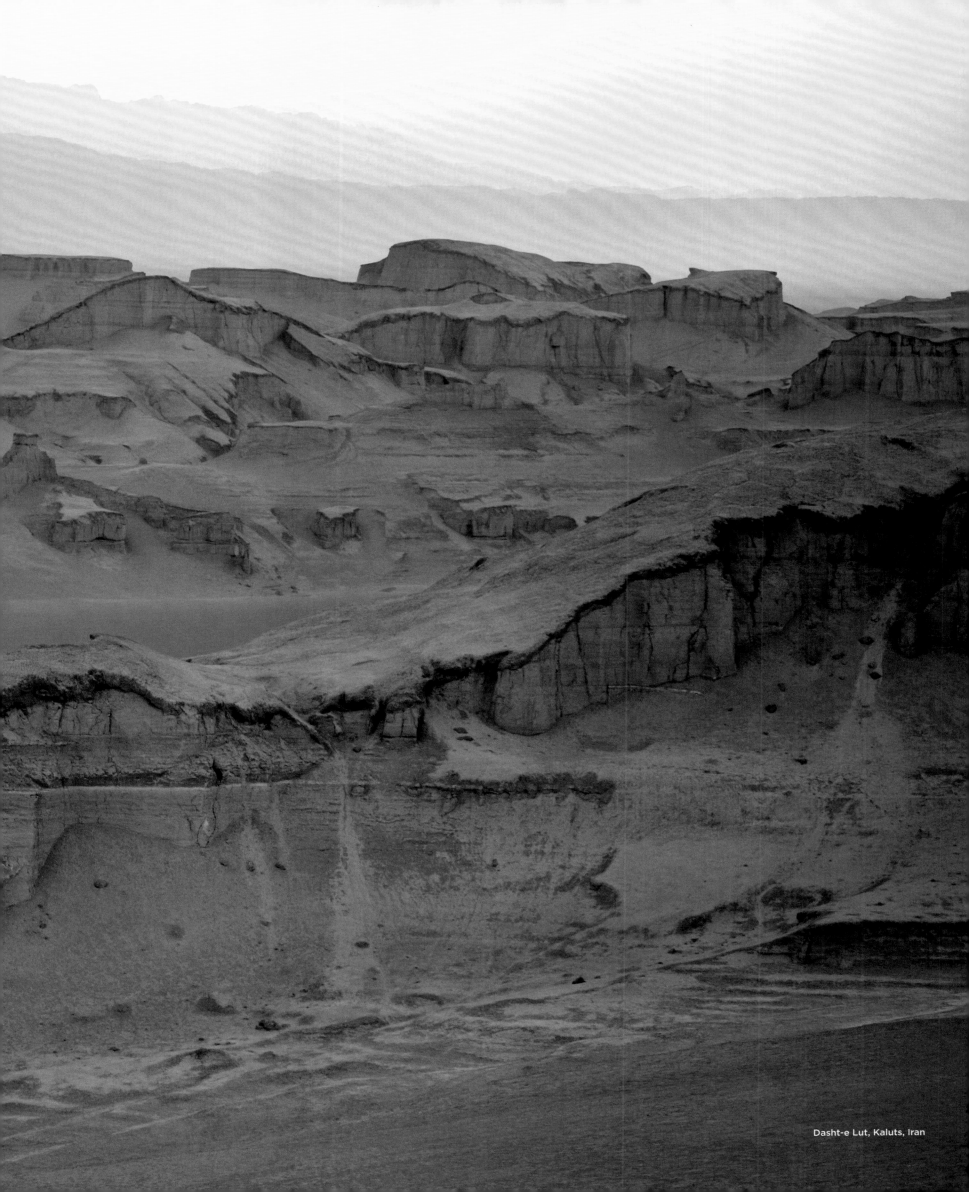

Dasht-e Lut, Kaluts, Iran

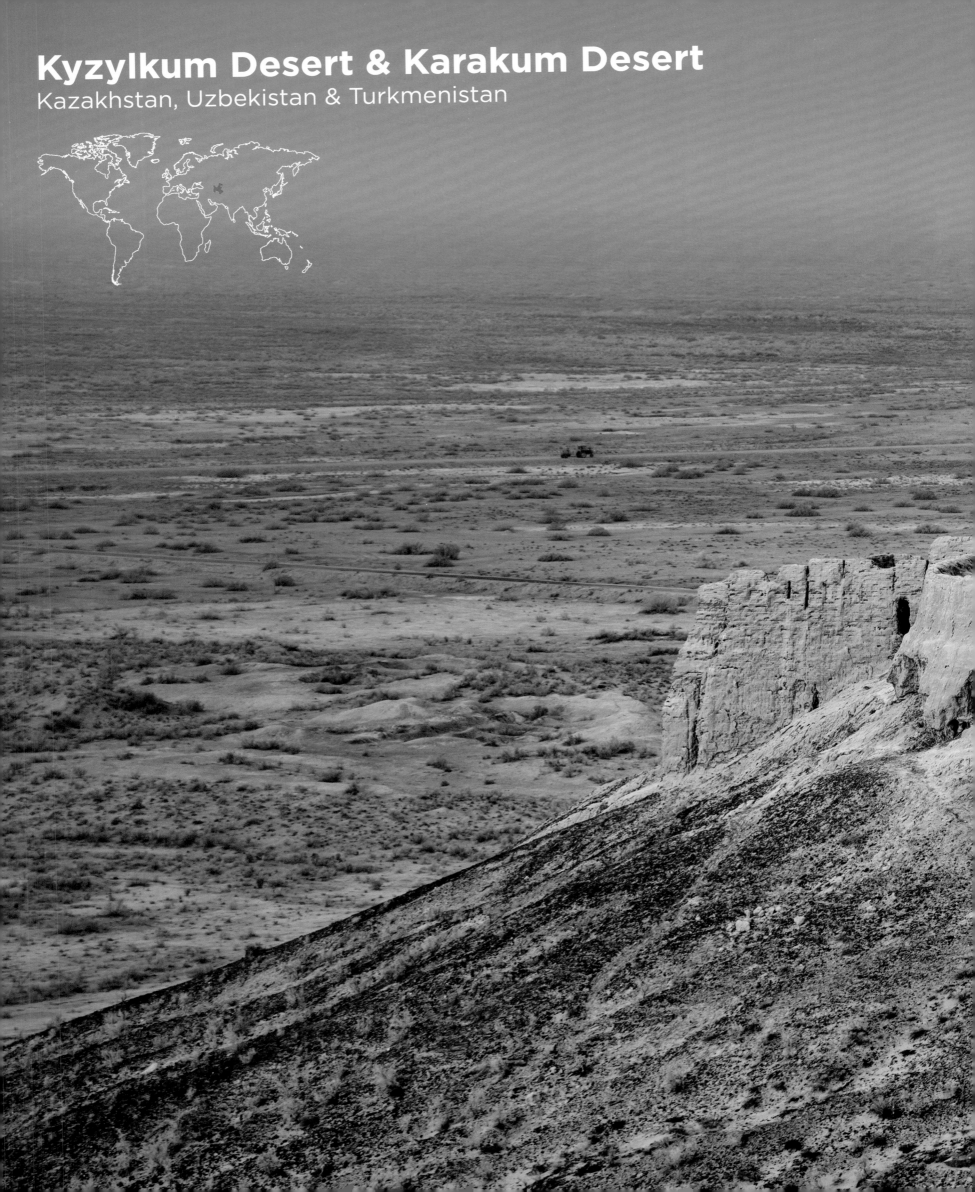

Kyzylkum Desert & Karakum Desert
Kazakhstan, Uzbekistan & Turkmenistan

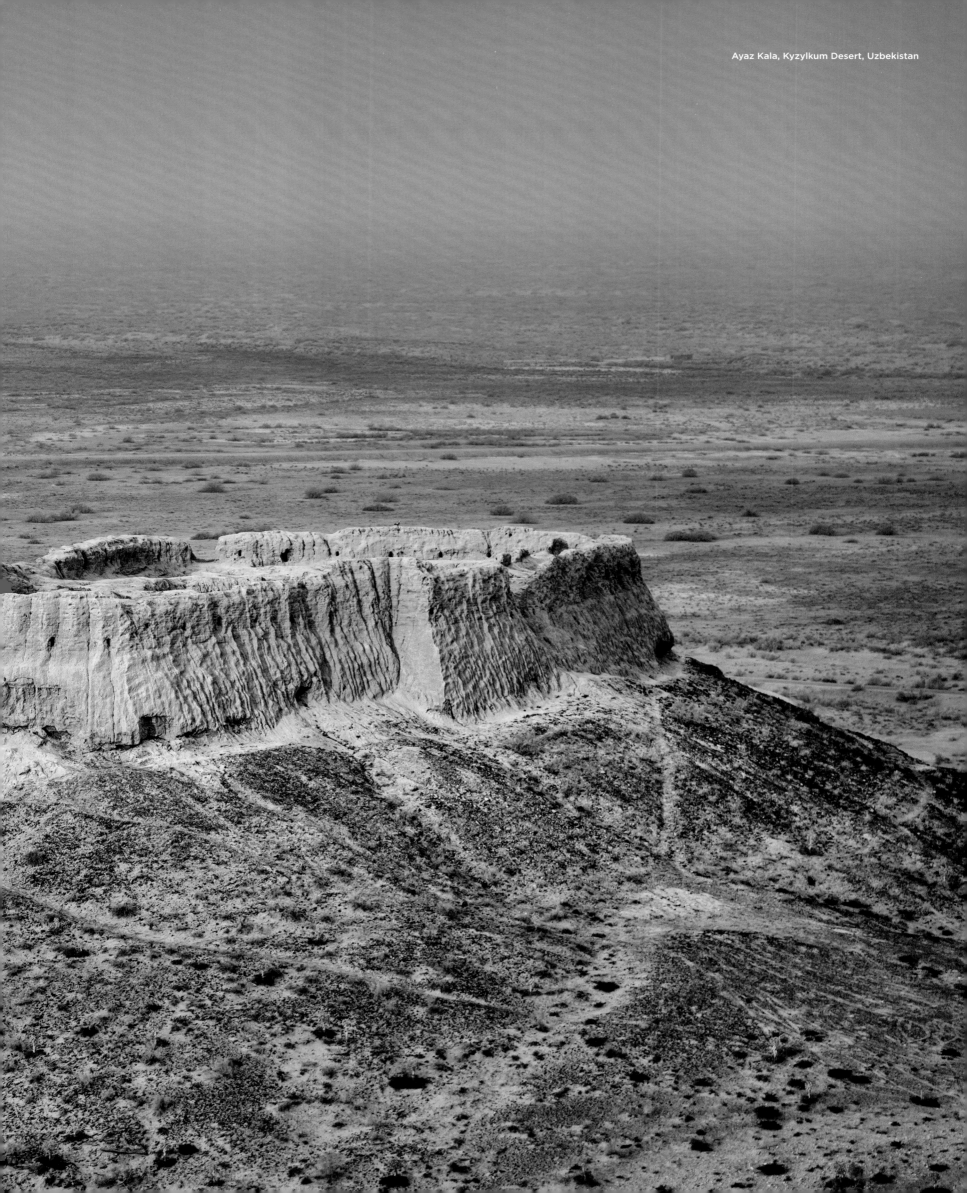

Ayaz Kala, Kyzylkum Desert, Uzbekistan

Kyzylkum Desert, Amudarja River, Uzbekistan

Kyzylkum Desert

With a name that means 'Red Sands' in the
languages of the region, the Kyzylkum Desert covers
298 000 sq km and is distinguished by its sand seas
of barchan (crescent-shaped) dunes, the classic
desert image, as well as salt lakes, clay pans, volcanic
craters and even seasonal grasslands. The latter allow
for grazing (including for dromedaries and Bactrian
camels) and farming along its fringes, as well as
providing habitat for the saiga antelope. The soil and
geological substrata have also yielded considerable
riches, from an invaluable fossil record to gold, silver,
uranium, copper and natural gas.

Désert de Kyzylkoum

Signifiant « sable rouge » dans la langue régionale,
le Kyzylkoum couvre une surface de 298 000 km²
et se distingue par ses mers de dunes « barcanes »
(en forme de croissant) – l'image classique du désert –
ainsi que par ses lacs salés, substrats d'argile, cratères
de volcans et prairies saisonnières. Ces dernières
offrent des pâtures aux bêtes (dont aux dromadaires
et aux chameaux de Bactriane), des lieux d'élevage
en lisière, et un habitat aux antilopes saïgas. Le sol
et le substrat géologique de ce désert regorgent
de richesses considérables issues d'un inestimable
gisement de fossiles comprenant de l'or, de l'argent,
de l'uranium, du cuivre et du gaz naturel.

Kysylkum-Wüste

Mit einem Namen, der in den Sprachen der Region
„Roter Sand" bedeutet, erstreckt sich die Kyzylkum-
Wüste über 298 000 Quadratkilometer und zeichnet
sich durch ihre Sandmeere aus sichelförmigen
Dünen, das klassische Wüstenbild sowie Salzseen,
Tonpfannen, Vulkankrater und sogar saisonale Wiesen
aus. Letzteres ermöglicht Beweidung (auch durch
Dromedare und baktrische Kamele) und Ackerbazu in
den Randgebieten, die aber auch den Lebensraum der
Saigaantilope bilden. Der Boden und die geologischen
Substrate bergen auch erhebliche Reichtümer, von
unschätzbaren fossilen Spuren bis hin zu Gold, Silber,
Uran, Kupfer und Erdgas.

Kyzylkum Desert, Uzbekistan

Desierto de Kyzyl Kum

Con un nombre que significa «arenas rojas» en los idiomas de la región, el desierto de Kyzyl Kum cubre 298 000 km² y se distingue por sus mares de arena de dunas de barján (en forma de media luna), la imagen clásica del desierto, así como lagos salados, cráteres de arcilla, cráteres volcánicos e incluso pastizales estacionales. Estos últimos permiten el pastoreo (incluidos dromedarios y camellos bactrianos) y la agricultura a lo largo de sus bordes, así como el hábitat del antílope saiga. El suelo y los sustratos geológicos también han producido considerables riquezas, desde un registro fósil invaluable hasta oro, plata, uranio, cobre y gas natural.

Deserto de Kyzylkum

Com um nome que significa 'Areias Vermelhas' nas línguas da região, o Deserto de Kyzylkum cobre 298 000 km² e se distingue por seus mares de areia de dunas barchan (em forma de crescente), a clássica imagem do deserto, bem como lagos salgados, panelas de barro, crateras vulcânicas e até gramados sazonais. Este último permite o pastoreio (incluindo dromedários e camelos bactrianos) e a agricultura ao longo das suas margens, bem como o habitat do antílope saiga. O solo e os substratos geológicos também renderam riquezas consideráveis, desde um registro fóssil inestimável até ouro, prata, urânio, cobre e gás natural.

Kyzylkum

Met een naam die in de regionale taal 'rood zand' betekent, beslaat de Kyzylkum 298 000 km² en onderscheidt hij zich door zijn zandzeeën met sikkelvormige duinen, het klassieke woestijnbeeld. Verder omvat hij zoutmeren, kleibekkens, vulkaan-kraters en zelfs seizoensgebonden graslanden. Door deze laatste zijn begrazing (ook door dromedarissen en kamelen) en akkerbouw mogelijk aan de rand van het gebied, waar ook de saiga-antilopes leven. De bodem en geologische substraten leveren bovendien aanzienlijke rijkdommen op: een onschatbaar fossielenbestand, goud, zilver, uranium, koper en aardgas.

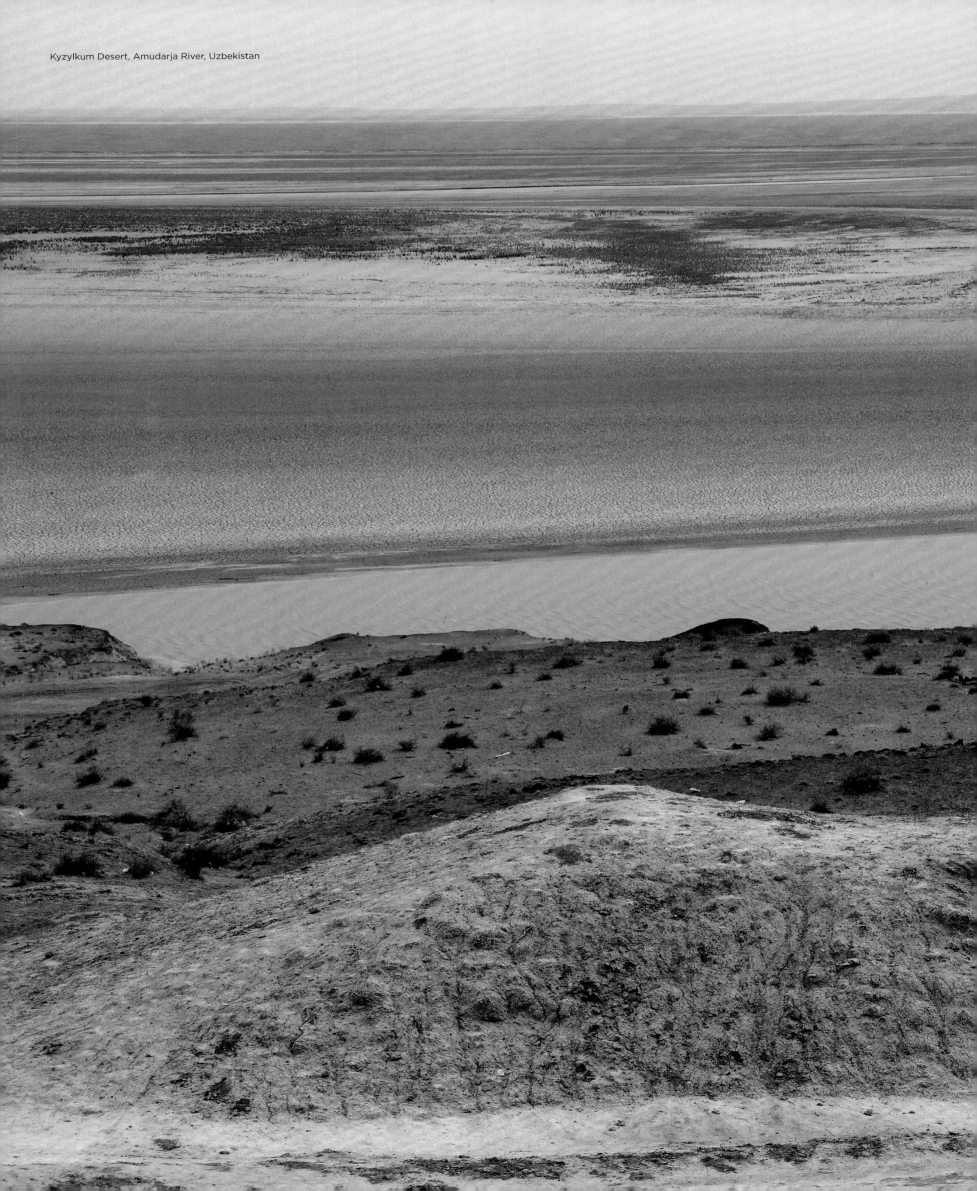
Kyzylkum Desert, Amudarja River, Uzbekistan

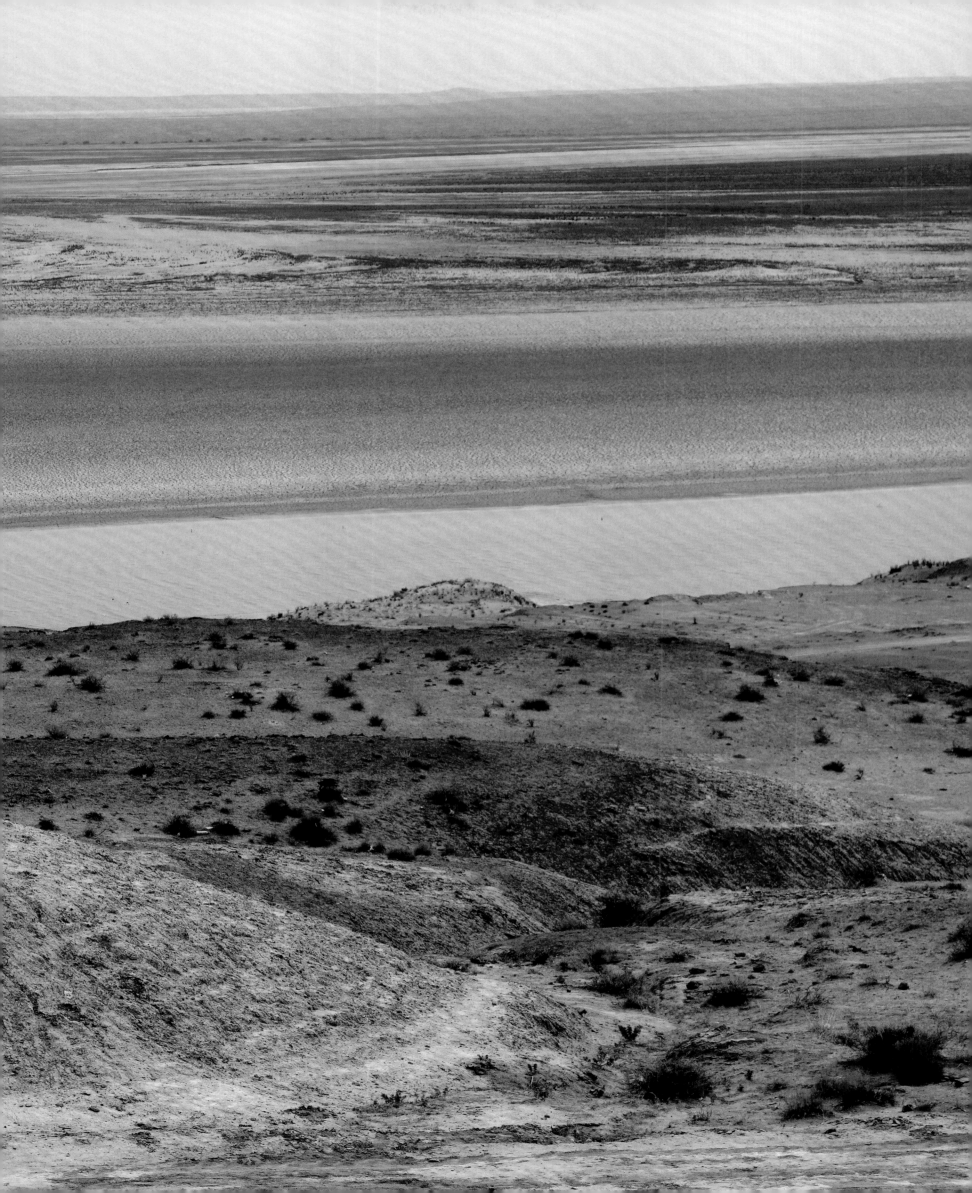

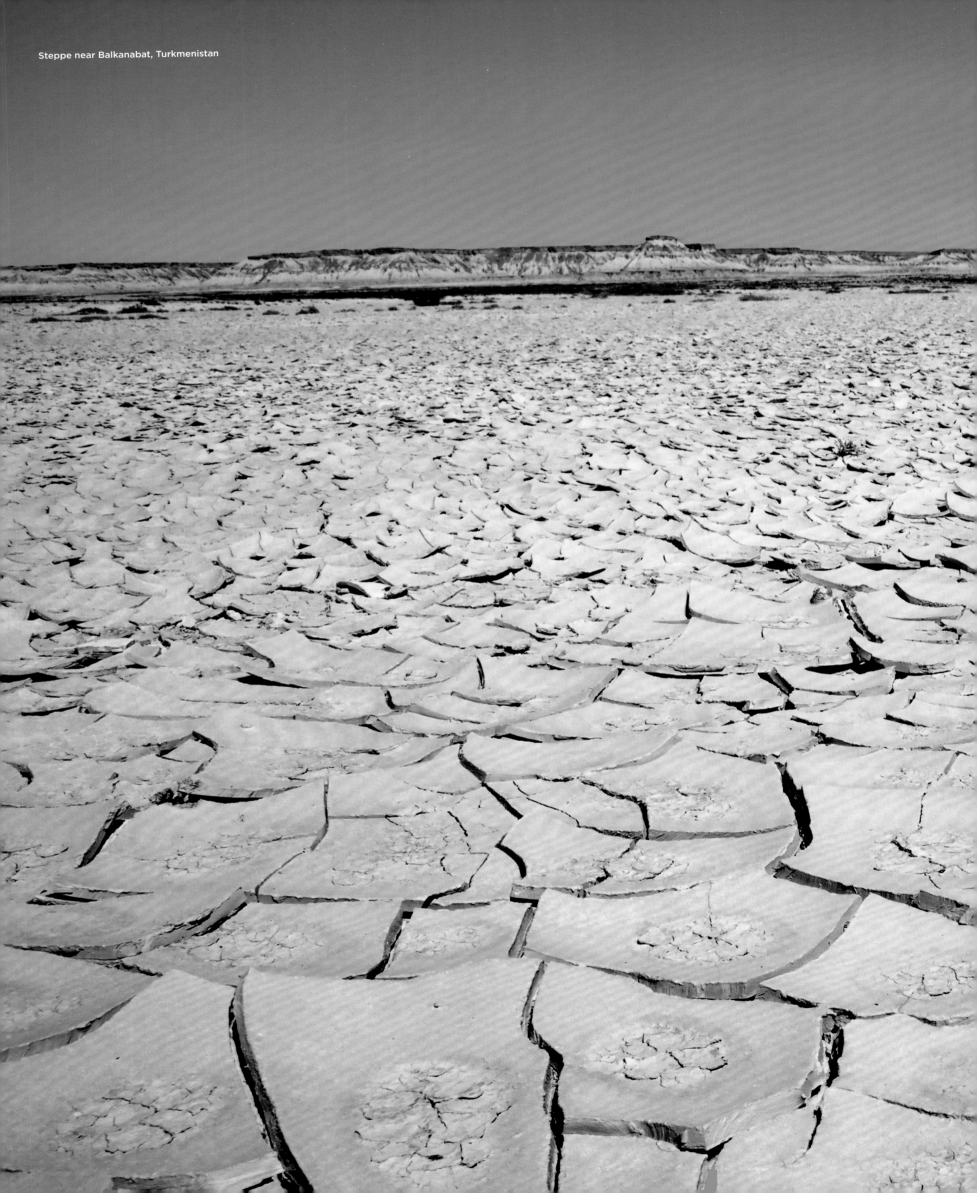

Steppe near Balkanabat, Turkmenistan

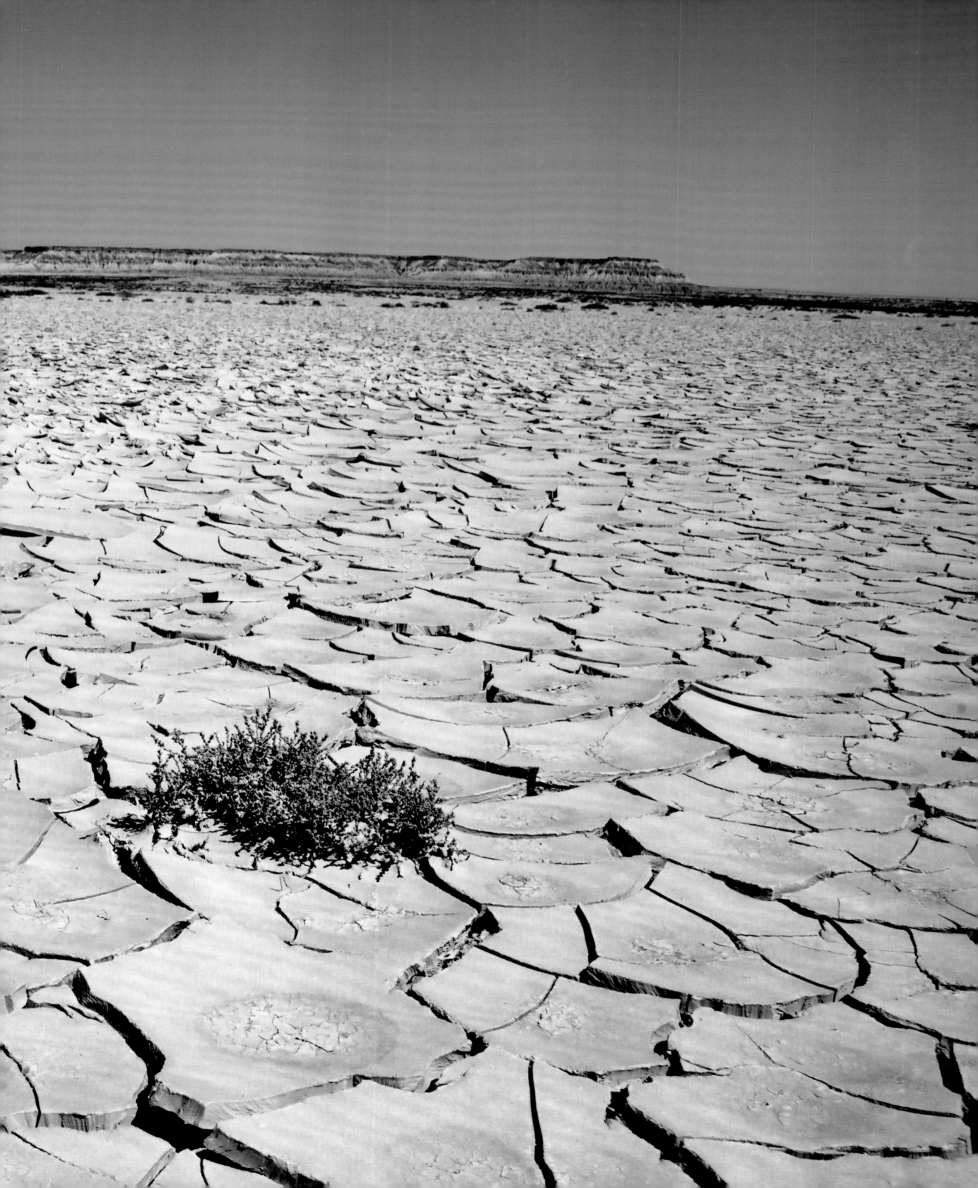

Mud Crater, Darvaza, Karakum Desert, Turkmenistan

Karakum Desert

Although sand dunes are the most obvious feature of the Karakum Desert, the name means 'Black Sand', a reference to the soil that lies beneath the sand. With its boundaries creeping further outward, the desert, which already covers 70 % of Turkmenistan's land mass, threatens to swallow the entire country. The Karakum borders the southern Aral Sea, which is shrinking as the desert continues its inexorable march. Dust from this section of the desert, the Aral Karakum, has been carried by winds as far as Greenland. The burning Darvaza Gas Crater, known locally as 'the door to hell' lies above an important source of natural gas and is a major tourist attraction.

Désert de Karakoum

Bien que les dunes soient la caractéristique la plus évidente du désert de Karakoum, ce nom signifie « sable noir », en référence à celui qui s'étend sous sa surface. Ses limites s'étendant de plus en plus, ce désert, qui couvre déjà 70 % de la masse terrestre du Turkménistan, menace d'engloutir le pays tout entier. Le Karakoum borde le sud de la mer d'Aral, qui s'assèche à cause de l'inexorable avancée du désert. La poussière de cette partie du désert – le Karakoum d'Aral – est charriée par les vents jusqu'au Groenland. Le cratère de gaz Darvaza, localement connu comme la « Porte de l'Enfer », constitue une source importante de gaz naturel et une attraction touristique majeure.

Karakum-Wüste

Obwohl helle Sanddünen das offensichtlichste Merkmal der Karakum-Wüste sind, bedeutet der Name „Schwarzer Sand" und ist ein Hinweis auf das, was unter den Dünen liegt. Die Wüste, die bereits 70 % der Fläche Turkmenistans ausmacht, droht mit ihrer fortschreitenden Ausdehung das ganze Land zu verschlingen. Die Karakum grenzt an den südlichen Aralsee, der mit dem Anwachsen der Wüste schrumpft. Der Staub aus diesem Teil der Wüste, der Aral-Karakum, wird von Winden manchmal bis nach Grönland getragen. Der Krater von Derweze, in der Umgebung „das Tor zur Hölle" genannt, ist eine wichtige Erdgasquelle und eine bedeutende Touristenattraktion.

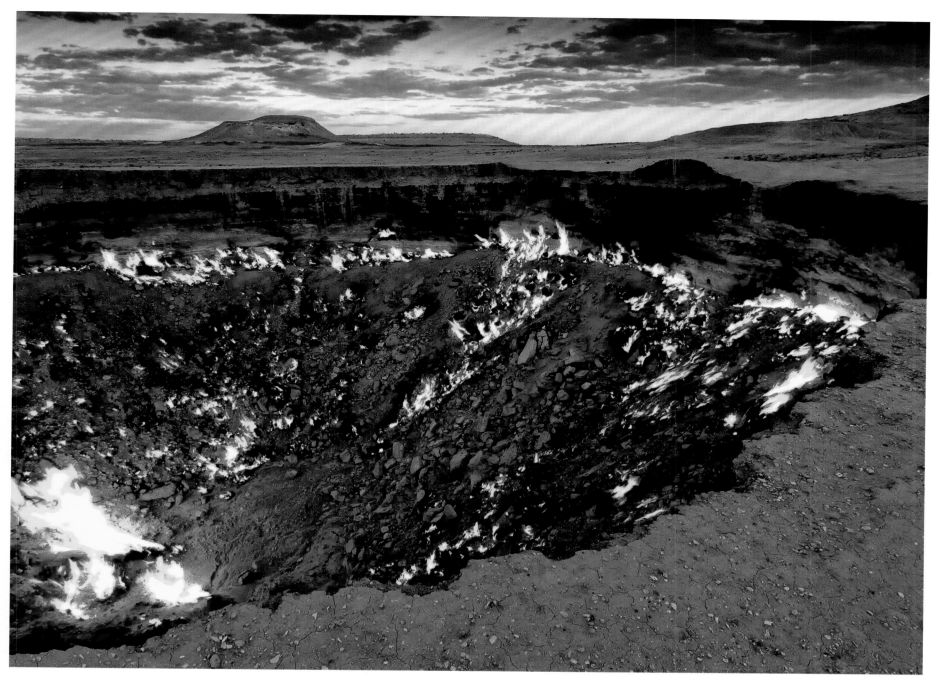

Darvaza gas crater, Door to hell, Karakum Desert, Turkmenistan

Desierto de Karakum

Aunque las dunas de arena son la característica más obvia del desierto de Karakum, el nombre significa «arena negra», una referencia a lo que yace bajo la arena. El desierto, que ya cubre el 70% de la superficie terrestre de Turkmenistán, amenaza con tragar a todo el país. El Karakum bordea el sur del Mar de Aral, que se está reduciendo a medida que el desierto continúa su inexorable marcha. El polvo de esta sección del desierto, el Aral Karakum, ha sido transportado por los vientos hasta Groenlandia. El cráter de gas de Darvaza, conocido localmente como «la puerta al infierno», es una importante fuente de gas natural y una gran atracción turística.

Deserto de Karakum

Embora as dunas de areia sejam a característica mais óbvia do deserto de Karakum, o nome significa "Areia Negra", uma referência ao que está debaixo da areia. Com seus limites se arrastando ainda mais para fora, o deserto, que já cobre 70% da massa terrestre do Turquemenistão, ameaça engolir o país inteiro. O Karakum faz fronteira com o sul do Mar de Aral, que está encolhendo enquanto o deserto continua sua marcha inexorável. O pó desta parte do deserto, o Aral Karakum, foi carregado por ventos até a Groenlândia. A Cratera de Gás Daryaza, conhecida localmente como "a porta para o inferno", é uma importante fonte de gás natural e uma grande atração turística.

Karakum

Hoewel zandduinen het meest opvallen in de Karakumwoestijn betekent de naam 'zwart zand', een verwijzing naar wat er onder het zand ligt. De woestijn, die nu al 70% van het oppervlak van Turkmenistan beslaat, dreigt door zijn gestage uitbreiding het hele land op te slokken. De Karakum grenst aan het zuidelijke Aralmeer, dat krimpt naarmate de woestijn zijn onverbiddelijke mars voortzet. Stof uit dit deel van de woestijn, de Aral Karakum, is door de wind meegevoerd tot aan Groenland. De Krater van Derweze, plaatselijk bekend als 'de poort naar de hel', is een belangrijke aardgasbron en een belangrijke toeristische attractie.

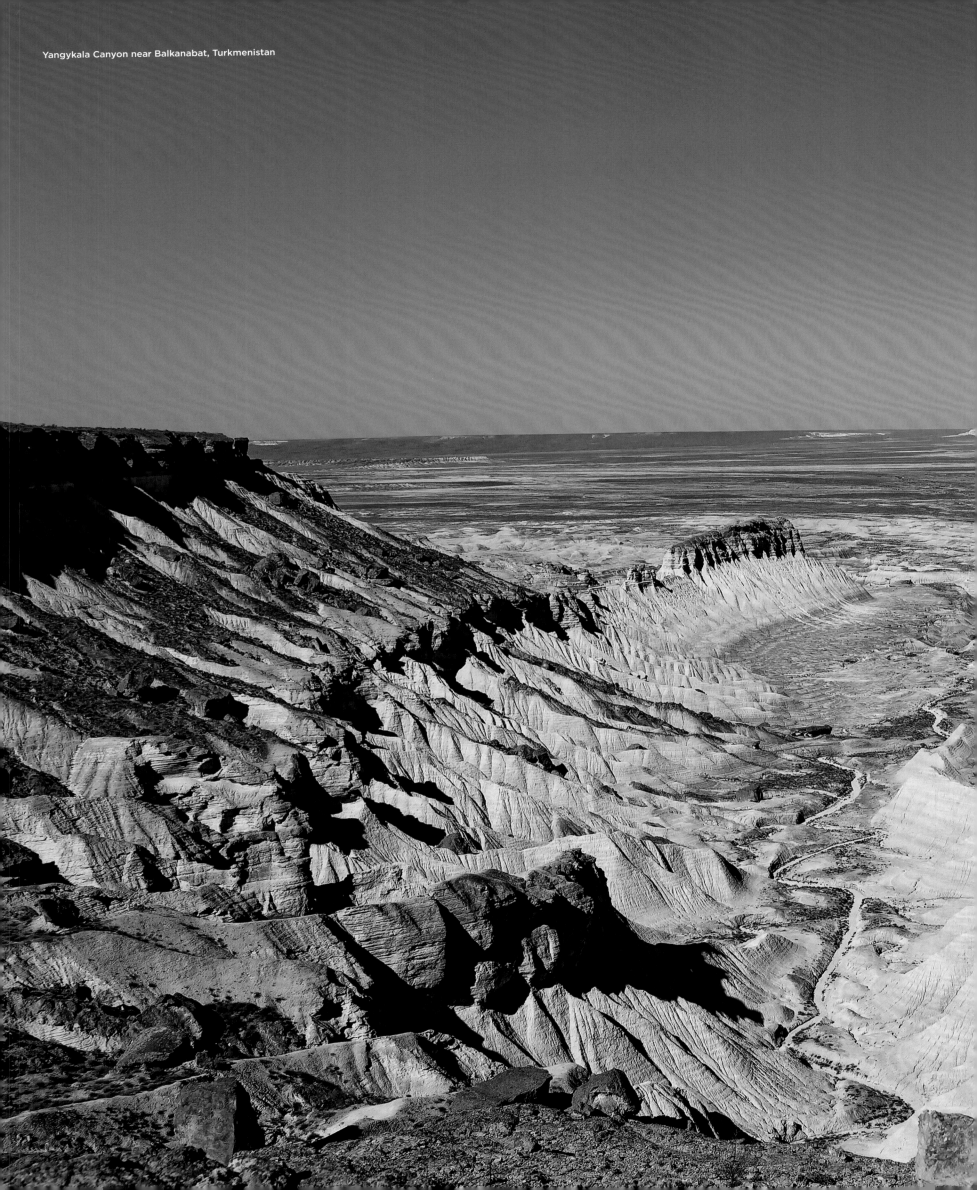

Yangykala Canyon near Balkanabat, Turkmenistan

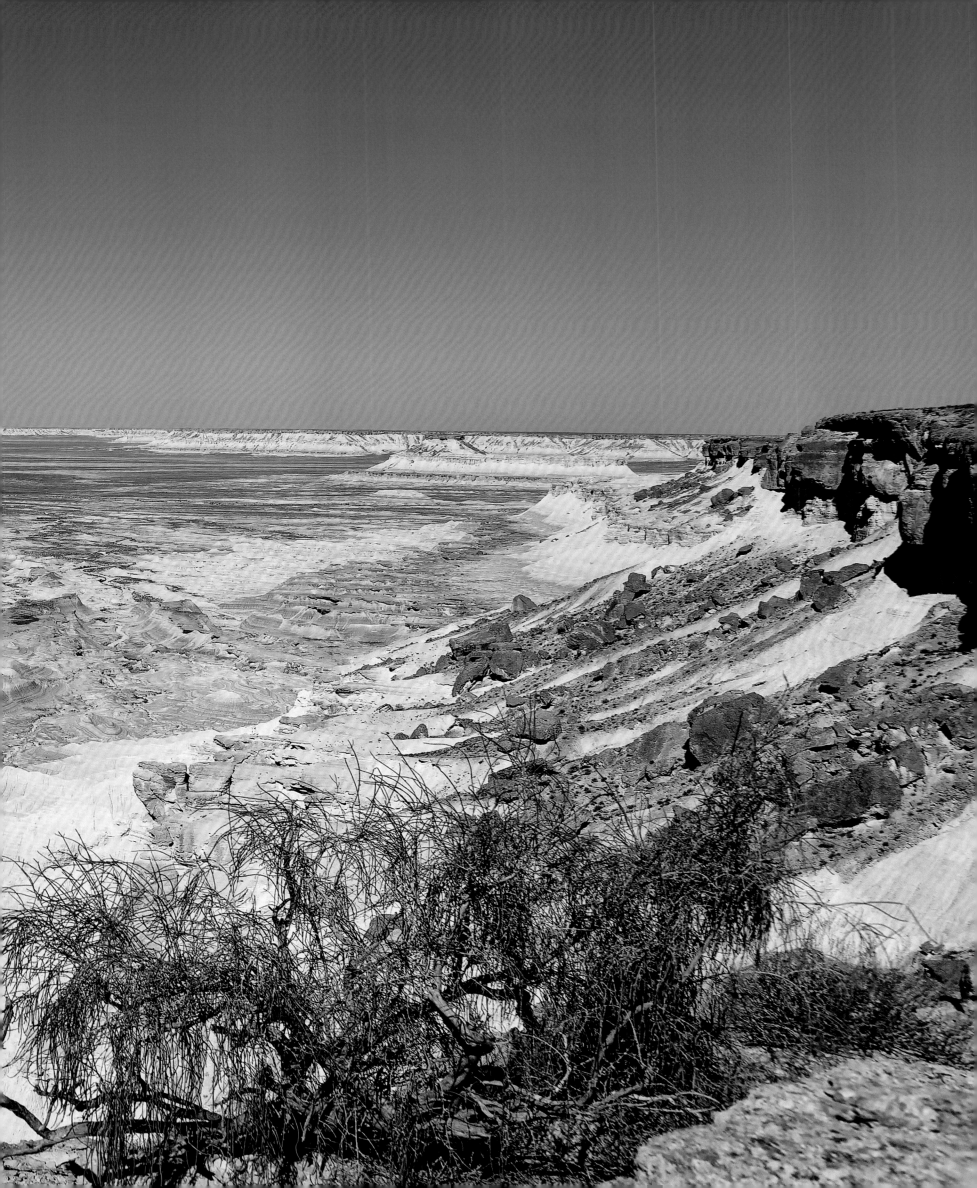

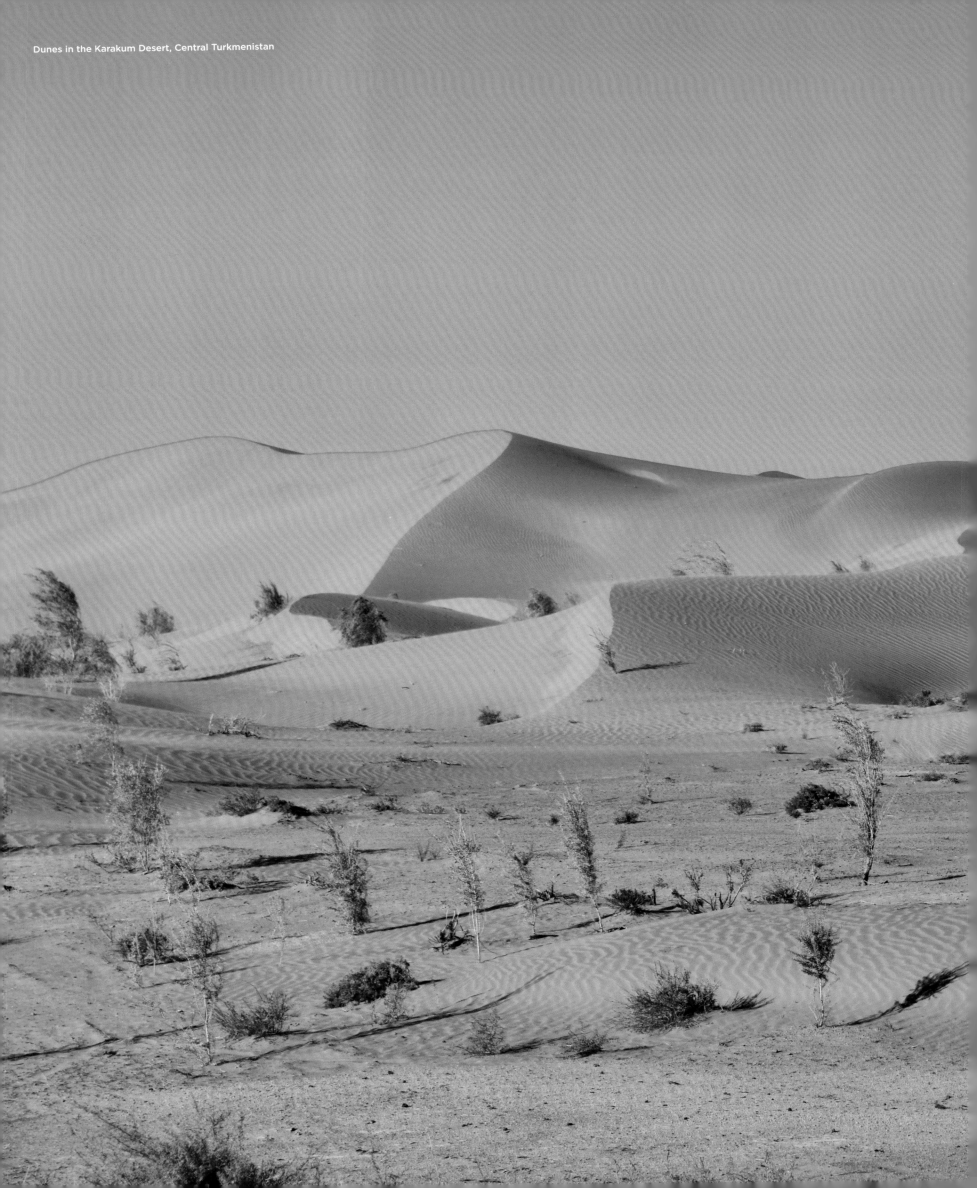

Dunes in the Karakum Desert, Central Turkmenistan

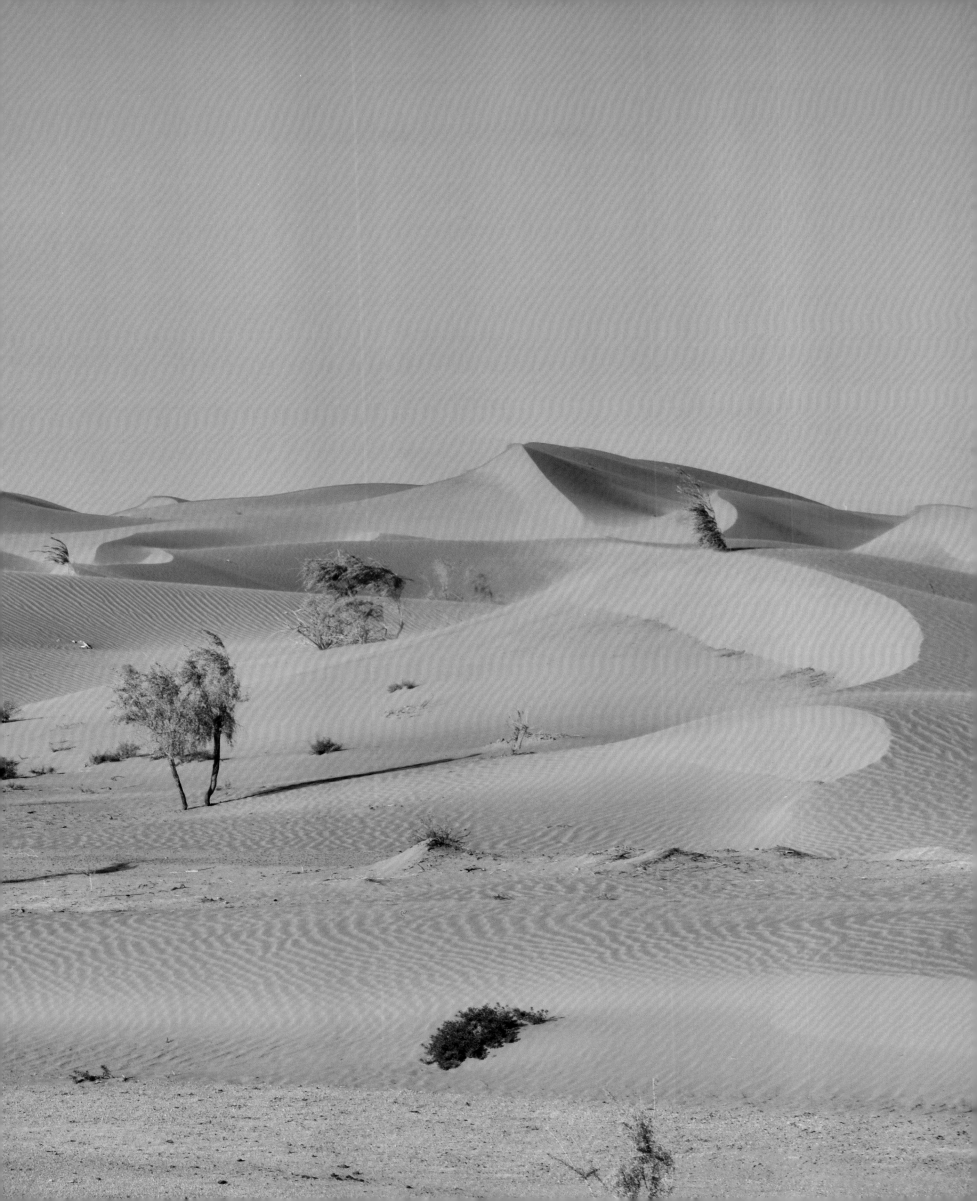

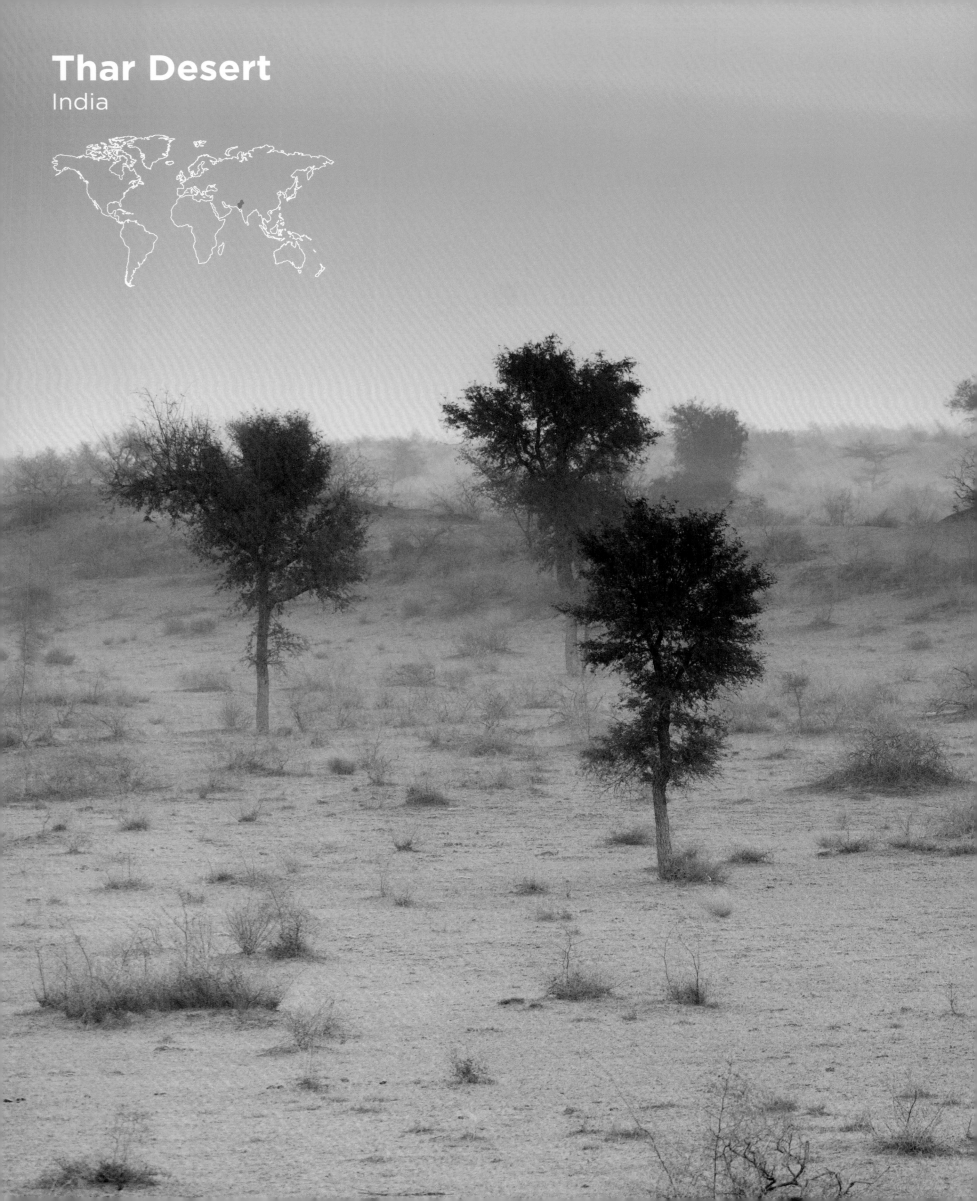

Thar Desert
India

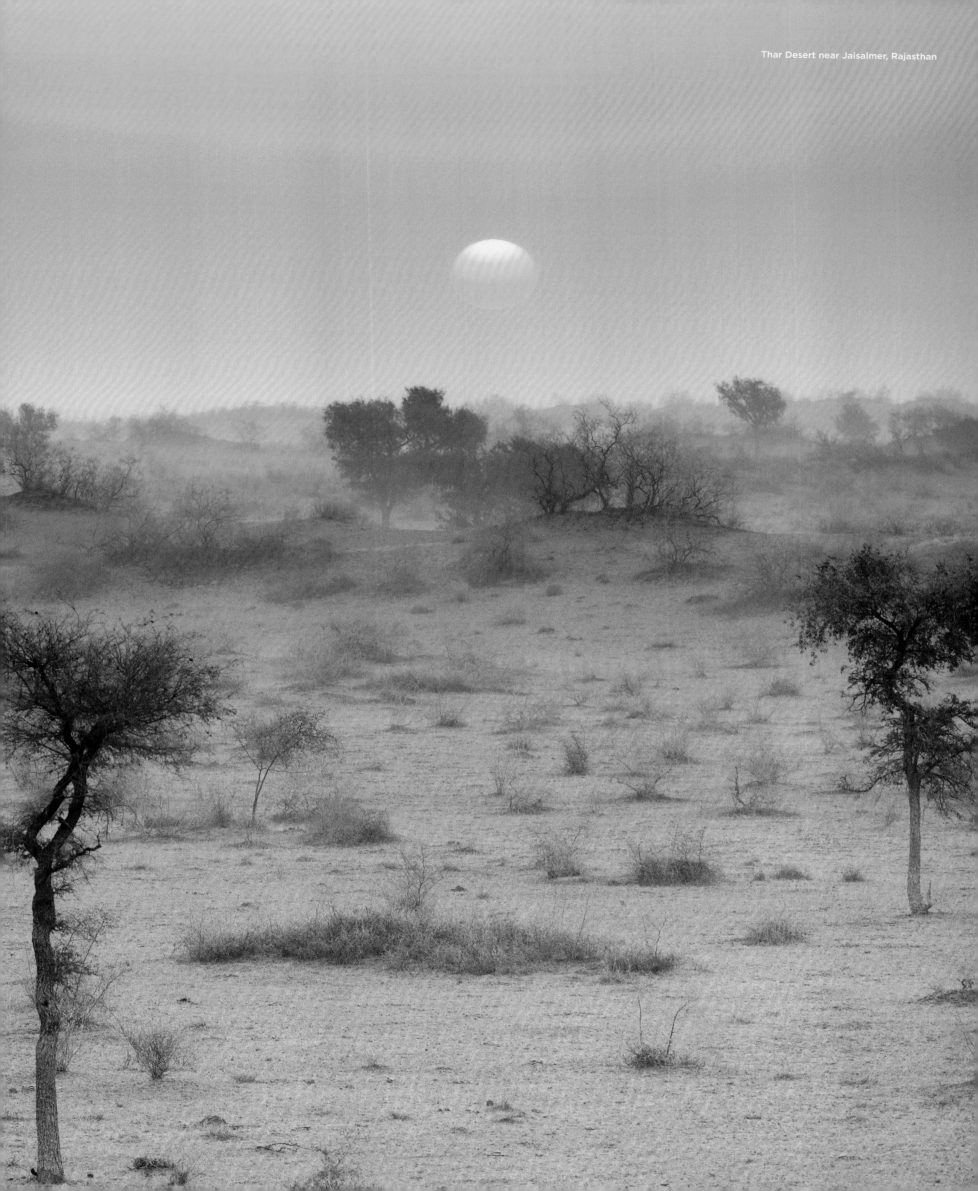

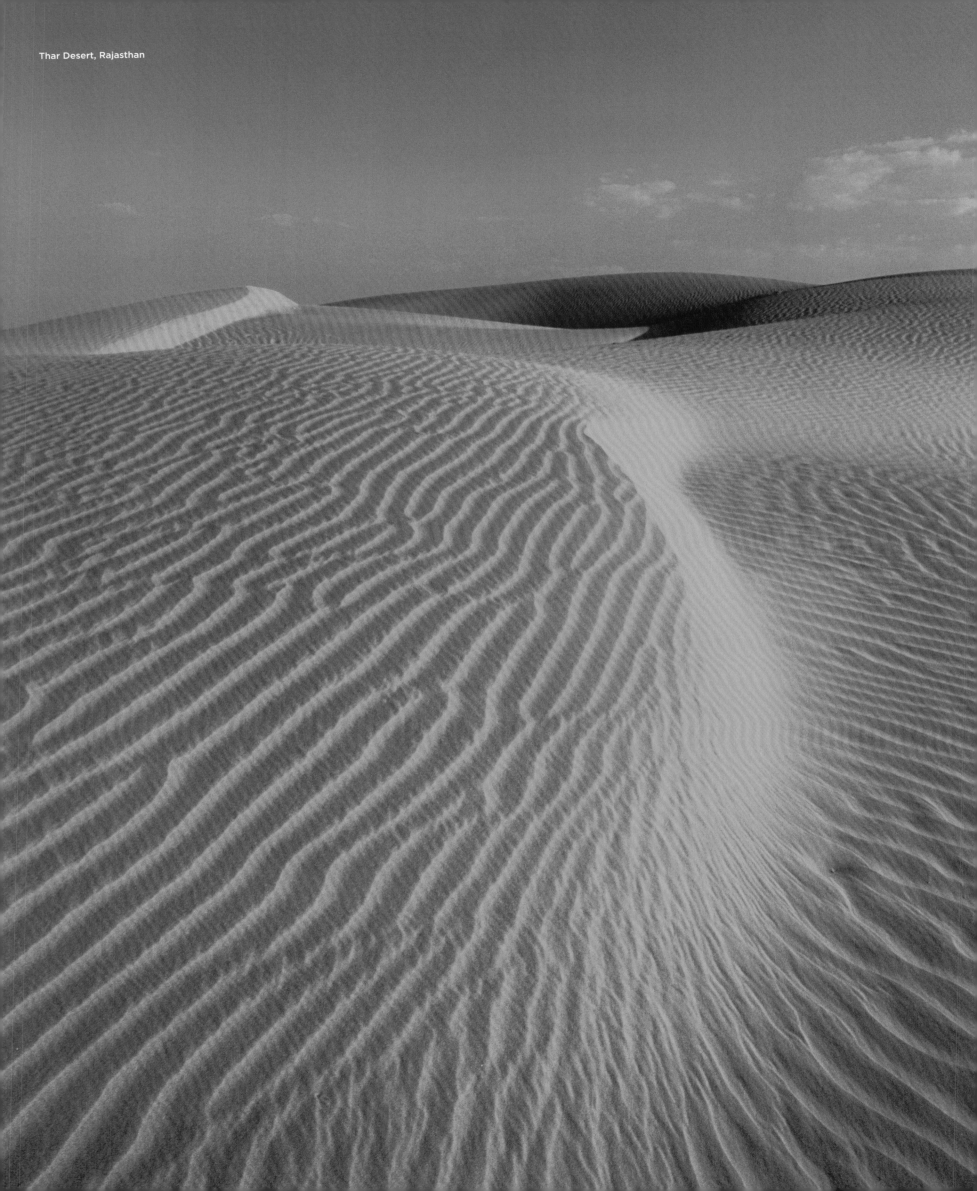

Thar Desert, Rajasthan

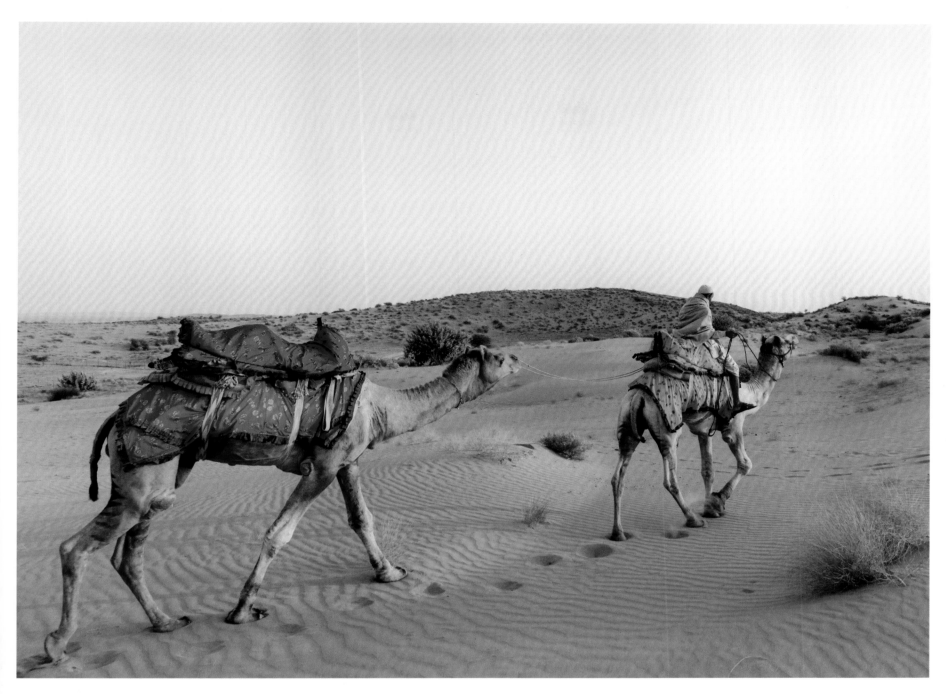

Thar Desert, Rajasthan

Thar Desert

Straddling the frontier between India (75%) and Pakistan (25%), the Thar is also called the Great Indian Desert and covers parts of Rajasthan, Punjab, Gujarat and Haryana. Its mobile sand dunes are a major environmental concern as this is the most densely populated desert in the world – around 40% of Rajasthan's population lives in the Thar Desert.

Désert du Thar

Chevauchant la frontière entre l'Inde (75%) et le Pakistan (25%), le Thar est également appelé le Grand Désert indien et couvre des parties du Rajasthan, du Pendjab, du Gujarat et de l'Haryana. Désert le plus peuplé du monde – environ 40% de la population du Rajasthan y vit –, ses dunes mobiles représentent un problème environnemental majeur.

Thar-Wüste

Die Thar, die sich über die Grenze zwischen Indien (75%) und Pakistan (25%) erstreckt, wird auch die Große Indische Wüste genannt und umfasst Teile von Rajasthan, Punjab, Gujarat und Haryana. Ihre Wanderdünen sind ein großes Umweltproblem, da es sich um die am stärksten bevölkere Wüste der Welt handelt – rund 40% der Bevölkerung Rajasthans leben in der Thar-Wüste.

Desierto de Thar

A caballo entre la frontera entre India (75%) y Pakistán (25%), el Thar es también llamado el Gran Desierto Indio y cubre partes de Rajastán, Punjab, Gujarat y Haryana. Sus dunas de arena móviles son una de las principales preocupaciones medioambientales, ya que se trata del desierto más poblado del mundo: alrededor del 40% de la población de Rajastán vive en el desierto de Thar.

Deserto de Thar

Atravessando a fronteira entre a Índia (75%) e o Paquistão (25%), o Thar também é chamado de Grande Deserto Indiano e abrange partes de Rajasthan, Punjab, Gujarat e Haryana. Suas dunas de areia móveis são uma grande preocupação ambiental, pois este é o deserto mais populoso do mundo – cerca de 40% da população do Rajasthan vive no deserto de Thar.

Tharwoestijn

De Tharwoestijn, die zich op de grens tussen India (75%) en Pakistan (25%) uitstrekt, wordt ook wel de Great Indian Desert genoemd en omvat delen van Rajasthan, Punjab, Gujarat en Haryana. De stuifduinen worden bedreigd doordat dit de dichtstbevolkte woestijn ter wereld is: ongeveer 40% van de bevolking van Rajasthan woont in de Tharwoestijn.

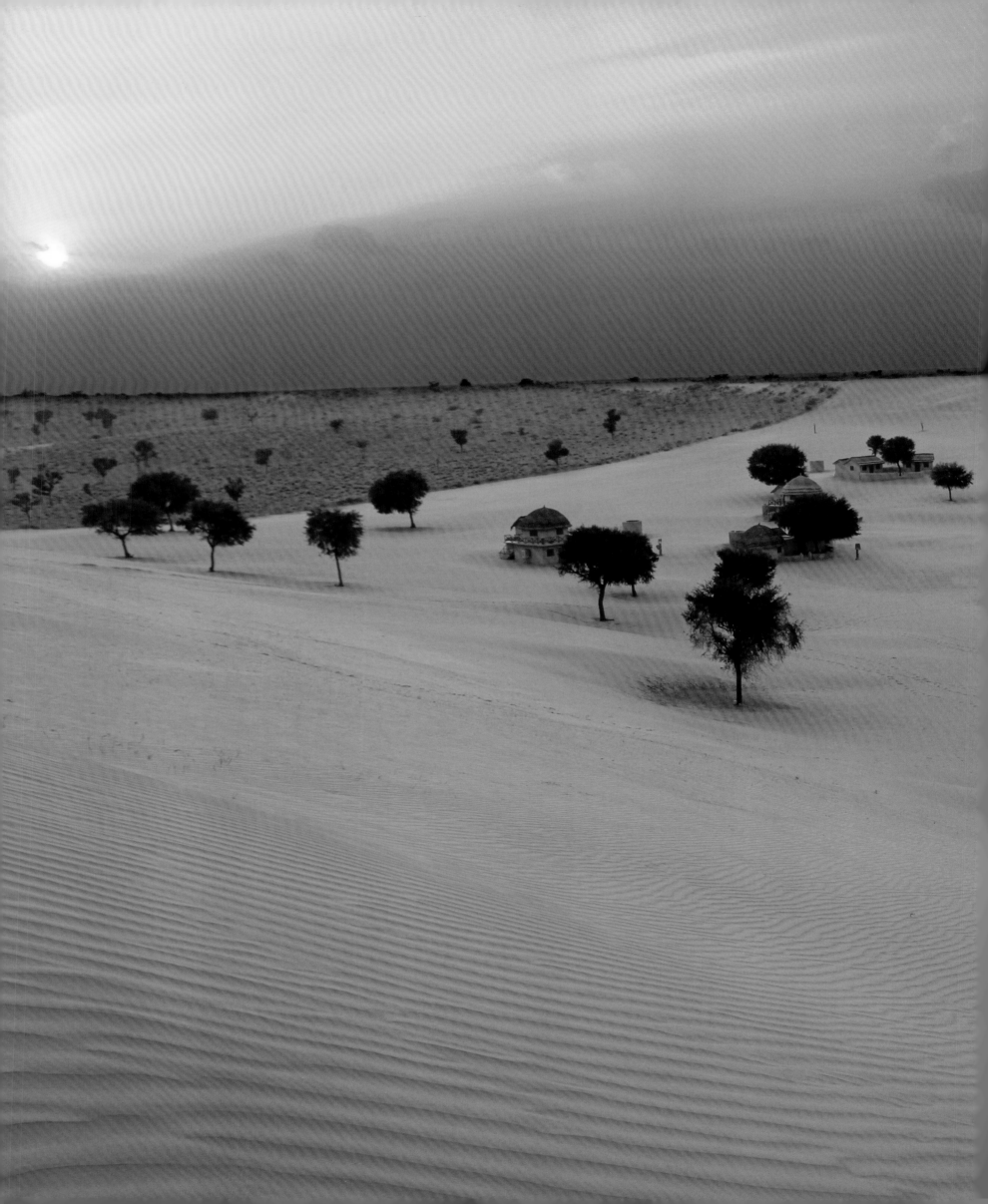

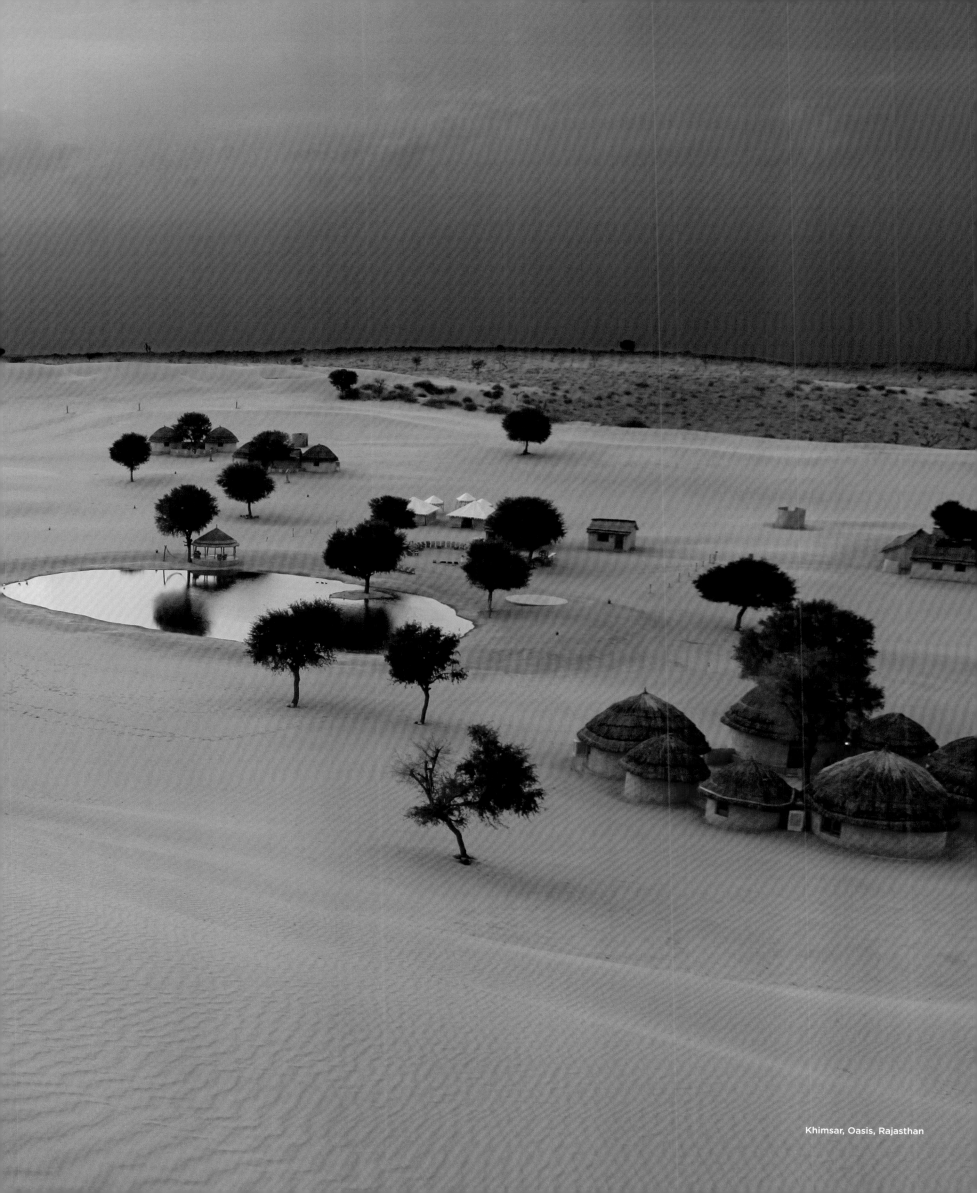

Khimsar, Oasis, Rajasthan

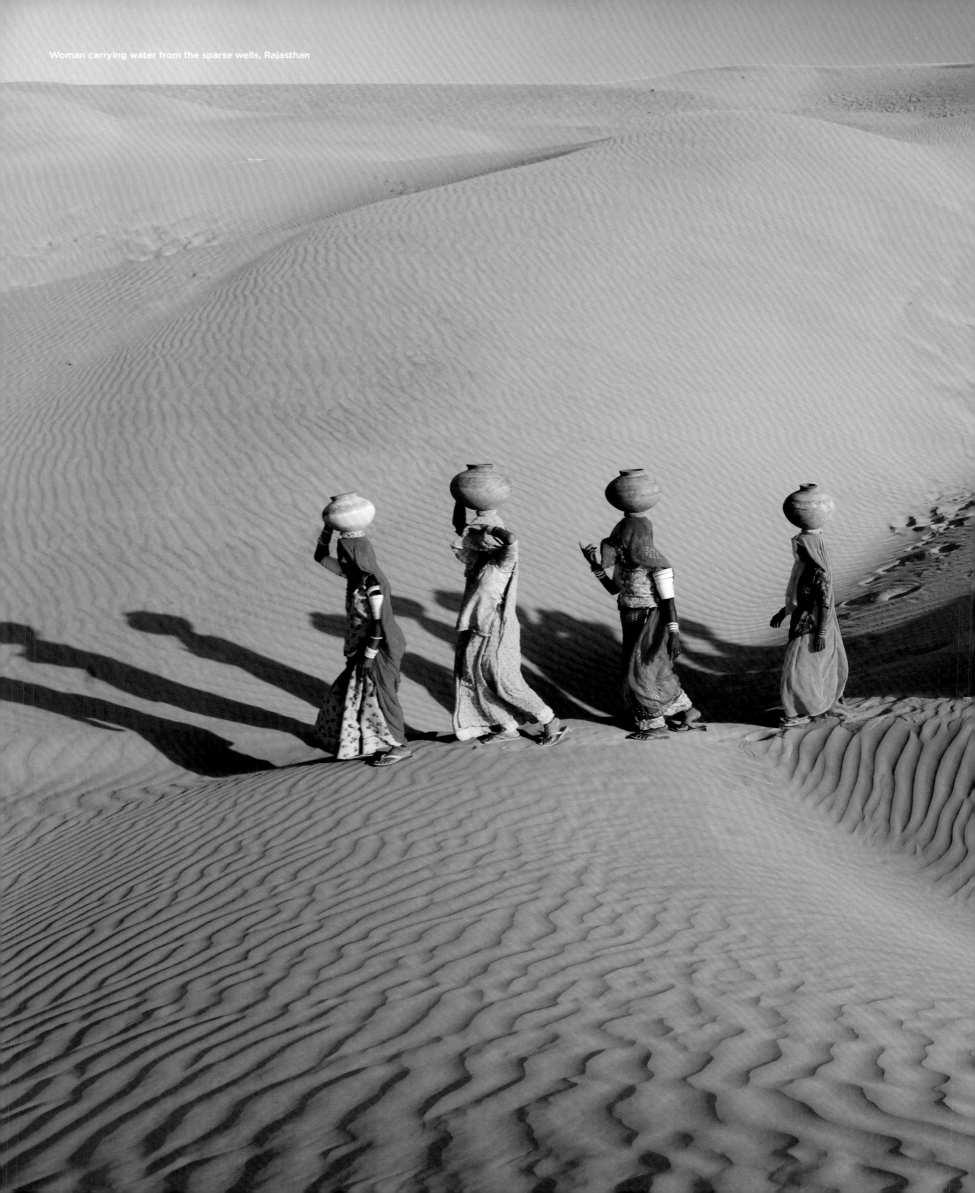

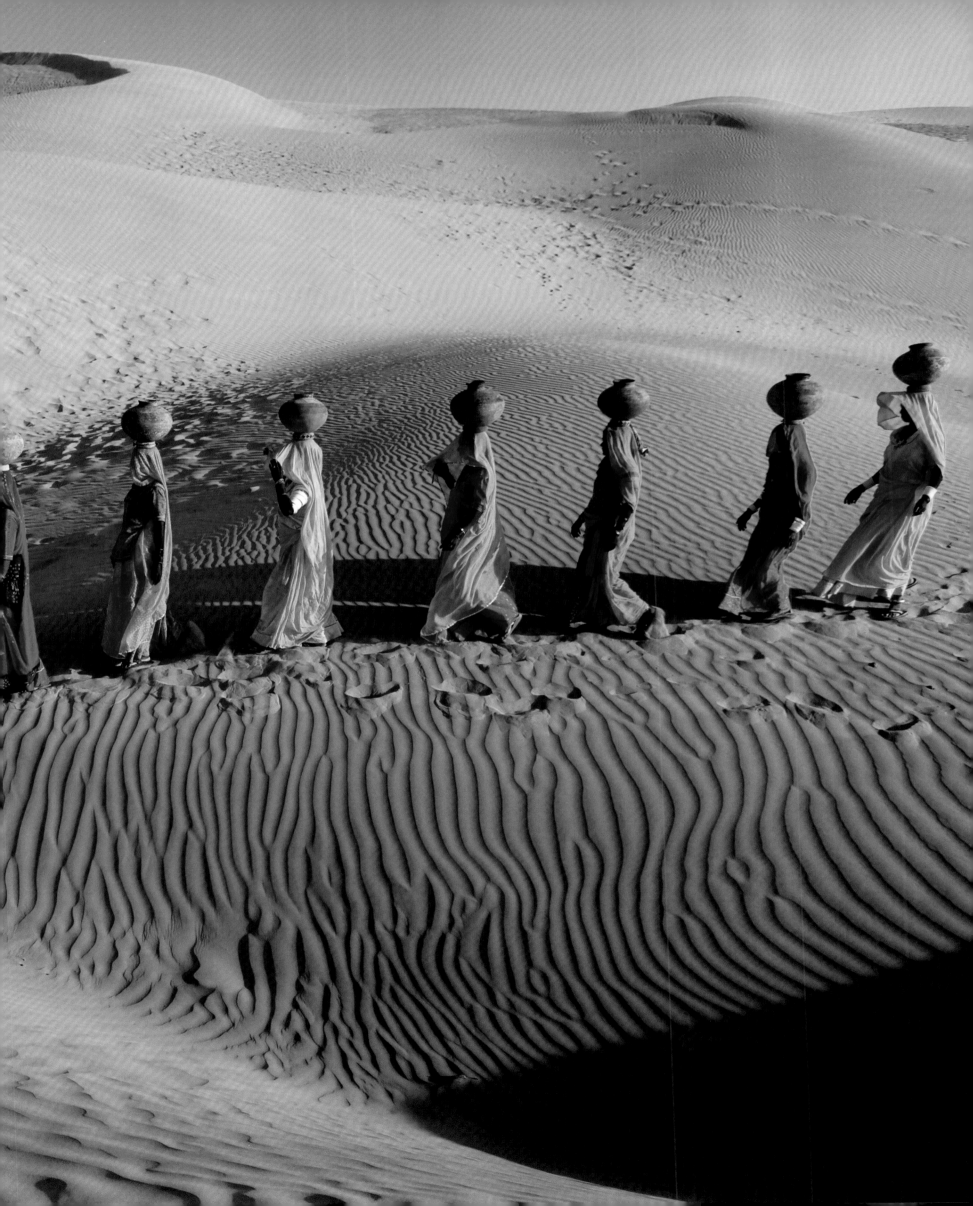

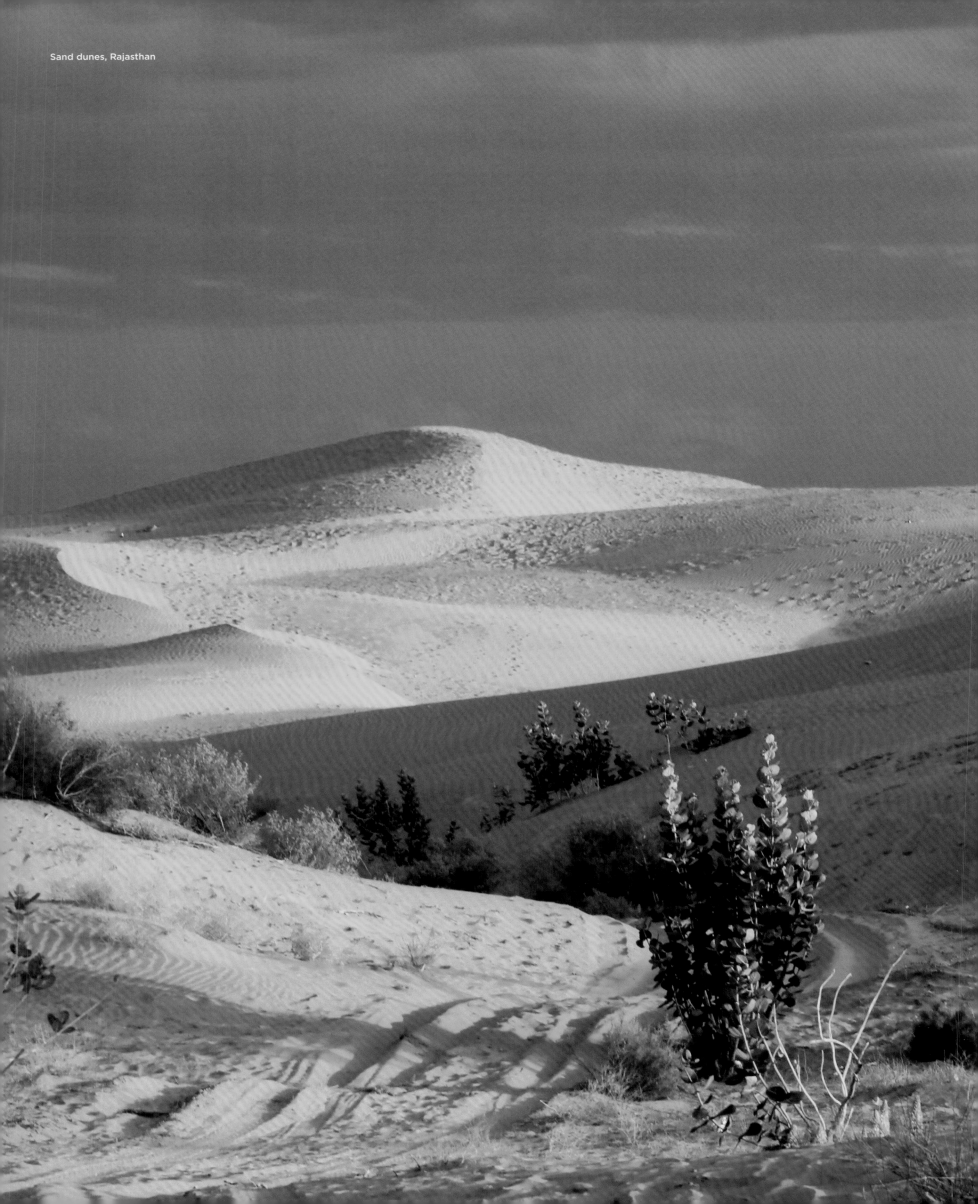
Sand dunes, Rajasthan

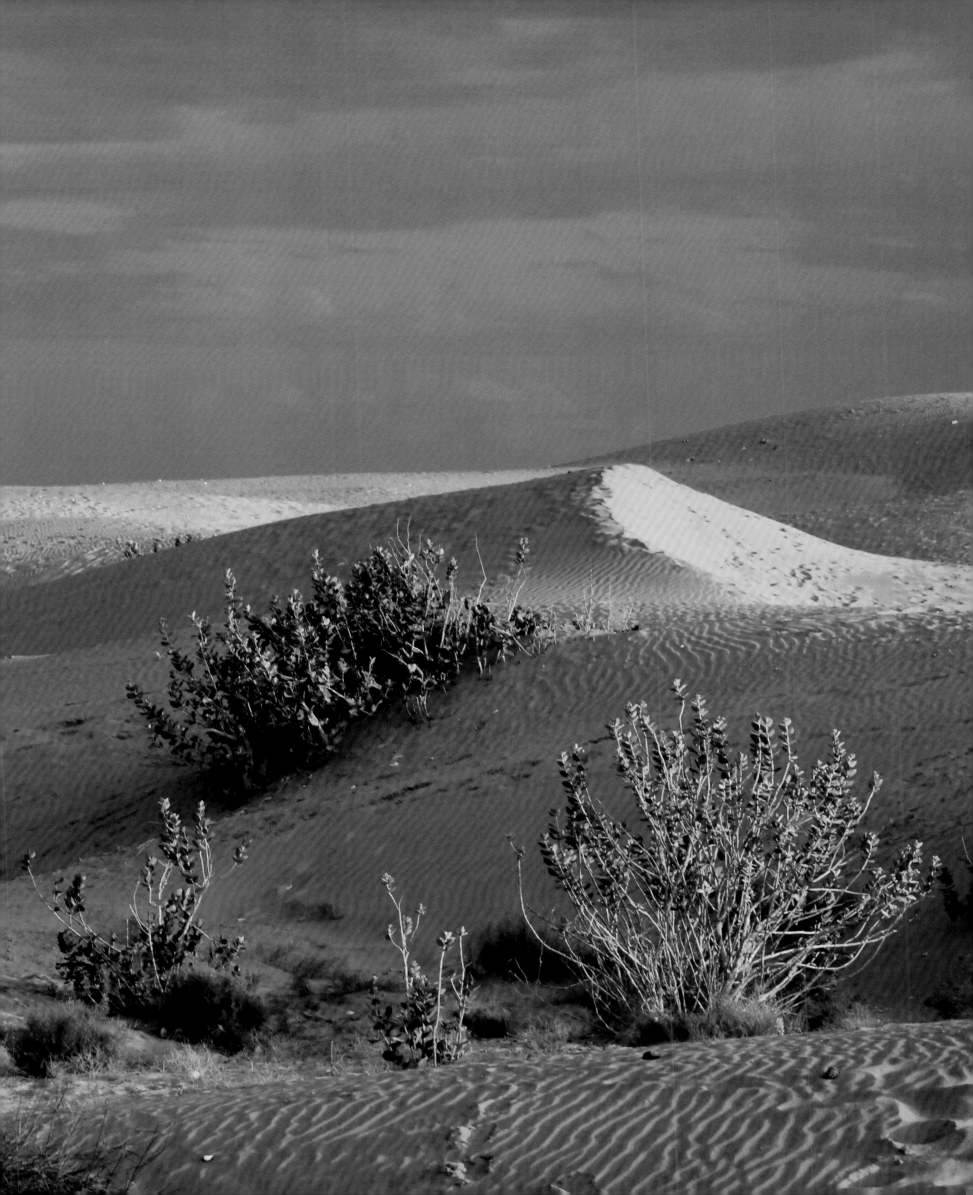

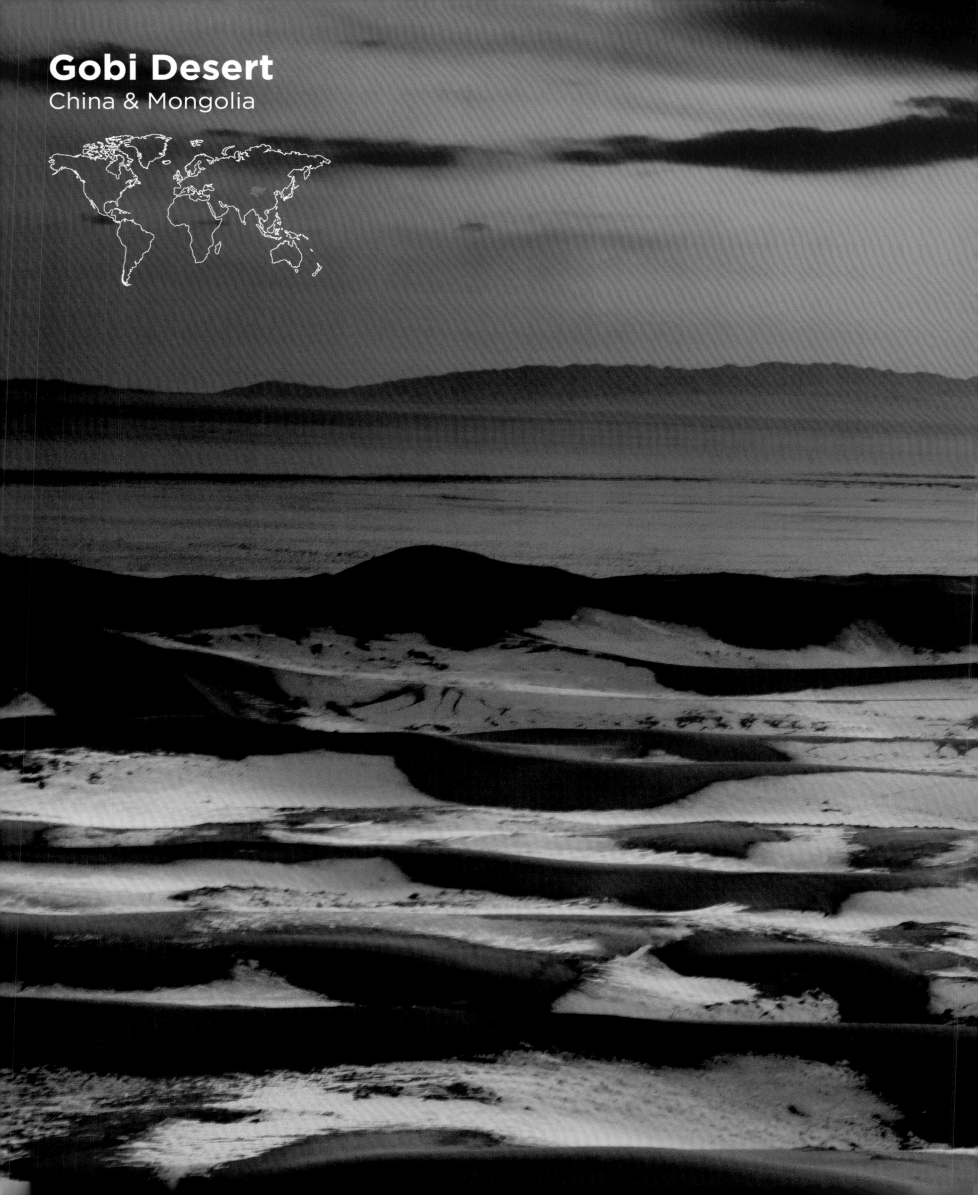

Gobi Desert
China & Mongolia

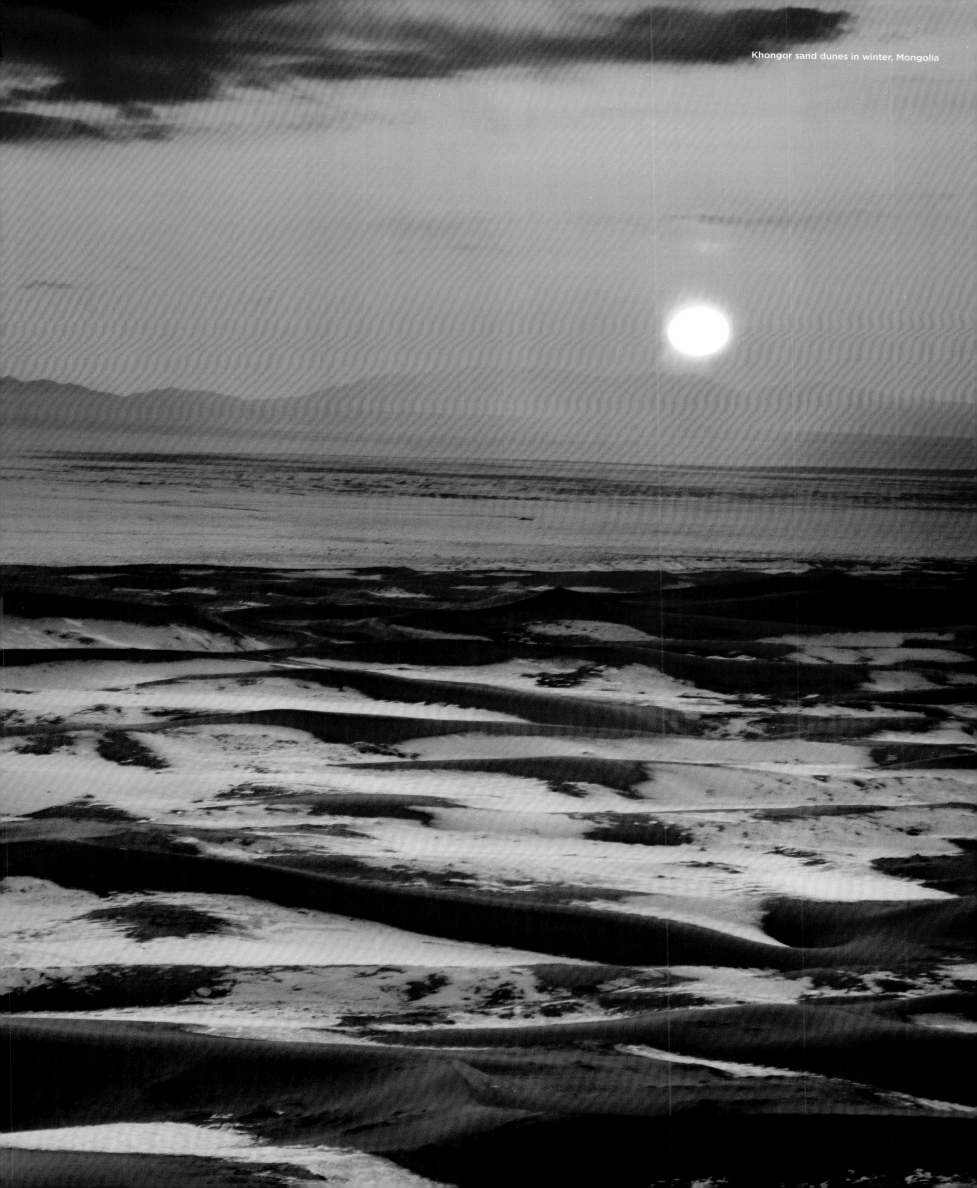

Khongor sand dunes in winter, Mongolia

Khongor sand dunes, Gobi Gurvan Saikhan National Park, South Mongolia

Gobi Desert

The vast Gobi is a cold desert and the world's fifth-largest. Like all deserts, it owes its existence to what lies close by – the Tibetan Plateau casts a rain shadow here, blocking rainclouds rising from the Indian Ocean and creating perfect conditions for a desert. Human history looms large over the Gobi – it was a part of the Mongol Empire and was crossed by the Silk Road. But human activity is causing the desert to grow, eroding topsoil, swallowing grasslands along its southern boundary and causing dust storms that threaten Chinese agriculture.

Désert de Gobi

Cinquième plus grand désert froid du monde, l'immense Gobi s'étire sur environ 1600 km du nord-est au sud-ouest, et sur 850 km du sud au nord. Comme tous les déserts, il doit son existence à son proche environnement – le plateau tibétain produit ici une ombre pluviométrique bloquant la pluie qui s'élève de l'océan Indien, et créé ainsi les conditions idéales pour un désert. L'histoire de l'humanité a beaucoup interagi avec celle du Gobi – il a fait partie de l'Empire mongol et était jadis traversé par la route de la Soie. Mais l'activité humaine, qui érode sa couche arable, étend la superficie du désert, engloutit les prairies le long de sa limite sud et provoque des tempêtes de sable, qui menacent l'agriculture chinoise.

Wüste Gobi

Die riesige Gobi ist eine Wüste mit Kontinentalklima und die fünftgrößte der Welt. Wie alle Wüsten verdankt sie ihre Existenz der Topologie ihrer Umgebung – das tibetische Plateau wirft hier einen Regenschatten, der die vom dem Indischen Ozean kommenden Regenwolken blockiert und so perfekte Bedingungen für eine Wüste schafft. Die Gobi hat eine wichtige Rolle in der Geschichte gespielt – sie war Teil des mongolischen Reiches, und die Seidenstraße führte hindurch. Aber menschliche Aktivitäten lassen die Wüste inzwischen wachsen, erodieren den Mutterboden, verschlingen das Grasland an ihrer Südgrenze und verursachen Staubstürme, die die chinesische Landwirtschaft bedrohen.

Domestic sheep and goats grazing in winter, Mongolia

Desierto de Gobi

El vasto Gobi es un desierto frío y el quinto más grande del mundo. Como todos los desiertos, debe su existencia a lo que hay cerca de él: la meseta tibetana proyecta una sombra de lluvia aquí, bloqueando la lluvia que se eleva desde el Océano Índico y creando las condiciones perfectas para un desierto. La historia de la humanidad se extiende sobre el Gobi, que era parte del imperio mongol y estaba atravesado por la Ruta de la Seda. Pero la actividad humana está provocando el crecimiento del desierto, erosionando la capa superficial del suelo, tragando pastizales a lo largo de su límite sur y causando tormentas de polvo que amenazan la agricultura china.

Deserto de Gobi

O vasto deserto de Gobi é um deserto frio e o quinto maior do mundo. Como todos os desertos, deve sua existência ao que está por perto - o platô tibetano lança uma sombra de chuva aqui, bloqueando a chuva que sobe do Oceano Índico e criando as condições perfeitas para um deserto. A história humana paira sobre o Gobi - era parte do Império Mongol e foi atravessada pela Rota da Seda. Mas a atividade humana está fazendo com que o deserto cresça, erodindo o solo, engolindo pastos ao longo de sua fronteira sul e causando tempestades de poeira que ameaçam a agricultura chinesa.

Gobiwoestijn

De reusachtige Gobi is een woestijn met een continentaal klimaat. Net als alle woestijnen dankt hij zijn bestaan aan de topologie van zijn omgeving: het Tibetaanse Hoogland werpt hier een regenschaduw, die de regen uit de Indische Oceaan tegenhoudt en de perfecte omstandigheden voor een woestijn creëert. De menselijke geschiedenis doemt groot op boven de Gobi. Hij maakte deel uit van het Mongoolse rijk en de Zijderoute liep erdoor. Maar door menselijke activiteiten groeit de woestijn, erodeert de boven-grond, verdwijnt het grasland langs de zuidelijke grens en zijn er stofstormen die de Chinese landbouw bedreigen.

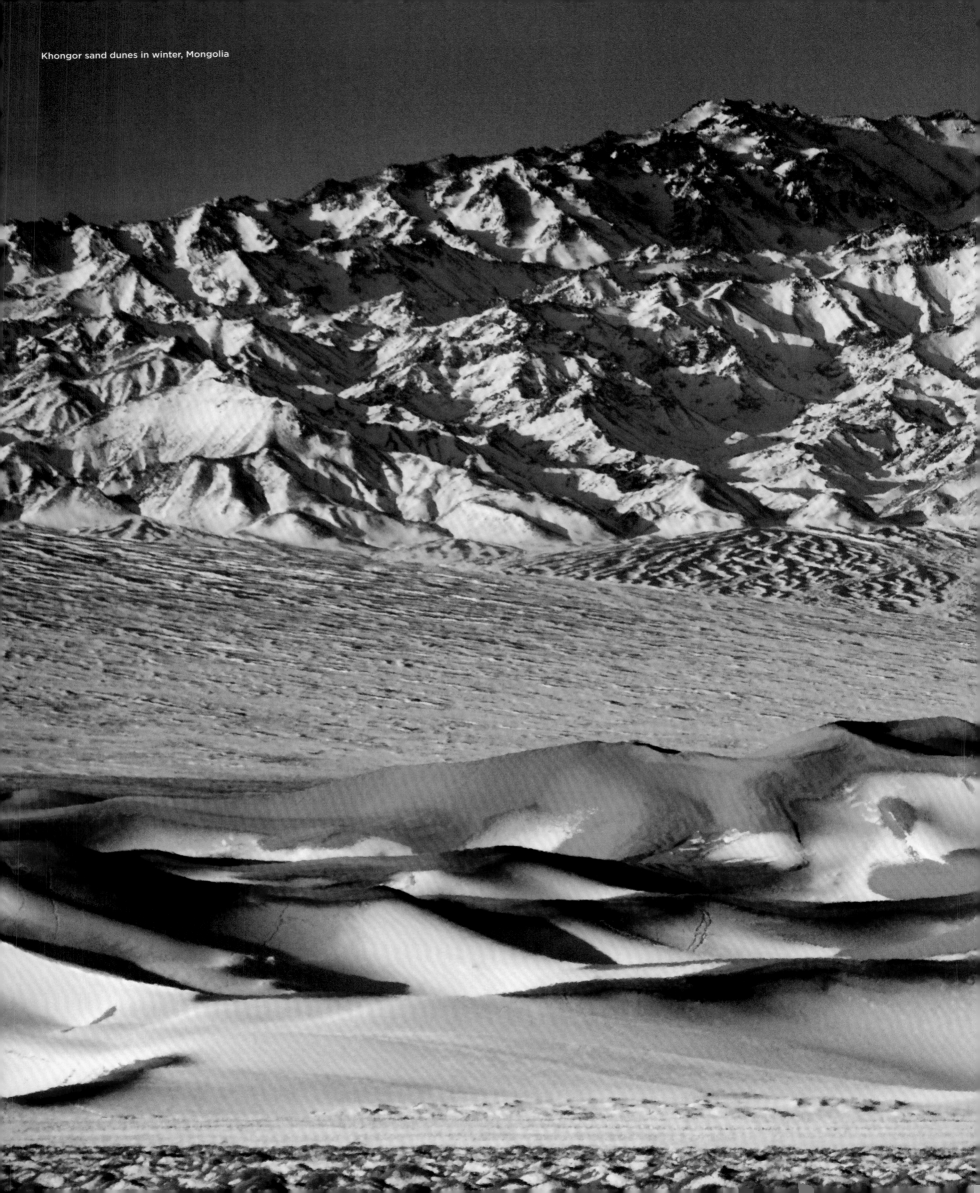

Khongor sand dunes in winter, Mongolia

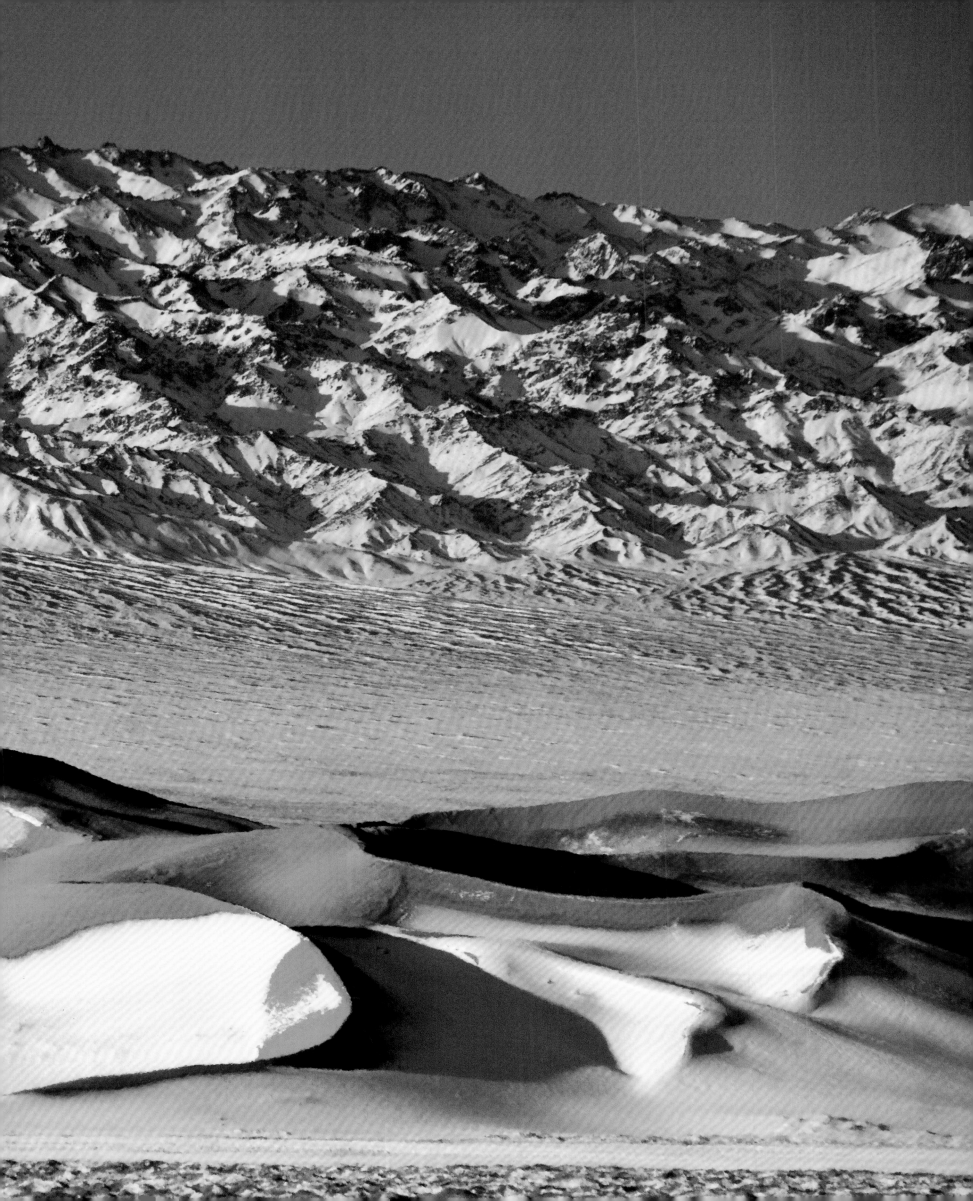

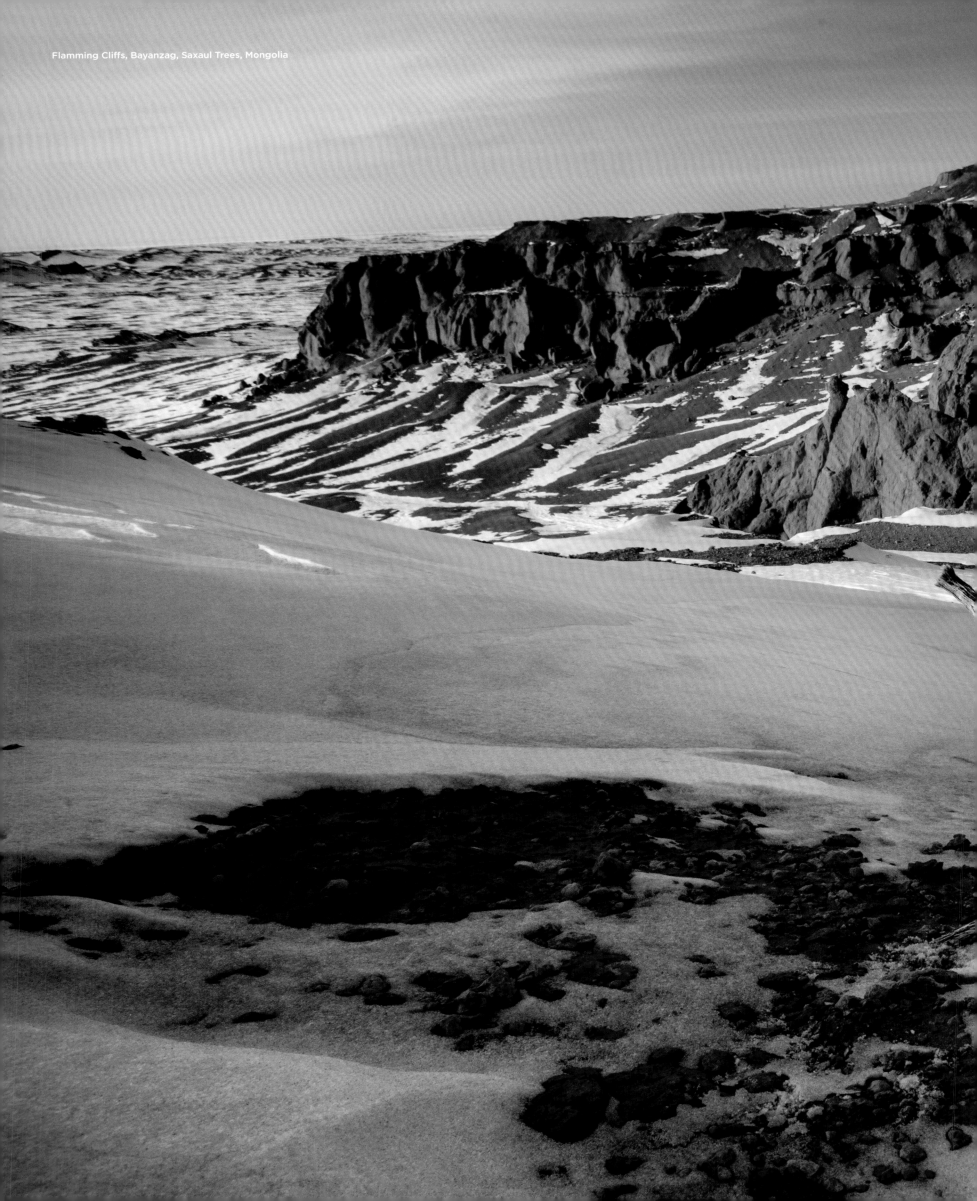

Flamming Cliffs, Bayanzag, Saxaul Trees, Mongolia

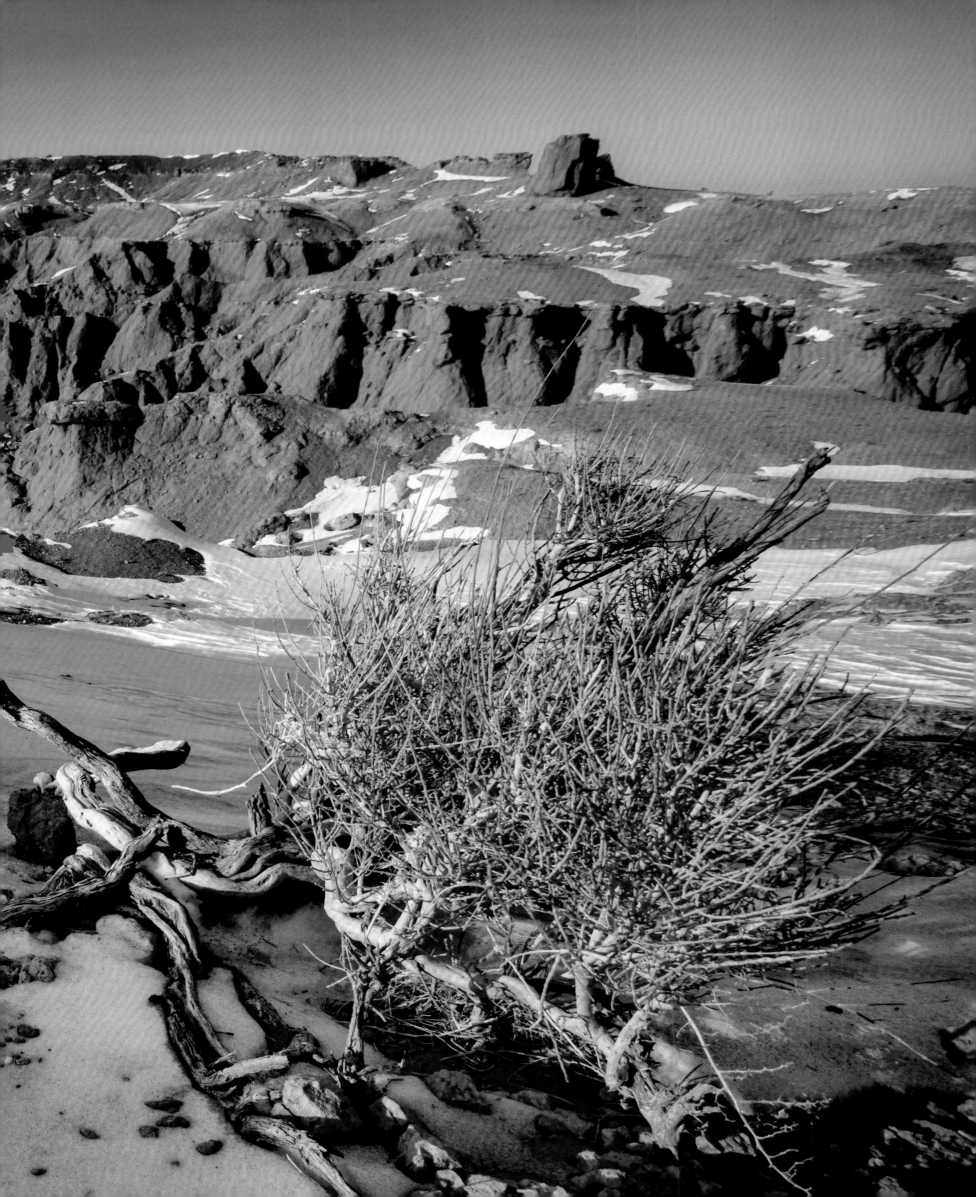

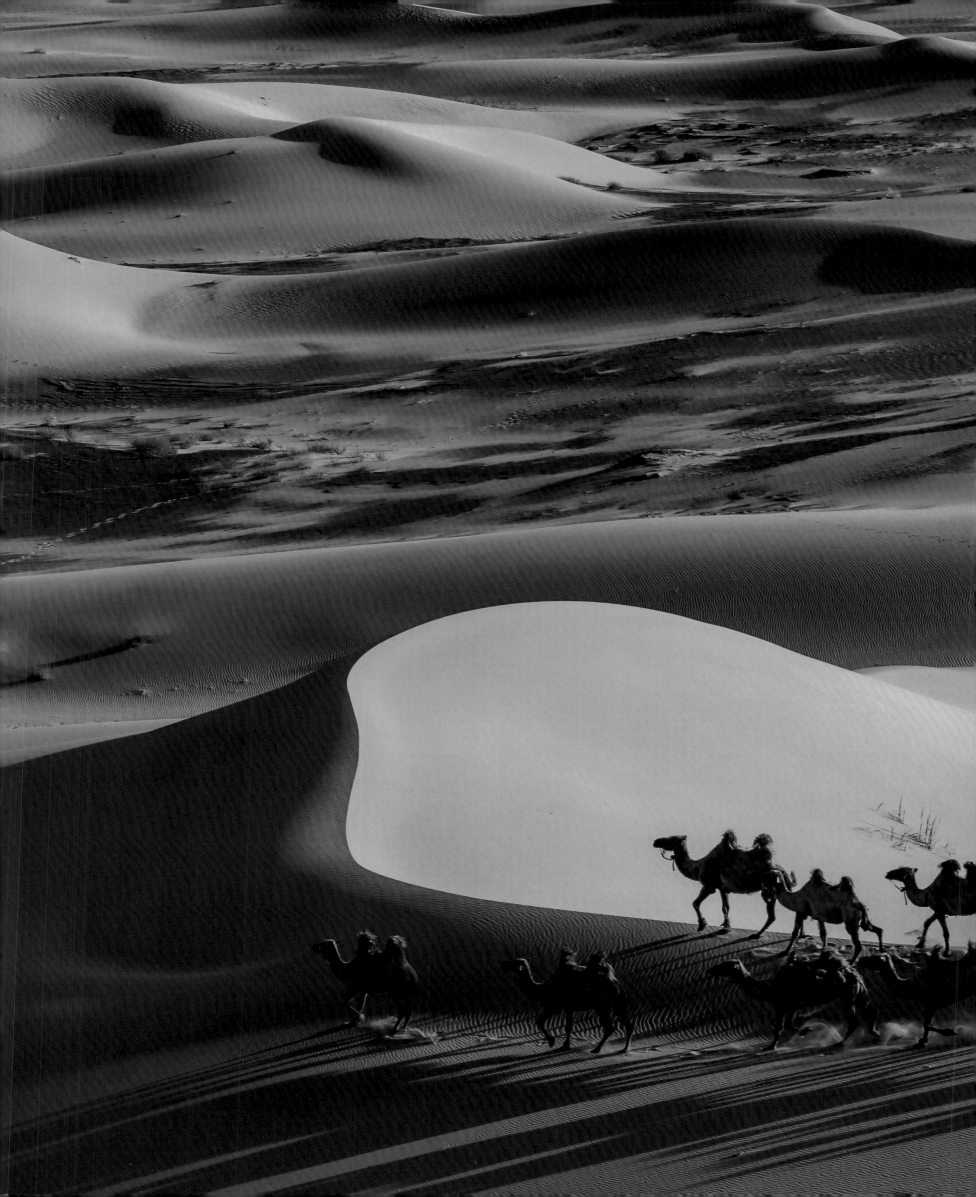

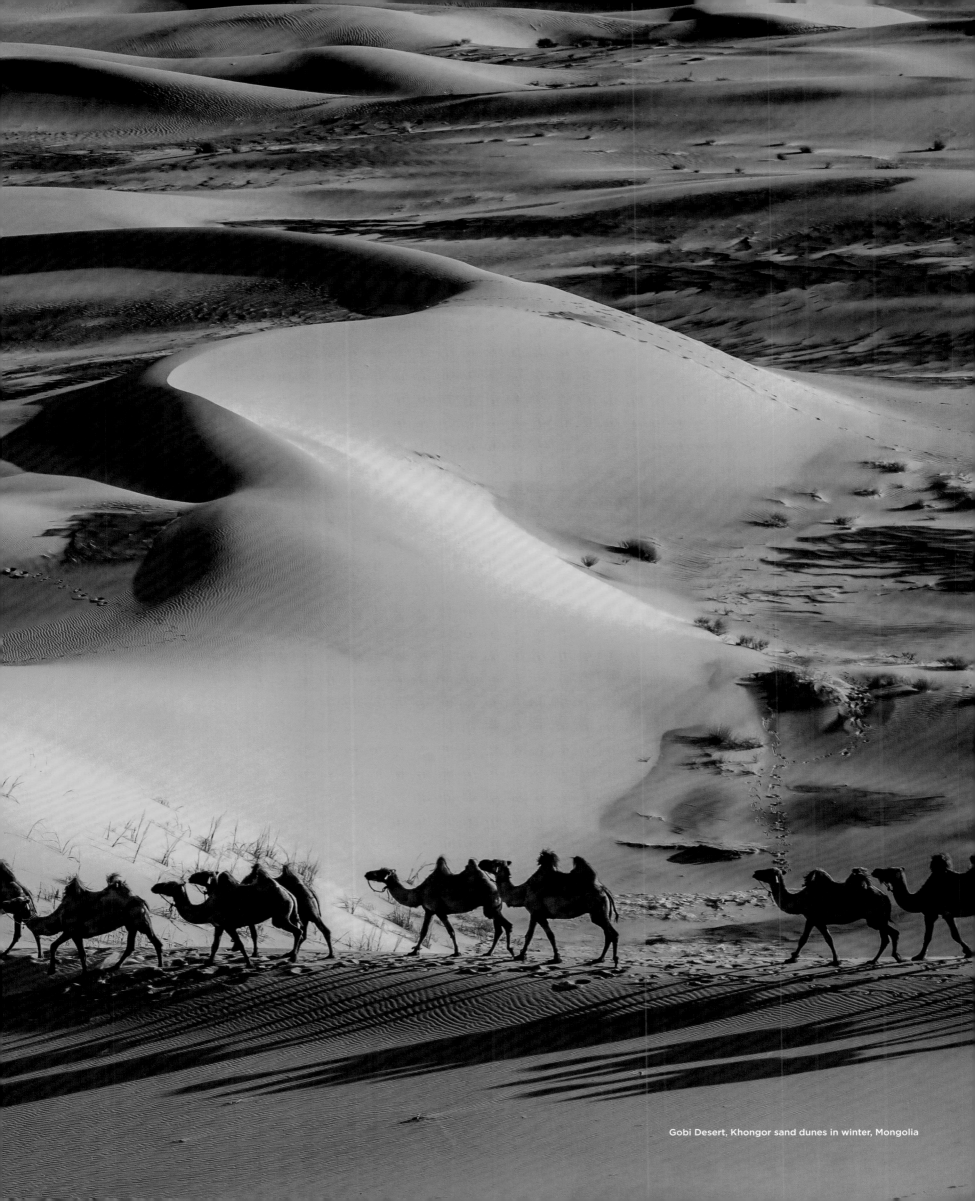

Gobi Desert, Khongor sand dunes in winter, Mongolia

Kumtag Desert
China

Turpan, Xinjiang

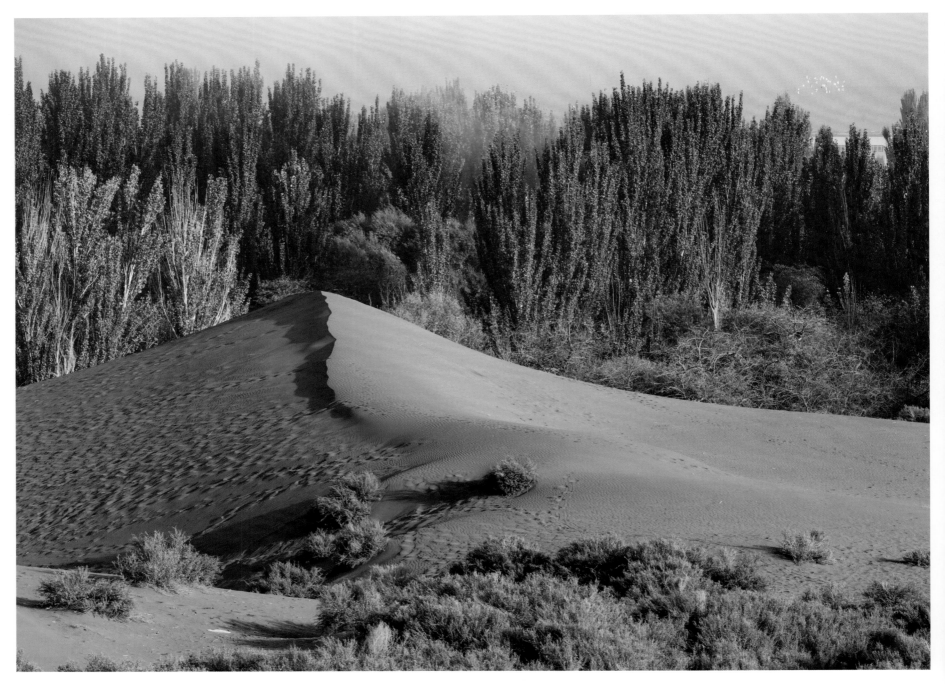

Desert vegetation, Xinjiang

Kumtag Desert

The Kumtag, whose name means 'Sand Mountain' in some regional languages, lies in north-western China and became a national park in 2002. In addition to its sand seas, the drift sand driven by prevailing westerly and north-westerly winds piles high against fragile desert massifs, creating sand dunes nearly 80m high, which may one day reach the mountains' summits. Kumtag is also characterised by mobile mega-dunes, which the Chinese authorities are watching closely to ensure that their relentless march across the desert floor doesn't swallow roads, the Golmud-Dunhuang Railway or even entire towns.

Désert de Kumtagh

Le Kumtagh, dont le nom signifie « montagne de sable » dans certaines langues régionales, s'étend dans le nord-ouest de la Chine, et a obtenu le statut de parc national en 2002. En plus de ses mers de sable, la dérive du sable provoquée par les vents dominants de l'ouest et du nord-ouest, s'amasse contre les fragiles massifs désertiques, créant des dunes hautes de pratiquement quatre-vingts mètres, qui pourraient un jour atteindre les cimes des montagnes. Le Kumtagh est également caractérisé par des dunes géantes mouvantes, que les autorités chinoises surveillent de près pour s'assurer que leur impitoyable avancée n'engloutisse pas les routes, la ligne de chemin de fer Golmud-Dunhuang, voire des villes entières.

Kumtag-Wüste

Die Kumtag, deren Name in einigen Regionalsprachen „Sandberg" bedeutet, liegt im Nordwesten Chinas und wurde 2002 zum Nationalpark erklärt. Neben den Sandmeeren gibt es Treibsanddünen, die von vorherrschenden West- und Nordwestwinden vor den Randbergen bis zu einer Höhe von 80 Metern angehäuft werden und die eines Tages die Gipfel der Berge erreichen könnten. Kumtag ist auch durch riesige Wanderdünen gekennzeichnet, die von den chinesischen Behörden genau beobachtet werden, um sicherzustellen, dass ihr unerbittlicher Marsch über den Wüstenboden nicht Straßen, die Bahnlinie Golmud-Dunhuang oder sogar ganze Städte verschlingt.

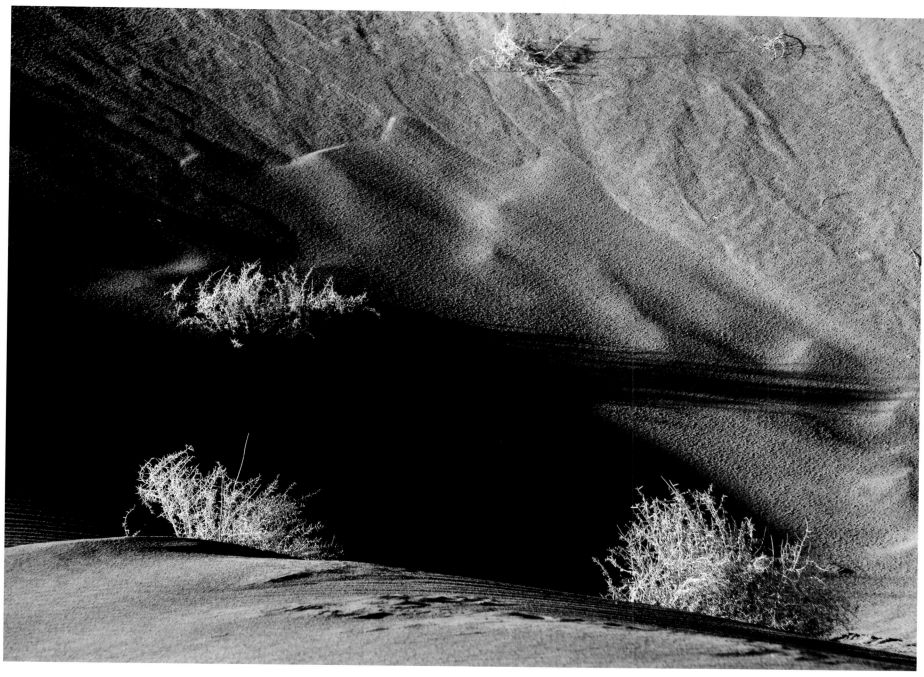

Desert plants, Xinjiang

Desierto de Kumtag

El Kumtag, cuyo nombre significa «Montaña de arena» en algunos idiomas regionales, se encuentra en el noroeste de China y se convirtió en parque nacional en 2002. Además de sus mares de arena, la arena a la deriva, impulsada por los vientos predominantes del oeste y del noroeste, se amontona contra frágiles macizos desérticos, creando dunas de arena de casi 80 m de altura y que puede que algún día alcancen las cumbres de las montañas. Kumtag también se caracteriza por megadunas móviles, que las autoridades chinas vigilan de cerca para asegurarse de que su implacable marcha a través del suelo del desierto no se trague las carreteras, el ferrocarril Golmud-Dunhuang o incluso ciudades enteras.

Deserto de Kumtag

O Kumtag, cujo nome significa 'Sand Mountain' em algumas línguas regionais, fica no noroeste da China e se tornou um parque nacional em 2002. Além de seus mares de areia, a areia levada pelos ventos predominantes de oeste e noroeste empilha contra frágeis maciços desérticos, criando dunas de quase 80 m de altura e que um dia poderão atingir os cumes das montanhas. O Kumtag também é caracterizado por Mega dunas móveis, que as autoridades chinesas estão observando atentamente para garantir que sua marcha implacável pelo chão do deserto não engula estradas, a Ferrovia Golmud-Dunhuang ou mesmo cidades inteiras.

Kumtag Desert

De Kumtag, waarvan de naam in sommige regionale talen 'zandberg' betekent, ligt in het noordwesten van China en is in 2002 een nationaal park geworden. Naast de zandzeeën zijn er zandverstuivingen, die zich door de overheersende westen- en noord-westenwinden hoog opstapelen tegen kwetsbare woestijnmassieven. Er onstaan zandduinen van bijna 80 meter hoog, die op den duur de toppen van de bergen kunnen bereiken. Kumtag wordt ook gekenmerkt door reusachtige stuifduinen, die door de Chinese autoriteiten nauwlettend in de gaten worden houden om te voorkomen dat ze tijdens hun meedogenloze opmars over de woestijnvloer wegen, de Golmud-Dunhuang-spoorlijn of zelfs hele steden opslokken.

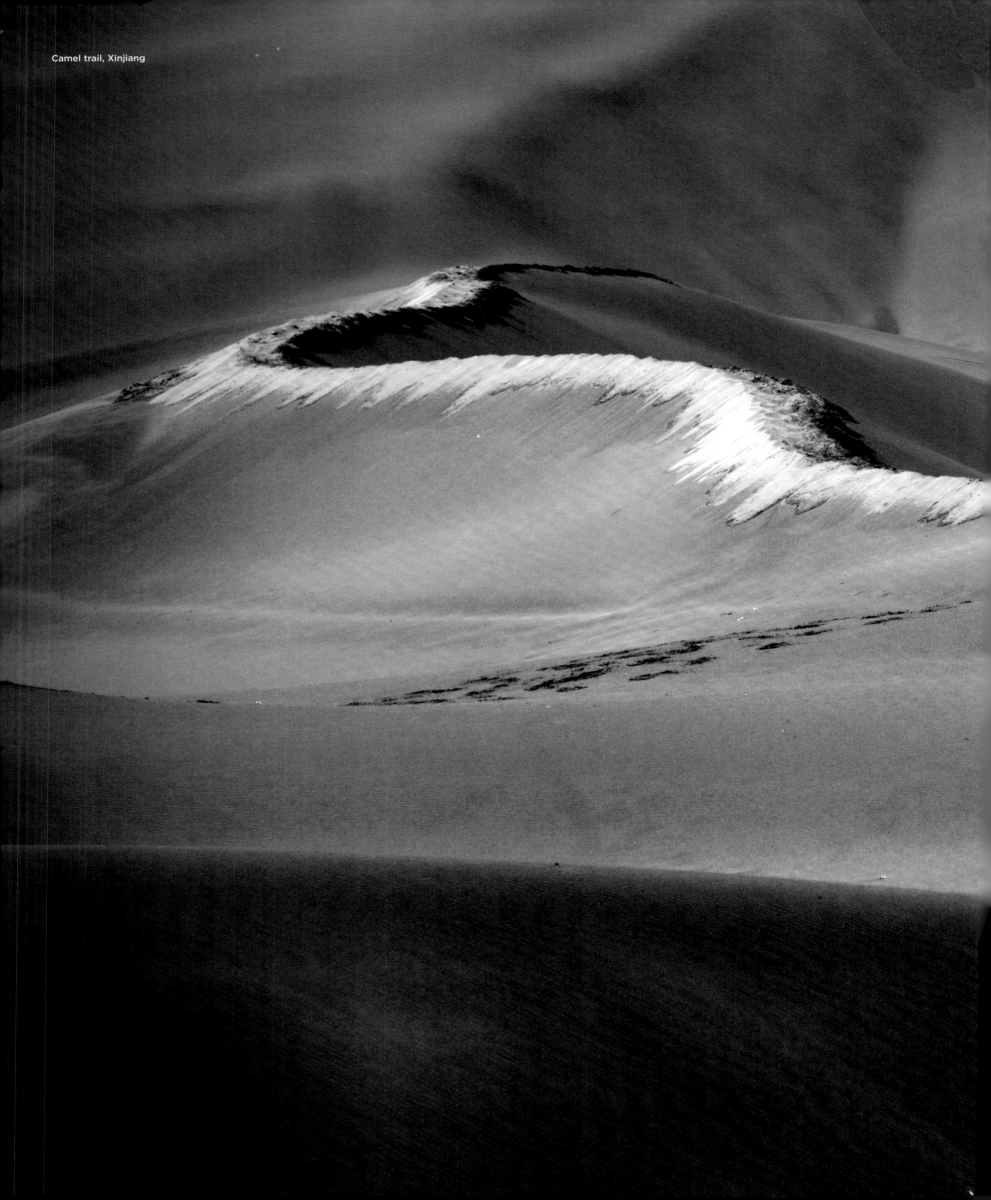

Camel trail, Xinjiang

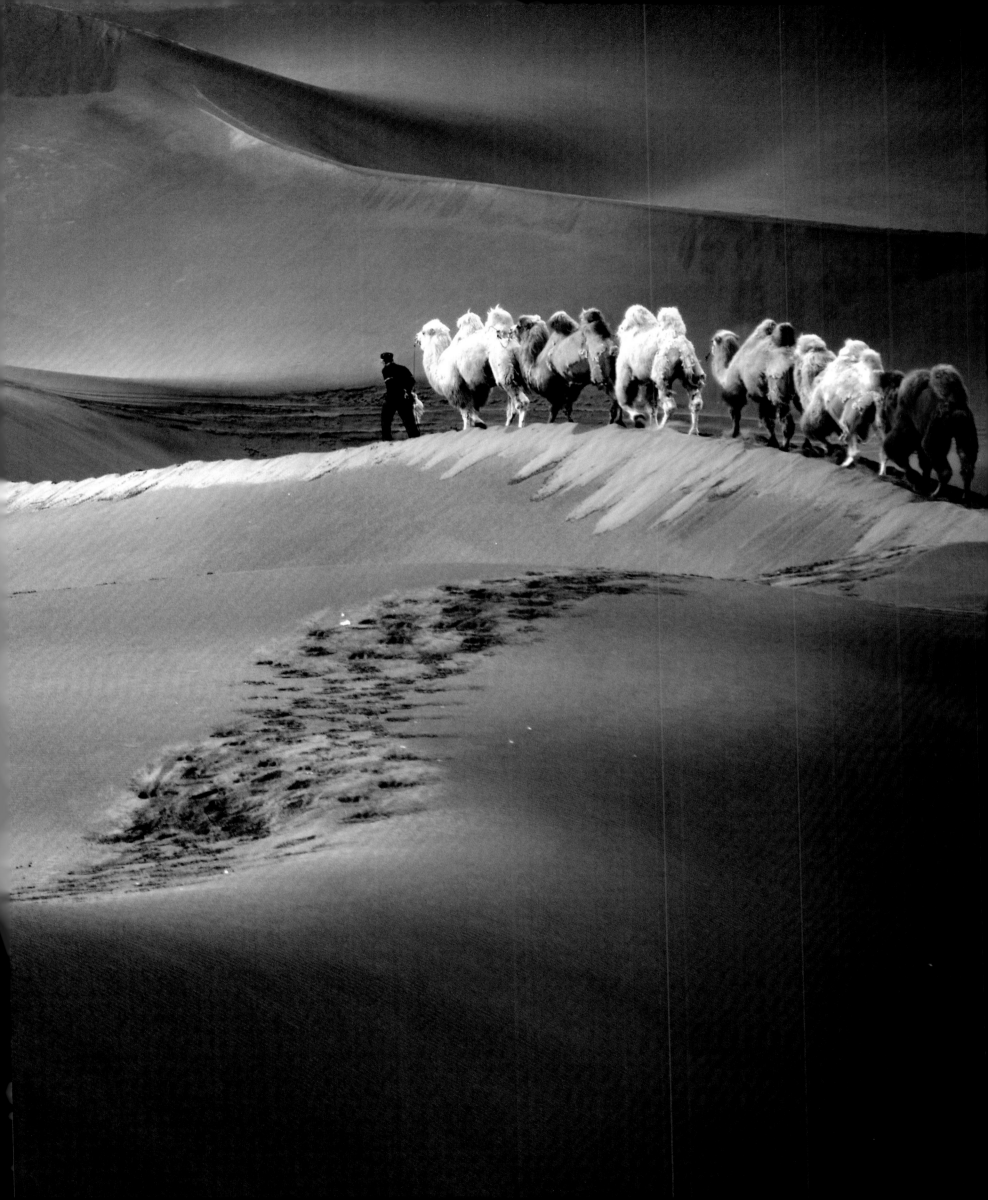

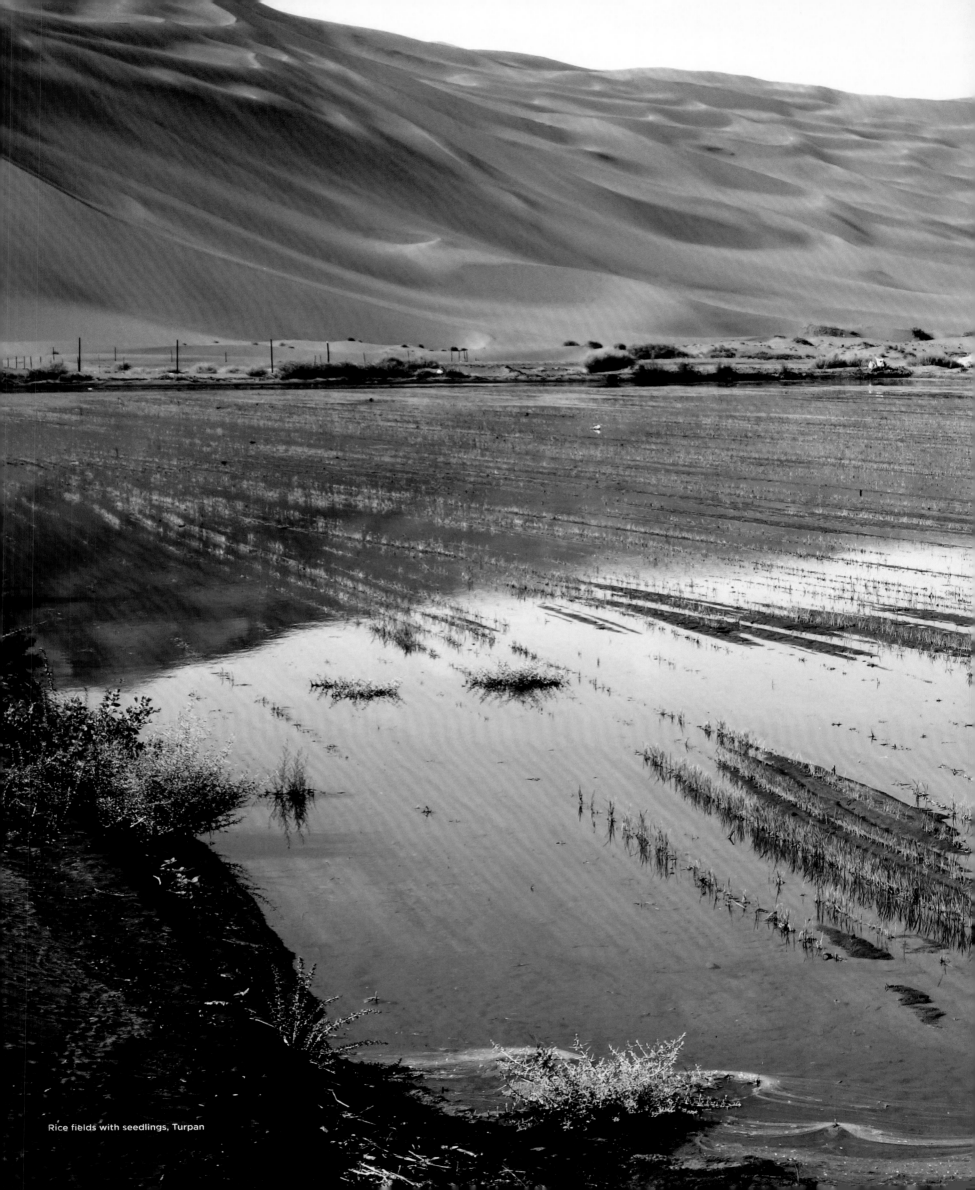

Rice fields with seedlings, Turpan

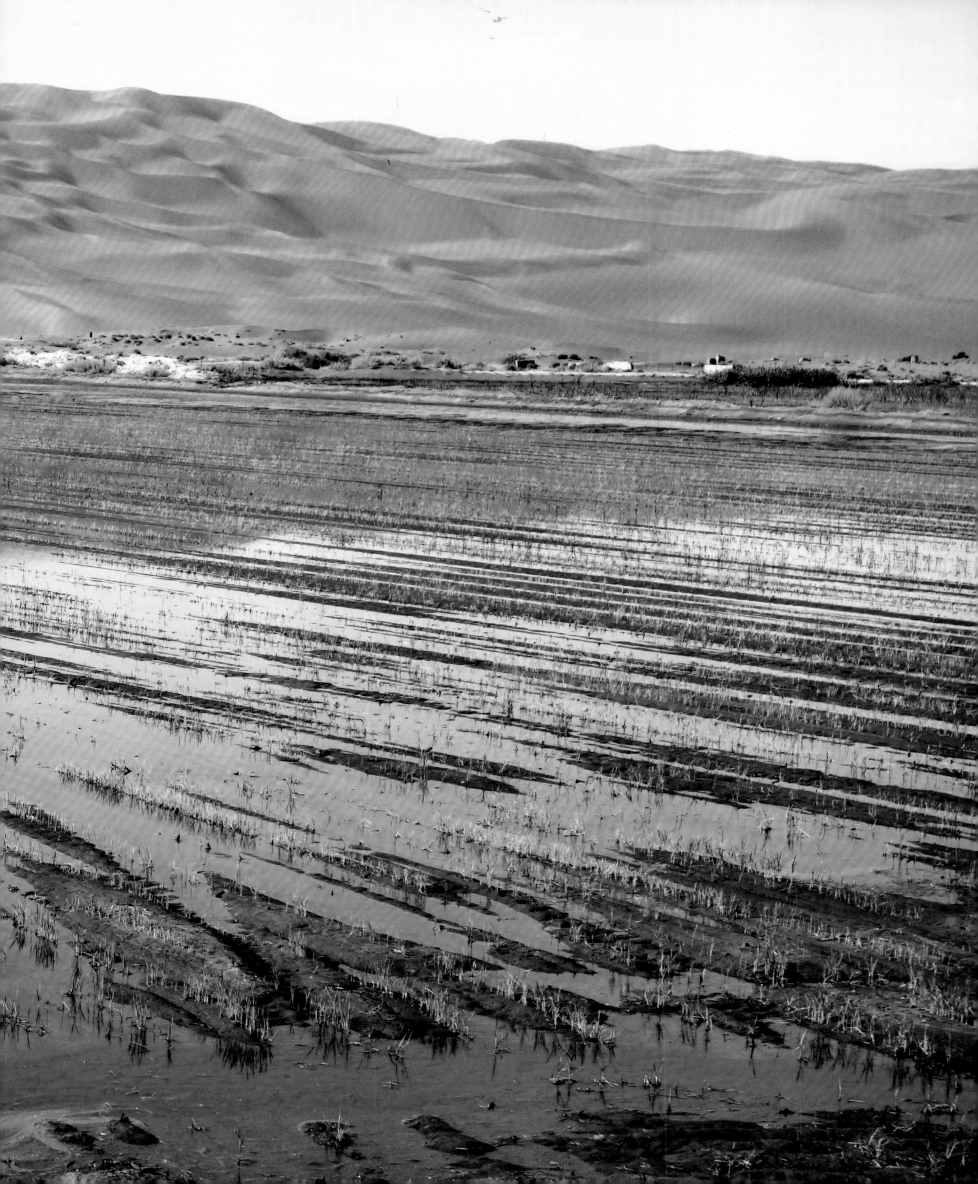

Kumtag Desert, Xinjiang

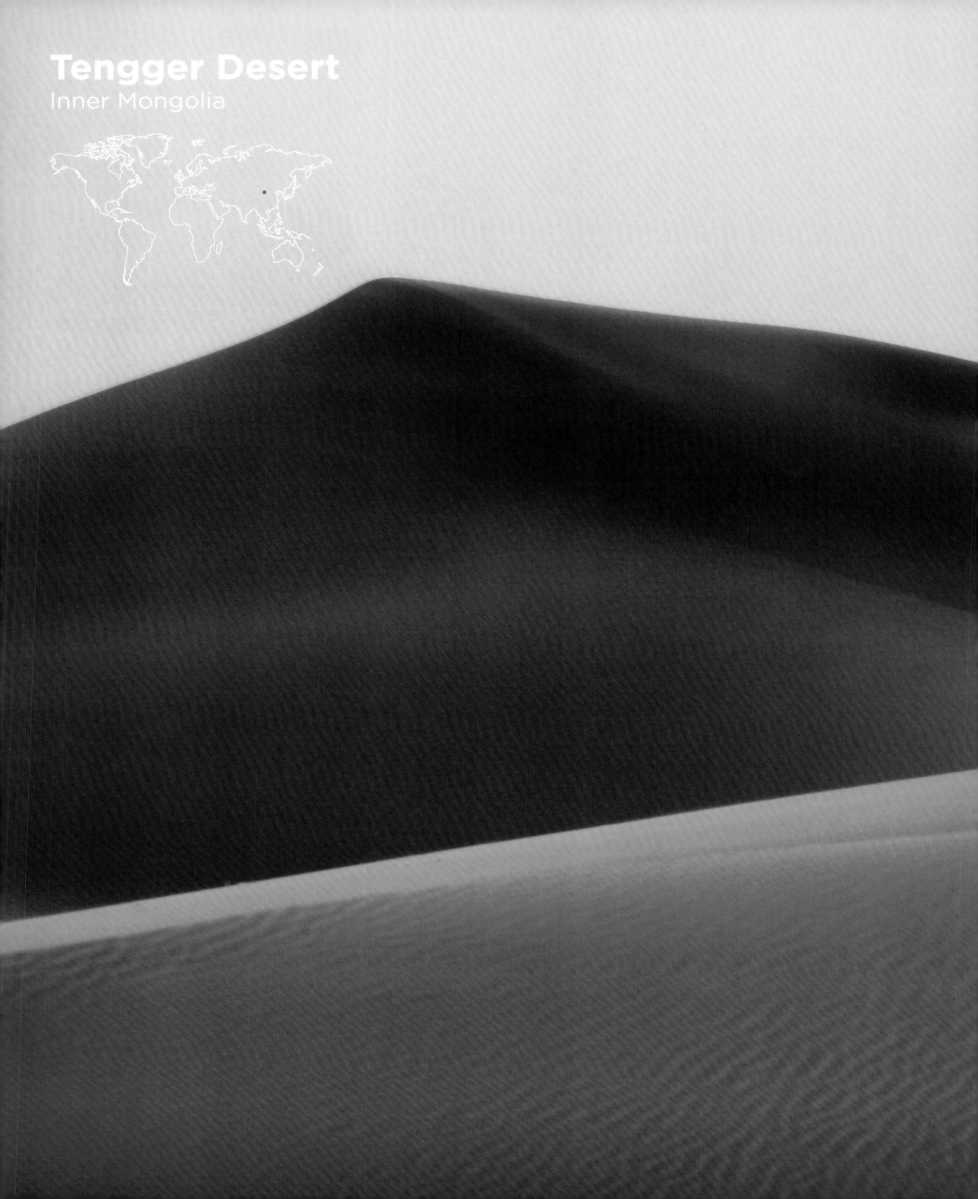

Tengger Desert

Inner Mongolia

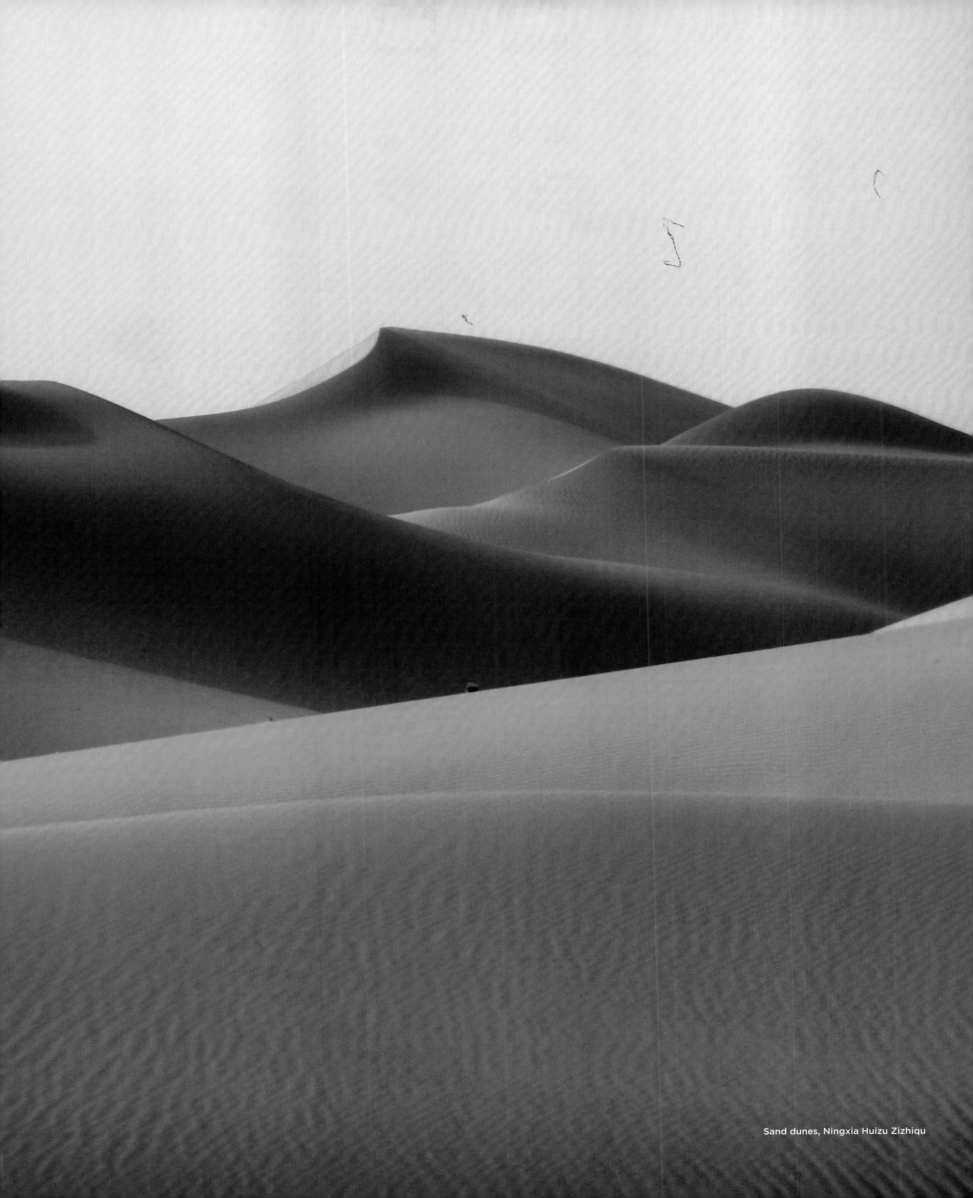

Sand dunes, Ningxia Huizu Zizhiqu

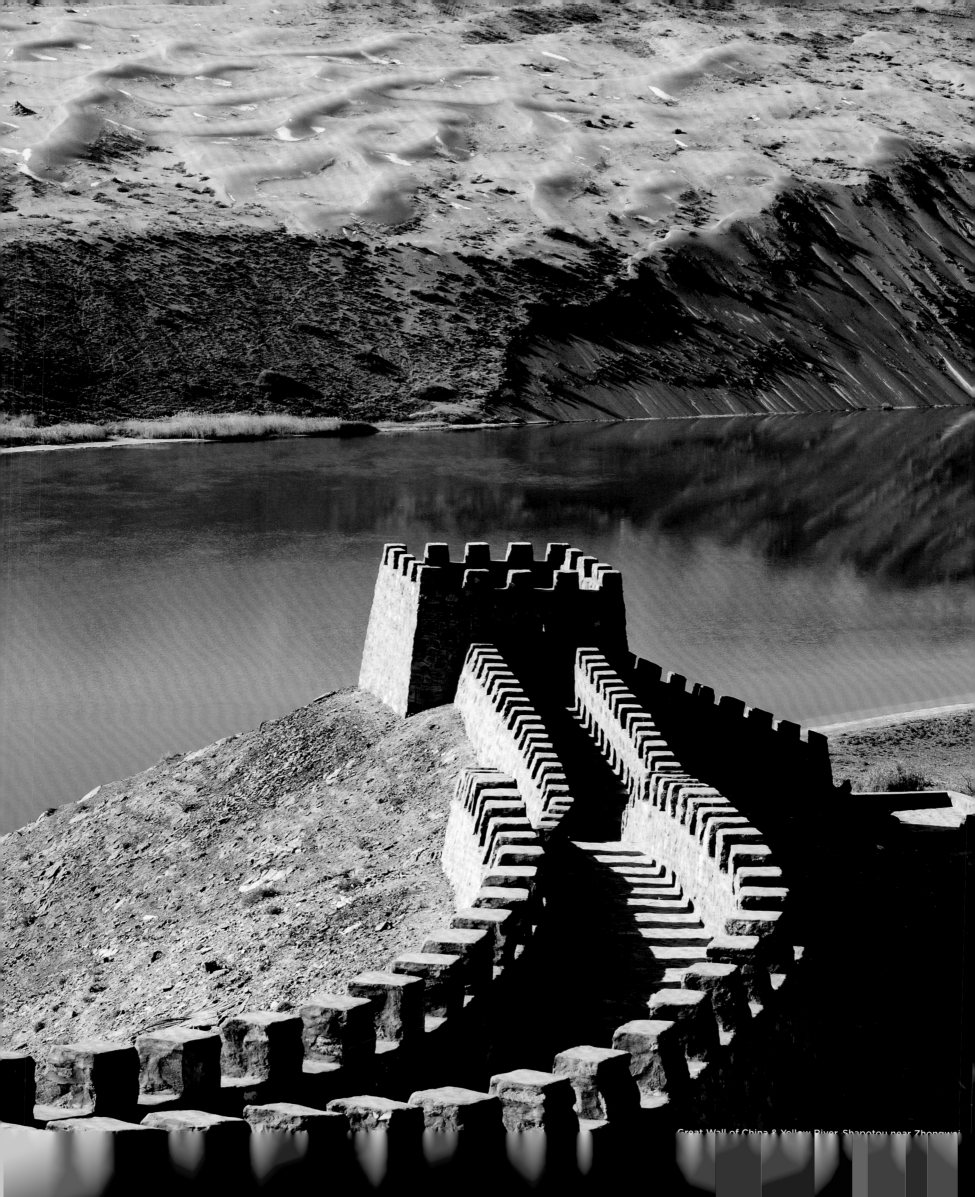

Great Wall of China & Yellow River, Shapotou near Zhongwei

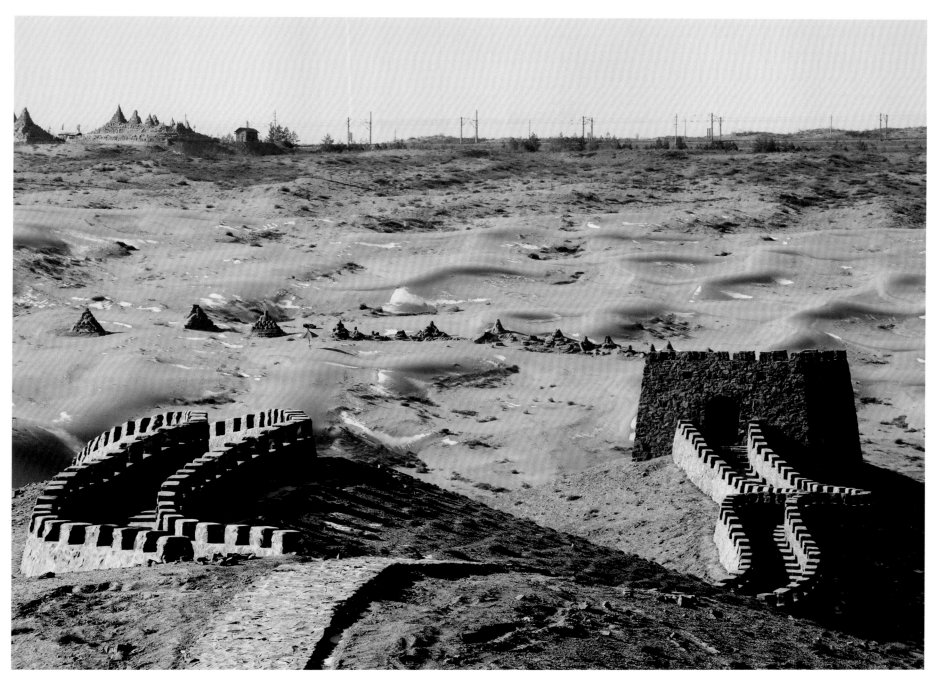

Great Wall of China at Shapotou near Zhongwei

Tengger Desert

The Tengger Desert is a sand desert where northern China borders on Mongolia. The desert's expansion is a pressing environmental concern, threatening as it does the agricultural livelihood of millions. The desert sands enveloping an outpost of the Great Wall of China have become an important image symbolising China's battle against desertification.

Désert de Tengger – Grande Muraille de Chine

Le désert de sable de Tengger se situe au point de rencontre entre le nord de la Chine et la frontière sino-mongole. L'expansion du désert est une préoccupation environnementale majeure, vu la menace qu'elle représente pour la subsistance agricole de millions de personnes. Un avant-poste de la Grande Muraille de Chine enveloppé de sable est devenu l'image du combat de la Chine contre la désertification.

Tengger-Wüste

Die Tengger ist eine Sandwüste, in der Nordchina an die Mongolei grenzt. Die Ausbreitung der Wüste ist ein drängendes Problem für die Umwelt, da sie die landwirtschaftliche Existenzgrundlage von Millionen Menschen bedroht. Der Wüstensand, der einen Außenposten der Chinesischen Mauer umgibt, ist zu einem wichtigen Symbol für den Kampf Chinas gegen die Wüstenbildung geworden.

Desierto de Tengger

El desierto de Tengger es un desierto de arena donde el norte de China se encuentra con la frontera China-Mongolia. La expansión del desierto es una preocupación ambiental acuciante, ya que amenaza el sustento agrícola de millones de personas. Las arenas del desierto que envuelven un puesto avanzado de la Gran Muralla China se han convertido en una imagen importante que simboliza la lucha de China contra la desertificación.

Deserto de Tengger

O deserto de Tengger é um deserto de areia onde o norte da China encontra a fronteira China-Mongólia. A expansão do deserto é uma preocupação ambiental urgente, ameaçando a sobrevivência agrícola de milhões de pessoas. As areias do deserto que envolvem um posto avançado da Grande Muralha da China se tornaram uma imagem importante que simboliza a batalha da China contra a desertificação.

Tenggerwoestijn – de Chinese Muur

In de Tengger, een zandwoestijn, grenst Noord-China aan Mongolië. Uitbreiding van de woestijn is een dringend milieuprobleem en vormt een bedreiging voor de landbouwactiviteiten van miljoenen mensen. Het woestijnzand dat een buitenpost van de Chinese Muur opslokt, is een belangrijk symbool geworden voor China's strijd tegen de woestijnvorming.

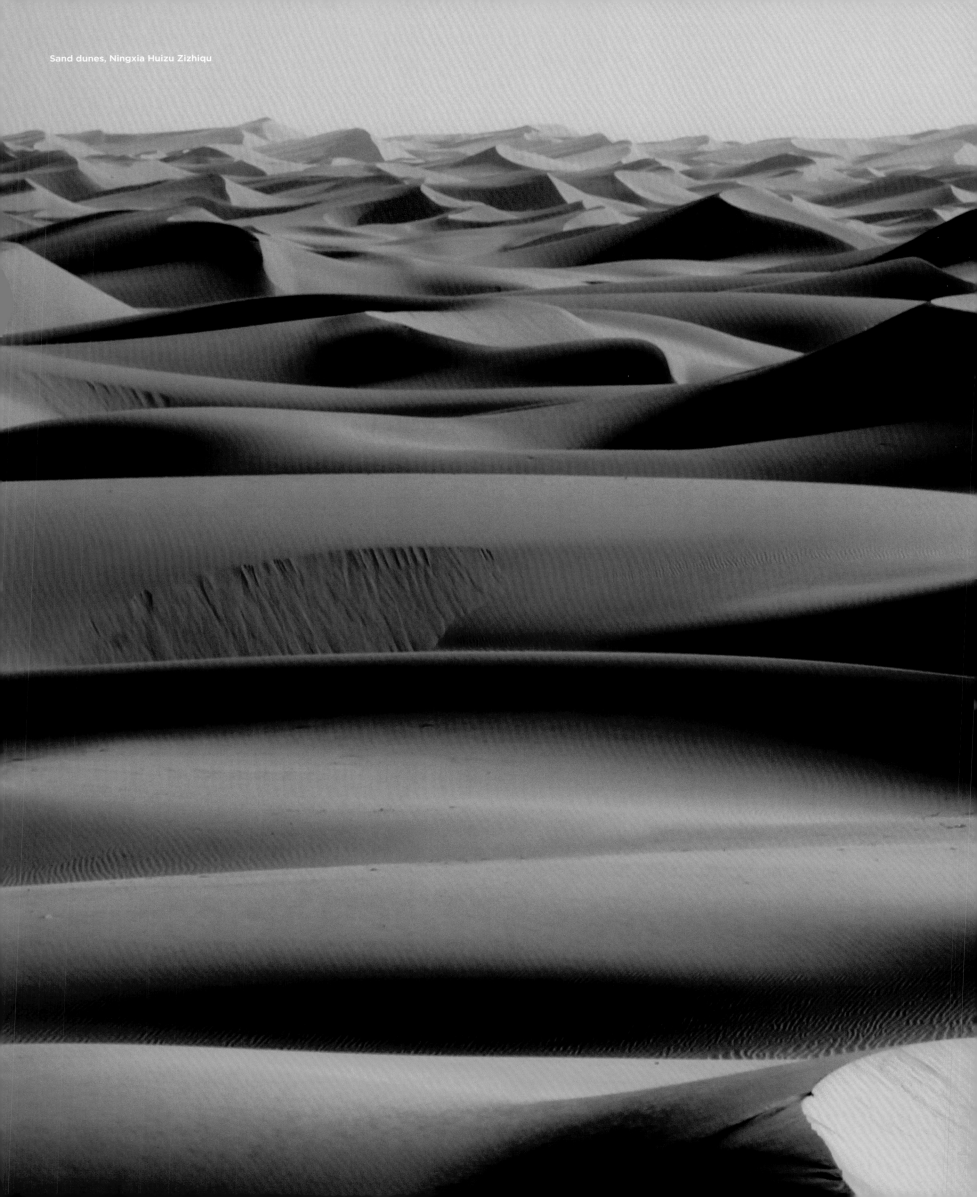

Sand dunes, Ningxia Huizu Zizhiqu

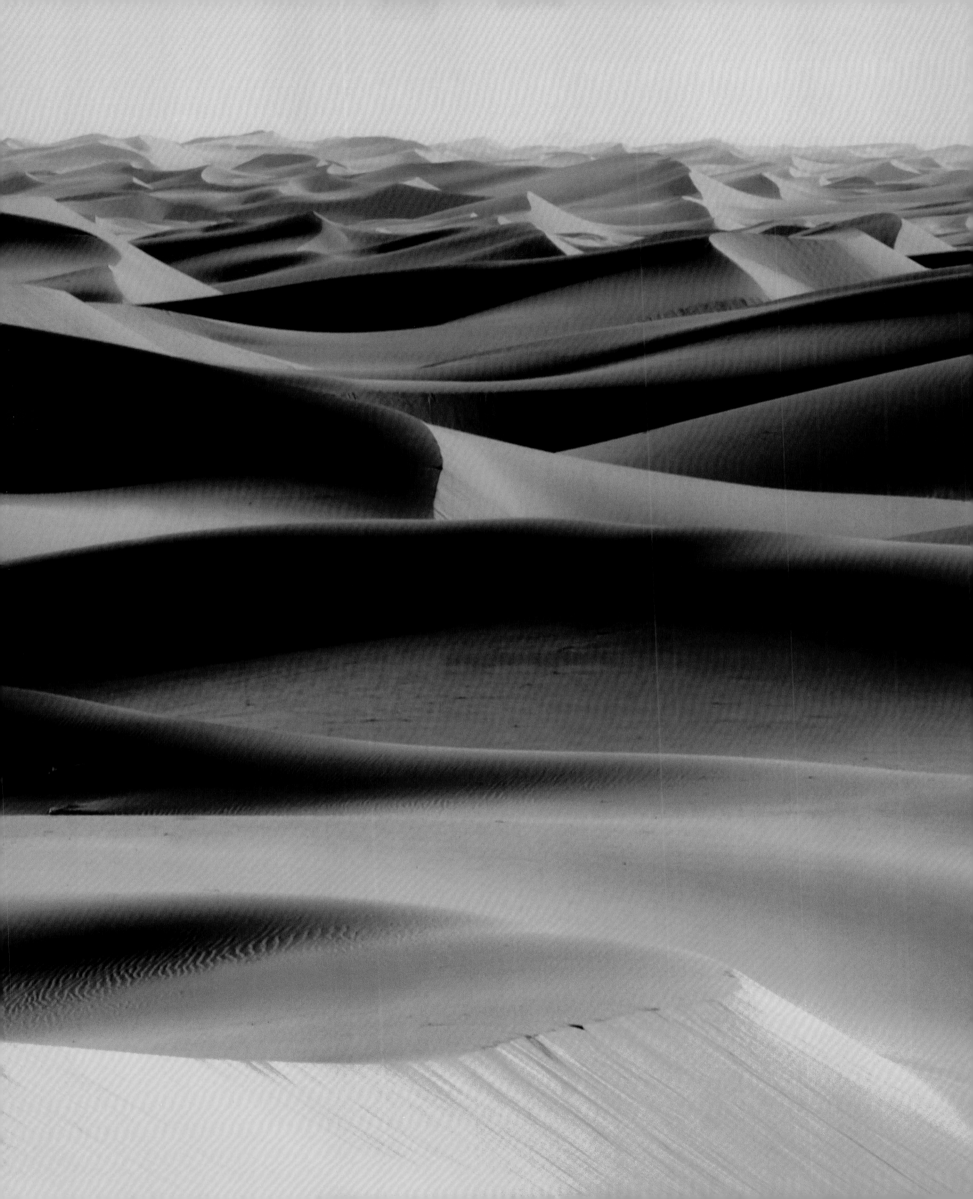

Taklamakan Desert
China

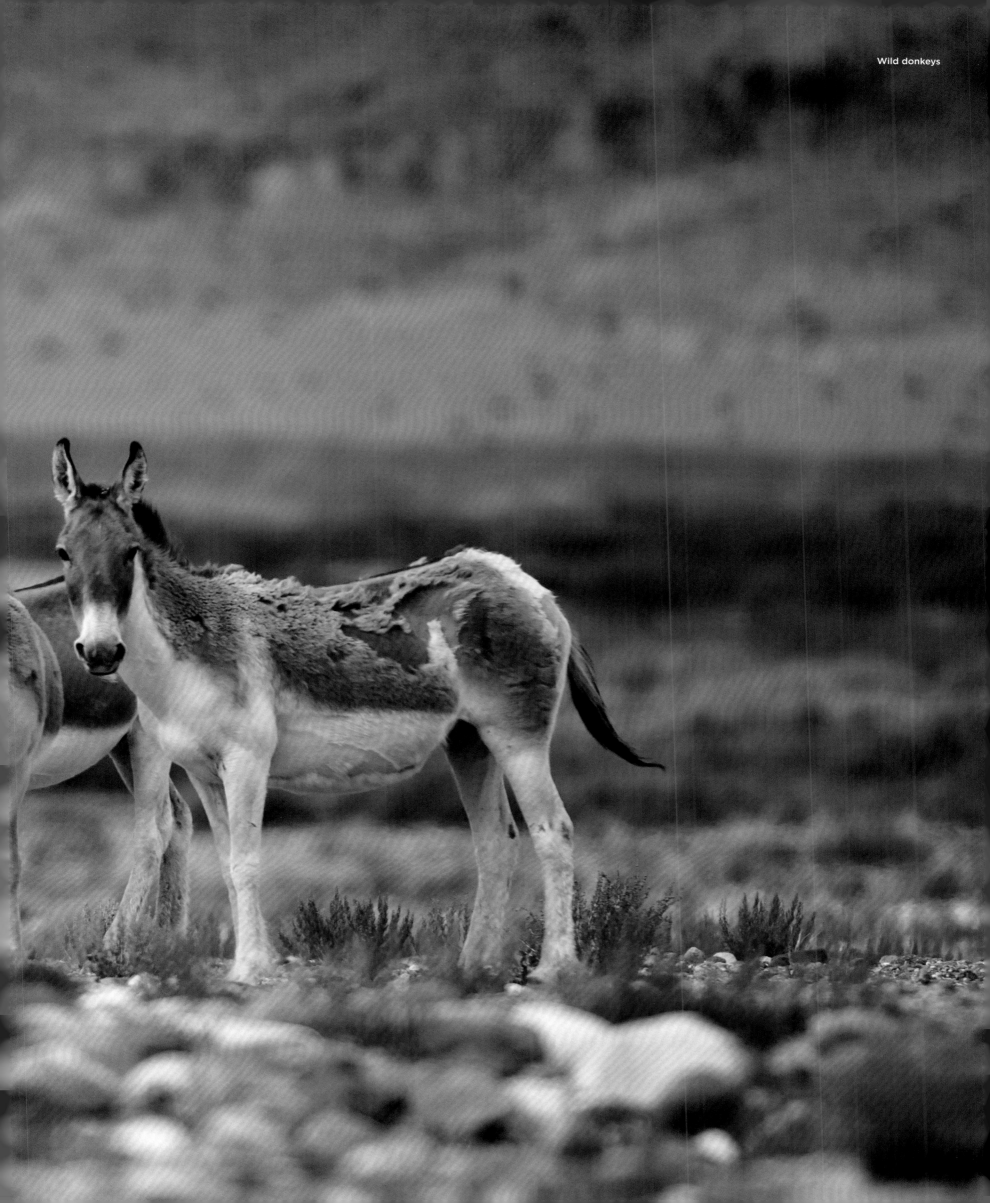

Wild donkeys

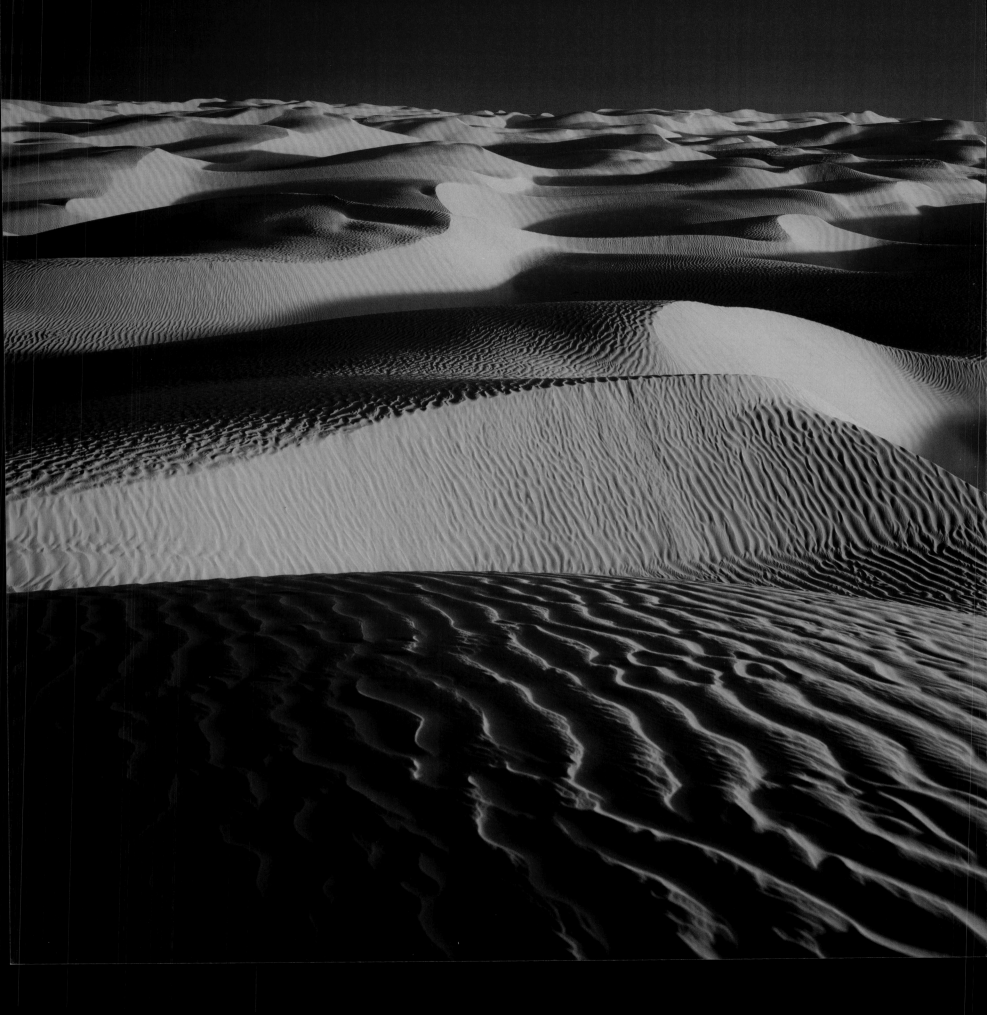

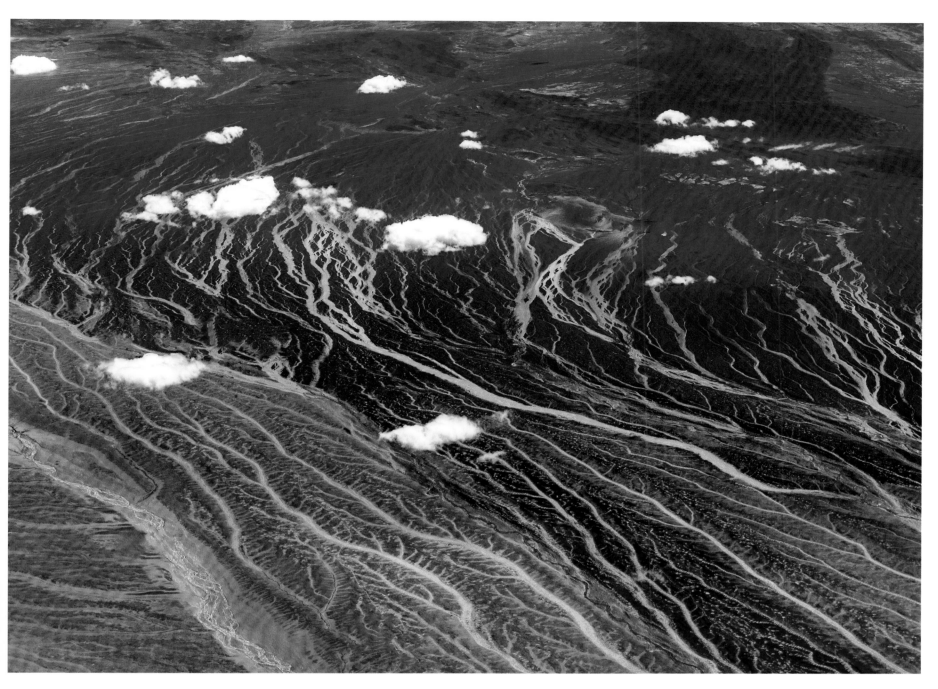

Aerial View of Tibet and Taklamakan Desert

Taklamakan Desert
No-one can be sure where the name Taklamakan, in south-western China, comes from, but theories range from 'Place of No Return' to 'Place of Ruins'. Most likely though is the meaning 'Land of Poplars'. Skirted by the Silk Road, bordered by the Gobi Desert, it is nearly as large as Germany, and is the world's second-largest shifting sand desert – nearly 90% consists of mobile sand dunes.

Désert du Taklamakan
Personne ne sait d'où le nom du Taklamakan, un désert situé au nord-ouest de la Chine, provient, mais les théories vont du « lieu de non-retour » à « l'endroit des ruines ». Contourné par la route de la Soie et bordé par le désert de Gobi, il est presque aussi grand que l'Allemagne et se place au deuxième rang des plus grands déserts mouvants du monde – il se compose à pratiquement 90% de dunes mobiles.

Taklamakan-Wüste
Niemand kann sicher sein, was der Name der Wüste Taklamakan im Südwesten Chinas bedeutet, aber die Theorien reichen von „Ort ohne Wiederkehr" bis hin zu „Ruinenstätte". Sie ist fast so groß wie Deutschland und die zweitgrößte Wanderdünenwüste der Welt – fast 90% bestehen aus Wanderdünen.

Desierto de Taklamakán
Nadie puede estar seguro de dónde proviene el nombre Taklamakán, en el noroeste de China, pero las teorías van desde «lugar de no retorno» hasta «lugar de ruinas». Bordeado por la Ruta de la Seda, bordeado por el Desierto de Gobi, es casi tan grande como Alemania, y es el segundo desierto de arena más grande del mundo; casi el 90% consiste en dunas de arena móviles.

Deserto de Taklamakam
Ninguém pode ter certeza de onde vem o nome Taklamakam, no noroeste da China, mas as teorias vão de "Place of No Return" até "Place of Ruins". Contornado pela Rota da Seda, limitado pelo Deserto de Gobi, é quase tão grande quanto a Alemanha, e é o segundo maior deserto de areia movediço do mundo – quase 90% consiste em dunas de areia móveis.

Taklamakam
Niemand weet precies wat de naam Taklamakam, een woestijn in het noordwesten van China, betekent, maar de theorieën variëren van 'plaats zonder terugkeer' tot 'ruïneplaats'. De woestijn is bijna net zo groot als Duitsland en is de op één na grootste zandwoestijn ter wereld. Bijna 90% bestaat uit stuifduinen.

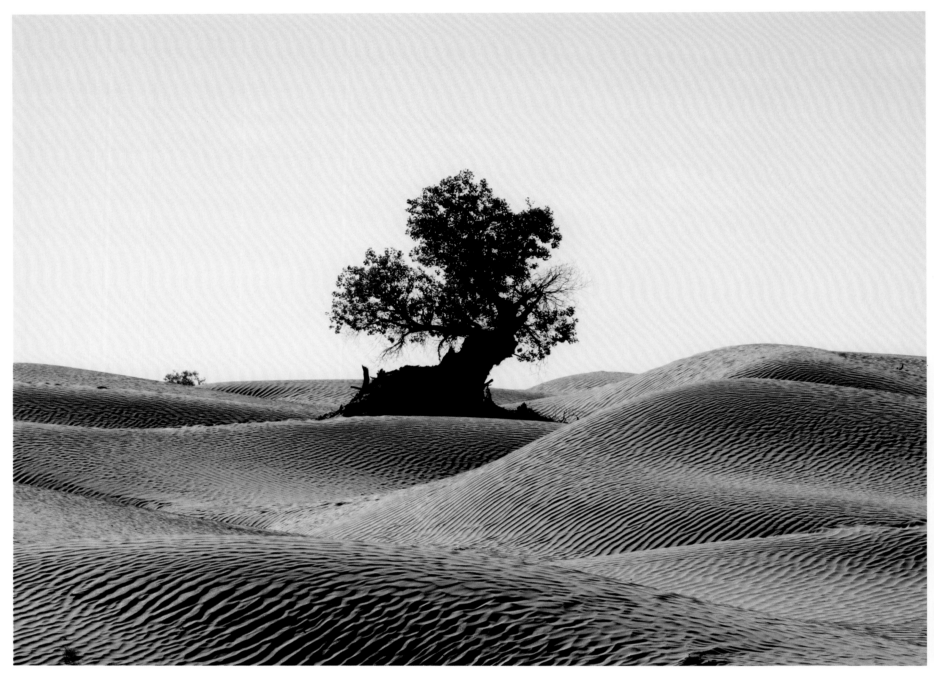

Desert Poplar

Cold Desert

Formed in the rain shadow of the Himalaya, the Taklamakan, like many Central Asian deserts, is a cold desert (−20 °C, or −4 °F) steeped in human history. It lay on the road between Chinese and Central Asian empires, and control of the oases in the Taklamakan was crucial in mastering trade routes such as the Silk Road, for empires from the Han Dynasty to the Mongols. Dust from the Taklamakan plays a role in forming clouds over the Western USA. Less seriously, the Takalamakan is a staple of Chinese films (such as the *Painted Skin movies*) and TV series, and Marco Polo got lost here in Neil Gaiman's *The Sandman.*

Désert froid

Formé dans l'ombre pluviométrique de l'Himalaya, le Taklamakan est, comme bon nombre de déserts d'Asie centrale, un désert froid (des températures proches de −20° y ont été enregistrées) dont l'histoire est intriquée avec celle de l'Homme. Il s'étend sur la route séparant la Chine et les empires d'Asie centrale et, de la dynastie des Hans aux Mongols, le contrôle des oasis du Taklamakan a toujours été crucial dans la domination de routes de commerce telle que la route de la Soie. La poussière du Taklamakan joue un rôle dans la formation de nuages au-dessus de l'ouest des États-Unis. Fait plus anecdotique, le Taklamakan est un incontournable des films chinois (dans les films de la saga *Painted Skin,* par exemple) et des séries télé ; Marco Polo s'y perd même, dans la série de romans graphiques *Sandman,* de Neil Gaiman.

Kalte Wüste

Im Regenschatten des Himalaya liegend ist die Taklamakan, wie viele zentralasiatische Wüsten, eine kalte Wüste (−20 °C), die von der Menschheits-geschichte geprägt ist. Sie liegt an der Route von den chinesischen zu den zentralasiatischen Reichen, und die Kontrolle der Oasen der Taklamakan war für von der Han-Dynastie bis zu den Mongolen entscheidend für die Beherrschung von Handelswegen wie der Seidenstraße. Staub aus Taklamakan spielt eine Rolle bei der Bildung von Wolken über den westlichen USA. Weniger ernst ist ihre Rolle als Kulisse chinesischer Filme (wie der *Painted Skin-Filme*) und TV-Serien. In Neil Gaimans Graphic Novel *Sandman* verirrt sich Marco Polo in ihr.

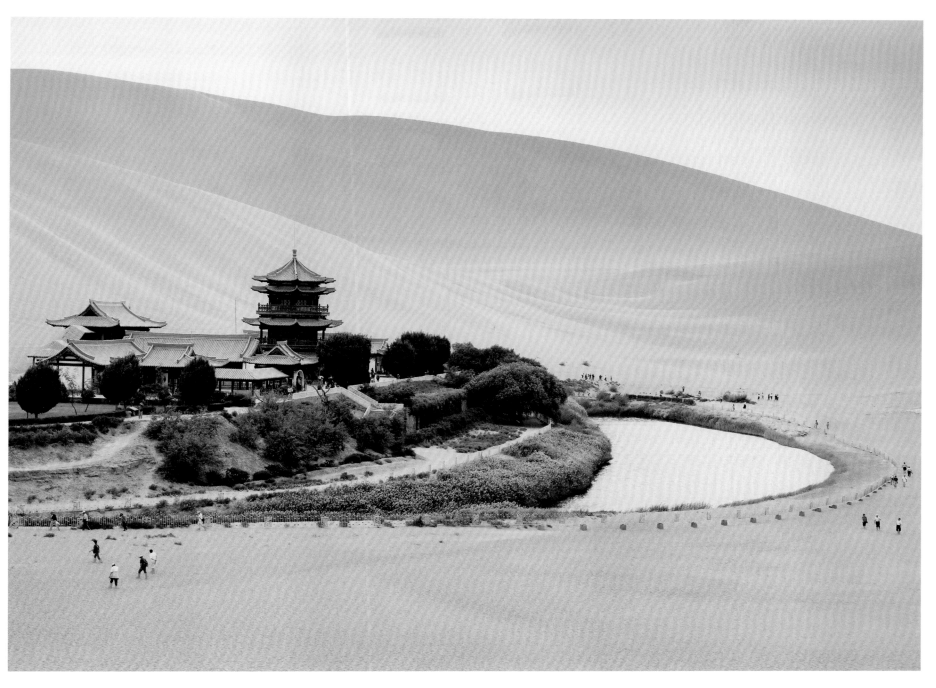

Oasis Park Mingsha Shan, Dunhuang, Gansu Province

Desierto frío

Formado a la sombra de la lluvia del Himalaya, el Taklamakán, como muchos desiertos de Asia Central, es un desierto frío (−20 °C) cargado de historia humana. Se encontraba en el camino entre los imperios chino y centroasiático y el control de los oasis del Taklamakán era crucial para dominar rutas comerciales como la Ruta de la Seda, desde la dinastía Han hasta los mongoles. El polvo del Taklamakán juega un papel importante en la formación de nubes sobre el oeste de los Estados Unidos. Y un dato menos serio: el Taklamakán es un producto básico de las películas chinas (como *las películas de Painted Skin*) y las series de televisión, y Marco Polo se perdió aquí en *The Sandman,* de Neil Gaiman.

Deserto Frio

Formado na sombra das chuvas do Himalaia, o Taklamakan, como muitos desertos da Ásia Central, é um deserto frio (−20 ° C) impregnado de história humana. Ficava na estrada entre os impérios chinês e da Ásia Central, e o controle dos oásis do Taklamakan era crucial para dominar rotas comerciais como a Rota da Seda, da dinastia Han aos mongóis. A poeira de Taklamakan desempenha um papel na formação de nuvens sobre os EUA ocidentais. Menos sério, o Takalamakan é um marco dos filmes chineses (como *os filmes de Painted Skin*) e séries de TV, e Marco Polo se perdeu aqui em *The Sandman,* de Neil Gaiman.

Koude woestijn

De Taklamakan, die in de regenschaduw van de Himalaya is gevormd, is net als veel Centraal-Aziatische woestijnen een koude woestijn (−20 °C is geregistreerd) vol menselijke geschiedenis. Hij lag op de weg tussen de Chinese en Centraal-Aziatische rijken, en de macht over de oases van de Taklamakan was van de Han-dynastie tot de Mongolen cruciaal voor de controle over handelsroutes zoals de Zijderoute. Stof uit de Taklamakan speelt een rol bij de vorming van wolken boven de westelijke VS. Minder serieus is dat de Takalamakan een hoofdrol speelt in Chinese films (zoals de *Painted Skin-films*) en tv-series, en Marco Polo verdwaalde hier in Neil Gaimans comic *The Sandman.*

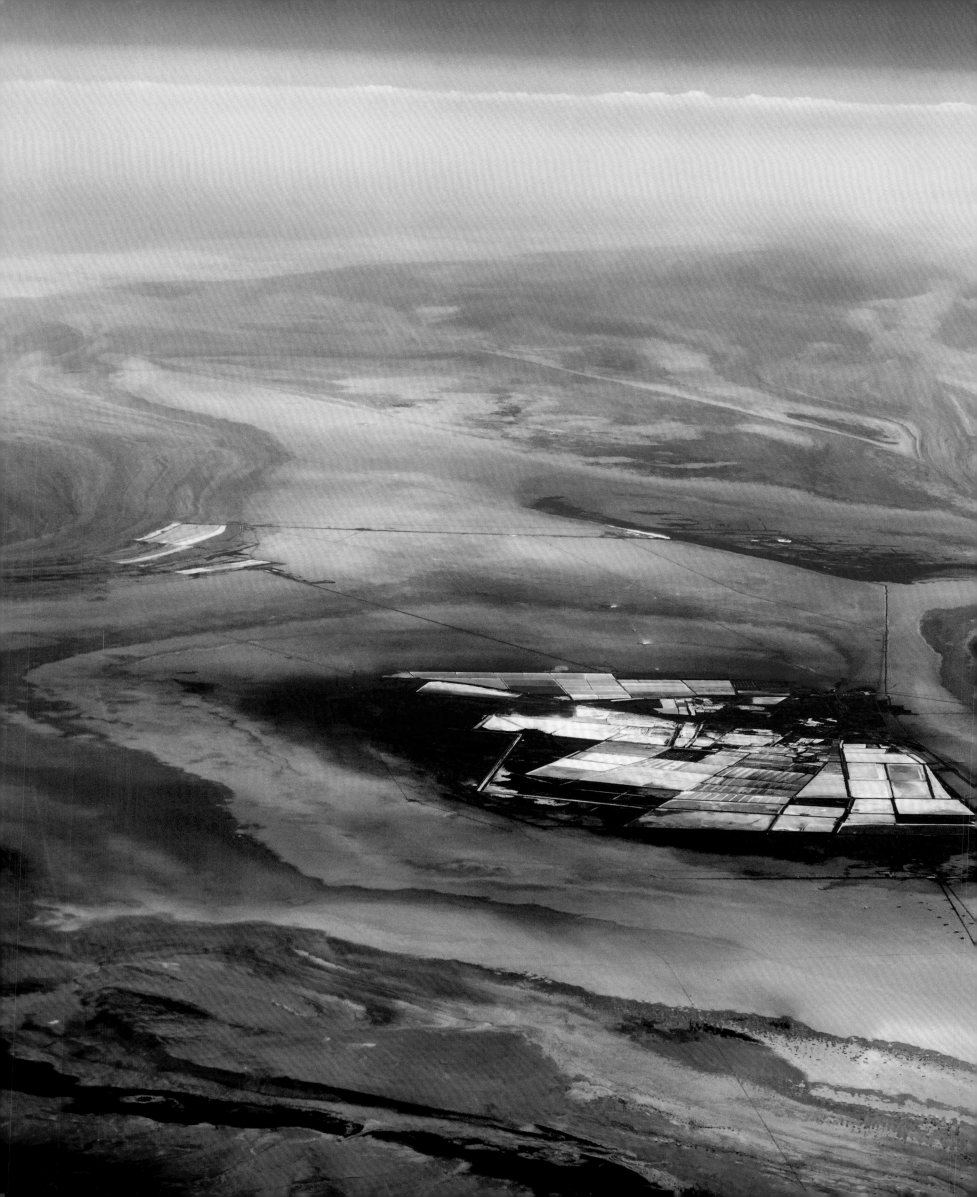

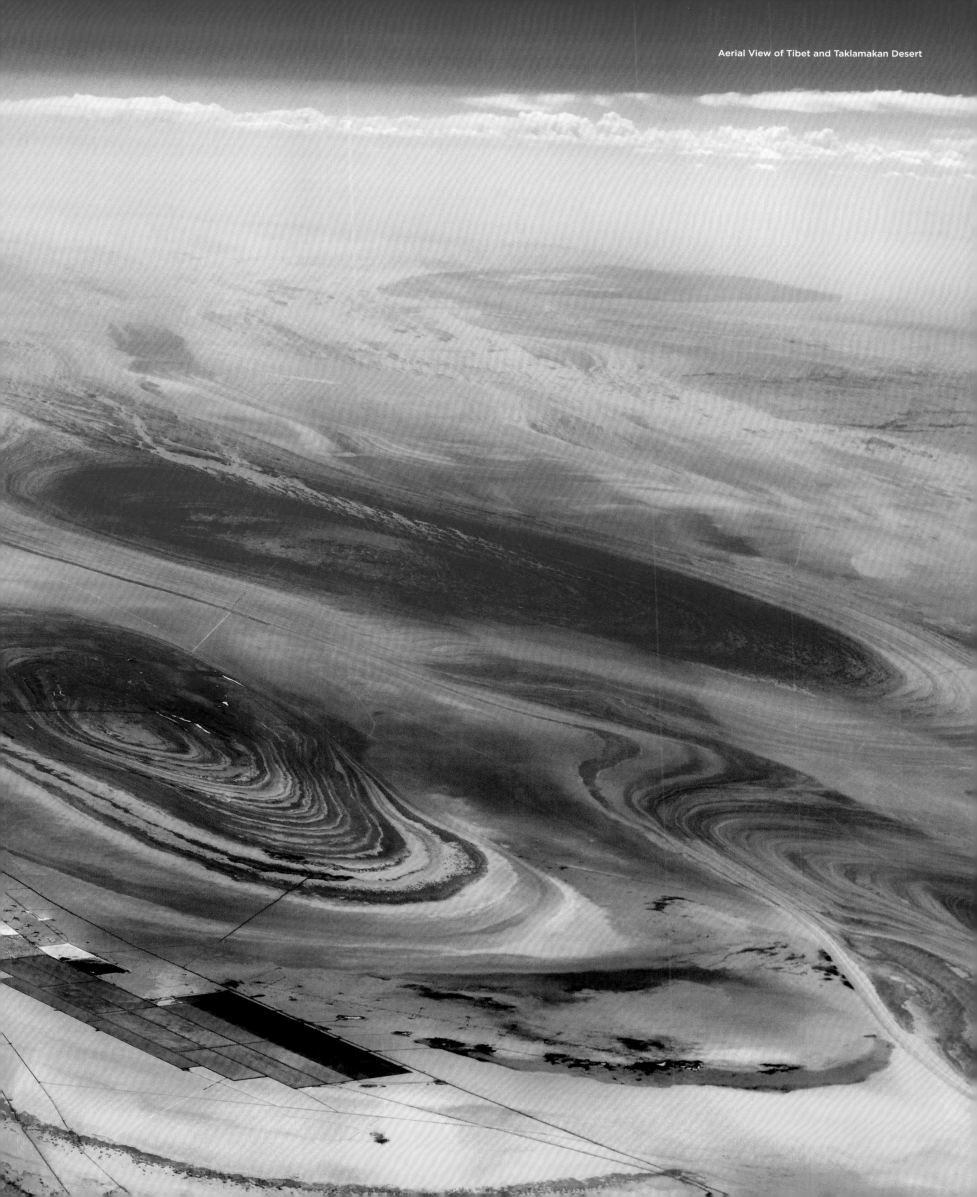

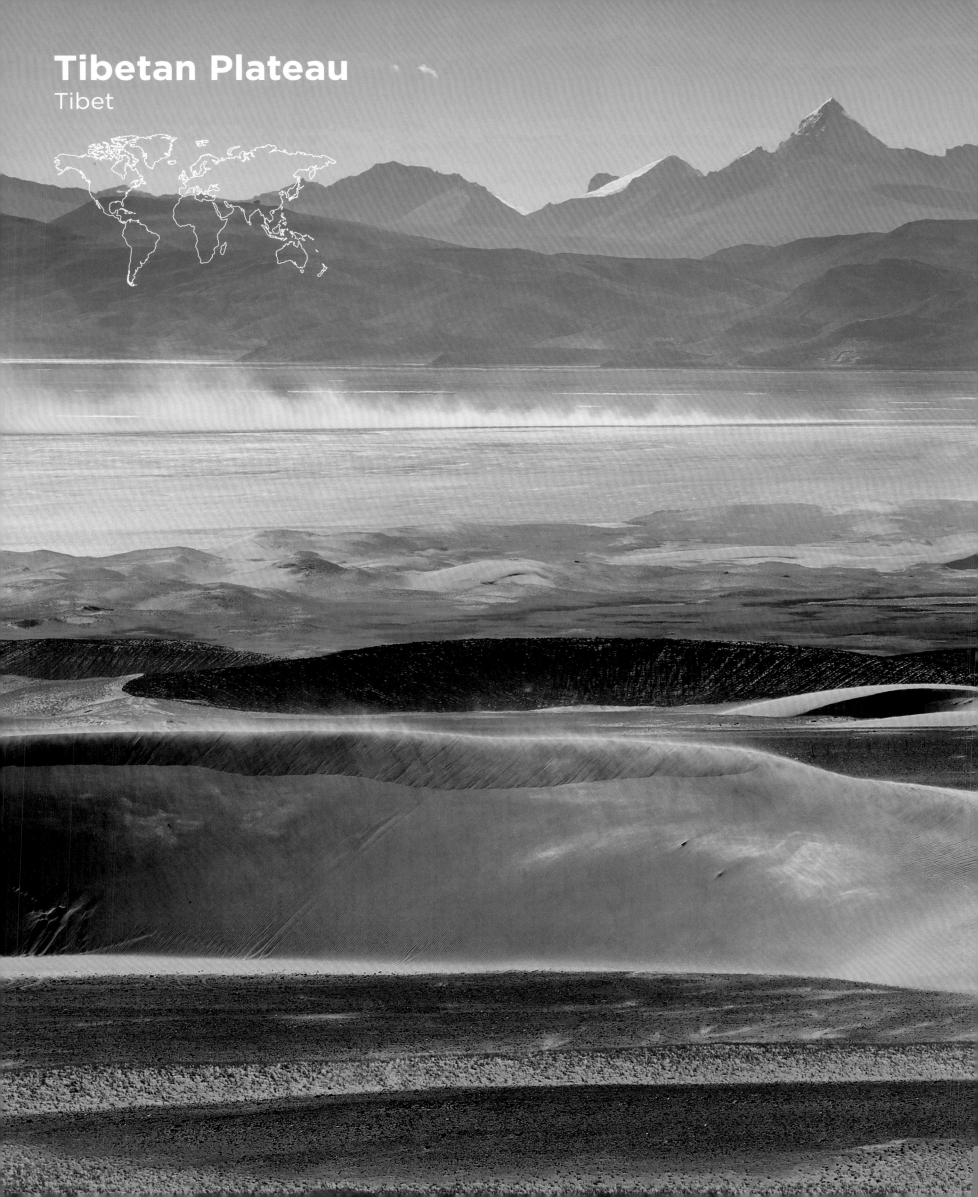

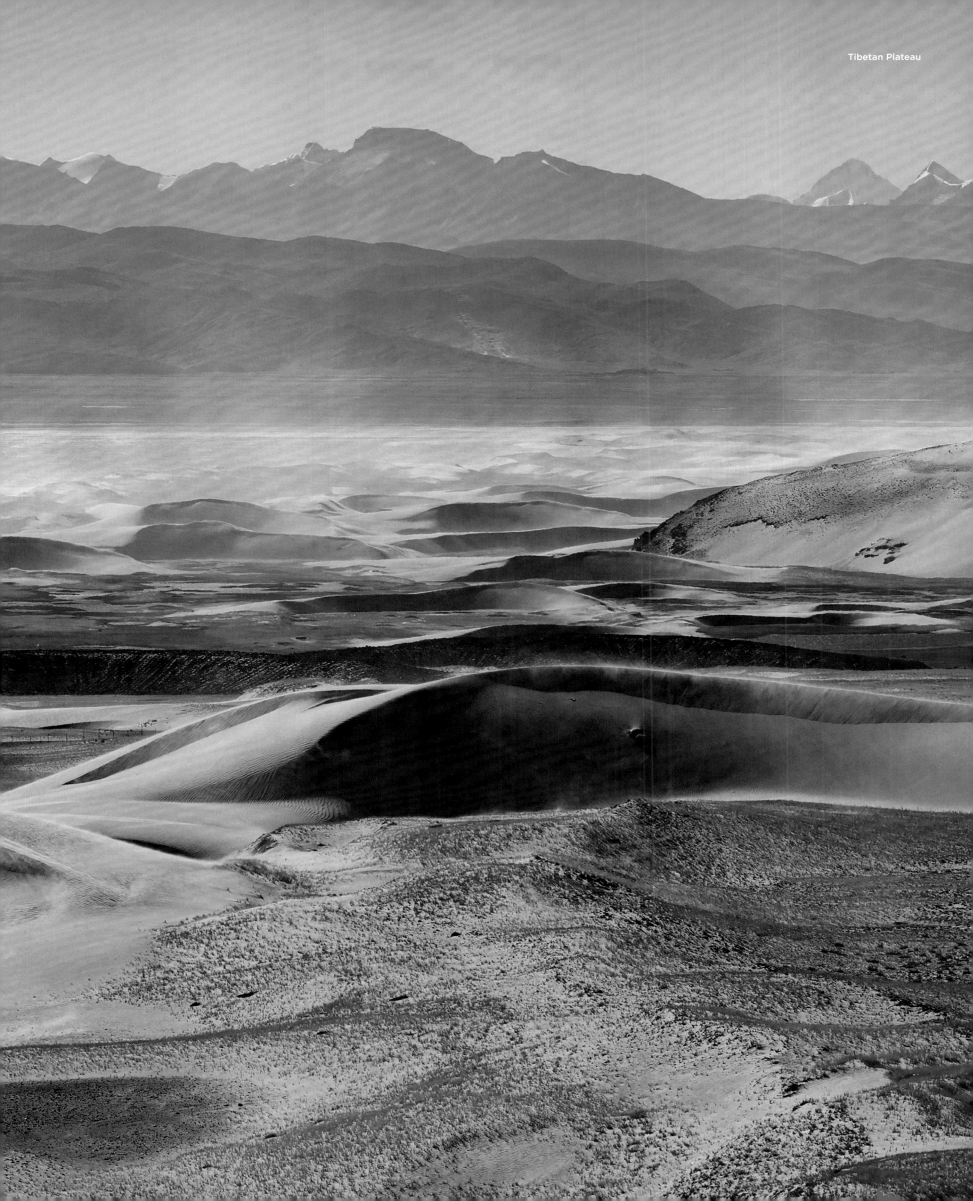

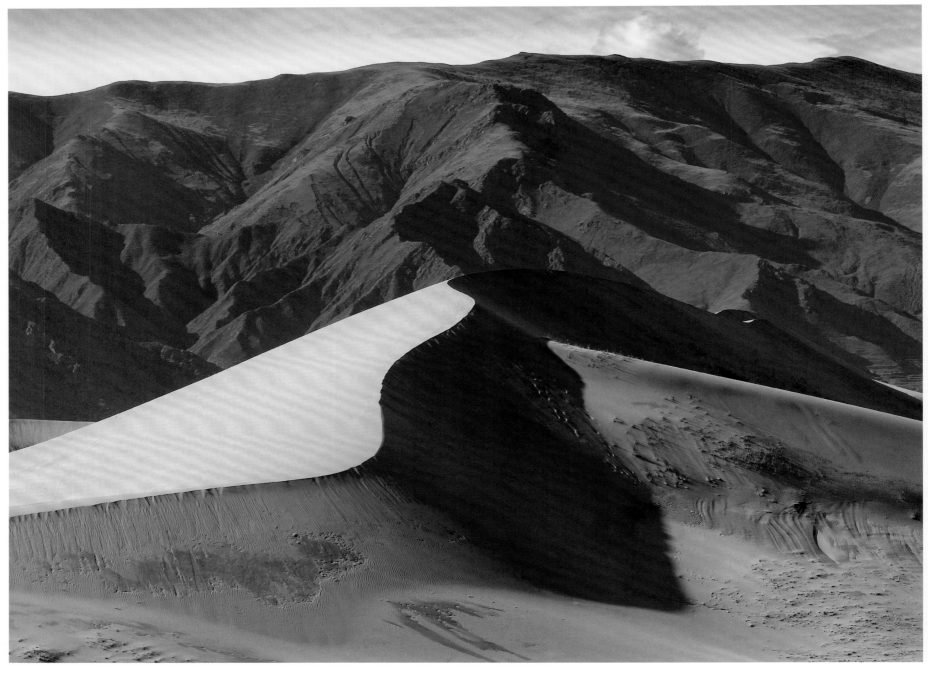

Sand dunes Tibetan Plateau

Tibetan Plateau

Wedged between the Taklamakan Desert and the Himalaya, the Tibetan Plateau goes by various evocative monikers – 'Roof of the World' (it's the world's highest and largest plateau and is five times the size of France) or 'The Third Pole'. Consisting of barren steppe, salty lakes and mountain ranges that ripple down off the Himalaya, it even experiences permafrost in many places. So harsh are the conditions here that population density is extremely low – only Antarctica and northern Greenland are less populated. Wildlife includes the gray wolf, snow leopard, wild yak, and the high-altitude jumping spider.

Plateau tibétain

Coincé entre le désert du Taklamakan et l'Himalaya, le plateau tibétain est connu sous divers sobriquets évocateurs – « Toit du monde » (mesurant cinq fois la France, il est le plus haut et le plus grand plateau du monde) ou « Troisième Pôle ». Constitué d'une steppe désertique, de lacs salés et de chaînes de montagnes qui descendent de l'Himalaya, il présente même du permafrost à plusieurs endroits. L'extrême rudesse des conditions climatiques explique la faible densité de population – seul l'Arctique et le nord du Groenland sont moins peuplés. La faune locale compte le loup gris, la panthère des neiges, et l'araignée sauteuse de haute altitude.

Hochland von Tibet

Das tibetische Hochland, das zwischen der Taklamakan-Wüste und dem Himalaya eingezwängt ist, wird mit verschiedenen eindrucksvollen Bezeichnungen belegt – „Dach der Welt" (es ist die höchste und größte Hochebene der Welt und fünfmal so groß wie Frankreich) oder „Dritter Pol". Bestehend aus karger Steppe, salzigen Seen und Gebirgszügen, die vom Himalaya hinabreichen, wird es vielerorts sogar durch Permafrost gekennzeichnet. Die Bedingungen hier sind so hart, dass die Bevölkerungsdichte extrem niedrig ist – nur die Antarktis und Nordgrönland sind weniger dicht besiedelt. Die Tierwelt umfasst den Grauen Wolf, Schneeleoparden, Yak und eine hochalpine Springspinnenart.

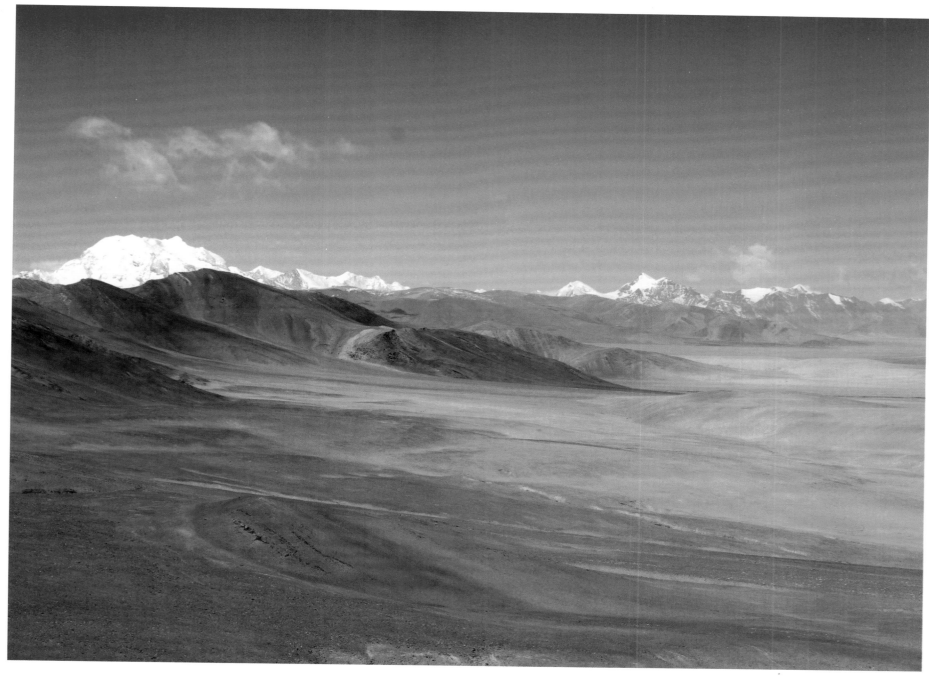

Ice covered mountain peak of Shisha Pangma (8013 m)

Meseta tibetana

Enclavada entre el desierto del Taklamakán y el Himalaya, la meseta tibetana recibe varios nombres evocadores: «echo del mundo» (es la meseta más alta y más grande del mundo y tiene cinco veces el tamaño de Francia) o «el Tercer Polo». Consiste en estepas estériles, lagos salados y cadenas montañosas que se extienden a lo largo del Himalaya, e incluso experimenta el permafrost en muchos lugares. Las condiciones son tan duras que la densidad de población es extremadamente baja: solo la Antártida y el norte de Groenlandia están menos poblados. La fauna silvestre incluye el lobo gris, el leopardo de las nieves, el yak salvaje y la araña saltarina del Himalaya.

Planalto Tibetano

Encravado entre o deserto de Taklamakan e o Himalaia, o planalto tibetano passa por vários monikers evocativos - "Roof of the World" (é o maior e mais alto planalto do mundo e tem cinco vezes o tamanho da França) ou "The Third Pole". Consistindo de estepes estéreis, lagos salgados e cadeias de montanhas que ondulam do Himalaia, até mesmo experimenta o permafrost em muitos lugares. Tão duras são as condições aqui que a densidade populacional é extremamente baixa - apenas a Antártida e o norte da Groenlândia são menos povoadas. A vida selvagem inclui o lobo cinzento, o leopardo da neve, o iaque selvagem e a aranha saltadora de alta altitude.

Tibetaans Hoogland

Het Tibetaanse Hoogland, dat ligt ingeklemd tussen de Taklamakanwoestijn en het Himalayagebergte, heeft verschillende namen: 'het dak van de wereld' (het is het hoogste en grootste plateau ter wereld en is vijf keer zo groot als Frankrijk) of 'de derde pool'. Het bestaat uit kale steppe, zoute meren en bergketens die van de Himalaya omlaag rimpelen en op veel plaatsen is zelfs permafrost. De omstandigheden zijn hier zo bar dat de bevolkingsdichtheid extreem laag is. Alleen op Antarctica en Noord-Groenland wonen minder mensen. Tot de wilde dieren behoren de grijze wolf, sneeuwpanter, jak en de op grote hoogtes levende springende spinnen.

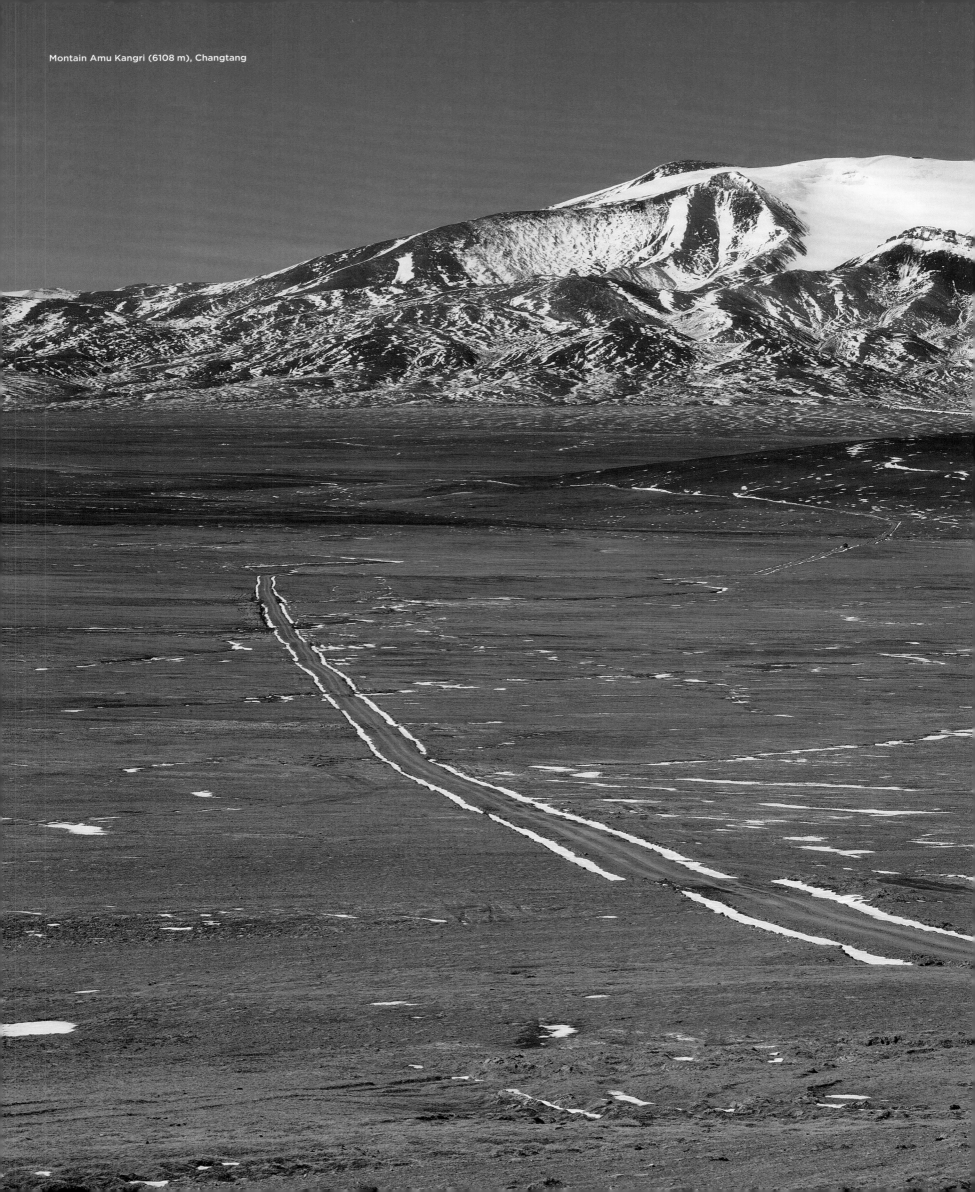

Montain Amu Kangri (6108 m), Changtang

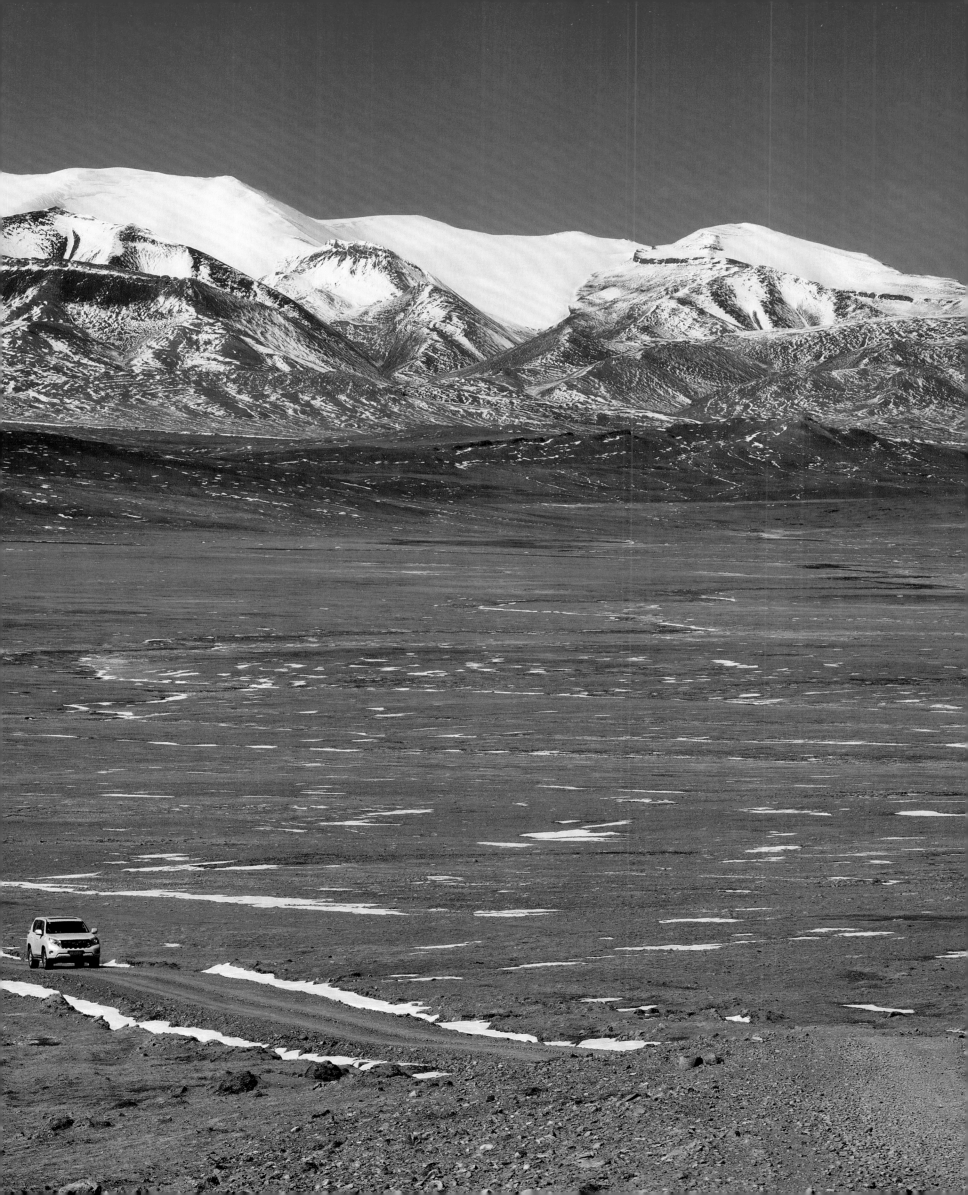

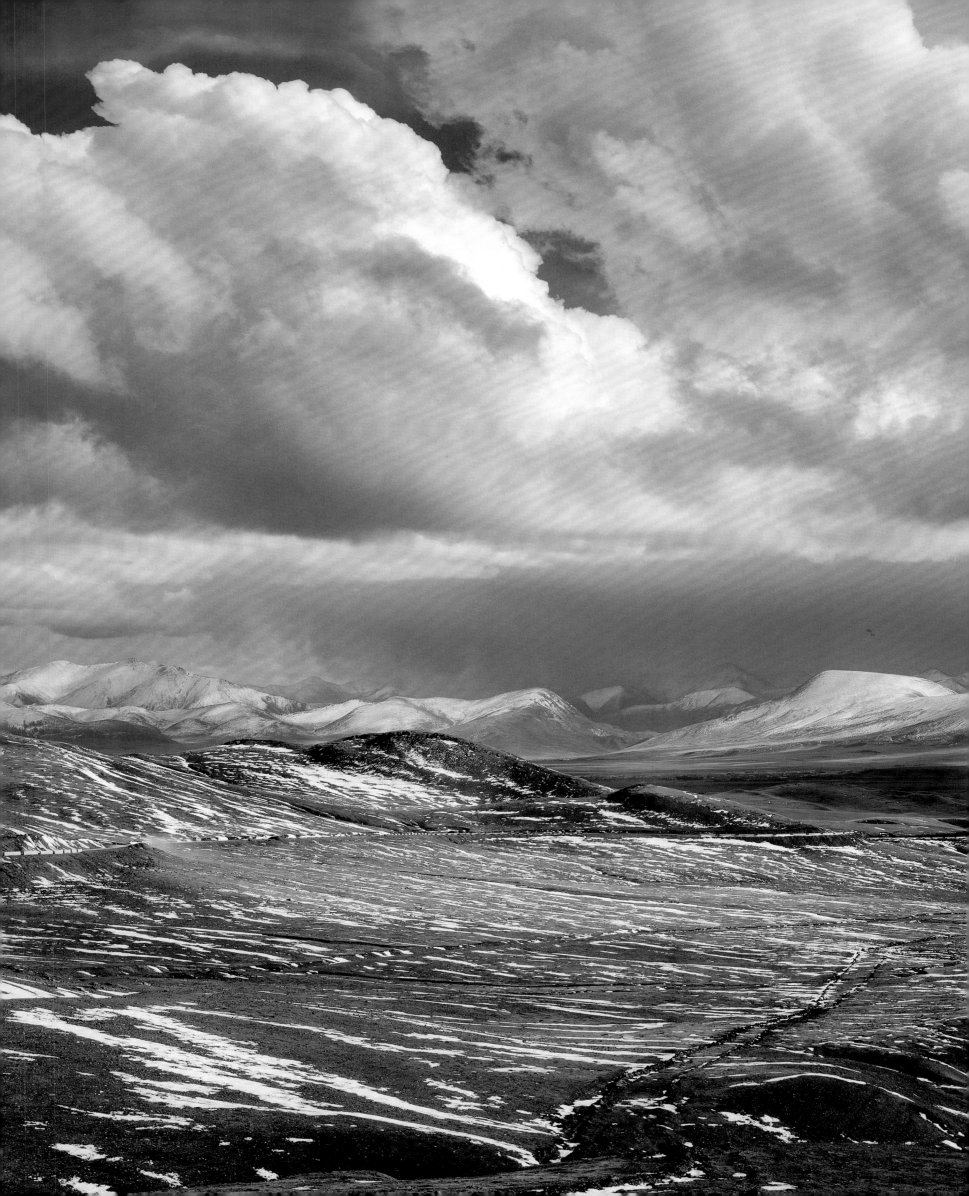

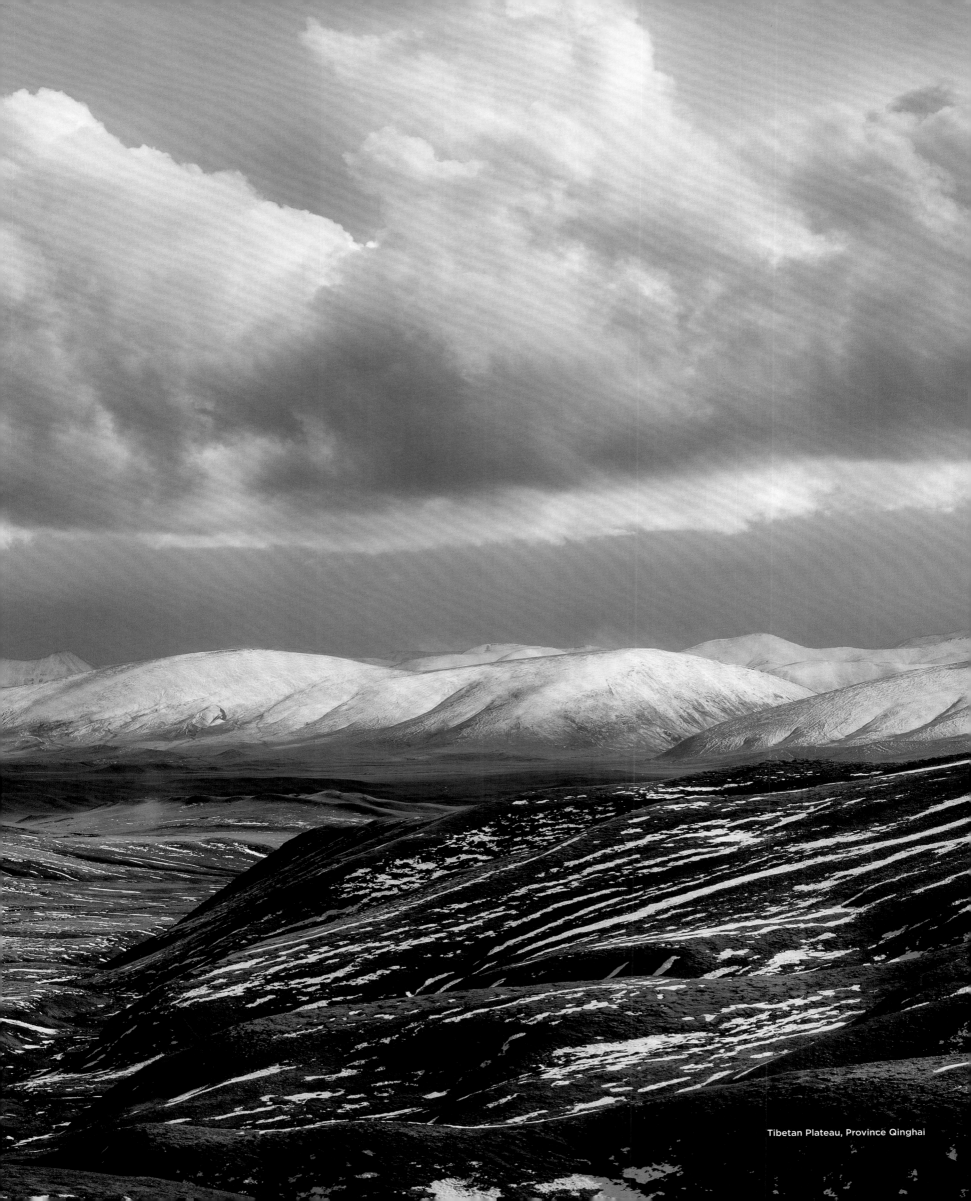

Tibetan Plateau, Province Qinghai

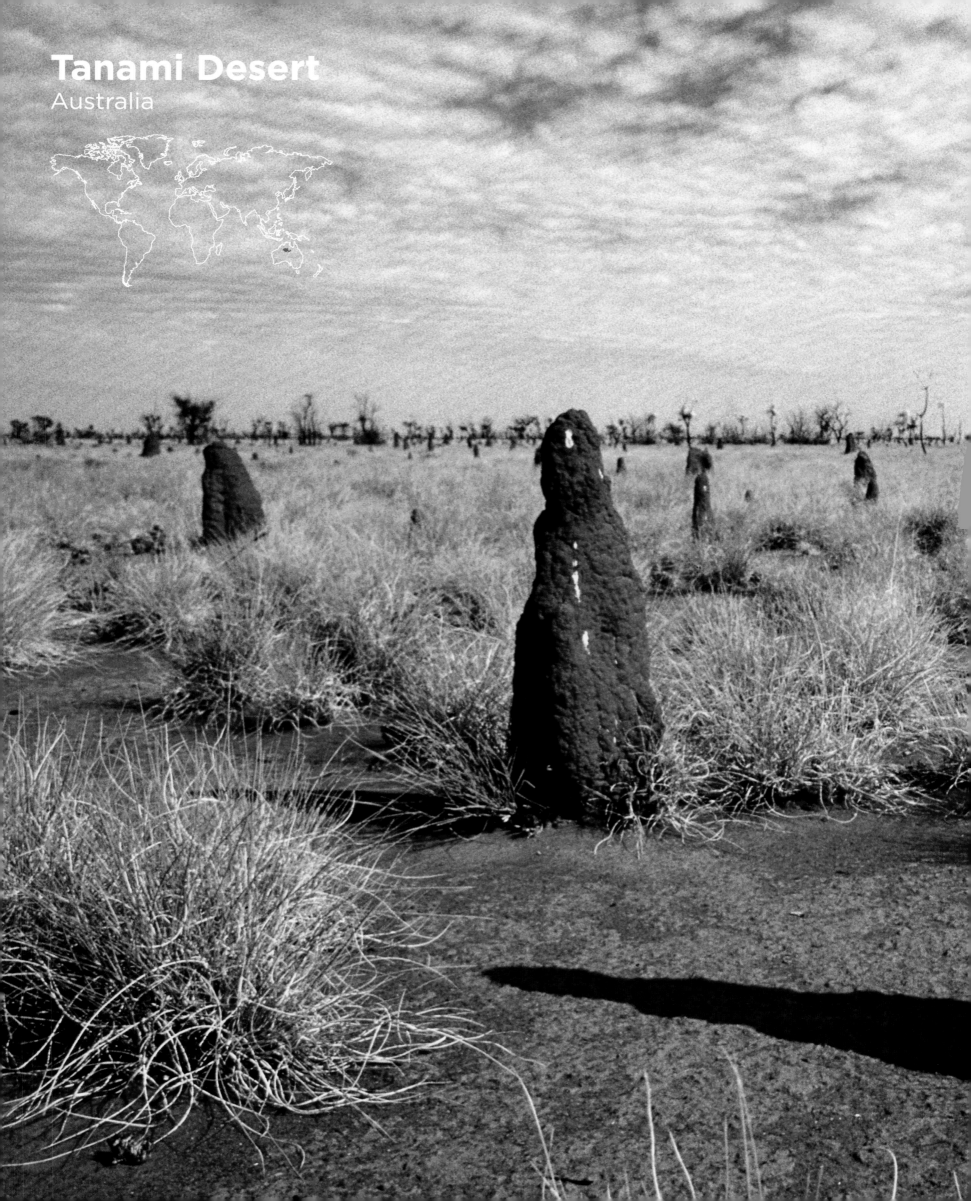

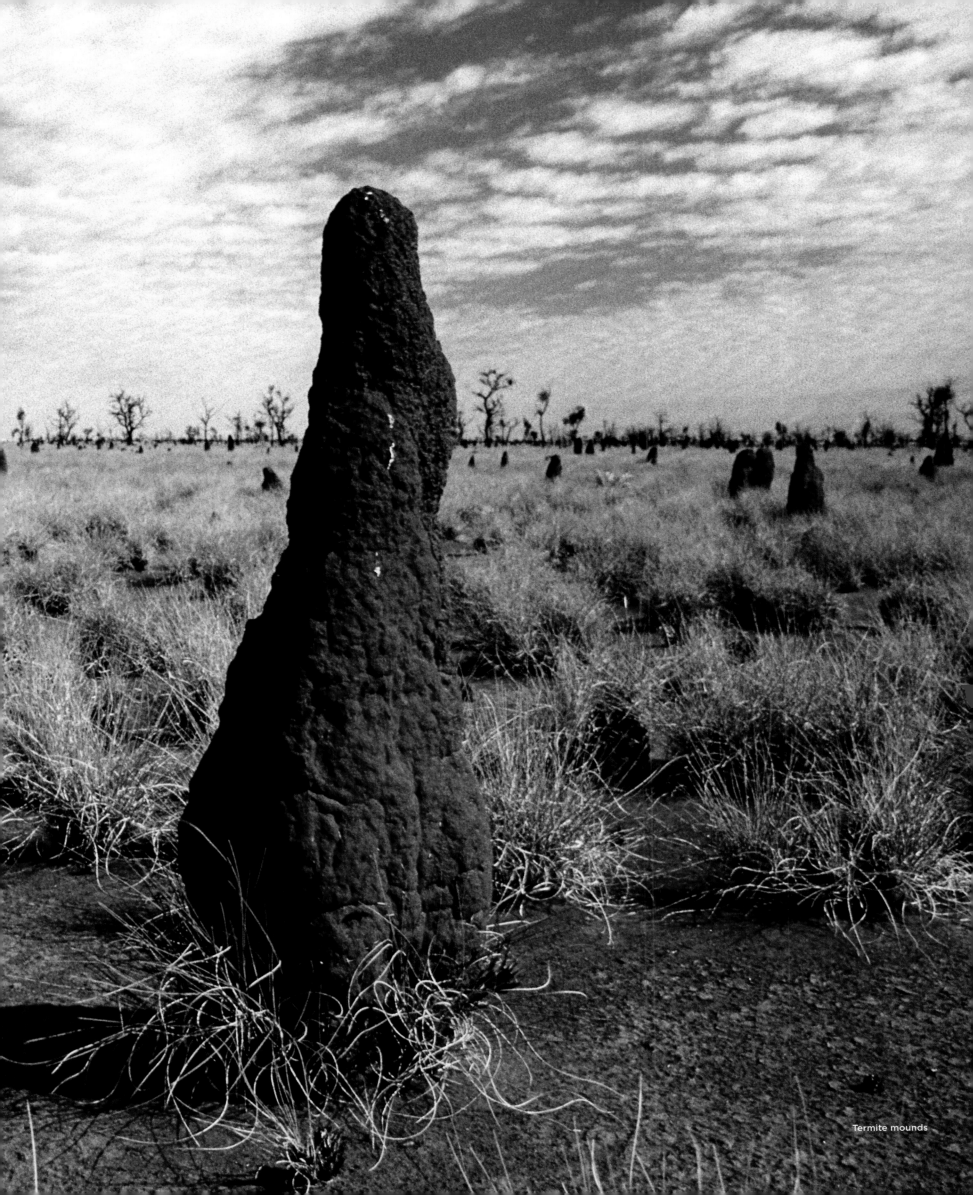

Termite mounds

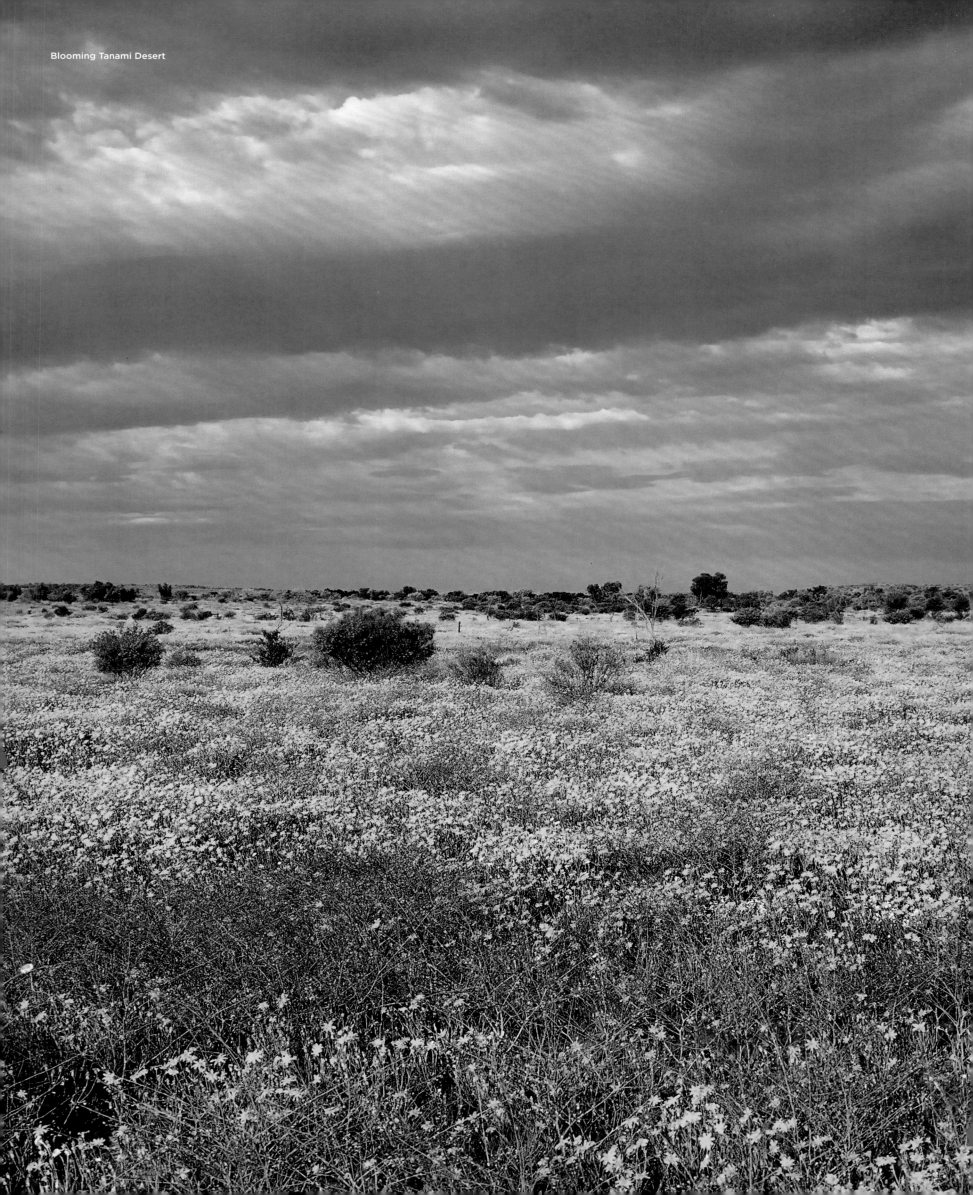

Blooming Tanami Desert

Spinifex Grass

Tanami Desert
The red-sand Tanami gets its name from the Walpiri Aboriginal word 'chanamee' ('never die'), a reference to reliable waterholes in this remote country. The Tanami's gravel plains are crossed by the Tanami Track – at over 1000 km from the Stuart Highway (Northern Territory) to Halls Creek (Western Australia), it's sometimes called 'the world's longest short-cut'.

Désert de Tanami
Le Tanami au sable rouge tient son nom du terme aborigène warlpiri « chanamee », (« ne meurt jamais »), en référence aux trous d'eau inépuisables de cette contrée reculée. Les plaines gravillonneuses du Tanami sont traversées par le Tanami Track – situé à plus de 1000 km de la Stuart Highway (Territoire du Nord) et de Halls Creek (Australie-Occidentale), on l'appelle parfois « le plus long raccourci du monde ».

Tanami-Wüste
Die Rotsand-Tanami hat ihren Namen vom Wort „chanamee" (nie sterben) der Walpiri-Aborigines, einem Hinweis auf zuverlässige Wasserlöcher in diesem abgelegenen Land. Die Kiesebenen der Tanami werden vom Tanami Track durchquert – der über 1000 Kilometer vom Stuart Highway (Northern Territory) nach Halls Creek (Western Australia) führt und manchmal als „die längste Abkürzung der Welt" bezeichnet wird.

Desierto de Tanami
El Tanami de arena roja recibe su nombre de la palabra aborigen Walpiri «chanamee» («nunca morir»), una referencia a los pozos de agua confiables de este remoto país. Las llanuras de grava de Tanami están atravesadas por la ruta Tanami Track, a más de 1000 km de la autopista Stuart Highway (territorio del norte) y Halls Creek (Australia Occidental), a la que a veces se le llama «el atajo más largo del mundo».

Deserto de Tanami
O Tanami, de areia vermelha, recebeu esse nome da palavra aborígene Walpiri "chanamee" ("never die"), uma referência a fontes confiáveis neste remoto país. As planícies de cascalho do Tanami são atravessadas pelo Tanami Track – a mais de 1000 km da Stuart Highway (Território do Norte) e Halls Creek (Austrália Ocidental), às vezes é chamado de "atalho mais longo do mundo".

Tanamiwoestijn
De Tanami met zijn rode zand dankt zijn naam aan het Walpiri-woord 'chanamee' ('nooit sterven'), een verwijzing naar betrouwbare waterpoelen in dit afgelegen land. De Tanami Track loopt dwars over de grindvlaktes van de Tanami – deze weg op meer dan 1000 km van de Stuart Highway (Northern Territory) en Halls Creek (Western Australia) wordt het ook wel 's werelds langste 'kortere weg' genoemd.

Outback road

Rocky red landscape, Balgo

Desert's treasures

Because of its remoteness, much of the Tanami was not fully explored by white settlers until well into the 20th century, although it was a homeland for the Kukatja and Walpiri Aboriginal peoples for thousands of years. It has become an increasingly important part of the Australian economy thanks to its gold deposits, and construction is currently underway for a natural gas pipeline. It is also considered an important last refuge for wildlife, with Newhaven, run by the Australian Wildlife Conservancy, among the largest feral-cat-free areas in Australia, which allows native animals like bettongs, bilbies and other endangered species to thrive.

Trésors du désert

À cause de son isolement, la majeure partie du Tamani a dû attendre le premier quart du XXᵉ siècle pour être entièrement exploré par des colons blancs, même s'il était le foyer des peuples aborigènes Kukatja et Warlpiri depuis des milliers d'années. Il est devenu une part de plus en plus importante de l'économie australienne grâce à ses gisements d'or et la construction d'un gazoduc est actuellement en cours. Il est également considéré comme un important refuge pour la faune, avec Newhaven. Sous la tutelle du Australian Wildlife Conservancy, il compte parmi les plus grands territoires d'Australie sans chats sauvages en liberté, permettant ainsi à des animaux indigènes tels que les rats-kangourous, bilbies et à d'autres espèces menacées d'extinction, de prospérer.

Die Schätze der Wüste

Wegen ihrer Abgeschiedenheit wurde ein Großteil der Tanami erst im 20. Jahrhundert von weißen Siedlern vollständig erforscht, obwohl sie jahrtausendelang die Heimat der Kukatja und Walpiri war. Dank ihrer Goldlagerstätten ist sie zu einem immer wichtigeren Teil der australischen Wirtschaft geworden, und der Bau einer Erdgasleitung ist im Gange. Newhaven, das vom Australian Wildlife Conservancy betrieben wird, gehört zu den größten Gebieten ohne verwilderte Hauskatzen in Australien, in denen einheimische Tiere wie Bürstenschwanz-Rattenkängurus, Kaninchen-nasenbeutler und andere bedrohte Arten gedeihen können.

Mud patterns on surface of a road

Tesoros del desierto

Debido a su lejanía, gran parte de los Tanami no fueron plenamente explorados por los colonos blancos hasta bien entrado el siglo XX, aunque durante miles de años fueron la patria de los pueblos aborígenes Kukatja y Walpiri. Se ha convertido en una parte cada vez más importante de la economía australiana gracias a sus yacimientos de oro, y actualmente se está construyendo un gasoducto de gas natural. También es considerado un importante último refugio para la vida silvestre, con Newhaven, dirigido por la Australian Wildlife Conservancy, una de las mayores áreas libres de gatos salvajes de Australia, que permite que los animales nativos como bettongias, bilbies y otras especies en peligro de extinción prosperen.

Tesouros do deserto

Devido à sua distância, grande parte do Tanami não foi totalmente explorada pelos colonos brancos até meados do século XX, embora tenha sido uma terra natal para os povos Aborígenes Kukatja e Walpiri por milhares de anos. Tornou-se uma parte cada vez mais importante da economia australiana, graças aos seus depósitos de ouro e a construção está em andamento para um gasoduto de gás natural. Ele também é considerado um importante último refúgio para a vida selvagem, com Newhaven, administrado pela Australian Wildlife Conservancy, entre as maiores áreas livres de gatos selvagens na Austrália, que permite que animais nativos como bettongs, bilbies e outras espécies ameaçadas prosperem.

Schatten van de woestijn

Vanwege zijn afgelegen ligging werd een groot deel van de Tanamiwoestijn pas in de 20e eeuw door blanke kolonisten verkend, hoewel hij al duizenden jaren het thuisland was van de Kukatja en Walpiri. Dankzij de goudvoorraden is hij steeds belangrijker geworden voor de Australische economie en er wordt momenteel een pijpleiding voor aardgas aangelegd. De woestijn is ook een belangrijk toevluchtsoord voor wilde dieren. Newhaven, dat door de Australian Wildlife Conservancy wordt beheerd, is een van de grootste gebieden zonder verwilderde katten in Australië, waardoor inheemse dieren zoals borstelstaartkangoeroeratten, langoorbuideldassen en andere bedreigde diersoorten hier kunnen gedijen.

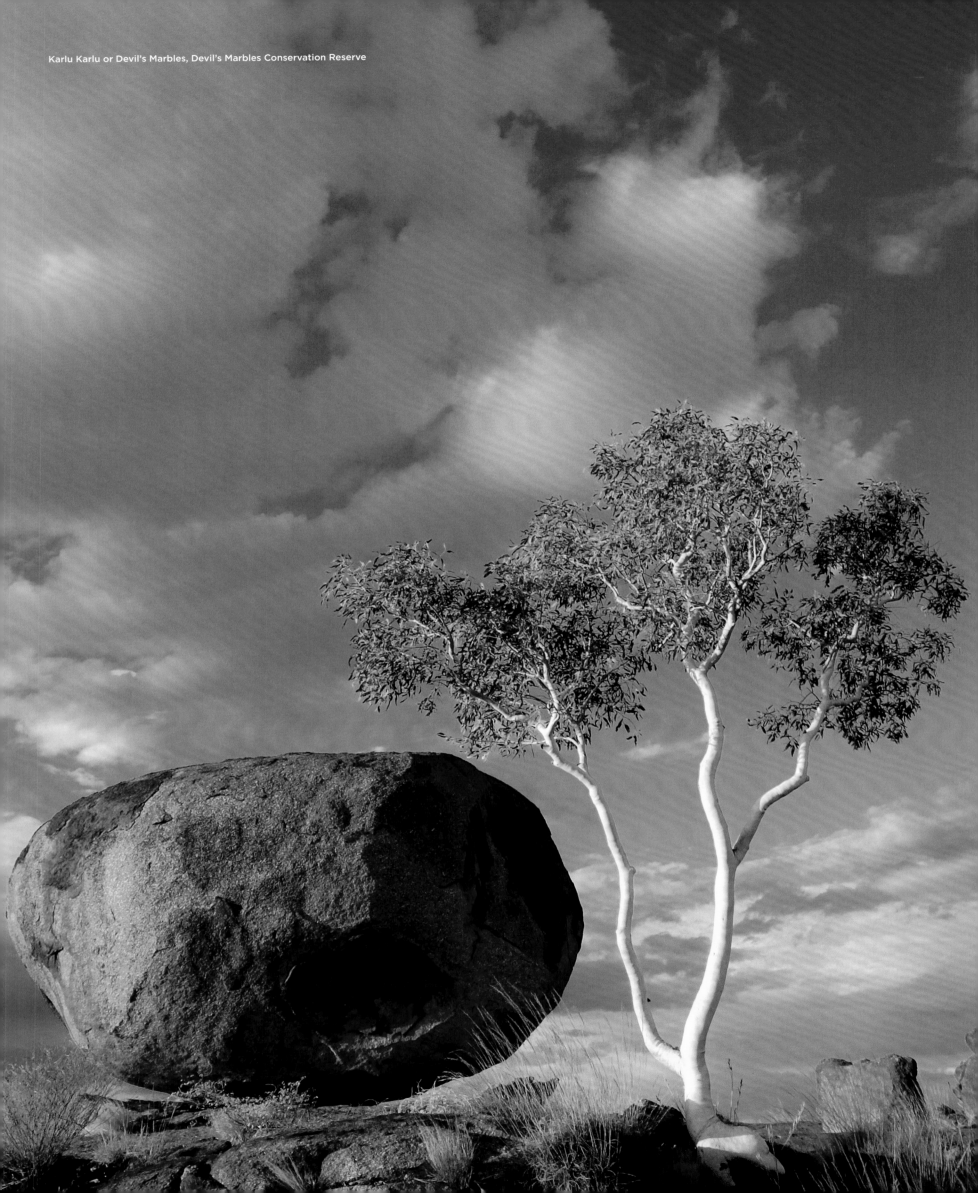

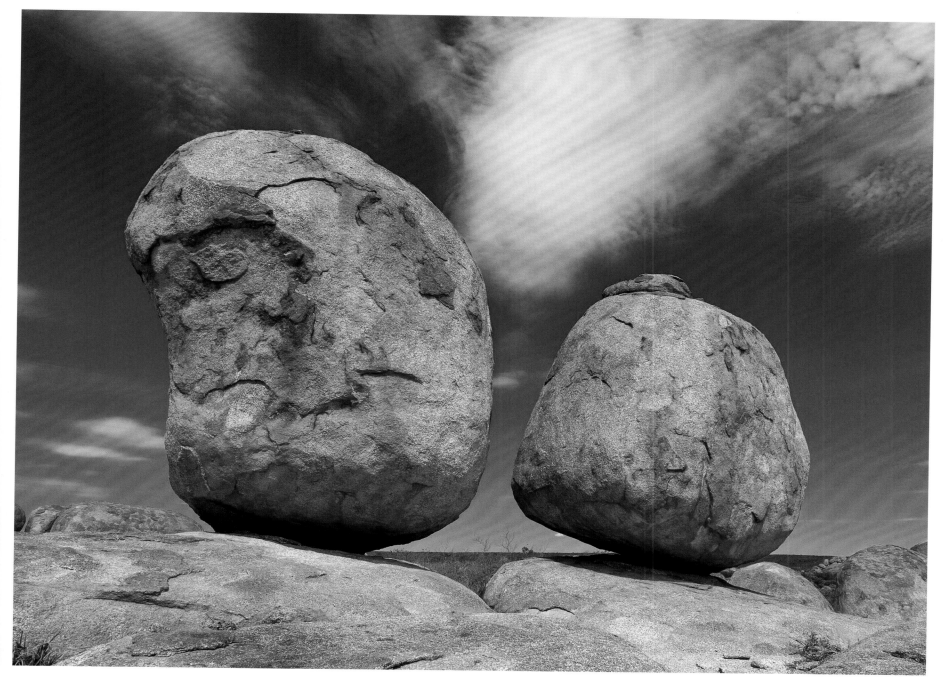

Karlu Karlu or Devil's Marbles, Devil's Marbles Conservation Reserve

Devil's Marbles

Close to 400 km north of Alice Springs in the heart of Australia, these soulful granite boulders (called Karlu Karlu in the local language) are sacred to the local indigenous population who believe that the rocks are the eggs of the Rainbow Serpent, the earth's Creator spirit. Extremes of temperature have caused many boulders to cleave in two.

Canicas del Diablo

Cerca de 400 km al norte de Alice Springs, en el corazón de Australia, estos conmovedores cantos rodados de granito (llamados Karlu Karlu Karlu en el idioma local) son sagrados para la población indígena local, que cree que las rocas son los huevos de la serpiente arco iris, el espíritu creador de la Tierra. Los extremos de temperatura han causado que muchas rocas se rompan en dos.

Devils Marbles

À près de 400 km au nord d'Alice Springs, au cœur de l'Australie, ces blocs rocheux granitiques très expressifs (nommés Karlu Karlu dans la langue locale) sont considérés comme sacrés par la population indigène locale, qui croit que les rochers sont des œufs du Serpent Arc-en-ciel, l'esprit du créateur de la Terre. Nombre de ces blocs ont été fendus en deux par les températures extrêmes.

Mármores do Diabo

Perto de 400 quilômetros ao norte de Alice Springs, no coração da Austrália, esses pedregulhos de granito (chamados Karlu Karlu no idioma local) são sagrados para a população indígena local que acredita que as rochas são os ovos da Serpente Arco-Íris, o espírito criador da Terra. . Extremos de temperatura fizeram com que muitos pedregulhos se dividissem em dois.

Devil's Marbles

Nahezu 400 Kilometer nördlich von Alice Springs im Herzen Australiens stehen diese seelenvollen Granitfelsen (in der Landessprache Karlu Karlu genannt), die der einheimischen Bevölkerung heilig sind. Sie glauben, dass die Felsen die Eier der Regenbogenschlange sind, des Schöpfergeistes der Erde. Temperaturextreme haben dazu geführt, dass viele Felsbrocken in zwei Hälften gespalten sind.

Devils Marbles Conservation Range

Bijna 400 km ten noorden van Alice Springs, in het hart van Australië, zijn deze bezielde granietblokken (Karlu Karlu genoemd in de lokale taal) heilig voor de inheemse bevolking. Die gelooft dat de rotsen de eieren van de regenboogslang zijn, de scheppergeest van de aarde. Extreme temperaturen hebben ertoe geleid dat veel rotsblokken in tweeën zijn gespleten.

Dingo, Devil's Marbles Conservation Reserve

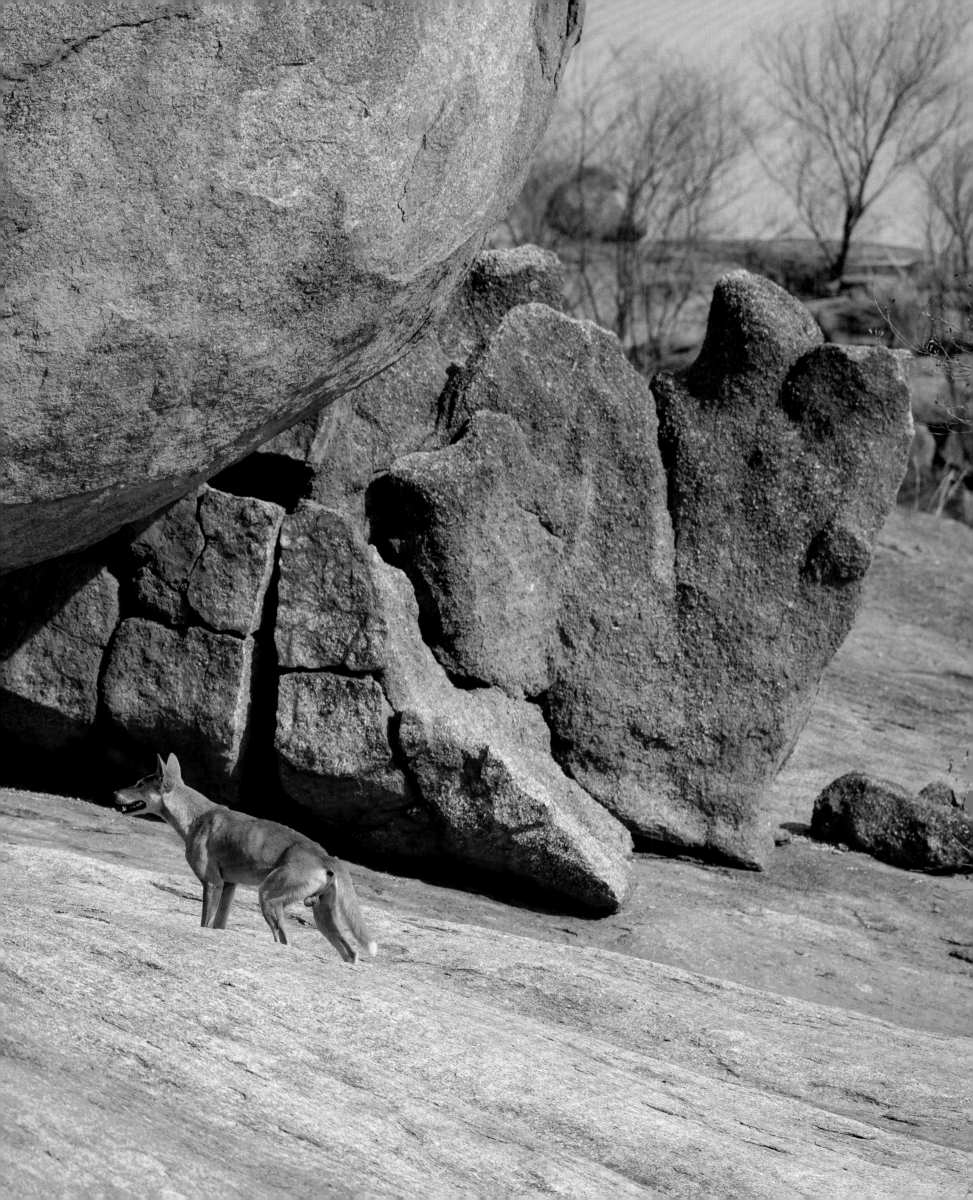

Great Sandy Desert & Little Sandy Desert
Australia

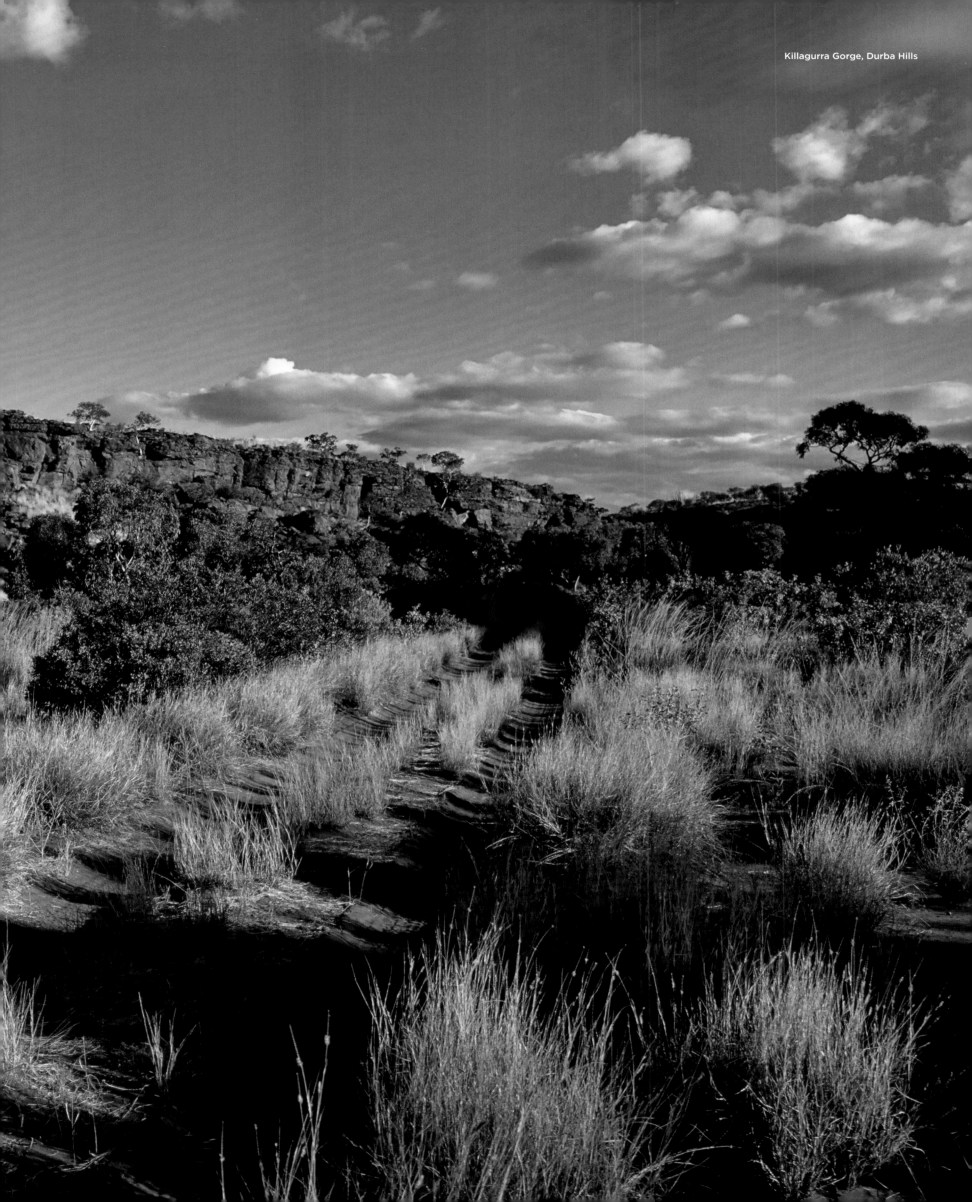

Killagurra Gorge, Durba Hills

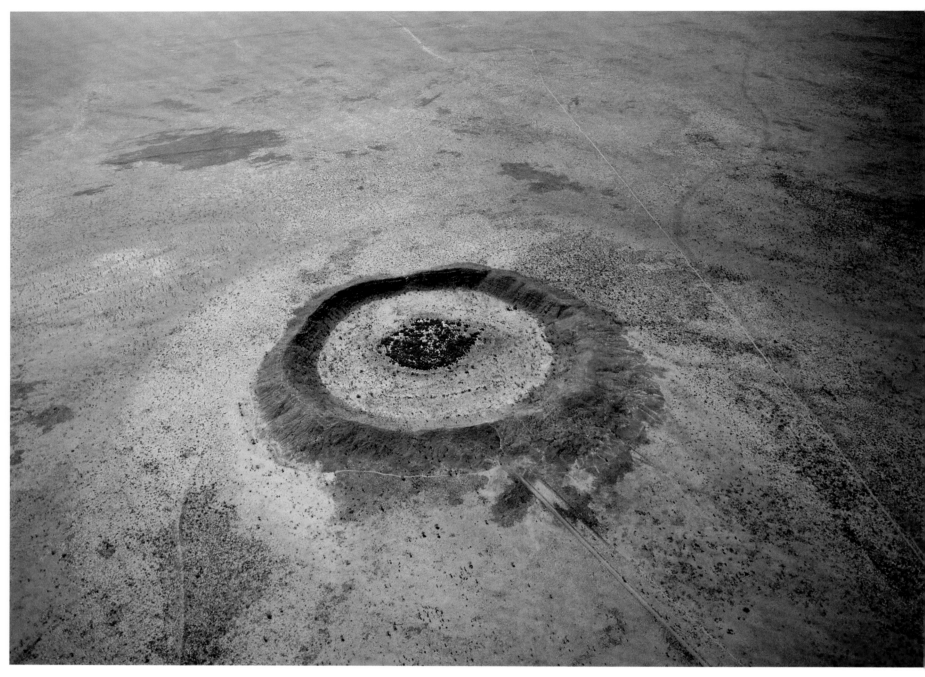

Wolfe Creek, Wolfe Creek Crater National Park

Great Sandy Desert and Little Sandy Desert

The Great Sandy Desert, in the heart of the state of Western Australia, is considered to be Australia's second-largest desert, and is one of the most thinly populated terrains on earth. Traditionally, the lands were the domain of the Martu and Pintupi Indigenous peoples; although they no longer lead traditional nomadic lifestyles, some have returned to the area after having been driven from their lands. Both deserts are crossed by the Canning Stock Route, a famous cattle run now beloved by 4WD enthusiasts, while the Wolfe Creek Crater, the result of a meteorite impact, plays an important role in Aboriginal creation stories.

Grand Désert de sable et Petit Désert de sable

Situé au cœur de l'État d'Australie-Occidentale, le Grand Désert de Sable est considéré comme le deuxième plus grand désert d'Australie, et constitue l'un des territoires les moins peuplés de la planète. Traditionnellement, ces terres accueillaient les peuples indigènes Martu et Pintupi ; même s'ils menaient surtout un mode de vie nomade, certains sont revenus dans la zone après avoir été chassés de leurs terres. Ces deux déserts sont traversés par la Canning Stock Route, une célèbre piste pour le bétail aujourd'hui chérie par les adeptes de véhicules à quatre roues motrices, tandis que le cratère de Wolfe Creek, causé par un impact de météorite, joue un rôle important dans les histoires aborigènes sur la Création.

Große Sandwüste und Kleine Sandwüste

Die Great Sandy Desert im Herzen des Bundesstaates Western Australia gilt als die zweitgrößte Wüste Australiens und ist eines der am dünnsten besiedelten Gebiete der Welt. Traditionell waren die Ländereien das Gebiet der indigenen Völker der Martu und Pintupi; obwohl sie nicht mehr einen traditionellen nomadischen Lebensstil führen, sind einige von ihnen in das Gebiet zurückgekehrt, nachdem sie von ihrem Land vertrieben wurden. Beide Wüsten werden von der Canning Stock Route durchquert, einer berühmten Viehtriebstrecke, die heute bei Allradfahrern beliebt ist. Der Wolfe Creek Crater, das Ergebnis eines Meteoriteneinschlags, spielt eine wichtige Rolle in den Schöfpungsgeschichten der Aborigines.

Balgo Hills after rain

Gran Desierto de Arena y Pequeño Desierto de Arena

El Gran Desierto de Arena, en el corazón del estado de Australia Occidental, es considerado el segundo desierto más grande de Australia, y es uno de los terrenos más poblados de la Tierra. Tradicionalmente, las tierras eran dominio de los pueblos indígenas Martu y Pintupi; aunque ya llevan estilos de vida nómadas tradicionales, algunos han regresado a la zona después de haber sido expulsados de sus tierras. Ambos desiertos están atravesados por la Canning Stock Route, una famosa carrera de ganado que ahora es amada por los entusiastas de los vehículos 4x4, mientras que el Wolfe Creek Crater, resultado de un impacto de meteoritos, desempeña un papel importante en las historias de la creación aborigen.

Grande deserto de areia e pequeno deserto de areia

O Great Sandy Desert, no coração do estado da Austrália Ocidental, é considerado o segundo maior deserto da Austrália, e é um dos terrenos menos povoados do planeta. Tradicionalmente, as terras eram o domínio dos povos indígenas Martu e Pintupi; embora eles levem mais estilos de vida nômades tradicionais, alguns retornaram à área depois de terem sido expulsos de suas terras. Ambos os desertos são atravessados pela Canning Stock Route, uma famosa corrida de gado amada por entusiastas de 4WD, enquanto a Wolfe Creek Crater, o resultado de um impacto de meteorito, desempenha um papel importante nas histórias de criação dos aborígenes.

Grote Zandwoestijn en Kleine Zandwoestijn

De Great Sandy Desert, midden in de Australische staat West-Australië, wordt beschouwd als de op een na grootste woestijn van Australië en is een van de dunst bevolkte gebieden op aarde. Traditioneel waren de landen het domein van de Martu en Pintupi. Hoewel deze aboriginalvolken niet langer een traditioneel nomadenbestaan leiden, zijn sommige teruggekeerd naar het gebied nadat ze van hun land verdreven waren. Door beide woestijnen loopt de Canning Stock Route, een beroemde veeroute die nu geliefd is bij bestuurders van terreinwagens. De Wolfe Creek Crater, het gevolg van een meteorietinslag, speelt een belangrijke rol in de scheppingsverhalen van de Aboriginals.

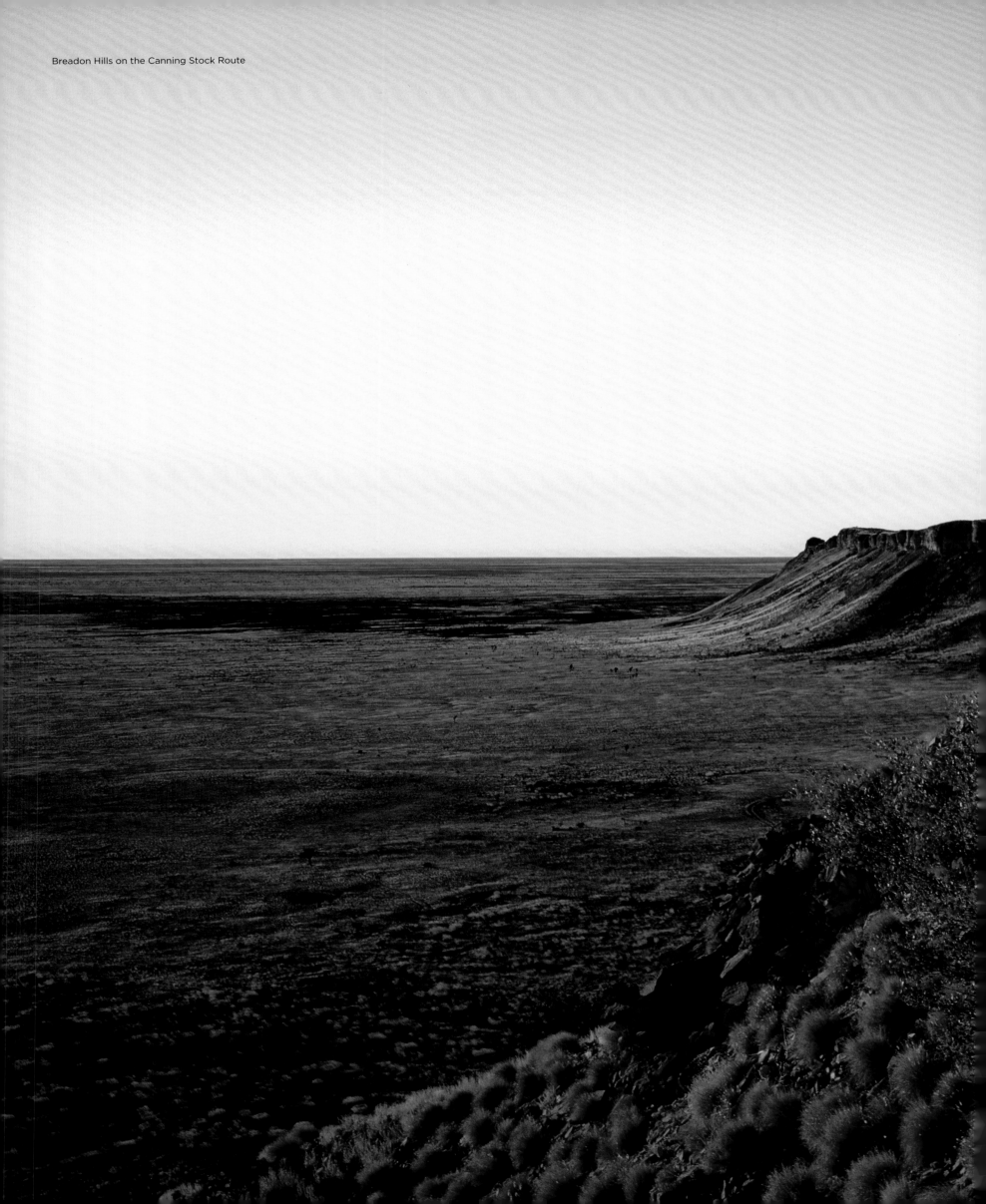

Breadon Hills on the Canning Stock Route

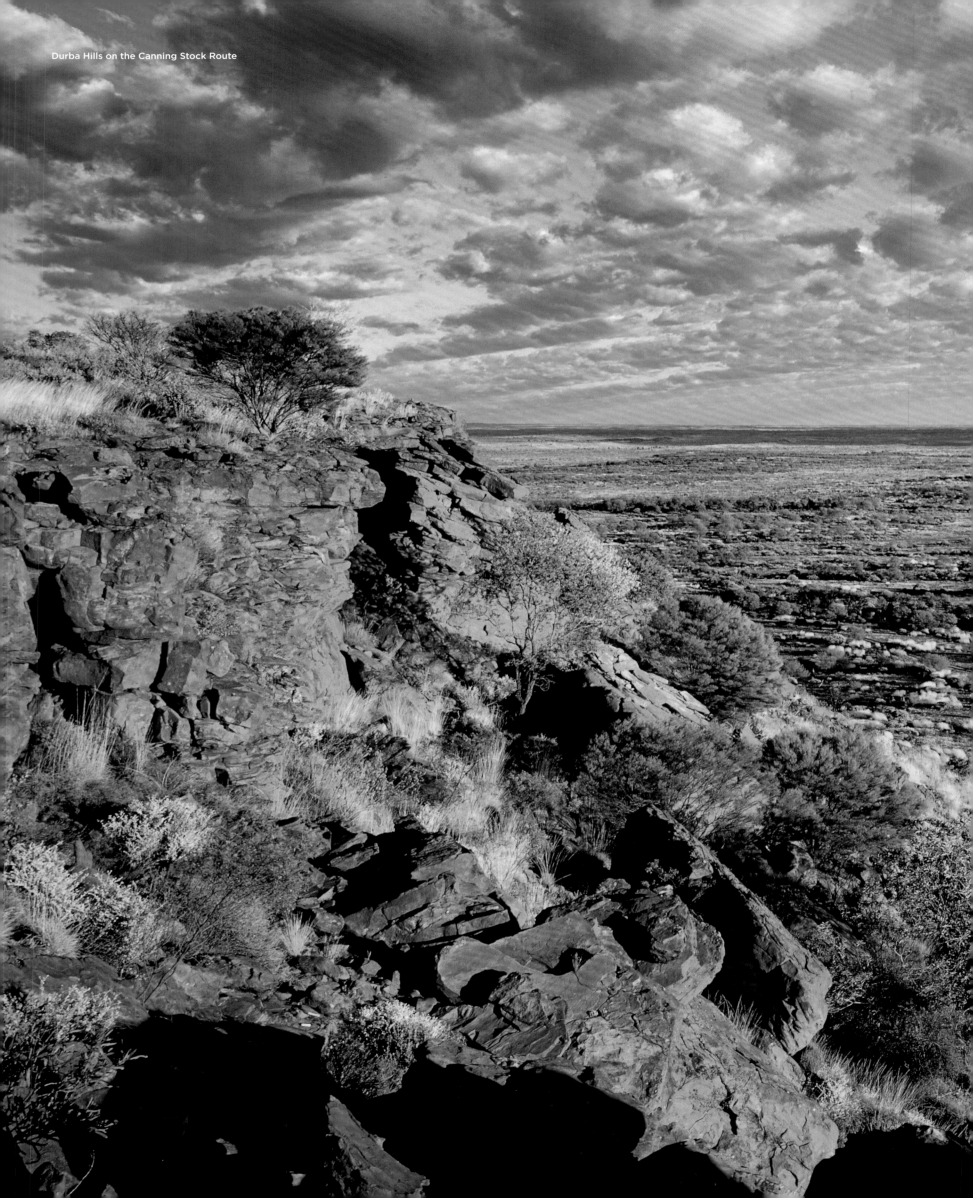
Durba Hills on the Canning Stock Route

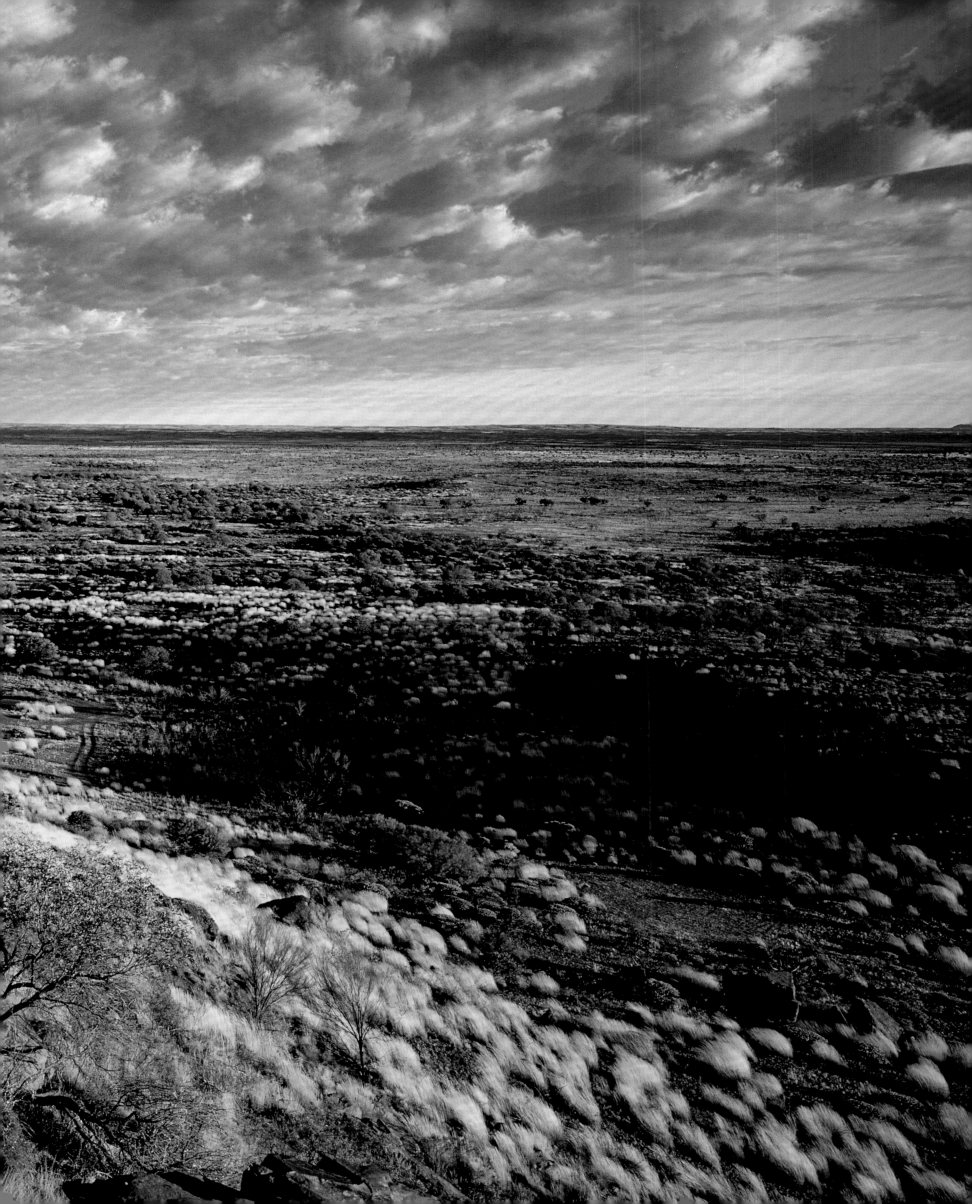

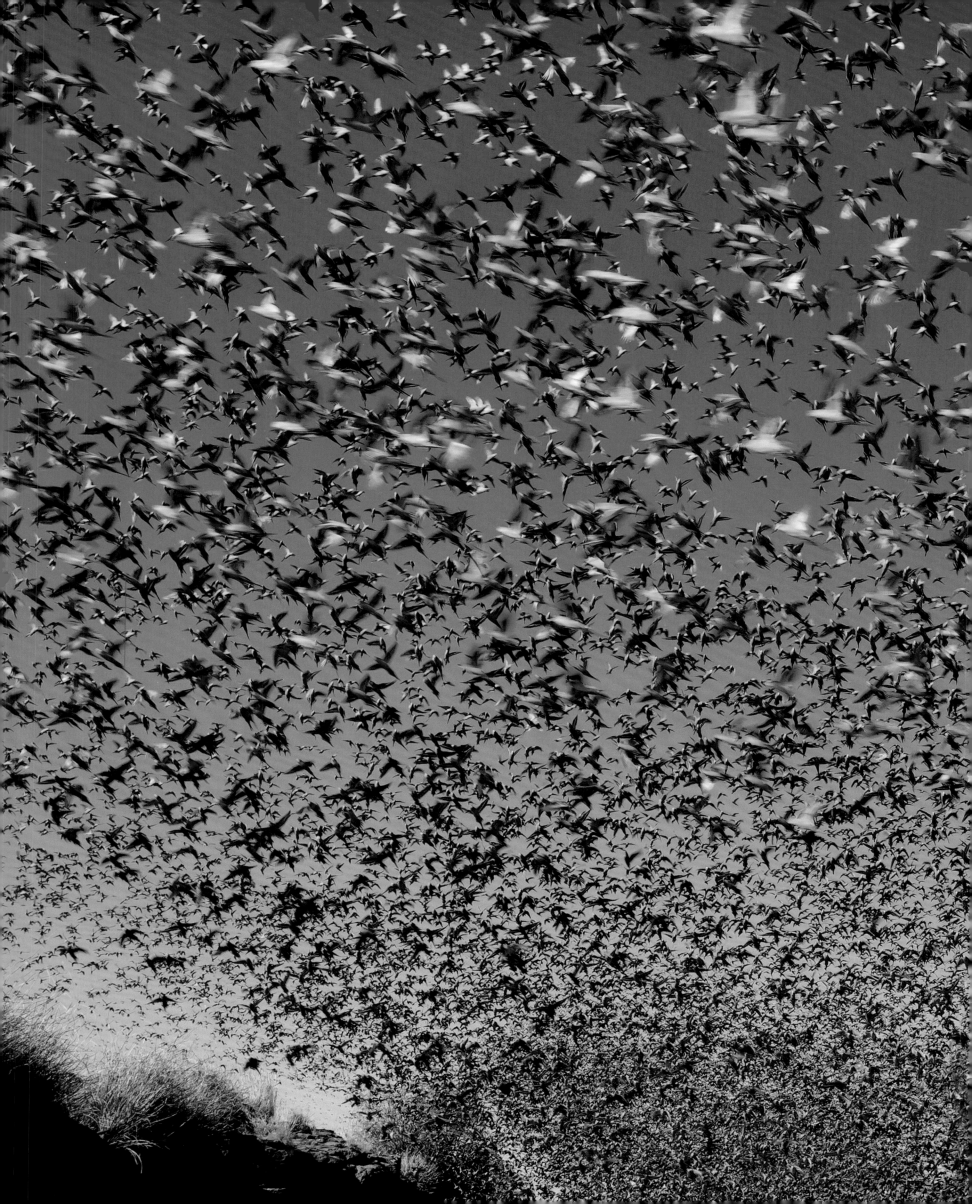

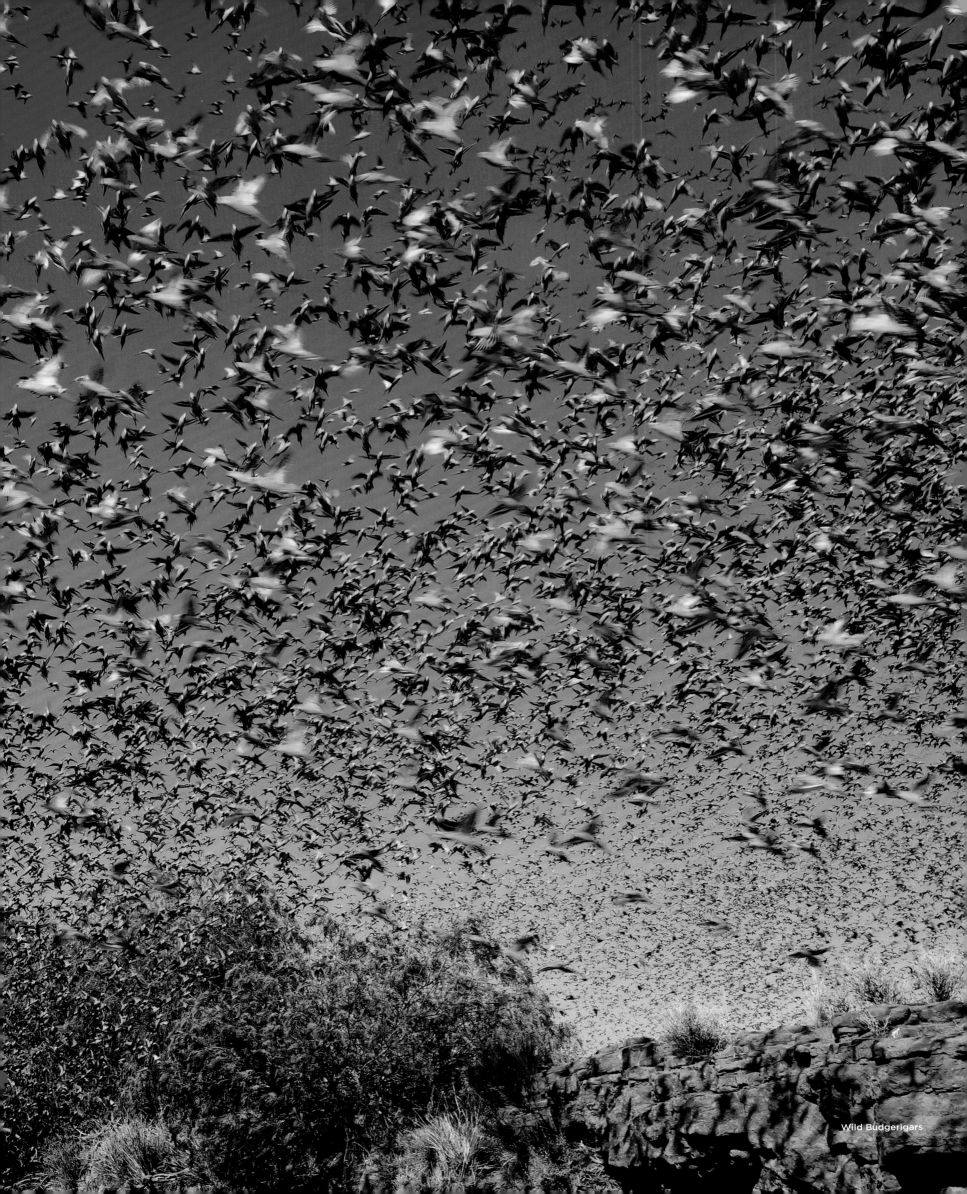

Wild Budgerigars

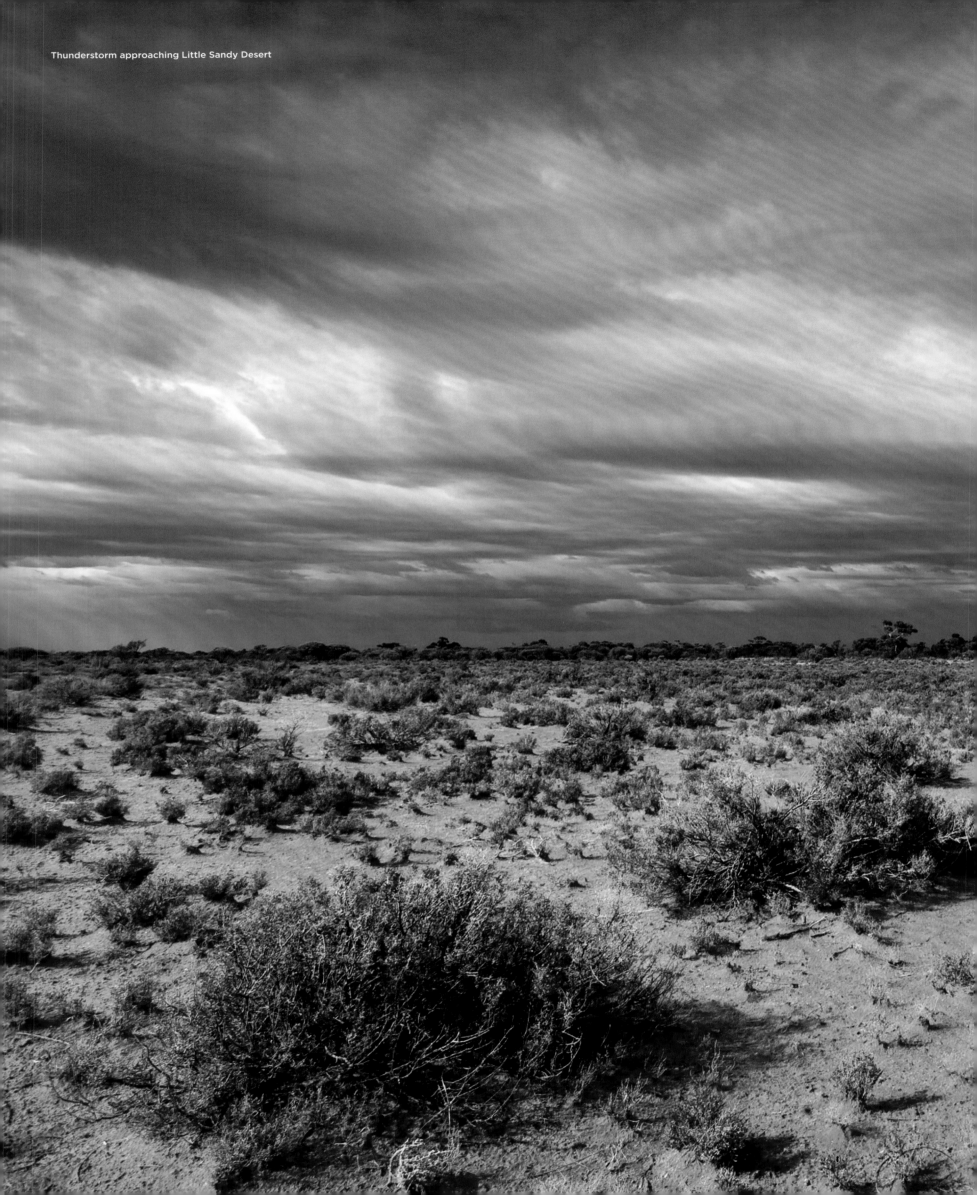
Thunderstorm approaching Little Sandy Desert

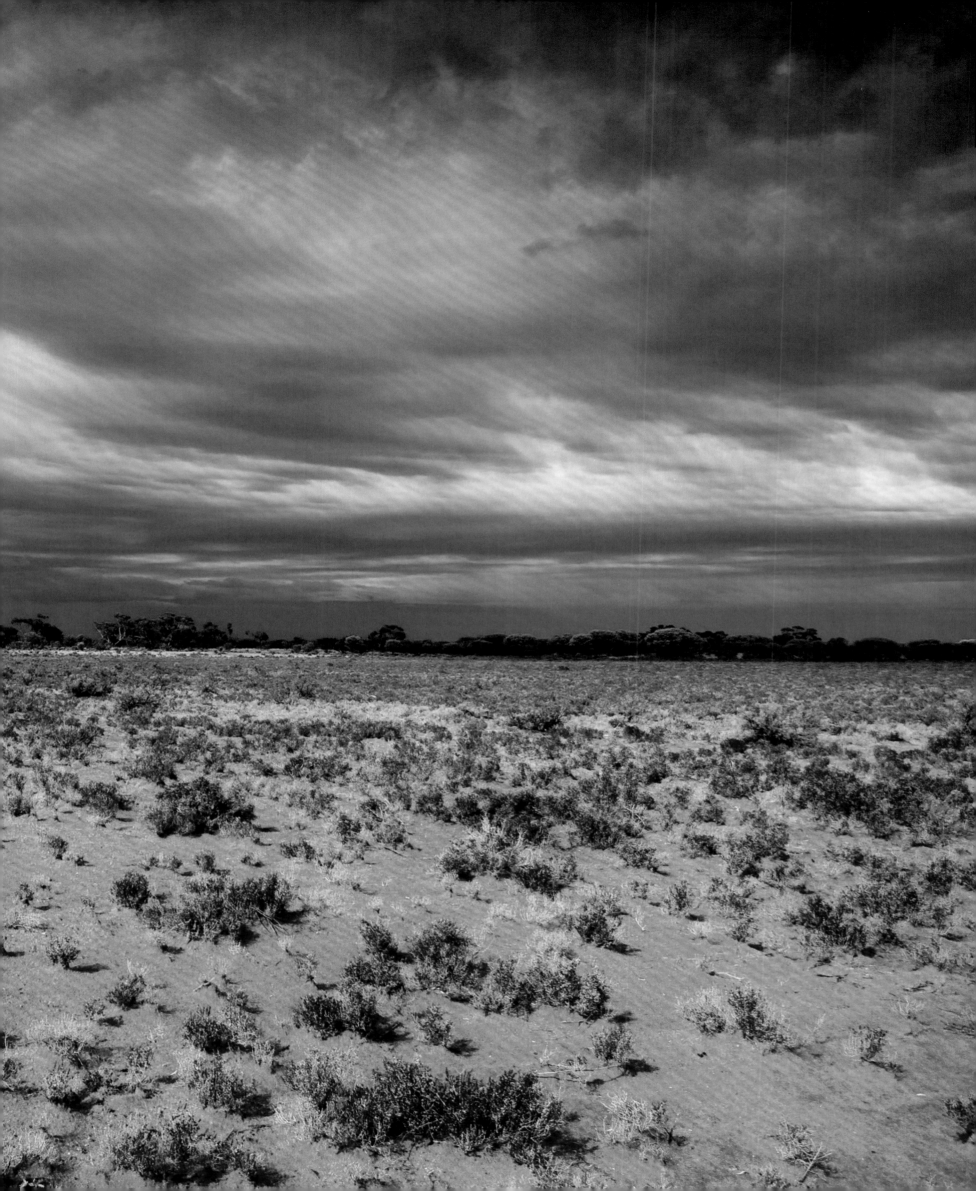

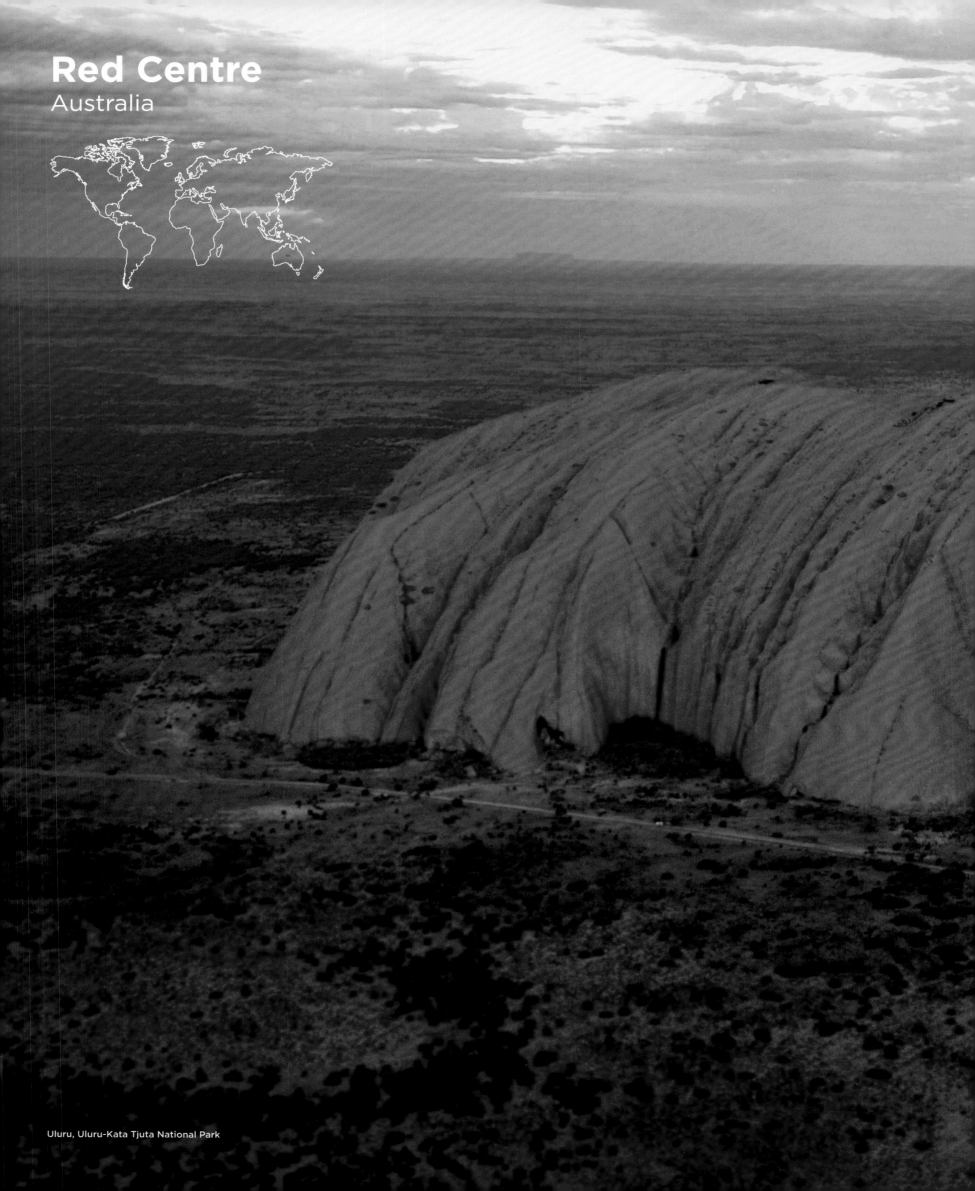

Red Centre
Australia

Uluru, Uluru-Kata Tjuta National Park

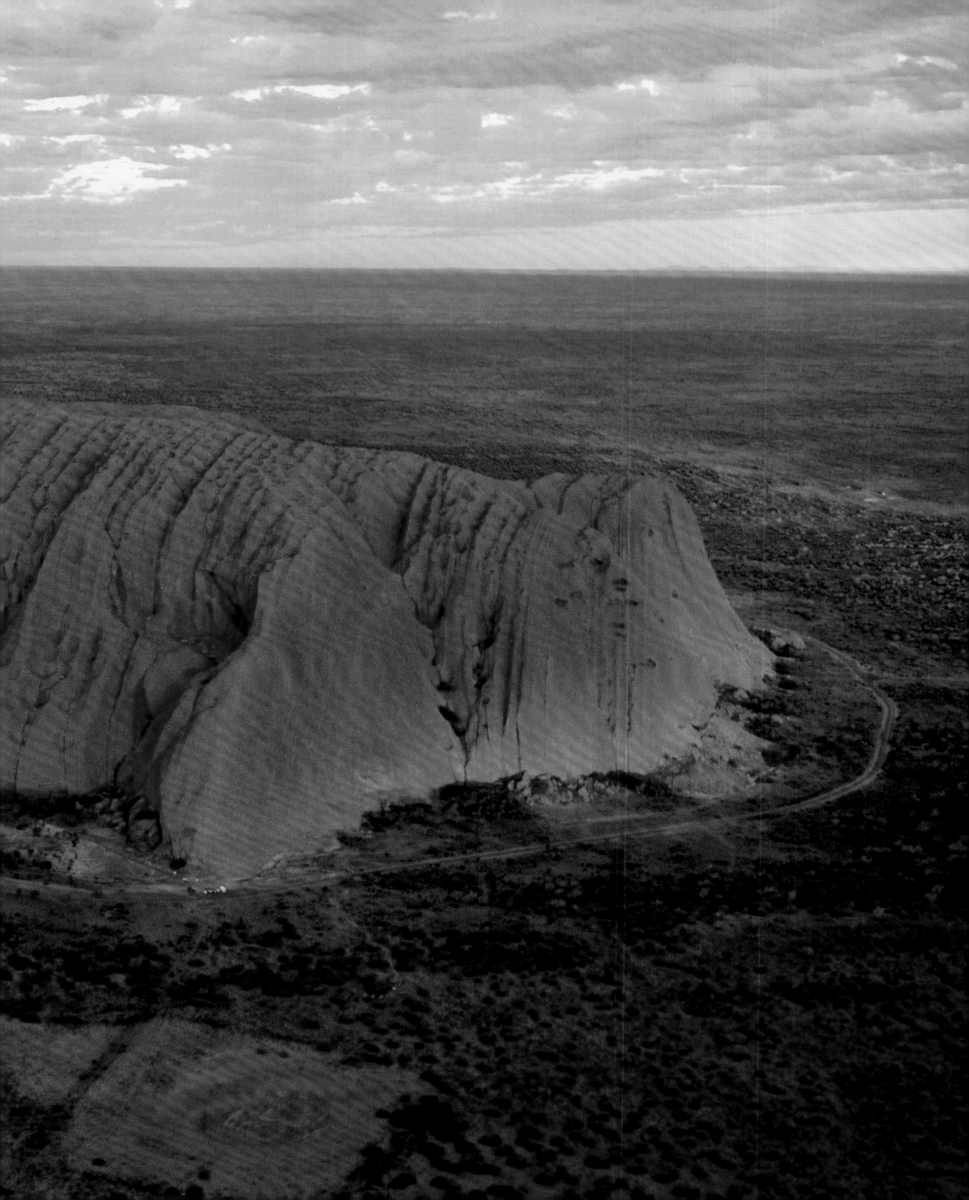

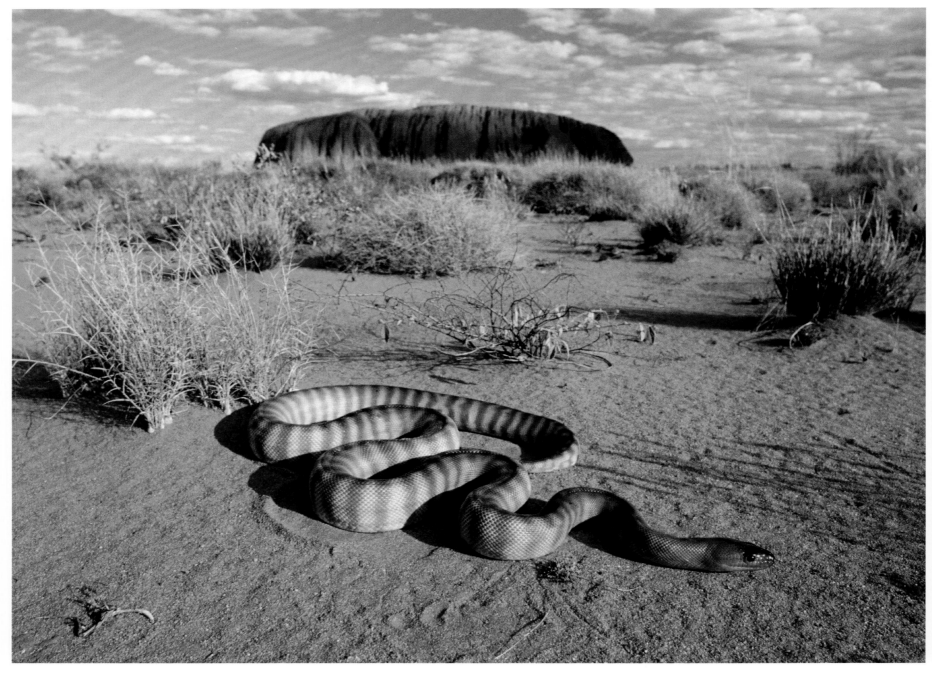

Ramsay's Python, Uluru, Uluru-Kata Tjuta National Park

Uluru and Kata Tjuta

An icon of Australia's Outback, Uluru is also one of Australia's most popular tourist attractions. Originally named Ayers Rock after the Chief Secretary of South Australia in 1873, it took on its current indigenous name in 1985 when title was returned to the traditional owners, the Anangu people in 1985. The land was leased back to the Australian Government who jointly administers the Uluru-Kata-Tjuta National Park, which takes in both Uluru and Kata Tjuta (formerly The Olgas). The Anangu owners have long requested that visitors not climb Uluru.

Uluru et Kata Tjuta

Icône de l'Outback australien, Uluru est également l'une des attractions touristiques les plus populaires. Originellement nommé Ayers Rock, d'après le Premier ministre d'Australie-Méridionale, en 1873, il a pris son nom aborigène actuel en 1985, quand le droit de propriété a été rendu au peuple Anangu. La terre a été relouée au gouvernement australien qui administre conjointement le parc national Uluru-Kata-Tjuta, implanté à la fois sur l'Uluru et le Kata Tjuta (anciennement les monts Olgas). Les propriétaires Anangu ont longtemps demandé à ce que les visiteurs ne gravissent pas l'Uluru, une ascension officiellement proscrite) partir du 26 octobre 2019.

Uluru und Kata Tjuta

Uluru ist ein Wahrzeichen des australischen Outbacks und auch eine der beliebtesten Touristenattraktionen Australiens. Ursprünglich im Jahr 1873 nach dem Premierminister von Südaustralien Ayers Rock benannt, erhielt der Berg 1985 seinen heutigen indigenen Namen, als der Besitz 1985 an die traditionellen Eignetümer, das Volk der Anangu, zurückgegeben wurde. Das Land wurde an die australische Regierung zurückverpachtet, die den Uluru-Kata-Tjuta Nationalpark verwaltet, der sowohl Uluru als auch Kata Tjuta (ehemals The Olgas) umfasst. Die Anangu haben schon lange darum gebeten, dass Besucher den Uluru nicht besteigen.

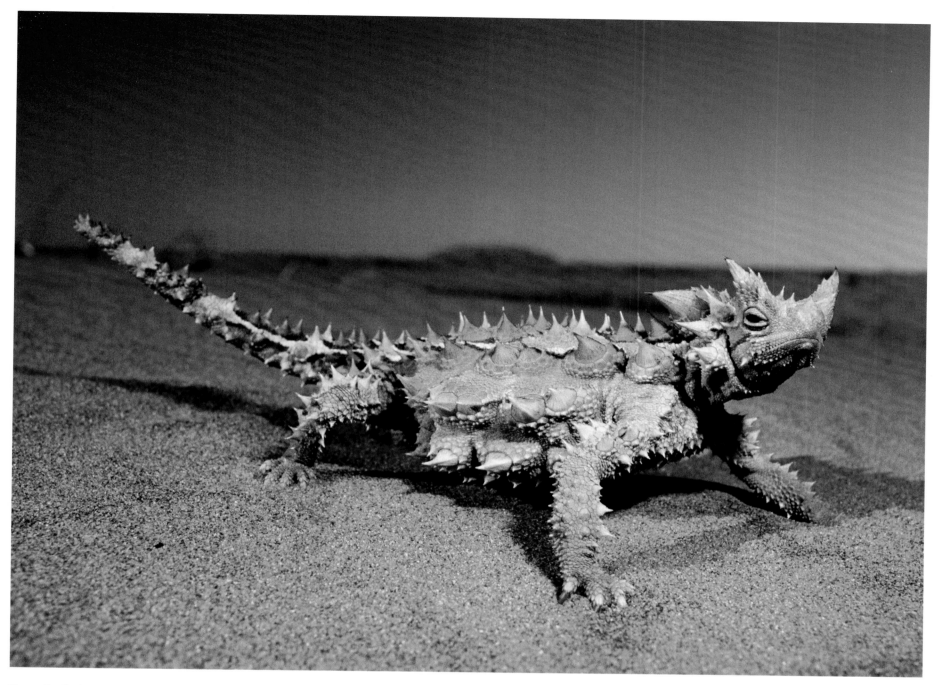

Thorny Devil, Uluru, Uluru-Kata Tjuta National Park

Uluru y Kata Tjuta

El Uluro es un icono del Outback de Australia y una de las atracciones turísticas más populares de Australia. Originalmente llamado Ayers Rock en honor al Secretario Principal de Australia del Sur en 1873, recibió su actual nombre indígena en 1985, cuando el título fue devuelto a los propietarios tradicionales, el pueblo anangu, en 1985. La tierra fue arrendada al Gobierno australiano, que administra conjuntamente el Parque Nacional de Uluru-Kata-Tjuta, que abarca tanto Uluru como Kata Tjuta (antes Las Olgas). Los propietarios de los anangu llevan pidiendo desde hace mucho tiempo que los visitantes no suban al Uluru.

Uluru e Kata Tjuta

Um ícone do Outback da Austrália, o Uluru é também uma das atrações turísticas mais populares da Austrália. Originalmente chamado Ayers Rock após o Secretário-Chefe da Austrália do Sul em 1873, ele assumiu seu nome indígena atual em 1985, quando o título foi devolvido aos proprietários tradicionais, o povo Anangu em 1985. A terra foi alugada ao governo australiano que administra conjuntamente o Parque Nacional Uluru-Kata-Tjuta, que leva em Uluru e Kata Tjuta (ex-The Olgas). Os proprietários de Anangu há muito solicitam que os visitantes não escalem Uluru.

Uluru en Kata Tjuta

Uluru, een icoon van de Australische Outback, is ook een van de populairste bezienswaardigheden van Australië. De berg, die in 1873 Ayers Rock werd genoemd naar de premier van South Australia, kreeg zijn huidige inheemse naam in 1985, toen de berg werd teruggegeven aan de traditionele eigenaars, het Anangu-volk. Het land werd weer verpacht aan de Australische regering, die het nationale park Uluru-Kata Tjuta beheert, dat zowel de Uluru als de Kata Tjuta (voorheen The Olgas) omvat. De Anangu hebben lang verzocht bezoekers te verbieden de Uluru te beklimmen.

Uluru, Uluru-Kata Tjuta National Park

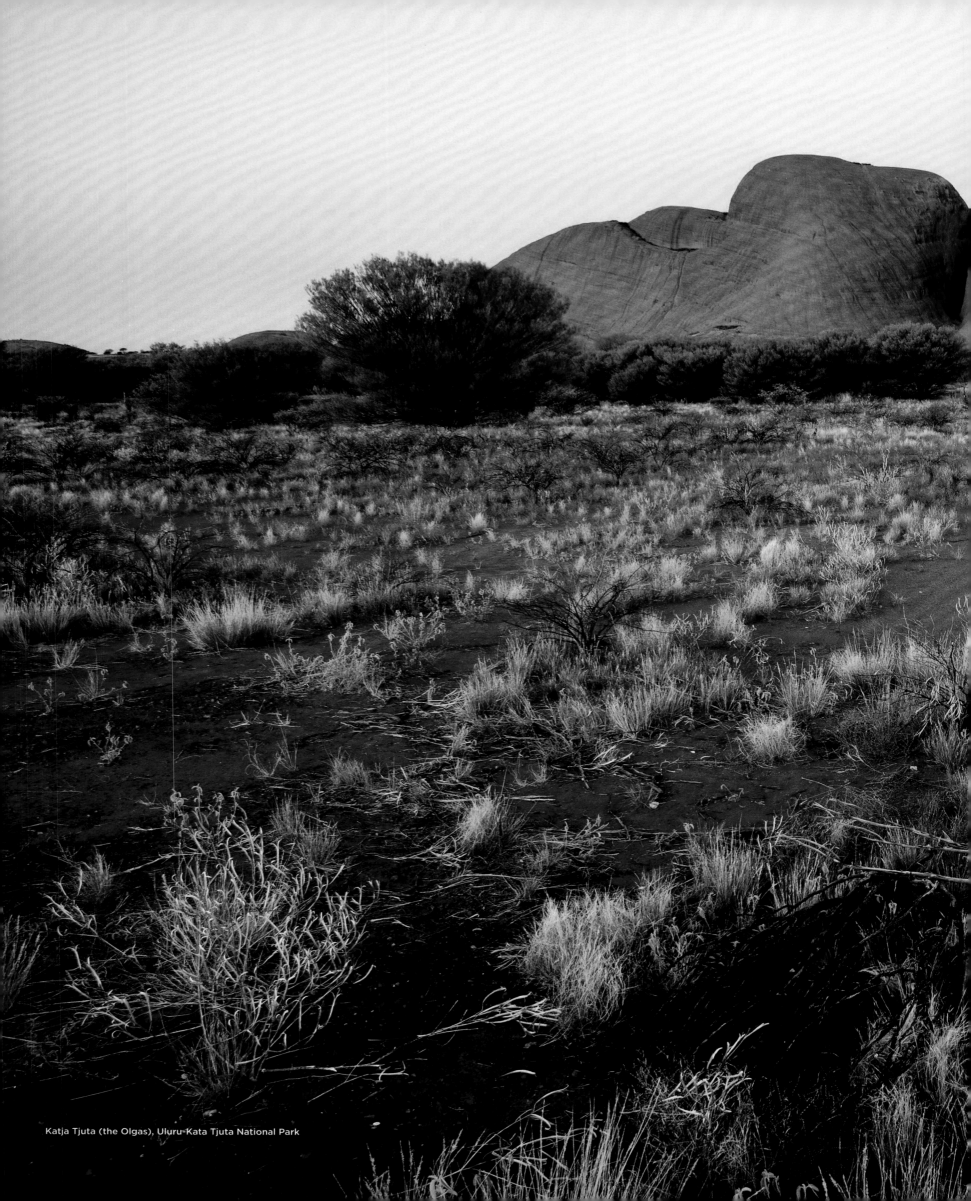

Katja Tjuta (the Olgas), Uluru-Kata Tjuta National Park

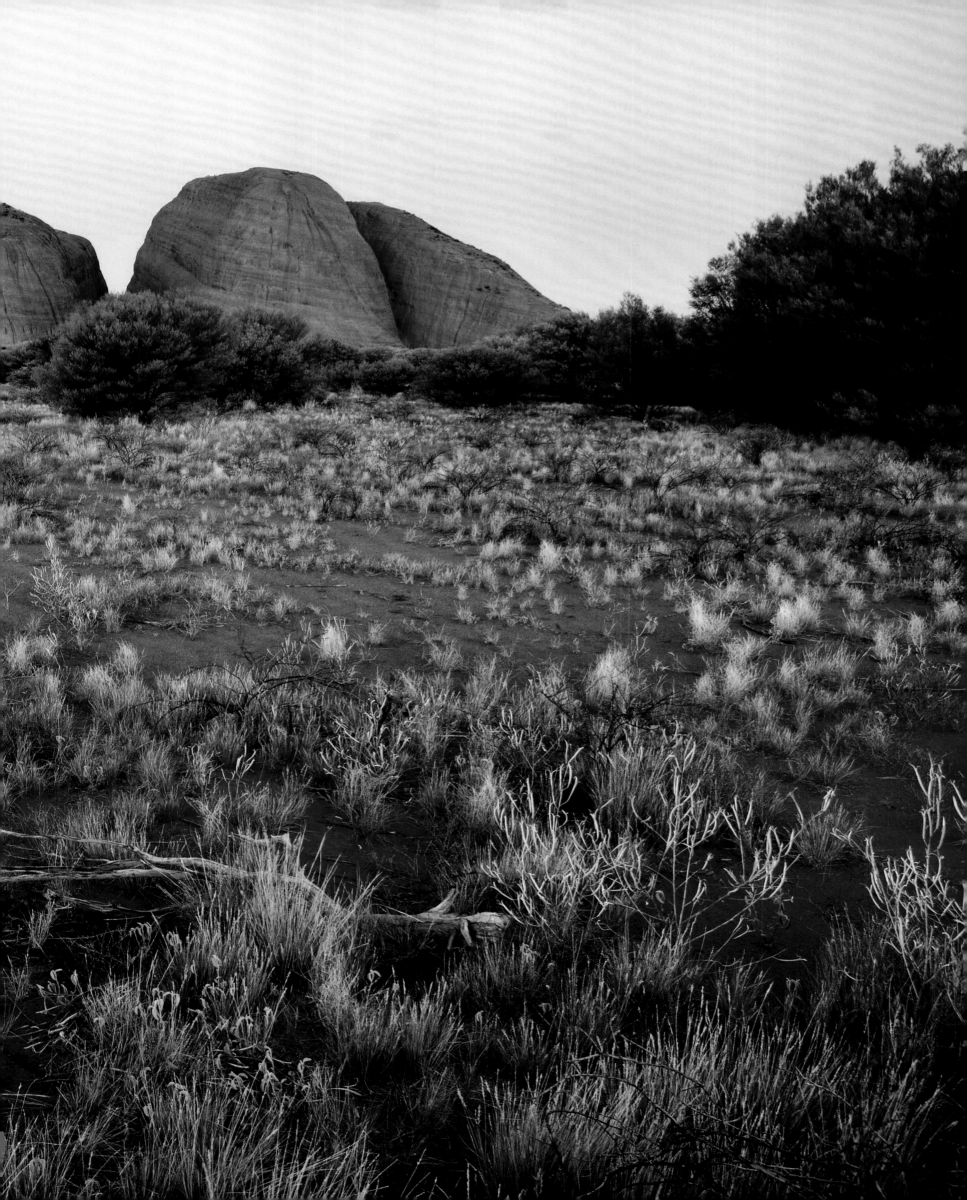

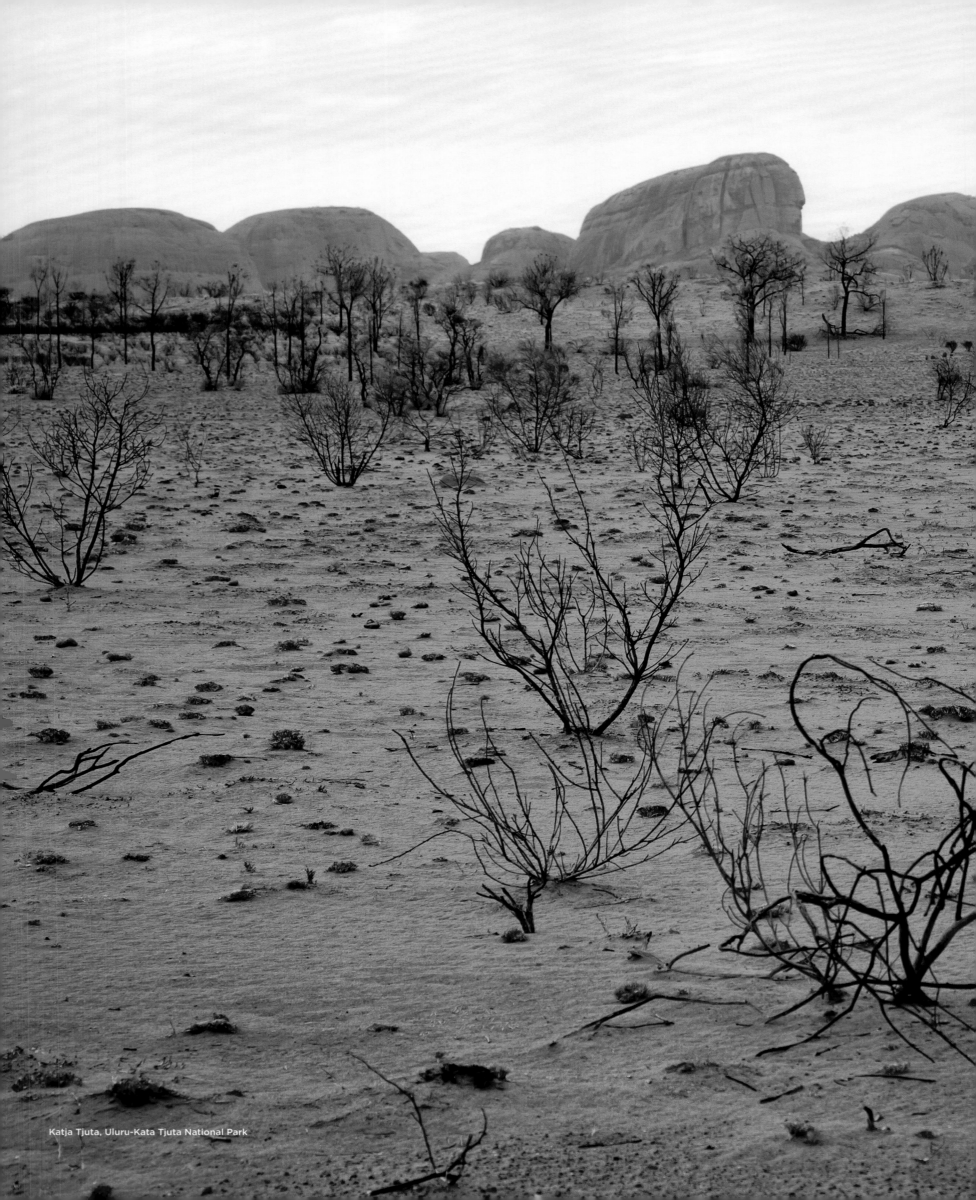

Katja Tjuta, Uluru-Kata Tjuta National Park

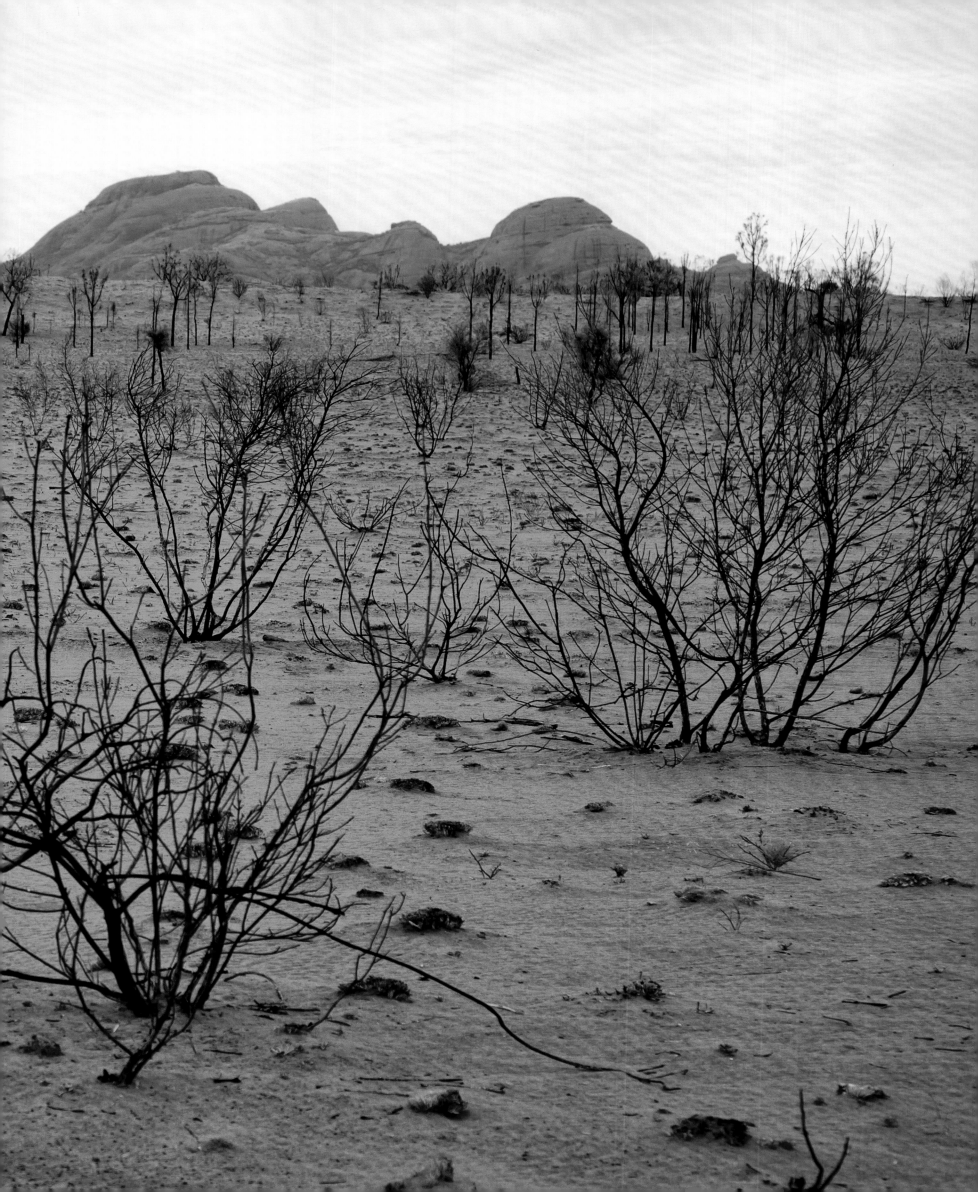

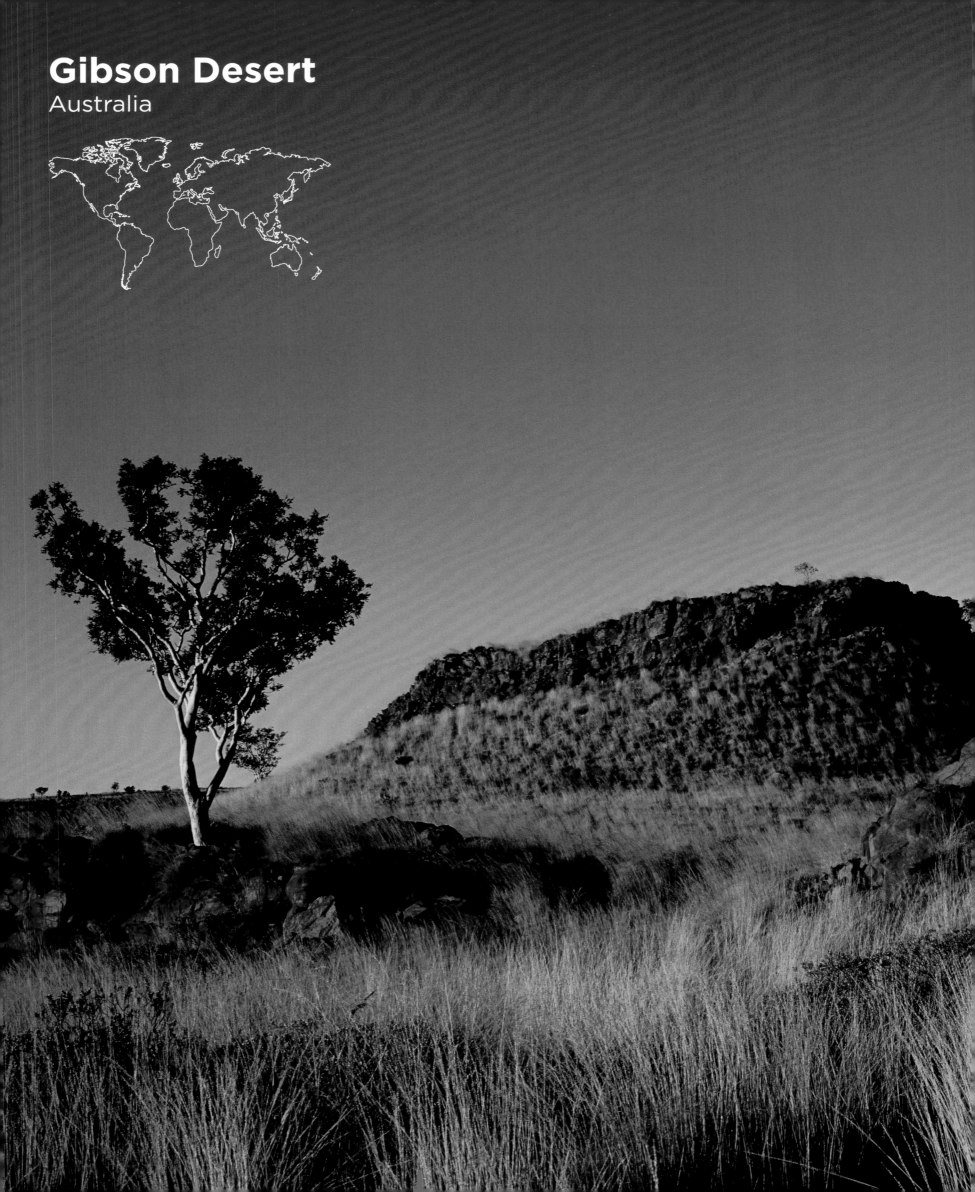

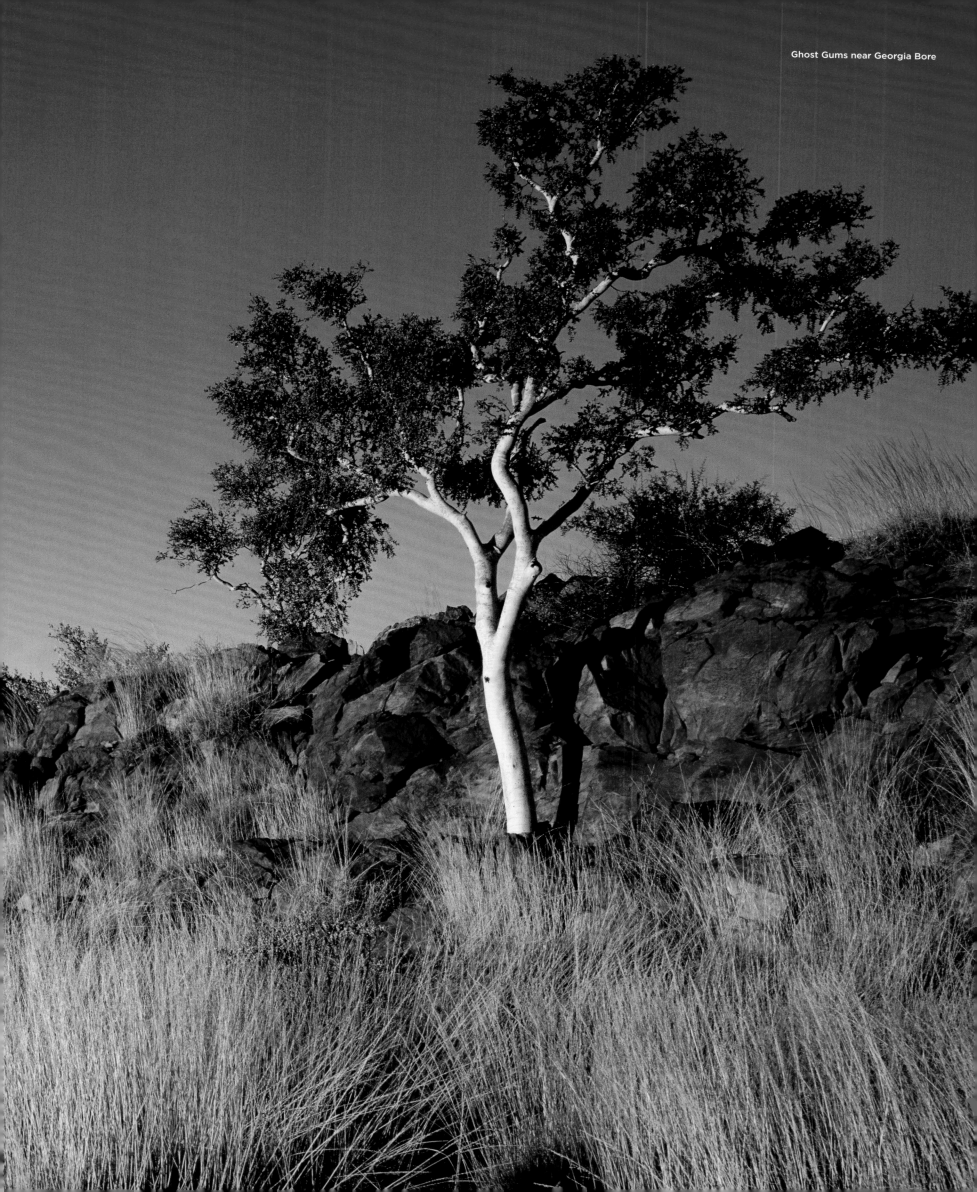

Ghost Gums near Georgia Bore

Parakeelya (Calandrinia polyandra)

Gibson Desert

One of the most remote deserts in Australia, the Gibson Desert is one of few places in Australia that remains largely unchanged from when white settlers arrived in the country in the 18th. century. Its red sands, whose colour comes from a high iron content in the soil, are interspersed with small escarpment-massifs and by large salt lakes, including the evocatively named Lake Disappointment. The desert was named by explorer Ernest Giles after a member of his expedition, Alfred Gibson, who became lost and was never found.

Désert de Gibson

Comptant parmi les déserts les plus reculés d'Australie, le désert Gibson est l'un des rares à ne pas avoir été transformé par l'arrivée des colons blancs dans le pays, au XVIIIe siècle. Son sable rouge, dû à un taux de fer élevé dans le sol, est parsemé de petits massifs montagneux escarpés et de grands lacs salés, dont le lac Déception au nom évocateur. Ce désert a été baptisé par l'explorateur Ernest Giles en hommage à un membre de son expédition, Alfred Gibson, qui s'était perdu et n'avait jamais été retrouvé.

Gibson-Wüste

Die Gibson-Wüste ist eine der abgelegensten Wüsten Australiens und eine der wenigen Gegenden in Australien, die weitgehend unverändert geblieben sind, seit im 18. Jahrhundert weiße Siedler in das Land kamen. Seine roten Sande, deren Farbe vom hohen Eisengehalt des Bodens herrührt, sind durchsetzt von kleinen Felsenrücken und großen Salzseen, darunter einer mit dem vielsagenden Namen Lake Disappointment. Der Entdecker Ernest Giles benannte die Wüste nach einem Mitglied seiner Expedition, Alfred Gibson, der verschollen ging und nie gefunden wurde.

Sturt's Desert Pea (Swainsona formosa)

Desierto de Gibson

Uno de los desiertos más remotos de Australia, el desierto de Gibson, es uno de los pocos lugares de Australia que permanecen prácticamente inalterados desde la llegada de los colonos blancos al país en el siglo XVIII. Sus arenas rojas, que se deben al alto contenido de hierro en el suelo, están intercaladas con pequeños macizos de escarpes y por grandes lagos salados, entre los que se encuentra el evocativamente llamado Lake Disappointment. El desierto fue bautizado por el explorador Ernest Giles en honor a un miembro de su expedición, Alfred Gibson, que se perdió y nunca fue encontrado.

Deserto de Gibson

Um dos desertos mais remotos da Austrália, o Deserto de Gibson é um dos poucos lugares na Austrália que permanece praticamente inalterado desde quando colonos brancos chegaram ao país no século XVIII. Suas areias vermelhas, que vêm de um alto teor de ferro no solo, são intercaladas com pequenos maciços de escarpas e grandes lagos salgados, incluindo o evocativo Lago Dececionante. O deserto foi nomeado pelo explorador Ernest Giles após um membro de sua expedição, Alfred Gibson, que se perdeu e nunca foi encontrado.

Gibsonwoestijn

Een van de meest afgelegen woestijnen in Australië, de Gibsonwoestijn, is een van de weinige gebieden in Australië die grotendeels onveranderd zijn gebleven sinds de komst van de blanke kolonisten in de 18e eeuw. Het rode zand, dat zijn kleur dankt aan het hoge ijzergehalte in de bodem, wordt afgewisseld met kleine steile bergen en grote zoutmeren, waaronder een met de veelzeggende naam Lake Disappointment. De woestijn werd door ontdekkingsreiziger Ernest Giles vernoemd naar een lid van zijn expeditie, Alfred Gibson, die verdwaalde en nooit werd teruggevonden.

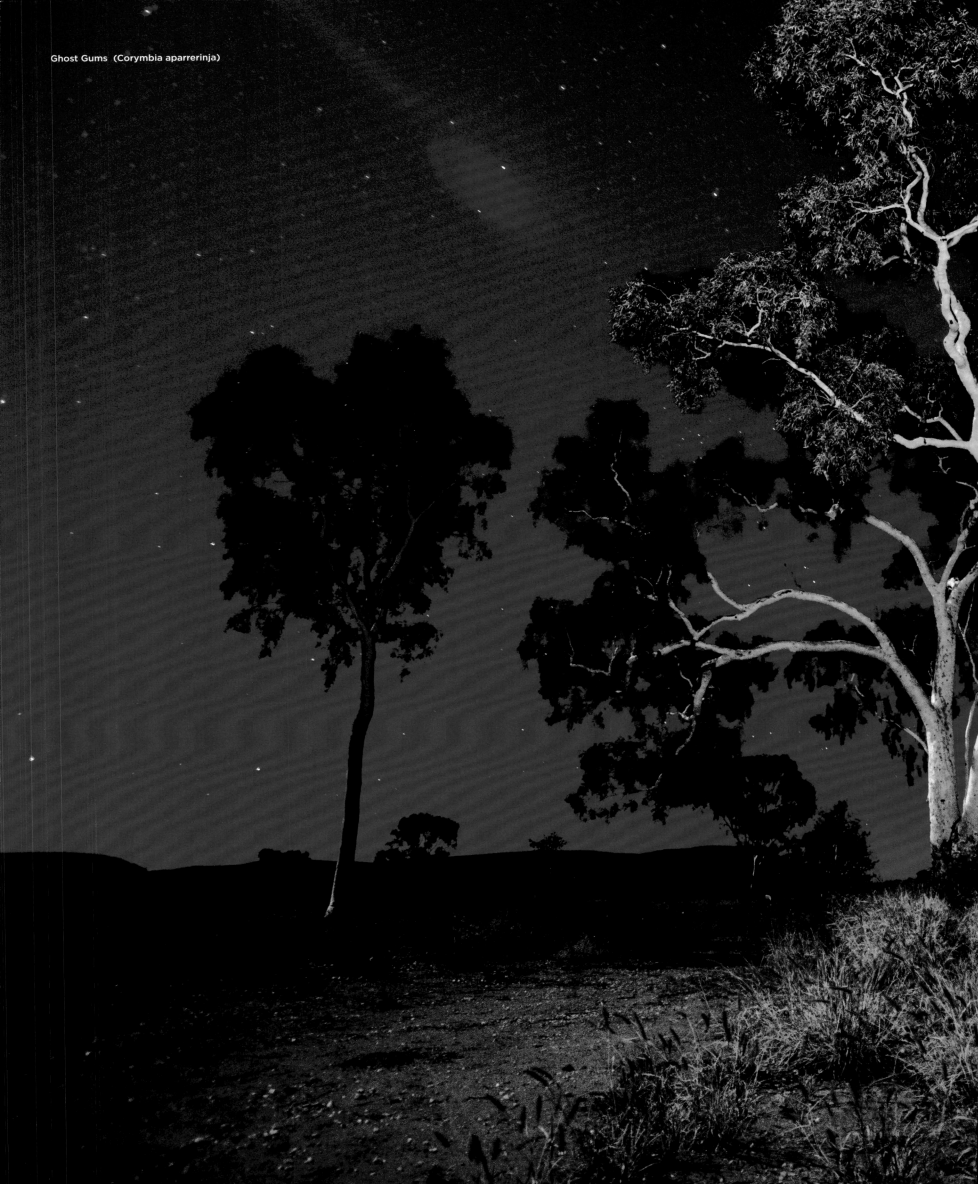

Ghost Gums (Corymbia aparrerinja)

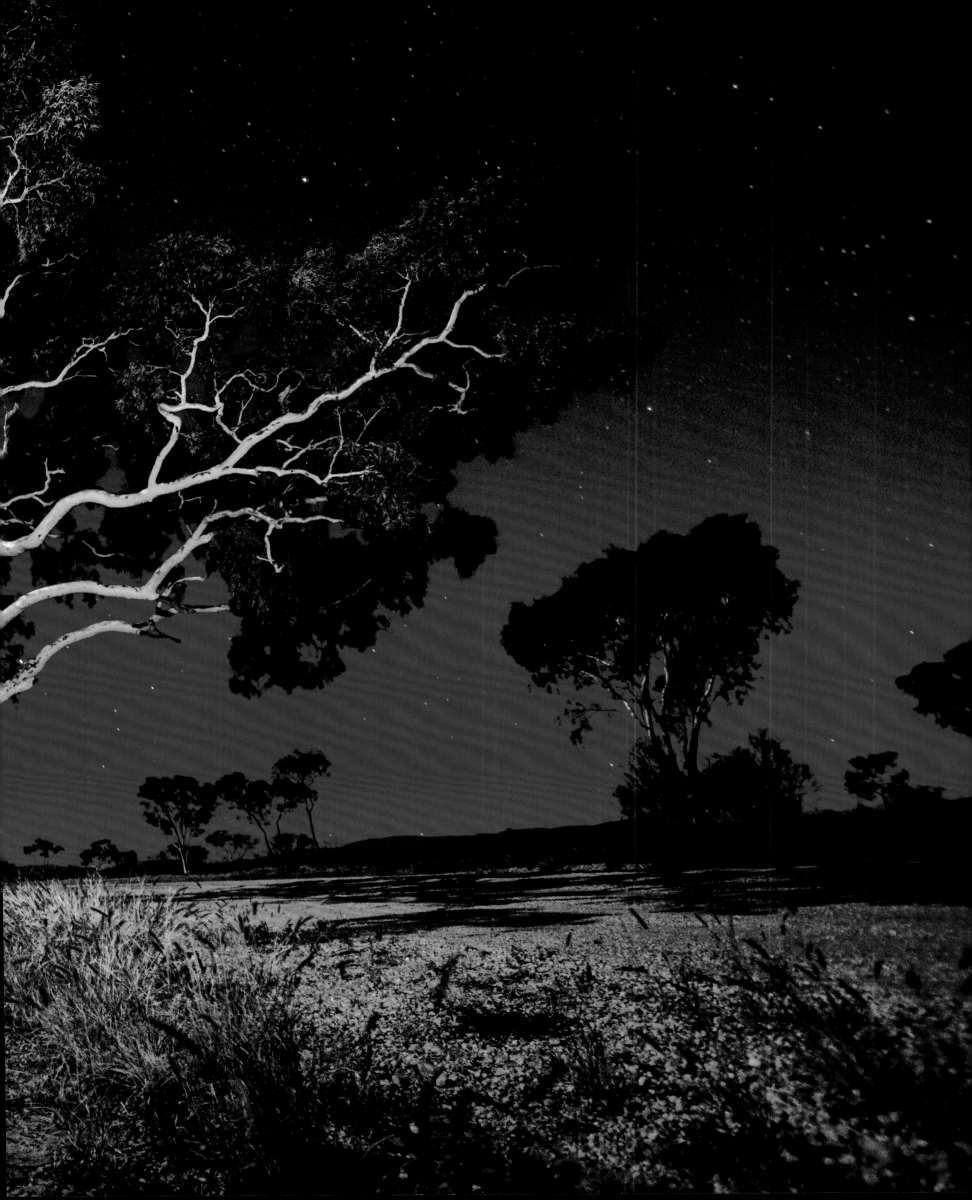

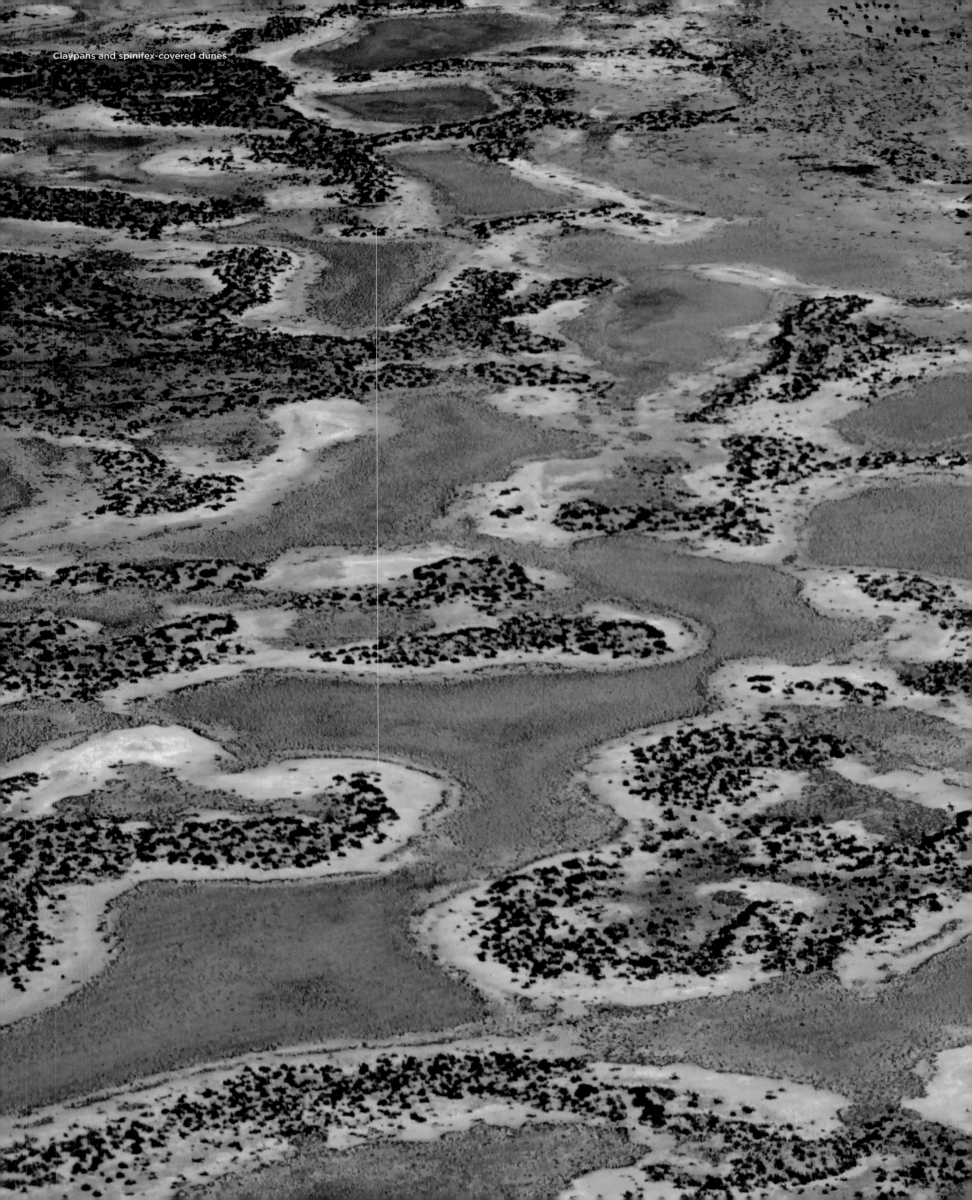

Claypans and spinifex-covered dunes

Satellite image of the Gibson Desert

The Last Nomads

In 1977, an elderly Pintupi Aboriginal couple (who had retreated into remote country years before to avoid punishment for breaching customary law) were found after never having had contact with the outside world. They were considered Australia's last nomads until 1984, when nine previously uncontacted Pintupi walked out of the Gibson Desert.

Los últimos nómadas

En 1977, una pareja aborigen Pintupi de edad avanzada (que se había retirado a un país remoto años antes para evitar ser castigada por infringir el derecho consuetudinario) fue encontrada después de no haber tenido nunca contacto con el mundo exterior. Fueron considerados los últimos nómadas de Australia hasta 1984, cuando nueve Pintupi no contactados anteriormente salieron del desierto de Gibson.

Derniers nomades

En 1977, un couple âgé d'aborigènes Pintupi (qui s'était retiré dans l'arrière-pays des années auparavant par peur d'être puni pour avoir enfreint le droit coutumier) a été trouvé alors qu'il n'avait jamais eu de contact avec le monde extérieur. Ses membres ont été considérés comme les derniers nomades d'Australie jusqu'en 1984, date à laquelle neuf Pintupis isolés ont surgi à pied du désert Gibson.

Os últimos nômades

Em 1977, um idoso casal indígena Pintupi (que havia se refugiado em um país remoto anos antes para evitar a punição por violar a lei consuetudinária) foi encontrado depois de nunca ter tido contato com o mundo exterior. Eles foram considerados os últimos nômades da Austrália até 1984, quando nove Pintupi, anteriormente isolados, saíram do deserto de Gibson.

Die letzten Nomaden

1977 wurde ein älteres Paar der Pintupi aufgefunden, das sich Jahre zuvor in ein abgelegenes Gebiet zurückgezogen hatte, um einer Bestrafung wegen Verletzung des Stammesrechts zu entgehen und das bis dahin nie Kontakt mit der Außenwelt gehabt hatte. Sie galten bis 1984 als die letzten Nomaden Australiens, als neun zuvor ebenfalls nicht mit Weißen in Kontakt gekommene Pintupi aus der Gibson-Wüste kamen.

De laatste nomaden

In 1977 werd een oud Pintupi-echtpaar (dat zich al jaren daarvoor had teruggetrokken in afgelegen land om een boete wegens overtreding van het gewoonterecht te voorkomen) gevonden dat nooit contact met de buitenwereld had gehad. Ze werden beschouwd als de laatste nomaden van Australië tot in 1984 negen Pintupi uit de Gibsonwoestijn kwamen die ook nooit contact met blanken hadden gehad.

481

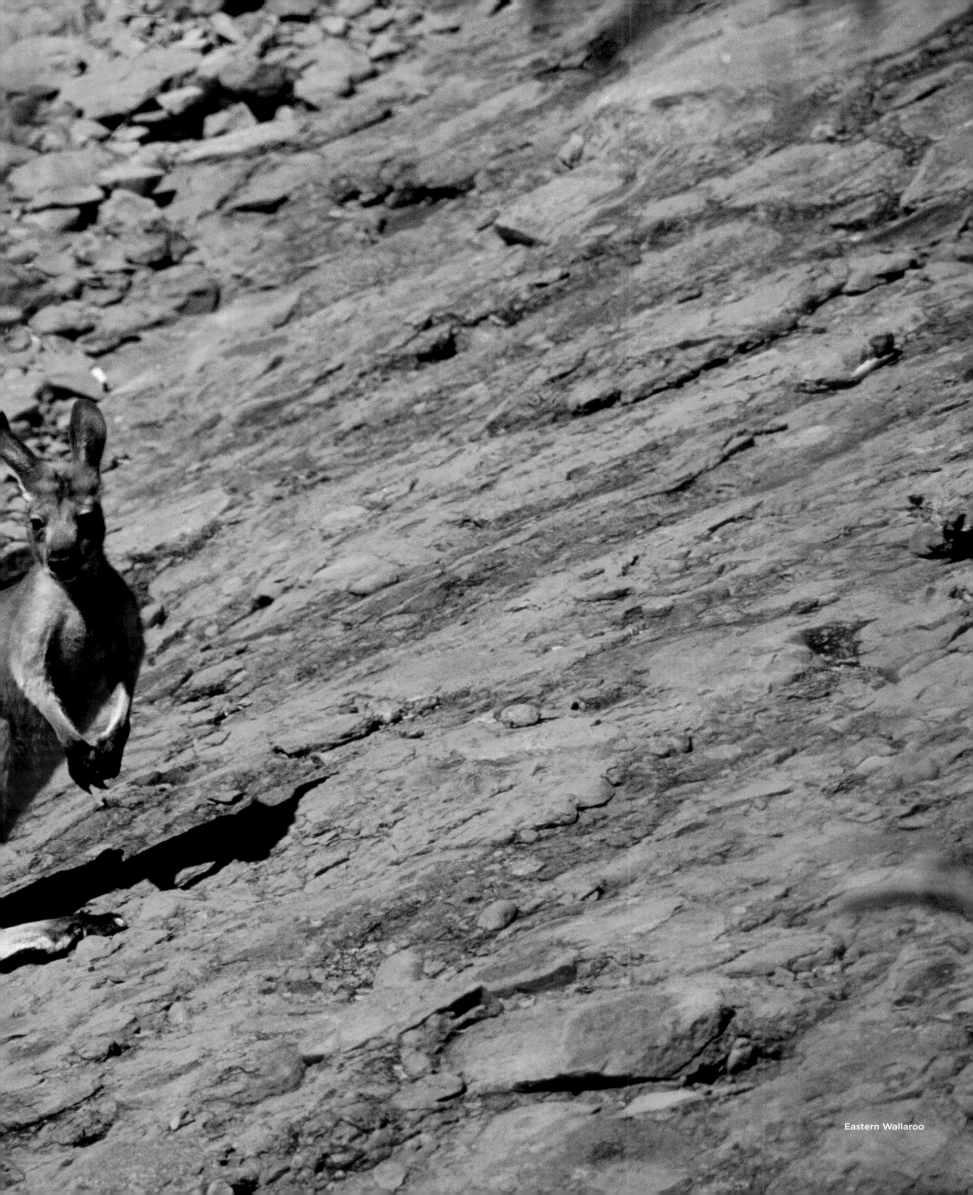

Eastern Wallaroo

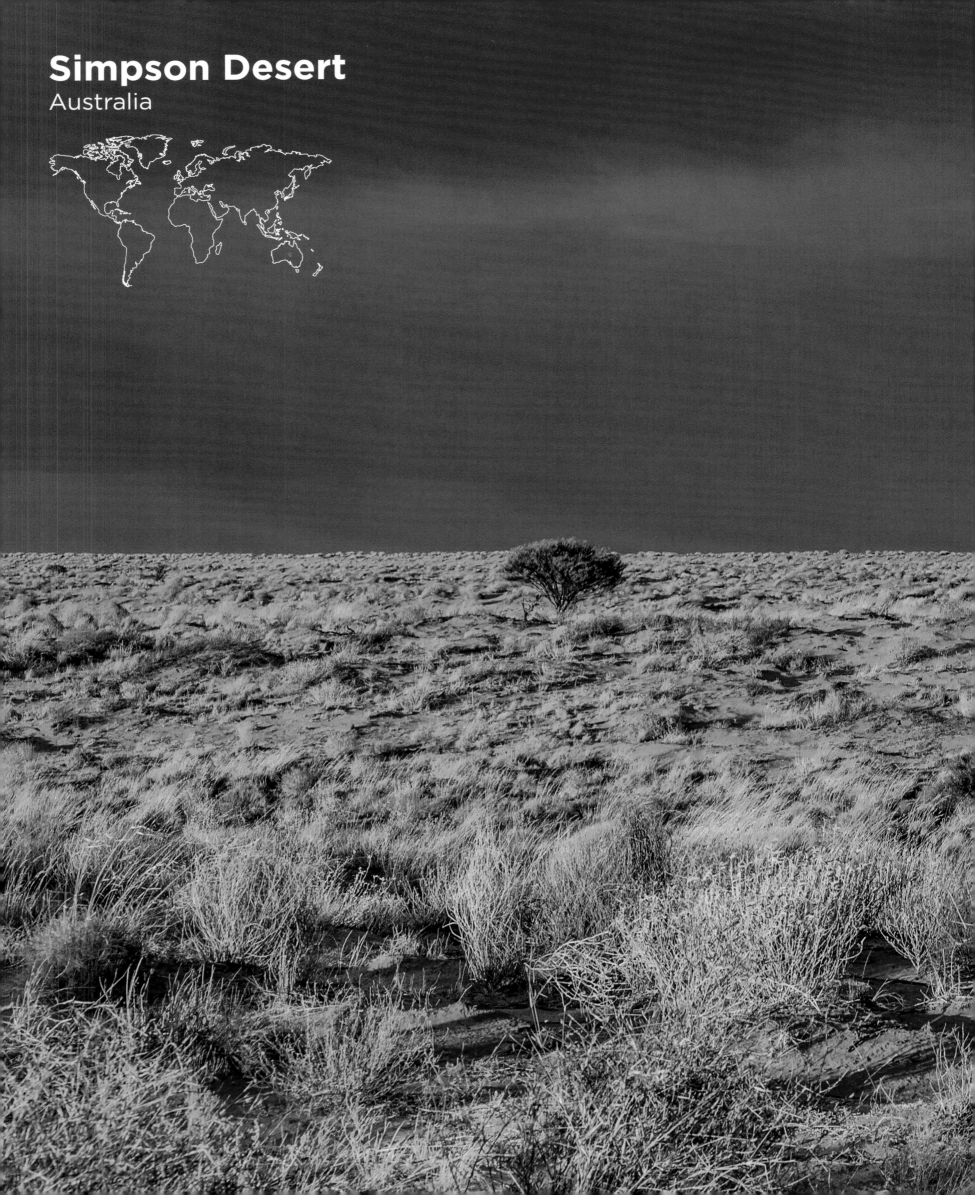

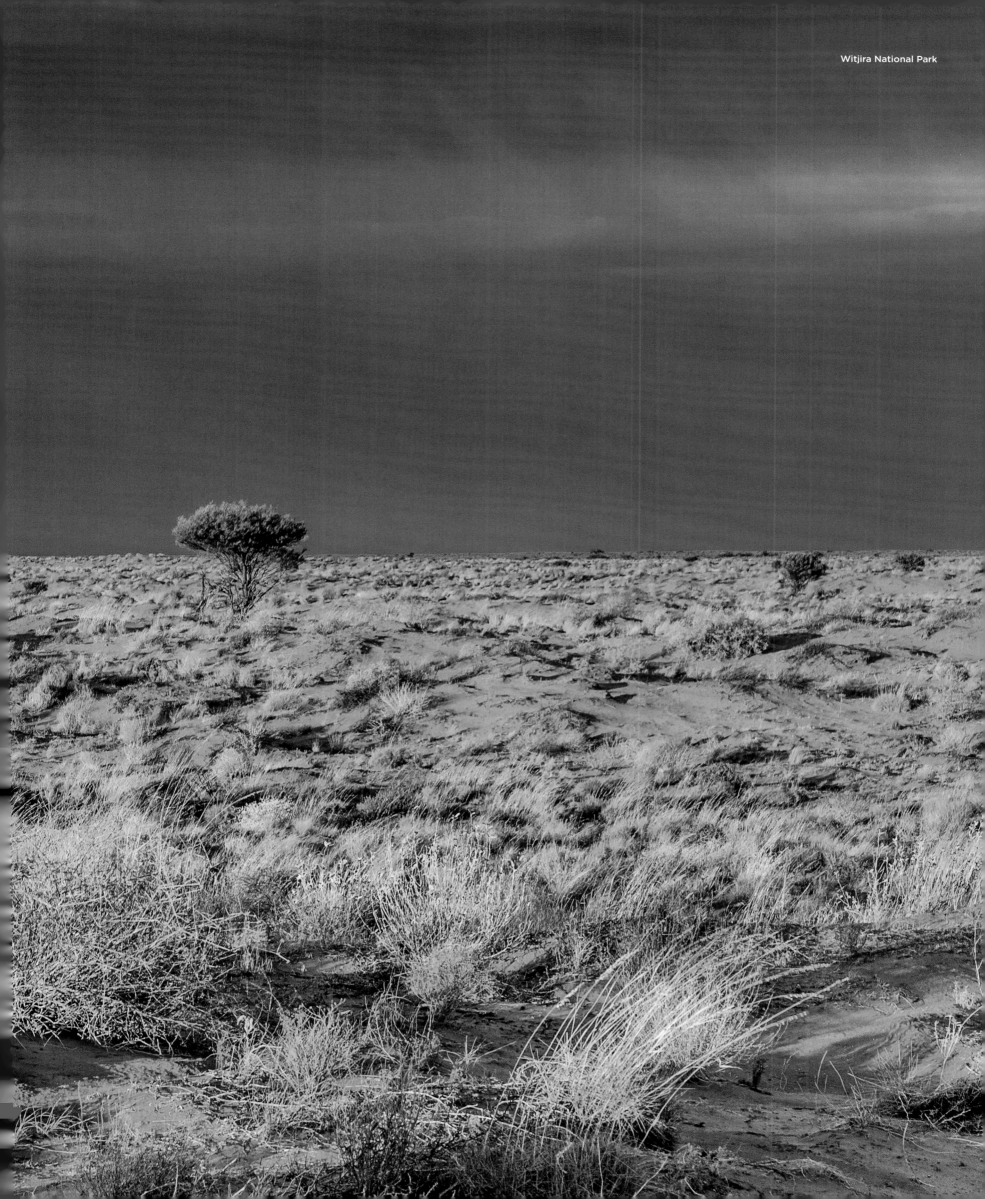

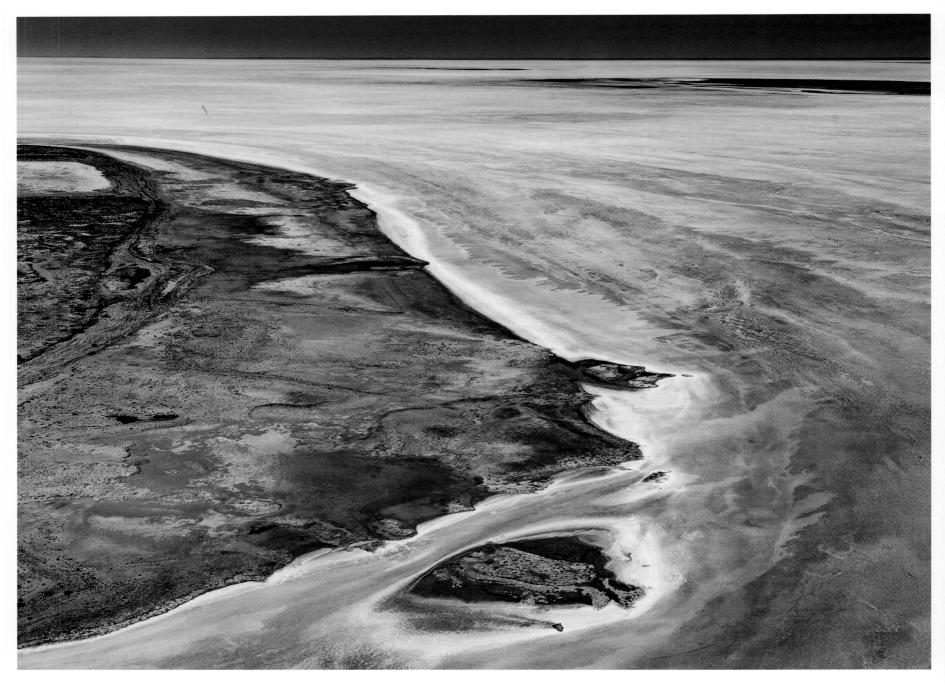

Algae patterns in salt lake, Lake Eyre National Park

Simpson Desert

Australia's Simpson Desert is held to be the world's largest sand-dune desert; in one area, the Simpson has more than 1100 parallel sand dunes. The Simpson is also home to Birdsville (an iconic Outback town and a reference point for the remote Outback in Australian popular culture) and Lake Eyre (Kati Thanda in indigenous languages), Australia's largest lake; when Lake Eyre has water, its salt levels are as high as in the ocean. Beneath it all lies the Great Artesian Basin, a vast reservoir of underground water filled by millennia of flash floods draining down into Lake Eyre from western Queensland's Channel Country.

Désert de Simpson

Le désert australien de Simpson est considéré comme le plus grand désert de dunes du monde, dénombrant plus de mille cent dunes parallèles à un endroit. Le Simpson est également le lieu d'implantation de Birdsville (une ville reculée de l'Outback devenue iconique dans la culture populaire australienne) et du lac Eyre (Kati Thanda dans les langues indigènes), le plus grand lac d'Australie ; lorsque le lac Eyre est rempli d'eau, il présente des niveaux de sel identiques à ceux de l'océan. En dessous s'étend le grand bassin artésien, un immense réservoir d'eau souterraine rempli au fil des millénaires à la suite de brusques crues du lac Eyre depuis le Channel Country, au Queensland.

Simpson-Wüste

Die Simpson-Wüste in Australien gilt als die größte Sanddünenwüste der Welt; an einer Stelle durchziehen mehr als 1100 parallele Sanddünen die Simpson. In der Wüste liegen auch Birdsville (eine legendäre Outback-Stadt, die in der australischen Populärkultur das abgelegene Outback verkörpert) und Lake Eyre (Kati Thanda in indigenen Sprachen), Australiens größter See. Wenn Lake Eyre Wasser hat, ist dessen Salzgehalt so hoch wie der des Ozeans. Unter all dem liegt das Große Artesische Becken, ein riesiges Reservoir an Grundwasser, das jahrtausendelang von Sturzfluten gefüllt wurde, die vom Channel Country im westlichen Queensland in den Lake Eyre abflossen.

Surface of Lake Eyre, Lake Eyre National Park

Desierto de Simpson

El desierto de Simpson en Australia está considerado como el desierto de dunas de arena más grande del mundo; en una zona, el Simpson tiene más de 1100 dunas de arena paralelas. En el Simpson también se encuentran Birdsville (una ciudad emblemática del Outback y un punto de referencia para el remoto Outback en la cultura popular australiana) y el lago Eyre (Kati Thanda en lenguas indígenas), el lago más grande de Australia. Cuando el lago Eyre tiene agua, sus niveles de sal son idénticos a los del océano. Debajo de todo esto se encuentra la Gran Cuenca Artesiana, una vasta reserva de agua subterránea llena de milenios de inundaciones repentinas que desaguan en el Lago Eyre desde el oeste del Channel Country de Queensland.

Deserto de Simpson

O deserto Simpson, na Austrália, é considerado o maior deserto de dunas de areia do mundo; em uma área, o Simpson tem mais de 1100 dunas de areia paralelas. O Simpson também é lar de Birdsville (uma icônica cidade do Outback e um ponto de referência para o remoto Outback na cultura popular australiana) e do Lago Eyre (Kati Thanda em idiomas indígenas), o maior lago da Austrália; quando o lago Eyre tem água, seus níveis de sal são idênticos aos do oceano. Por baixo de tudo isso fica a Grande Bacia Artesiana, um vasto reservatório de água subterrânea preenchido por milênios de inundações repentinas que desaguam no Lago Eyre a partir do oeste do Canal de Queensland.

Simpsonwoestijn

De Simpsonwoestijn in Australië wordt beschouwd als 's werelds grootste zandduinwoestijn: in één gebied heeft hij meer dan 1100 parallelle zandduinen. De woestijn herbergt ook Birdsville (een iconische Outbackstad die in de Australische populaire cultuur de afgelegen Outback belichaamt) en Lake Eyre (Kati Thanda in aboriginaltalen), het grootste meer van Australië. Als er water in Lake Eyre staat, heeft dat hetzelfde zoutgehalte als de oceaan. Daaronder ligt het Groot Artesisch Bekken, een enorm ondergronds waterreservoir, dat al duizenden jaren wordt gevoed door overstromingen die vanuit Channel Country in het westelijke Queensland uitmonden in Lake Eyre.

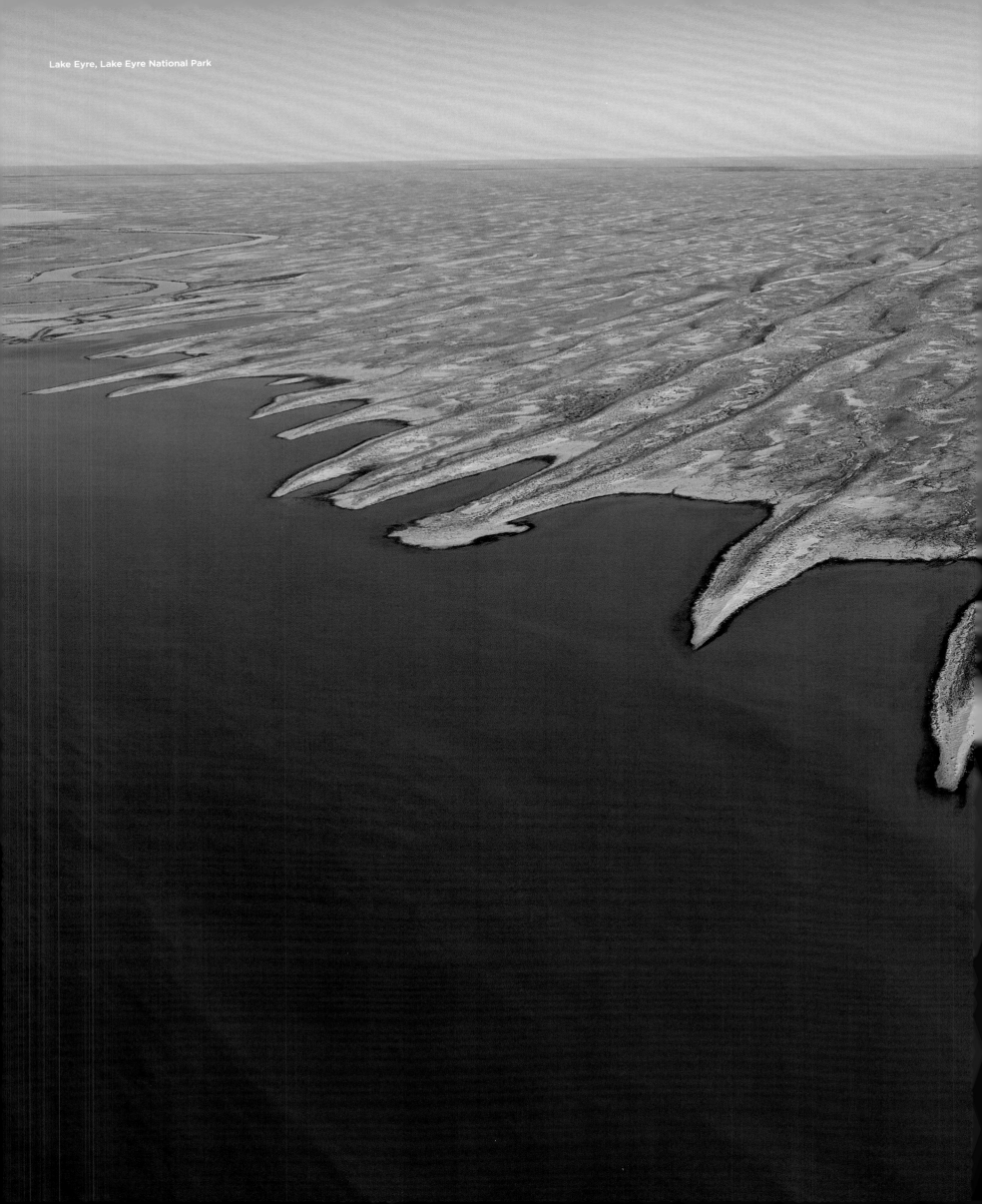

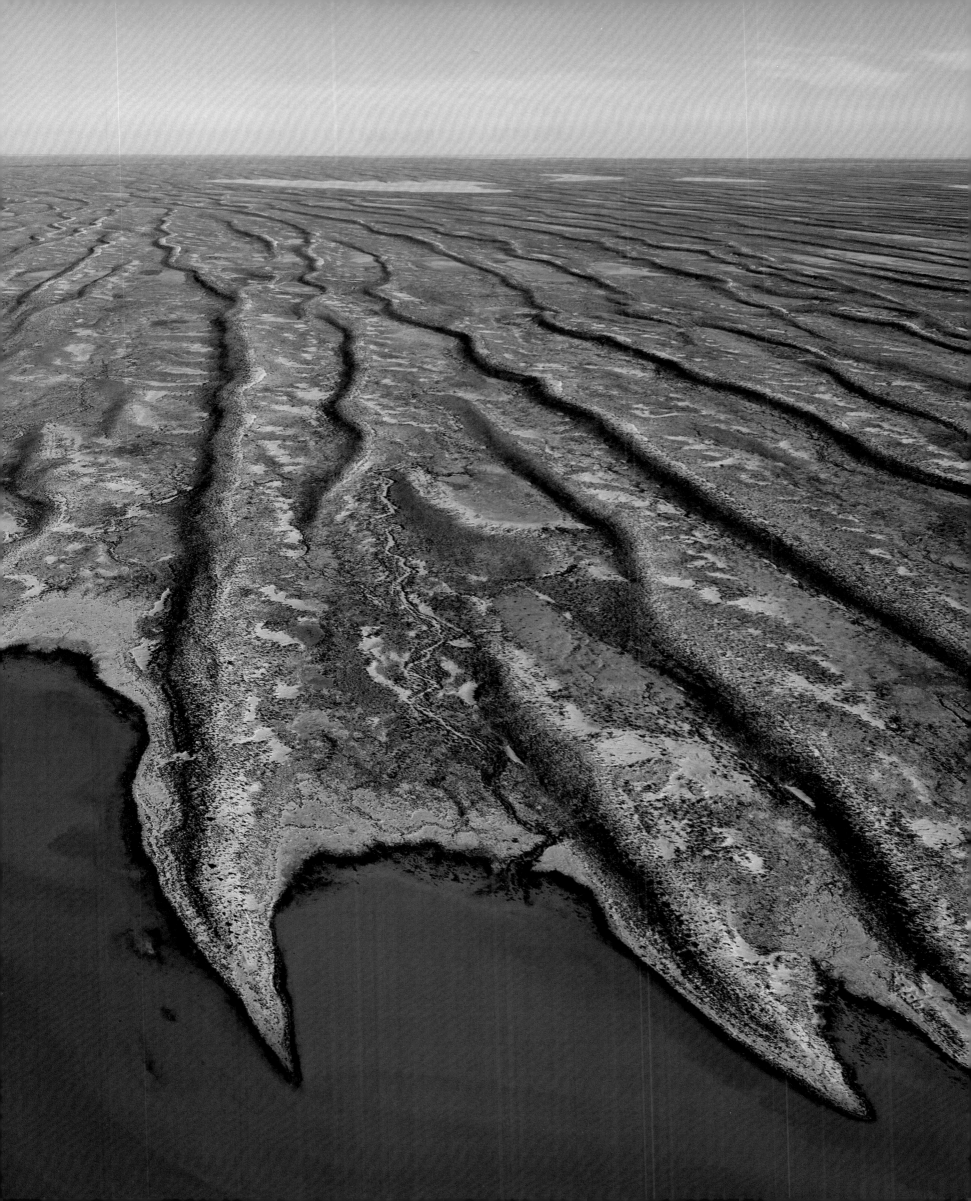

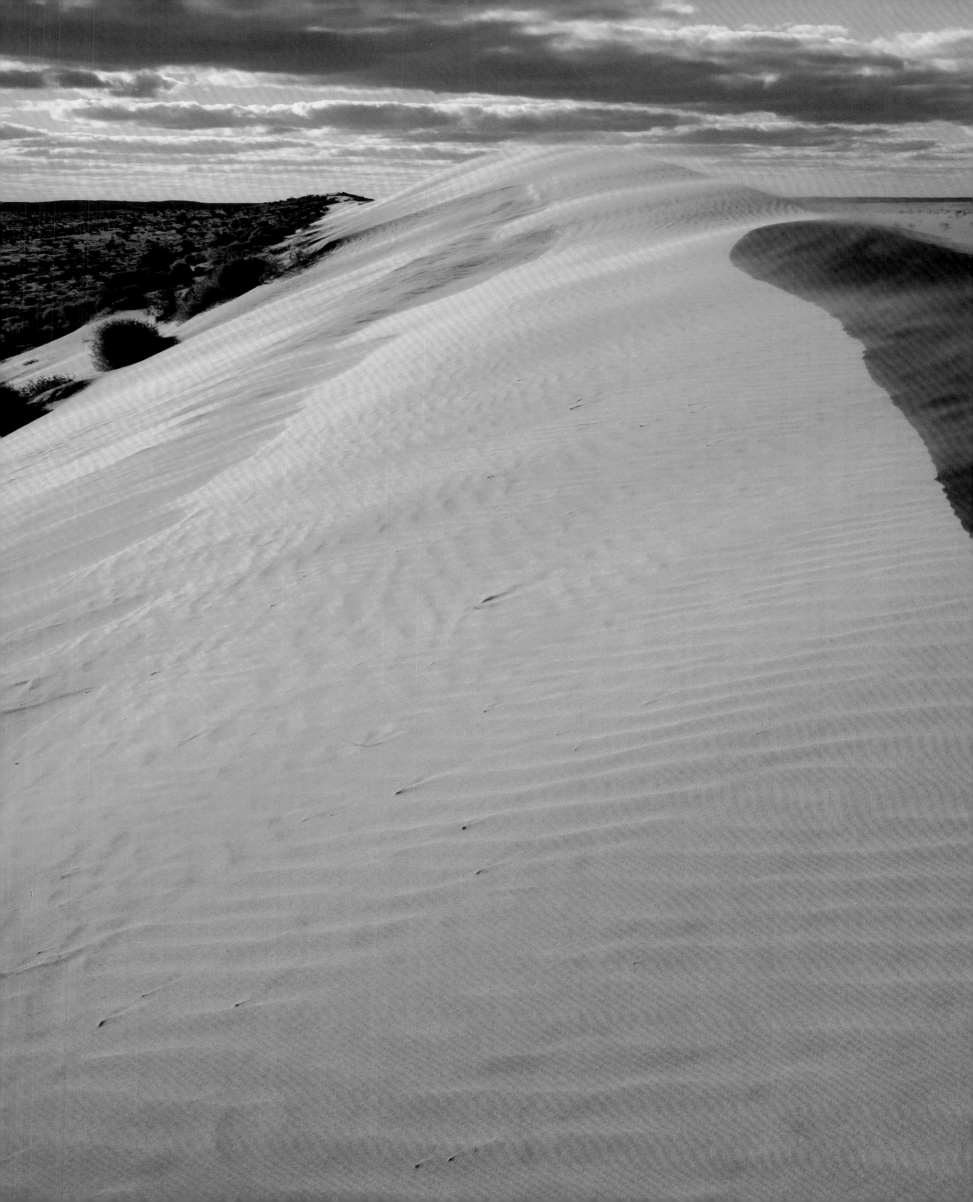

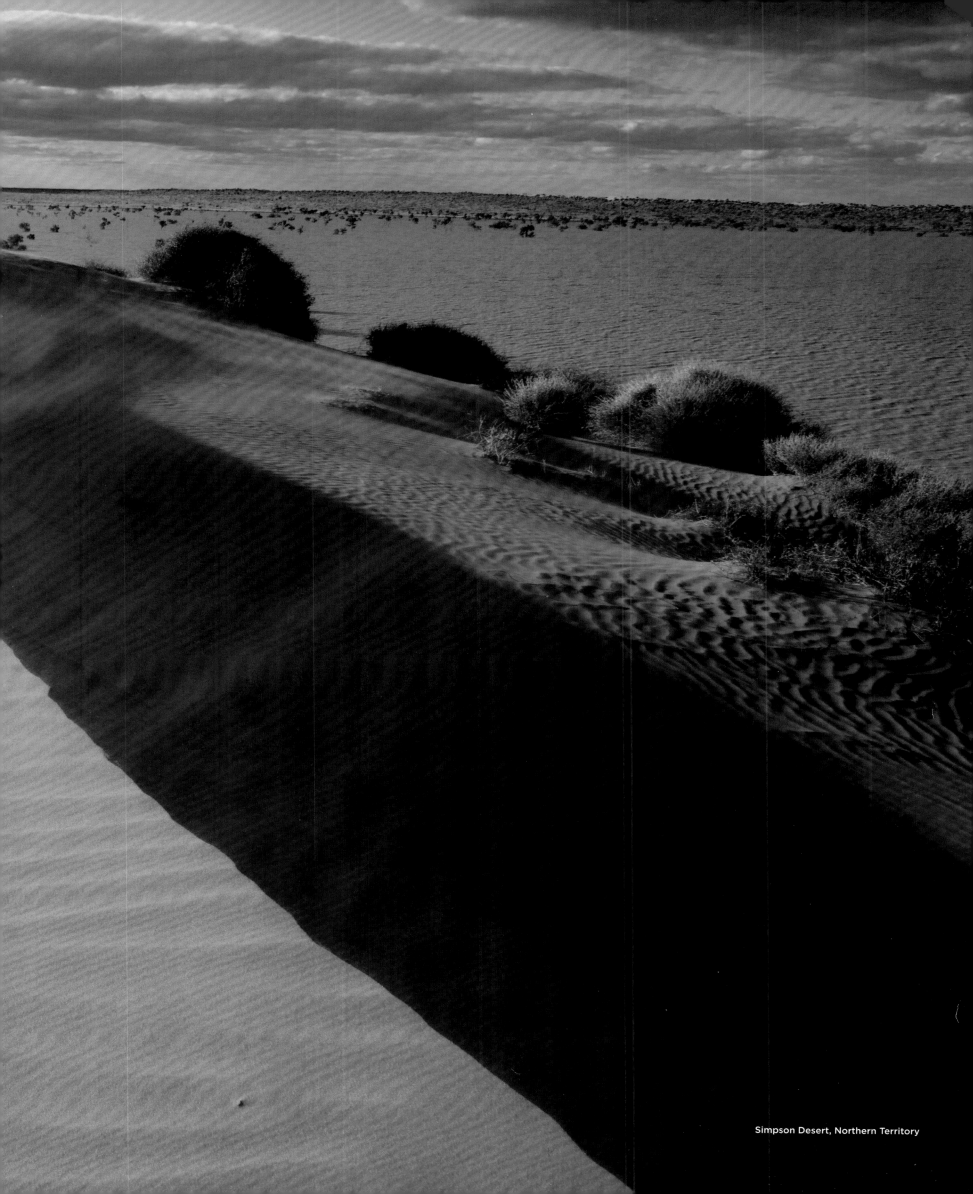

Simpson Desert, Northern Territory

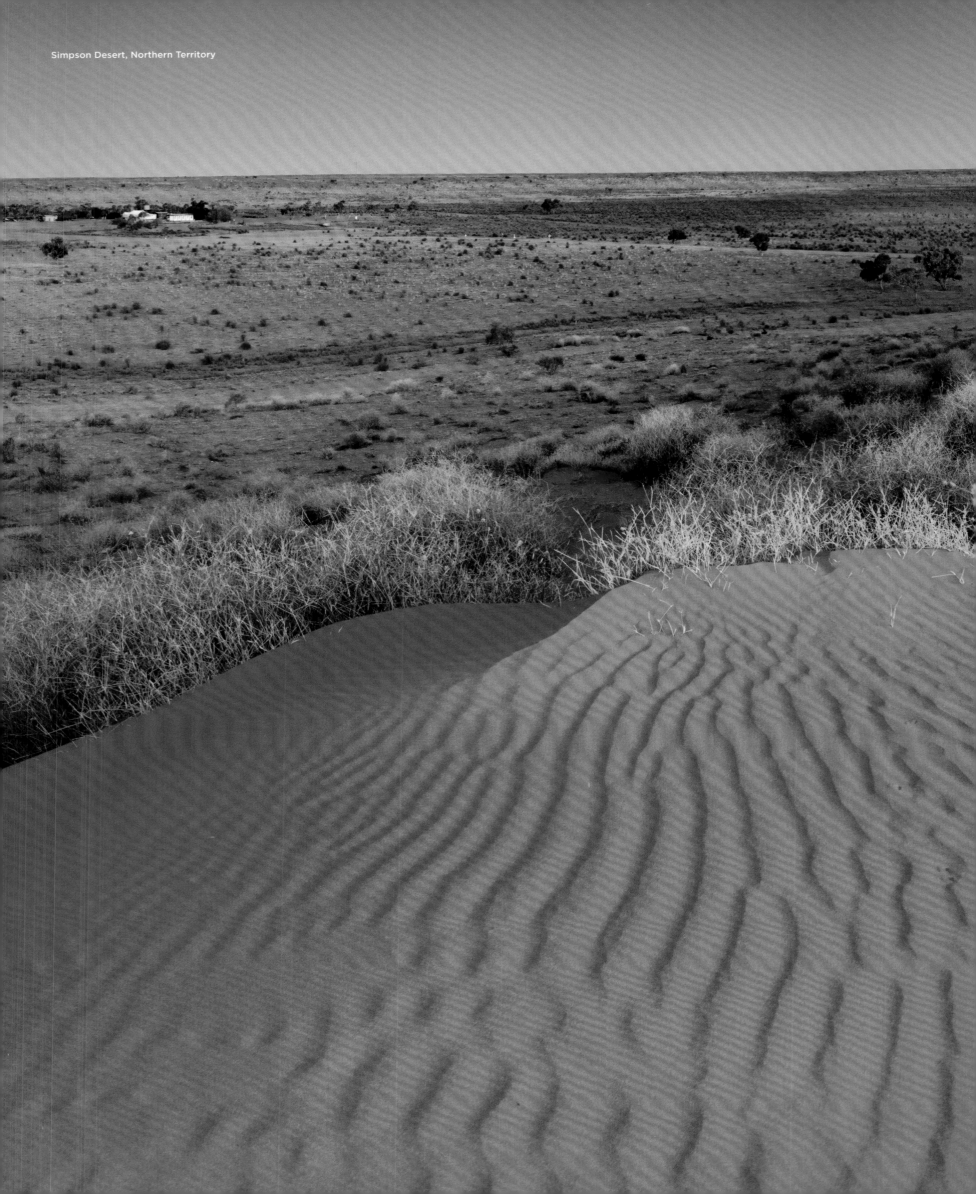

Simpson Desert, Northern Territory

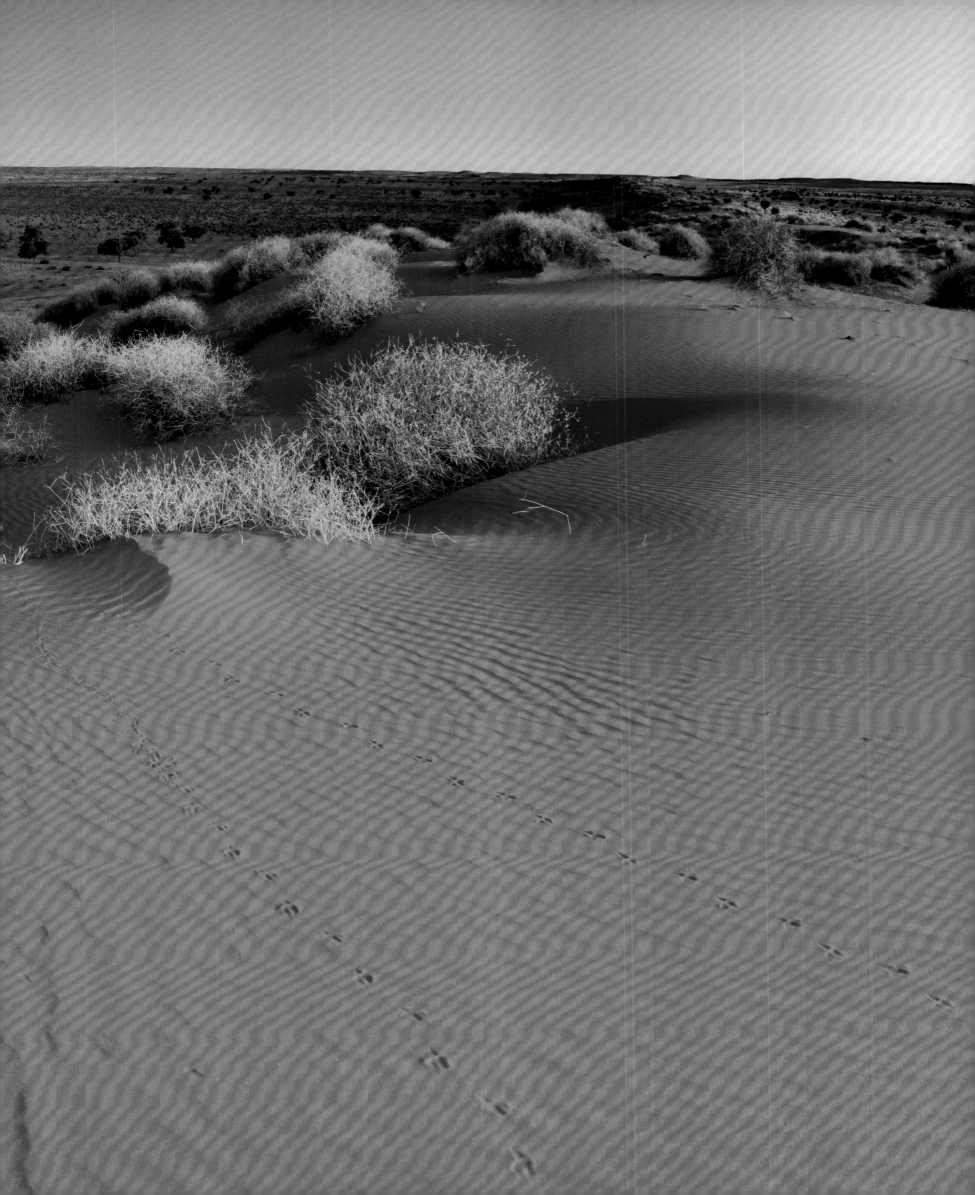

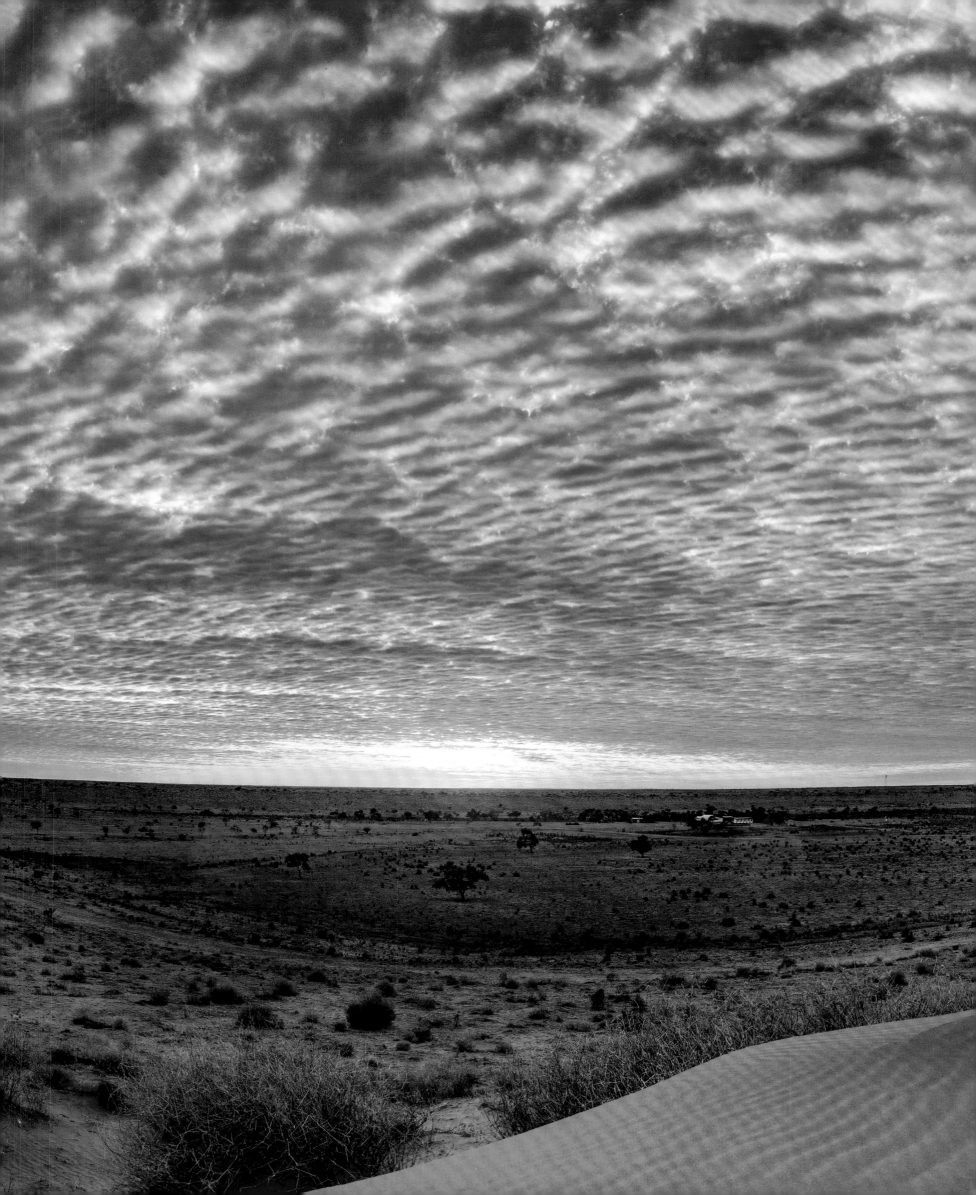

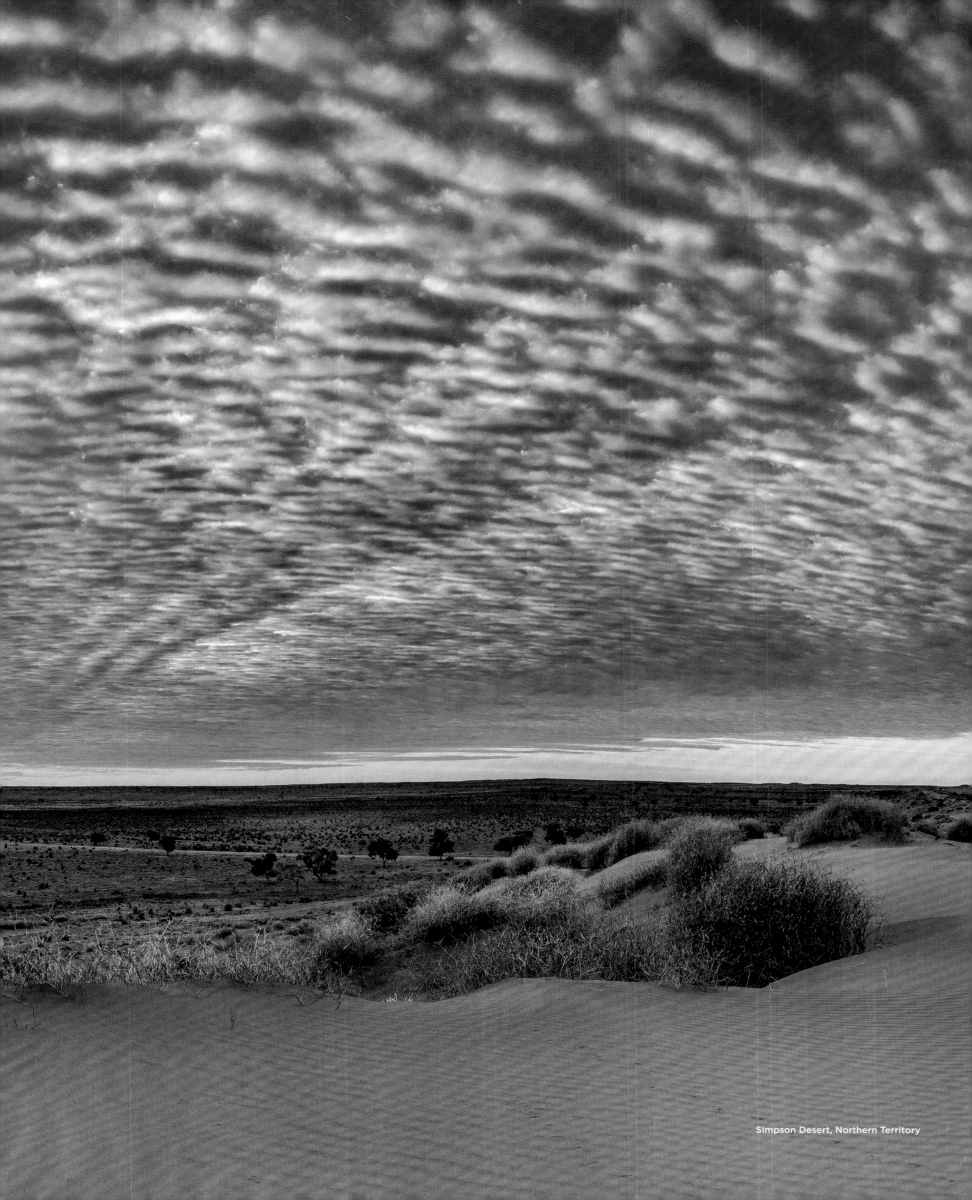

Simpson Desert, Northern Territory

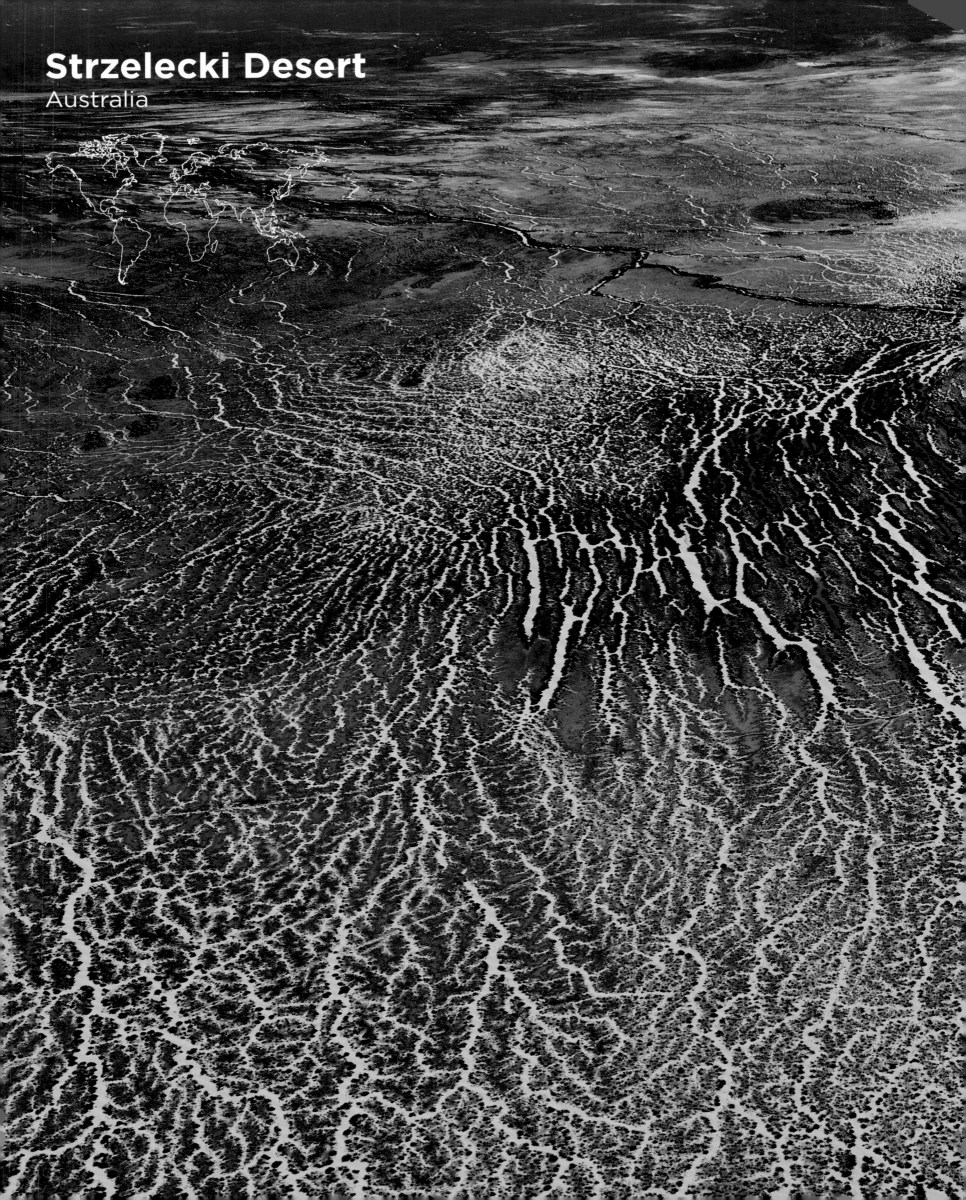

Strzelecki Desert
Australia

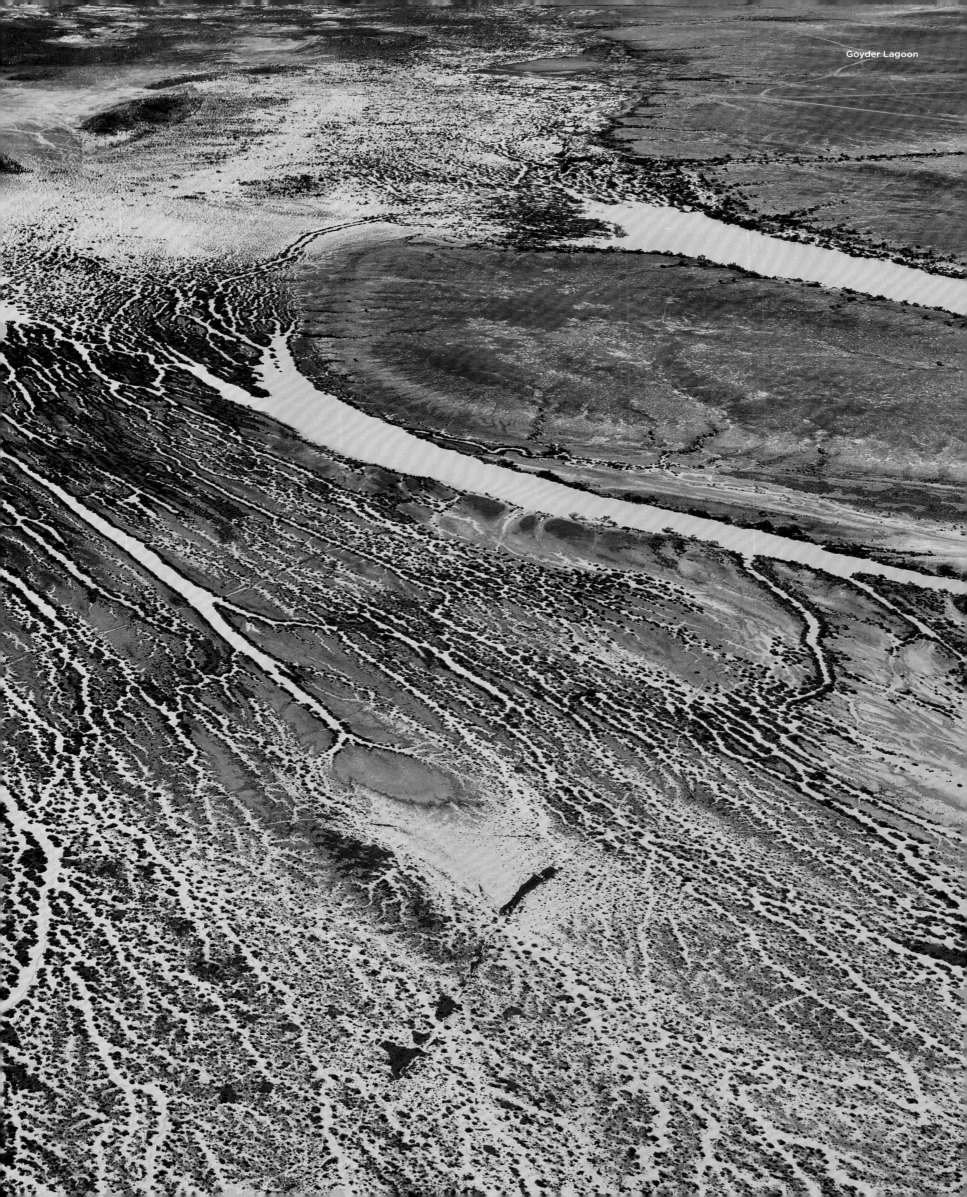
Goyder Lagoon

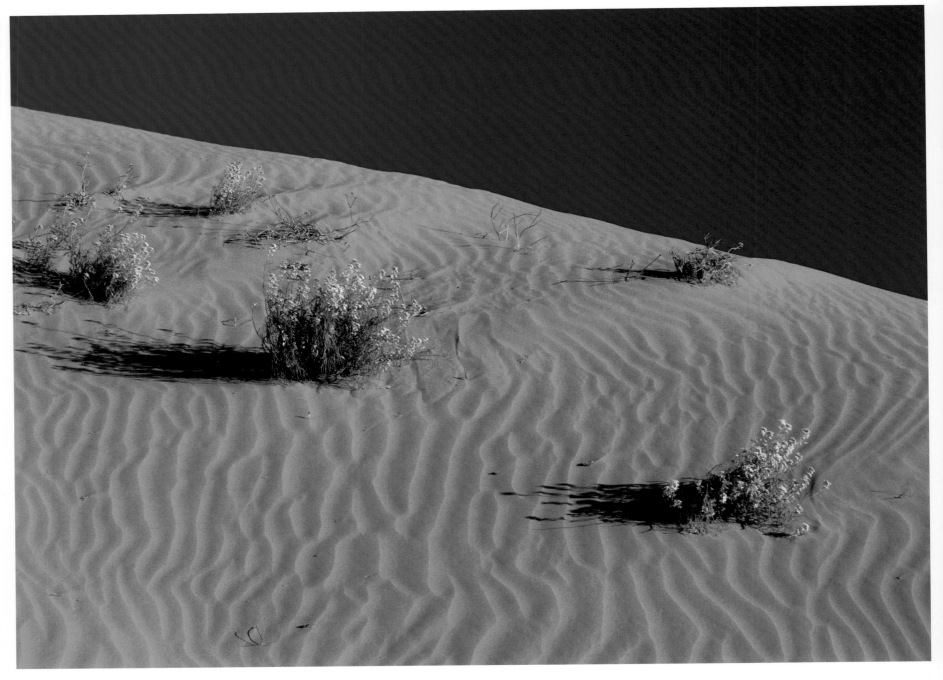

Dunes with vegetation

Strzelecki Desert

The Strzelecki Desert spreads across the intersection between the Australian states of South Australia, South West Queensland and New South Wales, and is crossed by the Birdsville Track, one of the greatest prizes for 4WD enthusiasts in the Australian Outback. It was also traversed by the ill-fated Burke-and-Wills expedition of 1860 to 1861; they died having reached Coopers Creek less than 24 hours after a relief party had left on the assumption that the men had perished. The sand dunes and gravel plains of the Strzelecki are an important refuge for a number of desert-adapted native Australian wildlife species.

Désert de Strzelecki

Le désert de Strzelecki est implanté au carrefour entre les États australiens d'Australie-Méridionale, du Queensland et de la Nouvelle-Galles du Sud, et est traversé par la piste de Birdsville, l'un des sentiers les plus prisés des adeptes de quatre roues motrices de l'Outback australien. Il a également été traversé par la funeste expédition de Burke et Wills de 1860 à 1861, dont les membres sont morts alors qu'ils avaient rallié la rivière Coopers Creek moins de vingt-quatre heures après qu'un groupe de sauvetage, présumant qu'ils avaient péri, était reparti. Les dunes et les plaines gravillonneuses du Strzelecki sont considérées comme d'importants refuges pour de nombreuses espèces autochtones adaptées au désert.

Strzelecki-Wüste

Die Strzelecki-Wüste liegt im Ländereck zwischen den australischen Bundesstaaten South Australia, Queensland und New South Wales und wird vom Birdsville Track durchquert, einer der attraktivsten Pisten für Geländewagen-Fans im australischen Outback. Die Wüste wurde auch von der unglückseligen Burke-and-Wills-Expedition der Jahre 1860 und 1861 durchquert. Deren Mitglieder starben, als sie Coopers Creek weniger als 24 Stunden nach der Abreise eines Rettungstrupps erreicht hatten, der annahm, die Männer seien schon umgekommen. Die Sanddünen und Kiesebenen der Strzelecki-Wüste gelten als wichtiger Zufluchtsort für eine Reihe von an das Leben in der Wüste angepassten einheimischen Tierarten Australiens

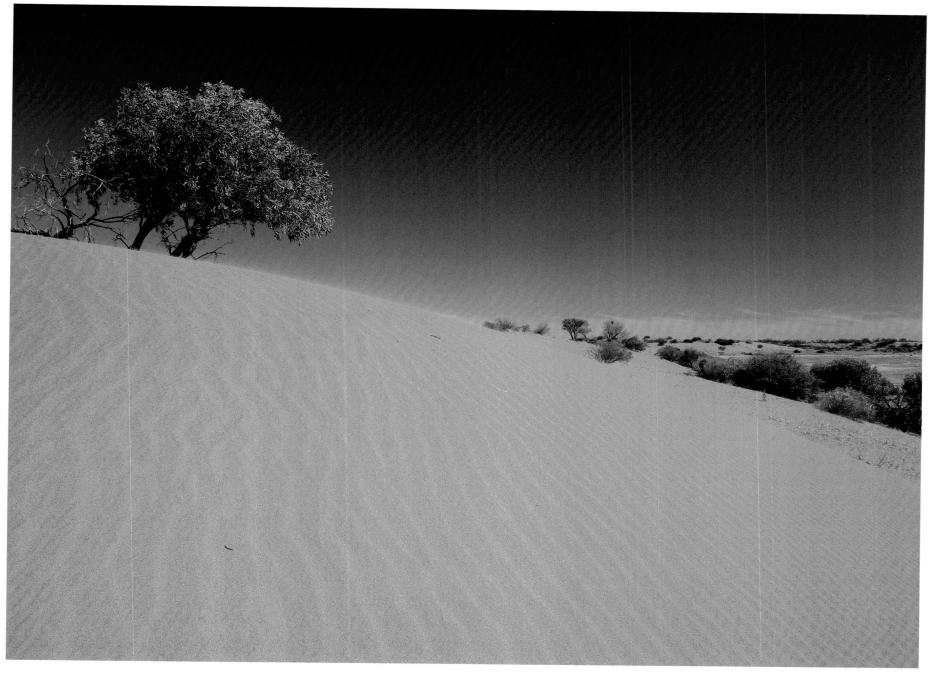

Dunes with vegetation

Desierto de Strzelecki

El desierto de Strzelecki habita en la intersección entre los estados australianos de Australia Meridional, Queensland Sudoccidental y Nueva Gales del Sur Occidental, y está atravesado por la ruta Birdsville Track, uno de los mayores premios para los entusiastas de las 4×4 en el interior de Australia. También fue atravesado por la desafortunada expedición de Burke y Will de 1860 a 1861; murieron al llegar a Coopers Creek menos de 24 horas después de que un grupo de socorro se hubiera marchado, suponiendo que los hombres habían perecido. Las dunas de arena y las llanuras de grava de Strzelecki se consideran un importante refugio para una serie de especies de fauna australiana nativas adaptadas al desierto.

Deserto Strzelecki

O Deserto Strzelecki habita a interseção entre os estados australianos da Austrália do Sul, Sudoeste de Queensland e o oeste de Nova Gales do Sul, e é atravessado pelo Birdsville Track, um dos maiores prêmios para os entusiastas das 4×4 no Outback australiano. Também foi atravessado pela malfadada expedição de Burke-and-Wills de 1860 a 1861; eles morreram tendo chegado a Coopers Creek menos de 24 horas depois que uma festa de socorro partiu com a suposição de que os homens tinham morrido. As dunas de areia e as planícies de cascalho do Strzelecki são consideradas um importante refúgio para uma série de espécies nativas australianas adaptadas ao deserto.

Strzelecki Desert

De Strzelecki ligt op de kruising tussen de Australische staten South Australia, South West Queensland en Western New South Wales. De Birdsville Track loopt er dwars doorheen, een van de aantrekkelijkste pistes voor bestuurders van terreinwagens in de Australische Outback. De woestijn werd ook doorkruist door de noodlottige Burke-and-Wills-expeditie van 1860 tot 1861. De deelnemers stierven nadat ze Coopers Creek minder dan 24 uur nadat een reddingsteam was vertrokken hadden bereikt. Het team was vertrokken in de veronderstelling dat de mannen waren omgekomen. De zandduinen en grindvlakten van de Strzelecki zijn een thuishaven van enkele wilde diersoorten die zich hebben aangepast aan de Australische woestijn.

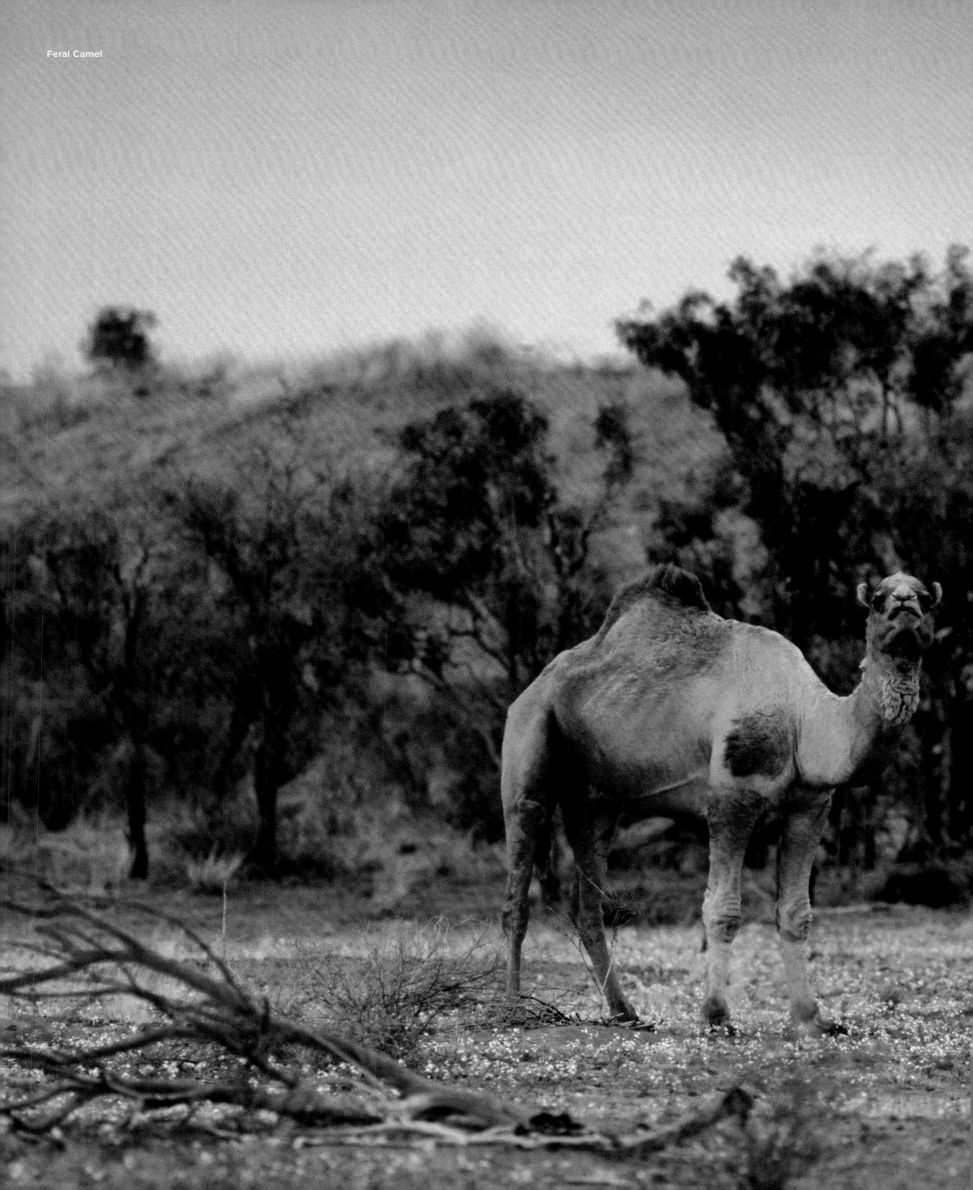

Feral Camel

Australian Animals

1 Termite mound; Termitière; Termitenhügel; Montículo de termitas; Monte cupins; Termietenheuvel

2 Bearded Dragon; Agame barbu; Bartagame; Pogona; dragão-barbudo; Baardagaam

3 Bilby; Bilbis; Kaninchennasenbeutler; Macrotis; Bilby; Langoorbuideldas

4 Australian Galah; Cacatoès rosalbin; Rosakakadu; Cacatúa Galah; Galah (Cacatua-de-peito-rosa); Roze kaketoe

5 Desert tree frog; Grenouille arboricole du désert; Wüstenbaumfrosch; Rana arborícola del desierto; Rã de árvore do deserto; Litoria rubella

6 Death adder; Vipère de la mort; Todesotter; Víbora de la muerte; Adicionador da morte; Doodsadder

7 Bearded Dragon; Agame barbu; Bartagame; Pogona; dragão-barbudo; Baardagaam

8 Australian fat-tailed Gecko; Gecko australien à queue grasse; Australischer Fettschwanz-Gecko; Gecko africano de cola gorda; Geco africano de cola gorda; Luipaardgekko

9 Rufous hare-wallaby with joey in pouch; Wallaby-lièvre roux avec un bébé dans sa poche; Zottel-Hasenkänguru mit Jungtier im Beutel; Ualabí liebre rojizo con cría en bolsa; Rufous Hare-wallaby com joey na bolsa; Westelijke buidelhaas met jong in de buidel

10 Olive python on top of a termite mound; Python olive au sommet d'une termitière; Olivpython auf einem Termitenhügel; Pitón olivácea sobre un montículo de termitas; Olive python no topo de um cupinzeiro; Olijfpython op een termietenheuvel

11 Thorny devil; Diable cornu; Dornteufel; Diablo espinoso australiano; Diabo espinhoso; Bergduivel

12 Australian feral camel; Dromadaires australiens; Australisches Wildkamel; Camello cimarron australiano; Camelo feroz australiano; Dromedaris

503

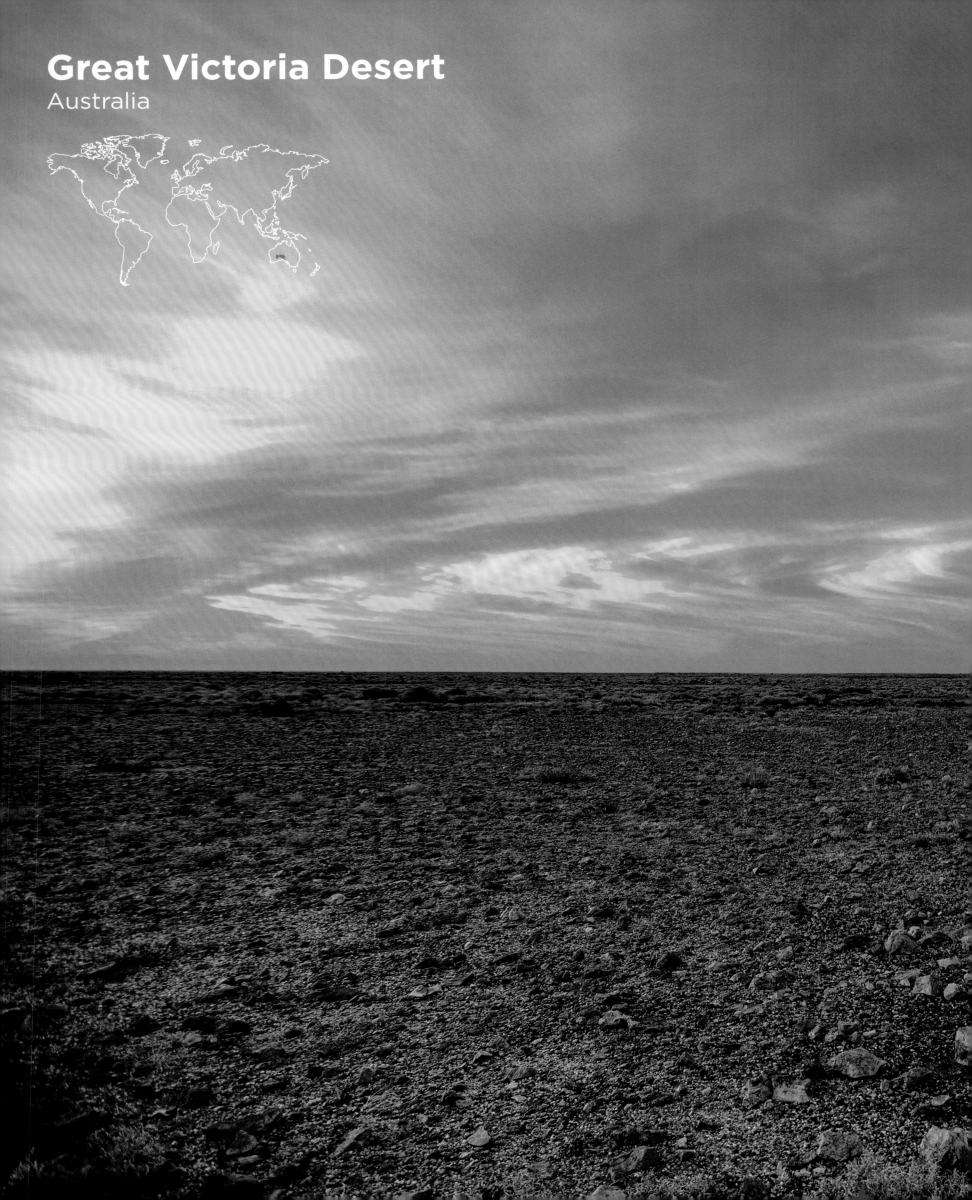

Great Victoria Desert
Australia

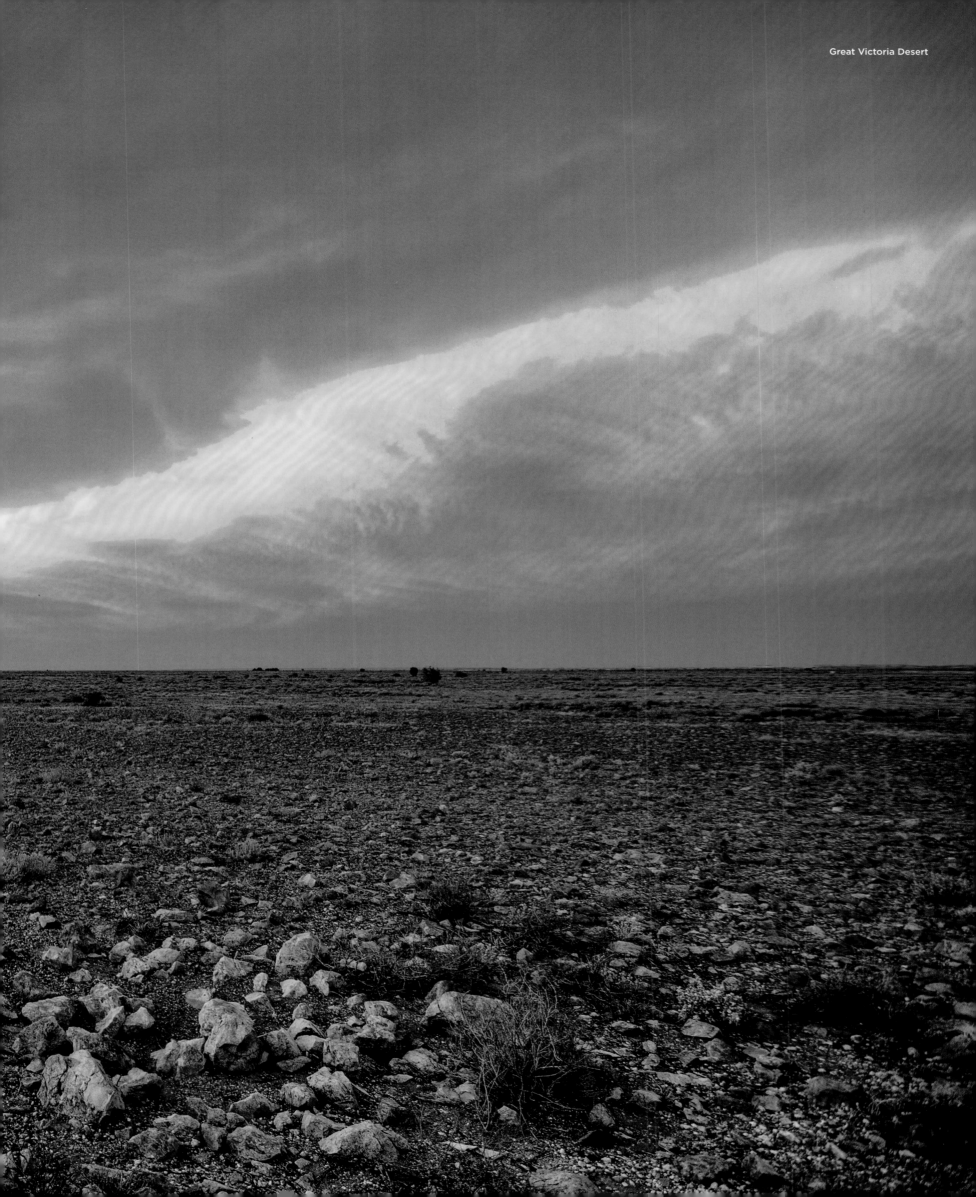

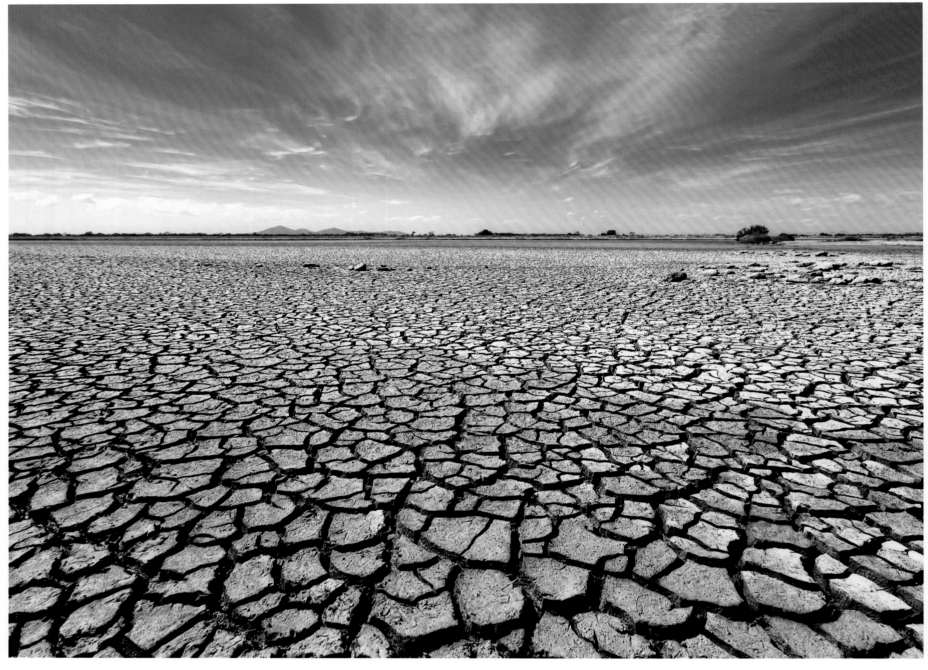

Barren plain with parched soil

Great Victoria Desert

Australia's largest desert extends from the heart of the Outback to the shores of the Great Australian Bight. British explorer Ernest Giles, the first white man to cross the desert in 1875, named it after and claimed it for Queen Victoria, although the traditional owners had long been the Kogara, Mirning and Pitjantjatjara people.

Gran Desierto de Victoria

El desierto más grande de Australia se extiende desde el corazón del Outback hasta las costas de la Gran Bahía Australiana. El explorador británico Ernest Giles, el primer hombre blanco en cruzar el desierto en 1875, le puso el nombre de la reina Victoria (y la reclamó en su nombre), aunque los propietarios tradicionales habían sido durante mucho tiempo los pueblos Kogara, Mirning y Pitjantjatjara.

Grand désert Victoria

Le plus grand désert d'Australie s'étend du centre de l'Outback jusqu'aux rivages de la Grande Baie australienne. L'explorateur anglais Ernest Giles, le premier homme blanc à l'avoir traversé en 1875, l'a nommé ainsi en hommage à la reine Victoria, même si les peuples Kogara, Mirning et Pitjantjatjara en étaient depuis longtemps les propriétaires.

Grande Deserto da Vitória

O maior deserto da Austrália se estende do coração do Outback até as margens do Great Australian Bight. O explorador britânico Ernest Giles, o primeiro homem branco a atravessar o deserto em 1875, nomeou-o depois (e reivindicou-o para) a Rainha Vitória, embora os donos tradicionais fossem desde há muito o povo Kogara, Mirning e Pitjantjatjara.

Große Victoria-Wüste

Die größte Wüste Australiens erstreckt sich vom Herzen des Outbacks bis an die Küste der Großen Australischen Bucht. Der britische Entdecker Ernest Giles, der erste Weiße, der 1875 die Wüste durchquerte, benannte sie nach Königin Victoria und beanspruchte sie für diese, obwohl die traditionellen Besitzer schon lange die Kogara, Mirning und Pitjantjatjara waren.

Grote Victoriawoestijn

De grootste woestijn van Australië strekt zich uit van het hart van de Outback tot aan de oevers van de Great Australian Bight. De Britse ontdekkingsreiziger Ernest Giles, de eerste blanke man die in 1875 de woestijn doorkruiste, noemde hem naar (en claimde hem voor) koningin Victoria, hoewel hij al heel lang werd bewoond door de Kogara-, Mirning- en Pitjantjatjara-volken.

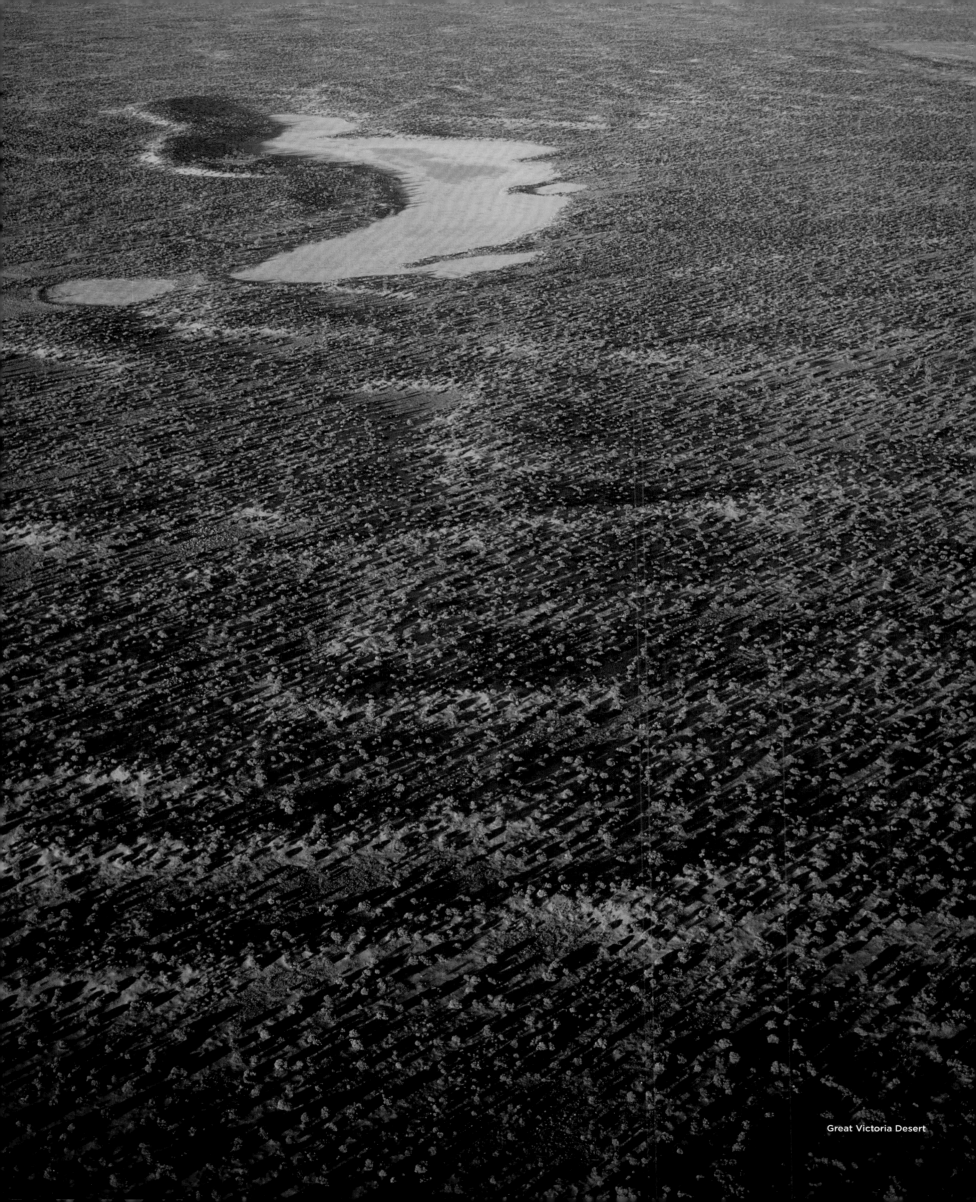

Great Victoria Desert

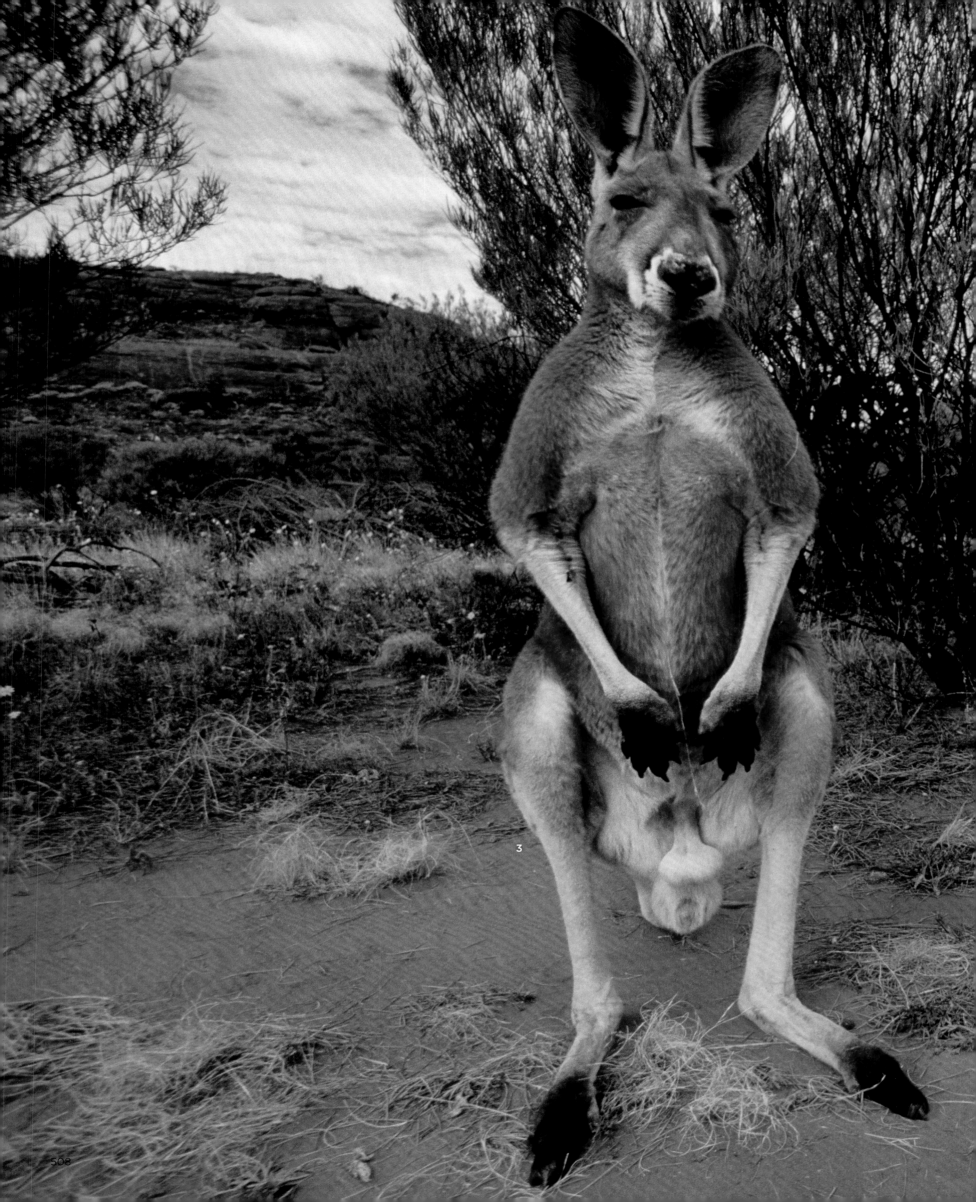

Red kangaroo (Macropus rufus)

Mulga and spinifex

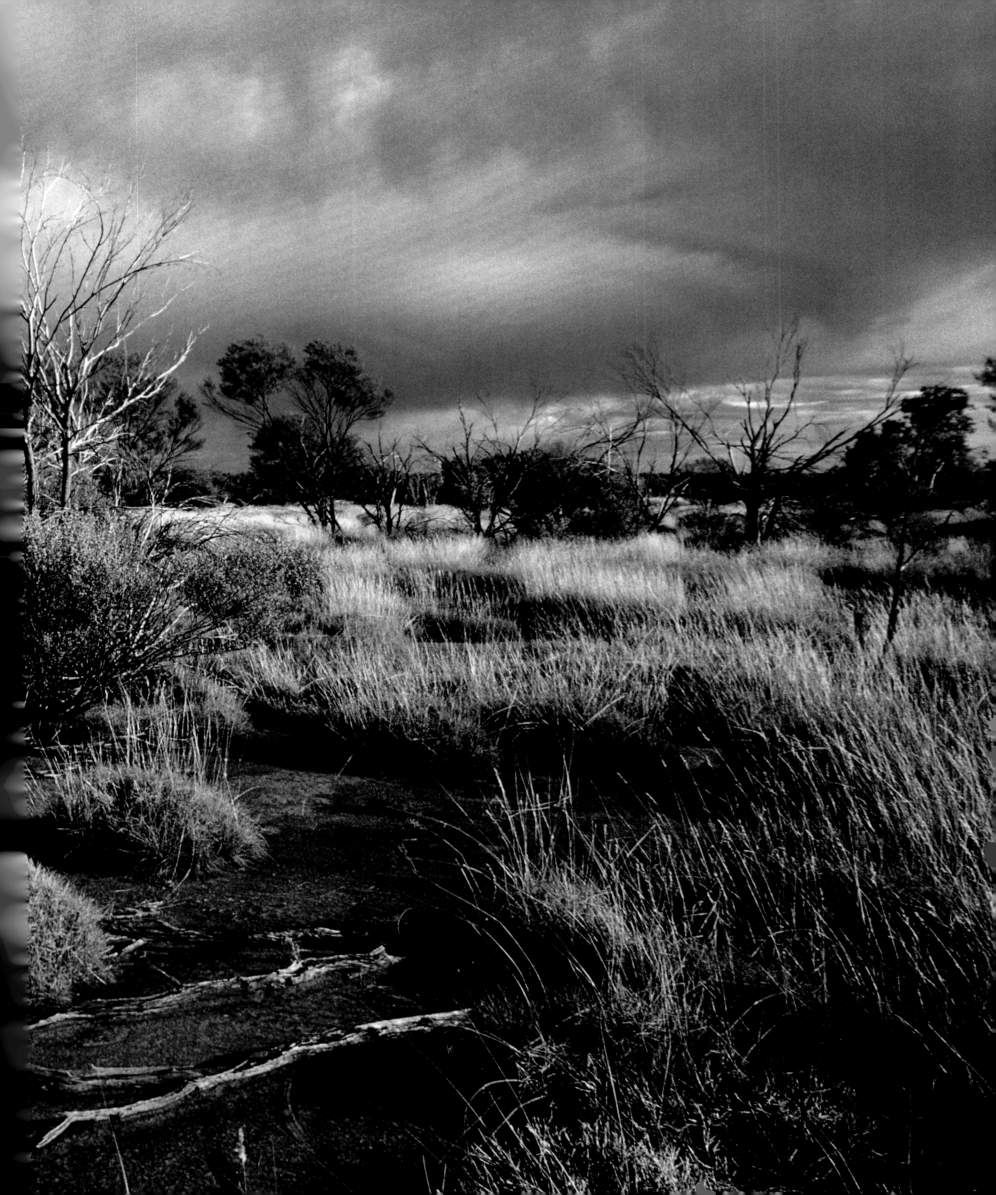

Photo credits